Neoclassicism and Romanticism

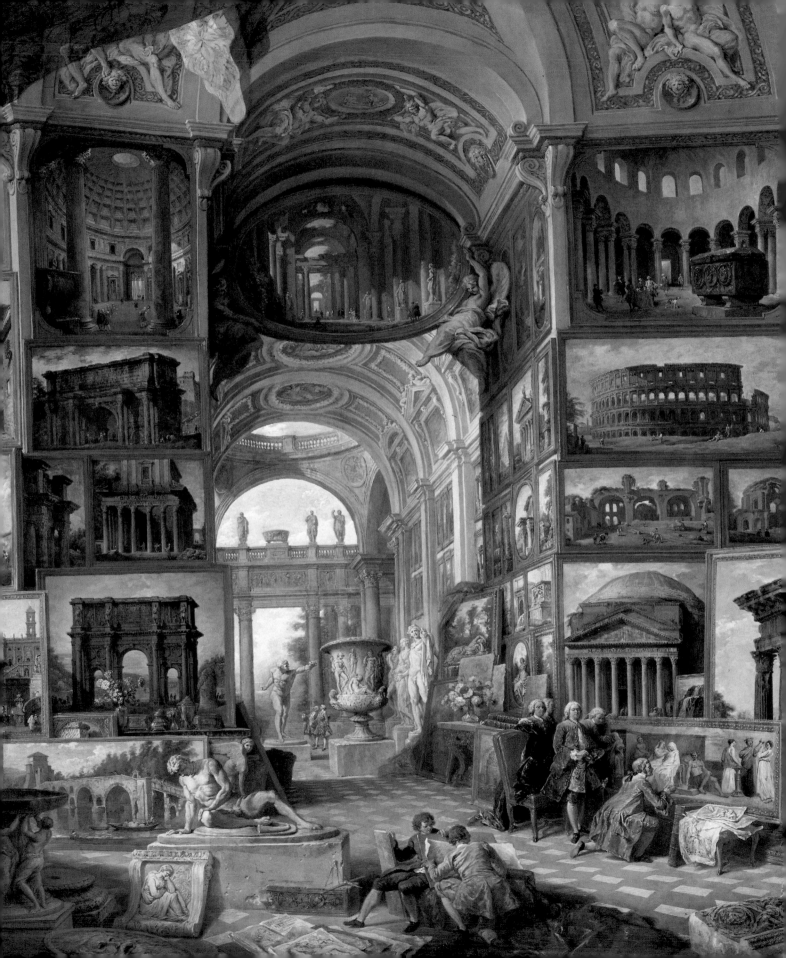

Neoclassicism and Romanticism

Architecture · Sculpture · Painting · Drawings

1750–1848

Edited by Rolf Toman

Photographs by Markus Bassler, Achim Bednorz,
Markus Bollen and Florian Monheim

ULLMANN & KÖNEMANN

© 2006 Tandem Verlag GmbH
KÖNEMANN is a trademark and an imprint of Tandem Verlag GmbH
Original title: *Klassizismus und Romantik*
ISBN-10: 3-8331-1430-4
ISBN-13: 978-3-8331-1430-4

Editing and Realization: Rolf Toman, Espéraza; Birgit Beyer, Cologne; Barbara Borngässer, Dresden
Editing and Preparation of Appendix: Ulrike Weber-Karge, Dresden
Photography: Markus Bassler, Dosquers (Girona); Achim Bednorz, Cologne; Markus Bollen, Bergisch-Gladbach;
Florian Monheim, Meerbusch
Picture Research: Monika Bergmann and Astrid Schünemann, Cologne
Cover Design: Werkstatt München

Translation from German: Paul Aston, Peter Barton and Eileen Martin in association with Cambridge Publishing
Management
Typesetting: Cambridge Publishing Management
Project Management: Jackie Dobbyne
Project Coordination: Kristin Zeier

© 2007 for this edition: Tandem Verlag GmbH
ULLMANN & KÖNEMANN is an imprint of Tandem Verlag GmbH
Special edition
ISBN 978-3-8331-3556-9

Printed in China

10 9 8 7 6 5 4 3 2 1
X IX VIII VII VI V IV III II I

Contents

Peter Pütz

The Renaissance to the Romantic Movement – An Outline of Ideas

In the Neoclassical and Romantic periods the fine arts were not only closely interwoven with the leading philosophical ideas of their time, but were also deeply rooted in the traditions of thought of the Modern Age. Since the end of the Middle Ages, the accent on the relationship between the human ego and the world outside it had been shifting increasingly away from the objective to the subjective standpoint. The shift in emphasis is evident in the theory of knowledge and in ethics, in social doctrine and theology. It is evident in Descartes' philosophy, when he based his doubting search for truth on *ego cogito* (I think) rather than on *cogitatum* (what is thought). That is, he based his philosophy on subjective awareness and not on something prescribed and pre-ordained. Kant and Fichte would later represent an even more radical view of the role played by the subject in cognition, but Spinoza, too, in his writings on knowledge, was concerned primarily to purify reason, and in his *Ethica ordine geometrico demonstrata* (Ethics demonstrated by Geometrical Method) he justified every person's need for happiness, explaining why no doctrine of virtue should ignore the self-preservation instinct. For Leibnitz, who coined the term "theodicy," the search to reconcile the presence of evil with the existence of God, not only must man justify himself to God, but God must also justify himself to man.

But the progressive subjectivization was not characteristic of philosophy alone; it was a key feature of other cultural phenomena in the Modern Age as well, and increasingly so during the Enlightenment. Since the Renaissance, the individual, with his or her unique powers and ability, had been sublimated in secular art, while in religious art the pietists moved away from a church that proclaimed objectivity. The guarantee of faith was no longer the Church itself, but the personal decision made in true conscience and direct partnership with the "spiritual bridegroom." We also see the advance of subjectivity in the increased battle against authority in the broadest sense. And the epochal event in art history, the discovery and mastery of perspective, was born of the same principle. For what else is perspective than the relation between the object observed and the position of the subject observing it? The flat painting of the Middle Ages ignored that standpoint. In its reference to the objective truths of salvation there was no room for relativity and perspective, but now the world was no longer seen as flat, there were no universal truths, and everything depended on the subject's position. And how deliberately strange, indeed eccentric perspectives were sought and represented? One only need recall the foreshortened bodies that Mantegna painted!

As far as the design of living space was concerned, in landscape and urban planning respect for the prescribed and God-ordained gave way to the almost imperial will of the intervening subject. Philosophical interest in method and practical application also spread to urban design. In his *Discours de la méthode* Descartes

complained bitterly of the state of the old towns, where the streets and alleyways were twisted and full of nooks and crannies, and where the houses were bizarrely irregular, as if chance and not the will of people of reason had set them there. Instead, he demanded the co-ordinating designs of engineers, and these demands were soon met: in the next few decades the streets were straightened and the house façades co-ordinated – as Goethe noted with approval on his arrival in Leipzig. And nature was literally "tackled": in French gardens the bushes and hedges were carved into pyramids and balls to create the *ordine geometrico*. As little scope as possible was to be left for things to grow naturally, to shoot and flourish at random, for nature to reign uncontrolled. This principle applied not just in town planning and gardening, but also in education. When Rousseau rebelled against this, he was not opposing the process of progressive subjectivization; he was in fact encouraging it, by defending the claims of individuality even beyond those of subjectivity.

The increasing role of the subjective in various fields was based on a fundamental attitude to life in the early Modern Age. The awareness grew that humans had replaced the Earth as the centerpiece of the universe. The accent shifted, from God and life after death to human beings and life on Earth. The idea that humankind was the standard by which all was measured was inherited from Antiquity. The re-emergence of this concept formed the core of the Renaissance and the Enlightenment. Theology and demonology acquired rivals in the natural sciences and history.

The history of man on Earth had little interest for thinkers in the Middle Ages. For them the way into this world led through a vale of tears, and the only way out was through salvation; it was this that primarily gave the world meaning. The end of the story, the Last Judgment, was awaited with fear or longed for in hope. The more concrete conditions under which people make history or suffer it were gifts from a gracious God or the consequences of the fall from grace. But from the 16th century the idea began to gain ground that humans were not helpless creatures, but were active subjects who could – and should – take their own history in hand. Hence the conditions that would make possible a reasonable life with a promise of happiness needed to be examined and improved. From the 16th century, Utopias and ideas on reform were put forward by thinkers from Thomas More and Campanella to Rousseau and Montesquieu. Towards the end of the Enlightenment they culminated in the central, overwhelming event of the French Revolution. Friedrich Schlegel placed it before Fichte's doctrine of knowledge and Goethe's *Wilhelm Meister* as "one of the greatest movements of the age."

All these ideas can be grouped under the term "progressive subjectivity" in the broadest sense. They were spread through ways that the Middle Ages had not known. After the invention of book printing, written works could be circulated at lower cost,

faster and with incomparably greater effect. Art and science were no longer the privilege of the monasteries and orders, but were accessible to individuals. Towns like Nuremberg, Frankfurt, and Augsburg were, from now on, trading centers not only for cloth and grain, but also for knowledge and skills. The first great step towards the intellectual development of the middle class came in the Renaissance, and the next followed in the second half of the 18th century, when book production multiplied. The art of the printer did the Enlightenment inestimable service.

The tendency to subjectivity that had been growing since the start of the Modern Age was not only part of the history of ideas, but also played a part in social history, in the development of the middle class. Subjectivity is the substratum of the middle class' self-awareness and self-assertion. While the aristocrat was privileged from birth through his mere membership of a class, the middle class could only distinguish themselves by their own achievement; they literally had to earn recognition. The nobleman could be content simply to be, as Goethe's Wilhelm Meister tells his brother-in-law, who has remained at home; but the middle-class man has to make himself into something. He never works – at any rate not consciously – for his class, always only for himself. He sees his fellow citizens primarily as competitors, and rivaling individuals do not constitute a closed group. For a long time the middle class did not even have a sense of community. Again, the aristocracy benefited from this deficit on the part of the middle class, for they used individuals for their purposes – as trading partners and stewards, officials or advisers, and sometimes as artists. Ultimately there was nothing more elevating for the individual citizen than to be ennobled by his lord in reward for his services.

OPPOSITE:
William Blake
Albion, Symbolic Figure, 1794–96
Copper engraving, color print, 25.3 x
18.8 cm
The British Museum, London

Man's radiant emergence from the chains
of the old orders also entailed a
confrontation with himself to an extent
hitherto unknown, to answer the
question: Who am I?
The newly-gained liberty freed the
individual, but it also forced him to
design his own life.

BELOW:
John Henry Fuseli
Self-Portrait, 1780–1790
Black chalk heightened in white
27 x 20 cm
Victoria & Albert Museum, London

The individual nature of the middle class may have prevented the development of a group mentality, but it also released enormous energies, which in the second half of the 18th century brought a huge upswing in economic prosperity and culture. As the middle-class could not be content simply to be, but must direct all their efforts to becoming something, this released strength that the nobility could not produce, because they did not need to. So middle-class subjectivism led to immense effort and even greater economic and intellectual achievements, resulting in the most far-reaching discoveries and inventions, things never thought before, dreams never dreamt before. The much-misinterpreted, ceaselessly striving "Faustian man" is in his innermost being a radical bourgeois.

The mercantilist economic system of the 17th century was no longer appropriate for the middle class with its emphasis on subjectivity, for it was solely directed to increasing the power of the absolutist ruler. The ruthless striving for an active trade balance reflected the centralist interests of the sovereign for his land and his dynasty. But the middle class, economically stronger in the second half of the 18th century, saw themselves as producers and merchants, not first and foremost bound to their land and prince. They pursued their own prospects of profit, and in doing so removed state controls on trade and engaged in business as they saw fit. In the place of mercantilism a liberal *laissez-faire* developed, in which middle-class capitalism could prosper. These business activities respected neither dynastic nor national frontiers, and this created the material basis for the cosmopolitanism of the age of Enlightenment.

All these tendencies to progressive subjectivity came together in the 18th century, working as driving forces for the Enlightenment. The essay that Kant devoted to this – *Beantwortung der Frage: Was ist Aufklärung?* (In Answer to the Question: What is Enlightenment?) – expresses the same idea in philosophical terms, when he uses the word "self" ("selbst") in various combinations in the very first pages ("self-indebted," "thinking for oneself," and so on). He repeats it in the same sense and gives it greater emphasis by speaking in positive terms of the individual's "own" reason and intellect. As the individual effort to obtain insight and knowledge – "Have the courage to make use of your own reason!" – can only be undertaken by the self, this effort is stimulated not by the generally binding laws of logically correct activities, but by individual acts of will, the power to take decisions. The enemies are not so much wrong decisions as "laziness and cowardice." Enlightenment is not based on logic, but on the ethics of cognition. So enlightenment is not the same as the cognition, scholarship or thinking that have always been pursued, but means to think differently. While the general exercise of reason is aimed exclusively or mainly at the acquisition of knowledge, enlightenment is directed to the same extent at and against resistance to the acquisition of knowledge. Resistance of this kind evolves out of

the inherent nature of the knowledge, in the form of prejudice and emotions that confuse reason, or, coming from outside, it blocks the way for reason in the form of authorities and the bearers of office. All these should be combated, and their claims warded off. Their values must be examined, reversed and if necessary destroyed. This is the intellectual dynamite of the Enlightenment.

However, in the 18th century, reversal as the basic principle of the Enlightenment, and as the logical-stylistic tool of its authors, did not lead to a reversal of all values and utter turbulence, to the predominance of negativity. The Enlightenment was not directed to disorder, but to a reordering of what already existed.

German Neoclassicism – in German the period is Classicism, in England and the U.S.A. it is known as Neoclassicism – provided a particular model for this, as its forms and ideas were, in many

9

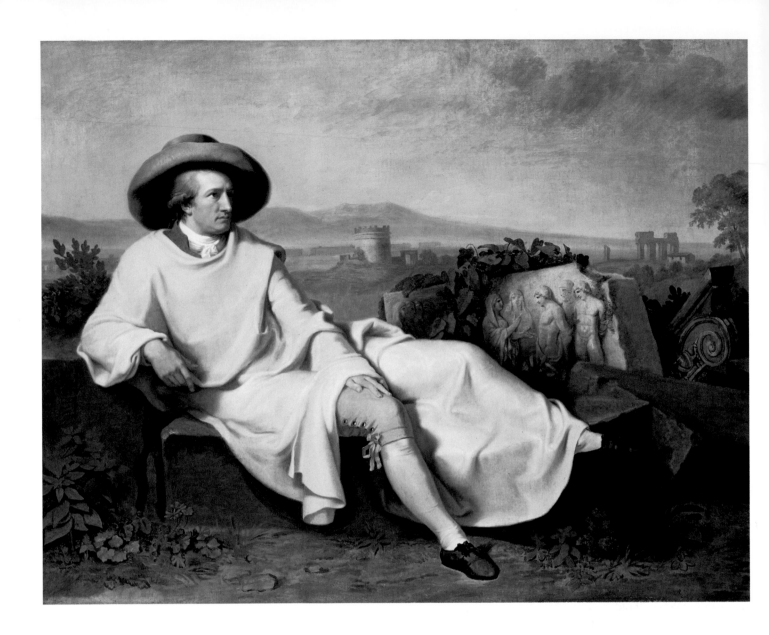

respects, based on the principle of the synthesis of opposites. As Kant in his *Critique of Judgment*, the "classical" book of German idealism, mediates between pure and practical reason, between freedom and nature, Schiller points to a third option, in which the antagonisms that still exist between grace and dignity, intuitive and analytical literature ("naive und sentimentalische Dichtung") appear to be reconciled. The attempts to mediate were not directed only at ethical-aesthetic problems, but at every area of human thought and life, human nature and history. So Neoclassicism aimed for a synthesis between Antiquity and Christianity, the Enlightenment and the age of the genius, the heart and reason, freedom and causality, even between God and man. The result of the mediation between historical, anthropological and theological opposites applies equally to aesthetic standards and poetical practice. Goethe transferred the synthetic principle of thought as a structural law to his literary works, in which – as in a classical

Greek temple – horizontals and verticals were to be linked in the simplest yet most necessary way. Neoclassicism manifests itself not only through the intended harmony of ideas, but also through the appropriate artistic organization of their form. In *Wilhelm Meister's Lehrjahre* (Wilhelm Meister's Apprenticeship) the desired representation of reconcilable totality corresponds for the first time in the history of the German novel to the universal relevance of its structural elements, in a way that permits no further external or isolated elements, and certainly not digression.

The principle of progressive subjectivity was promoted strongly in the age of Enlightenment and restrained only moderately by the German Neoclassical movement. In the literature and thought of the Romantic movement it became the total abandonment of all frontiers and limits.

For Fichte, the most stimulating mind of this period, the ego not only sets itself, it also produces the non-ego. Friedrich Schlegel

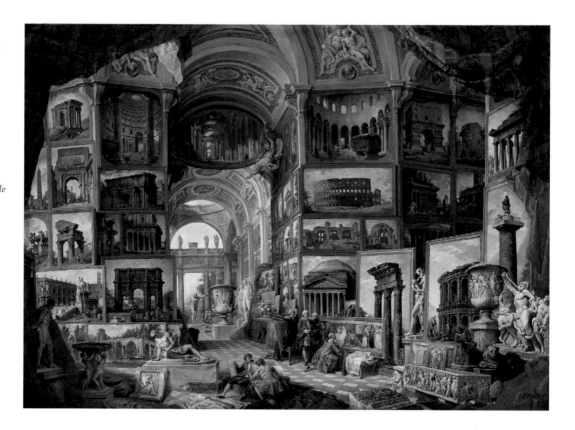

called his program "progressive universal poetry." "Progressive" meant that the Romantic movement did not abandon the principles of Neoclassicism, with its adherence to Antiquity, and it certainly did not reject them, but it did step beyond them. The undoubted perfection of Greek art was not to be conserved, but made part of a future-oriented process, the aim of which was to seek perfection over and over again. In their fundamental refusal to accept the idea of finality the Romantics did not crown their efforts with a final synthesis – the synthesis was whirled into the ceaseless movement of the progressive subject. For Romantic artists there was no "hold," and consequently nothing to cling on to; they were without ties and subject to no conditions. The core of their subjectivity expanded like a stellar system, as it were, into the universe. The images of this ceaseless striving are the Romantic motifs of people constantly setting off for new shores, because happiness has not been found at any of the places already reached. If the people depicted are not wandering in the open air, and in most cases away from something rather than towards something, they are listening and gazing longingly out of a window into the distance or out to the open sea, as if yearning for the boundless depth beyond the horizon.

The second word in Schlegel's formula "progressive universal poetry" also suggests the idea of transcending limits. The aim of the progressive is the universal in its unattainability. The limits to the depictable that were respected in the Enlightenment and Neo-Classicism are broken through in the Romantic movement. Now, what was hemmed in, or even banished, again becomes a favorite theme, like the wondrous, magic, and unearthly – as in the Middle Ages, which the Romantics so revered.

LEFT:
Asmus Jakob Carstens
Night with her Children, Sleep and Death, 1795
Black chalk heightened with white on brown paper
Two sheets joined and mounted on board
74.5 x 98.5 cm
Staatl. Kunstsammlungen, Weimar, Inv. KK 568

the fragmentary nature of their works. Some authors committed suicide, others converted to Catholicism.

In their tendency to the open form, genres also open to each other, and their borders become penetrable. Literature moved towards "universal poetry," while the favorite genre, the novel, absorbed lyrical and dramatic elements, thus anticipating Richard Wagner's concept of the total work of art. The theater played less of a part in the Romantic movement, disregarding from Kleist's monumental achievement. This was in keeping with the tendency to the open and illimitable, for the drama, like no other literary genre, demands concentration, limitation and conclusion. As "progressive universal poetry" cannot be restricted by specific contents and forms, it also breached its bounds and moved into arts outside literature. In no other period of German literature was there so much reference to music and painting. Conversely, composers and painters looked to literature – Franz Schubert, Robert Schumann, Caspar David Friedrich, Philipp Otto Runge. The impetus to the "progressive" not only went beyond the bounds of the genres and arts, it also moved into fields outside art, like theory and philosophy, until finally all areas of thought and existence were incorporated in the harmony of Romantic universality. Schleiermacher spoke out for theology, the Brothers Grimm founded the study of German language and literature, Savigny romanticized the doctrine

Literature opens to radical free thinking and free love (in Friedrich Schlegel's *Lucinde*), to the seraphic (Novalis) and the supernatural (E.T.A. Hoffmann), to the heavenly (Eichendorff) and hellish (Tieck's *William Lovell*). The lack of barriers in the subjects that writers choose is matched by their excessive forms of expression. Instead of discipline and moderation, unbridled passions now dominate mood and minds. Characters are inclined to extremes, they stop at nothing, they burn themselves out in intellectual radicalism, they reach no conclusion. The only alternative to self-destruction is often the abrupt break. The Romantics' abhorrence of a firm conclusion is evident, if only in

While Erhard's picture of friendship, *Two Artists Resting in the Mountains*, conveys the romantic mood of a serene summer day, Carsten's drawing (top) is an allegory on the relation between night, sleep, and death. This darker side of human life was rather suppressed in the Enlightenment, but the Romantics made it their own, in both literature and the fine arts.

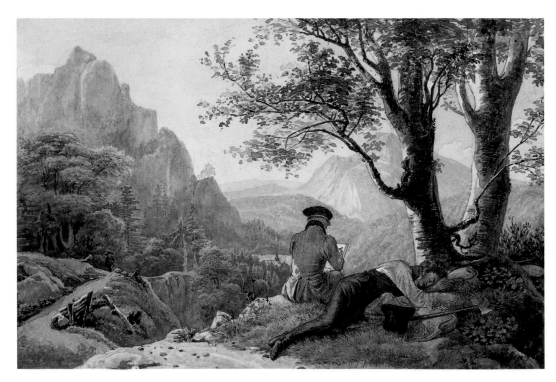

RIGHT:
Johann Christoph Erhard
Two Artists Resting in the Mountains,
1817
Watercolor, pen and black ink over
pencil, black outline
12.8 x 18.4 cm
Kupferstichkabinett, Kunsthalle,
Bremen, Inv. No. 52/226

Runge's drawing *The Poet at the Spring*
may look lyrical and tender at first sight,
but it is also an example of the high
intellectual standards Runge set in his
art. Humankind – particularly the child –

and nature were to him a symbol of the
cosmic relationship that governed all the
processes of creation and decline.

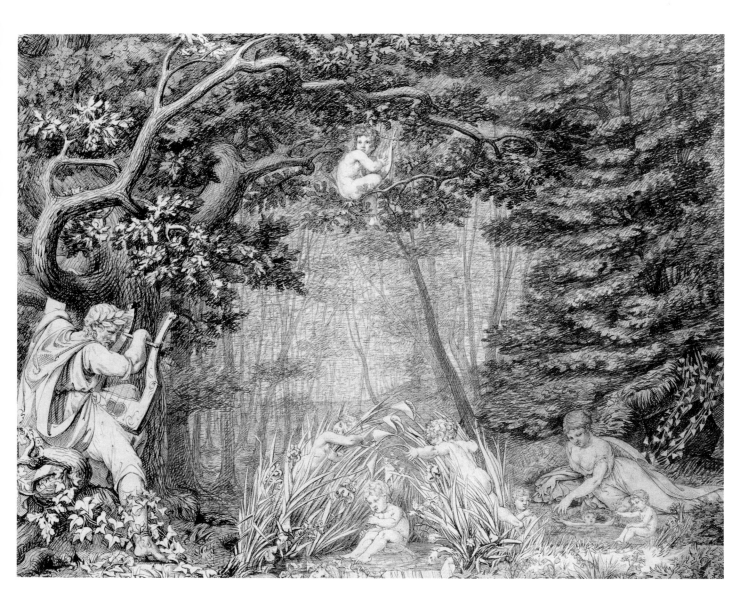

of law, and even the sober science of economics was given a stimu-lating upswing with Adam Müller's theory of state and society.

It would be a mistake to equate Romanticism with irration-ality, for the unbridled emotions were combined with an unswerving effort to comprehend, not only by Fichte, Schelling, and Schleiermacher. The barriers between feeling and thought were also lifted, so that even the most untrammelled emotion had to justify itself before the tribunal of self-reflection. In scarcely any other epoch of the history of ideas did writers reflect so critically on their activity, even to the point of questioning the process of

thinking about this thinking. How insistently they explored the conditions and scope of their own occupation is evident from Friedrich Schlegel's first Athenaeum fragment, which is aimed at philosophers: "There is no subject on which they philosophize more rarely than philosophy itself." This reproach that there was insufficient reflection on reflection makes the progressive crossing of frontiers into a program, leading to the negation of determinant and conclusive forces. In order to aim for a comprehensive whole, the Romantics demanded progression through ceaseless negation, and in that sense the Romantic program still continues today.

Ute Engel

Neoclassical and Romantic Architecture in Britain

Britain as a world power

In the second half of the 18th century, Britain rose to become a leading world power – a position that it would keep into the 20th century. The circumstances that brought this about were partly the constitutional monarchy created by the Glorious Revolution of 1688, which restricted the king's power in favor of Parliament, guaranteeing personal liberties and thus allowing the development of a self-confident middle class, and partly the country's great economic strength, which led to its early industrialization. A further important factor was a British colonial empire that spanned the globe, extending from Canada via India to Australia and Africa. In the coalition wars against Revolutionary and Napoleonic France between 1793 and 1815, Britain contributed decisively to the defeat of Napoleon, and at the Congress of Vienna in 1814/15 asserted its command of the sea and its policy of the balance of power.

From 1714, the German house of Hanover was on the throne of England. Only the third monarch of the dynasty, George III (reigned 1760–1820), played any significant part in British politics, but his effectiveness was so severely curtailed by periodic mental illness, which first became apparent in 1788, that from 1810 to 1820 his son, the later George IV, had to become Regent. Thus, while 18th-century British architecture from 1714 is overall called Georgian, the period from the end of the century through the first quarter of the 19th century is often termed Regency. More interested in pleasure than politics, George IV (reigned 1820–30) was an important patron of the fine arts and architecture. After his death, his brother William IV took his place, to be succeeded in turn by his niece Victoria (reigned 1837–1901) in 1837, whose reign marked a new epoch in British politics and culture.

Domestic politics in England in the 18th and 19th centuries were – and basically still are today – governed by the opposition of Whig and the Tory parties. The monarchist Tories represented the old aristocracy, and during the French Revolution developed into the Conservatives, while the normally reform-minded Whigs represented the gentry and prosperous middle class, adopting the position of the Liberals. Unlike in France, the constitutional monarchy in England proved both so flexible and so stable that political and social reforms were possible within the existing system without revolutionary coups.

The strength of the British economy – the result of a combination of naturally favorable circumstances (rapid access to the sea and a good river system, the presence of iron and coal, a leading position in textile production dating back to the Middle Ages, progressive agriculture) – increased hugely during the Industrial Revolution from about 1760, making the country the most important trading nation in the world. The infrastructure was improved, initially by a system of narrow canals, turnpike roads, and new bridges, and from 1825 by the development of a

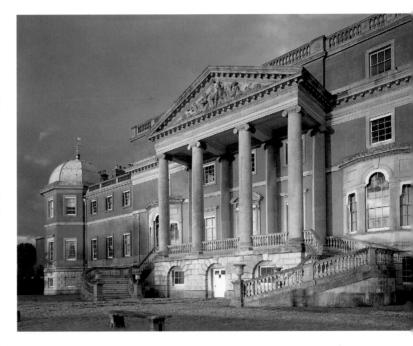

Isaac Ware
Wrotham Park, Hertfordshire
Garden façade, 1754

national network of railways. Britain also led the way in mechanization and inventing new techniques and production methods. Commencing with the textile industry, labor was now concentrated into factories, and a rapidly growing population crowded into the towns. At the beginning of the 19th century, London, with over one million inhabitants, was the largest city in Europe. Other large conurbations developed in the industrial centers of the Midlands and the North, such as Manchester, Birmingham, Liverpool, and Leeds.

The Industrial Revolution and the social changes associated with it affected the history of architecture in many ways. Whereas until well into the second half of the 18th century the principal building commissions had still been for palaces, churches and the great country houses of the aristocracy, from the beginning of the 19th century the focus was on public buildings to do with government and education, commerce and trade in the towns. The newly important and very wealthy middle class now constituted the most significant pool of clients.

The predominance of Palladianism

Until the mid-18th century, British architecture was wholly dominated by Palladianism. The confusions of the Civil War and the Glorious Revolution had been succeeded by a construction boom, which focused principally on the great houses in the country. Virtually every landowner wanted a showy residence on his estates and a town house in London. Society lived in town only during the winter (the *season*), while the summer was spent in the country minding the estates, pursuing field sports and socializing with the *county*.

After the introduction of the constitutional monarchy, aristocratic and wealthy middle-class clients, flushed with a new self-assurance, were the first in Europe to abandon the grammar of the Baroque for the design of their country houses and look for a more restrained, moderate concept of design that would nonetheless impress their friends and neighbors. They found it in the architecture of the Italian Renaissance architect Andrea Palladio (1508–80), whose buildings are distinguished by great simplicity and balance, based on the strict application of symmetry and a logically structured system of proportion. Palladio had already been blessed with national approval in that a major British architect, Inigo Jones, had used his works as a model back in the 17th century. Building Palladian in the 18th century thus meant building specifically British, in contrast to the cluttered Baroque style of the Catholic and absolutist countries in the rest of Europe. Consequently Palladio's architecture was endowed by English architects and patrons with the status of an ideal, the norm from which one could not deviate. Behind this conviction lay the view that beauty was something objective, resting on objective and universally applicable laws.

Thus, in the first half of the 18th century, the whole of Britain was covered with Palladian buildings consisting of clearly defined cubes, designed on a strict system of proportions and externally very sparingly decorated. Façades were marked with a large portico in the manner of classical temples, above a rusticated plinth level.

A second villa boom in the mid-18th century produced a crop of often smaller country houses around London for rich middle-class clients. An example is Wrotham Park (ill. p. 15), built by Isaac Ware for Admiral John Byng in 1754. The core of the house features basically the cube of a Palladian villa, with five window axes plus tetrastyle Ionic portico and pediment. The four floors consist of a rusticated plinth, a piano nobile, a mezzanine over it separated only by a simple band molding and, above the entablature, an attic floor with balustrade on top. The trade mark of Palladianism is also present in the outermost windows of the piano nobile, designed as typical Palladian Venetian windows – a round-arched central opening between two tall rectangular windows. But just at this point the plain cube is enlivened by a new, very British element: the windows are combined with three-sided polygonal bay windows rising from ground level. Bay windows featured in British architecture in the late Middle Ages and Renaissance, and from the mid-18th century were increasingly used in country houses. The polygonal ground plan is echoed in the corner towers.

15

Two revolutionary discoveries – Greek Antiquity and the Middle Ages

Even as Wrotham Park was being built, however, the supremacy of Palladianism was on the wane. The Enlightenment's thirst for knowledge had begun to spread to the investigation of classical sites; excavations began at Herculaneum in 1711, in Pompeii from 1733. The excavation finds increasingly showed that Palladio's data for classical houses was completely wrong. At the same time, traveling Britons began to venture more frequently beyond Rome, the traditional destination of the Grand Tour. In 1751–55, Nicholas Revett and James Stuart were the first to survey the classical temples in Athens. Published in 1762, their work *The Antiquities of Athens*, with its accurate plans and views, proved highly influential, as did the expedition by Robert Wood to Syria in 1750 to explore the ancient sites of Palmyra and Baalbek. Wood presented his studies in book form in 1753 and 1757, launching therewith a long series of great English archaeological publications. With these tomes in its hands, the scholarly world discovered – to its astonishment – that Greek temples looked quite different from Roman ones, that, besides the Doric order known from Roman architecture, there was another more archaic version without bases and with squat columns, and that the architecture of the great Roman Empire itself was very heterogeneous. Antiquity was proving to be much more varied than had previously been assumed, and quite different from what the study of the published works of Palladio and other Renaissance architects had led scholars to believe.

The history of architecture suddenly appeared in quite a different light – and all the more so as, around the middle of the 18th century, another age was "discovered," namely the Middle Ages. Here, too, Britain led the way. The breach of the Middle Ages had never been as abruptly implemented there as in other countries. The British Renaissance was strongly influenced by the Late Gothic tradition, and after Henry VIII's break with the Catholic Church, Britain had followed a generally independent course, contrary to the Italian. Thus medieval features had already begun to appear in late 17th-century Baroque, and great British Baroque architects were already re-using Gothic forms, especially where medieval buildings were being added to. Sir John Vanbrugh (1664–1726) even advocated preserving medieval ruins because they kept alive the memory of the people who lived there previously and blended with their environment as in a landscape painting. This was effectively the first harbinger of the late 18th and 19th-century Romantic passion for ruins.

Around the middle of the 18th century, the English preoccupation with Gothic grew stronger. Gothic was considered a Christian and national architectural style, and attention focused on the direct study of medieval English buildings, researched and documented with the same scholarly meticulousness as Antiquity.

At first limited to monographs about individual buildings, from the start of the 19th century the great series of works about English cathedrals by John Britton, John Carter, and Charles Wild made its appearance. A whole host of learned societies brought leisured noble and gentlemanly patrons together with artists and architects in order to promote classical and medieval scholarship alike. The Society of Antiquaries, founded in 1707, financed Stuart and Revett's survey of Greek temples in Athens; the Society of Dilettanti, established in 1733–34 especially to promote classical studies, financed Wood's expedition to Syria. In the first half of the 19th century, many local antiquarian societies were set up and made major contributions to medieval scholarship relating to the monuments in their area.

The roughly simultaneous "discoveries" of both Greek Antiquity and the Middle Ages around the mid-18th century brought with them a basic, revolutionary change in historical perceptions of the time. History, and with it the history of architecture, was no longer seen as a continuous current from Antiquity to the present, but was divided up into various periods and successive ages. When British architects and patrons now looked for a model for the design of their buildings, there was no longer a universally valid standard such as there had been in Palladianism up to the beginning of the 18th century. Now there were different styles of equal status from which one could choose. Selection was determined by the associations that went with particular styles and models and the function that a building had to fulfill. Beauty became more and more a subjective matter, and the great question that would preoccupy the whole 19th century was: "What style shall we build in?"

A new aesthetic principle: the picturesque

Two new aesthetic concepts exercised a decisive influence on the development of British architecture in the second half of the 18th century. Here too the classic, universally binding definition of beauty as harmony and balance was abandoned. In 1757, Edmund Burke published his influential essay called *A Philosophical Enquiry into the Origin of our Ideas of the Sublime and the Beautiful*, which notes that objects can evoke sundry sensations in the viewer, ranging from pleasure to fear and terror. With this, he established the foundations of an aesthetic philosophy of feeling that would lead to the Romantic principle. Burke made a distinction between beauty (the round, the smooth, and the soft) and the sublime (the infinite, the colossal, and the frightening). During the later 18th century, Burke's theory was elaborated with the addition of the picturesque, gaining theoretical underpinning in the 1780s and 1790s in publications by William Gilpin, Uvedale Price and Richard Payne Knight. The foreground was now occupied by variety, irregularity, the surprising, roughness, even decay. Landscapes and the buildings and objects

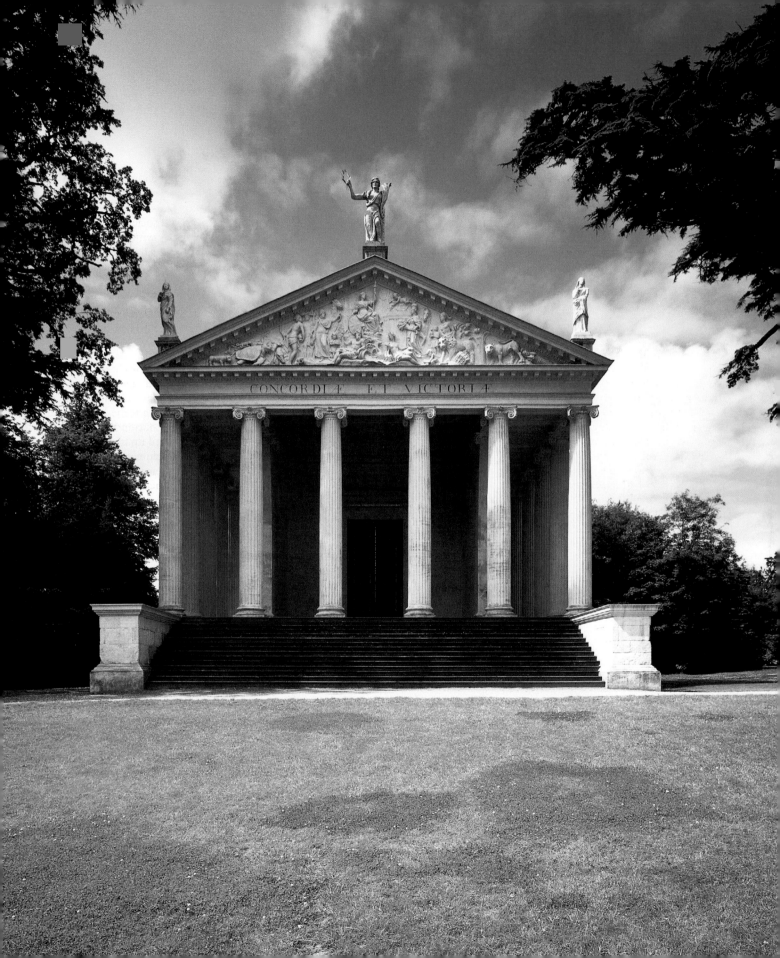

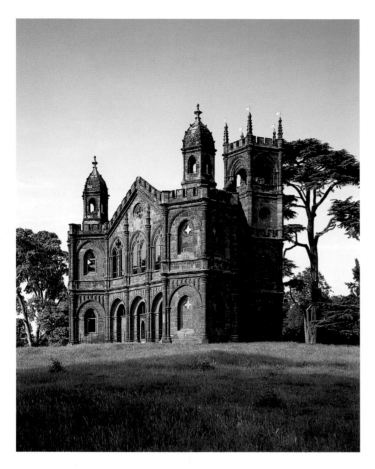

Experiments with landscape gardens

Thus the second half of the 18th century brought a wealth of new ideas for patrons and architects alike. Radical insights were gained into Antiquity, and the Middle Ages and Gothic architecture were discovered. New aesthetic concepts sharpened the eye to the associative and emotional qualities in architecture and its interplay with the environment. The opportunities for architectural design arising therewith were first tested in small-scale *staffage* buildings in English landscape gardens before they were transferred to large-scale structures. The English landscape garden was developed in the early 18th century in opposition to the geometric French garden, and in the orientation of its design to untrammeled natural growth was intended to symbolize the liberal, libertarian English political system after the Glorious Revolution. So most landowners of the reform-minded Whig Party often scattered small structures about their gardens that fulfilled the function of belvederes (summer houses) or garden houses only to a limited extent, being primarily bearers of a partially-coded political, moral or intellectual message.

An example of such a park is Stowe in Buckinghamshire. Here one of the first Gothic Revival buildings was constructed in 1741 (ill. p. 18) – a temple, a true folly, with a triangular ground plan and polygonal corner towers and asymmetrically placed turrets, adorned with round and pointed arches, quatrefoils, pinnacles, and battlements. The Gothic temple was dedicated to liberty; in its mosaic-decorated interior, the owner's Anglo-Saxon ancestors were commemorated. This early gothicizing was not seen as an overall architectural system but rather as a decorative vocabulary of individual features, and therefore was associated with a mixture of liberal ideas and glorification of the national past.

located in them were analyzed like paintings, with landscape paintings of the 17th century, especially the works of Claude Lorrain, Poussin and Salvator Rosa, supplying the models.

These new aesthetic theories led to the point where buildings were no longer considered as independent, self-contained formal units but as component parts of their environment. The effect of architecture on the viewer, the associations and feelings that various design approaches or building styles could conjure up, the alternation of light and shade, and projections and recessions, occupied the focal point of interest. A building now had to fit in with the surrounding scenery, and Uvedale Price demanded that the windows of a building should be so placed as to open the view on to particularly attractive objects and prospects. The ideal of symmetry was abandoned in favor of the more interesting asymmetry and irregularity, which permitted a more individual approach to design. Ultimately the new cult of the picturesque was linked with enthusiasm for ruins in their often painterly settings.

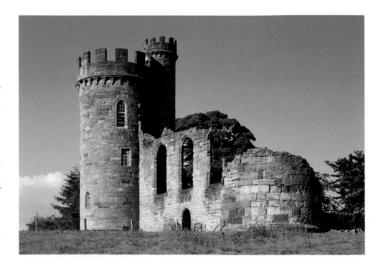

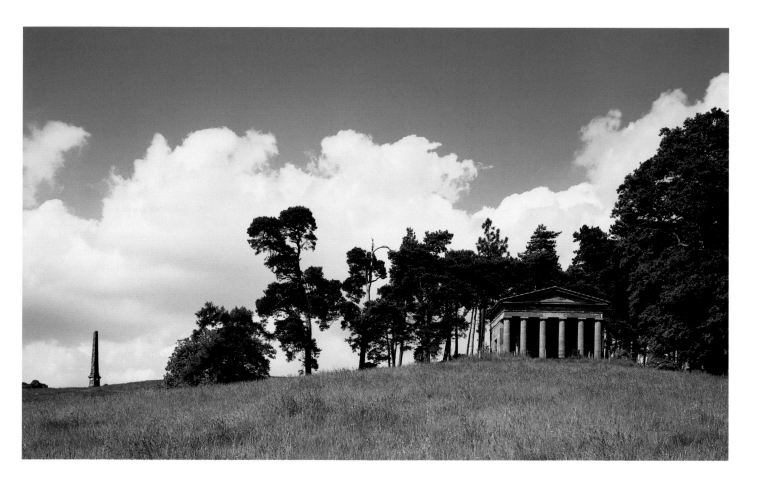

Yet the same idea was soon linked with Greece: around 1748, a "Greek Valley" was created at Stowe, presided over by a Greek temple containing a statue of Libertas Publica inside and the figure of Britannia on the tympanon (ill. p. 17). Though the structure is wholly modeled on antique models, they are not Greek models, which were not even known at the time, as we saw earlier, but in fact Roman, rather like the Maison Carrée in Nîmes, which the client may have seen on his Grand Tour.

The first faithful copy of a Greek Doric temple had to wait until 1758. It was built in the park of Hagley Hall, once again as a garden feature and placed picturesquely on a wooded hill (ill. p. 19). The temple, considered the first in the Neoclassical style, was constructed by the earlier-mentioned James Stuart soon after his return from Athens. Ten years earlier, in 1747, a Gothic counterpart had been built as an artificial castle ruin on another hill in Hagley Park by a founding father of the Revival, Sanderson Miller (ill. p. 18, bottom), and was used to house the park keeper.

Neoclassicism – Greek Revival

What had been tried out on a small-scale in landscape gardens was soon carried over into large-scale works, once again in both Neoclassical and Gothic versions. In both cases, it was country houses that led the way after the garden buildings, because there were no constraints arising from either the architectural environment or funding problems.

The new understanding of Antiquity, that was derived from archaeological expeditions and publications from the mid-18th century, resulted in clients and architects from the 1760s being dissatisfied with the classical grammar transmitted through the filter of the Renaissance. Instead, the aim was to turn directly to Antiquity for models, and an increasing number of archaeological publications provided accurate plans for these. In addition to this, it became customary for architects to survey and study Greek and Roman buildings on site as part of their training. The new direct approach to Antiquity first became apparent in the

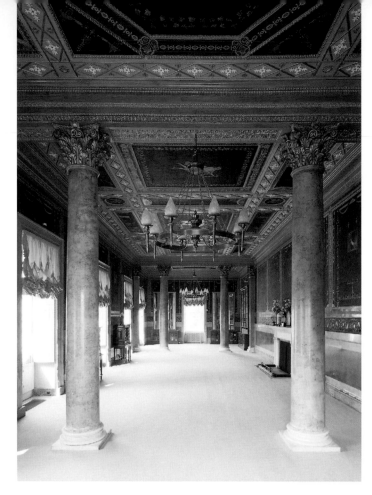

LEFT:
Joseph Bonomi
Pompeian Gallery, from 1782
Packington Hall, Great Packington,
Warwickshire

BOTTOM LEFT AND RIGHT:
Joseph Bonomi
St. James's Church, 1790
Great Packington, Warwickshire
Exterior and interior views

interiors of the great country houses. In this field, the uncontested master in the 1760s and 1770s was the highly successful architect Robert Adam, to whom a separate section is devoted (see pp. 37–42), as also to three other leading architects. In Great Packington, Roman-born architect Joseph Bonomi began work in 1782 on a Pompeian Gallery based on the wall designs discovered in Pompeii (ill. p. 20, left). The choice of color – black and red – was derived from paintings on Greek vases, of which the

client owned many. Likewise the church which Bonomi constructed in Great Packington in 1789–90 reflected an endeavor to create a radically new architecture on the basis of antiquity (ills. p. 20, bottom left and right). From outside, it consists of a pure cube with blank walls bare of all decoration, articulated only by semi-circular thermal windows and pepper-pot towers. The same purist severity reigns within. The four short, symmetrical cruciform arms, derived from Roman *thermæ* buildings, are roofed by coffered barrel vaulting. The groin vaulting of the square crossing rests on Doric columns in the corners with entablatures based on those in the Greek temples in Paestum.

However, most country houses built in the second half of the 18th century were less archaeologically accurate than Packington Hall. A good example is Dodington Park, constructed in 1793–1818 by the multi-talented James Wyatt (ill. p. 21, top). Externally much had changed in comparison with Palladian country houses of the first half of the 18th century. All decoration is dispensed with, and the windows are frameless. A monumental, hexastyle portico highlights the entrance façade. It stands directly on the ground, there being no rusticated plinth floor, nor indeed mezzanine and attic. Thus the house is only two-story, the grand rooms of the piano nobile moving to ground level. This innovation, appearing in country house design from the 1760s, had important consequences for the relationship between the house and its environment. First, the house is no longer elevated above garden level by a plinth, but is directly connected with it. This induced the important English landscape gardener Humphrey Repton to design the immediate environment of country houses as pleasure grounds, almost as extensions to the drawing rooms. Second, with regard to practical operation, the functions that had previously been housed at lower ground level or on upper floors

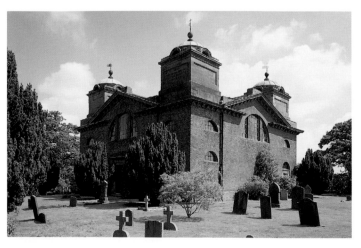

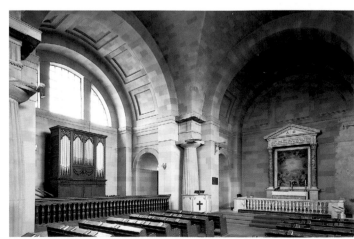

BELOW:
James Wyatt
Dodington Park, Gloucestershire
West façade, 1793–1818

BOTTOM:
William Wilkins
Downing College, Cambridge
North wing, seen from the south,
1807–21

(the kitchen, servants' rooms or guest rooms) had to be moved out of the house itself. This led to asymmetrically attached wings such as in Dodington, and a grouping of the architectural structures that corresponded to the theory of the picturesque.

After the beginning of the 19th century, it became increasingly fashionable to make accurate copies of Greek architecture, leading to a notably purist Greek Revival in Britain that affected all areas of building. Along with a general enthusiasm for Greek art and culture, Greek architecture was now considered unquestionably superior to Roman architecture. Particularly in the Doric Order, it was seen to embody an archaic ideal, the pure form from which everything sprang. By returning to Greek architecture, theorists saw the way to a new architecture reduced entirely to plain, cubic structures distinguished only by freestanding columns carrying porticos or colonnades. One of the first buildings to put this strict ideal into practice was another country house, The Grange in Hampshire, which William Wilkins rebuilt in 1804–09 as a Greek temple (ill. pp. 22/23). An outsize Doric double hexastyle portico rises in front of the façade on the model of the Hephaisteion and Theseion temple in Athens. The side façades follow the principle of prostyle temples. Wilkins used as his source Stuart and Revett's *Antiquities of Athens* as well as studies he had made on journeys to Greece, Italy and Asia Minor and published in 1807 as *Antiquities of Magna Græcia*. Like its small-scale predecessor, the Greek temple in Hagley Park, The Grange is located on the brow of a hill, and thus indicates a desire not just for archaeological accuracy, but also for the picturesque side of the Greek Revival. Another building by Wilkins belongs to the early period of this movement. Between 1807 and 1821 he was engaged on realizing his 1804 designs for Downing College in Cambridge, a completely unadorned elongated structure stretching alongside extensive lawns, accentuated only by Ionic porticos at the corners, which follow the model of the Erechtheion on the acropolis in Athens (ill. p. 21, bottom).

However, the greatest effect of the Greek Revival was felt in the new public buildings of the fast-growing cities. In this case, monumental temple forms were intended to express dignity and authority in governmental buildings or learning and intellectual grandeur in cultural institutions. In 1788, Thomas Harrison began his three-wing design for Chester Castle, which housed not only Cheshire County Hall but also the county court, a prison and barracks. The grounds are entered via a propylæum on the Athenian model (1810–22, ill. p. 23, top). The semi-circular Shire Hall with its coffered dome on full Ionic columns is fronted by a Doric portico. Authoritative porticos, pedimented façades, and rows of columns remained the chief characteristic of government buildings right down to the gigantic St. George's Hall in the prosperous industrial city of Liverpool, designed 1839–41 by Harvey Lonsdale Elmes and completed only in 1856 by C. P. Cockerell (ill. p. 23, below right).

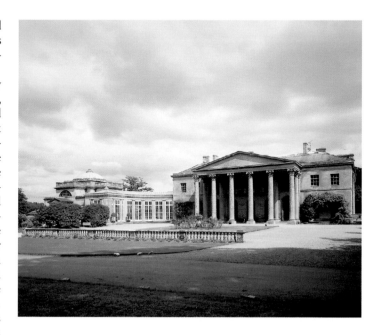

The Greek Revival proved particularly suitable for museum structures. In England, the most prominent representative of these new temples of the arts is the British Museum in London (ill. p. 24, top). It was constructed to house the collections of Greek sculptures acquired by the state from 1805. In addition, it acquired the royal library, which George IV made over to the nation in 1823, establishing the basis for what has now become the British Library. Robert Smirke began the now greatly

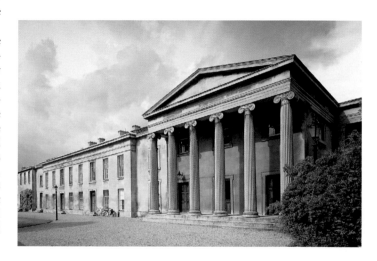

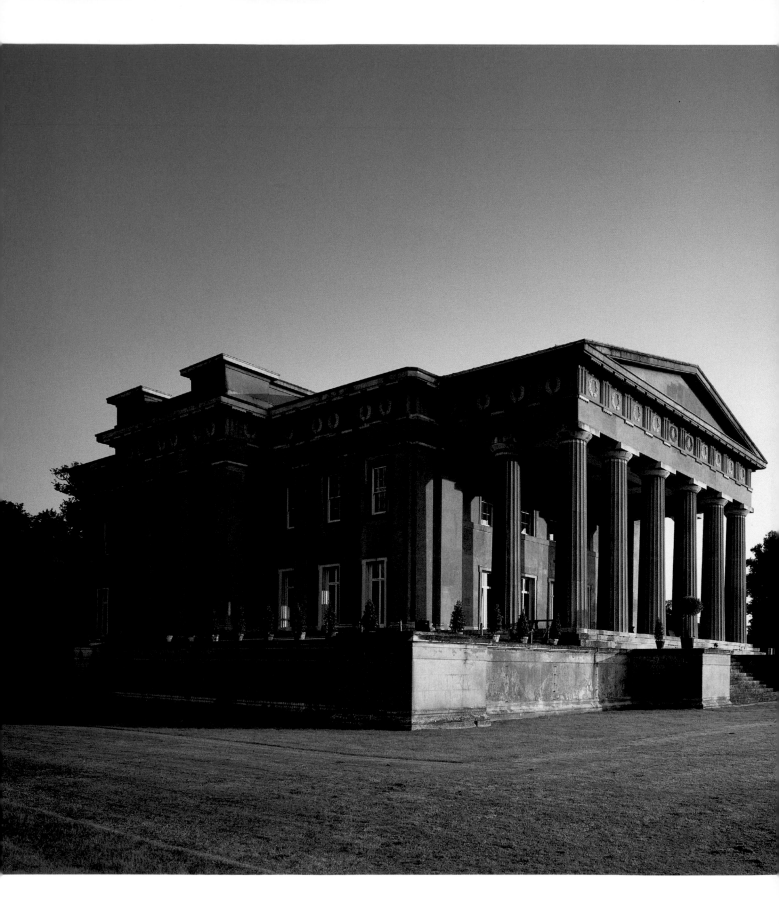

LEFT:
William Wilkins
The Grange, Hampshire, 1804–09

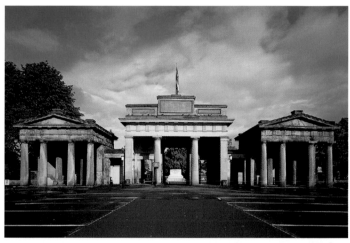

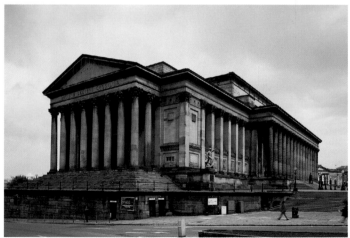

TOP:
Thomas Harrison
Propylæum, 1811
Chester Castle, Cheshire

ABOVE:
Harvey Lonsdale Elmes, Charles Robert Cockerell
St. George's Hall, Liverpool, 1839–54

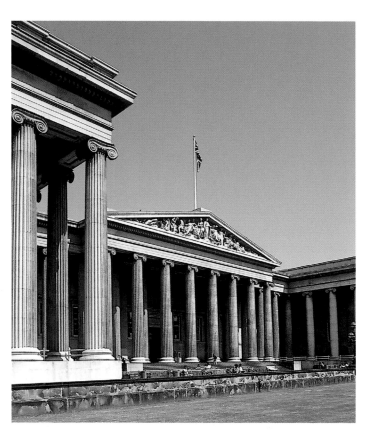

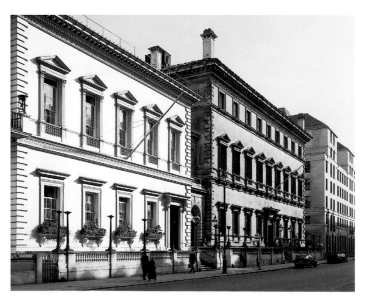

extended complex in the same year. Originally it had four longish wings around an open courtyard, which between 1852 and 1857 was covered in to form the British Museum's celebrated circular Reading Room. The entrance façade facing Great Russell Street was given two short side wings and a central portico at the top of a flight of steps. The whole façade was enclosed in a monumental sequence of 44 Ionic columns, which in proportion and detail exactly match the Temple of Athena in Priene in Asia Minor.

The Greek Revival also influenced English church building, which saw renewed activity in 1818, after the end of the Napoleonic wars. Under the Million Act, Parliament voted £1 million to construct new parish churches in the expanding suburbs of London and new industrial towns. These "Commissioners' Churches" were to be in general functional and cheap. However, many parishes with wealthy members were able to finance more lavish structures themselves.

One church built at this time was St. Pancras New Church in London, designed by William Inwood and his son Henry William. Though its ground plan followed the pattern for English church construction that had been rigorously followed since the early 18th century, i.e. a long nave and aisles structure, an altar niche at the east end and a portico, lobbies and tower at the west end (ill. p. 25, left), individual features of St. Pancras closely follow specific Athenian models of Greek Antiquity, wholly in the spirit of the Greek Revival. The portico with its fluted Ionic columns is based on the Erechtheion on the Acropolis, the west tower on the Tower of the Winds, and the sacristies at the east end are adorned with caryatids like those on the Erechtheion (ill. p. 25, right).

Quoting admired classical models could scarcely go much further, and indeed, from 1820–30 there was growing opposition to the Greek Revival. The endless rows of columns seemed too monotonous, the porticos all the same. The range of models to imitate was, moreover, too limited. A reaction to it came from Sir Charles Barry with his influential club buildings in London's Pall Mall, which used the model of Italian Renaissance palazzi (Travellers' Club 1829–31 and directly adjacent Reform Club 1837–41, ill. p. 24, bottom). Going still further, Charles Robert Cockerell's university and commercial buildings blended the whole tradition of classical building from Antiquity via the Renaissance to the Baroque. In country houses, a mixed English Renaissance (Jacobethan) style was taken as a model. The Historicist roundelay had begun.

William and Henry William Inwood
St. Pancras New Church, London
Façade, 1819–22

William and Henry William Inwood
St. Pancras New Church, London
Caryatid porch, 1819–22

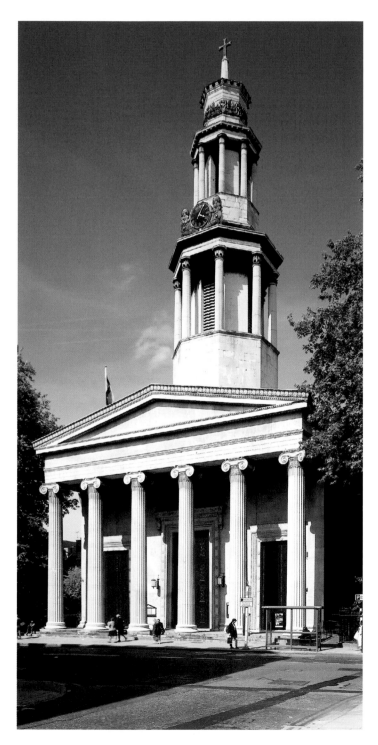

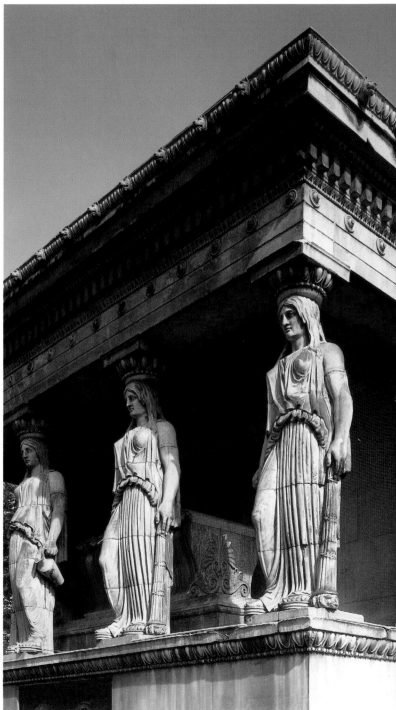

25

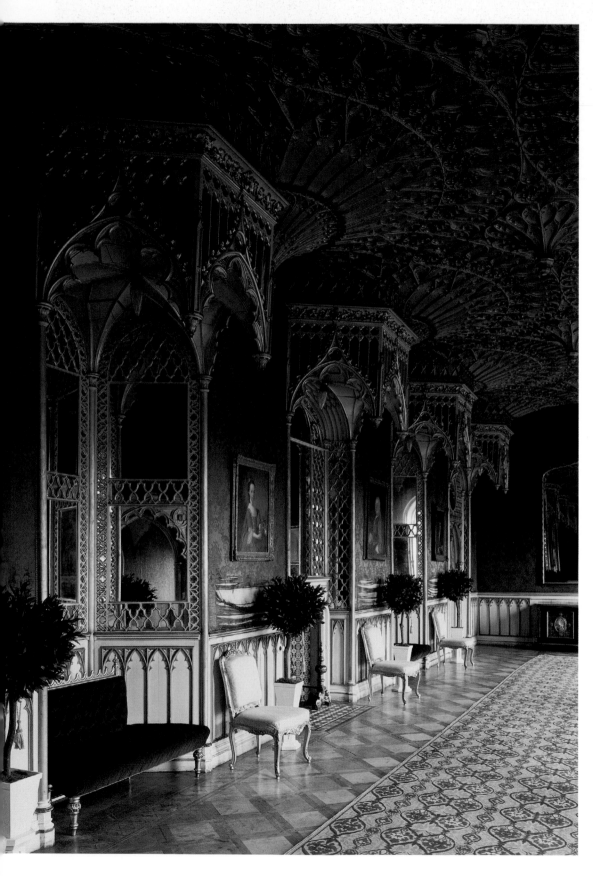

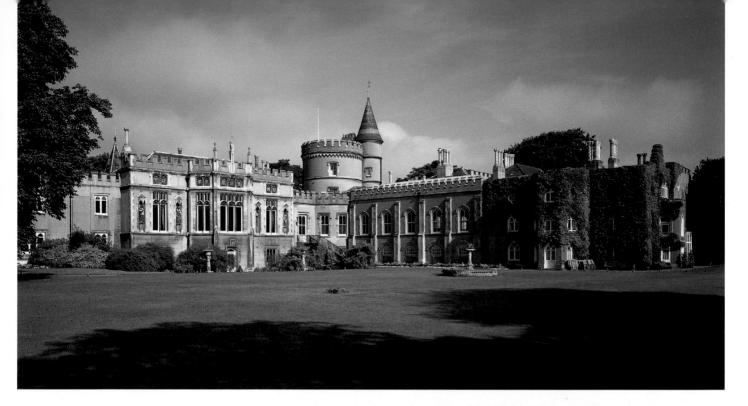

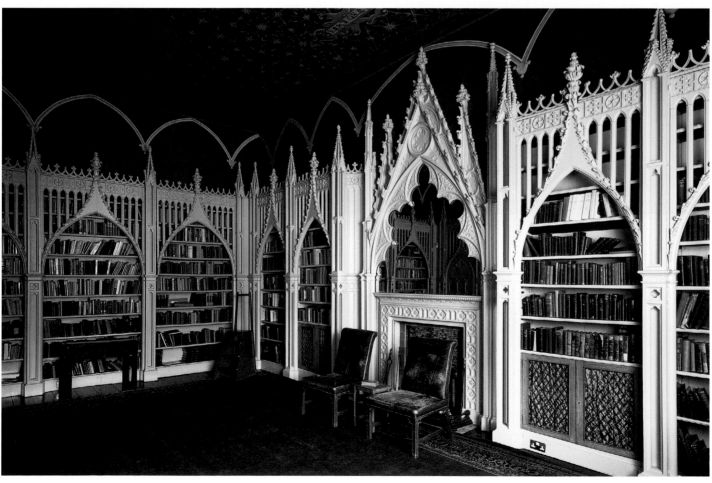

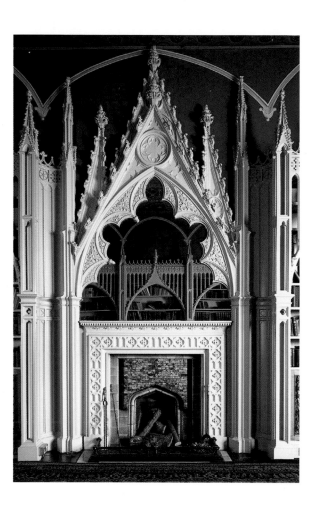

charming architectural cluster that put into effect the principles of the picturesque for the first time. The richly articulated exterior, with its projections and recessions, gables, towers and pinnacles and pointed arches, quatrefoil windows and battlements, was intended to imitate the evolved layout of a medieval structure. For the interiors, which are equally variegated, Walpole and his friends took as their models the illustrations in the few publications on medieval architecture then available. Their application was done in a purely decorative way. A Gothic tomb or rood screen could serve equally as a basis for a fireplace or bookshelves (ills. pp. 27, below, and p. 28, left). In this way, there arose an amalgam of diverse sources from different buildings and stylistic phases of English and French Gothic, all on a reduced scale, all made of plaster, wood or papier mâché, and brightly painted and enlivened with mirrors. It was an artificial, playful world that still had much to do with the Rococo and was concerned little with the archaeological seriousness that would subsequently overtake the Gothic Revival and Neoclassicism alike later on during the 18th century.

The cheerful, decorative side of this early Gothic Revival is represented particularly well by a small church built by a friend of Walpole's, Richard Bateman, on his estate in Shobdon in 1746–56, probably to plans by William Kent, who is otherwise known for his work in the Palladian style. On the outside, St. John the Evangelist looks just like a medieval parish church with its heavy battlements and central west tower. Inside, it is entirely white and pale blue, and dominated by that favorite Gothic Revival motif, the crocketed ogee arch (ill. p. 28, bottom). Quatrefoil tracery adorns the windows, and the same vocabulary is found in the pews and pulpit. The ceiling is fashioned with a mirror vault in Baroque fashion, indicating a transition in style.

The Gothic Revival

The new preference for medieval architectural forms, especially Gothic, had gripped British architecture even earlier than Neoclassicism did. A distinction is made between the continued, unbroken tradition of Gothic building called Gothic Survival (for example, in building colleges or new structures to blend with old ones) and the deliberate choice of Gothic for new work, called Gothic Revival. As with Neoclassicism, the style matured from trial buildings in gardens in its infancy to a stripling country house, the famed Strawberry Hill of Horace Walpole, in its youth. The son of the distinguished English prime minister Robert Walpole and author of the first Gothic novel *The Castle of Otranto* (1764), in the 1740s Walpole bought a small country seat in Twickenham near London, beside the Thames, which over some 30 years he converted into his "little Gothic castle" (ills. pp. 26–28). Over this period, it developed into an asymmetrical,

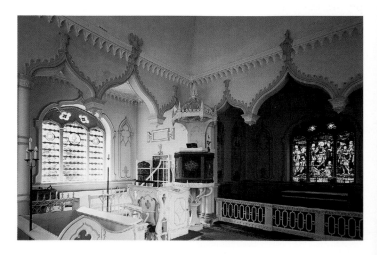

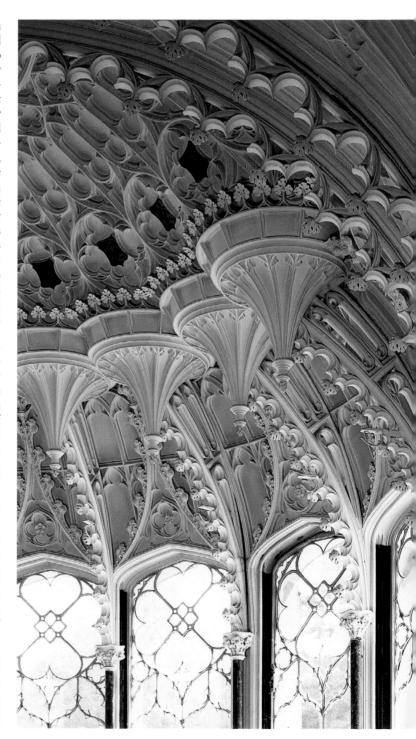

Roger Newdigate et al.
Arbury Hall, Warwickshire
Detail of bow window in drawing room,
completed 1798

Walpole's initiative in using Gothic Revival forms based on existing medieval models was taken up by one of his political rivals from the Tory party. In a project that took 50 years to complete, Sir Roger Newdigate rebuilt his country seat of Arbury Hall (Warwickshire) into one of the finest, though less well-known, Gothic monuments (ill. pp. 29–31). He began work on it in 1748 and was initially advised by another important amateur architect and Gothic enthusiast, Sanderson Miller, who had become known in the 1740s for his artificial castle ruins in land-scaped parks such as Hagley (ill. p. 18). Unlike Walpole, Newdigate opted for a specific medieval structure as a model, the opulently decorated Perpendicular Henry VII Chapel in Westminster Abbey (1502–09). Logically enough, he used the Abbey's consultant architect, Henry Keene, as his own builder from 1761–76. His desire to copy the designs of the models as accurately as possible went so far that Keene made plaster casts in the Abbey on which the details at Arbury could be modeled. Thus, as a result of this, Arbury Hall, unlike Strawberry Hill, is consistently decorated throughout with the rich architectural patterns of English Perpendicular, with flattened four-centered Tudor arches, tall, narrow tracery paneling, bay windows, and especially fan vaulting (ill. p. 29).

The asymmetrical layout of Strawberry Hill became the hall-mark of a whole movement that left its mark on English country house architecture towards the end of the 18th century, namely Castellated Gothic or the Castle Style. A country seat now had to look like a medieval castle, with compact masses and huge towers which, with the obligatory battlements, would convey a sense of fortification. Castle-like mansions with their irregularly grouped silhouettes blended picturesquely with their surroundings, prefer-ably, of course, on the edge of a ravine. The Castle Style was thus at the same time a perfect realization of the theories of both the picturesque and the sublime. Indeed, the first house of this move-ment was erected by one of the three proponents of the Picturesque, Richard Payne Knight, grandson of a wealthy iron-monger. He built himself Downton Castle, high above the River Teme in Herefordshire, the first work in Castellated Gothic to be laid out in an asymmetric design from the first. The exterior, with its smooth, unplastered masonry and the differently-shaped towers, was possibly inspired by the massive Gothic castles in nearby Wales. Bay windows and oriels open on to views of the impressive hill landscape round about. However, the interiors of Downton Castle are wholly in the Neoclassical manner.

The picturesque Castle Style soon achieved great popularity, and late 18th-century/early 19th-century architects switched effortlessly back and forth between the Neoclassical vein for public commissions and Gothic Revival for country houses. One of the most successful architects of the time was James Wyatt, mentioned earlier in connection with Dodington Hall. Between 1796 and

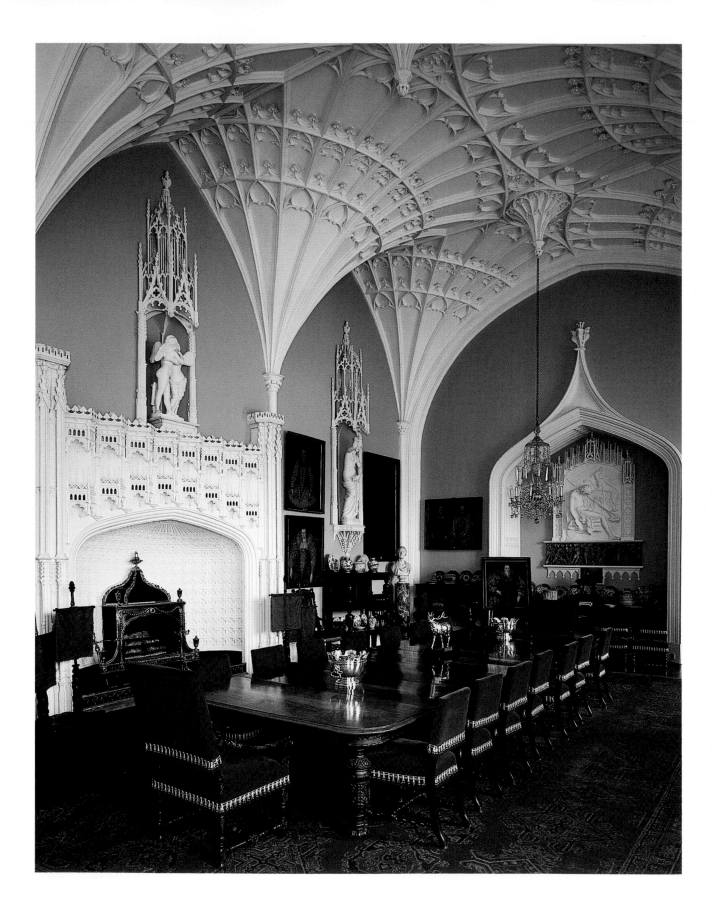

OPPOSITE:
Roger Newdigate, Henry Keene
Arbury Hall, Warwickshire
Dining room/ hall, 1762

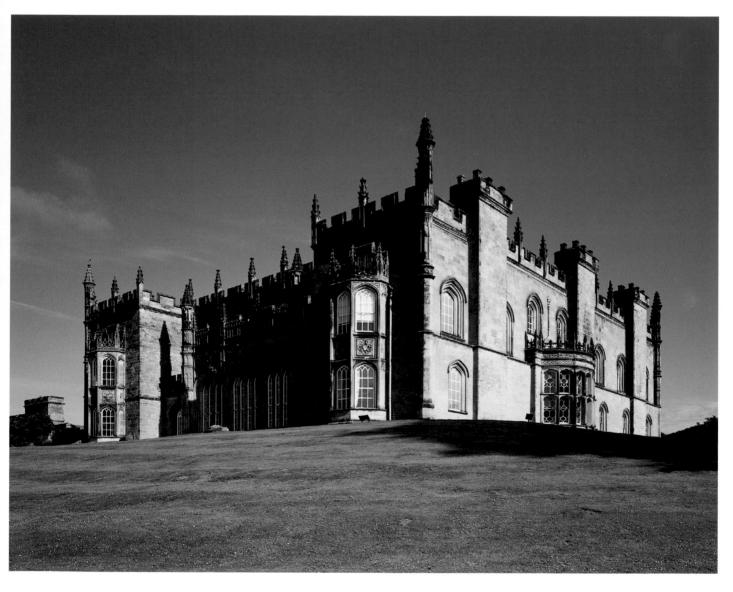

ABOVE:
Roger Newdigate, Henry Keene
Arbury Hall, Warwickshire, 1748–98
View from the south-east

Work began on the Gothic refashioning of Arbury Hall in 1748, and proceeded gradually. The first feature was a Gothic polygonal bay window on the south front. In 1755 the library was built, emulating that at Strawberry Hill, built shortly before. The hall in the center of the south façade with its loping fan vaulting is based closely on the Henry VII chapel at Westminster Abbey. The bow window in the drawing room of the east wing dates to the final phase of construction, being completed only in 1798.

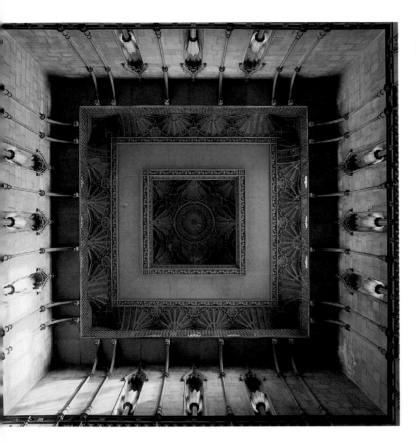

1812, he erected for the eccentric author William Beckford one of the most spectacular monuments of the Gothic Revival, renamed Fonthill Abbey. Some years later, its huge 276-foot (84m) tower collapsed. More durable were Wyatt's Belvoir Castle (ill. p. 32, bottom right), a perfect essay in the Castle Style, and his last Gothic Revival country house at Ashridge (ill. p. 32, bottom left), in Little Gaddesden, Hertfordshire (1808–17). The large central tower of the spacious building is completely occupied by a stairwell, which is open through the full height of the tower and enclosed by a fan vault (ills. pp. 32 and 33). In this building an overwhelming, almost awe-inspiring effect was sought, prompted by the crossing towers of medieval cathedrals.

A perceptible trend away from the Romantic and picturesque view associated with the Gothic Revival became evident in the 1810s and 1820s as a greater insistence on imitating medieval architectural styles correctly became apparent. Scholarship and documentation of the original Gothic structures conveyed increasingly accurate insights into the way they were designed. More architects acquired experience in restoring medieval buildings, not least because it profited their own building work. The Gothic Revival began to be considered as a serious style for more than country houses, rivaling the predominant Neoclassicism. Naturally one of the first areas in which the Gothic Revival emerged triumphant was church building. It was after all *the* Christian style. Thus some of the already mentioned Commissioners' Churches began to use the grammar of Gothic, with Perpendicular being the preferred style. As was the case with Neoclassical examples, the pattern of the exterior was for a tall

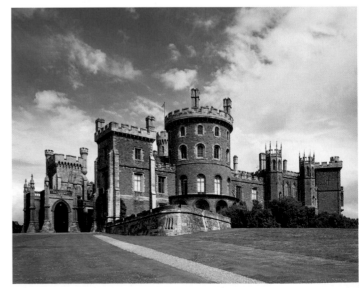

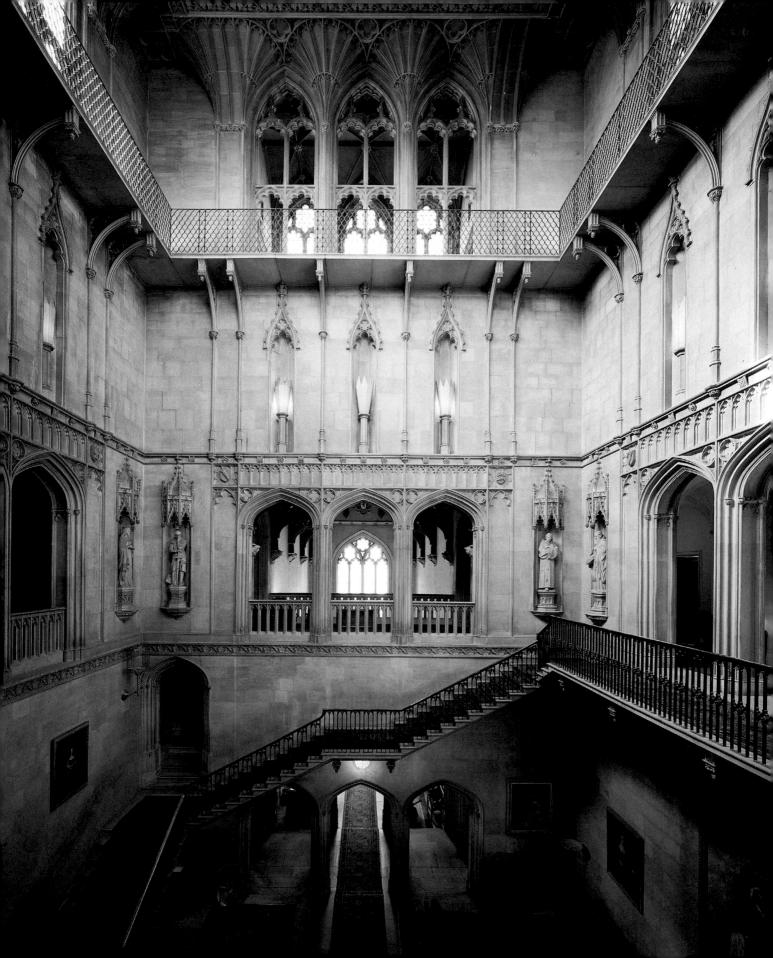

west tower, though furnished with large tracery windows, buttresses and pinnacles. In the relatively lavish design of St. Luke's in Chelsea, London, built 1820–24 by James Savage, the western classical portico is replaced by a low Gothicizing porch with pointed arches and ogee hoods (ill. p. 34, left). The nave and aisles within are completely vaulted in stone, thereby attempting to imitate Gothic not only in decoration but also in the structure. A different approach was adopted by Thomas Rickman, to whom we owe our present terminology of Early English, Decorated and Perpendicular phases of Gothic (1818). In the parish church of St. George's in Heyworth Street, Everton, Liverpool (1812–13), he experimented with the local iron manufacturer John Cragg in combining Gothic structures with up-to-date technology. The interior of the church is executed entirely in cast iron, even the window tracery (ill. p. 34, right).

It was no accident that the Perpendicular was the focal point of English enthusiasm for the Middle Ages in the first decades of the 19th century. Like no other stylistic phase of English Gothic,

Perpendicular could be considered an independent English creation, independent of France and the Continent. After the end of the Napoleonic wars, there was a great desire, as in other countries, to come up with a distinct national style. The culmination of these endeavors was the rebuilding of the Houses of Parliament in London, after the devastating fire of 1834. For the first time with such a major commission, the Gothic Revival was considered appropriate for a building of such national significance. The competition was won by Sir Charles Barry, better known for his buildings in various Neo-Renaissance styles (ill. p. 24), and his design as realized in the Perpendicular style has become a national symbol (ill. p. 35). Externally, apart from the Gothic detail, it conforms to the requirements of both Classical and Picturesque architectural doctrines. In its ground plan and especially the river façade the building is largely symmetrical, but is enlivened by irregularly distributed tower features. The narrow sides are distinguished by the Victoria Tower over the royal portal and, though not symmetrically placed, the famous clock tower of Big Ben.

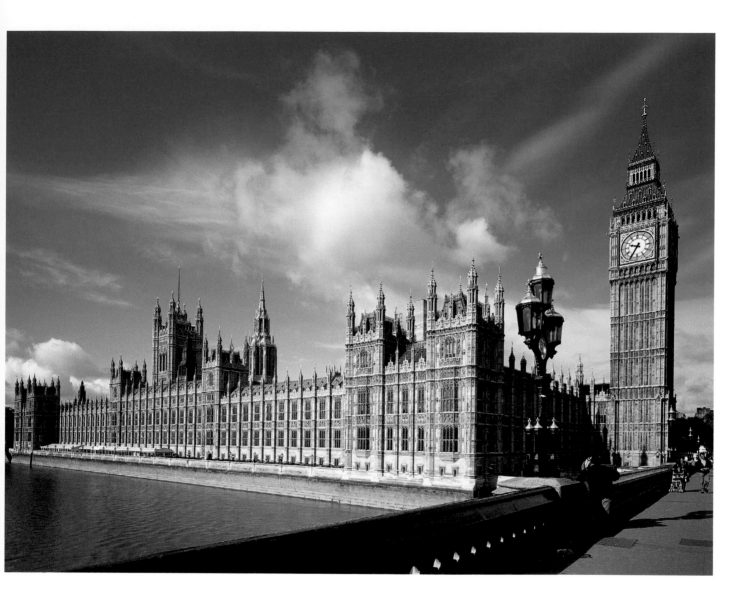

The thoroughly rich details of the interiors of the Houses of Parliament were designed by Augustus Welby Northmore Pugin, the London born architect who took the Gothic Revival forward to a new phase. In his influential writings, especially *Contrasts; or a Parallel between the Noble Edifices of the Fourteenth and Fifteenth Centuries, and Similar Buildings of the Present Day; Shewing the Present Decay of Taste* of 1835, he elevated Gothic Revival to the status of the *only* style, combining architecture and morality in a new fashion. A convert to Catholicism, Pugin contrasted the moral decay of his own day with the idealized world of the Middle Ages. The renewal of architecture, he believed, should go hand in hand with a revival of Christian values. Pugin's ideas culminated in the assertion that good architecture could only be Gothic, and good architects could only be Christian architects. This philosophy awoke an enthusiastic response in the public, and the Gothic Revival became the dominant style of English revivalism for the rest of the 19th century.

Four great architects

After this overview of the development of English architecture of the second half of the 18th century to the 1830s, it is worth having a closer look at four architects who played major roles during this period as rival pairs.

William Chambers (1723–96): the heir of Palladianism

Along with Robert Adam, Swedish-born, English-educated Chambers was the most influential British architect of the 1760s and 1770s. The rich experience which he garnered in his youth predestined him for a leading role. As a young man, he worked for the Swedish East India Company, on whose behalf he traveled to China and Bengal several times between 1740 and 1749. In 1749, he studied architecture for a year in Paris at Jacques-François Blondel's influential École des Beaux Arts, where Chambers got to know leading architects of French Neoclassicism. Between 1750 and 1755 he continued his studies in Rome, absorbing further influences from the French and from Giovanni Battista Piranesi.

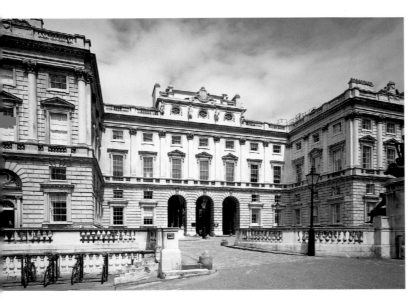

to Asia in his youth, than for Somerset House or his other buildings in the Classical style. Having published his observations in *Designs of Chinese Buildings* in 1757, he was immediately commissioned to design Princess Augusta's Gardens in Kew, beside the Thames in London. Chambers furnished the park with a variety of classical and exotic buildings, including a mosque, an Alhambra, a Gothic cathedral, a Confucian house and the famous pagoda, which has survived, though without the ornament of its gilt dragons (ill. p. 36, bottom). The purpose of these garden buildings was to set the contrasting mood for each landscaped garden setting, as a visual aid to the visitor. They varied from the cheerful to the eerie, analogously to the aesthetic principle of the beautiful and the sublime propounded by Chambers' friend Edmund Burke. Thus, although Chambers was on the one hand a champion of the classical tradition while vehemently rejecting an archaeologically faithful imitation of Greek antiquity, on the other hand he was also building in a variety of other styles, anticipating the trend of the next century.

In 1755 he settled in London, where thanks to his excellent contacts he embarked on an immediately successful career as an architect. In 1756, he became architectural tutor to the Prince of Wales, and once the Prince succeeded to the throne as George III in 1760, Chambers rose to become eventually Surveyor General, assuming responsibility for all Crown and government buildings. In 1759, he published an influential *Treatise on Civil Architecture*. In his private commissions he quickly abandoned his French-trained style in favor of the Palladianism still dominant in England, but in his greatest public building project, he sought to combine French Neoclassicism with English Palladianism and other models from Roman antiquity to the Italian Renaissance.

Constructed between 1776 and 1801 on an extensive but irregular plot on the Thames Embankment in London, Somerset House was one of the first public buildings designed exclusively to house government and educational institutions. The building is a four-wing complex around a large interior court and two narrow lateral courts. The north wing facing the Strand is separated from the others and architecturally particularly emphasized, as it was to house the learned institutions of the Royal Academy and the Society of Antiquaries (ill. p. 36, top). Borrowing from palace architecture, it has a giant order of pilasters and engaged columns spanning the piano nobile and mezzanine. The windows are marked with pediments or straight heads. The extremely long river façade is subtly organized into groups and crowned by a dome responding to the attic level of the north wing.

However, Chambers was more famous for his first-hand knowledge of Chinese architecture, acquired during his journeys

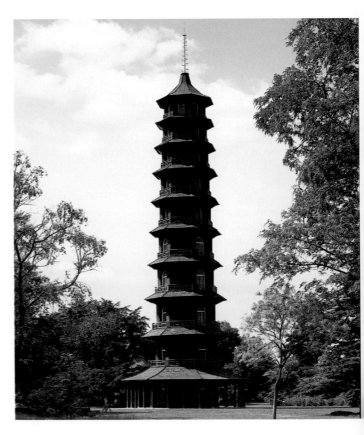

BELOW:
Robert Adam
Syon House, Brentford, Middlesex
Gateway, c. 1773

BOTTOM:
Robert Adam
Syon House, Brentford, Middlesex
Library (former Long Gallery), 1766

Robert Adam (1728–92): the successful innovator

Scots-born Robert Adam reached London three years later than Chambers, with the ambitious aim of making history as an innovator in architecture. Like Chambers, Adam spent two years in Rome (1755–57), where he studied the ruins of Antiquity under the direction of Charles-Louis Clérisseau and, like Chambers, Piranesi as well. His interest focused less on the temples than on ancient houses and their decoration, as he thought he could make better use of these for his later architectural practice in Britain. Thus Adam was already mapping out his career while in Italy. To this end he cultivated a close network of contacts with potential noble British patrons who were staying in Rome on their Grand Tour. In addition, he drew up an archaeological publication concerning Diocletian's palace in Spalato (Split, Dalmatia), which appeared in an impressive binding in 1764. Back in London, he set up an architectural practice jointly with his brothers James and William as business managers. The practice flourished, and within just a few years Adam had developed a very individual style which did indeed revolutionize British architecture. Like Chambers, he drew on a whole variety of models, ranging from Antiquity via the Renaissance to the Baroque, but, unlike chambers and the Palladians, Adam did not grope for eternally valid rules of architecture, instead used his models with great freedom, more or less as a quarry for his own ideas. His new architecture was to be varied and pleasing, and he aimed to generate movement in his buildings, in two ways in particular: first, by creating contrast between architectural blocks both internally and externally, and second, by constantly altering decoration, which would keep the eye of the observer in motion. He was so proud of his achievements that he presented his buildings to the public in two books (*The Works of Robert and James Adam*, London 1773–78), in which he deliberately drew a veil over his sources.

Adam notched up his greatest successes in private houses, whether in London or in the country. He often rebuilt older or already started houses, which made him the most sought-after specialist for modernizing interiors. In Syon House (ills. pp. 37–39), Adam developed his individual approach to its full form, spurred on by the ticklish starting point of an existing 15th to 17th-century building. On three sides of the four-sided plan, he constructed between 1761 and about 1770 a series of spectacular apartments, in which rooms succeed one another without a corridor, on the Baroque *en enfilade* principle, but with each room maximally contrasted with the next in shape, articulation and color scheme. The starting point is the transverse rectangle of the great hall in the west wing (ill. p. 38). Adam offset the impression of length by introducing an apse on the north side and a rectangular recess, vaulted as a transverse coffered arch, on the south side.

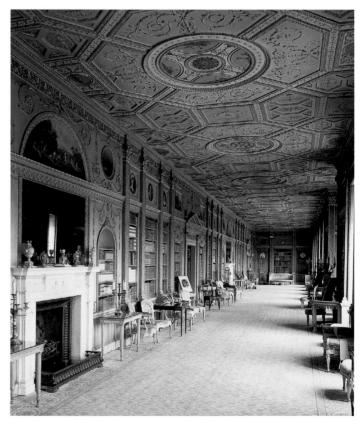

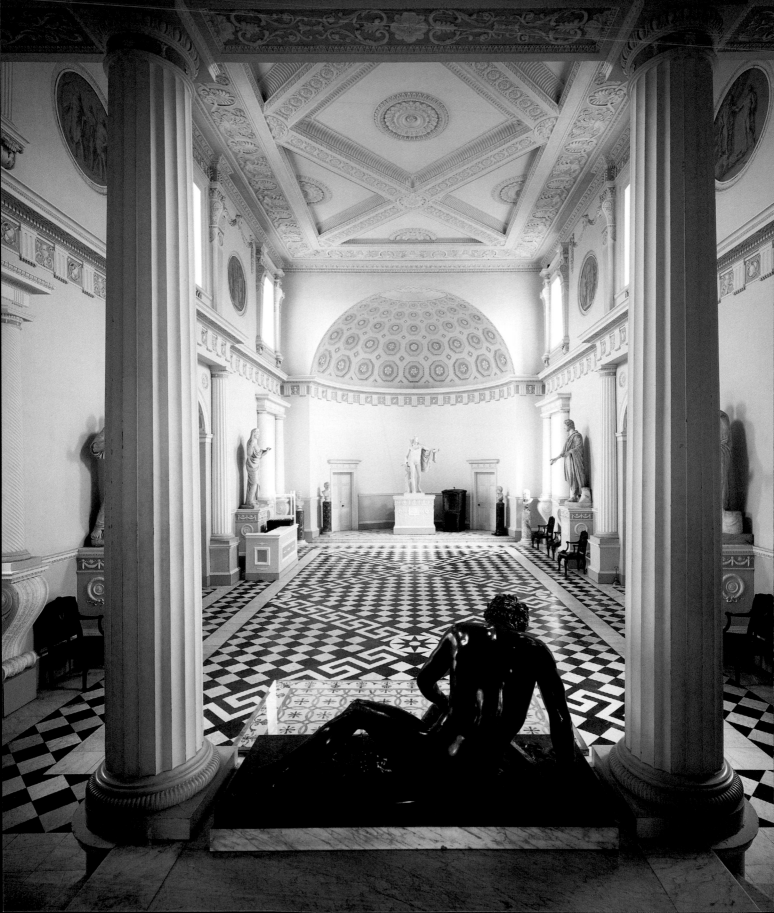

OPPOSITE:
Robert Adam
Syon House, Brentford, Middlesex
Entrance hall, from 1761

BELOW:
Robert Adam
Syon House, Brentford, Middlesex
Ante-room, c. 1765

Into the opening of this recess he inserted one of his favorite devices, a screen formed by a beam supported like a bridge on two slender Roman Doric columns. The niche and main hall are thus both separate from each other and connected. Columns and beam are echoed in the doorways on the long sides. The frieze of the entablature continues round the room, unifying the whole space but without a supporting architrave, so that the metopes and triglyphs of the frieze are, as it were, suspended in mid-air – a treatment which is typical of the liberties that Adam allowed himself in the use of the classical orders. The flat ceiling is articulated by a heavy frame and diagonal ribs, whose shape is mirrored in the black-and-white fret pattern of the tiled floor. The whole space is finished in a discreet cream-and-gray color scheme.

A new departure introduced by Adam is the inclusion of copies of antique statues as part of the total composition. The north apse contains the Apollo Belvedere, responding to the Dying Gaul, equally admired in the 18th century, between the columns at the south end. Behind the latter a round-arched doorway leads into the ante-room in the south-west corner of the house (ill. p. 39). Here again, the visitor is surprised by an unusual spatial arrangement, but even more by a wealth of color hitherto wholly unusual in English architecture. Adam articulates the walls on all sides with detached columns of grayish-green marble deriving directly from Rome. On the south wall, he brought the columns so far forward as to create a square, even though the room itself is rectangular. The columns terminate in gilt Ionic capitals, the frieze and tendril reliefs above them having gilt highlights on a blue-green ground. The entablature projects over the columns, so that there is room for similarly gilt classicizing statues on them. The ceiling is in gold and white, while the floor is reddish brown, yellow and gray scagliola. This colorful space is followed by the much more restrained dining room, again with both long sides featuring a screen of columns, this time in front of apses. Another color scheme is presented in the adjacent drawing room (a room for (with-)drawing into after a meal). Its gleaming red silk wallpaper acts as a background for paintings, while the trough-vaulted ceiling is littered with a host of small colorful medallions. The Library (ill. p. 37, bottom), a converted long gallery, forms yet another dramatic contrast, extending for the whole length of the east wing. Decorated in lime green and gray, the wall is articulated with shallow pilasters, with windows between them on one side and mirrors or built-in niches for bookshelves on the other.

The combination of rooms both sculpturally molded with niches, apses and columned screens, and designed with walls and ceilings in schemes of white and gold pastel tones, became a trademark of the Adam style, which was famous even in his day. Moreover, Adam designed the furnishings of the interiors himself, and in his mature phase covered his ceilings, to which he

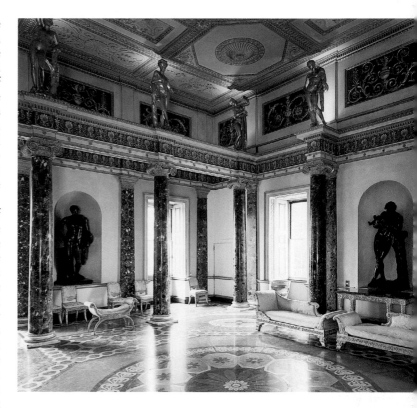

attributed particular importance, with a very flat, delicate plaster. The decorative patterns were inspired by Roman interiors such as those surviving in Herculaneum and Pompeii and by the ornamental grotesques of the Renaissance. The library in Kenwood House, which he built for Chief Justice Lord Mansfield in 1767, is one of the high points of Adam's decorative art (ill. p. 40). The long rectangular room again ends on both sides with apses and a screen of columns. Opposite the windows, rectangular niches are let into the walls and furnished with mirrors in order, as Adam said, to bring the lovely outside view into the room. Over the gilt entablature is a segmental barrel vault with painted oval, round or rectangular medallions, framed with delicate white plasterwork on a light blue ground in rectangular frames.

In the 1770s, Adam worked mainly on building projects in London. In a number of town houses he was able to demonstrate his skills in extremely confined spaces. A well-preserved example is Number 20, Portman Square, erected in 1773–76 for the Countess of Home. Adam used the ground floor and floor above it for four rooms of completely different design (ground plan, p. 41), which on social occasions could be treated as a circuit of great variety. The circular stair well (ills. p. 41, top) is removed to

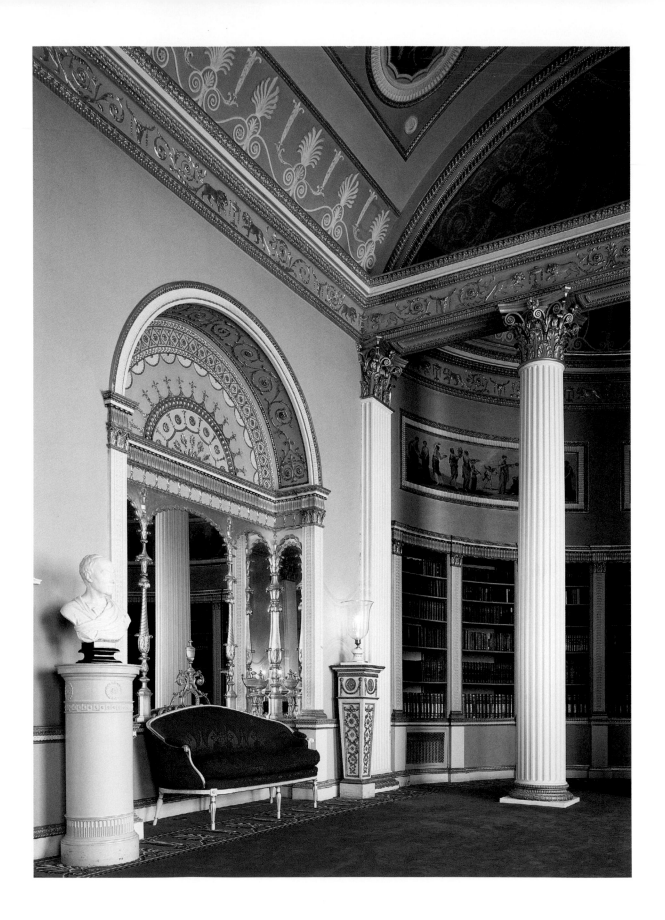

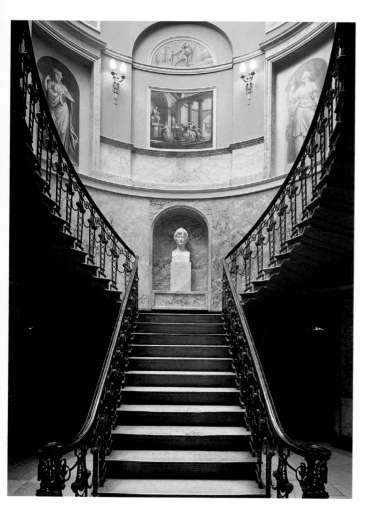

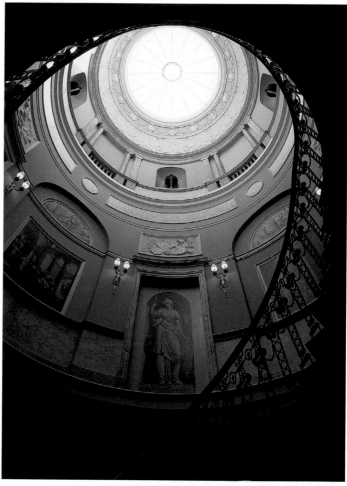

THIS PAGE:
Robert Adam
20 Portman Square, London, 1773-76
Stairwell (above and above right)
Music Room (right)
Ground plan of piano nobile (below)

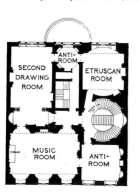

OPPOSITE:
Robert Adam
Library, Kenwood House, 1767
Hampstead Heath, London

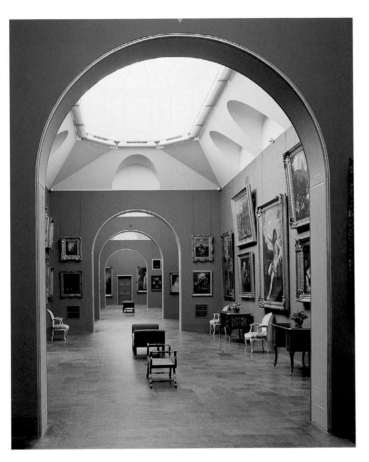

Sir John Soane (1753–1837): the individualist

His contemporaries could not have accused Sir John Soane, one of the most original architects of the next generation in England and indeed Europe, of superficiality. Soane was a pupil of George Dance, and from 1771 of the newly-founded Royal Academy. A protégé of William Chambers, he was awarded a traveling scholarship, and spent 1778–80 in Rome and Sicily. His chief interest in Antiquity lay in vaulted Roman buildings such as the thermae and mausolea, the Pantheon or Hadrian's Villa in Tivoli. Back in England, his commissions up to 1791 had been mainly for country houses. In Wimpole Hall in that year, he first put into practice the idea of top-lighting, a domed interior lit from above, which would become a leitmotif of his work (ill. p. 43). The Yellow Drawing Room is constructed over a square with two lateral apses and a barrel-vaulted long axis. Over the center space, Soane combined a pendentive and umbrella dome, which opens into a large glass lantern.

In 1788, he was appointed surveyor to the Bank of England. This was a major position that he would occupy for the rest of his life, and it gave him scope to develop his theme of the dome in a very individual manner. Within the site of the Bank in London, he had built by 1833 a whole series of domed spaces, all of which were top-lit by lanterns and lunette windows. At a lower level, he had, like Adam, no scruples about taking liberties with Classical grammar. But where Adam enriched and varied the orders of Antiquity to obtain ever fresh, surprising effects, Soane took the opposing route of reduction to the essential. He sought a road back to the primitive, basic form. Even in Wimpole Hall the pilasters were very flat and framed by thin lines. In the banking rooms the articulation was reduced to incised grooves, and in his last rooms Soane had the piers go over into the broad arches without capitals (ills. pp. 45, 46). This was a radical departure from the Classical tradition as Soane developed a highly austere, even somber, archaic-looking architecture with dramatic light effects, that had much to do with the architecture of the French Revolution and is nonetheless very original. Unfortunately, Soane's banking rooms were completely destroyed in the 1920s.

Absolute reduction is also the most prominent feature of the painting gallery that Soane built 1811–14 for Dulwich College in London (ill. p. 42). This is innovative not only in its appearance, but also in the structure itself and its design. This is the first detached museum building in England and one of the first top-lit exhibition buildings in Europe. The extended succession of five exhibition rooms projects into two short wings to the west. Small low annexes are attached to the gallery wing on this side, which originally housed needy old women who had previously occupied the site. In the middle a small cruciform building projects, a mausoleum for the founder Sir Francis Bourgeois and the art collector Noel Desenfans, who supplied the pictures exhibited. The individual blocks of the

the left side of the building, and is, moreover, not axially accessible. The balustrades and the cupola providing natural light are made of the new materials iron and glass. The center of the house is the Countess' music room on the upper floor, with its windows and doors set in niches (ill. p. 41 below). It is highly delicately designed, with very narrow, flat pilasters with mirrors between them, and circular medallions on walls and ceilings. A filigree, lacey ornamentation in white and gold on various shades of lime green covers the whole room.

The elegant Adam style suddenly fell out of fashion from the late 1770s, as quickly as it had become popular. It was criticized as being too pretty and superficial, while the lavish decorative features appeared over-expensive. Nonetheless, the Adam brothers created some of the most important interiors of early Neo-classicism, and their style was imitated throughout Europe.

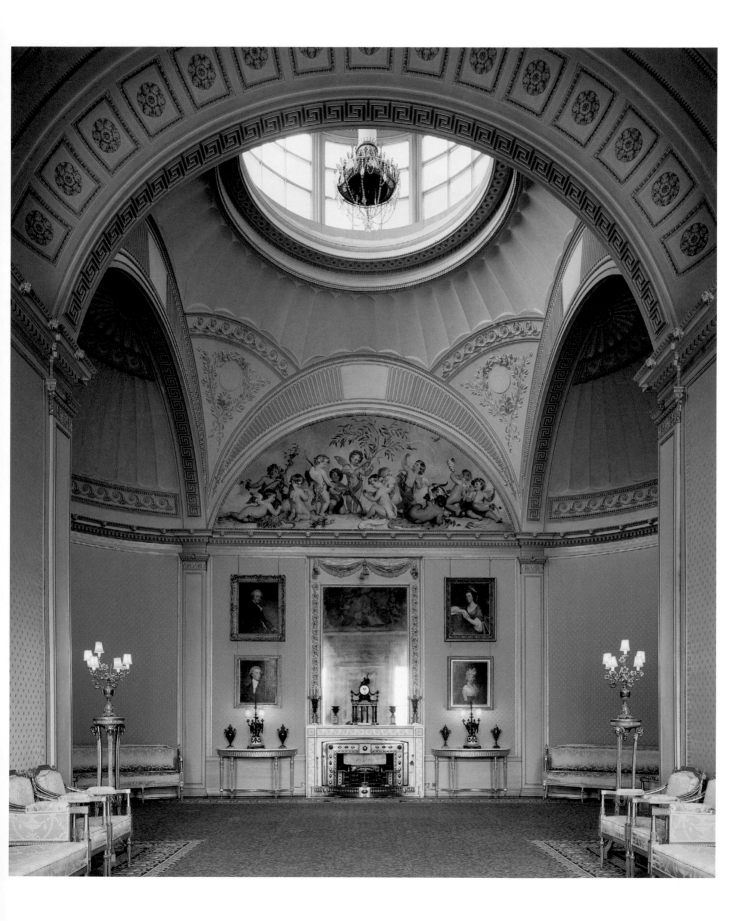

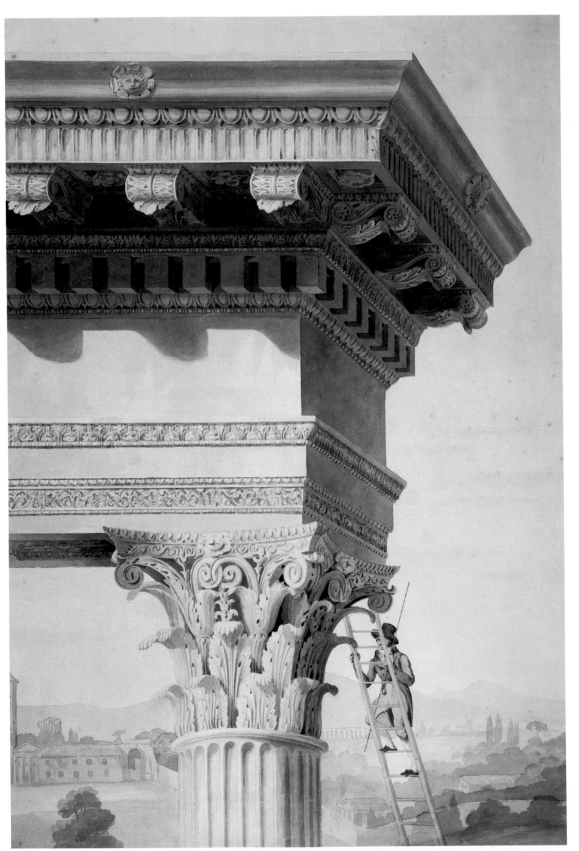

Henry Parke
Student surveying the Castor and Pollux
temple in Rome, 1819
Pen and watercolor, 93.5 x 63.5 cm
Sir John Soane's Museum, London

At the turn of the 18th and 19th
centuries, architects studied and
meticulously documented – often at the
cost of great physical exertion – the
buildings of Antiquity, even in the
countries of Asia Minor, before they
started designing new architecture. Being
also children of the Romantic age, they
liked just as much to present their own
buildings as ruins.

LEFT:
Joseph Michael Gandy
A vision of Sir John Soane's design for the rotunda of the Bank of England as a ruin
1798
Watercolor, 66 x 102 cm
Sir John Soane's Museum, Lincoln's Inn Fields, London

These two "views" of the Bank of England are at the same time wonderful examples of the Romantic love of ruins, expressing a passion for the vanished worlds of Antiquity and the Middle Ages

BELOW:
Joseph Michael Gandy
Bird's eye view of the Bank of England as completed by Sir John Soane in 1830
Pen and watercolor, 72.5 cm x 129 cm
Sir John Soane's Museum, Lincoln's Inn Fields, London

A pupil of Soane's, Gandy created this vision from the reality of his teacher's work, anticipating – wholly without suspecting it – the tragic fate of the Bank buildings when they were almost completely torn down in the 1920s.

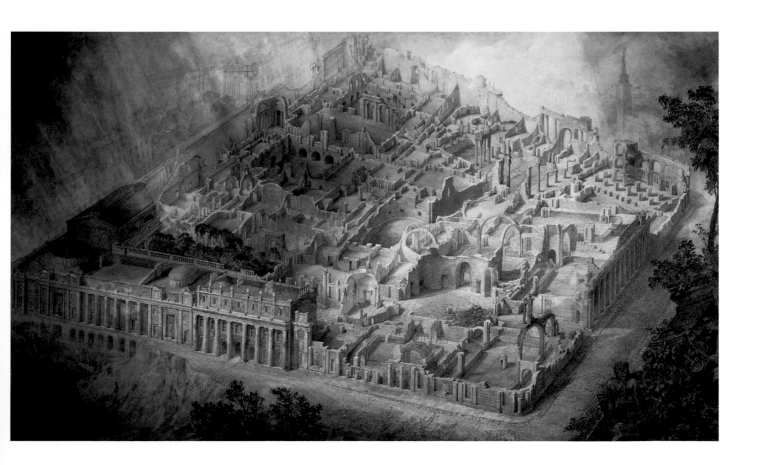

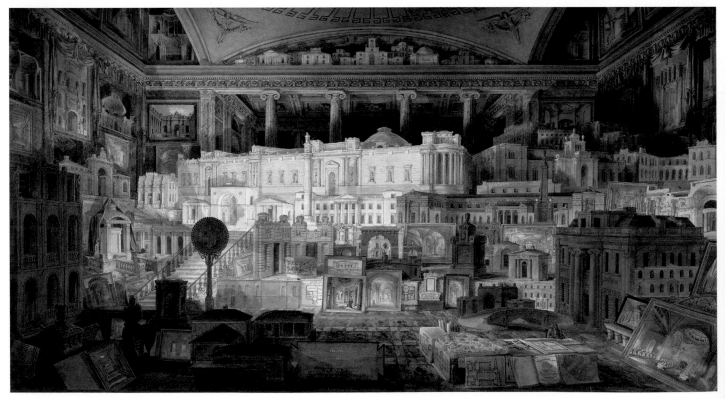

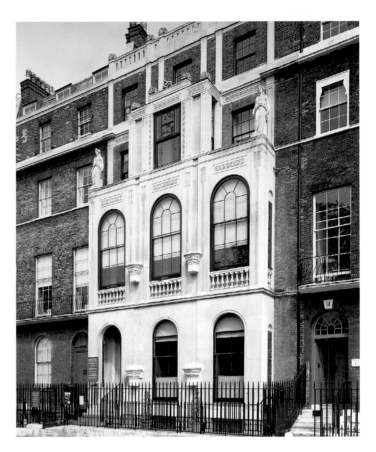

site are linked, but also marked off from each other by small recesses in the masonry. The building consists entirely of plain brick except for the light bands of the plinth, cornice and lantern over the mausoleum, and is articulated only with plain round arches and vertical masonry strips. This gives it more the appearance of a factory than a temple of the muses, in stark contrast to Smirke's British Museum not much later. In Dulwich, the building masses are modeled by light and shade through recessions and projections instead of the Classical orders. In the interior, light likewise plays the most important part. Natural light floods through the great top-lights in the exhibition rooms. The mausoleum, on the other hand, is bathed in a diffused yellow light from the glass of the lantern, the effect of which is reinforced by the contrast with the dark vestibule and its heavy Doric columns.

In his own house in London, Soane brought together all his design features: top-lighting or side-lighting (direct or indirect) illuminating a room in unusual ways; domed rooms; and the reduction of Classical grammar to the simplest, basic rectangular forms and flat linear patterns. The latter are best observed in the façade. Between 1792 and 1824, Soane successively bought the houses at Numbers 12, 13 and 14 Lincoln's Inn Fields, which he converted into a residence, office and exhibition area for his art collection. The buildings are typical Georgian terrace houses of brick, each with three narrow window axes facing the street, with great depth towards the rear, and with a backyard. Only Number 13 was given a projecting façade of dressed stone (ill. p. 47). The ground floor and first upper floor feature large round-arched windows. Those on the upper floor originally opened into a loggia. The window axes are separated from each other by flat recessions in the wall. In the upper floors, the windows are also flanked by pilasters of a sort, which in fact consist only of strips of wall with incised ornamentation. Over the windows meanders are applied, a decorative feature much favored by Soane, who also enlivens his flat architecture with acroteria and original Gothic consoles from the Palace of Westminster. Such a combination of classicizing and medieval elements was something completely new. It spilled over into Soane's major collection of art, which brought together fragments of Antiquity and the Middle Ages, plus architectural drawings and paintings by his contemporaries. To house these objects, he covered in the yards of the three houses to form a museum of his own, which consists of a lot of rooms of different sizes that interlock in a very complex system. The walls are covered with works of art and lit by top-lights or candles hidden behind screens. The result is a puzzling juxtaposition of the most discrete associations that are no doubt destined to inspire the visitor, but probably confuse him as well. The front residential rooms are also linked with the museum rooms in a variety of ways. There, too, the walls are covered with works of art, book-shelves and mirrors, which blur the boundaries of rooms over and

again. Soane united all his architectural effects in the breakfast room (ill. p. 46, top left). The small square room is vaulted by a shallow sail dome, which rests on its points only. An umbrella vault is introduced only as ornamental incisions. Mirrors are applied in the spandrels, ceiling girders and piers, while a large tilted mirror hangs over the fireplace. Light is provided from several, partially concealed sources: a lantern in the dome, a window facing the inner court, and top-lights in two lateral annexes of the room that rise higher than the sail dome and cannot be looked through directly from the breakfast room itself. One of these annexes opens beside a bookcase a view to the center of the museum, known as the Dome (ill. p. 46, top right).

What did Soane want with all these rooms, which from a modern point of view seem overloaded with architectural ideas, fittings and works of arts and so completely contrast with his reductionist architecture elsewhere? As a child of the Picturesque and Romantic, he sought poetry in architecture, mystery in lighting, a connection between objects that is associative and emotion-based rather than logical and rational – but also the primeval essence in any shape. At the same time, he wanted to re-interpret the language of Antiquity in a new, individual way. He succeeded in this, but Soane's radical architecture found followers only in the early 20th century.

John Nash (1752–1835): the ever-accommodating
Another child of the Picturesque, but quite different in kind from the introverted Soane, was his great rival John Nash. Nash did not make any educational trips to Italy, but started straight away

BELOW:
John Nash
Blaise Hamlet, 1811
Henbury, Bristol

OPPOSITE:
John Nash, James Thomson
Cumberland Terrace, Regent's Park
London, 1826

using the opportunity to create the very image of the Picturesque Style with this artificial idyll (ill. p. 48). The cottages, which are loosely clustered around a village green, are all completely different from each other, with low-slung, interlocking roofs of stone slate, pantiles or thatch, bay windows and additions, picturesque dormers, and a whole variety of chimneys.

But greater things awaited the enterprising Nash. A scheme was afoot to develop London's West End. Nash used the opportunity to draw up a large-scale piece of town planning, which he submitted in 1811 and which immediately won the approval of the Prince Regent. Nash designed a new street axis linking the Prince's residence of Carlton House in St. James with a new park to be developed north of Marylebone Road, called Regent's Park. The novelty of this piece of town planning, implemented from 1812, was that the new Regent Street axis did not run straight but was moderated by several curves, being additionally interrupted on the way by two circular junctions at Piccadilly Circus and Oxford Circus. This provided a series of interesting prospects along a very varied new street. Nash in fact must be given the credit for carrying the principle of the picturesque over into town planning. Unfortunately nothing is left of the buildings constructed by Nash along Regent Street. Only his *point de vue* in Langham Place still stands, where the church of All Souls smoothes the transition from Regent Street to the Adams brothers' Portland Place. Taking account of the bend in the street, the church faces both directions, with a circular vestibule and spire instead of a traditional rectangular portico. Just before it runs into Marylebone Road, Portland Place opens into the semicircular Park Crescent. Beyond Marylebone Road is Regent's Park. Following a tradition established by John Wood and his son in the first half of the 18th century in Bath, Park Crescent was developed as a single architectural composition. Around Regent's Park, Nash built further such homogeneous rows of houses, this time in longitudinal blocks called terraces (ill. p. 49). They are up to 1,000 feet (300 m) long, and each block is different from the other. Generally the terraces have four stories: a plinth level (mostly rusticated), two upper floors (often decorated with giant pilasters or detached columns), and an attic above the entablature. To break up the great length, Nash uses temple projections, bay windows or pedimented porticos. In some places, the terraces are linked by open arches on the model of triumphal arches. Behind the lavish, palatial language of these façades is a series of ordinary terrace houses and apartment blocks. But each resident enjoyed an undisturbed prospect on the park landscape as if he were living in the middle of his own estates and not in a city. With their monumental colonnades and occasional theatrical flourishes, Nash's terraces around Regent's Park are among the great townscape achievements of Neoclassicism, and yet they consist, like a stage set, only of plaster and stucco on plain brick structures.

as a developer in London in 1777. By 1783 he had already gone bankrupt as a speculator and retired to Wales. There he began again as an architect, meanwhile catching up on Uvedale Price and his theory of the picturesque. Variety, fluid transitions from architecture to landscape, and the creation of picturesque views and sights were henceforth his architectural creed, which up to 1810 he successfully turned into numerous country houses. He switched effortlessly between versions of Castellated Gothic, Neoclassic or Italianate styles, as the client's whims dictated.

However, Nash also took commissions for smaller-scale country dwellings or *cottages ornés*, which, imitating country cottages, aroused great interest at the time as expressions of an idealized rural existence. In Henbury near Bristol, Nash designed in 1811 a whole village of little cottages, called Blaise Hamlet,

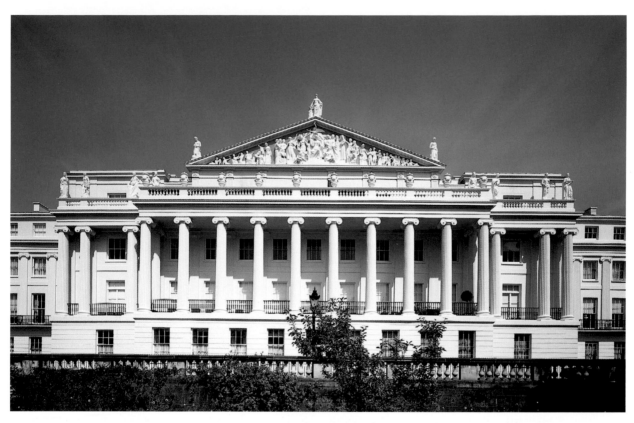

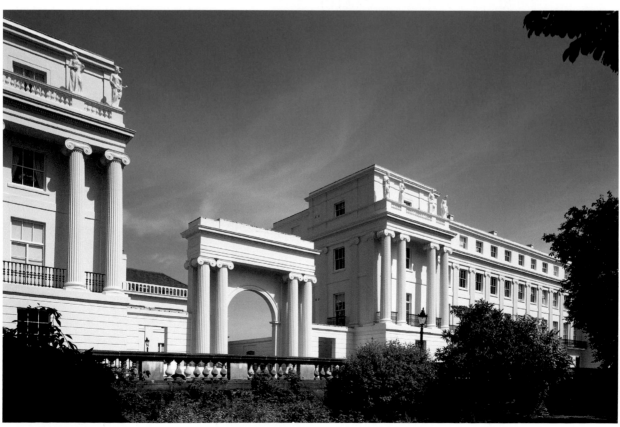

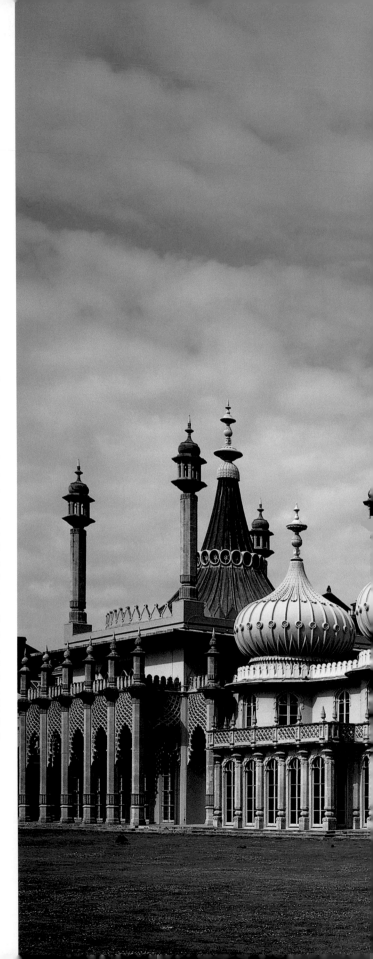

However, Nash's best-known work, the Royal Pavilion in Brighton (ills. pp. 50–52), is neither Neoclassical nor Gothic Revival, but exotic. From 1783 the Prince of Wales often spent the summer season at the fashionable seaside resort of Brighton, where he soon fell in love with the young but Catholic widow Maria Fitzherbert, whom he secretly married in 1785. In 1787, he commissioned Henry Holland to build him a villa with a central domed rotunda and two bow windows on each side. At the end of the Napoleonic wars, the Prince, by then Regent, commissioned Nash to modernize the building. Between 1815–22, Nash and his extravagant client transformed the modest villa into an opulent, exotic dream world, where no costs were spared. Nash extended the villa by a large new room at both north and south ends to make a banqueting room and music room, and transformed the rooms along the garden façade into a series of splendid drawing rooms. He used for this a mixture of Chinese and other oriental styles. In the banqueting room for example (ill. p. 52), the walls are covered with Chinese paintings, and the dome opens into a painted sky, where the astonished visitor's gaze falls on the giant, partly illusionistically painted, partly projecting sculptured leaves of a banana palm. In the middle, an equally huge silver dragon supports an enormous chandelier with further dragons and lotus blossoms.

Even more bizarre than the interior is the exterior of the Royal Pavilion (ill. pp. 50 and 51). Nash retained the basic Neoclassical villa with its central rotunda and bow windows at the sides, but clad it in a decorative style borrowed from Mogul India, with quatrefoil and horseshoe arches, pierced latticing, polygonal piers growing from lotus blossoms, and a busy roofscape of tent roofs, minarets, and onion domes.

Fantastic and picturesque though the Royal Pavilion seems, it owes its appearance not only to its exotic decorations, but also to the employment of new, forward-looking building materials, with which Nash experimented on many of his building projects. The central dome of the Pavilion is supported on an iron frame, and the supports in the kitchen (ill. p. 52) are made of the same material, though decoratively finished as palm trees. The outer skin of the domes is made of Hamlin's Mastic, an early form of cement that unfortunately did not prove very durable. The lighting of the great chandeliers was already provided by gas.

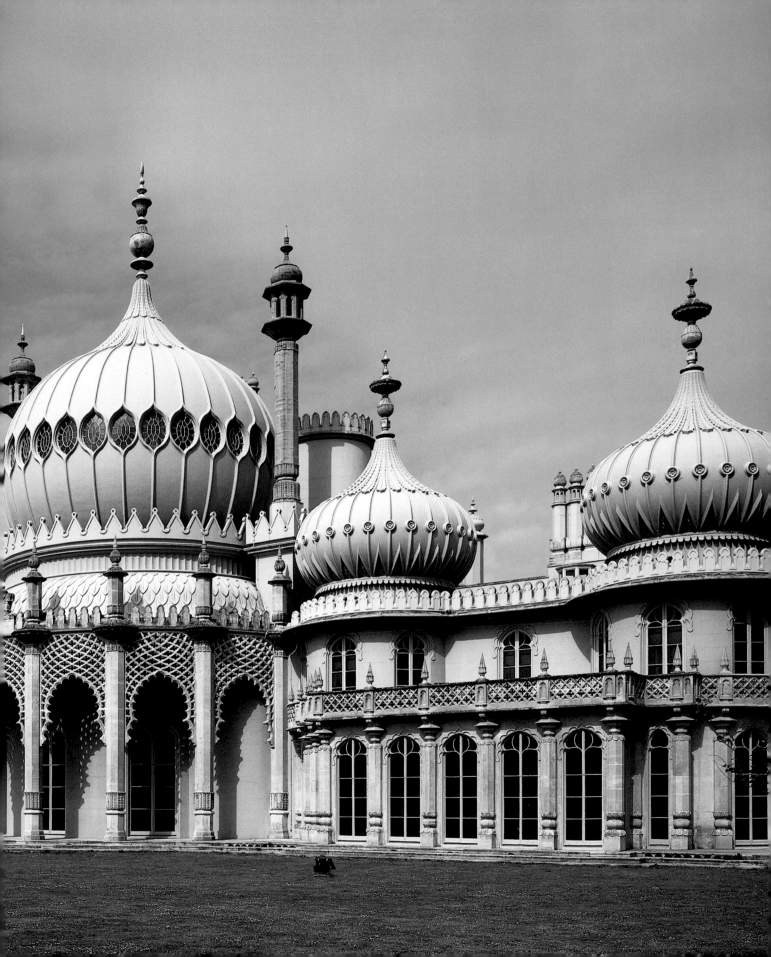

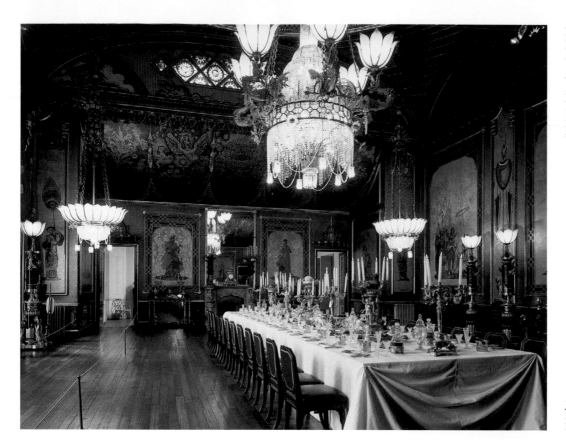

OPPOSITE, TOP:
Isambard Kingdom Brunel
Clifton Suspension Bridge
Clifton, Bristol, 1829–64

This is one of the first and technically most daring suspension bridges. The towers are modeled on Egyptian pylons, blending technical progress and Romanticism even in an engineering structure

John Nash
Royal Pavilion, Brighton
Banqueting Room, 1815–22

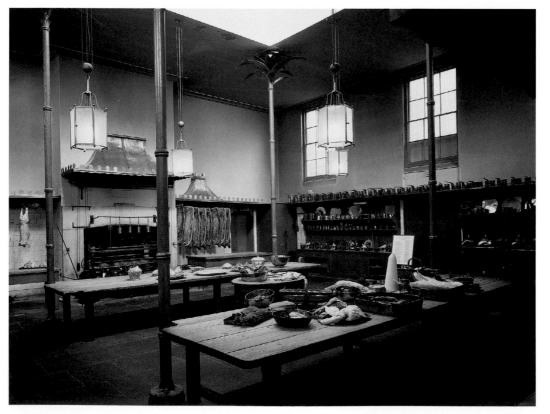

John Nash
Royal Pavilion, Brighton
Kitchen, 1815–22

The opulent dream world of the Royal Pavilion was only possible with the (artfully concealed) use of modern technology. Iron was used for the structural work and even the slender columns disguised as palm trees, while gas was used for the huge chandeliers and an early form of cement (Hamlin's Mastic) for the outer skin of the domes.

OPPOSITE, BOTTOM:
George Gwilt, William Jessop
Warehouses, West India Docks, Poplar, London, 1802–03

New building materials and industrial buildings

As in industrialization generally, Britain pioneered the use of the new building materials of iron and glass. In the course of the 18th century, cast iron had become available in great quantities as a result of improved production processes, and by 1800 was being introduced here and there for supports or balustrades. An important area for the use of iron was for bridges. In Ironbridge, near Coalbrookdale (Shropshire), the center of English iron production in the 18th century, the first purely iron bridges in the world were built between 1777–79, followed in the early 19th century by the technique of suspension bridges, such as that built in Bristol by Isambard Kingdom Brunel (ill. p. 53, top). In the new field of factory construction, fireproof structures could be created with iron. The still-surviving Marshall, Benyon & Bage Mill in Shrewsbury of 1796–97 is the first multi-level building in the world with an internal iron frame, where the supports, beams and even the window frames are made of iron. The (still load-bearing) external walls are, like all early English factories and the large warehouses, built of brick. These new types of building are mostly on five floors, with sparingly articulated building masses of impressive gravity, like the warehouses in London's West India Docks of 1802–03 (ill. p. 53, bottom).

A major center of English industrialization was Derbyshire with its wool manufacture, dominated in the late 18th century by Richard Arkwright and Jedediah Strutt. Originally a barber and a prototype of the new entrepreneur, Arkwright invented in 1768 an improved spinning frame, which enabled warp-quality cotton thread to be mass-produced. From 1771, he constructed

in Cromford his first factories powered by steam engines, invented by James Watt in 1764. They are simple structures with numerous windows, having blind walls at ground level as a protection against anti-machinery riots (ill. p. 54, left). By the end of his life, Arkwright had accumulated a knighthood and an enormous fortune. No doubt this derived mainly from the unscrupulous exploitation of cheap labor, but nonetheless he did have some sense of conscience as an employer, and between 1771–76 built a whole street (North Street) of three-story terrace houses for his workers – the beginning of specially constructed industrial housing (ill. p. 54, bottom right). The attic floors of the houses in Cromford had larger windows so that families of employees could make garments on looms at home.

The other new material in architecture, large panes of glass, was used from the 1810s in hothouses in conjunction with iron structures, as can be seen in the still-extant great Palm House in Kew Gardens, dating from 1844–48 (ill. p. 55). From there, glass moved on to the great exhibition halls, notably Joseph Paxton's Crystal Palace south of London in 1850–51, leading to a revolution in architecture which would later become the full-blown skeleton construction system.

Barbara Borngässer
Neoclassical Architecture in the United States of America

The skyscrapers of Chicago or New York were not the first great buildings to raise the profile of the United States of America as a "nation of architecture." Long before, in the late 18th century, architecture had assumed an eminent role in the northern states of the newly independent colony: architecture was to demonstrate the pride and self-confidence of a young, democratic society. Today the Capitol and White House in Washington are the best-known symbols from this epoch, buildings that are synonymous with government and state power. American Neoclassicism became the flag-bearer for republican ideology; by both absorbing and adapting classical forms,

it was able to give tangible form to the pragmatism of the "New World."

Architecture and ideology were always closely related – the concept of politics, after all, is derived from the Greek word for city, *polis*. Greek *agorá* represented concentrations of ancient "political" life, while medieval cathedrals came to symbolize God's power on earth, and the Baroque castle became a symbol of the absolutist power of princes. All these building types developed in parallel with the institutions they represented – the ancient *polis*, the bishoprics, the sovereign. Even the *palazzi pubblici* of Tuscan cities belonged to a tradition of feudal fortification, and it was in this

form that they challenged the power of the church.

When the ideas of the Enlightenment began to spread in the mid-18th century, its general aims seemed clear enough: to put an end to Baroque excesses and personalized expressions of power, and to eliminate the opulence of courtly self-dramatization and rampant ornamentation. As the shop window of ideology, it fell to architecture to give this visible expression. It was no mere coincidence, therefore, that the first real architectural movements occurred at this time of radical change. A knowledge of Greek Antiquity, and of its political thought, its literature, and architecture was rediscovered, setting off a wave of enthusiasm which gripped not only Europe but also its colonies. In the search for their own identity far from the centers of power, the colonies were less burdened by history than their colonizers. They then began a long and arduous struggle for their rights and independence – based though they were on the ideals of their European forefathers. The United States of America was the first country to enter this new age when it declared its independence in 1776. Architecture in the young republic became a unique testimony to this revolution.

The colonial legacy

As in all colonies, North American architecture showed the influence of the various origins of the country's settlers. As was the case in central as well as South America, however, buildings were adapted to local geographic, climatic and infrastructural conditions. In southern regions there was a fruitful exchange between local building techniques and Spanish architecture: churches and other public buildings in New Mexico, for example, were constructed from *adobe* – fired bricks – and were therefore closely related to the natural resources available, the weather and, ultimately, the technical abilities of their builders. On the Mississippi, where French fur traders had settled, towns were established with tree-lined squares and wrought-iron balconies; in various other places in the north-east, such as New Amsterdam, there were Dutch, German or Swedish variants, though these eventually lost ground to influences from Britain.

In the British colonies, building was at first limited to the essentials: in

contrast to the Roman Catholic and more hierarchical south, there was no demand for a state architectural style. Exuberant décor in religious buildings was considered "papist," and therefore bordering on the unacceptable. The assembly rooms of the Puritans were simple and spartan, as the famous Old Ship Meeting House in Hingham, Massachusetts (1682), shows. There is a legend that its ceiling, which looks like the hull of a ship, was actually made by ships' carpenters. Settlements were often not built to last and had no architecturally prominent focus. Intended as service centers for large tracts of farmland, these townships were often separated by great distances. More imposing farm houses were occasionally built but, because wood was the preferred construction material, only a few such structures have survived to the present day. Building types were based on either the English or Dutch models, which reminded carpenters of their native countries. The planning as well as execution of these buildings was in the hands of tradesmen; there was no demand for trained architects.

The impetus for a non-functional architecture came when the capital of Virginia, an important plantation state, was moved from Jamestown to Williamsburg in 1699. Although the Baroque design of the complex recalled the older planned cities of Charleston (1680), Philadelphia (1682) and Annapolis (1694), it outdid these previous examples in terms of monumentality and representativeness, features which were to define Neoclassicism in North America. In general the architectural paragon for the American colonies was Christopher Wren and his classical Baroque style, though James Gibbs' unconventional church of St.-Martin-in-the-Fields in London was often copied in the New England states. It is possible that Wren himself provided designs for the College of William and Mary in Williamsburg (1695–1702), a building which, like those on the Capitol, ushered in an age of European-influenced architecture.

As in England, the mid-18th century saw a turn away from Wren's "Roman" classicism and a search for severer and purer forms. The founding structure of North American Neoclassicism, therefore, is considered to be the Redwood Library in Newport, Rhode Island, built by Peter Harrison between 1749 and 1758 (ill.

William Thornton, Benjamin Latrobe, Charles Bulfinch
Capitol, Washington D.C., 1792–1827

p. 57, top). For the first time in North America a building was defined by the elegant façade of a classical temple. Harrison was actually an English ship-builder, woodcarver, and captain. He created his designs after Palladio's patterns in the fourth of his books on architecture, rendering them for the most part in wood. Other details from the building indicate the influences of English Neo-Palladianism. Harrison also built other classically inspired churches including King's Chapel in Boston, a building whose present discreet solemnity is attributable to its missing its original color scheme.

An interest in architectural treatises or traditional design books was a constant feature of the age – and not just of colonial architecture. Handbooks for the instruction of architects, stonemasons, and carpenters had circulated since the Middle Ages to a much greater extent than has previously been acknowledged. From technical advice to typological and stylistic patterns, they conveyed a catalogue of theoretical and practical knowledge for clients and builders alike. Any half-serious engineer or tradesman owned a well-ordered library of relevant technical titles. As colonialism spread, this literature attained an enormous political significance which went far beyond its practical uses. Architectural design books served to bolster ideology – whether it was religious orders spreading their message of salvation through their building regulations, or architecture being used to illustrate hegemonic claims to colonial power. Understandably, few renowned European architects were prepared to undertake the risky journey to the colonies, and it was left to the architects of monastic orders or engineers to carry the architecture of their religions or political masters to the New World. Such architectural missions were only made possible by the availability of a theoretical framework and illustrative material: works such as Giacomo Leoni's *English Palladio* (1716), James Gibbs' *A Book*

of Architecture and Batty Langley's *The City and Country Builder's and Workman's Treasury of Design*. Today one can only guess at how many of these valuable sources were claimed by storms or other calamities occurring on their voyage to the Americas.

Around the middle of the 18th century, however, it was less often spiritual or political matters that dominated these design books. Instead, they were characterized by an apparently scientific interest in the "real" ancient world, which was to be explored through the study of antiquities. This antiquarian approach was also bound up with a profound mistrust of the Roman-Baroque pathos of the Late Georgian Style that had begun to be thought of as conservative. "The genius of architecture seems to have shed its maledictions over this land," was the opinion of the Secretary of State, and later, the third president of the United States, Thomas Jefferson (1743–1826).

Thomas Jefferson and the Federal Style

Jefferson became a key figure in the turn to Neoclassicism, at the same time pioneering an independent North American architecture. As a connoisseur he had studied the works of the English Neo-Palladians early on in his career, and from 1768 had begun to draw his own designs. In 1769 he designed and built a villa modeled on Palladio's centrally planned structures for his country estate in Monticello, Virginia (ill. p. 57). Influenced by his years as ambassador in Paris – which had brought him into contact with contemporary French architecture – he later redesigned crucial features of this building, lending it more monumentality and grace. The ground plan was extended to provide for two halls along the central axis and a double series of rooms in the side wings that end in polygonal apses. The white portico on four Corinthian columns rises to the height of a single floor and is clearly differentiated from the broad brick expanse of the body of the house. A dome on an octagonal drum signals this as being the most important part of the house. In a language of classical forms Jefferson created a building whose elegance – and, in particular, its integration into the surrounding landscape – directly address the viewer's senses. Raised on a discreet plinth, the building forms an inseparable whole with the natural surroundings, lending them a sense of majesty. Jefferson was

also a very practical thinker: he invented numerous technical innovations for the house such as dumbwaiters and folding beds.

The villa in Monticello became the cradle of the Federal Style, as the architecture of the newly independent 13 North American states was called. As in France, this Neoclassical style was combined with Enlightenment thought, while at the same time its monumentality and dominance of landscape could be translated into ever greater dimensions. Such were the intellectual and formal foundations of the young nation's architecture, although the transition from Jefferson's work as a "gentleman builder" to a fully-fledged national architectural language was by no means sharply defined (Monticello, for example, was not completed until 1809).

Jefferson's second project, the Virginia State Capitol in Richmond, clearly showed what kind of architectural signals the young republic wished to broadcast. Again it was a French model that provided the decisive inspiration for the federal seat of government: the Maison Carrée in Nîmes, a Roman podium temple which Jefferson had studied devotedly.

Together with Louis Clérisseau he elevated it into the ideal of a new American architecture. "An old Roman temple, the most perfectly preserved example of what could be called 'Cubic Architecture'." The Virginia State

LEFT AND BOTTOM:
Thomas Jefferson
University of Virginia
Pantheon Library and pavilions
Charlottesville, Virginia
1817–1826

From a cultivated Boston family, Bulfinch undertook a two-year study tour to Europe after completing his doctorate at Harvard. After returning to the United States, he decided in 1787 to turn his love of architecture into a profession. Although he was soon awarded contracts in other northern cities, he did his best work in Boston. Among his earliest works there is the Beacon Hill Memorial from 1791, a vast Doric column crowned by an eagle. There followed the Massachusetts State House, built between 1795 and 1798, which dominates its surroundings with its colonnaded frontage. As with much of his work, he looked to the example of older English architects, especially the designs of court architects William Chambers and Robert Adam. He translated their slender designs into rawer, more monumental forms, often using brick. Perhaps more interesting than his government buildings are Bulfinch's rows of houses for wealthy Boston merchants.

Tontine Crescent – designed in 1793 after similar streets in Bath, England – was a prototype of upper-class American residences. Also executed in brick, its façades were painted to resemble stone and were designed in a discreet classical manner, relief being provided by a central triumphal arch. At the end of his career in 1835, Bulfinch built the temple-shaped railway station at Lowell, Massachusetts – one of the earliest and surely most attractive examples of this building type.

Capitol, completed in 1796, was again defined by a monumental portico, though this time in the delicate Ionic order expressed in the arrangement of pilasters which wound around the entire building. A powerful pedestal and a harmoniously composed triangular pediment provided the necessary distancing effect and urban accent.

Jefferson's major work was without doubt the founding and planning of the University of Virginia in Charlottesville, a complex which was not completed until 1817. It is one of the earliest examples of a "campus university," in which buildings are loosely grouped in a pavilion system and integrated into the surrounding landscape (ill. p. 58, top and bottom). The precursors for this concept, which replaced the self-contained, monastic type of college building, can be found in Cambridge (England) and – ironically – in the design of Absolutist palaces. In Charlottesville, Jefferson successfully managed to redefine a centuries-old building type, while allowing the full spectrum of Classical architecture to emerge anew: the heart and highpoint of this "academic village" – which was to have exemplary character for American society – is the rotunda, which accommodates the library and the country's first observatory. Around about it, and organized by colonnades, are grouped two rows of five pavilions each, which house the various academic disciplines. Their architecture is intended to replicate a stroll through the monuments of ancient Rome; quotes from the Pantheon, the Temple of Fortuna Virilis, and the Baths of Diocletian combine with Neoclassical interpretations of the antique. The whole ensemble is bound by spacious green areas, which reinforce the impression of an Arcadia of learning.

Like Jefferson, Charles Bulfinch (1763–1844) was a "gentleman builder" in the most positive sense of the term.

At this historical juncture the same conditions applied to the building of private homes as to public architecture: because there were no professional architects, design books provided the educated and interested layman with the necessary practical tools for the job. Asher Benjamin's compendia, which were published from 1797, were highly successful. *The American Builder's Companion* from 1806 provided a series of patterns for city and country houses that catered to a variety of different needs.

Washington

In 1790 Congress decided, after long debate, to establish a new seat of government, on a ten-square-mile piece of territory on the Potomac River. The new capital was called Washington in honor of the first President of the United States. Plans were drawn up by a French major, Pierre Charles L'Enfant (1754–1825), with Jefferson advising. L'Enfant, who had fought in the American War of Independence as a volunteer, was originally from Versailles, and his memories of the axial layout of Le Nôtre's gardens almost certainly found their way into his Washington designs. The traditional chessboard plan was modified by allowing for differing widths of blocks and boulevards. Over the grid broad diagonal boulevards were laid, which met to form spacious star-shaped squares, and the most important of the city's institutions were placed at these nodes. A high point of the design was the 400-foot-wide mall, which led from the Capitol to the Potomac River. The proportions of

the city were unprecedentedly generous, and numerous *points de vue* animated the long perspectives of the city's axes.

Of the government buildings, only the Capitol and White House were initially completed (ills. p. 56 and p. 60, top). Competitions had been held for both in 1792, and an effort had been made to ensure contributions were received from American architects. Their proposals failed to convince the judges, however, and the commission was eventually awarded to an Irishman, James Hoban (c. 1762–1831). His project borrowed heavily from a design for a country house by the English architect James Gibbs, which had been published in his *Book of Architecture* in 1728. The office of the President of the United States was therefore built in a very traditional, even old-fashioned manner – and, of course, in the style of the country's former colonial masters. The complex history of the Capitol reveals even greater problems: here, too, the competition was initially unsuccessful before unanimity was finally reached on a design by the doctor and amateur architect William Thornton (1759–1828). His proposal for a broad, domed building in the classical style was reworked by Frenchman Stephan Hallett and, still later, by the American Benjamin Latrobe.

When the British pillaged Washington in 1814, the first thing they destroyed was the still incomplete Capitol. Latrobe played a crucial role in its hasty reconstruction. His alterations – some of which were extensive –

lend the ascetic building greater charm and elegance. The White House also owes its characteristic portico to Latrobe, and it was he who designed the Capitol's stylish interiors. His elegant Corinthian columns, whose acanthus leaf capitals are transformed into corn leaves, still draw admiring comments today.

Greek Revival

Benjamin Latrobe is a key figure in the Greek Revival in America. His deliberate return to the art of Greek Antiquity was combined with notions of archaeological authenticity and purity of style. Latrobe, who was the United States' first professional architect,

William Thornton, Benjamin Latrobe, Charles Bulfinch
Capitol, Washington D.C., 1792–1827

James Hoban and Benjamin Latrobe
White House
Washington D.C., 1815

LEFT:
Benjamin Latrobe
Portico of the White House
Washington, D.C.
1815

BOTTOM:
Benjamin Latrobe
View of the Bank of Pennsylvania in
Philadelphia, watercolor sketch by the
architect, 1799–1800

studied in Leipzig, Germany and worked under the English architect and archaeologist Charles Robert Cockerell, from whom he learned his passion for authentic classical architecture. At first he worked as an engineer in Virginia before Jefferson hired him to work on the Capitol in Richmond. Latrobe's first important independent project was the state prison in Richmond, Virginia (1797–1798), which shows early evidence of his cubic, clearly defined style.

His Bank of Pennsylvania represented a quantum leap in American architecture (ill. p. 60). Its structure was laconic in its simplicity, and composed of a long rectangle whose two ends featured Greek-Ionic temple façades. The interior space was vaulted with a dome after the Pantheon. The Bank of Pennsylvania fulfilled the requirements of the French theorist, Abbé Laugier, but John Soane's Bank of England may also have provided inspiration. The beauty of the building lay in the harmonization of its volumes and the subtle design of the façades. Its central hall – the first in America to feature a stone vault – constituted a grandiose setting for the bank's business. Built between 1789 and 1800, the bank was unfortunately destroyed 60 years later.

Latrobe's second great project was Baltimore Cathedral, the first large-scale Catholic church in the USA. Latrobe prepared two designs in both Gothic and "Roman" styles, preference finally being given to the latter in 1804 (ill. p. 61). Here, too, sobriety and logical coherence are the main characteristics of the building, which in spite of its simplicity, radiates a sense of elevated dignity. This is largely due to its Ionic portico and the shallow stone dome, which is reminiscent of the Pantheon and rises above the crossing.

In spite of Latrobe's new additive approach to the design, the model for the cathedral is clearly Jacques-German Soufflot's church of Ste-Geneviève in Paris (ill. p. 69). In 1803 Latrobe was appointed to the office of inspector of public buildings; in this capacity it was his duty to oversee the rebuilding and completion of the White House and Capitol in Washington. His design for the Supreme Court Chamber (1815–17) with its squat Doric sandstone columns shows the full range of his imagination, which, even here, did not shrink from combining styles.

In the period around 1815 nationalistic tendencies were strengthened in the context of the British-American war. The liberation struggle of this young country almost a quarter of a

Benjamin Latrobe
Cathedral, Baltimore, 1804–1818
View of the exterior, drawing by the
architect, 1804 (right)
Interior (bottom)

century earlier during the American Revolution was seen as a parallel to the Greek war for independence, which was raging at the same time. The Romantic-Classical movement of the "philhellenists" had cast its spell on figures like Lord Byron, and it also fired the enthusiasm of the young American nation, leading to a renewed study of Greek Antiquity. The publications of James Stuart and Nicholas Revett had already acquainted a broader circle of readers with the antiquities of Athens, leading to a popularization of classical architecture. The fashion affected not only public buildings; wooden country houses were decorated with simple, elegant forms and featured the harmonious proportions that, it was believed, abounded in classical Greece. Minard Lafever's book *The Modern Builder's Guide* (1833) was only one of many manuals containing directions on the construction of "Greek houses" which poured into the United States.

Latrobe's pupils, Robert Mills (1781–1855) and William Strickland (1788–1854), stand at the crossroads between the Greek Revival and the more broadly conceived movement known as Historicism (Revivalism), which began to make itself felt in the 1830s. Mills, who claimed to be the first architect born and educated in America, called for the use of meaningful, logical forms. They should, he thought, relate to the tastes and requirements of the USA, but also help to ground the classical style in the New World. "Study your country's tastes and requirements and make classic ground *here* for your art," he demanded. He went on: "We have entered a new era in the history of the world. It is our destiny to lead, not to be led." In spite of these proud words, Mills was unable to develop his own independent style – the time for that had not yet arrived.

Nevertheless, some of Mills' buildings, such as the octagonal Monumental Church in Richmond (1812) or the County Record Office in Charleston (1822), are steeped in pragmatism and rationality, even though they are derived from traditional models. Due to its non-combustible stone vault, the Record Office was named the "Fireproof Building." While Mills' work appears functional and coarse, William Strickland's Second Bank of the United States in Philadelphia (1818–1824) is a noticeably elegant structure, which owed much to Latrobe's Bank of Pennsylvania.

Ten years later in the same city (1832–34) he built the Merchants' Exchange on a challenging corner property. Its sweeping half-round portico, which extends upwards to form an elegant tower, is an impressive focal point in the surrounding streets. Its style is characterized by obvious quotes from Greek monuments – in this case the Monument to Lysicrates in Athens.

Strickland's pupil, Thomas U. Walter, was also inspired by classical buildings, but knew how to adapt them to "the requirements of the country": outwardly the main building of his Girard College in Philadelphia (1833–1847) presents itself as a Corinthian peripteral temple, but inside it contains vaulted rooms over three floors which, at Mills' insistence,

offered protection against fires. For the portico of the Hibernian Hall in Charleston, S.C. (1835), on the other hand, Walter drew inspiration from the Erechtheion on the Acropolis.

With Walter's monumental Ohio State Capitol in Columbus (designed 1838, begun 1848) it became clear, however, that the era of American classical architecture had drawn to a close.

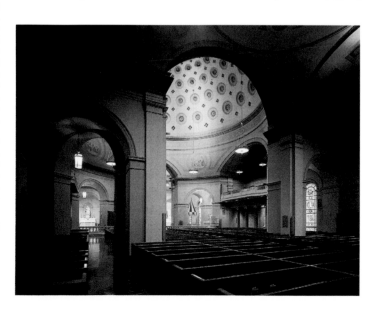

Georg Peter Karn

Neoclassical and Romantic Architecture in France

Background

Though 1789, the year of the Revolution, counts as a turning point in French history, it was also the ultimate outcome of a long drawn-out crisis. Economic problems, the collapse of state finances, failed harvests and famines all added to growing popular discontent, which the political weakness of the monarchy under Louis XVI could not counteract. The philosophy of the Enlightenment, which questioned the divine right of benevolent despotism and postulated the equality of all men, had moreover undermined the ideological basis of the *Ancien Régime* and created the intellectual conditions for radical political change. In the following years, cultural development responded in many ways to the external changes, the most obvious of which were the successive forms of government ranging from the National Assembly (1792) via the Directoire (1795), the Consulate (1799) and Napoleon's empire (1804) to the restoration of the Bourbons and the citizen kingship of Louis Philippe (1814/15–48). Cultural development reflected even more strongly the intellectual currents that preceded the political changes. Within architectural history itself, this involved a sustained, continuous process of modification that cannot be adequately described in terms of bare stylistic catchwords. Thus the period known as Neoclassicism, spanning more than half a century of architectural history, encompasses a rich spectrum with varying aspects. Even if the model of classical Antiquity was at the heart of it, different facets of it were spotlighted at different times and linked with new trends, which ultimately led to its supreme authority being overturned in the Romantic and Historicist periods.

A break in the development was caused mainly by the rejection of the hitherto unconditional obligation laid down by the Académie de l'Architecture to follow Vitruvian doctrine, at whose heart was the classical system of orders. The god-given nature of their proportions had already been questioned in the 17th century by the scientist and architect Claude Perrault, and this ushered in a process of questioning that subsequently gained strength from the study of ancient buildings. After the middle of the 18th century, there was also criticism of Rococo, whose undisciplined frivolity was contrasted with the *belle simplicité* of Antiquity. However, it was only with a return to the *grand manière* of Louis XIV that a way could be seen to bring *le bon goût* back into architecture.

During the reign of Louis XIV (1723–74), a major figure was Madame de Pompadour (1721–64), the king's mistress for many years. As she was in contact with leading intellectuals, it was through her that new ideas reached the court. Her brother, later the Marquis de Marigny (1727–81), was only 24 when he was appointed to the key position of Surintendant des Bâtiments.

Under Louis XV, Jacques-François Blondel (1705–74) represented the official architectural style. From 1743, he collected

Ange-Jacques Gabriel
Buildings in the Place Louis Quinze (now
Place de la Concorde), Paris
Begun 1755

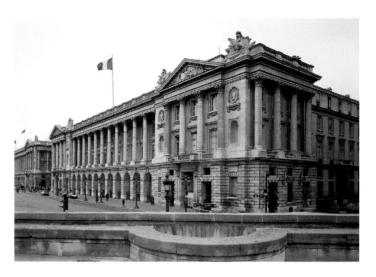

pupils around him in his own architectural school, and from 1762 did the same as professor at the Académie, making his teachings accessible to a larger public in his *Cours d'Architecture*, published from 1771. Though Blondel stuck to the sanctity of Vitruvian rules of proportion, he also introduced the concept of *caractère* as an essential factor in judgment. *Caractère* described the specific form of expression befitting each building, and was derived from the functional character of the building and the rank of its possessor. The use of ornamentation and articulation via the orders was thus subject to the gauges of *convénance* and *bienséance*. Blondel's models were the buildings of 17th-century French classicism and pre-classicism, especially the works of François Mansart, whom he revered.

Ange-Jacques Gabriel and royal architecture

In the second half of Louis XV's reign, the central figure in royal architecture was Ange-Jacques Gabriel (1698–1782). He came from a dynasty of important architects related to Mansart, and succeeded his father Jacques V. Gabriel as *premier architecte du Roi* (first architect to the King) in 1742. In the 30 years or so until he retired in 1775 after the death of the king, he shaped the official style of architecture, leading it into the nascent Neoclassical era without surrendering the link with tradition. Borrowings from the admired architecture of the Sun King were supplemented by elements of the Italian cinquecento, especially motifs derived from the northern Italian architect Andrea Palladio, such as could be seen in contemporary English architecture. Where the Gros Pavillion of the château at Fontainebleau (1750–54) draws on LeVau's garden front at Versailles, Gabriel's little château of the Petit Trianon (1762–68, ill. p. 66, top) in the park there, with its cubic structure and differentiated orchestration of individual façades by means of giant pilasters or columns, reflects Palladian influences.

One of the most grandiloquent urban planning projects of the capital, Gabriel's design for the Place Louis Quinze, now the Place de la Concorde (ill. p. 63), dated back to the middle of the century, but it was not until the 1770s that it was carried out. After the Treaty of Aachen in 1748, Paris' traders had subscribed for an equestrian statue of the king, which required a suitably important site. Once the king had made a plot in the Tuileries available, Gabriel began work on the job, making use of the results of two competitions. The result was a new kind of natural park on the periphery of the urban built-up area, in whose center stood Bouchardon's equestrian statue of the king (later destroyed in the Revolution). The large rectangle enclosed by water channels is overlooked only by two symmetrically placed buildings on the narrow northerly side opposite the Seine. These two buildings were there solely for aesthetic planning reasons and were allocated functions post hoc; the right building became the royal utensils store, for example. Their articulation by means of corner pavilions and the absence of a central feature are attuned to the open center axis of the square, the termination of which was to be marked by the dome of Contant d'Ivry's Madeleine church. The two-story colonnade between end pavilions is clearly related to Perrault's famous east façade of the Louvre not far away, but, thanks to the use of single instead of double columns, is translated into a lighter but at the same time less taut version in the 18th-century manner. The vigorous rustication of the ground floor reveals English influence, while details such as the balcony brackets are borrowings from Michelangelo.

Unlike this major urban design achievement, most of Gabriel's *grands projets* for extending and enlarging the royal palaces did not proceed beyond the planning stage, as a result of the heavy drain of the Seven Years' War on state funds. An exception was the construction of the château at Compiègne (1751–86). Similarly, the systematization of the *cour d'honneur* at Versailles, which had already been mooted during Louis XIV's reign and for which Gabriel had drawn up plans both in 1743 and 1759, was actually begun only in 1772, and was still incomplete in 1783. Of that large-scale project, which involved the *Cour de marbre* along with parts of the original layout of the hunting lodge dating from the first half of the 17th century, in the end only the right wing, the *Aile du Gouvernement*, was actually carried out. The extravagant stairwell planned for it, which was intended as a replacement for LeVau's Ambassadors' Steps (removed in 1752), was dropped entirely. In its basic features, the façade was oriented to the design of 1759 (ill. p. 64, top) and once again demonstrates Gabriel's established style. With its giant order interrupted only in the side parts of the

Ange-Jacques Gabriel
Plans for rebuilding Palace of Versailles,
1759
Court façade (above)
Engraving (1888) with interior view of
Opera House (below)

OPPOSITE:
Ange-Jacques Gabriel
Interior view of Court Opera House,
Versailles, 1765–1770

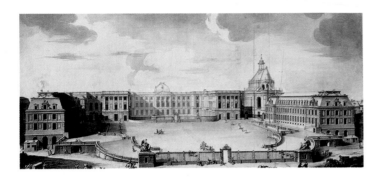

lateral wings above a rusticated socle level, it is formally harmonized with the pilaster articulation of the neighboring chapel by Jules Hardouin-Mansart.

The exclusive, differentiated use of disengaged and engaged columns strikes a note of Louis XIV's *grand goût*, and follows the principle of subordination. While the block-like character of the buildings with the surmounting balustrade, flat roofs and alternate, pedimented windows betrays the influence of Bernini (especially his last project for the east front of the Louvre), Gabriel used traditional French features as well. This is evident in the emphasis on the vertical in the occasionally pedimented projections, but above all in the *dôme carrée* of the center projection, which is derived from the Pavillon d'Horloge in the Louvre. When work began finally after 13 years, the end walls of the corner pavilions, originally intended to have a horizontal termi-

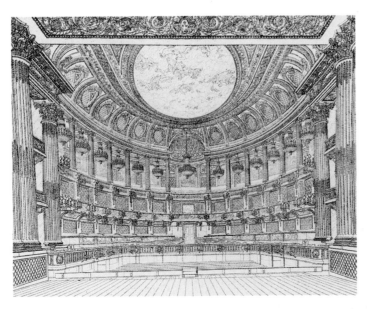

nation, were given conventional pediments to match the other projections. The left wing was completed only in 1814–29.

Unlike the courtyard façade and the main stairwell, Gabriel succeeded in getting another project, for the court opera house in Versailles (ill. p. 64, bottom left and p. 65), actually built. Envisaged since Hardouin-Mansart's day, the project for a theater at the head of the exterior right wing was begun in 1765 and completed in 1770, in time for the wedding of the Dauphin (the later Louis XVI) with Marie Antoinette. On an oval ground plan with its Corinthian colonnade running all the way round above the circle, the auditorium goes back to classical models as already re-used in Palladio's Teatro Olimpico in Vicenza. The continuous rows of seats, which in Palladio's building reflect humanistic ideals, were tailored by Gabriel to court use by the insertion of boxes, and differentiated hierarchically by the niche-shaped royal box on the center axis. The flavor of the *grand siècle* in the furnishing is unmistakable: the decoration is in a rich range of blues, pinks and golds, and includes a ceiling painting by Louis-Jean-Jacques Durameau, gilt reliefs by Augustin Pajou and ox-eyes in the cavetto. However, the lozenge-patterned coffering of the conch above the royal box, inspired by the ancient temple of Venus and Roma in Rome, originated with Charles de Wailly, thus representing the contribution of a younger generation of architects, schooled on classical models.

Another project heavily pruned before it was carried out was Gabriel's design for the École Militaire in Paris (ill. p. 66, bottom). Originally the scheme, for which Gabriel presented an ambitious first draft in 1751, was conceived as an educational institution for young aristocrats, and was intended to rival the nearby Hôtel-des-Invalides by Libéral Bruant and Jules Hardouin-Mansart in scale and standards. The version actually implemented after the Seven Years' War (1768–73) as a military academy was limited to the château-style principal building. The main façade facing the Champs de Mars, drawn together by a strongly projecting entablature, is dominated by the central pavilion. Its domed roof on a square base and the austere pedimented windows once again draw on French 17th-century tradition. Unlike the courtyard façade, where the two-story loggia is a token allusion to the Hôtel-des-Invalides and is enclosed laterally between projections, the outer front dispenses with all corner features. Although the staggered Corinthian columns in the centerpiece lead over into the side wings in Palladian tradition, there is a marked contrast with the plain, unarticulated walls of the latter. In this clear distinction of stories and palpable separation of subsidiary parts, a new philosophy can be discerned, compared with the integrated masses of the *cour d'honneur* façade at Versailles. Classical borrowings are added, such as the barrel-vaulted rectangular plan of the chapel with its half-column articulation, inspired by reconstructions of Roman basilicas based on Vitruvius.

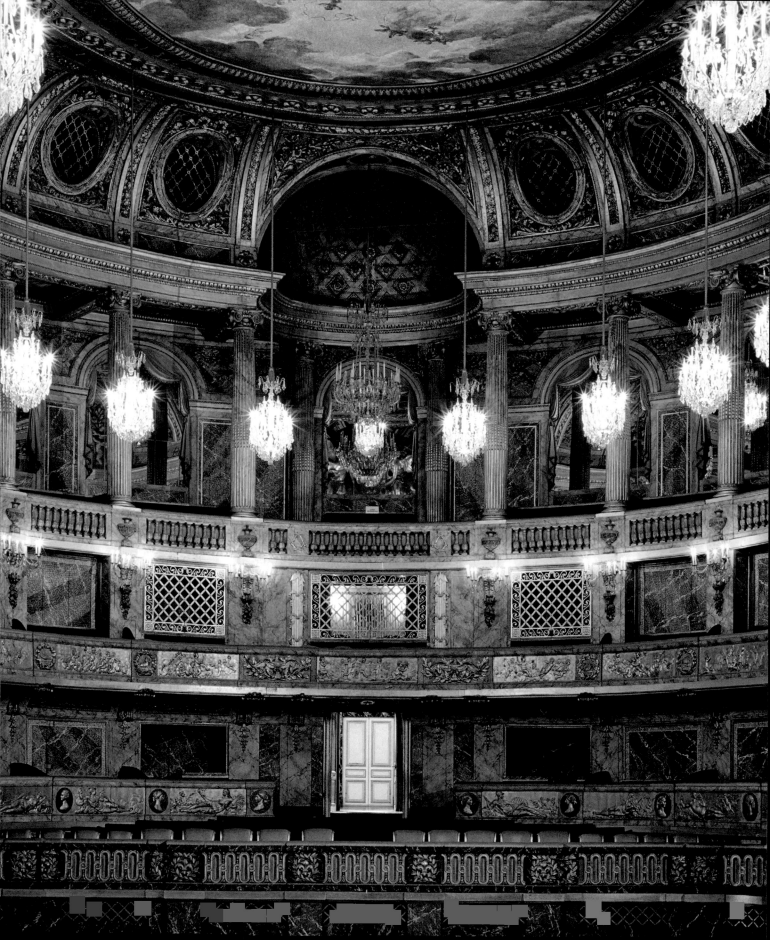

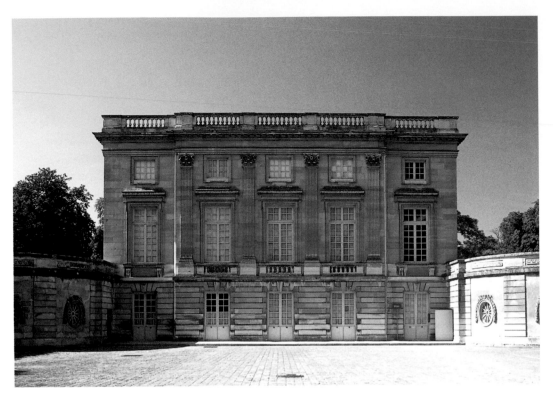

OPPOSITE:
Jacques-Denis Antoine
Münze, Paris, 1771–85
Central hall

LEFT:
Ange-Jacques Gabriel
Petit Trianon, Versailles, 1762–68
Façade of *cour d'honneur*

Built for Madame de Pompadour, the house has the cuboid structure and giant order of a Palladian building. For all the lavishness, the four façades are carefully tailored to match the character of each aspect. The façade facing south-east is the entrance side, and is emphasized by giant pilasters over a rusticated socle level, facing the *cour d'honneur*.

BELOW:
Ange-Jacques Gabriel
École Militaire, Paris
First design 1751, construction 1768–73

The trends apparent in Gabriel's École Militaire became even more noticeable in a further secular building of the 1770s, namely the royal mint by the Seine, not far from the Pont Neuf. Here again, construction had first to go through a long period of gestation, interrupted by the Seven Years' War and several changes of location.

The winner of the competition for the design in 1768 was Jacques-Denis Antoine (1733–1801). Site work began in 1771, but the interiors were not completed until 1785. The complex contains several courtyards, and makes clever use of an irregular site. The main front faces the river, and in its château-like appearance represents national prosperity. The central projection is stressed by giant Ionic free-standing columns, but there is no comprehensive scheme of orchestration, nor are the corners emphasized by pavilions. The increased severity is, above all, the result of the reduction in stories and concentration of columns in a single façade level. It is intensified by the unusually pronounced stress on the horizontal, created partly by the new-style attic in place of a pediment, which is uncommon in a secular building. The decorative statues in front of the attic represent personifications of Peace, Commerce, Wisdom, Justice, Strength and Plenty, which is iconographically not just a reference to the function of the building, but also a statement of the state's image of itself.

The rusticated podium was deleted at the planning stage. It would have been integrated into the embankment wall along with a large-scale flight of steps, and would thus have lent the façade a more dramatic aspect. The fortified look to the heavy rustication of the left rear wing continues a long tradition for mint buildings, dating back to the 16th century. The treatment of the interiors likewise demonstrates Antoine's unremitting attention to detail, proved in countless drawings. The stairwell and two-story center room (ill. p. 67), which were given particularly lavish treatment, are articulated by wall columns and galleries diagonally spanning the corners. The ceiling painting over a steep cavetto follows the stylistic tradition of the 17th century, but the classicizing, lozenge-shaped coffering once again gives proof of Charles de Wailly's influence and newer thinking.

However, even Antoine was keenly aware of the archaeological discoveries of his time, which is proven by his no longer extant portico for the Hôpital de la Charité in Paris, dating from the 1760s. The sturdy columns of the Doric temple front stood – for the first time in Paris – directly on the base plinth, in accordance with Greek models. As a contemporary source reveals, they were intended as allusions to the propylæum of the Acropolis in

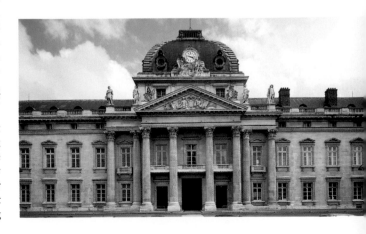

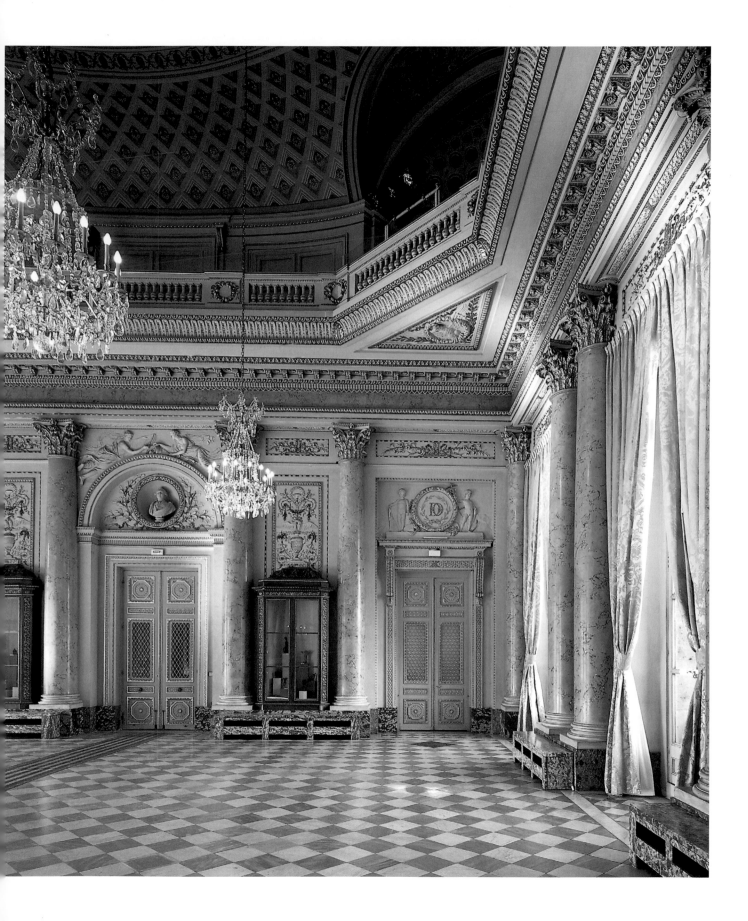

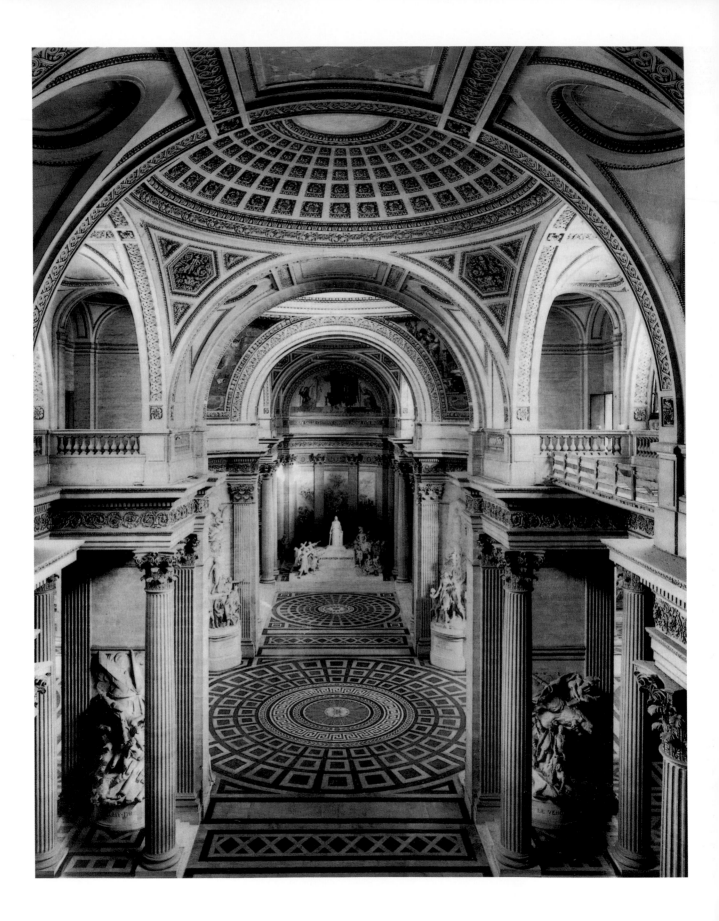

Athens, published in 1758 in Julien-David Leroy's *Les Ruines des plus beaux monuments de la Grèce*.

The reform of church building

Since the mid-century, architectural writers had produced quite a number of new ideas for church architecture. A key publication in this respect was the *Essai sur l'Architecture* by the former Jesuit priest Marc-Antoine Laugier (1713–69), which appeared in 1753. Laugier advocated a thorough reform of architecture and, influenced by Jean-Jacques Rousseau's populist demand for a return to the purity of the natural state, had proposed a "primeval hut" consisting of four tree trunks, cross pieces and a saddle roof as his basic architectural model. Laugier was particularly critical of contemporary church architecture, which since Counter-Reformation days had been distinguished by barrel-vaulted longitudinal structures and crossing domes in the tradition of St. Peter's or the Gesù in Rome. Instead of the prevailing massive and – in his view – ponderous arcade of piers, he wanted detached columns and continuous architraves, which he considered combined the structural boldness and lightness of Gothic with the formal canon of classical Antiquity. Similar demands had been made by Abbé Jean-Louis de Cordemoy back in 1706, and proponents could indeed point to specific examples in an early project of Claude Perrault's for Ste-Geneviève in Paris, presumed to date from 1675, and Hardouin-Mansart's palace chapel in Versailles (1689–1710). Finally, since the 1740s, notably Pierre Contant d'Ivry (1698–1777) had introduced the columns and architrave system in several church buildings, such as the abbey church of St.-Vaast in Arras (from 1755).

Though Laugier's book on the subject was much discussed and gained surprising popularity, the real impact of his ideas had to wait for their monumental implementation in the new monastic and pilgrimage church of Ste-Geneviève in Paris by Jacques-Germain Soufflot (1713–80). Soufflot was the protégé of the Marquis de Marigny and had traveled with him to Italy both in 1731 and 1749–51. He therefore got the commission for the spectacular new project, which was to outshine the most splendid churches in Europe (among them St. Peter's in Rome and St. Paul's in London). After criticism from the conservative-minded clergy, Soufflot, like Wren, had to modify his first draft to make it more conventional. The plan had envisaged a central building based on a Greek cross with a temple façade and crossing dome over the saint's grave. Despite the criticism, the church's brightly lit, airy interior nonetheless struck contemporaries as an epoch-making work and the very essence of the new church architecture (ill. p. 68, left). The elegance of the slender columns and daring opening up of the wall surfaces by means of large windows were technical master strokes, achieved mainly through the novel employment of relieving arches, flying buttresses and concealed iron stays. Soufflot

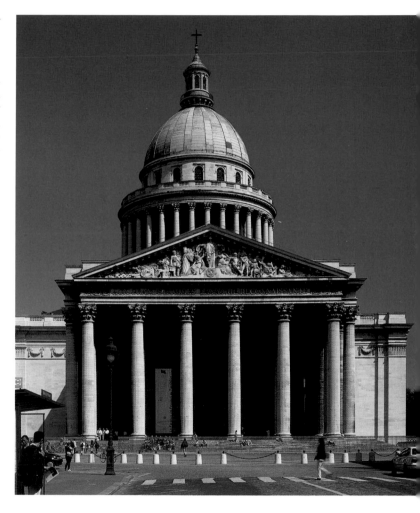

had already resorted to these techniques in completing the unfinished Louvre colonnade. During the planning process, the initially lavish decoration in late Baroque tradition was gradually reduced and replaced by classical motifs. Examples of the latter include the tendril frieze on the exterior, borrowed from the tomb of Cæcilia Metella in Rome, and the stepped dome planned at one point on the lines of the mausoleum at Halicarnassus. In spite of the acrimonious discussion triggered off by architect Pierre Patte in 1769 concerning the load-bearing strength of the design, and despite masonry cracks that appeared in 1776, the dome was enlarged still further. Finally, it was encased in a ring of Corinthian columns, based on the model of St. Paul's in London, but combined with features from Bramante's design for the dome of St. Peter's (ill. p. 69). The result was the most often imitated dome of the 18th

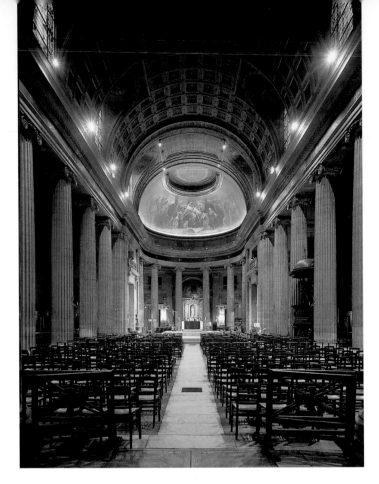

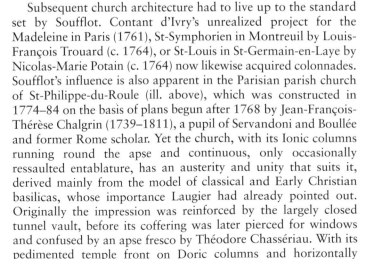

orthogonal grid. Decorative elements are limited to a few places such as the tympanon of the triangular pediment.

The Rome scholars

From the 1740s, enormous influence was wielded on the development of secular architecture by the "Rome scholars." They constituted a counterweight to the formal grammar of Gabriel and Antoine based on the traditions of French classicism and pre-classicism. As participants in the *grands prix* competitions organized by the Académie d'Architecture – and occasionally with the specific assistance of a patron – they spent time at the French Academy in Rome intensively studying the buildings of Antiquity, but also looking at the works of Michelangelo or Bernini. Thanks to contact with Roman-based artists such as Piranesi or Jean-Laurent Legeay, whose imaginative settings in drawings and series of engravings brought the antique world to life, they introduced new insights into architecture that initially bore fruit in interior decorations and theater and festive decor. Additional pressure for fundamental change was exercised by the growing number of published studies of buildings of Antiquity. First to appear were critical analyses of Greek culture, which was seen as the cradle of Roman architecture. Examples included Julien-David Leroy's *Les Ruines des plus beaux monuments de la Grèce* (1758) or James Stuart and Nicholas Revett's *Antiquities of Athens* (1762). When they returned to France, the ex-scholars popularized the *style grec*, an imaginative and successful mixture of features derived from Antiquity, the Renaissance and the Baroque, thus preparing the way for Neoclassicism.

One of the most demanding projects by this younger generation of architects in Paris was the construction of the Comédie Française, now the Théâtre Odéon (1779–82). The first plans for this were

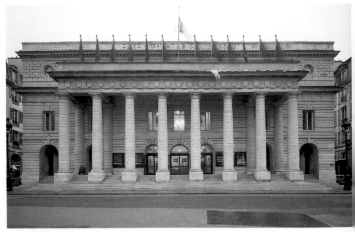

century. Soufflot, alas, did not live to see the completion of his masterpiece. In 1791, after the Revolution broke out, the National Assembly decided to reclassify the church as a *Panthéon des Grands Hommes*, and the architect Quatremère de Quincy embarked on numerous alterations. Following the removal of all decorative features and partial blocking up of the windows in accordance with new notions of architectural taste, the unified massivity of the structure became its most prominent feature.

Subsequent church architecture had to live up to the standard set by Soufflot. Contant d'Ivry's unrealized project for the Madeleine in Paris (1761), St-Symphorien in Montreuil by Louis-François Trouard (c. 1764), or St-Louis in St-Germain-en-Laye by Nicolas-Marie Potain (c. 1764) now likewise acquired colonnades. Soufflot's influence is also apparent in the Parisian parish church of St-Philippe-du-Roule (ill. above), which was constructed in 1774–84 on the basis of plans begun after 1768 by Jean-François-Thérèse Chalgrin (1739–1811), a pupil of Servandoni and Boullée and former Rome scholar. Yet the church, with its Ionic columns running round the apse and continuous, only occasionally ressaulted entablature, has an austerity and unity that suits it, derived mainly from the model of classical and Early Christian basilicas, whose importance Laugier had already pointed out. Originally the impression was reinforced by the largely closed tunnel vault, before its coffering was later pierced for windows and confused by an apse fresco by Théodore Chassériau. With its pedimented temple front on Doric columns and horizontally roofed side entrances, the west front is conceived in terms of an

BOTTOM:
Charles de Wailly and Marie-Joseph Peyre
Drawing for the interior of the Comédie
Française, Paris, 1771

Jacques Gondoin
École de Chirurgie, Paris, 1769–74
Entrance screen including triumphal arch

submitted in 1769 by Marie-Joseph Peyre (1730–85) and Charles de Wailly (1730–98), who had both been in Rome in the mid-1750s.

The job aroused as much public interest as the construction of Ste-Geneviève. The popularity of the theater had grown considerably during the course of the Enlightenment. This is evident from the exhibition of the building plans at the Salon in 1781 and the treatise with which the architects sought to justify their project theoretically. After initially experimenting with a circular auditorium that would show in the exterior as well (which became very common in the first half of the 19th century), the auditorium was lengthened into an oval and clad in a rectangular exterior. With its taut rustication and portico of Tuscan columns beneath a tall attic – a novel, horizontally terminated, but monumental type of portico-Peyre's broad façade (ill. p. 70, bottom right) reveals a strictly architectural conception. In contrast, the (now altered) interior (ill. p. 71, bottom left) with its splendid furnishings bore witness to the rich decorative and theatrical imagination of de Wailly, who had also learnt to appreciate the High Baroque buildings of Bernini during his time in Rome. New standards were set, not least in the treatment of the subsidiary spaces, which were extended because of the increasing social importance of the theater, and which adopted features of palace building. Two symmetrically laid-out stairwells resembling columned halls led from the upwardly open lobby into the airy, two-story foyer, where theatergoers could watch the public from an orbital gallery beneath a frescoed domed ceiling. The reduction of the walls separating the boxes provided for the dress circle were to gain a different sort of esteem under wholly different circumstances during the Revolution.

A further example of the high standards of public architecture is the École de Chirurgie of 1769–74 (ill. p. 71, top and bottom

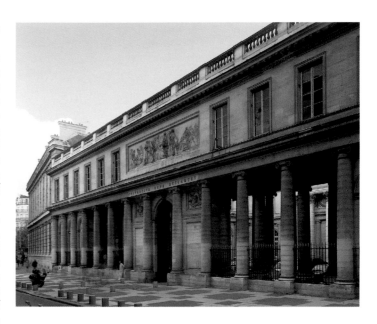

right). The Paris-based institution intended its new building to raise the scientific reputation of surgery, for which a separate academy had been founded in 1731. Its architect, Piranesi's friend Jacques Gondoin (1737–1818), had enjoyed the special favor of the King and spent four years in Rome (until 1764), albeit without winning the Grand Prix. A passing ambition there had been to excavate the ruins of Hadrian's villa in Tivoli. Gondoin chose for his model for the École de Chirurgie the typical aristocratic town house (*hôtel*), with a *corps de logis* set back behind a *cour d'honneur*. However, in his thorough rethinking of the façades he

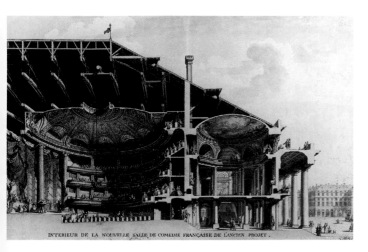

INTERIEUR DE LA NOUVELLE SALLE DE COMEDIE FRANÇAISE DE L'ANCIEN PROJET.

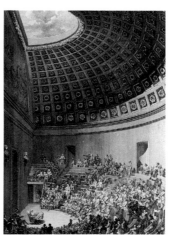

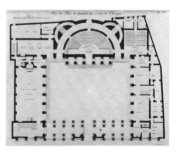

Jacques Gondoin
École de Chirurgie, Paris, 1769–74
Ground plan (above)
Interior (left)

broke with tradition and developed an influential new approach: the "screen" on the street front consisting of several rows of Ionic columns is indeed reminiscent of Gabriel's château at Compiègne, but, due to the tall attic floor and continuous, uninterrupted entablature, it looks quite different.

The triumphal arch-style gateway is wholly incorporated into the colonnade. The attic-level relief in it displays the goddess Minerva and Louis XV (replaced in 1794 during the Revolution by the personification of Charity), who, surrounded by the sick, orders the construction of the school. The colonnade continues round the entire court in rigid uniformity as two-thirds columns, but sharply distinct from the smooth wall surfaces and round-arched windows, in the manner of an ancient peristyle. The peristyle even continues behind the tall temple façade of full Corinthian columns that marks the entrance to the anatomy room, thereby elevating the teaching institute to the status of an Aesculapian temple. In the pediment relief, the personifications of Theory and Practice seal their unity at an altar. The anatomy

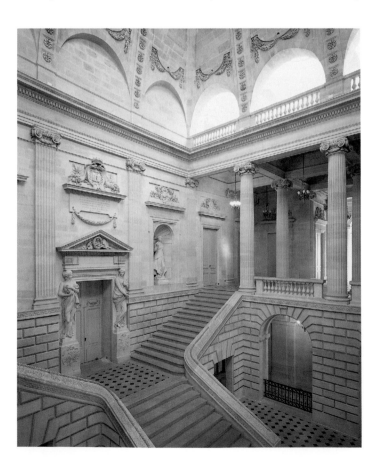

theater, on a semi-circular ground plan with ascending rows of steps, became a prototype for the architectural design of parliamentary chambers. With its coffered conch opening into an opaion, it is based on the model of the Roman Pantheon.

In the provinces too, buildings were constructed that attempted to keep pace with the standards of the capital. Certainly the provincial *intendants* – the arms of central government at a remove – were happy to indulge in public grandeur. Thus Besançon, for example, capital of Franche-Comté, became an outpost of Parisian architectural development under the enlightened leadership of Charles-André de la Coré. In 1778–84, Claude-Nicolas Ledoux built the city theater here, whose ring of Doric piers in the auditorium further develops the scheme of the Versailles court opera house in a classical manner and, with its democratic/egalitarian rows of continuous seating in the circles, introduced a further forward-looking feature.

To build the Hôtel-de-l'Intendance (1770–78), De La Coré engaged the architect Victor Louis (1731–c. 1795), who despite being disqualified in the Grand Prix of 1755 spent four years in Rome, where he developed his characteristic picturesque style and his particular feeling for theatrical effects. The Intendance (ill. p. 73, top) followed the usual pattern of a *cour d'honneur* screened from the street and semi-circular on one side. Continuous Ionic pilasters, which become engaged two-thirds columns in front of the elongated, pedimented centerpiece of the court façade, evenly divide the *corps-de-logis*, which has a rectangular ground plan. The wall surfaces are mainly taken up by large, rectangular windows, which function as *portes-fenêtres* at the upper level. On the garden side (ill. p. 73, bottom) the domed center salon forms a convex projection – a motif probably borrowed from the model of rustic *maisons de plaisance*. The delicate surface treatment of the façades with fluted pilasters, a continuous, uninterrupted entablature and festoon reliefs over the ground floor apertures is characteristic of Louis' decorative touch, but also strikes a traditional note. Louis applied a comparably uniform scheme of articulation – similarly rich in detail – in the façades of the Palais Royal, extended in 1780–84 for the Duc de Chartres, where the rhythm of the pilasters seems infinitely extended without looking monotonous.

Incontestably Louis' masterpiece is his theater in Bordeaux, which must be reckoned as one of the most ambitious and largest theater buildings of the 18th century. Constructed 1772–88 under the Duc de Richelieu as governor of the province of Guyenne, the internal layout displayed the complex arrangement expected of a modern theater and allowed a thoroughly exciting and effective succession of spaces. Inserted between the entrance area and the auditorium is a huge stairwell (ill. p. 72), typologically derived from LeVau's Ambassador's Steps in Versailles and Gabriel's designs for the Louvre in 1754. It is

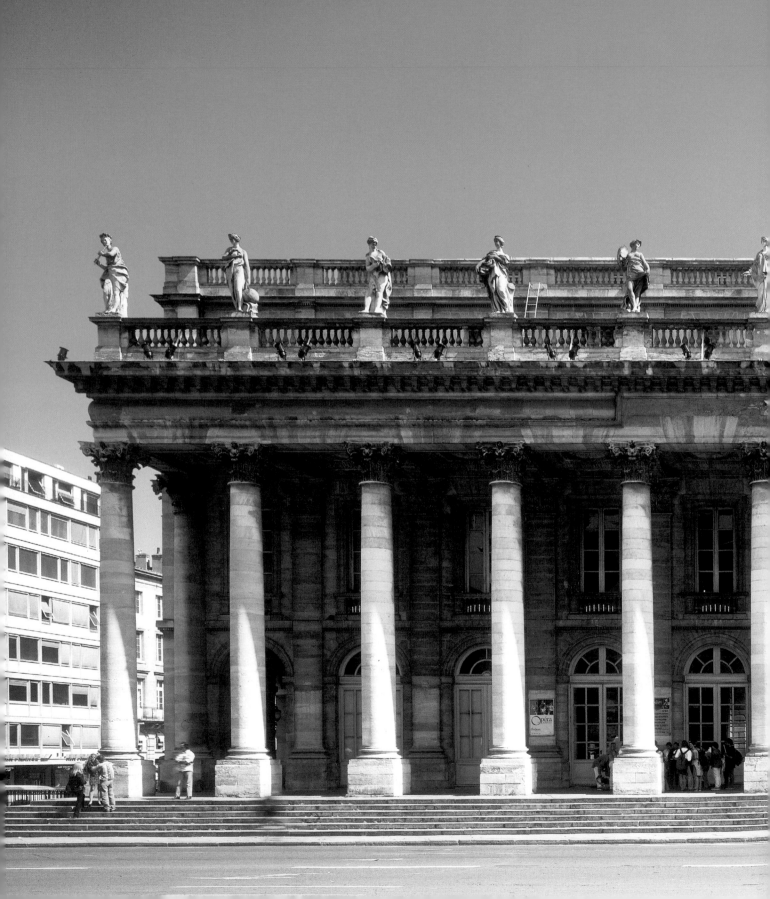

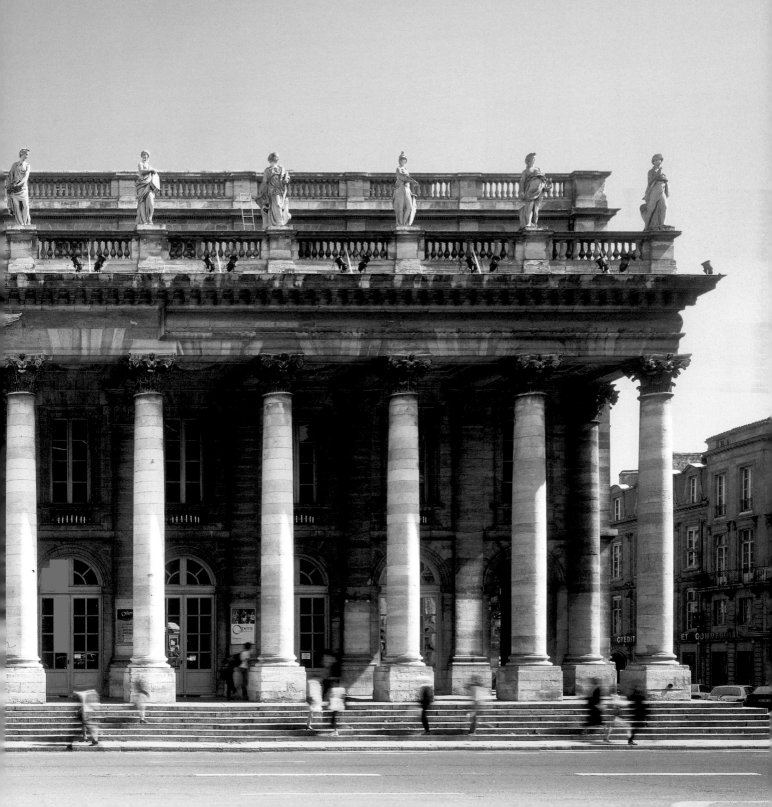

higher than the other spaces. In its breadth and lightness it contrasts vividly with the low, dark lobby, which corresponds to an oval concert room on the upper floor. Above the closed walls of the ground floor, where the vigorous rustication betrays the influence of English Palladianism, the stairwell opens into columned arcades, matched by a further rise in the vaulting, to reach the galleries and ample dome spaces, lit by lunettes. The almost circular auditorium, altered in the 19th century, is articulated by columns running through all floors, with the boxes suspended between them. The main façade (ill. pp. 74/5) is dominated over its full width by a Corinthian portico crowned with statues. The unbroken horizontal of the portico was a feature that would echo into the 19th century, right up to Brongiart's Paris Stock Exchange.

Trends in private architecture

In private architecture, the traditional type of Parisian *hôtel* reigned supreme. However, the restrictions of *convenance* required by the Académie and Blondel increasingly had to yield to vaulting architectural ambitions. An example of this is the Hôtel Gallifet, built by Étienne-François Legrand c. 1775 for a baron grown rich from his plantations in the Caribbean. Virtually the whole court façade (ill. p. 77, bottom left) is a

stately temple front over two stories with a horizontal top, a scheme more appropriate to the decorum of public buildings such as the École de Chirurgie than the residence of a social climber.

A monumental columned front in the tradition of Gondoin's building also adorns the court side of the Hôtel de Salm, erected in 1784 to designs by Pierre Rousseau (1751–1810). The lower order of the side sections likewise consists of detached columns. The river façade looks a little less abrupt, with a domed, semicircular central projection, but, unlike the similar arrangement on the façade of the Intendance in Besançon, the columned articulation of the centerpiece contrasts sharply with the rusticated wings and is borrowed from a classical round temple.

Among the most important architects of the second half of the century was Claude-Nicolas Ledoux (1735–1806). A pupil of Blondel's, he was appointed Architecte du Roi in 1773. The work he did in both public and private sectors, in practical planning and visionary architecture alike, is notable for the brilliant solutions he came up with. Though Ledoux never went to Rome or even Italy, he did visit England between 1769 and 1771, and learnt much of which he could make use.

Even before this trip, he built the château of Bénouville (ill. p. 76) in Normandy for the Marquis de Livry, begun 1768. The blocked, closed building mass is articulated by a giant Ionic

OPPOSITE AND RIGHT:
Claude-Nicolas Ledoux
Château Bénouville, near Caen, Normandy
begun 1768
Façade (opposite page)
Stairwell (this page)

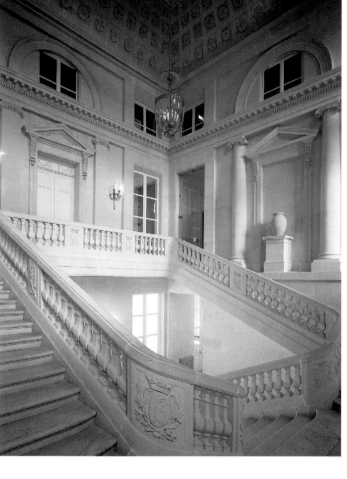

order, which consists of pilasters on the garden side and contrasts sharply with the ashlar masonry of the façades and the frameless window apertures. The columned portico with its crest on the *cour d'honneur* side is tied in horizontally by the continuous entablature and the tall attic floor, revealing a more austere approach compared with the contemporary, likewise two-level center projection of Gabriel's École Militaire.

Unusually, the stone staircase is located on the garden side (ill. p. 77, top right). Its dome, designed with an oculus as a *dôme percé,* represents remarkable ambitiousness, echoing great château staircases of the 17th century, such as the designs by Mansart in Blois or Maisons-la-Fitte.

In his Parisian *hôtels*, Ledoux came up with a similar range of inspired schemes that brought acclaim and made him one of the most sought-after private architects. At the Hôtel d'Uzès, where the *corps de logis* was rebuilt by 1769, the site was unusually narrow and deep, with the building at the end of a long, tree-lined drive enclosed between walls. Ledoux's use of a giant order of pilasters and columns is reminiscent of the château at Bénouville. At the Hôtel d'Hallwyl (1766), Ledoux enclosed the small garden with Tuscan colonnades in the manner of a classical peristyle, extending it illusionistically with a painted colonnade. In the design for the Hôtel de Montmorency (1769), he exploited the corner site to make a diagonal entrance.

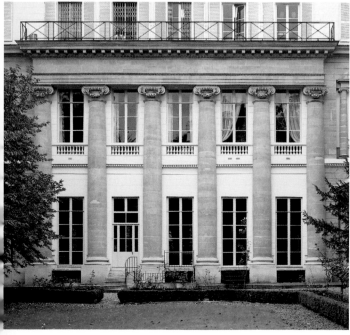

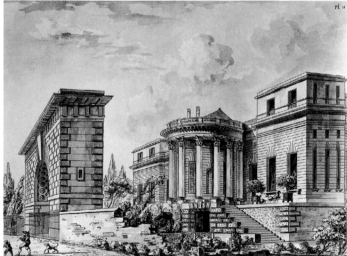

LEFT:
Étienne-François Legrand
Hôtel Gallifet, Paris, 1775–92
Detail of garden front

ABOVE:
Claude-Nicolas Ledoux
Hôtel de Thélusson, Paris, 1777–81
Perspective view

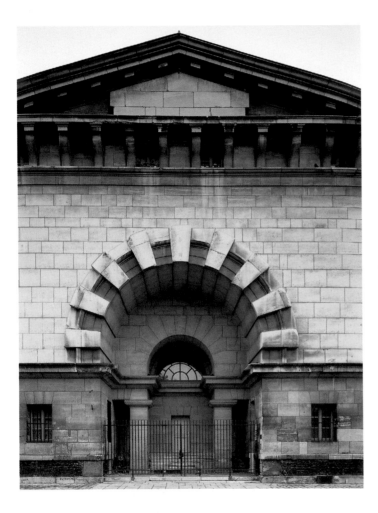

BELOW:
Claude-Nicolas Ledoux
Barrière du Trône, Paris
post 1784
Detail of façade

BOTTOM:
Claude-Nicolas Ledoux
Barrière de la Villette, Paris, post 1784

OPPOSITE:
Claude-Nicolas Ledoux
Saline Royale (Royal Saltworks),
Arc-et-Senans, 1775–79
Bird's eye perspective (above)
Engraving of 1804
Administration building, flanked by
thorn houses (below)

The most remarkable private house by Ledoux was the Hôtel de Thélusson (ill. p. 77, bottom right), built 1777–81 for the widow of a Swiss banker. Demolished in 1824, the building caused such a sensation that the pressure of visitors could only be controlled by issuing entrance tickets. The limited depth of the site meant the English-style garden had to be placed in front of the building, but it was sunk so far as to forestall direct axial access to the *corps de logis*. The broad entrance gateway resembled a stage set, and with its low imposts itself looked sunken, thus recalling the ruin and bridge motifs in Piranesi or Hubert Robert. As such, it provided a highly theatrical view towards the main residence on its plinth, framed by end pavilions. Flights of steps flanked the entrance façade, which was dominated by a central projection in the form of a circular temple. It loomed over naturalistic rocks and a grotto, thus evoking the classical temple of the Sibyl in Tivoli. With its full Corinthian columns it contrasted dramatically with the rusticated façade surfaces.

Ledoux's architectural mastery also showed itself in smaller-scale buildings, especially in his Pavillon Guimard, which he built 1770/71 for a dancer from the Opéra at her lover's expense. The rusticated front of the cubic structure, which was divided up inside with great sophistication, was accentuated by a large entrance niche, screened off by the Ionic portico. The coffered calotte of the niche reached attic-level.

Promotion of the "Public Good" and "Private Retirement"

Ledoux's *barrières* or tollhouses became a distinctive feature of the Parisian cityscape (ill. p. 78, top and bottom). Privatized on a leasehold basis, the *Ferme Générale* was responsible for administering taxation. Its aim with the *barrières* was to contain the flourishing smuggling trade in the growing city behind a new ring of masonry. Ledoux was commissioned in 1784 to build more than 50 such *barrières*, but only four have survived. In view of the large number of pavilions with identical functions, Ledoux made an effort to come up with an architecture that was not only appropriate to the exposed positions, but also both showy and varied. Vigorous rustication, derived from North Italian Mannerism, emphasized the fortified nature of the buildings. However, the *caractère* of the buildings was evident primarily in their squareness and massiveness. Ledoux restricted himself throughout to the combination of just a few stereometric masses, which he embellished with classical or cinquecento features. His Barrière de Montceaux was given the shape of a round Doric temple, while the Barrière de la Villette (ill. p. 78, bottom left) consists of a cubic block with a cylindrical drum, borrowing its serliana motifs from Palladian architecture. The marked simplification of individual forms, such as in the low pillared porticos and the preference for the Doric order, were as calculated for suggestive effect as the emphasis of the ashlar walls.

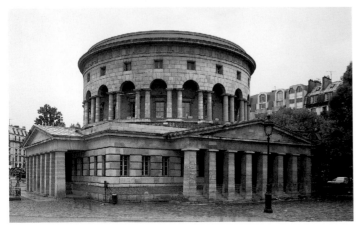

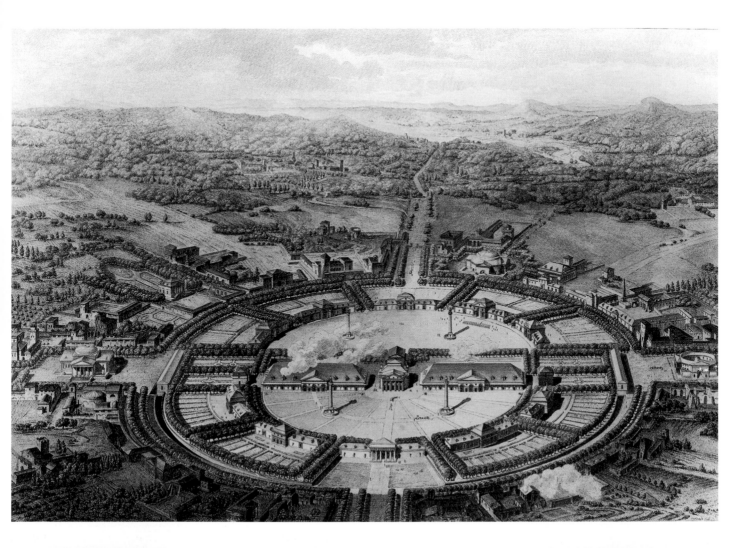

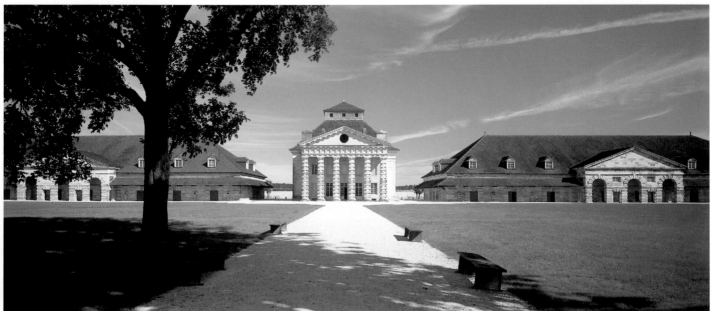

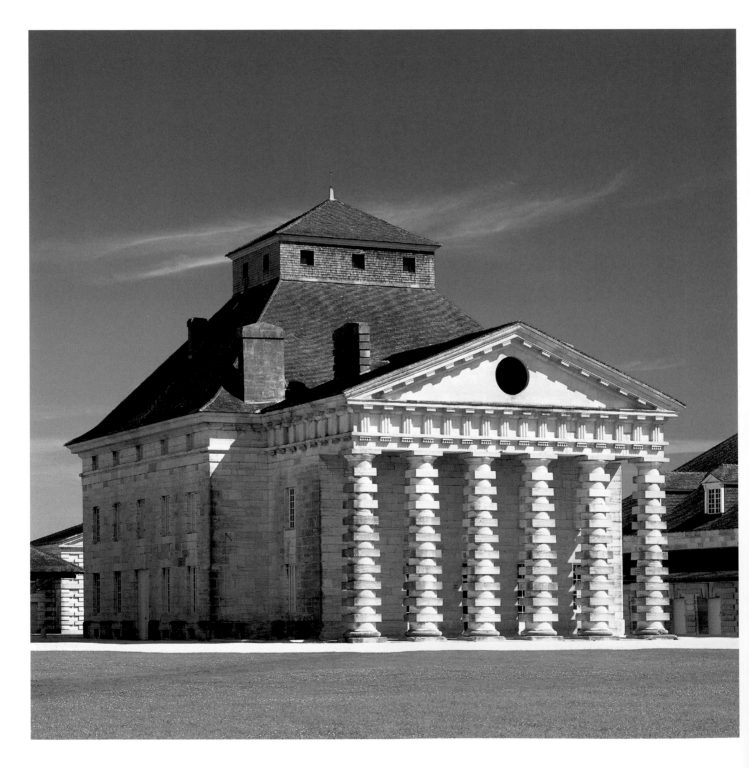

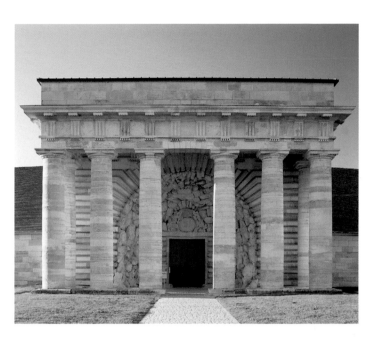

Ledoux designed his best-known work, the Saline Royale at Arc-et-Senans (ills. p. 79 and pp. 80/81), also for the Ferme Générale. Built in 1775–79, the buildings are arranged in a semi-circle, in emulation of château schemes conceived in the absolutist Baroque fashion, but there are also parallels with schemes for ideal cities from the 16th century. The strikingly grand scale is indicative of the gradual rise in the status of utilitarian building commissions during the period of the Enlightenment. Matching the function, the articulation of the stereometric masses is presented once again in a markedly vigorous formal grammar inspired by Palladio or Giulio Romano. This and the use of Doric and Tuscan orders lent the complex a decidedly masculine character. In the center of the site is the director's building (ill. p. 80), which with its chunky rusticated temple front anticipates Ledoux's later Barrière de l'Étoile. Adjacent on each side are the thorn houses, and the arc is made up of stores, workshops and workers' dwellings. The grotto-like niche of the entrance gateway (ills. p. 81, top and bottom), a derivative of the Pavillon Guimard front, constitutes a primitive kind of visual expression akin to "speaking architecture." The town meant to be built by the Saline Royale was never carried out. It would have completed the circle of the site.

After the outbreak of revolution, Ledoux received scarcely any commissions, and so he turned to writing. In *L'Architecture considérée sous le rapport de l'art, des mœurs et de la législation*, published 1804–07 (the title is an allusion to Montesquieu), he developed an extended model of his ideal city, which acquired Utopian features in the visual translation of all important functions and didactic intentions. This was due partly to the very direct formulation of the *architecture parlante* in the individual buildings. Water courses, for example, were to be diverted through the river inspectors' house, which looked like a cylinder on its side (ill. below).

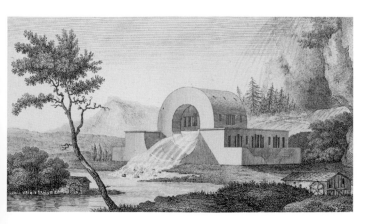

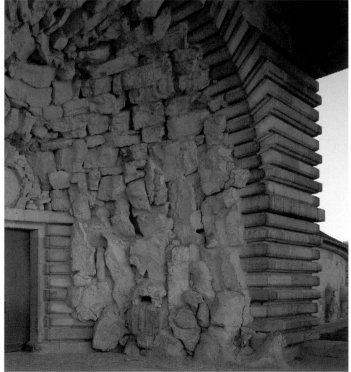

81

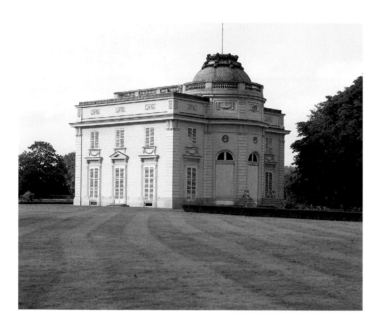

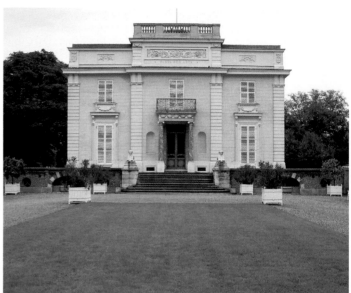

The high programmatic expectations of public utilitarian buildings is also evident from the Halle au Blé in Paris (ill. p. 82, bottom right), intended as a market hall and warehouse. Built by Nicolas Le Camus de Mezière in 1762–66, this is a circular building enclosing an interior court. With its vaulted halls at ground floor level, it generated associations with a Roman amphitheater, which illustrates the high status of the public good. The later (1782–83) work of roofing over the court with a wooden dome, to a design by Jacques-Guillaume Legrand (1753–1809) and Jacques Molinos (1743–1831), attracted particular attention, the span covered making it a piece of technical virtuosity. The architects resorted to a truss system developed in the 16th century by the architect Philibert de l'Orme. The retracted dome impost and oculus at the top revives basic features of the Pantheon in Rome. The calotte was rebuilt by Francois-Joseph Bélanger in 1809–13 after a fire, as one of the earliest iron and glass structures in architectural history.

Bélanger was convincing in the private sector as well. Among his best-known works was the little lodge of Bagatelle in the Bois de Boulogne (ills. p. 82, above, left, and right), erected in 64 days in 1777 as a result of a wager with Queen Marie Antoinette, only sister-in-law to Comte d'Artois, who had the lodge built. Altered in the 19th century, the pavilion structure displays a domed, semi-circular, projecting drawing room. The austere rustication of the façade contrasts charmingly with surrounding English gardens, designed by the Scot Thomas Blaikie and furnished by Bélanger with numerous *fabriques* (including a Gothic Revival

pavilion). Marie Antoinette created a further idyllic retreat in the *hameau* in the Park in Versailles. Likewise set in a landscape garden, this is a planned hamlet, which was designed by her architect Richard Mique (1728–94) in 1783–85. Besides thatched cottages in the Norman style, the hamlet contains a mill and a lighthouse as well. The whole scheme reflects the retreat to the simplicity of nature that was propounded by Rousseau. Typically, the rustic effects stopped at the exterior. The thoroughly complex but intimate interiors have all the sophistication of the outgoing Rococo.

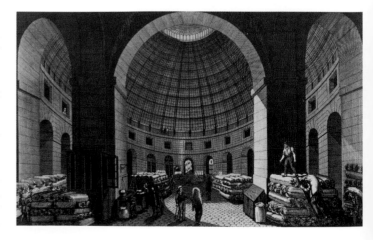

Richard Mique
Hameau de la Reine, Versailles, 1783–85
Queen's House (above)
Mill (below)

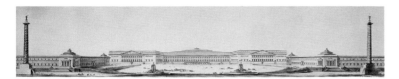

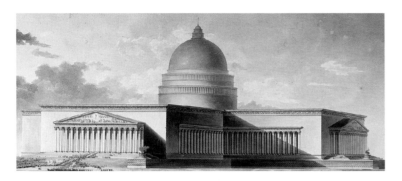

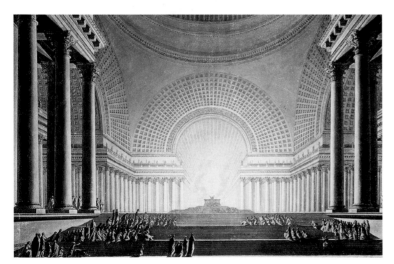

Boullée and Revolutionary architecture

In another genre of architecture, pictorial design, as especially evident in the later buildings of Ledoux, led to a further step towards the utopian in the idealized schemes of Revolutionary architecture. Outstanding architects made their contributions to these, treating them in the spirit of the academic competitions – but also because major commissions were dwindling. Though few generally came to fruition, the schemes gave shape to theoretical and social utopian concepts of the day. The term *caractère* now combined the specific emotions generated by architecture and thus also its perceived pedagogically beneficial effects. The

concept of Revolutionary architecture as propounded by Emil Kaufmann is thus fundamentally misleading, inasmuch as most of the projects concerned were developed under the *Ancien Régime* and not at all in opposition to it. Moreover, research in recent decades into what was generated has shown it was in no way restricted to France, but was an international phenomenon.

Nonetheless, certain definitive criteria stand out that indicate a breach with traditional values. The Vitruvian proportions so jealously guarded by the Académie were now pushed aside in favor of directly observable, basic geometrical forms and their simple relationships. Architects aimed to overcome the viewer emotionally through a virtually megalomaniac increase in scale, combined with the formation of smooth, unbroken surfaces and effectively infinite multiplication of features of articulation. A major influence in this was exercised by aesthetic notions of the Sublime imported mainly from England, as formulated, for example, by Edmund Burke in his *Philosophical Enquiry into the Origin of our Ideas of the Sublime and Beautiful* in 1757.

Along with Ledoux, the most important representative of Revolutionary architecture was Étienne-Louis Boullée (1728–99), who, after initial successes in the private sector, increasingly relied on his work as a teacher and graphic artist. A project for the reshaping of the palace of Versailles (ill. p. 84, top left), developed in 1780 within the framework of a competition, already shows characteristic features of his architectural approach, particularly when compared with the earlier design by Gabriel. The complex hierarchy and carefully differentiated orchestration of façades, with vertical accents in line with Baroque principles of subordination, are reduced in Boullée to a few huge masses in which horizontals dominate. Columned centerpieces with exaggerated pediments are stuck on smooth cubes like appliqués. In the middle section of the main court, a central highlight is totally absent from the continuous, almost endless row of columns, because, according to contemporary theory of the Sublime, this evoked the suggestion of unlimited extent.

The project for a *métropole* (ills. p. 84, center and bottom left), which Boullée included in his unpublished *Essai sur l'Art*, shows the same traits. The disposition of the cubes is worked out even more clearly here. The massive dome on the cruciform building with an encircling colonnade is derived both from Soufflot's Ste-Geneviève and Bramante's project for St. Peter in Rome, which Boullée expressly admired. However, the scale has undergone a considerable enlargement here. The three-dimensional aspect of the building mass is expressed not least through the stark contrast between highlighted and shadowed zones, which Boullée deliberately brought out in order to create, in his own words, an *architecture des ombres*. He presented interior views, with the rows of columns and massive barrel vault, showing both day and night aspects, that is the different effects of sunlight streaming in and a ghostly artificial lighting.

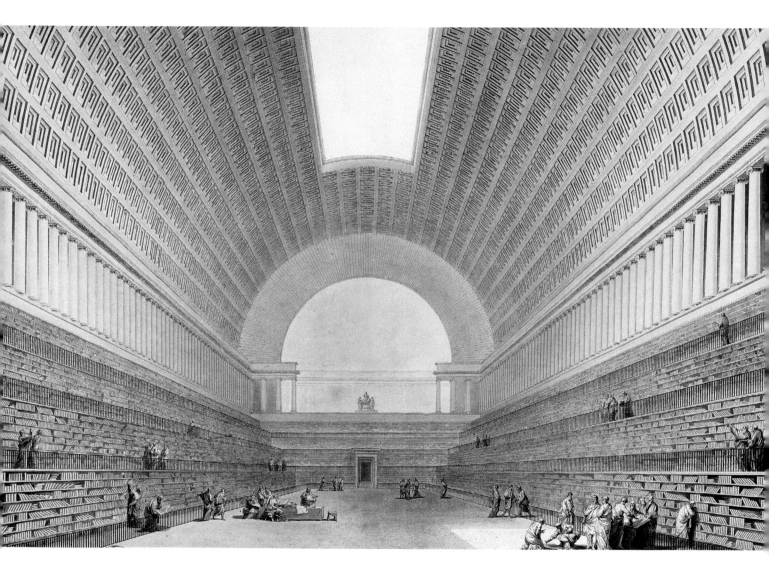

A huge coffered barrel vault linking colonnades receding into the depths also distinguishes his project for the huge reading room of a projected National Library (ill. p. 85), which goes back to a specific design from 1785. In Boullée's own words, Raphael's painting of the *School of Athens* has imbued his representation, which highlights both his iconological pretensions as well as his pictorial understanding of architecture. A novel and influential motif is the opening of the vault in an elongated top-light. The exterior, on the other hand, consists of a largely unarticulated cube; apart from the garland frieze and two tablets with inscriptions, it is only the doorway provides relief, its globe, borne by two Atlas figures, clearly alluding to the "universe of knowledge." Boullée's most famous project, his cenotaph for the physicist Isaac Newton (1784, ills. p. 86) indicates on one hand the increasing respect shown to civilian "intellectual heroes" since the Enlightenment, and on the other constitutes a very clear example of the explicitly commemorative character of Revolutionary architecture.

With its global figure describing the sphere of the universe, the huge monument forms a high point of *architecture parlante*, especially since in the interior the vaulting is perforated into a giant starry sky, or in the first version lit by a large astrolabe. Beneath the

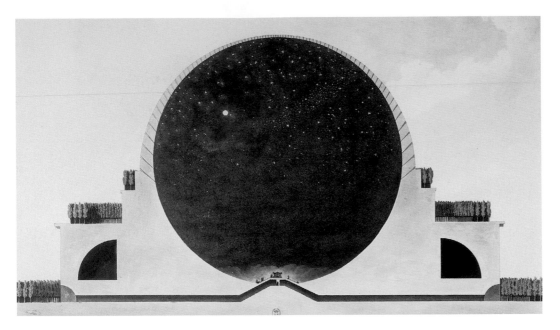

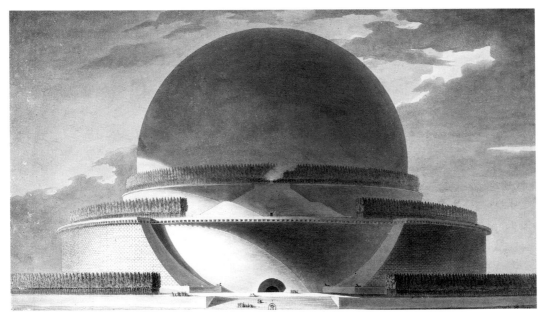

immensity of this "vault of heaven" for visitors to get lost in, rises the sarcophagus of Newton on a stepped plinth, Newton having acquired for Boullée the status of a world-class "intellectual creator" with his pioneering work. Besides the abstract and yet thoroughly traditional interpretation of the globe as a pure stereo-metrical form, sundry other allusions can be identified, e.g. the rows of cypresses running round the outer terraces, borrowed from classical tombs such as the Mausoleum of Augustus. Trained in his youth as a painter, Boullée preceded his *Essai sur l'Art* with the motto attributed to Correggio: "Ed io anche son pittore" (I too am a painter). It was in this sense that he sought to "bring Nature into play" (*mettre la nature en œuvre*) in his architecture, analogously to mood effects that accompany the change of seasons.

A more superficial form of *architecture parlante* expressed verbally in extreme terms was represented by Lequeu (1756–1825). Many of his designs bear downright bizarre features, such as the cow byre in the shape of an outsize cow. For all their striking but shallow directness, such designs remained a fringe phenomenon in the architectural current of the time.

Trends after the Revolution

While the Revolution was going on, building work more or less came to a standstill in both country and capital. One of the few developments of the period was the conversion of the old theater in the Tuileries for the National Assembly, carried out by Étienne Laconte and Boullée's pupil Jacques-Pierre Gisors in 1795–97,



"Charles Percier, Pierre-François-Léonard Fontaine
Rue de Rivoli, Paris, begun 1802

The creation of this street axis, extended again 1849–54, was among the most ambitious urban development measures of the Napoleonic era in Paris.

The homogeneous façades continue the tradition of the great squares of the 17th and 18th centuries."







"where the rising semi-circular terraces..."

"themselves. On top of this..."













Charles Percier, Pierre-François-Léonard Fontaine
Rue de Rivoli, Paris, begun 1802

The creation of this street axis, extended again 1849–54, was among the most ambitious urban development measures of the Napoleonic era in Paris.

The homogeneous façades continue the tradition of the great squares of the 17th and 18th centuries.

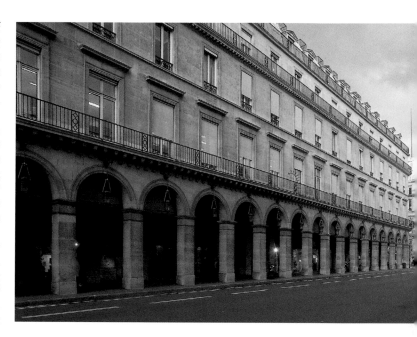

where the rising semi-circular terraces followed the tradition of the École de Chirurgie. Larger-scale plans, such as the project for a square to replace the demolished Bastille, never came to anything. After the dissolution of the Académie in 1793, the École Polytechnique was set up with a more practical educational purpose that complied with current utilitarian doctrine. The institution would become very important under Napoleon.

The leading figure representing the new direction in education was Jean-Nicolas-Louis Durand (1760–1834). After a period as Boullée's assistant, he was appointed professor at the École Polytechnique, where he trained a whole generation of young architects from home and abroad, including Schinkel, Weinbrenner and Klenze from Germany. His *Recueil et Parallèle des édifices de tout genre*, published in 1800, included all historical styles since the Egyptians in an encyclopedic and non-judgmental presentation.

However, Durand's teachings are best traced in his *Précis des leçons d'architecture données à l'École Polytechnique*, published in the form of a pattern book between 1802 and 1805. Moving away from the pictorial, visionary and psychology-based ideas of his teacher Boullée, Durand standardized his design methods and thereby made them universally accessible, effectively independent of the specific genre. Durand extended the previous generation's breach with Vitruvian rules, placing the concepts of *convenance* and *économie* in the foreground, both to be subject to functionally interpreted criteria. In accordance with this approach, the disposition of buildings was the chief consideration, which he schematized in his characteristic standardized drawings. Even the deliberate reduction to orthogonal representational forms of ground plan and elevation was aimed at providing a uniform planning approach and at disseminating his teachings.

However, the line of a strict, rule-based Neoclassicism was championed at the École des Beaux-Arts, set up as part of the re-established Académie and dominated from 1816 by Antoine-Chrysostome Quatremère de Quincy (1755–1849).

To channel the urban development of Paris as befitted a capital city, in 1800 Bernard Poyet (1742–1824) submitted the *Projet des Places et Edifices à ériger pour la Gloire de la République*, which took up elements of the *Plan des Artistes* already formulated in 1793 during the Revolution. It envisaged developing squares on the sites of demolished monasteries, removing the fortified Châtelet and constructing new bridges over the Seine, including the Pont des Arts, built of cast iron in 1802–03, and later the Pont d'Austerlitz and Pont d'Iéna.

The most successful all-round planners of the Napoleonic era were Charles Percier (1764–1838) and Pierre-François-Leonard Fontaine (1762–1853), who was appointed *Architecte des Palais de Premier et Deuxième Consul* in 1801. The joint activity of the two ranged from urban development and civil architecture to the decorative arts, in which they made a particular name for themselves. On top of this, Percier and Fontaine published designs and models in several publications which, given the poor outlook for normal commissions, not only established their reputations, but also guaranteed their influence both at home and abroad.

Their most notable work in urban development also marked the beginning of what became a period of major changes to the Parisian cityscape in the 19th century. The Rue de Rivoli, opened up in 1802 (ill. p. 87), provided a long-wished for link to the Place de la Concorde, and was, moreover, the foundation of a large-scale project for regulating the quarter around Napoleon's city residence in the Tuileries. As the scheme developed, several monasteries fell victim to it in order to enlarge the north wing of the Louvre. The uniform fronts of the houses, linked and drawn together by continuous cornices and balconies, introduced new features of Italian origin into the urban landscape with their open arcades at street level and characteristic rooflines inspired by Palladio's basilica in Vicenza. Laid out in 1798, Poyet's Rue des Colonnes, with its stocky arcades and archaizing columns displaying features of Revolutionary architecture, can be considered as a precursor.

Empire architecture

Large-scale showy public buildings were only commissioned in Empire days, and then particularly after the victory at Austerlitz in 1806. In view of the already extant Residences, no new palace-style buildings were required. Percier and Fontaine's plan of 1811

for a huge palace complex on the north bank of the Seine for
Napoleon's newly born son, the king of Rome, got no further
than planning stage. The extensive scheme would have towered
up from terraces and flights of steps to form a fitting conclusion
to the Champs de Mars opposite, where a forum with public
buildings was to open.

To satisfy his immediate need for display, Napoleon had alter-
ations undertaken at the former royal palaces plundered by the
revolutionaries, and this work was entrusted mainly to Percier
and Fontaine. Whereas during the Revolution the ancient Roman
Republic had been the ideal to imitate as a cultural model, now
the main influence was Imperial Rome, whose successor
Napoleonic France claimed to be. Additional features were drawn
from the Italian Renaissance, which the two architects had studied
intensively during their stay in Italy in 1786–92 and made avail-
able in publications. In 1804, to mark the coronation, particular
attention was lavished on the Tuileries palace, originally dating
from the 16th century (later burnt down during the Commune in
1871). The two-story principal room in the center pavilion, called
the Salles de Maréchaux because of the portraits of imperial
generals that it contained, had a splendid doorway framed by
caryatids that related to a similar example by Jean Goujon in the
Salle des Caryatides at the Louvre, restored by Percier and
Fontaine themselves.

More intimate, but no less splendid, were the furnishings of
Château Malmaison, acquired for Napoleon's wife, Josephine.
The work was carried out by Jean-Baptiste Lepère to designs by
Percier and Fontaine and completed in 1803. Displaying classical
architectural forms, strong contrasting colors, mahogany
paneling highlighted with gilt bronze appliqués, and ceiling
paintings in imitation of Pompeii and Herculaneum, the interiors
exude luxury. This is particularly evident in the tripartite former
library (ill. p. 90). The Conference Room, Josephine's (ill.
p. 88/89) and Napoleon's bedrooms, also the glazed entrance
hall, take the form of tents, thus alluding to the Corsican's
successful campaigns. The costly, classically inspired furniture
likewise derived from designs by Percier and Fontaine.

Evocation of Imperial Rome was also a prime purpose of the
commemorative structures, most of which were dedicated to
Austerlitz. Constructed by Percier and Fontaine in the *cour
d'honneur* of the Louvre in 1806–08, the Arc-de-Triomphe-du-
Carrousel – crowned with the Byzantine bronze horses
plundered from San Marco in Venice – borrows directly from
the triumphal arch of Septimius Severus in Rome.

The column erected in the Place Vendôme for the same reason
in 1810, following a design by Gondoin and clad in reliefs made
from the bronze of looted cannons, is based on ancient triumphal
columns such as those of Marcus Aurelius or Trajan. The subject
was given a somewhat freer treatment in the Arc de Triomphe on

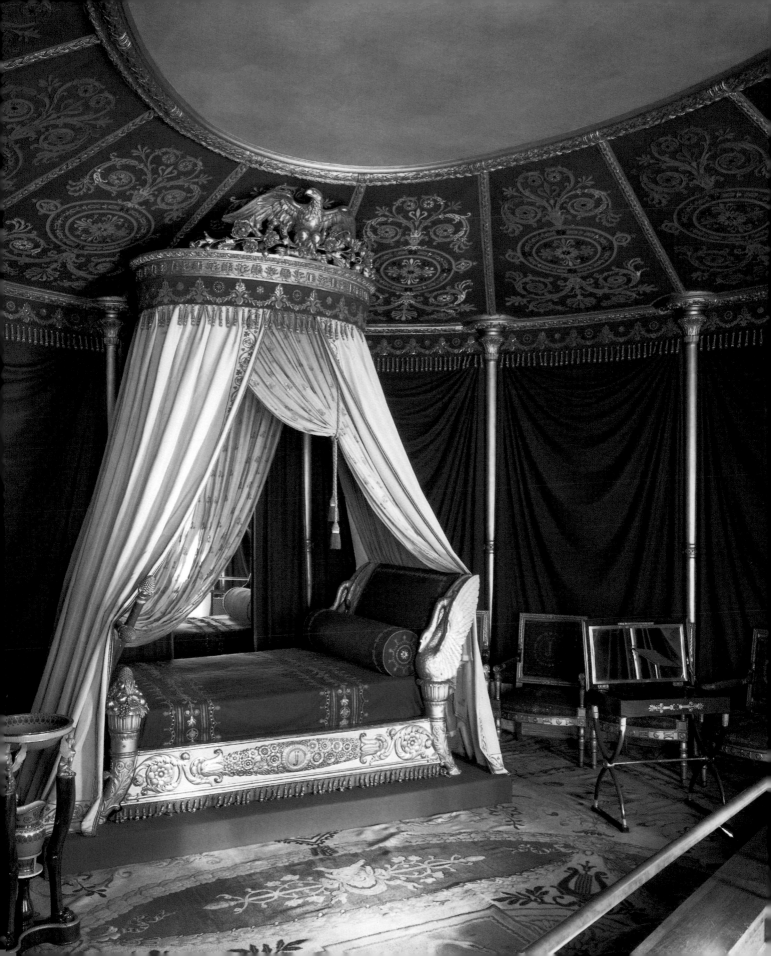

**Charles Percier, Pierre-François-Léonard
Fontaine and Jean-Baptiste Lepère**
Château Malmaison, near Paris
Library, 1803

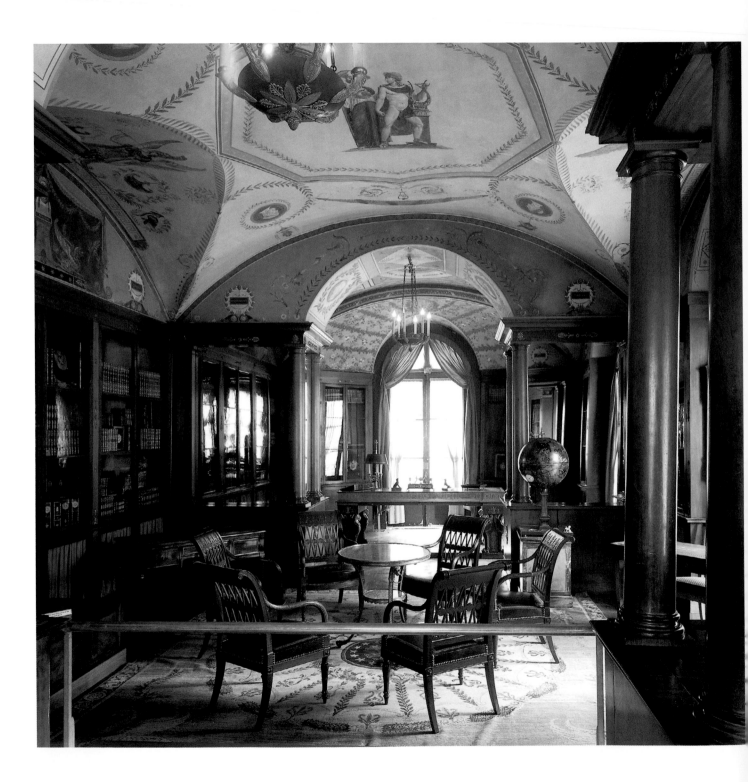

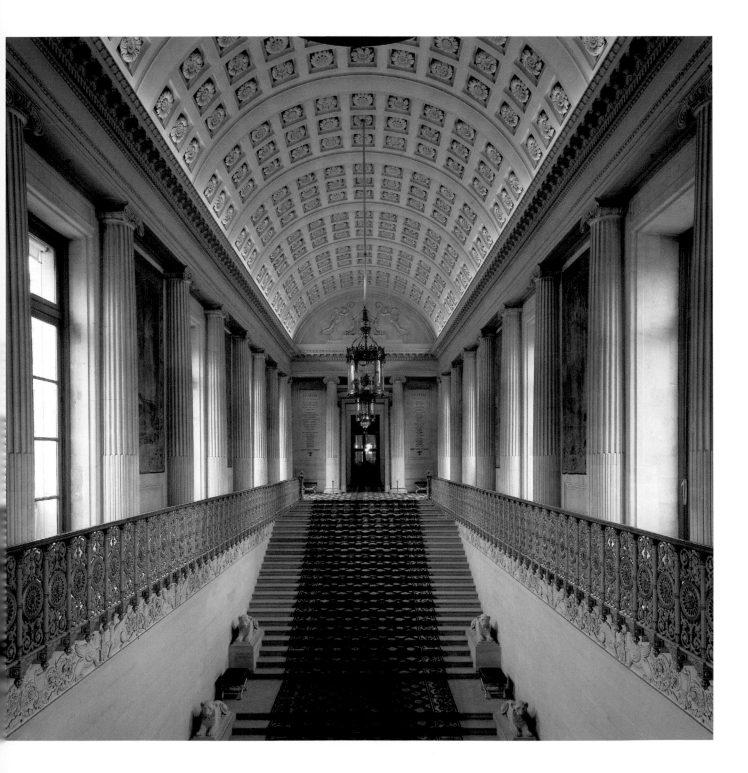

91

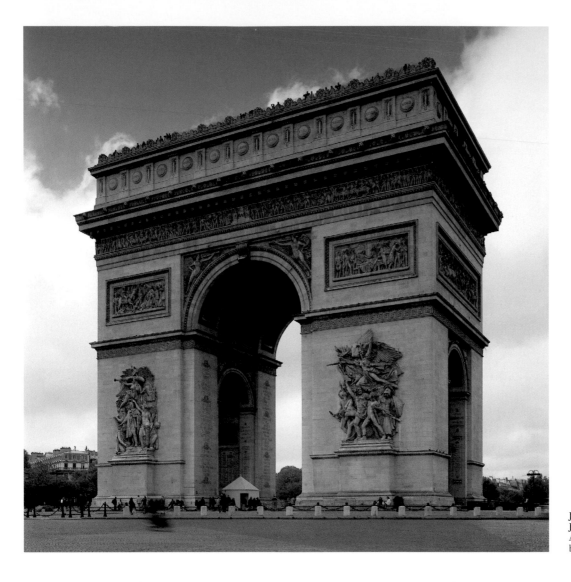

Jean-François-Thérèse Chalgrin and
Jean-Arnaud Raymond
Arc de Triomphe de l'Étoile, Paris
begun 1806

the former Place de l'Étoile (ill. p. 92). Begun in 1806 to plans by Chalgrin and Jean-Arnaud Raymond (1742–1811), work was suspended after Napoleon's downfall until 1823, but was finally completed with a modified attic by Guillaume-Abel Blouet (1780–1840). Over 160 feet (49 m) high, the massive dimensions and emphatic squatness of the arch, dispensing with the otherwise customary articulation by columns, are reminiscent of Revolutionary architecture. Set off against the smooth ashlar surfaces are the relatively small-scale sculptural groups done by leading sculptors of the time, the subjects of which were adapted before execution as political circumstances changed. The already magnificent position was later reinforced by Baron Haussmann when he focused major streets on the site.

Chalgrin, who had successfully continued his professional career from the *Ancien Régime* into the Empire era, was involved in the extension of the Senate in the Palais du Luxembourg, where he had previously worked in 1787. The semicircular Salle du Sénat, inserted in the place of the old stairwell of the principal pavilion in 1801 and altered in 1836, followed the tradition of

Gondoin's École de Chirurgie. The new staircase (ill. p. 91), which occupied the space of the Medici Gallery decorated by Rubens, was given a classical look with continuous three-quarter Ionic columns and coffered barrel vaulting.

The most important contribution to church architecture in the Napoleonic period was the construction of the Église de la Madeleine (ill. p. 93). After Contant d'Ivry's ambitious project of 1761 had ground to a halt at the early stages and consideration had been given to constructing the Stock Exchange on the site, at the height of Napoleon's power in 1807 a competition was launched for a hall of fame for the Grande Armée. The commission for this national monument went, however, not to the first prize-winner Claude-Étienne de Beaumont, but to the Emperor's favorite, Pierre-Alexandre Vignon (1763–1828), a pupil of Ledoux.

In 1813, after military defeats, the original function of the building as a church was revived, though it took until 1840 for the expensive structure to be completed, so that it became as much a monument of the Restauration period. In accordance with Napoleon's wish, the main mass is a massive Corinthian

Alexandre Vignon
Church of the Madeleine, Paris, 1807–42
Façade

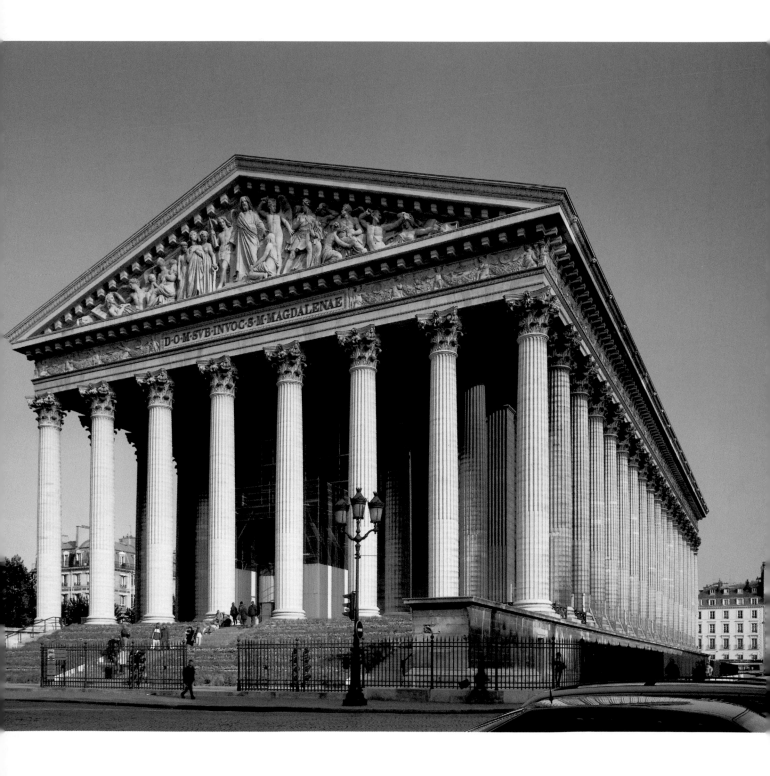

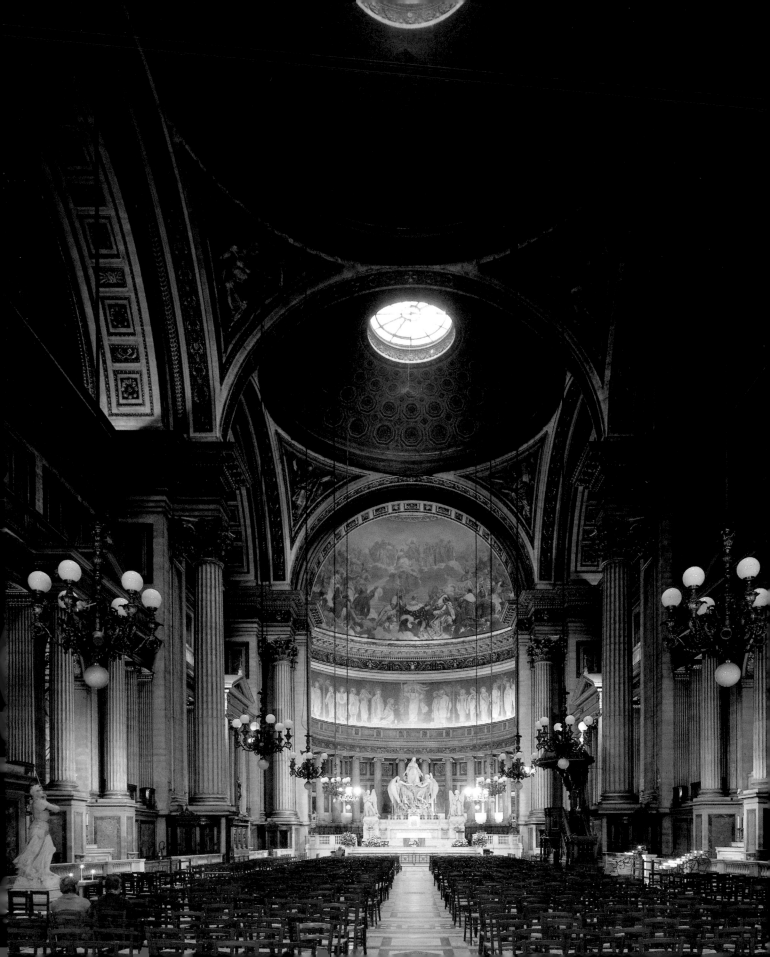

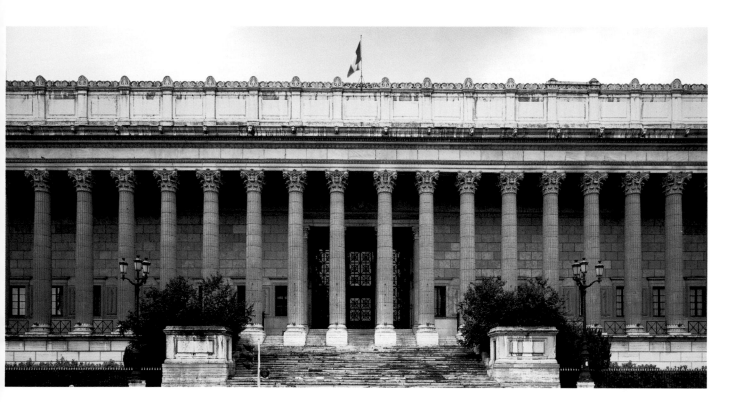

peripteral temple, whose pedimented façade on a podium is dramatically positioned so as to dominate the axis of the Rue Royale between Gabriel's buildings on the Place de la Concorde. The interior, completed in modified form by Jacques-Marie Huvé (1783–1852), is overlaid with colored marble (ill. p. 94), and the use of three pendentive domes in a row springing from ressauted columns is reminiscent of Roman *thermæ*.

In public secular buildings, the temple façade likewise constituted the preferred motif for lending dignity. Enlarged on a colossal scale, it also appeared appropriate to express the glory and grandeur of empire. In its ultimate unspecific application, however, it was very soon criticized. In 1806–10, the 18th-century Palais Bourbon was converted into the *Corps Législatif*, acquiring a broadly laid-out portico designed by Bernard Poyet, containing 12 huge Corinthian columns. In cityscape terms, the parliament building forms a pendant to the Madeleine across the Place de la Concorde. Similarly, the Stock Exchange, erected 1808–26 by Alexandre-Théodore Brongniart (1739–1813), which Napoleon desired should be lavishly executed as befitted the *grandeur de la capitale*, was (until reconstructed in 1902) laid out as a free-standing peripteral. Boullée's pupil, of course, preferred horizontal terminations without pediments, in the

tradition of the late 18th century. For the inner structure, the type followed was, in accordance with the function, that of the classical basilica, but avoided the characteristic retracted upper level that distinguishes buildings in the Palladian tradition, such as Thomon's famous Stock Exchange of St. Petersburg. The large hall in the center is tall and glazed at the top, with arcading on both floors, thus creating the impression of a version of the basilica of Vincenza turned inwards. In the all-pervasive ground plan grid, the influence of Durand's rationalist approach to design cannot be ignored.

The tradition of the horizontally terminated, columned front remained dominant during the July Monarchy, thanks to the influence of the École des Beaux-Arts, as is evident in the Palais de Justice in Lyons (ill. p. 95) erected by Louis-Pierre Baltard (1764–1846) from 1835. His elongated Corinthian colonnade between a high podium and the attic has, despite the monumentality, an almost tiring effect. Again, the *Salle des Pas Perdus* in the interior is derived from Roman baths and recalls the Madeleine.

Private architecture during the Empire likewise employed the classicizing rhetoric of Imperial buildings, if on a reduced scale. The top category was represented by the Hôtel Beauharnais in the rue de Lille, Faubourg St. Germain, extended by Nicolas

OPPOSITE AND BELOW:
Hôtel Beauharnais, Paris
Four Seasons Room
General view (opposite page)
Detail of console table (below)

Bataille from 1803 for Napoleon's stepson and later Viceroy of Italy, Eugène Beauharnais. At ground level, the original building by German Boffrand dating from 1714 was given a new Neo-Egyptian portico with battered piers adorned with reliefs and lotus-blossom columns (ill. p. 96). It is attributed to Jean-Augustin Renard. Like other exoticisms, the use of Egyptian motifs went back to the 18th century, but the throng of scholars who accompanied Napoleon on his expedition to Egypt in 1798 triggered off a full-blown fashion that gave rise to fountains as well, including the Fontaine du Fellah by Bralle in the Rue de Sèvres (1806–09) and the columnar Fontaine du Palmier in the Place de Châtelet (1808). The interior of the hôtel, later transferred to the Empress Josephine and Napoleon's brother Jerôme, bears witness to another decorative fashion of the time in the Turkish boudoir. However, most of the rooms follow the prevailing classicizing style with its rich variety of forms. The walls of the splendid drawing room, which is decked out in white, gray and gold (ills. p. 96 and p. 97), are furnished with full-height allegorical representations of the Four Seasons. The paintings, framed between Corinthian pilasters, are attributed to Charles de Boisfremont (1773–1838). The overdoors are decorated with Pompeian scenes.

Restauration and Romanticism

The return of the Bourbons after Napoleon's fall triggered a return to earlier ways in architecture, as elsewhere. Church

Louis-Hippolyte Lebas
Notre-Dame-de-Lorette, Paris, 1823–26
View towards altar

Louis-Hippolyte Lebas
Notre-Dame-de-Lorette, Paris, 1823–26
Portico

building, for example, resumed apace after years of suppression, though this reflected in part the growth of the city. Between 1816 and 1826 Fontaine and his pupil Louis-Hippolyte Lebas (1782–1867) built the Chapelle expiatoire on the site of the cemetery where Louis XVI and Marie Antoinette were buried. This was a domed central plan with a pedimented portico in a severe Neoclassical style. However, the Campo Santo surrounding the chapel is derived from Early Christian or medieval models in Italy. The same trend is even more evident in the small church of Notre-Dame-de-Lorette, likewise constructed by Lebas between 1832 and 1836, whose portico of Corinthian columns (ill. p. 98, right) develops the model of St-Philippe-du-Roule with great verticality and depth. In the interior, however (ill. p. 98, top left), the verticality and introduction of a clear story above the Ionic colonnade is closer to the Early Christian model. The coffered ceiling recalls Roman ceilings of the Renaissance, such as the one in the Lateran. Despite its imitated colored marble inlays, it was the building's rich quattrocento-style interior painting that aroused particular interest.

Bearing witness to greater ambition from the outset, and visibly on a grander scale, is the parish church of St-Vincent-de-Paul, built 1830–46. This was largely due to the particular interest of the Crown, which wanted to give tangible expression to its traditional link with the Church, even if the execution came right at the end of the reign of the Citizen King. Cologne-born Jacob Ignaz Hittorf (1792–1867) took over the commission from his father-in-law, Jean-Baptiste Lepère (1761–1844). Hittorf had trained as an architect under Fontaine, and earned a reputation both for his study of polychromy in the buildings of Antiquity and for his achievements in urban development. Thus the church soars dramatically at the end of a street above a large flight of steps, dominating the immediate urban environment (ill. p. 99, bottom).

The classical motif of the hexastyle pronaos is here combined with a double-tower façade, the horizontal termination of which

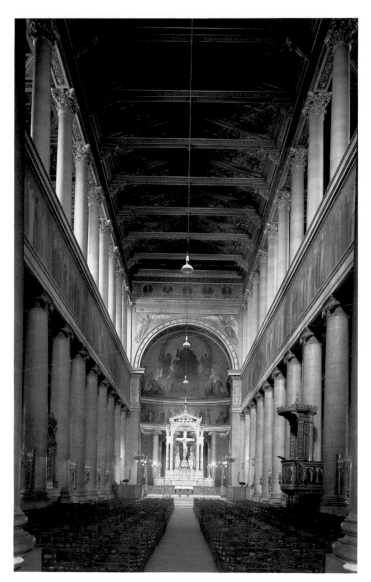

is reminiscent of Servandoni's façade of St.-Sulpice, but interpreted with Neoclassical severity. The interior (ill. p. 99) is laid out as a basilica with double aisles, galleries and an open truss roof, a scheme the architect would have seen in Italy 1822–24, during a tour of Early Christian churches. The same applies to the splendid furnishings, where Hittorf wanted to recreate his impressions of the cathedral in Monreale. Here too, the sensational polychromy in blue, red and gold set a new style, even though the novel enameled panels by Jules Jolivet in the vestibule had to be taken down again following fierce criticism.

The Gothic Revival asserted itself in current architectural development relatively late. There had, of course, been sporadic Gothic building even in the 18th century, but this was generally either an attempt to retain stylistic unity in a continuation of older buildings (for example, in the building of Orléans Cathedral), or derived only from universally admired designs that could be combined with classical forms within the scope of the Graeco-Gothic movement. Likewise, Gothicizing buildings were built time and again in landscape gardens alongside exotic works, as staffage or atmospheric additions.

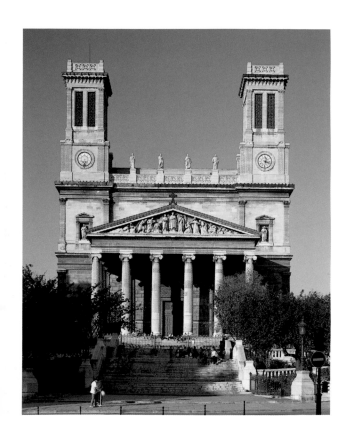

The mood changed in the early 19th century, triggered off by the publication of *Le génie du Christianisme* in 1802. Written by François-René de Châteaubriand (1768–1848), who was one of the great figures of French Romanticism, this crusaded against the materialism of the Enlightenment, championing a revival of religious feeling. In his work, Châteaubriand attributes to Gothic architecture a special function in awakening such feeling. At the same time, he also lauded the national importance of Gothic cathedrals as *l'architecture de la patrie*, and compared their effect with the mythical forests of Gaul. The appearance of Victor Hugo's novel *Notre Dame de Paris* in 1831 merely served to reinforce the popularity of medieval architecture. After the establishment in 1837 of the *Commission des monuments historiques*, to which the writer Prosper Merimée also belonged, work started on systematically restoring important monuments such as the Sainte-Chapelle and cathedral of Notre Dame in Paris. In 1845–50, Eugène Viollet-le-Duc (1814–79) and

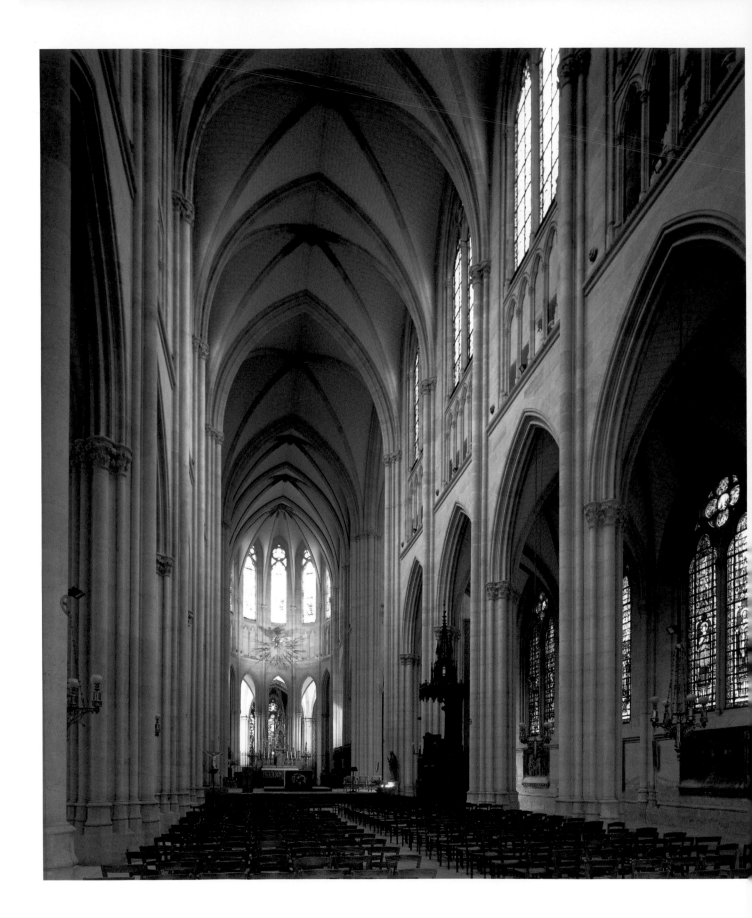

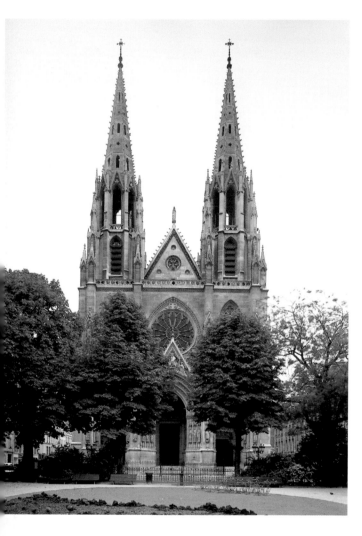

Jean-Baptiste-Antoine Lassus (1807–57) added a new sacristy here in the 13th-century style.

Viollet-le-Duc became the leading representative of a structuralist view of Gothic. In Rouen, the medieval abbey church of St. Ouen was given a Gothic Revival west front from 1838. However, it was only in 1845 that work was begun on the first newbuild church in Paris, the controversial Ste-Clotilde (ills. p. 100–101). In his reply to attacks by the École des Beaux-Arts, which maintained unwavering support for strict Neoclassicism and rejected the project as "plagiarist" and "counterfeit Gothic," Viollet-le-Duc stressed the national component in the choice of style. The German-born architect Franz Christian Gau (1790–1853) had already submitted a project in 1839, but in the end had to leave the execution to his colleague Théodore Ballue (1817–85), who made alterations to the towers. The stately west front with its twin steeples and expansive triple doorway group and the three-story elevation of the interior re-introduce motifs of 13th-century cathedral Gothic, but translated into a flatter, linear version, in which the Neoclassical tone is still evident. Even the criticism of contemporary champions of the Gothic Revival must be seen in the light of this attitude; they accused the church of being overloaded in detail with sculptures and stained-glass windows.

The importance of national awareness in the early phase of historicism in France can also be traced in the church of St. Paul in Nîmes (ill. p. 102), built by Charles-Auguste Questel (1807–88) between 1838–50, following a competition in 1835. The

The official, academically sanctioned view of contemporary architecture, which after the retirement of Quatremère de Quincy showed a growing preference for an Italianate Neo-Renaissance style, was given concrete form by the new École des Beaux-Arts, built 1832–58 by Félix Duban (1797–1870), a pupil of Percier. The wing facing the court on the Rue Bonaparte adopts an articulation of arcading on piers fronted by half-columns, an arrangement taken from cinquecento Roman palace architecture. The architect would have become familiar with this style during his visit to Rome after winning the Grand Prix in 1823.

Following the July Revolution of 1830, new ideas emerged among the younger generation of architects, ideas relating not just to choice of style, but also to a rational, function-oriented design and use of materials. One of the most important representatives of this approach was Henri Labrouste (1801–75), a product of the École des Beaux-Arts who turned against the dogmatism of his alma mater. The ground plan of his Bibliothèque Ste-Geneviève (ill. p. 103, left above and below), built 1844–50, was developed from pragmatic considerations. The large, two-aisle reading room, visible in the interior as a cast-iron structure, occupies the upper story. The spare decoration of the façade in an Italian Renaissance style is subordinated to the effect of the cubic structural mass. Above the plinth-style ground floor, the apertures of the large pillared arcading are partly filled with inscription panels, corresponding to the bookshelves inside; they also help to articulate otherwise blank wall surfaces and illuminate the function of the building.

Labrouste developed his design principles further in the reading room of the Bibliothèque Nationale (1862–68). The cast-iron supports have Corinthian capitals, but these supports are so thin that this is no more than a nod towards classical architecture (ill. p. 103, right).

Finally, there were commissions for completely new types of buildings. Among them were the reception buildings of the railway network that spread through the whole of Europe in the 1830s. Whereas most early buildings sought to conceal technical installations behind showy public architecture, the Gare de l'Est in Paris, built by François Duquesney 1847–52, was among the first of its type to evolve an independent symbolic solution. The giant lunette towering above arcading of Florentine columns enclosed between three-story wings in a Renaissance style clearly branded the cast-iron railway train-shed. This forward-looking motif, developed from the design logic, was not the first step, but it was an important one, on the way to an aesthetically autonomous engineering-based architecture.

vaulted basilica with transept is based on Romanesque models in France, such as, for example, the crossing tower of the Burgundian abbey of Paray-le-Monial. Here too the lavish furnishing with stained-glass windows from a workshop in Metz is an essential feature of the spatial design, bearing witness to the growing interest in medieval art.

The Gothic Revival was interpreted as the expression of national self-confidence in secular architecture as well, especially by the representatives of the old aristocracy, who resented the citizen kingship of Louis Philippe and had retired to their rural estates, building châteaux in medieval styles. The château of Challain-La-Potterie, built for Albert de La Rochefoucauld-Bayers to a design by René Hodé dated 1846 and carried out 1847–54, vies with the 15th and 16th-century châteaux of the Loire with its corner turrets and lucarnes. At the same time, its symmetrical façade acknowledges its debt to Neoclassicism.

Henri Labrouste
Bibliothèque Ste-Geneviève, Paris, 1844–50
Detail of façade (above)
Reading room on upper story (below)

Henri Labrouste
Bibliothèque Nationale de France, Paris, 1855–75
Reading room, 1862–68

Georg Peter Karn

The Architecture of Neoclassicism and Romanticism in Italy

Neoclassicism and the study of Antiquity in Rome

Following the wars of succession in the first half of the 18th century and the Treaty of Aachen in 1748, a balance of power was established between the major European powers that enabled Italy to enjoy half a century of consolidation. The major dynasties, which effectively meant the Habsburgs in Lombardy and Tuscany, the Bourbons in the kingdom of Naples and – as the sole successful Italian ruling house – to a lesser extent the House of Savoy as kings of Sardinia and Piedmont, used this period of stability to reform their administrations and economies, within the framework of benevolent despotism. Flickerings of life were evident in the cultural sphere as well. Things were less promising in the more backward small states, including Papal Rome, where political stagnation prevailed. The invasion of French Revolutionary troops under Napoleon from 1795 changed all this abruptly. Over the next decade or two, political and cultural conditions converged over a large part of the country, with the effects still perceptible in the Risorgimento in the second half of the 19th century.

Despite the growing political weakness of the Papacy during the 18th century, Rome remained a focal point of architectural developments. It was here that tastes changed decisively towards Neoclassicism in the second quarter of the century, particularly during Corsini Pope Clement XII's pontificate. New ideas came to the fore in the Eternal City that sought to replace the received Bernini and Borromini styles with an architecture based on strict Vitruvian principles. The new tautly articulated façade (begun 1732) of St. John Lateran by Florentine architect Alessandro Galilei (1691–1737) was a highly controversial indication of the new mood. Other architects, such as Ferdinando Fuga (1699–1781), Luigi Vanvitelli (1700–73), and Nicola Salvi (1697–1751), were less radical, trying to combine current trends with late Baroque tradition by borrowing from the cinquecento. After the completion of costly schemes such as the Trevi Fountain (1735–62), the Palazzo della Consulta (1732–34) and the façade of S. Maria Maggiore (1741), the political and economic situation in the second half of the century did not permit many more major commissions, so many architects moved their working bases to Italy's more dynamic political centers in Naples, Milan, and Turin, taking Roman stylistic fashions with them. Cosimo Morelli's Palazzo Braschi for Pius VI from 1790 was a last major private palace conjuring up the Renaissance tradition.

Fundamental to the development and spread of Neoclassical trends were the roles of the Accademia di San Luca and the French Academy in Rome, which became meeting places and debating forums for young architects from all over Europe. Their competitions and exercise projects allowed their students to develop ambitious projects – without regard to practical requirements or financial limitations – that sought direct comparison with classical remains in the city, or even with the works of great

architects such as Bramante, Michelangelo or Vignola, and subsequently influenced the architecture of their native countries. The study of ruins went hand in hand with increasing efforts to research and conserve them. The writings of Winckelmann (1717–68), who worked as a librarian for the connoisseur and collector Cardinal Alessandro Albani (1692–1779), gave the veneration of Antiquity a scholarly basis.

A figure of great influence on the younger foreign (often French) architects was Giovanni Battista Piranesi (1720–78). Though he constructed relatively few buildings, his series of engravings popularized a wholly new perception of Antiquity. Piranesi was much less interested in objectively reproducing the Roman ruins than in suggestively depicting them in exaggerated form in picturesque circumstances. This had a substantial effect, not only on historical attitudes, but also on the perception of architecture in a pictorial sense.

Typical of the watershed situation of those years was the "Greek or Roman" debate, the controversy that broke out between scholars following investigations of the Greek temples of Paestum and the Acropolis in Athens. The emancipation of Greek art demanded by French and English architects (and Winckelmann), who elevated its *belle et noble simplicité* into a new model for architecture, conflicted with Piranesi's conviction of the priority and superiority of Roman Antiquity, and thus appeared to endanger his city's claims to cultural leadership. After increasingly losing ground in the course of a rather vitriolic debate, in his *Parere sull'Architettura* in 1765 Piranesi shifted his ground and unexpectedly adopted a stance of pluralistic openness with regard to the most diverse styles of antiquity, none of which could claim sole pre-eminence.

This eclectic attitude, which allowed access to the cultural achievements of history free of value judgments, found visual expression in Piranesi's *Diverse Maniere d'adornare i Cammini*

of 1769 (ill. p. 105, top), which contains a freely assorted collection of Greek, Etruscan, Roman and even Egyptian forms. The philosophy that developed from Piranesi's personal reactions anticipated 19th-century Historicism. Influences on it included the rationalist theories of the Venetian Franciscan priest Carlo Lodoli (1690–1761), who rejected Vitruvianism's traditional rules in favor of a functionalism based on the *natura della materia*, which interpreted ornamentation as an arbitrary addition that could be selected in accordance with the "character" of the building.

Milan under the Habsburgs

Among Italian regions, Habsburg-ruled Lombardy played a leading role. Thanks to Maria Theresia's reformist policies, the economy flourished, generating a remarkable prosperity that also benefited the construction industry. Along with numerous measures to improve the infrastructure, building work was most noticeable in the capital Milan, commissioned by both the court and the local nobility. Until the French invasion in 1796, the post of *architetto di stato* was occupied by Giuseppe Piermarini (1734–1808). As a pupil of Carlo Vanvitelli, who had recommended him to Milan in 1769, he represented the Roman tradition, as is evident from his rebuilding of the basically medieval Palazzo Ducale for Archduke Ferdinand in 1769–78. The façade of the three-wing building, which is open towards the cathedral, has an order of giant pilasters borrowed from Bernini's palace façades, thus adopting a feature much imitated in the Habsburg heartlands as well.

Piermarini's design for the Palazzo Belgioioso (ill. p. 106, bottom right), built 1772–81 for Alberico Belgioioso d'Este, who had been raised in rank from privy councilor to prince, follows a

horizontal rectangular reliefs above the windows and the accompanying pilasters over the windows of the first upper floor. The columns and pediments and accompanying pilasters are reminiscent of the centerpiece of the façade at Caserta by Piermarini's teacher Vanvitelli, but their three-dimensional force is here reduced to surface treatment.

Piermarini's cautious translation of traditional types into a fashionably restful formal language is once again evident at the Villa Arciducale (later Reale), which he built in 1776–80 for Archduke Ferdinand in Monza. The three-wing layout follows the Baroque tradition, but simplifies its opulent silhouette with plain attic structures.

Piermarini's most celebrated building was the Teatro della Scala in Milan (ill. p. 106, top left), rebuilt in 1776–78 at the expense of the box-holders after fire burnt down the old Teatro Ducale. Again, the architect ultimately remained attached to received styles. With 2,800 seats, the splendid auditorium – refurbished in 1807 and 1830 – was the largest of its time (ill. p. 106, bottom left). The oval ground plan followed the mold-setting court theater of Turin (1738–40). The boxes, which were fitted out individually by their owners, are distributed over the bottom four tiers, the two galleries above having standing places. The façade to the square is articulated by coupled columns and pilasters over a rusticated ground floor, pedimented windows and a tall attic floor, mixing cinquecento elements with French influences similar to those displayed, for example, by the university building in Vienna, built by Jean-Nicolas Jadot 20 years earlier. The depth of the projection features is differentiated on each story, creating a busy effect, while the porte cochère at the main entrance represents a forward-looking element.

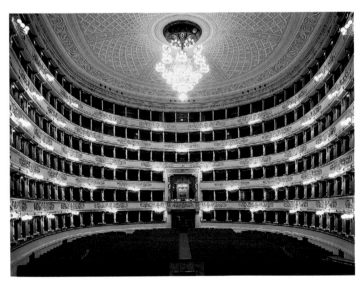

similar arrangement, though because of the elongation of the façade the pilasters are sometimes projected to form rhythmic sub-groupings. The flat rustication and continuous entablature produce an almost two-dimensional effect. Although the articulation of the façade evokes Bernini models once more, its severe orthogonality and clear separation of levels nonetheless carry the hallmarks of early Neoclassicism. Similarly Neoclassical are the

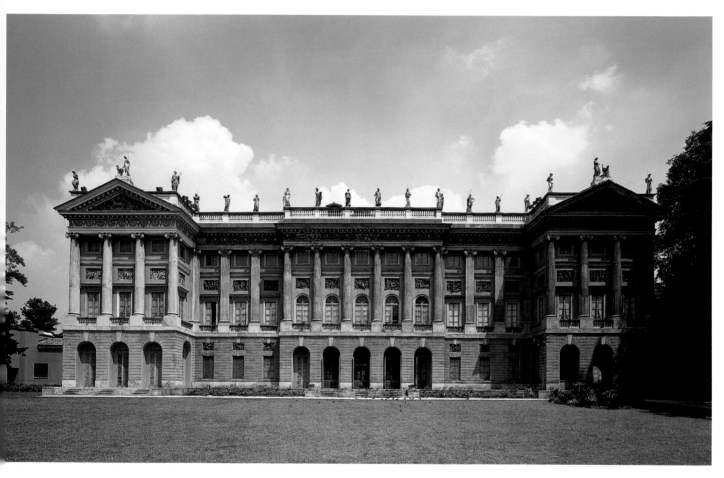

Piermarini's pre-eminence as court architect for almost 25 years had a marked effect on other building work in the Habsburgs' Italian capital. Among the last showy buildings built before the political upset was the Villa Belgioioso (ill. p. 107), built 1790–93 for Ludovico Barbiano di Belgioioso. The architect was Leopold Pollack (1751–1806), son of a Viennese builder, who had previously worked for Piermarini on the conversion of the Palazzo Ducale. Unusually located within the city fortifications, the three-wing design combines the traditional type with elements of a French *hôtel*. The garden front is dominated by strongly projecting pedimented side pavilions and a broader but less pronounced center pavilion incorporated in the horizontal. The giant order of fluted Ionic pilasters and columns over a rusticated ground floor adopts Piermarini's scheme, but the close colonnading and packed decoration covering all surfaces with reliefs and ornamental friezes are reminiscent of the buildings of Victor Louis in France. A balustrade with numerous statues provides a final flourish at the top.

On the *cour d'honneur* façade, however, the columns of the central pavilion contrast with the smooth, undecorated surfaces of the recesses, which have no corner projections. The classical pedigree of the forms is evident in the baseless Doric columns in the center of the rusticated court screen. The splendid, high-quality furnishing of the interiors was done only in the early 19th century by Luigi Canonica, before the building was made over to Napoleon's stepson, Eugène Beauharnais, as a summer residence. The gardens are among the earliest in the English style in Italy. According to an early source, they derive from Capability Brown, but are more likely to have been designed by Pollack himself.

Napoleonic Italy

With the occupation by Napoleon, Habsburg rule, and thus temporarily Habsburg cultural influence, came to an abrupt end. The Repubblica Cisalpina proclaimed in 1796 was above all a product of bourgeois intellectuals and nobles, who had already

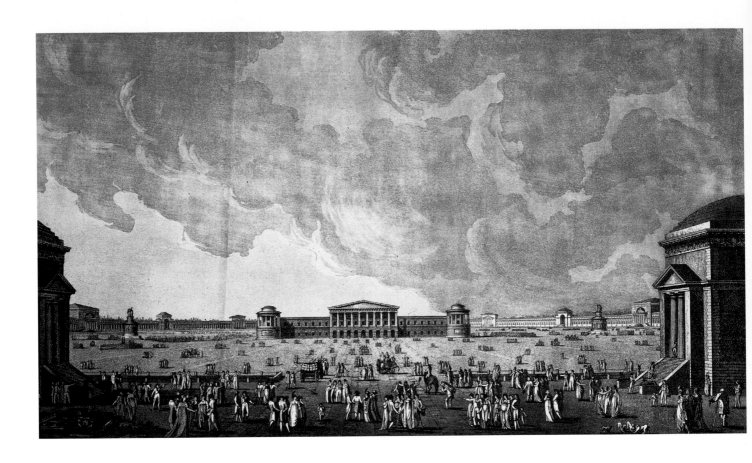

voiced opposition to Vienna's centralist policies, but were now conscripted for France's political hegemony. Napoleon's triumphal re-entry after the victory over the coalition army in the Battle of Marengo in 1800 was celebrated with a triumphal arch of the classical type, the Porta Ticinese (ill. p. 108, bottom). It was built in 1801–13, even before the arches in the French capital, to a design by Luigi Cagnola (1762–1833), and demonstrated a programmatic adoption of classical Roman features. Initially self-taught, Cagnola had taken up architecture in Rome, but became interested in Renaissance as much as ancient buildings. Despite the grand dimensions, the arch structure with its slender Ionic columns enclosed between antae piers looks open and airy. The tall round-arched openings in the side walls and pediment on top betray the influence of Palladio. More closely modeled on a specific building is the Arco di Sempione, constructed by Cagnola a few years later to mark the wedding of the Viceroy with Augusta Amalia of Bavaria, originally as an ephemeral structure but later rebuilt in stone. Begun in 1806, at the same time as the Arc de Triomphe de l'Étoile in Paris, with which it is closely related, the triumphal arch is based on the ancient arch of Septimius Severus in Rome. Like the Arc de Triomphe de l'Étoile in Paris, it remained uncompleted after the fall of Napoleon. Just as there, the arch was unhesitatingly adapted to the new political realities. After a long lull, it was completed in 1838 as the "Arco della Pace," but then renamed "Arco di Sempione" in 1859 on the occasion of a peace treaty with France. A further triumphal arch-shaped city gate of the Napoleonic period is the Porta

ABOVE:
Giovanni Antonio Antolini
Foro Bonaparte, Milan, 1800
Engraving by Sanquirico, 1806

BELOW:
Luigi Cagnola
Porta Ticinese, Milan, 1801–14

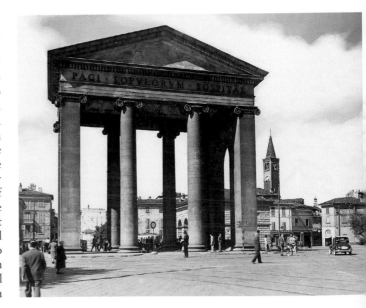

Nuova, built in 1810–13 by Giuseppe Zanoia (1752–1817), which is reminiscent of the Arch of Titus in the Roman Forum, though extended with angled projecting wing structures like a propylæum. When Habsburg rule was reinstated in 1815, the tradition was continued with the Porta Comasina (1826 by Giacomo Moraglia) and the Porta Venezia (1827–33, by Rodolfo Vantini), which recalls Ledoux's *barrières* (toll houses) in Paris.

Lombardy owed the Napoleonic era not just a fundamental reform of its law and administration, based of course on Austrian foundations, but also an expansion of the road network and promotion of public construction works. Designated capital of the kingdom of Italy in 1805, Milan was intended by Napoleon to be appropriately enhanced with various large-scale development schemes, on which in the event only a start could be made. Nonetheless, the regulatory plan drawn up in 1807 by a building committee remained in force until late in the 19th century. It provided, among other things, for various straight streets to be broken through the old city. The most important project was a huge Foro Bonaparte (ill. p. 108, above), planned in 1800 for the Castello Sforzesco area by Giovanni Antonio Antolini (1756–1841) during the period of the Repubblica Cisalpina. Antolini had likewise taken up architecture in Rome, and as a supporter of the Revolution had earlier won a Milan competition for a monument to commemorate Napoleon's victory at Marengo. His expansive, circular open space, 2000 feet (600 m) in diameter, encloses the Castello Sforzesco in its center. Napoleon had refused permission for it to be demolished, as the Revolutionaries had demanded following the example of the Bastille. Instead, the medieval building would be "regularized" by the addition of new façades. Tempietto-style towers were to be provided at the corners plus giant temple façades in the center of both main fronts, their sturdy Doric columns recalling the "Greek" or "Etruscan" temples of Paestum and seen as the "Republican order" in the context of the Revolution. Incorporated in the colonnaded ring of buildings are 12 public buildings, which include (among others) the theater, stock exchange, a museum, a bath-house and various official organizations. The circular layout with its blocks of buildings recalls Ledoux's concept of an ideal city at Chaux and the designs for a "Revolutionary" architecture. However, in recent years research has shown that a similar idiosyncratic tendency contemporary with that in France existed within the ambiance of the Roman academy. Along with classicizing forms, the porticos and colonnades on socles of the Sforzesco scheme display mainly the influence of Palladio and Bernini.

Because of expense, Antolini's project – except for the ring road – never got beyond the preliminary stage. Instead a more modest plan by Luigi Canonica (1762–1844), a pupil of Piermarini, was partly implemented in 1802. It provided a square exercise ground, the

middle of whose sides are marked by the Castello, the abovementioned Arco della Pace and an arena in the style of an ancient Roman amphitheater, where naval battles were performed in 1811 to mark the baptism of the King of Rome.

Napoleon and his adopted son and Italian viceroy, Eugène Beauharnais, tried to launch grand urban schemes for other cities in Italy as well, to evoke the glory of Imperial Rome – a sentiment that became increasingly pronounced under the Empire and the kingdom of Italy proclaimed in 1805.

In Rome, annexed in 1809, the plans comprised not only the systematization of streets and squares, but also excavations of Imperial *fora* and palaces to bolster this programmatic ambition in visible form. Among the most important projects were the reconstruction of the Piazza del Popolo in the north of the city and the layout of a garden on the adjacent Pincio. The first plans had been submitted to Pope Pius VI by French-trained architect Giuseppe Valadier (1762–1839) in 1794. They envisaged a trapezoid square enclosed in colonnades. After the birth of the heir to the throne, named as King of Rome, the designs were enlarged in scale and reworked by French architects Louis-Martin Berthault (c.1772–1823) and Guy de Gisors (1762–1835). The new scheme extended the space between the city gate and the twin Baroque churches at the junction of the Corso to make an exedra. And, using a system of ramps, it overcame the problem of the rising land up to the properly planted park on the hill, which was to be linked with the nearby Villa Medici. However, the planned monument that was supposed to be a focal point (Valadier's designs show a pyramid or classical domed structure, thus

LEFT:
Giuseppe Maria Soli
West wing of Procuratie Nuove, Venice,
begun 1810

BELOW:
Giovanni Perego
Palazzo Rocca-Saporiti, Milan, 1812
Detail of façade

OPPOSITE:
Giuseppe Venanzio Marvuglia
Villa Belmonte, Palermo, 1801–06

evoking associations with the tradition of late 18th-century visionary architecture) was never implemented. After the withdrawal of Napoleon and return of the Pope, it was to be rededicated as a monument to the Christian religion and the monarchs allied against Napoleon. All that came of it in the end was a greatly scaled-down version by Valadier in 1816, with a three-arch portico and end terrace, plus the Casina erected in 1813–17 at the summit of the park (ill. p. 109), which was redesigned in the Neoclassical style in the long tradition of Roman garden buildings. The various parts of the scheme – terraces, balconies and roof superstructures, and a central belvedere tower, all clearly setting off the plain cubic buildings articulated by shallow corner projections – are assembled like pieces from a building kit. The baseless Tuscan order columns at socle level recall the abrupt formal language of Revolutionary architecture, while the vase-topped granite Ionic columns on the main floor add a cheerful note-matching the suburban environment.

In Venice too, incorporated into the new kingdom of Italy in 1805, measures were taken to improve the infrastructure of the city, including moving the cemeteries out to an island in the lagoon and laying out public parks. A new art academy displayed the new regime's cultural credentials. More restrained was the erection of a Residence for Napoleon and his viceroy Eugène Beauharnais, who opted not for the Doge's palace but the Procuratie Nuove, also in St. Mark's Square, the city state's administrative building constructed by Vincenzo Scamozzi in the late 16th century. The new wing to house the stairwell and grand room constructed from 1810 by Giuseppe Maria Soli (1747–1822) on the west side of the square opposite S. Marco's (by then transformed from the State Church to Venice Cathedral) conformed with the scheme of the Renaissance façades in the square (ill. p. 110, top). Only the tall attic in place of the second upper floor, creating a transition between flanking façades of different heights, betrays its date of construction in emphasizing the horizontal. The imperial statues erected in front of the attic tally with the iconographical concept of Empire. The richly decorated interiors were only completed in 1822 on the basis of designs by Lorenzo Santi (1783–1839). Santi also built the Palladian-style Palazzo Patriarcale besides S. Marco, begun in 1837.

Palaces and villas

Private palaces in the early 19th century kept to the existing types, but adapted them to changed tastes, often by using Palladian or other cinquecento features. Examples of this can be seen in the palazzi built in Milan in the second decade in comparison with the buildings of Piermarini. The Palazzo Rocca-Saporiti, for example (ill. p. 110, below), built in 1812 for Gaetano Belloni and sold in 1818 to the Marchese Saporiti, sports a rusticated ground floor and a colonnade on the upper floor terminating in corner projections, following the pattern of Gabriel's buildings in the Place de la Concorde in Paris. Instead of the continuous and yet differentiated orchestration typical of 18th-century buildings, however, the row of columns in front of the shadowed background of the loggia now provides a stark contrast with the smooth wall surfaces of the end pavilions and their separately formed openings. The taut emphasis of the horizontal by the cornices and strongly projecting entablature at the top is reinforced by the absence of pediments over the end pavilions, such as still featured on Pollack's Villa Belgioioso 20 years earlier. The characteristic figured frieze running behind the columns on the piano nobile had already been used by Simone Cantoni (1736–1818) in his Palazzo Serbelloni in 1794. The design for the Palazzo Rocca-Saporiti originated from Giovanni Perego (1781–1817), who also designed stage sets. The direct juxtaposition of isolated columniation and flat surfaces is likewise a characteristic of the Palazzo Besana, built three years later in the Piazza Belgioioso, the façade arrangement of which otherwise conforms to the tradition of Bernini's influential Palazzo Chigi-Odescalchi.

For early 19th-century villa architecture, the most influential source was Palladio, with his clear, cubic structures. An example

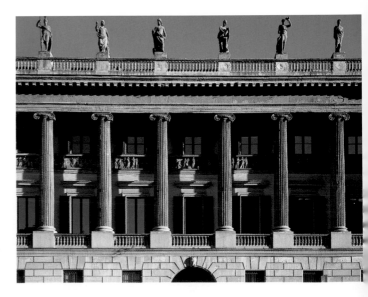

is the Villa Belmonte (ill. p. 111), high above Palermo on the slopes of Monte Pellegrino, built 1801–06 by the Roman-trained architect Venanzio Giuseppe Marvuglia (1729–1814) for Giuseppe Ventimiglia, Prince of Belmonte. With its stately proportions and grand articulation by a rusticated ground floor and strongly projecting centerpiece of raised Ionic columns, the massive villa is set dramatically against a rock face, and shows clear links with villa designs by Vincenzo Scamozzi. In the adjoining park, a classical round temple and a Gothic Revival pavilion represent the range of types and styles available for garden buildings. At the same time, they clearly illustrate the Prince's anglophile attitude which, thanks to the English fleet's guaranteed protection of the island from Napoleonic expansion, had a current political dimension.

In contrast, Luigi Cagnola's idiosyncratic Villa La Rotonda in Inverigo (ill. p. 112, above), which the architect built for himself in 1814–30, is peppered with classical allusions. Though many of its basic features follow Palladio's famous Villa Rotonda in Vicenza, the domed center block evokes the Pantheon in Rome, and is

confronted on the main façade by two prostyle podium temples. Cinquecento and even Neo-Egyptian features underline the eclectic character of the building. Palladian design continued to be acceptable, as is evident from the Villa Torlonia on the Via Nomentana in Rome, rebuilt 1832–39 by Giovanni Battista Caretti.

The change in villa types resulting from the emphasis on surface geometry typical of the period around 1800 is the distinguishing feature of the main façade of the Villa Poggio Imperial in Florence (ill. p. 112, bottom left). After a lengthy suspension of work during the Revolution, the elongated structure, which dates principally from the 17th and 18th centuries, was due to be completed in 1806 by Pasquale Poccianti (1774–1858). In fact it was only finished under Ferdinand III of Habsburg-Lorraine after the abdication of Napoleon appointee Queen Maria Luisa of Etruria in 1807 and the French annexation of 1824.

Despite the prominence of the center projection, horizontal elements dominate the design. They include not just the great length of the façade, clear division of floor levels and continuous cornice, but also the remarkably elongated pediment,

which is moreover set against an attic floor extending far beyond even the width of the projection. The non-classical form is reminiscent of buildings in Revolutionary architecture, such as Antolini's Foro Bonaparte or Boullée's visionary projects in France. On the ground floor of the center block the cushioned rustication echoes Florentine buildings of the quattrocento or cinquecento. The upper floor, added in the second phase of building work by Giuseppe Cacialli (1778–1828), reduces the effect of a temple façade by its smooth, closed-looking side bays, which optically seem to bear the load of the pediment more than the columns between them, which were originally planned as an open loggia.

This semi-abstract interpretation of classical architectural grammar goes still further in the façade of the Teatro San Carlo in Naples (ill. p. 112, bottom right), which Antonio Niccolini (1772–1850) grafted 1810–11 on to the building erected in 1737 by Giovanni Antonio Medrano. An Ionic colonnade is inserted like a decorative strip between closed corner blocks, which continue upwards as pylons. The continuous balcony carried on brackets and hiding the bases of the columns, and the strongly projecting cornice emphasize the horizontal element, as does the attic floor across the whole width, which rises towards the middle like a pediment – again a feature of Revolutionary architecture. Numerous figures and ornamental reliefs are partly sunk into the ponderous rustication of the ground floor without any vertical relation. After the Baroque theater burnt down in 1818, Niccolini, who also worked as a stage designer, undertook the reconstruction himself.

Leopoldo Laperuta
Foro Murat (Foro Ferdinandeo), Naples,
begun 1809
Church of S. Francesco di Paola by Pietro
Bianchi, 1836

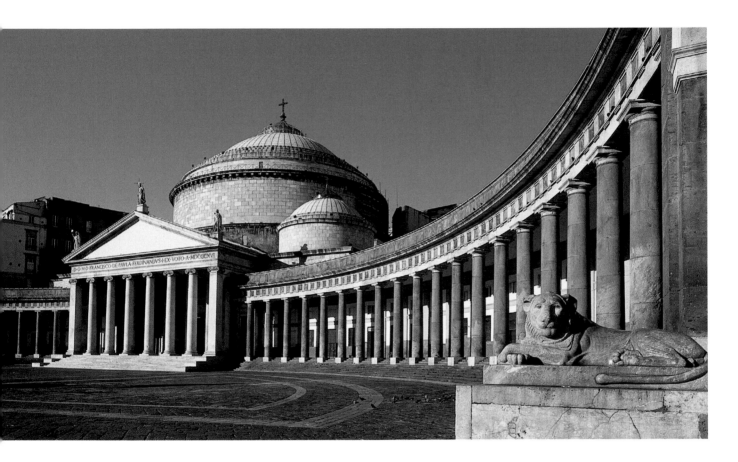

Developments in church building

The early 19th century had a predilection for the Roman Pantheon as a model for church building, which had already played a dominant role in competition designs at academies during the second half of the 19th century. The combination of a rotunda and a temple façade managed to satisfy the desire for both stereometric clarity and classical grandeur. Moreover, with its monumental look it was excellent for including in showpiece public urban planning settings.

One of the most ambitious finished projects of this kind was the Foro Murat opposite the Palazzo Reale in Naples (ill. p. 113), begun in 1809 under the Emperor Napoleon to designs by Leopoldo Laperuta (1771–1858). Named for Napoleon's brother-in-law Joachim Murat, who was installed as viceroy, the square is enclosed by sweeping colonnades in a segmental arc that follow both the tradition of St. Peter's Square in Rome and Palladian models as well. The square was completed by the Bourbons on their return in 1815, who renamed it Foro Ferdinandeo in accordance with the new political set-up. The

construction of the church of S. Francesco di Paola planned for the center was put out to competition and awarded to Pietro Bianchi (1787–1849), a pupil of Cagnola, who completed the work by 1836. To dramatic effect, Bianchi designed an Ionic temple façade projecting over lower colonnades and set against the windowless ashlar wall of the rotunda, which is flanked by two domed chapels. The magnificent interior (ill. p. 114) has a two-story arrangement on the classical model, but uses the upper floor for galleries. Unlike in the numerous derivatives of the type from Renaissance and Baroque periods, the colonnade runs uninterrupted round the inside of the rotunda, thus stressing the regularity of the space. Only the main axis is stressed, by means of a canopy on the upper level borne on caryatids.

Another impressive example for the townscape effectiveness of such "pantheons" is the Chiesa di Gran Madre de Dio in Turin (ill. p. 115, bottom left). The church was built in 1818 on a podium on the other side of the river, on the occasion of the return of Victor Emanuel I of Savoy. It was based on plans by Rome-trained architect Ferdinando Bonsignore (1767–1843), who

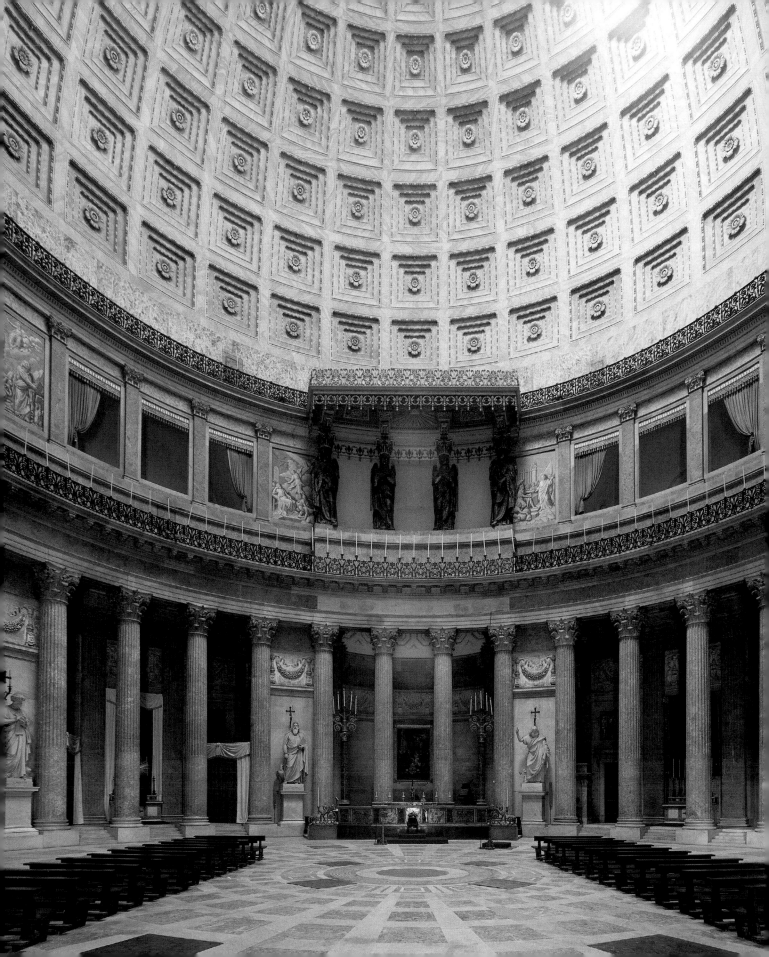

used the church as an effective focal point for the Via Po from the direction of the palace square. Notable features borrowed from the Pantheon include a shallow calotte, stepped at the bottom, and a tall attic floor behind the pediment. These are supplemented by further classical motifs such as the frieze of garlands on the rotunda, borrowed from the tomb of Cæcilia Metella on the Via Appia in Rome. The arched stone bridge, planned on the axis of the church after the demolition of the eastern city gate under French rule in 1805, was begun in 1810, but work on the square itself, which opens theatrically towards the Po, but is rounded off by an exedra at the city end, began only in 1825. The façades along the street were designed in homogeneous style by Giuseppe Frizzi, with street-level arcades reproducing a typical feature of the large-scale Baroque town plan, since the rectangular street patterns based on classical Roman models accorded with urban planning notions of Neoclassicism.

Such pantheons occur in other cities of Italy, for example in Milan (S. Carlo al Corso, 1832–47, by Carlo Amati) or as part of designs for cemeteries, such as in Brescia (1815–49, by Rodolfo Vantini) and at Staglieno near Genoa (1840–61, by Giovanni Antonio Resasco). Besides the stately rotunda by Luigi Ganola in Ghisalba near Bergamo dating from 1834, special mention must also be made of the Tempio Canoviano in Possagno in the Veneto (ill. p. 115, top right), built in his native town by the sculptor Antonio Canova (1757–1822), presumably in conjunction with Giovanni Antonio Selva (1751–1819). The effect of grandeur is reinforced here by the extreme reduction of forms. The almost wholly unarticulated rotunda has an octastyle Doric portico placed directly in front of it without the usual attic, its baseless fluted columns being derived from the Parthenon on the Acropolis in Athens.

The classical temple front also served as a model for longitudinal buildings. The cathedral of Schio near Vicenza (ill. p. 115, center right), constructed dramatically on a podium by Antonio Diedo from 1805, also reveals the influence of the Pantheon,

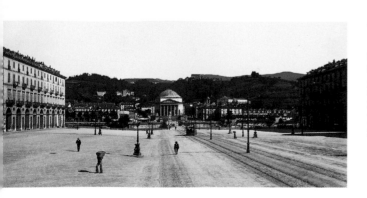

whose Baroque towers flanking the pediments (removed only in 1883) were faithfully copied. The portico in Schio, enclosed at the sides by arches, is a borrowing from Palladio, whose tempietto on the Villa Maser not far away was similarly furnished with towers even earlier than the Roman model. However, the frieze running behind the columns is a typically Neoclassical feature. Other models for façades were offered by Palladio's Venetian churches, like those imitated by Valadier for Urbino cathedral (1789–1802) and S. Rocco in Rome (1834).

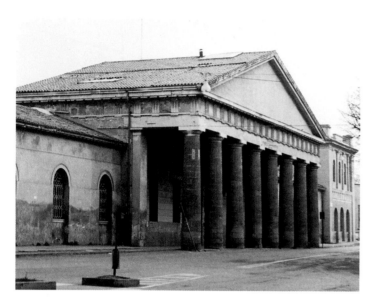

Public buildings

In the first half of the 19th century, the motif of the temple front remained reserved not just for traditionally important building commissions, but spread to virtually all types of architecture. The architectural status of public utilitarian buildings had increased considerably following the Enlightenment focus on the public good. This is quite evident from the public meat market (*macello*, ill. p. 116, top) of Padua, constructed by the Venetian Giuseppe Jappelli (1783–1852). With its eight sturdy baseless columns standing on a low step supporting a broad pediment, the center section seems to have been inspired by the Greek temples in Paestum, but at the same time is reminiscent of the use of Doric by Revolutionary architecture, with which Jappelli was familiar through his teacher Giovanni Antonio Selva. The restrained, conventionally articulated wing blocks are clearly distinct from the showy centerpiece. Likewise inspired by visionary architecture of around 1800 is Jappelli's huge but unrealized project for the university of Padua, dated 1824/25.

The Cisternone of Leghorn (ill. p. 117), built by Pasquale Poccianti (1774–1858) as part of the scheme for extending the local water system between 1829 and 1842, followed the same tradition. A continuous entablature subdivides the blocked building mass, whereas the openings, which vary from floor to floor, "swim" in the smooth ashlar surfaces. Above an unpedimented octastyle screen of Doric columns, the main façade is dominated by a huge niche. Stepped on the outside and coffered on the inside, the calotte again echoes the dome of the Pantheon. The striking combination of portico and niche was used by

Ledoux in the 1780s in his Parisian *barrières* and pavilion structures, but the motif also occurs in designs by Antolini for the Foro Bonaparte. The ambitious nature of the building is also reflected in the multi-aisle structure of the interior, with its domed vaults on slender columns.

Admiration for the fine engineering achievements of Roman Antiquity, to which Piranesi had already given voice, likewise found expression in contemporary functional architecture. The three-tier arching of the viaduct across a deep valley to Ariccia near Rome (ill. p. 116, bottom), built by Ireneo Aleandri (1795–1885) between 1847 and 1854 during Pius IX's papacy, clearly emulates classical aqueducts. The classical model had already been imitated by Luigi Vanvitelli in his monumental Acquedotto Carolino to Caserta, built in 1752–69.

Aleandri opted for inspiration from the theaters and arenas of antiquity when he came to build the Sfisterio at Macerata (ill. p. 118 top) in the Marches. This was a sports arena big enough for 10,000 spectators and built from public subscription. Erected in 1820–29, Aleandri's design with its arch-shaped enclosure terminating in rectangular structures drew on visionary architecture such as, for example, the megalomanic competition project of 1813 by Giuseppe Pistocchi (1744–1814) for a monument to Napoleon on Monte Cenisio. The rows of arches on the exterior with niches and oculi in between also draw on cinquecento motifs, while the interior, with its tall Doric colonnade over three stories, is indebted to classical models as interpreted by Palladio.

One of the forward-looking type of commissions of the second half of the 18th century was the museum. The development of historical sciences and the pedagogical aspects of the Enlightenment had their effects on the nature of collections. In Rome it was Johann Winckelmann who showed the way forward, following his appointment as curator of the Papal collection of antiquities in 1763. From 1770, but especially during the papacies of

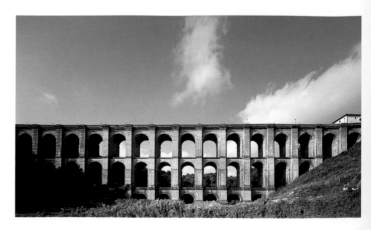

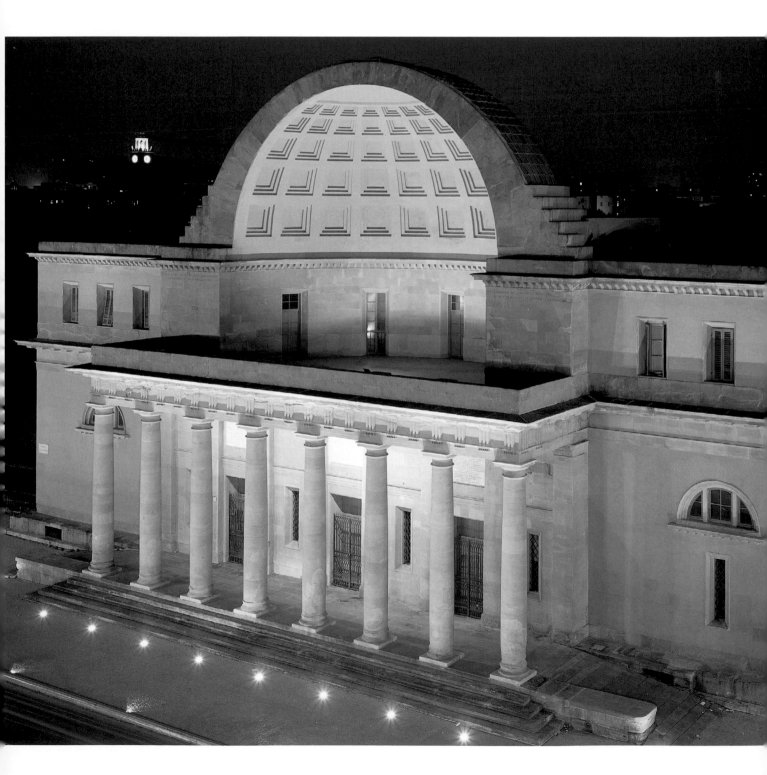

RIGHT:
Ireneo Aleandri
"Il Sferisterio," Macerata, 1820–29

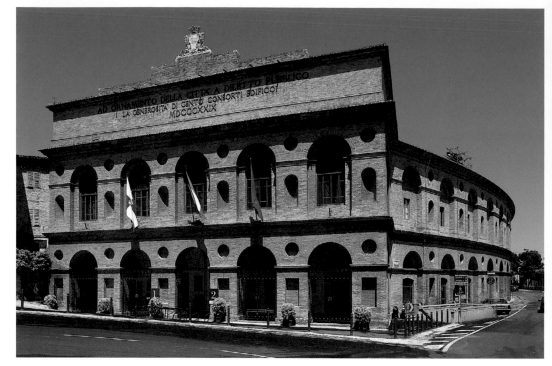

BELOW:
Raffaello Stern
Braccio Nuovo, Vatican, Rome, 1817–22
Interior view

The elongated gallery with its domed space follows a scheme developed in the 18th century. The lavish use of marble and Roman floor mosaics provide a splendid setting for the classical statues. The extension of the Vatican museum was intended to demonstrate tangibly the leading role of the papacy in cultural and antiquarian matters.

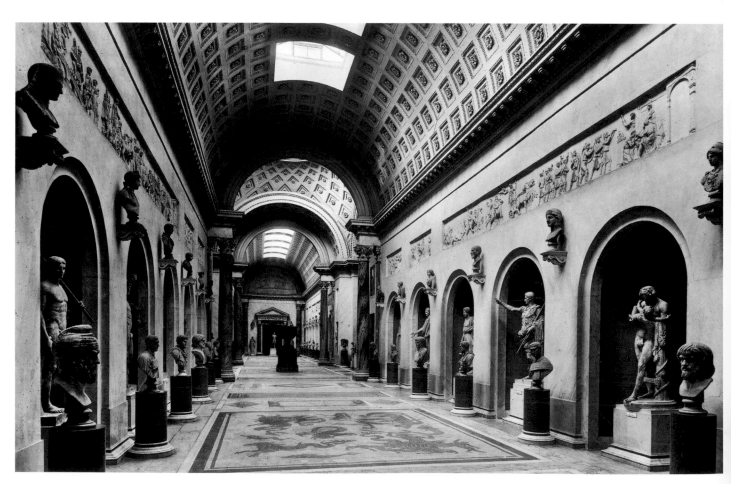

Giuseppe Jappelli
Caffè Pedrocchi, Padua
Main façade, completed 1831 (below)
Gothic Revival extension (Il Pedrocchino), 1837
(bottom)

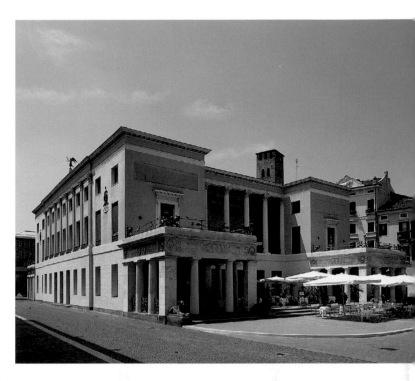

Clement XIV and Pius VI, the facilities for accommodating the countless classical and Early Christian works of art owned by the Church were steadily improved by successive extensions to the Vatican palace. Whereas the Cortile Ottagono, Sala della Muse and Sala della Croce Greca (1770–1784, by Michelangelo Simonetti and Pietro Camporese) were given the traditional treatment of columns and pilasters of cinquecento origin, the Braccio Nuovo gallery of 1817–22 (ill. p. 118, bottom) erected by Raffaello Stern (1774–1820) in Bramante's Belvedere court features smooth walls. They are articulated only by the series of niches and the horizontal feature of a classicizing relief by Max Laboureur. The classical statues exhibited and the busts on brackets are incorporated into the interior as integral components. Modern elements are the top-lights incorporated in the barrel vaulting, such as had previously appeared in projects by Boullée and the reconstruction of the Grande Galerie of the Louvre. However, the type of coffering used followed classical precedents, whose lozenge pattern in the dome of the center space, which is marked off by recessed arches, echoes the apse of the temple of Venus and Roma in the Forum.

Stylistic pluralism and nascent Historicism

Piranesi had already done the theoretical groundwork for a pluralistic approach to styles back in the 18th century. Especially theater sets and pavilion buildings in landscaped English gardens provided great architectural opportunities, thanks to their informal nature. However, since the early 19th century a wider spectrum had also become evident in buildings designed for urban contexts. Early examples were found in the very popular institution of public coffee houses. Piranesi had furnished his Caffè Inglese in Rome with Neo-Egyptian decor in 1760 (ill. p. 105, top). The stately Caffè Pedrocchi in Padua (ill. p. 119, top) was constructed in 1816 by the earlier-mentioned Giuseppe Jappelli, who on his travels had developed a broad familiarity with work elsewhere in Europe, including northern Europe. Construction lasted to 1831, during which time sundry additions were made that illustrate the eclectic approach to the design. The main façade with a two-story colonnade of slender Corinthian columns between corner projections follows a standard Palladian pattern for villas and palaces. The novelty is the porches at street level in front of the end projections. These have the squat columns and heavy entablatures of Revolutionary Doric, while the lion figures flanking their steps go back to Egyptian models. Finally, in 1837, Jappelli built an extension at the back (Il Pedrocchino, ill. p. 119, bottom) in the Gothic Revival style. The numerous café rooms of the interior on two floors display the same catholicism of styles.

Within church architecture – as with parallel developments in other countries – interest from the 1820s was directed towards

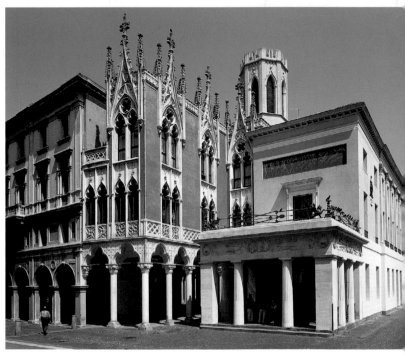

Early Christian basilicas. The most spectacular example of this is the reconstruction of the 14th-century Roman pilgrimage church of S. Paolo fuori le Mura following a fire in 1823. After prolonged debate, the plan carried out by Luigi Paoletti (1792–1869) was for the complete demolition of the ruins and construction of a new build with "purified" forms. In Turin, the design submitted by Luigi Canina for the rebuilding of the cathedral to an Early Christian style arose in conjunction with architectural historical research.

Because of the emphasis on the classical tradition, medieval forms were far less readily adopted than in northern Europe. One of the most lavish representatives of the Gothic Revival in the realm of landscape gardening is the Margheria (ills. pp. 120/121) attached to the residence of the Prince of Carignano in Racconigi in Piedmont. The courtyard layout (ill. p. 120), erected between 1834–49 on the edge of an extensive English garden planned by Savoy court gardener Saverio Kurten (Xaver Kürten), goes back to

designs by architect and stage designer Pelagio Palagi (1775–1860). While the complex silhouette, with its corner towers, battlements and pinnacled pediments, is clearly inspired by English models, the ground plan with three wings round a court is unmistakably derived from Baroque villas. The *cortile* on the other hand, enclosed by pointed arches, is reminiscent of a cloister garth.

Within the genre of church buildings, the porch added to the cathedral of Biella by Felice Marandono in 1824–26 is among the first examples of the Gothic Revival in Italy. At the same time, the details contain Egyptian and classical motifs. The choice of style was probably mainly due to the prevailing doctrine in current architectural theory of matching to the existing style, here a mainly early 15th-century building.

The centuries-old debate over a suitable style for the façade of Milan Cathedral was decided in the same way. An initiative deriving from the Emperor Napoleon to get the west front completed was carried out by Giuseppe Zanoia (1752–1817) and

BELOW:
Pelagio Palagi
Margheria, Racconigi, 1834–39
Façade

BOTTOM:
Orangery, Margheria, Racconigi

Presumably erected by Palagi's pupil Carlo Sada (1809–73), the Gothic
Revival building became famous in its day because of a novel heating
system installed by the English engineer Taylor.

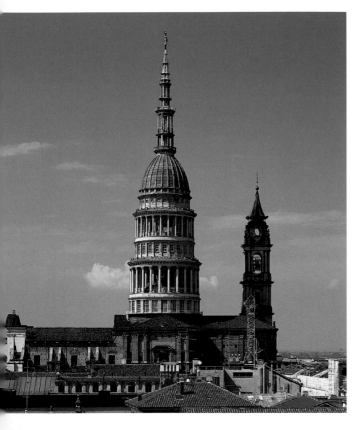

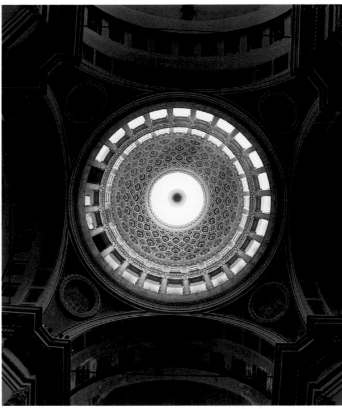

his assistant Carlo Amati (1776–1852) in 1806–13, based on designs by Felice Soave and Leopold Pollack (ill. p. 122). The screen of tracery left the 16th-century doorways and windows by Pellegrino Tibaldi intact, an approach which was soon criticized as illogical. Nostalgia for the indigenous Gothic style, represented for example by the work of Jappelli's pupil Pietro Selvatico (1803–80) and Camillo Boito (1836–1914) and fed by nationalism directed against the tradition of "Austrian" Neoclassicism, culminated in a widely followed competition only in the second half of the century.

Among forward-looking developments in the first half of the 19th century was the emancipation of engineering-led building, resulting from the establishment of technical high schools. Whereas in England and France iron structures were being built, in Italy it was the daring stone buildings of Alessandro Antonelli (1798–1888) that caused a sensation. Working in the tradition of rationalist architectural writers such as Padre Lodoli, his idea was to exploit the given material to the utmost. However, the use of classical architectural forms – in Antonelli's case a preference for columns is particularly noticeable – gave his buildings a hybrid character, and recalls the almost megalomaniac aggrandizement of scale in Revolutionary architecture. Antonelli's principal work, the huge Mole Antonelliana in Turin (1863–88), falls outside the time frame of this book, but one of his first spectacular works of this kind is the 1841-built crossing tower of Pellegrino Tibaldi's church of S. Gaudenzio in Novara (ill. p. 123, left), under construction since the late 16th century. The dizzying height of the slender structure (400 feet/121 m) was made feasible by the insertion of concealed iron stays. The use of a tholos with a circular colonnade, the retracted upper story and the slender, ribbed dome call to mind the model of Soufflot's church of Ste-Geneviève in Paris, but the scheme gains an effect of progressive height from its telescoped layering. The discrepancy between the modern structural frame and the traditional (and at the same time tradition-rejecting) articulation indicates that once again architecture had come to a turning point.

Barbara Borngässer

Neoclassical and Romantic Architecture in Spain and Portugal

Neoclassical Architecture in Spain

The "birth" of Neoclassicism in Spain can be accurately dated to the year 1752, when Ferdinand V founded the Real Academia de San Fernando in Madrid. This event elevated the Neoclassical style to the status of an official state art, and Neoclassicism became the country's dominant architectural style until the 1840s. The period of time under discussion here encompasses the reigns of the Bourbon kings Ferdinand VI (reigned 1746–59), Charles III (1759–88), Charles IV (1788–1808), Ferdinand VII (1808, and 1813–33) and his widow Maria Christina (1833–40). It also includes the period of Napoleonic rule between 1808 and 1813 as well as the abortive attempt to steer the country towards liberalism with the constitution of Cádiz in 1812.

Despite political troubles, the first decades marking the transition between Baroque absolutism and the Enlightenment were a period of great artistic productivity. Under Charles III and Charles IV, foreign artists of repute gathered at the Madrid court, amongst them the Italian Giovanni Battista Tiepolo, and the German Anton Raphael Mengs.

Contrary to the impression given above, Spanish architecture had been changing for some time before 1752. The alleged excesses of the Baroque had been roundly criticized before 1750, and there were increasingly loud calls for a return to the architecture of the Greeks and Romans. The demand for a Neoclassical art was lent greater urgency by the fact that two contradictory movements struggled for predominance in early 18th-century Spain: the architecture of the royal house largely followed the Baroque Neoclassicism of the French and Italian models, while the great cities of the empire preferred the extravagant decorative style of Churriguera, Pedro de Riberas, and Francisco de Hurtados. Preferred by the church and private clients, this latter style clung on into the second half of the century and provided a counter-model to the imported tastes of the court.

The founding of the Academia de San Fernando resulted in the Bourbon court completely controlling the direction of artistic production. Amongst the tasks of the institution, which was modeled on its counterparts in Paris and Rome, was the selection of six scholarship holders to study in Rome; the investigation of architectural matters according to scientific principles; the compilation of an inventory of artistic monuments; and the education of architects, painters and sculptors. One consequence of the centralization of all these activities was a greater consistency of artistic achievement within Spain. In the case of architecture, royal control went as far as to decree that no public building could be started without the prior approval of the Academy, and that architects must not call themselves *arquitecto* or *maestro de obras* without submitting themselves first for examination.

Great importance was placed on a "rationalization" of education and construction techniques – possibly more so, in fact, than

Ventura Rodríguez
El Pilar, Zaragoza, rebuilt from 1753
View into the chapel of Nuestra Señora
del Pilar

was invested in formulating a unified artistic style. A large reservoir of workers, amongst them many engineers, was therefore available for work on the court's prestige projects.

One of the first directors of the Academy's department of architecture was Diego de Villanueva. A connoisseur of Italian and French architectural theory, he wrote numerous treatises in which he called for an honest approach to architecture that was appropriate to its tasks and its methods. In addition, he encouraged the translation of historic source material; this included José Castañeda's publication in Spanish of Vitruvius' *Ten Books about Architecture* in 1761 (from Claude Perrault's French version). Significantly, the translation featured a changed frontispiece. Instead of the Louvre façade of the French edition, the monastic imperial residence of El Escorial was chosen and so given a Vitruvian legitimacy. This act initiated a thorough reappraisal of Juan de Herreras' architecture. Herreras' severe style was in complete harmony with the new interest in Classical models, and his early Romantic ideas allowed him to be effortlessly categorized as a "national architect." José de Hermosilla went a step further in this respect by studying and publishing work not just on El Escorial, but also on Charles V's palace in the Alhambra (including the Moorish complex).

Two components characterized Spanish architecture in the 18th and 19th centuries: Neoclassicism on the French and Italian models, as well as the influence of the monastic residence of El Escorial as an ideal image of a bygone era of Spanish global power. The political intention of all this was unmistakable: the French Bourbons who had ascended to the Spanish throne in 1700 were, on the one hand, determined to distance themselves from the prevailing late Baroque era by adopting a modern, international architectural style. On the other hand, they sought to stress their connection to the culture of the "Siglo del Oro" (Golden Age) to underscore the legitimacy of their claims to the Habsburg legacy.

Ventura Rodríguez and Juan de Villanueva

Two architects made a critical contribution to the spread of Neoclassicism in Spain: Ventura Rodríguez (1717–85) and Juan de Villanueva (1739–1811), brother of Diego. Ventura Rodríguez's work heralded the transition from a late Baroque architecture to the Neoclassical style at the end of the 18th century. Amongst the teachers from whom Rodríguez received his education were two Italians active in Spain: Filippo Juvarra and Giovanni Battista Sacchetti. Until the death of Ferdinand VI, Rodríguez enjoyed a considerable reputation as court architect and afterwards held the post of professor at the Academy – though his was a controversial appointment. Of the many designs he produced for the court, the academy or private clients, only around 50 were ever carried out, and only a few of these are discussed here.

While his early works were clearly patterned after the Italian Baroque of the era from Bernini to Guarino Guarini, towards the

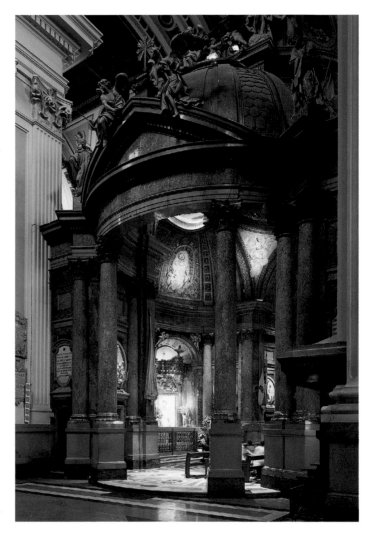

end of the 1750s the influence of François Blondel's "Architecture française" can be detected in his work, and this development was to lead him to academic Neoclassicism. His first great work, the parish church of S. Marcos in Madrid (1749–53), was designed wholly in the spirit of the Baroque, but at the same time he was already selecting Neoclassical forms for the redesign of the pilgrims' cathedral of El Pilar in Zaragoza (built from 1753). In the interior he concealed the Baroque structure begun by Francisco Herrera with a decorative scheme of Corinthian pilasters, which lent the space greater tranquility. The sacred pillar ("el pilar"), on which the Virgin had appeared to the apostle James, was a more difficult proposition. It was to remain

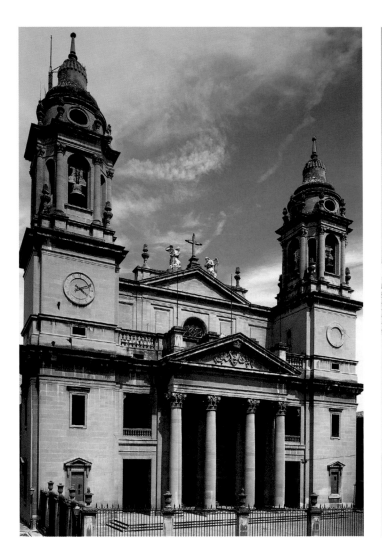

unaltered, yet still had to be visible to the many pilgrims who flocked to the church (ill. p. 125).

Rodríguez altered the space immediately surrounding the pillar in the west of the nave, designing an elliptical space with four conches covered by a dome. Three of these sides were open and featured Corinthian columns, while the fourth – or western – side was closed off and served as the altar wall. Rather than being located in the center, the pillar of the miracle is displaced from the main axis and located in the right exedra.

Contrasting with this ultimately Baroque spatial concept, his design for the church of the Convent of Augustinian Missionaries of the Philippines in Valladolid (1760) is lucid and functionally

designed in Neoclassical style, and shows a relationship to th unornamented architecture of Herrera. The influences of S Peter's in Rome are obvious in the design for S. Francisco Grande in Madrid (Biblioteca Nacional). The building wa however, executed from a design by Francisco de la Cabeza an featured a drumless dome 33 m in diameter (ill. p. 126, top right Under Joseph Bonaparte it was used as the assembly of th Cortes, and became the Panteón Nacional in 1837. This buildin is the last resting place for some of Spain's most famous figure including Ventura Rodríguez himself.

The façade of Pamplona Cathedral (1783, ill. p. 126, top lef had a more long-lasting effect than Rodríguez's failed design fo

BOTTOM:
Juan de Villanueva
Casita del Príncipe, El Pardo, 1784
Central projection of façade

Juan de Villanueva
Museo del Prado, Madrid, 1785–1819
North façade

S. Francisco; the monumentality and pathos of the Pamplona project foreshadow the Romantic style of the 19th century. A Corinthian portico is positioned between two tall bell towers; its rows of double columns form a magnificent entrance way into a church whose origins date back to 1026. Vivid clarity and archaeological authenticity characterize this late work by Ventura Rodríguez.

The key figure in the diffusion of Neoclassical architecture in Spain, however, was Juan de Villanueva. As court architect to Charles III and Charles IV he was responsible for extending the *Sitios Reales* (royal properties) of El Escorial, El Pardo and Buen Retiro, as well as for building the Museo del Prado and the observatory, which were royal grants. As *arquitecto mayor de Madrid* he planned numerous public buildings for the Spanish capital. Villanueva spent several years in Rome, an experience which, together with his influence on the curriculum of the Academia de San Fernando, made him one of the most important mediators of Enlightenment artistic theory in Spain. Villanueva's first large commission was for the erection of two *casitas* in San Lorenzo de El Escorial. These country houses were integrated into the garden of the estate and intended for the heir to the throne, D. Carlos, and his brother, D. Gabriel. These buildings enjoyed great popularity; because of their intimate character they allowed for a less inhibited treatment of new stylistic forms. The Casita del Príncipe (1771) displayed unique compositional principles alien to the Baroque, such as the creation of a line of relatively independent elements and the almost painterly technique of juxtaposing contrasting volumes. A short time later (1784) this additive approach was taken a step further in the Casita del Príncipe in El Pardo (ill. p. 127, bottom): five virtually independent structures are enclosed within the parenthesis of the entablature's theme.

This solution clearly anticipates Villanueva's Museo de las Ciencias, which later became the Museo del Prado.

Villanueva's appointment to the position of *arquitecto y maestro mayor de Madrid* marked the beginning of a 25-year career as the Spanish capital's architect, during which time the city was thoroughly remodeled. Villanueva first built the Gallery of Columns for the Casas de Ayuntamiento and reconstructed the Plaza Mayor, which had been destroyed by fire. Of major importance from the point of view of architectural history was the construction of what is today the Museo del Prado and the observatory. Both were royal grants in the spirit of the Enlightenment, and both became major works of Spanish Neoclassicism.

The Prado was not originally planned as a picture gallery. After designs by Ventura Rodríguez had been rejected, Villanueva produced several plans for a natural history museum and the Academy of Sciences, which were to be integrated into a park-like area near the Buen Retiro. One of the first sketches provided for a central rotunda joined to two exedra by porticos and *paseos*. Parallel to this, and on a second axis, was a spacious auditorium, which communicated with the rotunda by means of a narthex and whose long extended spaces led to two projecting wings at the corners of the building. The building was eventually completed in 1819, after suffering damage caused by occupying French troops. The final version retained the original layout, although it had only one axis instead of two. The *paseos* were rearranged into galleries of Ionic columns, which masked the upper floor, while the ground floor was articulated by arcades and rectangular niches. The corner pavilions were enlarged and their interiors given a grander appearance with rotundas (ill. p. 127, top). The projecting Doric portico forms the entrance to an enclosed semi-circular room, which is the center of the complex.

OPPOSITE:
Juan de Villanueva
Museo del Prado, Madrid, 1785–1819
View into the gallery

RIGHT:
Juan de Villanueva
Observatory, Madrid, 1790–1808

BOTTOM RIGHT:
Juan de Villanueva
Museo del Prado, Madrid, 1785–1819
View into the room of the *Meninas*

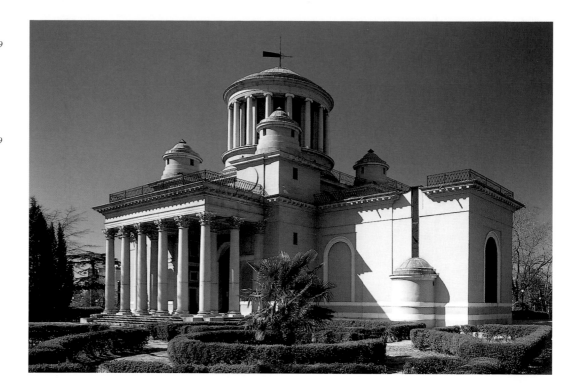

The exhibition spaces are in the Roman style, with coffered half-barrel vaults and domes (ills. pp. 128 and 129, bottom). Although indebted to the Museo Pio Clementino in the Vatican and various projects of the Academy, the Prado became a model for public museums of later epochs.

The nearby Observatorio Astronómico (ill. p. 129, top) was Villanueva's last great work. Built on a cross-shaped ground plan, the observatory – in spite of numerous alterations – is evidence of the absorption of Neo-Hellenistic forms into Spanish architecture. Begun in 1790 and largely completed in 1808, the building's elevation is defined by functionality and geometric severity. The contrast of the Corinthian portico with that of the round temple, which defines the central hall, is an expression of the search for opposites and can be seen as a staging of picturesque qualities – aspects of the design which anticipate the Romantic movements of the 19th century. Nevertheless, the building is highly functional: the *tholos* was able to accommodate the astronomical observatory with all its instruments.

Extensions to the residences

The extension and modernization of the palaces founded by the Habsburgs in the area around Madrid were among the great projects of the Bourbon kings. These affected the *reales sitios* of El Escorial, Aranjuez, El Pardo and Riofrio – the planning and execution of which, with the exception of El Escorial, had become bogged down in the 16th century – as well as the continuation of work on La Granja de San Ildefonso near Segovia, which had been begun by Philipp V. Thanks to the strict organization of architectural offices, in the late 18th century many of these prestigious projects could be designed and completed according to the wishes of their new clients.

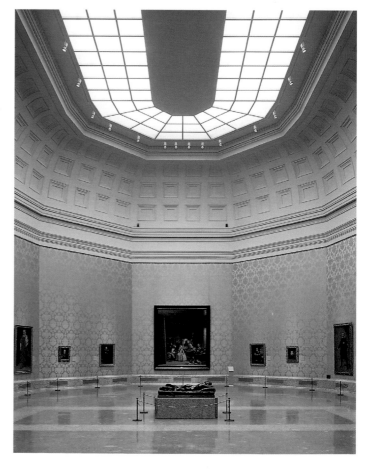

Santiago Bonavia
Court church of San Antonio, Aranjuez
1768

OPPOSITE:
Juan de Villanueva
Round temple in the palace garden,
Aranjuez, 1784

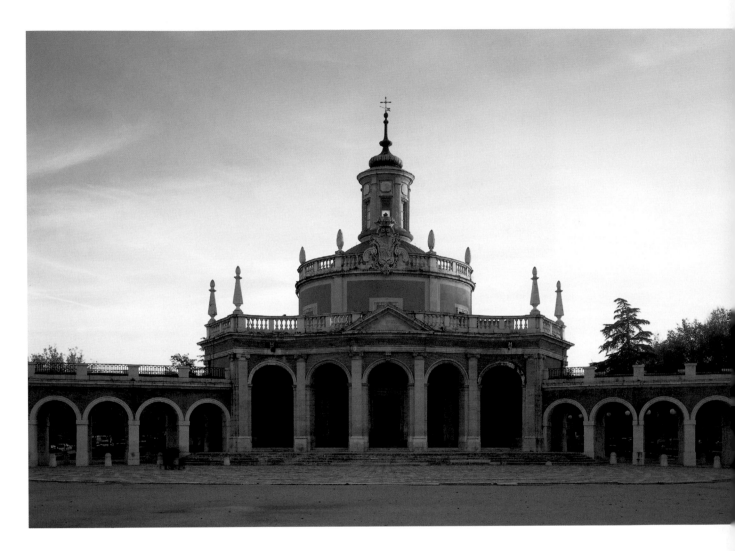

We have already indicated the extreme importance of the *casitas* in the formation of a Neoclassical style in Spain. Aranjuez, the former summer residence of Philipp II, is another monument that exhibits almost all facets of Spanish Neoclassical architecture. The palace and its park, which were situated in an area of abundant lakes and forests on the banks of the Tajo, occupied a special place in the affections of the Bourbons.

They expanded the extensive gardens and palace complex on numerous occasions, adapting them to the needs of the court. Work began in 1731 under the direction of Santiago Bonavia, but entered a critical phase after 1744 with plans for a town of 20,000 – all employees of the court. Its geometric network of streets was bisected by a new long-distance route connecting

Madrid with Andalucia, for which a bridge had to be bui across the river Jarama. The palace itself, a design by Jua Bautista de Toledos and Juan de Herreras, was only partly rea ized by Juan Gómez de Mora and was badly damaged by a fir in 1748. Its reconstruction under Ferdinand VI was largely afte Herrara's ideas, which provided for a building of two floors an four wings with an accentuated façade on the western side an corner towers. Side wings were added to the central core of th palace in 1771 by Francisco Sabatini, and these lent the buildin an appearance appropriate to its representative state function The church of S. Antonio, completed in 1768 from plans b Bonavia, also belongs to the palace complex. Curved arcade situated in front of the domed building lead to the cou

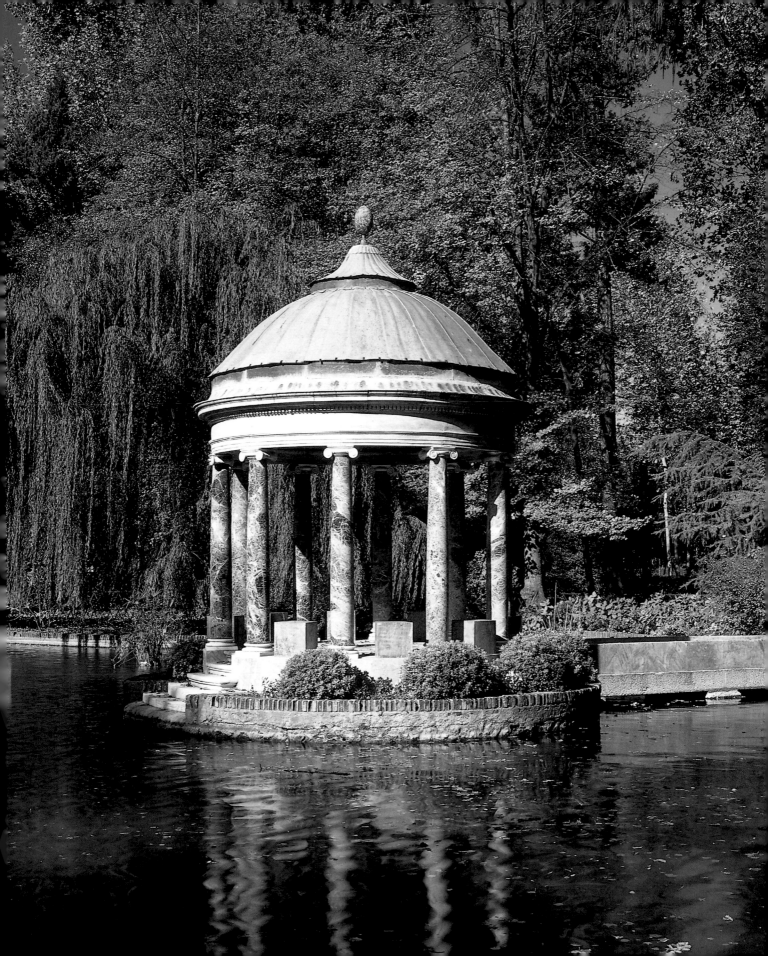

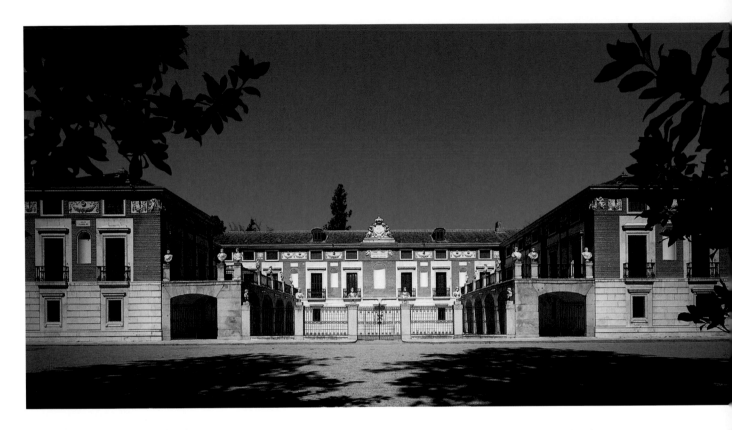

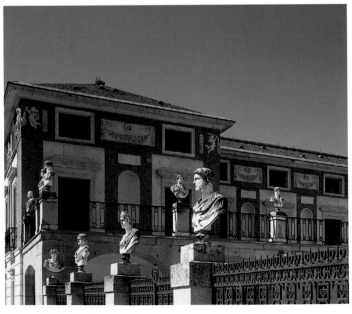

complex (ill. p. 130). Its interior displays an interesting arrange
ment of space: at the front is a rotunda in which the lay brother
would gather for their devotions, while the rectangular sectio
at the back was reserved for the monks of the Order of Nuestr
Señora de la Esperanza. A common altar both connected an
separated these two zones.

Villanueva contributed two exceptionally charming pavilion
to the park. One has the form of a classical round temple (i
p 131), and the other is in the shape of a Chinese pagoda.

In the eastern part of the park Charles IV had a pleasur
palace built at a place where, in 1792, he had come across
modest farmhouse while out hunting. This building, the Casa d
Labrador, is among the most beautiful works of Neoclassicism i
Spain (ills. pp. 132 and 133). In the hands of Isidro Gonzále
Velázquez, who transformed designs prepared by Juan d
Villanueva, the resulting structure was anything but a simple hu
becoming instead a Roman villa built to the most exacting stand
ards. The main transverse section is formed from a plinth, mai
floor and attic, and is adjoined by similarly designed wing
which enclose a small courtyard. The contrast of light-colore
stonework and red brick animates the façades, but the real char

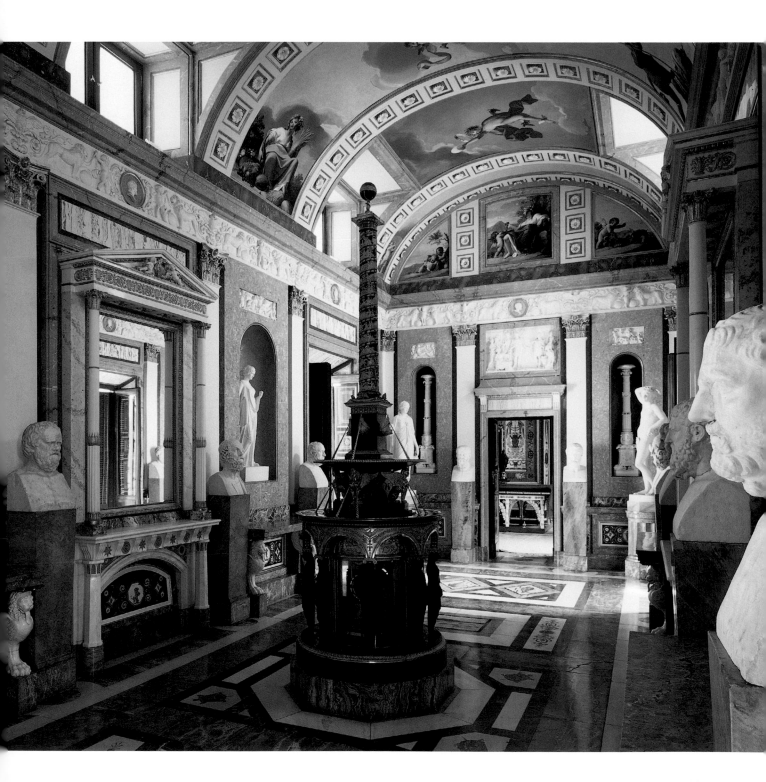

Isidro González Velázquez
Casa del Labrador, Aranjuez, 1803
View into the statue gallery

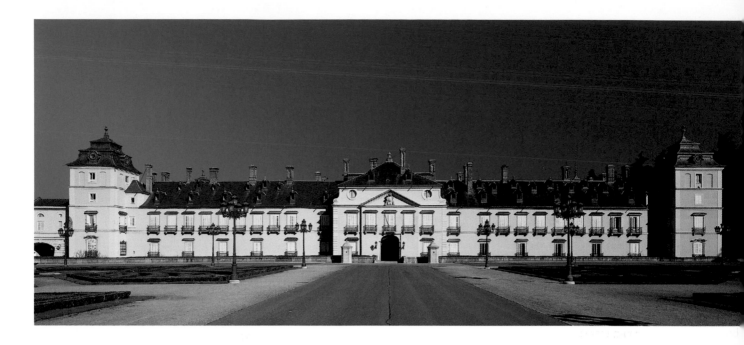

of the building is provided by its mock antique décor and antiquarian furnishings. Niches for sculptures are built into the façades, while busts of Roman emperors decorate the balustrade and fences. The interior, with its festival hall, statue gallery, billiard room and various other galleries is luxuriantly ornamented with antique collector's pieces. Mythological frescoes and carpets, as well as furniture and clocks – the latter a passion of the Bourbons – decorate the rooms. The enthusiasm for learning, common to the age, and the joy taken in precise archaeological reconstruction, are all evident in this "farmhouse".

The Bourbons took an equally great interest in the former Hieronymite monastery of La Granja de San Ildefonso near Segovia, which Philipp V and Isabella Farnese had built as a kind of Spanish Versailles. Here too Charles III built a court complex with various ancillary buildings and workshops, including the famous Real Fábrica de Cristales. In the course of these extensions the eastern façade of the palace church was also redesigned to reflect its state function (ill. p. 134, bottom left). The two towers of the choir with their colossal pilasters and strongly defined attic floor are probably attributable to the previously mentioned architect, Francesco (Francisco) Sabatini. Sabatini, who had worked with Luigi Vanvitelli in Caserta, thereby coming into contact with the future Spanish king, occupied an influential position at the Bourbon court. His occasionally quite traditional designs were often preferred to the more modern schemes of Ventura Rodríguez or Juan de Villanueva.

In El Pardo, Francesco Sabatini created a building in 1772 (ill. p. 134, top) which was perfectly in tune with its times. He doubled the ground plan of the 16th and 17th-century palace, which was still crowned with defensive towers, laid out a central axis, and undertook cosmetic changes to the façades. The other palaces altered by the Bourbons in the 18th century did not bring any artistic innovations. Riofrío, which was built as early as 1752 from plans by Virgilio Ravaglio, is a smaller version of the Madrid palace.

Urban planning

It was no coincidence that town planning gave such a boost to Spanish Neoclassicism. The need for order and functionalism, and especially for egalitarian structures, was a fundamental tenet of the Enlightenment. It was, above all, the court that propagated these reformist ideas, establishing them as the basis for the modernization of the royal residences. A characteristic example is provided by the city of Barcelona: the Barri de la Ribera, a fishermen's quarter which was forced to make way for a fortress under Philipp V's troops, was rebuilt in 1753 as La Barceloneta on alluvial land. Constructed according to the plans of the military engineer Prosper Verboom, its design was based on the most modern concepts: broad streets intersected at right angles, and low-rise buildings guaranteed residents light, air and comfort. Reformist plans for existing cities were generally based on grid structures with a central square, the Plaza Mayor. Paving and street lighting and the layout of parks and open spaces were intended to promote the safety and health of citizens, and the unified style of the façades was to eliminate the differences between social classes. Hardly any of these utopian projects were ever finished; generally work was limited to a redesign of the Plaza Mayor.

A far-reaching reform of Madrid had already been initiated in the 1760s under Charles III, and the work undertaken then is still evident there today. Among the most fundamental reforms was the integration of the previously isolated Palacio Real into the fabric of the city and especially the grand design and construction of the boulevards to open up the urban space. The Calle de Alcalá, for example, was given an imposing architectural element (ill. p. 135, top) with the triumphal arch of the Puerta de Alcalá (Francesco Sabatini, 1764–68), a work that still exhibited the Baroque style. The Plaza de Sol, too, was given a greater importance in the network of inner city streets. Shortly after, in 1775, Sabatini erected another triumphal arch – the Puerta de San Vicente – on the Paseo de la Florida. The severe Doric forms of this monument are a clear outward sign that stylistic perceptions had begun to change.

In 1782 the Paseo del Prado was enlarged by José de Hermosilla, becoming a tree-lined boulevard with fountains. The Buen Retiro, which had been the setting for courtly pleasures under Philipp IV, was now transformed into a "science park" of the most modern kind. Charles III provided for an observatory (ill. p. 129, top), a museum of natural history and a botanic garden.

Charles IV continued the Enlightenment building programs of his predecessor, but was unable to complete most of them due to the upheavals of the late 18th and early 19th centuries. The occupation of Spain by French troops in 1808, the popular uprising of May 2, the liberation struggle, and the short period of Liberalism between 1812 and 1814 were understandably not the glorious age of architecture. Joseph Bonaparte, who had declared Madrid the seat of government for the French regime, introduced his

reforms by demolishing numerous churches and planning several new squares. He made no further progress, however, and after the return of the Bourbon king Ferdinand VII in 1814 the most important task was the clearing of these ruins. Amongst them was the Plaza de Oriente – recently given a more prominent position in the urban fabric – with the Teatro Real by Antonio López Aguado, a pupil of Villanueva's (ill. p. 135, bottom). In 1843 the equestrian statue of Philipp IV from the Buen Retiro was transferred here. Similarly, the hexagonal opera house – designed in

135

1818 but not built until 1850 by Isidro González Velázquez – has recently been restored to its original appearance.

In 1819 Ferdinand VII was finally able to dedicate the Prado, not – as originally intended – as a museum of natural history, but as a picture gallery. López Aguado redesigned the interior to make it suitable for its new function (ills. pp. 127–129). Aguado also received the commission for the state monument that marks the end of this part of our survey, the Puerta de Toledo (ill. p. 136, left). The king ordered this city gate to be built in 1816/17 as a visible sign of the restoration of Bourbon rule. This severely-designed triumphal arch was the last to be built in Madrid. The representation of a victorious Spain in its sculptural program could not, however, conceal the fact that the Spanish monarchy had reached an historical low point. Constitutional struggles and the Carlist wars were to define the coming decades, and a new upturn was not to set in until the process of industrialization and its associated social changes began in the second half of the century.

BELOW:
Ignacio Haan
University, Toledo,
Inner courtyard, 1790

BOTTOM:
Vicente Acero, Torcuato Cayon
Cádiz Cathedral
1722, 1762 to mid-19th century

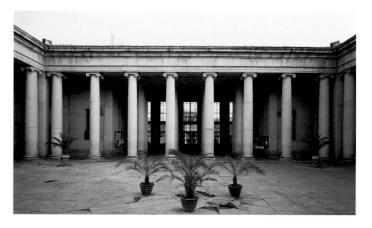

Neoclassical architecture outside the court

The architecture of the court has occupied most of this discussion on Spanish Neoclassical architecture. Almost all important commissions, including most urban planning, were intimately connected with the Bourbon monarchy. Sacral buildings have received little attention so far; where mentioned it has usually been in the context of urban development or in connection with innovative structural or stylistic forms. Although our overall impression of the epoch will not be radically revised by an examination of non-court architecture, several outstanding buildings by other – generally clerical – clients are worthy of mention.

Toledo owes many of its functional buildings – a new sword factory, a mental asylum, and the university – to the far-sightedness of Cardinal Francisco Antonio de Lorenzana. The university (ill. p. 137, top) was built by Ignacio Haan, a pupil of Sabatini and a scholarship holder in Rome, who created two buildings that represent the pinnacle of their age. The university, with its dignified, Ionic patio from 1790 and Corinthian assembly hall, the paraninfo, merge unobtrusively into the modest architectural scale of Toledo in spite of their monumentality and marked differences in height.

In the Basque country, Silvestre Pérez, a gifted pupil of Juan de Villanueva later much in demand at court, created an architectural style with his churches in Motrico (1798), Mugardos (1804), and Berneo (1807) which approached the so-called revolutionary architecture of Claude-Nicolas Ledoux and Étienne-Louis Boullée. In Galicia, the church of La Peregrina (António Souto, 1778–82) is a most original work suspended between the Baroque and Neoclassicism (ill. p. 136, right). The slim rotunda is fronted by a similarly rounded narthex, whose Neoclassical structure is transformed by a massive relief and abstract décor on the façade.

Finally, the Andalucian city of Cádiz merits discussion. In the second half of the 18th century this maritime city had developed into one of the centers of the Neoclassical movement. In 1812 the town rose to prominence when the Cortes met there to deliberate on the first Spanish constitution. Cádiz also produced important architects in Torcuato Cayon de la Vega and his successor Torcuato Benjumeda, who provided the city with a contemporary, cosmopolitan appearance. The observatory in San Fernando (1793), the royal jail (1794), and the town hall (begun in 1816) are evidence of this flourishing period. The cathedral, however, remained a chimera. Built over a period of more than a hundred years, it tells the story of its construction (ill. p. 137, bottom). Founded in 1722 and begun on Churriguresque lines by Vicente Acero, its design was "unraveled" – i.e. Neoclassically replanned – for the first time in 1762. Even the experts from the Academia de San Fernando were unsuccessful in their calls for "the most dreadful heap of stones in the world" to be pulled down, and building work – annually consuming a quarter of all the gold entering Spain from her American colonies – continued until 1838.

Neoclassical architecture in Portugal

The Enlightenment, and with it Neoclassicism, gained a foothold in Portugal unusually quickly and effectively. In its formation of a modern state and attempts to create a more just and egalitarian social order, Portugal was ahead of other European nations. The catalyst for these astonishing developments was a natural disaster: the appalling earthquake that took place on All Souls' Day, 1755. In just a few minutes the capital of a global empire was laid to waste – a metropolis of 250,000 inhabitants which, not long before, had prided itself on being the richest city in Europe. Whatever survived the earthquake was quickly consumed by fires started by candles which had been burning all over the city in honor of the religious festival, or fell victim to flooding caused by the tidal waves which swept up the river Tejo.

On November 1, 1755 it was not just the proud city of Lisbon that was destroyed, but also an essential part of the "Old World." In the general atmosphere of upheaval that gripped Europe in the middle of the century, the earthquake in Lisbon was seen as a portent of a profound crisis; philosophers like Voltaire, Rousseau, Kant – and later Humboldt and Goethe – made this catastrophe the subject of their writings. At the beginning of the century, immediately after the discovery of gold and diamond mines in Brazil, the empire of João V had been blessed with inconceivable wealth. The King, however, largely squandered the country's riches in pursuing utopian building projects or in satisfying his own whims. When he died in 1750, the state coffers were empty and Portugal had been bled dry. Joseph I and his minister Sebastião José de Carvalho e Melo (1699–1782), who later became the Marquês de Pombal, were confronted with a depressing predicament. In the context of this situation, the earthquake in Lisbon must have seemed like an act of God.

Pombal, a pragmatic man who recognized the mood of the times, quickly took control of the situation after the catastrophe. His primary concern was to establish a new layout for the inner city, the Cidade Baixa (Lower City), which had previously been dominated by the royal palace on the banks of the Tejo, and which was surrounded by narrow, winding streets. Together with the architects Manuel da Maia and Eugénio dos Santos, he had the 212,000-sq-m area between the river and the chain of hills beyond built as a modern planned city (ill. p. 138, bottom): broad north–south axes were regularly intersected at right angles by smaller crossroads, and two great squares, the Praça do Comércio in the south and the Rossio in the north, defined the limits of the Baixa. Further grids adjoined this area to the west, while in the east the Castelo de S. Jorge – a site of importance to the former Roman and Arab occupiers of Portugal – remained unchanged. The Praça do Comércio (ill. p. 139, top) may well be considered the most spectacular of these new innovations. It forms a generous open urban space, where until 1755 the royal palace had stood – an alternative

name for it, Terreiro do Paço (King's Square), is still in common usage. This square reoriented Lisbon completely. Here, where the city faces the sea – is its new heart, the trading center. The state buildings of stock exchange, customs hall, and arsenal line the edge of the square, while only echoes of the palace architecture remain in the "torreões," the imitations of Herrera's palace towers.

Pombal's service to the city and the achievements of his colleagues do not end with the creation of a new city plan acknowledging the importance of commerce to Lisbon. At least as innovative were the measures he took in order to rebuild the city quickly according to his own vision. During 1758 and 1759, almost all the relevant legislation affecting the building of the new Baixa was passed. At the same time, Manual de Maia, Eugénio dos Santos and the Hungarian architect Carlos Mardel worked out plans for the layout of houses, for their use, the arrangement of their space, their heights and the design of their façades.

The characteristic mansard roofs and use of roofing tiles in many city blocks are also attributable to Mardel. The industrial

BELOW:
Carlos Mardel
Mãe d'Água (water reservoir)
Lisbon
Mid-18th century

BOTTOM:
Mateus Vicente and Reinaldo Manuel
Basílica da Estrela, Lisbon, 1779–92

most lavish, but they too are more impressive for their size than for their artistic sophistication. As a rule, the many prosperous foreign merchants who came to Portugal under Pombal settled in Benfica and Sintra. In this idyllic coastal landscape they built picturesque country houses that anticipate Romanticism. The only projects to which Pombal conceded a certain amount of ornamentation were the churches. But here too he aspired to a unified look. In fact, sacral buildings are all a variation on one theme, that of the 150-year-old Igrejade de S. Vicente de Fora. Two towers frame a tripartite structure of two floors crowned by a triangular pediment. Occasionally, as in S. António de Sé, rounded and broken pediments linger on from the age of João V.

The greatest church built during the Pombal era, the Basílica da Estrela appears to be something of a paradox. Built in an exceptionally prominent position in the city between 1779 and 1792 by Mateus Vicente and Reinaldo Manuel, it is clearly a riposte to the severity of the dominant architectural style. It should, however, be remembered that the design of this massive domed building was subject to other laws than those that applied

production of building elements was introduced in order to translate rapidly the planning process – in which considerations of hygiene as well as the provision of light and air played important roles – into reality. This development went hand in hand with a change in the role of the architect: no longer a "genius" figure who was able to anticipate the wishes of a princely patron, he became a pragmatist and an engineer responsible for the rational design, professional construction and, ultimately, the "serial production" of a highly functional architecture.

Impressive evidence of the quality of Portuguese engineering can be seen in the Mãe-d'Agua, the "mother of waters," a reservoir at the end of the Aqueduto dos Águas Livres. The network had already been laid out under João V and provided all of Lisbon with fresh drinking water. Although the reservoir was not built until several decades later, Carlos Mardel's design shows the importance attached to such projects. The Mãe-d'Água is a small block-shaped palace in Neoclassical form, decorated by a double staircase and dual corner pilasters. Its interior is composed of a great vaulted hall of pillars.

Pombal and his architects faced a difficult task in deciding what to do with the palaces of the nobility. Here, too, he devised a solution that was astonishingly radical for its day: the damaged structures – frequently abandoned by their owners – were converted into apartment buildings, subdivided, and clad in severe "Pombalesque" façades. Large sections of the aristocracy obviously bowed to the dictates of this style as many of the newly erected or renovated palaces exhibit only a restrained décor in their façades. The urban houses of the new class of capitalists are the

BOTTOM:
Mateus Vicente and Reinaldo Manuel
Basilica da Estrela, Lisbon, 1779–92
Interior

BELOW:
José da Costa e Silva
Teatro S. Carlos, Lisbon
Façade, 1793

to Pombal's churches. A votive church endowed by Maria I on the occasion of the birth of an heir to the throne, it expresses all the pomp of the era of João V. It is, moreover, a smaller version of the gigantic monastic residence at Mafra, which was never completed. In spite of these contradictions its majestic interior with its superb marble finishing makes it one of the great achievements of Portuguese art.

At around this time the Teatro de S. Carlos was built a structure which could hardly represent a greater contrast to the Basilíca da Estrela. Lisbon's new opera house in the Chiado was erected in just six months in 1793 due to generous donations from the city's merchants. The coherently Neoclassical structure replaced the famous opera house of Giovanni Carlo Bibbienas on the banks of the Tejo, which had been destroyed in the earthquake of 1755, after opening just seven months previously. The new architect, José da Costa e Silva, had received his education in Bologna, and he, too, looked to Italian models. For the exterior he chose the austere but dignified forms of the Scala in Milan – a rusticated ground floor with dramatically projecting portico –

while the interior recalls the opera house in Naples, which also bore the name of San Carlos.

The Teatro de S. Carlos signaled the arrival of Neoclassicism as the legitimate architectural style for buildings representing the interests of the middle classes. Court architecture, on the other hand, found it difficult to shake off entirely the influence of the Baroque. An example was provided by the laying of the foundation stone in 1802 for the new Palácio da Ajuda, which had been destroyed by fire (ill. p. 143, top). Initially a "Baroque" design by Manuel Caetano de Sousa was under consideration before a Neoclassical solution was eventually decided upon. The residence was begun from plans by Francesco S. Fabri and José da Costa e Silva and it recalls the work of Caserta. Napoleon's invasion, however, prevented work from progressing, and it was finished only in 1835.

At this point Neoclassical palace architecture in Lisbon once again almost exhausted itself. The redesign of the Palácio das Necessidades, a late Baroque monastic residence, into an imposing palace was undertaken under Possidónio da Silva from 1844-46. This building, which today houses the Portuguese Foreign Ministry, is a monumental structure displaying a cool elegance.

Lisbon was, without doubt, the architectural center of the Enlightenment in Portugal, but other parts of the country – as well as the overseas colonies – aspired to replace the predominant late Baroque style with a more rational formal language. The pragmatism of the "Pombalesque" style, therefore, had a number of successors in Portugal as well as in Brazil and parts of India. The city of Vila Real do Santo António in the Algarve, and the urban renewal projects in Porto are especially interesting in

this regard. In the north-east of Brazil and even in distant Goa (in India) Pombal's urban planning approach was obligatory for new settlements and modernizing projects.

In Porto, Pombal's concepts combined with the Neo-Palladian ideas of the city's English colony, which had dominated the port wine trade since the Methuen Treaties of 1703. Evidence of this so-called "port wine architecture" can be found in the enormous Hospital de S. Antonio with its Neoclassical portico (ill. p. 142, top left). It is the work of the English architect John Carr, who delivered the plans in 1769, without ever having set foot in Portugal. In this Baroque maritime city, it must, at first, have appeared as if it had been set down in the wrong place, but a short while later it was followed by various other Palladian buildings – the Praça da Ribeira and the Feitoria Inglesa, which was the meeting place of English merchants. The neighboring Carmelite churches – the Igresas do Carmo – are also defined in terms of opposites. The right-hand church was built from a commission by the Tertians from 1756-68, and its interior exhibits an impressively Neoclassical layout (ills. p. 142, bottom). The austere

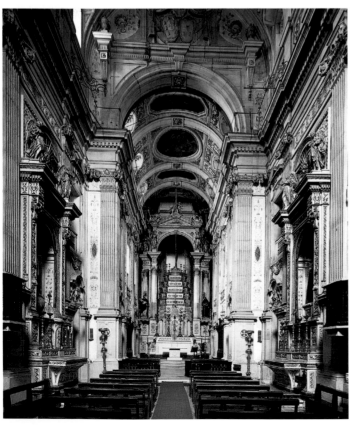

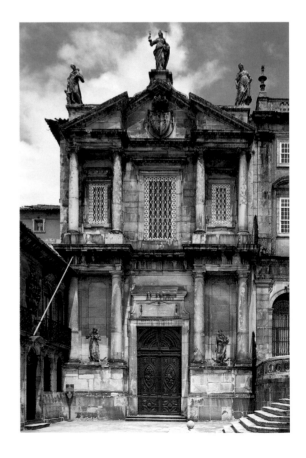

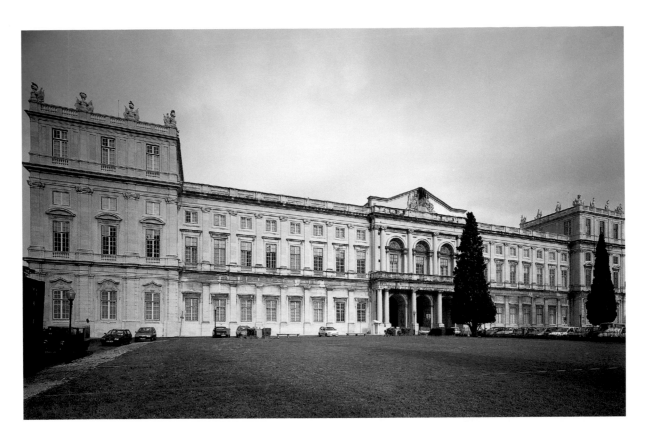

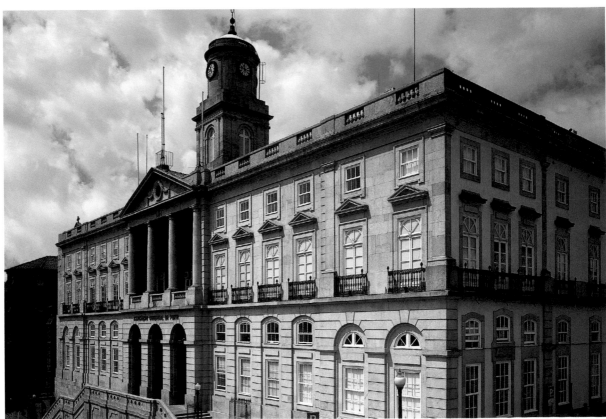

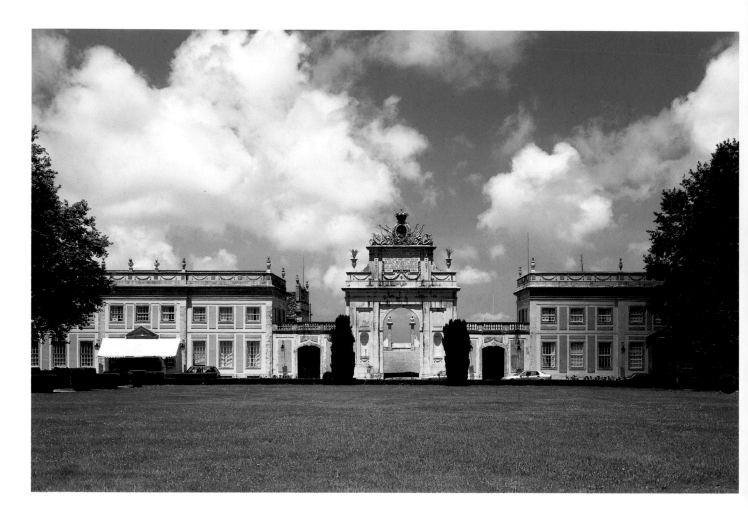

Palácio da Bolsa with its tripartite portal, loggia, and triangular pediment was built by Joaquim da Costa e Lima in 1842 (ill. p. 143, bottom). Its interior tends towards the Romantic and eclectic architecture of the second half of the century.

In any overview of Portuguese architecture it is important to mention the idyllic town of Sintra – despite the fact that most of its monuments either date back to the 15th and 16th centuries, or can be seen as part of the historicising movements of the second half of the 20th century. Nevertheless the rediscovery of this "glorious Eden," as Lord Byron described it, certainly belongs to the Neoclassical period. The densely forested Atlantic coastline had enchanted both the Romans and the Moors, and ultimately the Portuguese kings fell under its spell too, proceeding to build their summer residences here. In the 19th century the area became a destination for English and German travelers looking for the spirit of Romanticism, and they discovered in Sintra living traces of Portugal's diverse culture. Neoclassicism had only a minor influence in Sintra, though during the Pombal era the region saw a concentration of wealthy merchants who were seeking to escape the rigid building regulations of Lisbon by building their villas "in the country." The largest of these is the Palácio dos Séteais (ill. p. 144), begun in 1787. The owner of this palace, which features clearly demarcated buildings and a central triumphal arch, was a Dutch diamond merchant, who was also consul.

The most important 19th-century building in Sintra is, however, the Palácio da Pena, built for Ferdinand of Saxony-Coburg by the Hessian architect and naturalist Baron Wilhelm von Eschwege in 1839. It represents an early, if not *the* earliest attempt, to combine the styles of various eras and nations in a single picturesque whole. This bizarre castle represented the fulfillment of a life's dream for

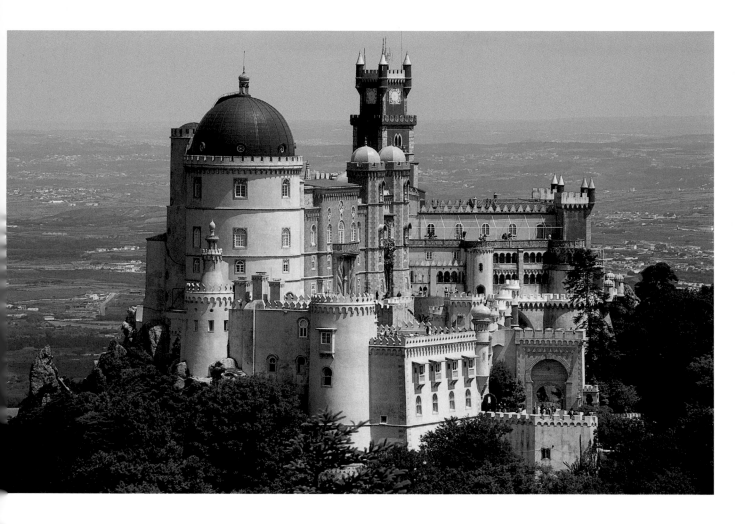

Dom Fernando II as Ferdinand was known in Portugal and his second wife Edla, an opera singer. Unfortunately, the imaginative work was not completed until 1885.

Entry to the fairytale palace, situated high on the Monte da Lua (ill. p. 145), is gained through a Moorish portal. Its "medieval" towers and façades are in dazzling canary yellow, strawberry red and aquatic blue. In spite of the intense colors the visitor is reminded of both German castles and the Manueline royal residences of Portugal. The interiors are more diverse still, as are the furnishings that were designed to harmonize with them. The most magnificent example is without doubt the "Arabian Room" with its *trompe l'oeil* paintings on the walls and ceilings (ill. p. 147). The pleasure taken in "oriental" décor is shown in the Salão Nobre and in the bed chamber, while other rooms have Renaissance or Baroque themes. Costly porcelain

from Saxony can be seen virtually everywhere. The cloister and chapel of an Hieronymite monastery from the 16th century occupies part of the complex. Ferdinand integrated them into the palace, so preventing further deterioration. The triton arch, watched over by a sea god, serves as a reminder of a glorious era in Portugal's history. Regardless of what they think of this "Portuguese Neuschwanstein", visitors to the castle are always impressed with the unique view from its terraces and towers 520 m above sea level. The park with its exotic trees, springs and neat pavilions is one of the most impressive of such complexes in Europe. Richard Strauss summed up his impression of the Palácio da Pena in the following words: "This is the happiest day in my life. I have been to Italy, Sicily, Greece and Egypt. But never have I seen anything more fascinating. This is the most beautiful place I have ever laid eyes on."

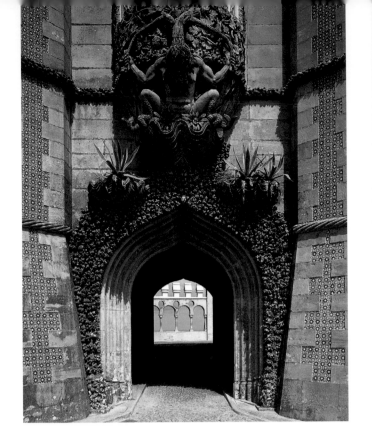

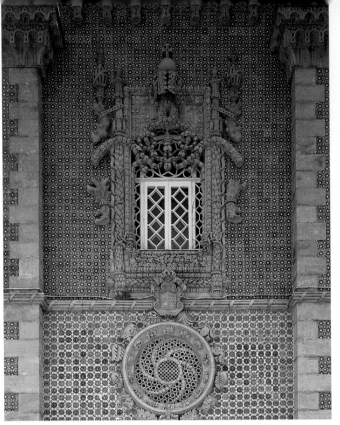

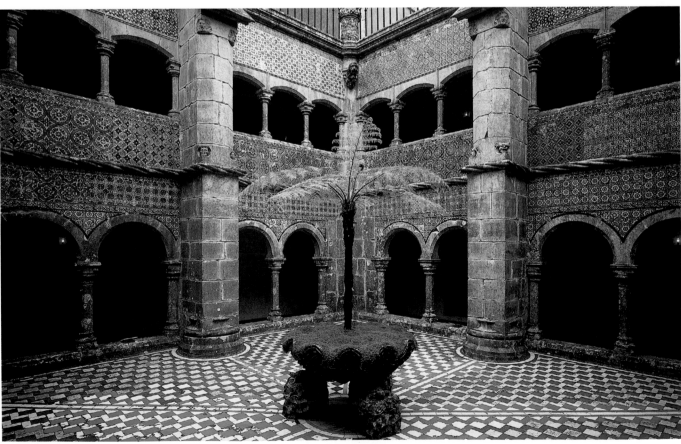

OPPOSITE:
Baron Wilhelm von Eschwege
Palácio da Pena, Sintra, 1839–85

Triton arch (top left)
Manueline window (top right)
Manueline cloister built by João Potassi
1503–11 (bottom)

BELOW:
Baron Wilhelm von Eschwege
Palácio da Pena, Sintra, 1839–85
Arabian Room

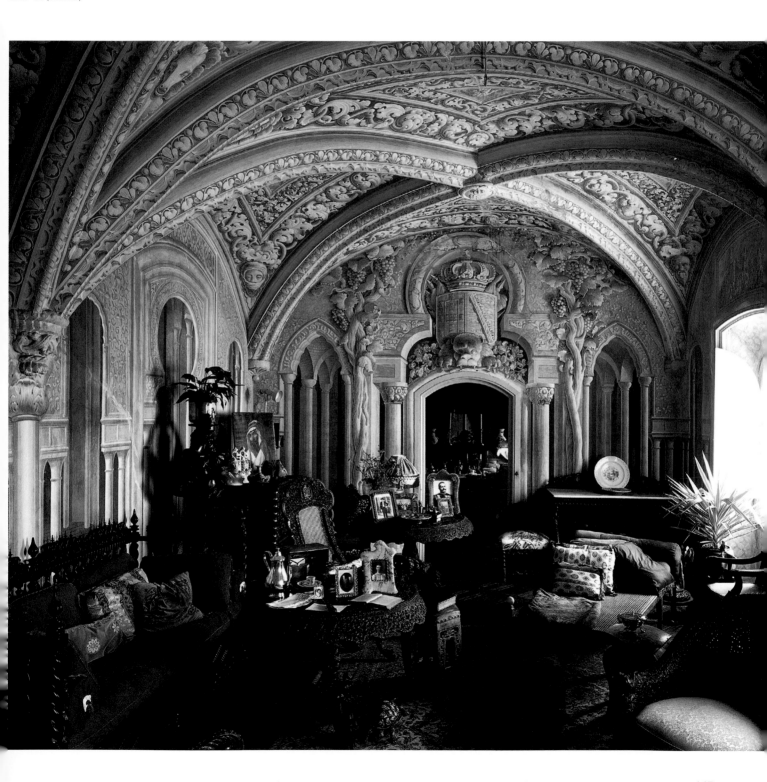

147

Ehrenfried Kluckert
Historicist and Romantic Architecture in Holland and Belgium

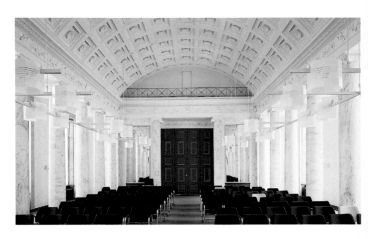

The architectural histories of the southern and northern Low Countries did not diverge until the 17th century. While French architecture dominated Belgium – formerly the southern Netherlands – a national style was able to develop in Holland, the northern Netherlands, which slowly crystallized out of the bright, distinct forms of the Renaissance. Baroque architecture in the north was rejected as representative of Catholic rule, so architects looked elsewhere for clear principles of design, finding them – as their English counterparts had – in Palladian architecture. The leading Dutch architect of the time was Hendrik de Keyser (1565–1621), whose Protestant churches represented a building type that soon spread

décor was characterized by the playful use of Renaissance elements. But de Keyser's architectural rhetoric did signal a new direction, which was to be logically pursued in the decades to come.

Amsterdam's Town Hall was built in 1648 by the Haarlem architect Jacob van Campen and may be considered a further milestone on the road to a Dutch Neoclassicism. This magnificent building, known today as the "Paleis op de Dam," was praised in its day as the eighth wonder of the world. The building's decoration was minimized and a succinct Palladian style allowed to emerge so that the façade, despite – or perhaps because of – its simple design, appears monumental and regal; this was to be a characteristic of the

Jacob van Campen
The Hague, Mauritshuis, 1633–1644

throughout Holland and the coastal regions of Germany as far as Danzig. The model for these churches was de Keyser's Westernkerk in Amsterdam, a centrally planned building in the shape of a Greek cross, erected in 1620. Simplified forms and adoption of the antique order of columns distinguished this architect's works from the Baroque forms that were still prevalent. His façades, however, were not yet what could be called Neoclassical as their

later Neoclassical style. Another of van Campen's works, built before the Amsterdam Town Hall, deserves mention in this context – his Mauritshuis in The Hague, which was probably the earliest example of an early Neoclassical style (ill. p. 148). Van Campen designed the Palais, built between 1633 and 1644, from a simple but dignified concept that featured flat Ionic pilasters in the manner of Palladio.

A further step towards Dutch Neoclassicism may be seen in the influence of French architecture, which was at first modest. The style was introduced to Holland by the Frenchman Daniel Marot the Elder, who arrived in the country as a religious refugee in 1685. He entered the service of William III, and built the hunting lodge of De Voorst for his new patron. Marot developed a comprehensive style which soon became popular in Holland, and it contributed greatly to lending dignity and severity to the work of the late Baroque; conspicuous architectural decoration was abandoned and styles became more Palladian. Palatial patrician houses were soon being built in Amsterdam with staircases penetrating deep into the space of the building and with austere façades executed in ashlar.

The early Neoclassical style gradually changed around 1760 under the influence of French architecture in the reign of Louis XVI, and this tendency gathered strength in the following decades. As in other European countries, French influences became more and more evident, particularly through the work of the Parisian Académie Royale de l'Architecture and its director Jacques-François Blondel. The model and founding document of Neoclassicism was François Mansart and Robert de Cotte's palace chapel at Versailles, built between 1689 and 1710. The Corinthian columns of its unusually high gallery, which tower over the arcade, were also used by Blondel as both an architectural and aesthetic point of reference.

One of the first great Neoclassical churches in Holland was that of St.

Rosalia in Rotterdam, which was built by Jan Guidici between 1777 and 1779, its architectural structure and décor borrowed from Mansart's chapel at Versailles.

The spectrum of Dutch Neoclassicism, however, was not limited to the French model. The ballroom in the Knuiterdijk Palace in The Hague, designed by Jaan van Greef in 1820, was patterned after the Egyptian Hall described by Vitruvius (ill. p. 148, top). This was a hall with a double colonnade, which in Greek architecture was given a basilican cross-section with light entering from a triforium. Palladio resurrected this building type and passed it on to English Neoclassical

Jan van Greef
Palais Knuiterdijk, The Hague
Courtyard façade, 1820

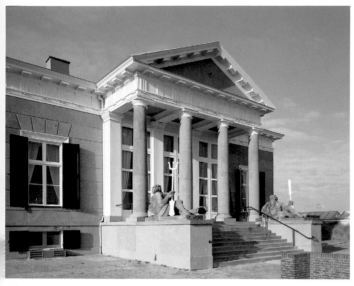

The portico of the Scheveningen Pavilion from 1826 is still indebted to the severe Neoclassical style.

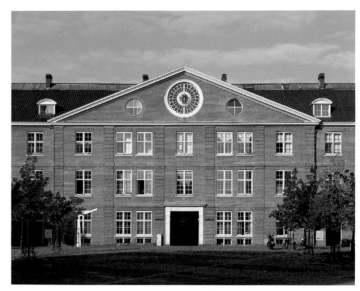

Abraham van der Hart
Orange Nassau Barracks, Amsterdam, 1813

The Gothic Hall of Knuiterdijk Palace in The Hague, 1840, signals the advent of the Historicist style.

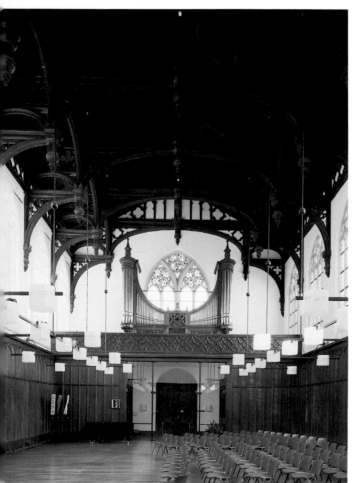

architects, who in turn were probably the inspiration for van Greef.

Until 1840, Dutch Neoclassicism took on a great variety of forms within the spectrum described here. German architects were also active in the Netherlands. Friedrich Ludwig Gunckel built the Governor's Palace in The Hague between 1772 and 1796 in a severe and monumental style that was distinct from French taste and more closely related to German Neoclassicism.

The political map of Europe changed with the emergence of Napoleon. Almost unnoticed, the French Emperor annexed the Netherlands in 1810 after his brother had turned the country into a kingdom in 1806, ruling it without success. Abraham van der Hart's Orange Nassau Barracks in Amsterdam from 1813 display a sober aesthetic, and the building is simply and sparingly executed (ill. p. 149, top right). A similar approach is apparent in buildings by Munro and Noordendorps: the Town Hall in Rotterdam from 1823 and the Palace of Justice in The Hague from 1830.

The pavilion in Scheveningen (ill. p. 149, top left) from 1826 and the Law Courts in Leeuwarden, built in 1846, are also worthy of mention. This latter building – and there are traces of a similar process at work in the Scheveningen pavilion – shows the first evidence of Historicism, that is tendencies to transform and integrate the motifs of past architectural styles. At first Neo-Gothic motifs were used to inject a Romantic mood into the rather cool and sober Neoclassical style. Examples of this movement can be seen in the Catholic Church in Harmelen built in 1836 (ill. p. 149, bottom right), the Gothic hall under Knuiterdijk Palace in The Hague (1840, ill. p. 149, bottom left), and the former railway station in Rotterdam (1847). A short while later this Romantic concept architecture gained wide acceptance, though it largely concentrated on the adoption of Romanesque elements. Together with the interplay of Baroque forms and motifs from the Renaissance, this finally led to the rise of international Historicism.

The southern Netherlands were originally Spanish, belonging to the Habsburgs in the 18th century and

Harmelen
Catholic Church, 1838

149

later, in 1831, becoming the independent kingdom of Belgium. In the 17th and 18th centuries its architecture was largely influenced by France. Architectural language emancipated itself only slowly from Baroque forms and never achieved such a decisive break as it did further north.

The first to develop a distinct Neoclassical style was a pupil of Vanvitelli's, Laurent Benoit Dewez, who built a palace in Seneffe for Duke Julien de Pestre in 1760 (ill. p. 150, top left and top center). He elegantly arranged the façade with Corinthian columns and designed the colonnades of the court gallery with Ionic columns. The concept of the building was patterned after English country houses – themselves inspired by Palladio – but the details of the decorations are largely of French origin.

Claude Fisco, born in Louvain in 1737, was trained as an engineer in the army and in 1775 built the Square of the Martyrs in Brussels. Fisco surrounded the spacious, oblong square with buildings in a monumental and uniform style similar to that of Louis XVI. As the dimensions of the complex are not on the same gargantuan scale as those in Paris, the resulting structure has a friendly and intimate appeal.

When the old ducal palace went up in flames in 1731, agreement could not be reached on a new building. It was only in 1775 that the architect Nicolas Barré was called from Paris to redesign the square. The first steps in the building of the Place Royale were made before another Frenchman, Gilles Barnabé Guimard, was brought in. He altered the first plan, preferring a square with arcades and roofs lined with balustrades on the model of the Place Royale in Reims (1760). A year later Guimard was commissioned to build the church of St. Jacques in Brussels. He designed a colonnaded basilica with an antique temple frontage, which conformed to the traditional Neoclassical pattern without a hint of originality.

Today's Royal Netherlandish Theater (ill. p. 150, bottom left) was built by Pierre Bruno Bourla as the Théâtre Royale Français from 1829 to 1834 in the same classicizing style, though more imaginatively and with much greater variety. The architect modeled his work on the Classical circular temple, placing figures on the cornice above the columns in the manner of Palladio. Tondi with busts were set over the volutes of the pediments of the upper floor windows.

Influenced by the "architecture of the revolution," Charles Van der Straeten built the Orangery and Conservatory of the Botanical Gardens in Löwen between 1819 and 1823.

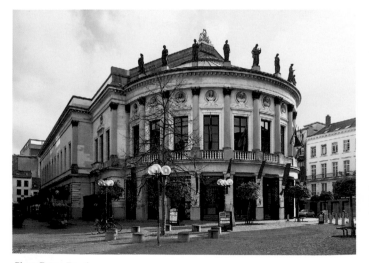

Pierre Bruno Bourla
Royal Netherlandish Theater, Antwerp
1829–34

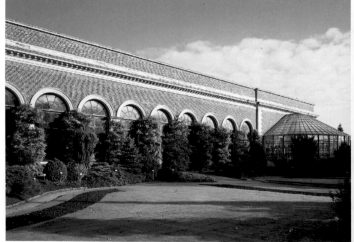

Charles Van der Straeten
Orangery and conservatories of the
Botanical Garden, Löwen, 1819–1823

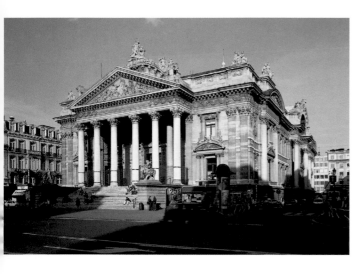

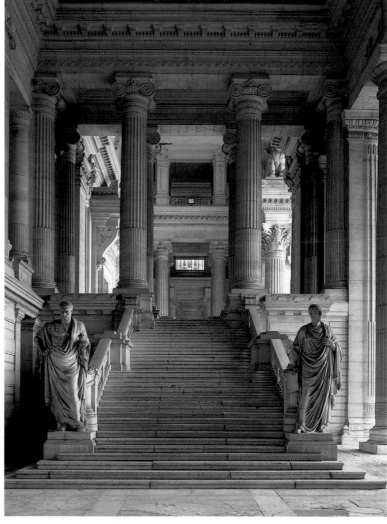

The semi-circular structures of glass and iron that protrude from the slight projections of the side wings give the building a modern or even postmodern appearance (ill. p. 150 bottom right). Straeten designed the palace of the Prince of Orange (1823–26) – which is today's Academy Palace in the rue Ducale in Brussels – together with Tilman-François Suys. He avoided the severity of his Orangery and gave the façade, with its distinctively projecting corners, colossal Ionic pilasters based on the model of Palladio (ill. p. 151, bottom).

There is, however, no specifically Belgian or southern Netherlands form of Neoclassicism. French influences, filtered through Palladio and the style of "Revolutionary architecture," were dominant, especially as French architects were often appointed for important state commissions. The Kingdom of Belgium was created as Neoclassicism was nearing its end. Joseph Poelart, the first prominent Belgian architect, developed the Palace of Justice in Brussels in 1866 from a sensibility for Neoclassical architectural language. Today it can be debated whether this building represents the first and last expression of monumental Neoclassicism in Belgium, or whether – in line with current art historical readings – it is a Neo-Baroque building and therefore already part of the Historicist trend. The palace's pompous staircase, with sculptures attired in Roman robes (ill. p. 151, top right), supports the Neoclassical case. The lively exterior, on the other hand, featuring building masses that project and recede as well as columns, pilasters, and portals, marks it out as a Neo-Baroque structure. Whatever the case, Poelart's Palace of Justice in Brussels became one of the most influential buildings in Europe.

ABOVE:
Joseph Poelart
Palace of Justice, Brussels, 1866
Staircase

TOP LEFT:
Léon Suys
Stock Exchange, Brussels, 1871–73

While Poelart's Palace of Justice displays Neoclassical elements - at least in the staircase - the Neo-Baroque Stock Exchange is already a definitive example of Historicism.

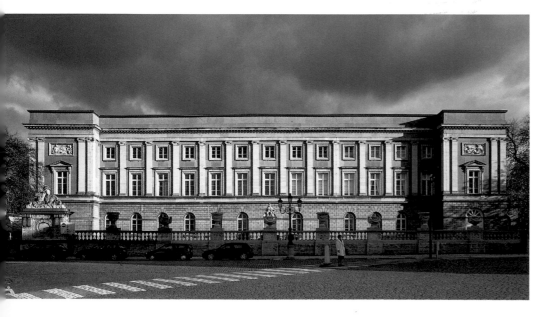

Tilman-François Suys, Charles van der Straeten
Palace of the Prince of Orange
(Academy Palace), Brussels, 1823–26

Klaus Jan Philipp

Neoclassical and Romantic Architecture in Germany

The period between the mid-18th and mid-19th centuries was a decisive phase in the development of architecture in Germany. This was the time that saw the foundations laid for the stylistic trends that would mark the 19th century and prepare the way for 20th-century modernist architecture. The period also planted the seeds of our present system of institutional architectural training and – associated with that – the beginnings of architectural journalism. Architecture was no longer solely the affair of emperors, kings, princes and the churches, but became public, an object of general civic interest. The tasks of an architect were no longer just to fulfill an enlightened but despotic client's need for public statements. Architecture now had an active role in the social process, demanding to be acknowledged and esteemed as a socially useful art. The whole period was concerned with the basic issue of how this high requirement of architecture could be met. What style was appropriate for an enlightened, civic society at the beginning of industrialization and capitalism? How could such a society find a style suitable for the new construction work required at the time? What would the social changes mean for the architect's self-image?

Architectural publications and the training of architects

These questions were not confined to the narrow sphere of those directly involved in the building industry, but were discussed by a broad public. Many building projects were decided in competition, with competing designs judged by a select but nonetheless large public. From 1789, architectural matters in Germany were debated in architectural publications written not just for experts, but also for laymen and amateurs interested in progress and the opportunities offered by architecture. The first such publication was the *Allgemeine Magazin der Bürgerlichen Baukunst* (General Magazine of Civil Architecture), edited by Gottfried Huth and published in Weimar from 1789 to 1796. Huth's magazine also dealt with problems of crafts, construction physics and the economics of construction, besides the philosophy and aesthetics of architecture. He justified the wide-ranging content by saying it was essential to disseminate widely the "true and basic knowledge of architecture," and to promote "the inner perfection of architecture itself," thereby "gradually ridding it of the weeds of taste that have taken root in its fields in great number." Huth wanted the study of architecture to find more followers: "if more sound minds then take up the subject, it will be the more highly esteemed." Comparable enlightened programs were presented in the other architectural publications, which were initially addressed to both lay and professional readers and only after about 1829 really turned into publications for professionals. Following Huth's "magazine" came the *Sammlung nützlicher Aufsätze die Baukunst betreffend* (Collection of Useful Essays Concerning Architecture), which was published by members of the Berlin Architectural Academy as an illustrated periodical from

1796 to 1806 (ill. p. 153). After the wars of liberation and establishment of the new German states following the Congress of Vienna, came more periodicals, initially the south-German *Monatsblatt für Bauwesen und Landesverschönerung* (Building Industry and National Improvement Monthly, 1821–30) by Johann Michael Vorherr, and subsequently the important pan-regional *Allgemeine Bauzeitung* (General Building News), published in Vienna by Christian Friedrich Ludwig Förster, which lasted from 1836 to 1918. In Prussia, the largest single state in Germany, the mantle of the *Collection of Useful Essays* was picked up in 1829 by the *Journal für die Baukunst*, whose influence went beyond state borders and which lasted until shortly before the death of its founder August Leopold Crelle in 1851. In Prussia and Berlin itself the *Notizblatt des Architektenvereins* (Gazette of the Association of Architects) (1833–51) – continued as the *Zeitschrift für Bauwesen* (Building Industry Periodical) – along with the *Architektonische Entwürfe* (Architectural Designs) and *Architektonisches Album* (Architectural Album) were the central organs that reported on and illustrated developments, including the monthly competitions organized by the Berlin Architectural Academy from 1827.

At the same time that architectural periodicals appeared, the importance of architecture for the general interest was further highlighted by many architects publishing their designs or their completed buildings in the form of samples [*Stichpublikationen*]. These publications made their work known outside their immediate area, thus recommending them for higher offices in the building industry; and they could provide clients with ideas for projected buildings. An important organ here around the turn of the 19th century was the *Ideenmagazin für Liebhaber von Gärten* (Ideas Magazine for Lovers of Gardens) (1796–1806), published by Johann Gottfried Grohmann, in which many young architects presented their designs for country houses and small garden buildings. Other topics were dealt with in Friedrich Meinert's *Schöne Landbaukunst* (Beautiful Architecture in Agriculture), (1798–1804), which presented designs for agricultural buildings, barns and livestock buildings. Many architects published their designs for fashionable topics, such as country houses, at their own expense. And designs for competitions like, for example, that for a Luther monument in the earldom of Mansfeld, were published as engravings and could thus be publicly discussed. A high point of all this journalistic activity was the *Sammlung architektonischer Entwürfe* (Anthology of Architectural Designs) (1819–40) by Karl Friedrich Schinkel, which included all important buildings by the Berlin architect. Similar design publications by Friedrich Weinbrenner (1766–1826), Heinrich Hübsch (1795–1863), Leo von Klenze (1784–1864) and many others did not enjoy the same prestige as Schinkel's *Sammlung* with its superior quality and informative form of presentation.

These publications and periodicals, which carried news of "fine architecture" and dealt especially with technological problems of the construction industry – the construction of canals, docks, fire-proofing safety, roof structures and so on – ensured that construction questions in general were publicly discussed. The importance of architecture for the education and propagation of bourgeois society, its economic prosperity and social peace was highly esteemed. This is reflected in the promotion and institutionalization of architectural training from the mid-18th century. Architectural courses were established at the royal and princely academies on the model of the Parisian *Académie royale d'architecture*. The prime reason was to train the next generation of artists who were to decorate and adorn court and country, but a secondary reason was to promote the crafts and maintain independence from foreign suppliers. Additionally, towards the end of the 18th century there was a growing tendency to monitor "good taste" in architecture. In the words of the *Regulations for the Academy of Fine Arts and Mechanical Sciences in Berlin* dated 1790, all building plans were to be submitted to the Academy by the *Oberhofbauamt* (the Court's head Department of Works) for

Friedrich Gilly's 1786 design for a memorial to Frederick the Great, King of Prussia, is considered an early example of Neoclassicism in Germany (ill. below). The design was exhibited at the academy exhibition in Berlin in 1796, where it aroused enormous interest with its monumental use of classical grammar. The Doric temple on a tall polygonal stone plinth inspired Leo von Klenze's design for Valhalla near Regensburg (ills. pp. 187–188). It was seeing Gilly's design that apparently prompted Schinkel to become an architect. Many designs and buildings by Schinkel exude the noble pathos of Gilly's Romantic Neoclassicism, for example, the Rotunda of the Altes Museum in Berlin (ill. opposite). However, Schinkel's architecture is more dispassionate. His design for the architectural academy (ills. below and p. 193) features a building that impresses for its rationality and marks the beginning of a new era in German architecture.

OPPOSITE PAGE:
Karl Friedrich Schinkel
Altes Museum, Berlin, 1823–30
Rotunda

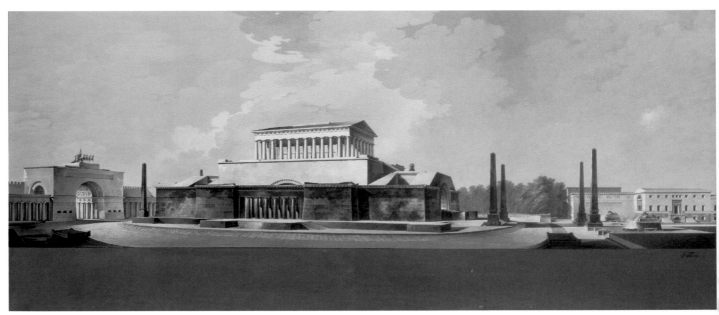

Friedrich Gilly, design for a temple as a monument to King Frederick the Great of Prussia, exhibited in Berlin in 1796. Staatliche Museen zu Berlin – Preussischer Kulturbesitz, Berlin

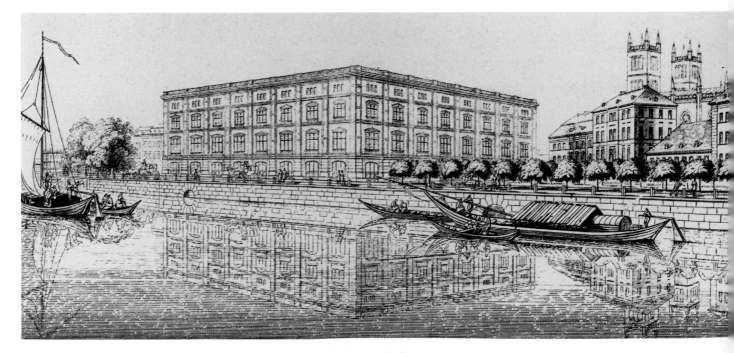

Karl Friedrich Schinkel, design for the architectural academy in Berlin, Staatliche Museen zu Berlin – Preussischer Kulturbesitz. See also page 193.

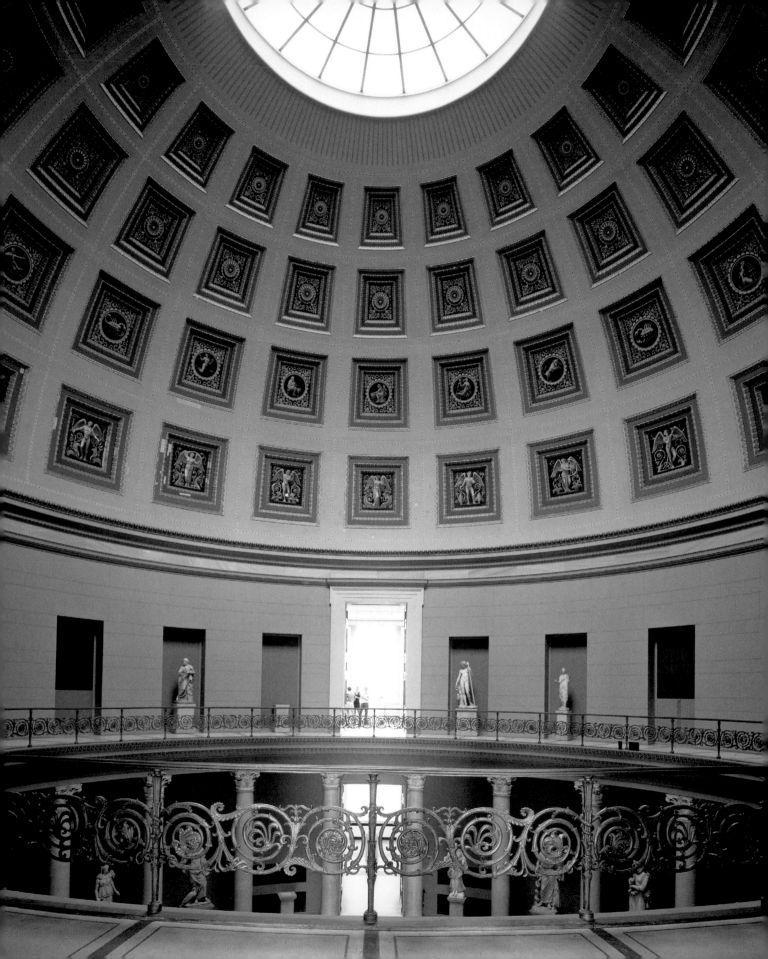

consultation on "the true and simple principles of beauty" and "the best means for the dissemination of good taste." Architectural courses at the academies in Dresden (1763), Düsseldorf (1780), Stuttgart (Hohe Karlsschule, 1778), Kassel (1781) and Munich (1808) had comparable programs. A major role in increasing interest in architecture may be attributed to the annual exhibition of designs by professors and pupils, particularly at the academies in Berlin and Dresden, where printed catalogs appeared with brief descriptions of the entries submitted.

Also important in architectural training were schools financed privately or by the cities, set up by architects in many different locations. Mostly these courses were held on a Sunday or in the evenings, so that skilled workers could attend for further training after their normal working hours. In some towns, these private teaching institutions later developed into architectural academies, crafts schools, or polytechnic schools, on which the Technical Universities and their architectural courses were later based. David Gilly (1745–1808), for example, ran a private architectural school in Berlin that can be considered the core of the Berlin Architectural Academy. Though reserved for an exclusive circle, the Private Society of Young Architects founded by Gilly's son Friedrich in Berlin likewise exerted great influence by inviting leading architects such as Klenze and Schinkel to discuss fundamental problems of architecture. In Karlsruhe, Weinbrenner's architectural course covered a comprehensive curriculum, based on languages, geography and history (principally of ancient Greece and Rome). Then came the auxiliary sciences, such as geometry, mechanics, and mathematics. This general instruction was complemented by specific architecture-centered subjects such as geometric, perspective and architectural drawing, and the theory of architecture.

Such universal teaching programs sought to unify the training of engineers and architects. It had become increasingly evident since the mid-18th century that the building industry was separating into "technical" and "aesthetic" branches. The potential for innovation was all with the technical side, including especially the introduction of new building materials such as iron and glass and efforts to evolve innovative construction techniques such as clay building or ways of saving wood in construction, especially in roof structures. The need to bring these two sides of architecture together again was recognized early on, but convergence was really only achieved with the founding of polytechnic schools on the model of the École Polytechnique in Paris. Meanwhile, the Berlin Architectural Academy's polytechnic courses became a model for many polytechnic and craft schools set up all over Germany in the 1820s and 1830s. After the liberation wars and reconstitution of the German states, a veritable wave of such new schools came into being: a crafts academy in Berlin (1821), polytechnic schools, craft schools or technical institutions in Karlsruhe (1825), Darmstadt (1826),

Munich (1827), Dresden (1828), Stuttgart (1829), Kassel (1830), Hanover (1831), Augsburg (1833) and Brunswick (1835). The modern architect was created at these schools, with their institutionalized teaching in classes, their scientific and technical syllabus and new practical involvement that especially included construction work for state institutions and catered for the new demands of society. Thanks to an industrially-focused syllabus and corresponding practical work based on exercises in architectural drawing, freehand drawing and architectural history, the gap between architect and engineer was closed.

For the time being, architectural theory was still based on Vitruvius's *Ten Books on Architecture*, which August Rode published in a new German translation in 1796. However, the dogma was increasingly stripped out of Vitruvius' doctrines as familiarity grew with Antiquity, particularly Greek Antiquity. This was mainly the result of scholarly works by English and French travelers, whose publications were greeted with great interest in Germany. Similar journeys to Greece and southern Italy were undertaken by German architects only after the wars of liberation. They included Carl Haller von Hallerstein (1774–1817), Klenze, Gottfried Semper (1803–79) and Ludwig von Zahnt (1796–1864), who discovered the polychromy of the Greek temples in Sicily jointly with the Paris-based architect Jakob Ignaz Hittorf and thus triggered off a momentous discussion now known as the Polychromy Debate. In the field of construction technology and agricultural building the writings of David Gilly were significant: Gilly proclaimed the advantages of plank roofs (supposedly timber-saving) and building with rammed earth (*pisé* technique). Very influential for some decades was Gilly's *Handbuch der Landbaukunst* (Manual of Agricultural Art, 1798), where this highly esteemed aspect of architecture was dealt with in detail. The overall state of architecture at the end of the 18th century was summed up in Stieglitz's *Encyklopädie der bürgerlichen Baukunst* (Encyclopedia of Civil Architecture, 1792–98). Textbooks covering the whole range of architectural studies were published in the early 19th century by Weinbrenner, Heinrich Gentz (1766–1811) and Karl Friedrich von Wiebeking. Also influential in Germany were the writings and rational doctrines of Jean-Nicolas-Louis Durand, professor at the École Polytechnique in Paris (*Précis des leçons*/Summary of Lessons, 1802), and of Jean-Baptist Rondelet (*Traité théorique et pratique de l'art de bâtir*/Theoretical and Practical Discussion on the Art of Building), which were also translated into German.

Architectural history, care of monuments

The history of architecture ranked very high in the syllabuses of the academies, private schools and polytechnic schools alike. The history of architecture from the Egyptians through the Greeks and Romans down to the Middle Ages and the modern era had

Typical page from *Untersuchungen über den Charakter der Gebäude* (Inquiries into the Character of Buildings), 1788

The doctrines of physiognomy were applied to the outlines of buildings, and conclusions made about the character of their inhabitants.

monuments in the early 19th century, an activity that is still important for the preservation of historic buildings and the care of monuments. Even the idea of completing unfinished medieval cathedrals and their towers was rooted in this new awareness of history. As early as 1814, Joseph Görres was calling for the resumption of work on Cologne Cathedral, though work actually began only in 1842. In a rescue action, architect Johann Claudius von Lassaulx (1781–1848), noted for his Neo-Romanesque buildings and designs, relocated the Late Romanesque chapel at Ramersdorf, which was threatened with demolition, to the old cemetery in Bonn. In 1817, Stieglitz regothicized the collegiate church at Wurzen, installing choir stalls, organ case and seating to his own Gothic designs. Carl Alexander von Heideloff (1788–1865) fought for the preservation of the historic buildings of Nuremberg. The cathedrals of Bamberg, Regensburg and Speyer, the abbey church of Heilsbronn and Isar Gate of Munich were restored under the supervision of Friedrich von Gärtner (1791–1847), being returned to their original condition minus the Baroque overlays. Unfortunately, these "restorations" – supposedly stylistically correct – also destroyed for ever many original furnishings and paintings.

Architectural theory

The view of history presented in Stieglitz's history had a direct effect on new architectural work as well. Stieglitz's book combines the history of architecture with political and social developments, and considered the high points of architecture were only attained when art and life were in harmony. This (he said) only happened with the Greeks in Antiquity and in Germany during the Middle Ages. Nevertheless, Stieglitz gave other styles credit, and in 1834 recommended the following styles for use by architects for sundry building types: the Greek style, the round-arch style, the pointed-arch style and (as a mixed form) the Italian style (early Renaissance). These styles were, however, not to be used indiscriminately, but were suited to particular types of building, "inasmuch as this or that [style] is adequate for the requirements of the structure to be designed and does not conflict with its character." Stieglitz was not propagating a theoretical stylistic pluralism, but was reflecting the actual state of architecture in Germany at the end of the 1830s. At the same time, he revived the mid-18th-century doctrine of the "character" of a building.

One of the most important achievements of architectural theory in the second half of the 18th century was the abandonment of the hierarchical ranking of building types according to the feudal social order. Instead, there was a new order, in which the character of the building was the most important classification to be made. As a palace or church could not have more character than (for example) a prison or barn but only a different one, the ranking of building types became purely relative.

been a core topic in the above-mentioned periodicals since the 1780s. Architects became deliberately "correct" in their work, and it was recognized that every time and country had evolved its own style. In 1827, the law-trained dilettante architect and art critic Christian Ludwig Stieglitz of Leipzig (1756–1836) published the first history of architecture in a modern sense under the title of *Geschichte der Baukunst vom frühesten Alterthume bis in die neuern Zeiten* (History of Architecture from Earliest Antiquity until Modern Times).

At the same time as architectural history evolved as an independent scholarly discipline, came the birth of the modern idea of caring for ancient monuments, the notion that even structures built without commemorative intention may constitute historic monuments. In many German states patriotic associations (Vaterländische Vereine) were set up with the aim (among others) of preserving and restoring historic buildings, especially medieval ones. From their work developed the making of inventories of art

A barn could be the subject of as much aesthetic and architectural attention as a church. The distinctive feature was no longer the position within the political and social hierarchy, but the preservation and assertion of the building's character. A church should not look like a barn, and a country house should no more resemble a palace or castle than the latter a country house. In *Untersuchungen über den Charakter der Gebäude* (Inquiries Concerning the Character of Buildings), published anonymously in 1788, the doctrine of character is taken to extremes, with the lessons of physiognomy being applied to the outlines of buildings and conclusions being drawn from the profile of a house as to the character of its residents (ill. p. 157).

Particular meanings began to be attributed to particular styles. The Egyptian style with its simple masses and heavy forms was particularly suited to the construction of tombs and other commemorative architecture. Moorish or Turkish motifs were used principally for buildings for leisure and recuperation (ill. p. 164, left). Medieval architecture counted as the ideal style for buildings with religious functions and for buildings with ancient Teutonic associations. The round-arch style of the Italian Early Renaissance, on the other hand, was to be used for buildings with civic functions and residential buildings. Along with these architectural styles, the classical orders remained important as means of distinguishing the hierarchy of buildings. Corinthian columns were reserved for religious and princely buildings, the Ionic order for buildings functioning as museums or for artistic purposes, and the Greek Doric order, which around 1800 constituted a veritable fashion of its own, was considered appropriate for fortified buildings.

The Enlightenment's aim in evolving this doctrine of the character of buildings was to develop an architectural language comprehensible to all. It should be possible to identify the function of a building directly without first having taken archaeological instruction, opined Karlsruhe-based architect Heinrich Hübsch in his influential essay *In welchem Style sollen wir bauen?* (What style should we build in?), of 1827. In this, Hübsch identified the principal concern of architecture in Germany since the mid-18th century. How can a style be found that is appropriate to an enlightened society and that can also act as a force for enlightenment, by intervening actively and effectively in the process of civilization? This lofty objective had already been set by the enlightened princes of the mid-18th century. Thus King Frederick II of Prussia had virtually prescribed his architects a design manual based on buildings and designs by Andrea Palladio, Giulio Romano, Sir William Chambers and others. The French Church (1752–53) built by Georg Wenzeslaus von Knobelsdorff to a rough design by Frederick II follows the example of the Roman Pantheon. The Nauen Gate commission, on the other hand (1754–55, reconstructed 1867–69), he handed to Johann Gottfried Büring (1723–88) along with a design for a medieval city gate with two round towers. By selecting from various styles, Potsdam as a civic entity for all was to be the model city of benevolent despotism.

Wörlitz and the consequences
More comprehensive was the program laid down for his principality in 1758 by Leopold Frederick Francis III, prince of Anhalt-Dessau. In this case, it was not a matter of the design of individual

building but the reshaping of a small but, it was hoped, influential principality into a "cultural landscape" with the installations of Wörlitz as its heart. Prince Francis' kindred spirit in this venture was Friedrich Wilhelm von Erdmannsdorff (1736–1800), who was already admired by contemporaries as one of German architecture's innovators. The princely program included promoting agriculture, industry and art; and introducing school reform and reshaping the country on uniform principles. Thus long-distance roads were reconstructed as metalled park lanes with benches and inns, so that travelers would see the advantages of the model state immediately they crossed its frontiers. Extensive tracts of the country were transformed into park landscapes used for agricultural purposes, becoming the parks of Sieglitz and Kühnau and the Luisium and Georgium complexes. The parks in Wörlitz also have large agricultural areas with nurseries, orchards and pastures, which were to serve as model farms for the agricultural population. A similar pedagogical purpose lay behind the park and its buildings, laid out on the pattern of an English garden. Models for these developments had been seen by Prince Francis and Erdmannsdorff on their joint travels to Italy and England. However, the scheme did not stop with this formal presentation, but pursued a comprehensive pedagogical and social program for the "children of the land." Linked by long axial views, the small buildings (*fabriques*) in the garden unfolded a cross-section of the history of man, natural history and architectural history, ranging from the Egyptian crypt under the Roman Pantheon to the Gothic house (ill. p. 161), from Rousseau island to fiery, bubbling Vesuvius. The artificial lake and its tributaries are crossed by numerous bridges that illustrate the history of bridge-building. The program starts with the primeval bridge and a Chinese suspension bridge, and passes through bridges based on designs by Palladio to the iron-built bridge emulating the first iron bridge in Coalbrookdale in England (1779). The *Schloss*, really just a country house (1769–73), is based on English Palladian models, but is tailored both in the building and its furnishings to the overall moral and educational objective (ill. p. 159). The sole expression of grandeur is a four-column portico with Corinthian columns and a pediment, in front of a plain cubic residence. Behind is an inner court. Only two statues in niches beside the main doorway, the inscription on the architrave, the dentils on the cornice, and window pediments on the model of late Roman buildings in Baalbek indicate that the cubic mass is the residence of a prince.

A trend towards a comparable squareness of the building mass and reduction of architectural decoration was a feature evident throughout Germany. In the west and south it was mainly French architects who introduced a new formal language based on French (and English) models, in an environment still dominated by late

François Ignaz Mangin
Schloss Monaise, 1779–86
Trier, Archbishopric of Trier

Mangin succeeded in combining French
(Neufforge) and English Palladian
influences to create a style of his own

Baroque and Rococo buildings. The change of style came with the construction of the *Schloss* in Koblenz by Antoine François Peyre (1739–1823) and Pierre Michel d'Ixnard (1723–95) from 1777, and in south-west Germany with the work of architects Louis Philippe de la Guêpiere (c. 1715–73), Nicolaus de Pigage (1723–96), Emanuel Joseph d'Herigoyen (1746–1817) and Nicolas Alexandre Salins de Montfort (1753–1839). The work they did designing, furnishing and building in Trier, Stuttgart, Buchau, St. Blasien, Mannheim, Würzburg, Aschaffenburg, Frankfurt, Regensburg and other places transmitted the quasi-official architecture of Louis XVI promoted by the Académie Royale d'Architecture in Paris, known in other German states as *Zopfstil*. Between 1779–86, architect François Ignaz Mangin, who was active in the Trier and Mainz region, built Schloss Monaise near Trier for the Counts of Walderburg (ill. p.160). Mangin demonstrated here his skill in blending the latest French and English architectural ideas to create a style wholly his own. The building follows the tradition of the Trianon in the palace park at Versailles and exploited both English Palladian influences and designs from the *Recueil élémentaire d'Architecture* (1763) by Jean-François De Neufforge. The deanery of Mainz Cathedral, built by Mangin in 1781–86 and destroyed in 1793 during the revolutionary wars, was one of the most modern buildings of its day in Germany, and was based on Ledoux's Hôtel d'Uzès in Paris. In Berlin it was mainly Karl von Gontard (1731–91) and Knobelsdorff who led the way, working in a *zopf* style that was

nonetheless reduced to basic stereometric forms. In Dresden and, under the influence of the Dresden Academy, in Leipzig and throughout Saxony, it was architects Friedrich August Krubsacius (1718–90), Christian Traugott Weinlig (1739–99), Gottlieb August Hölzer (1744–1814) and Johann Carl Friedrich Dauthe (1746–1816) who introduced the latest ideas from France and England and disseminated them through their teaching. The next generation, whose most important representatives were Christian Friedrich Schuricht (1753–1832) and Gottlieb Friedrich Thormeyer (1757–1842), maintained the high standards of architecture in Dresden. During the "Goethe period" Weimar attracted numerous important architects such as Gentz, Johann August Arens (1757–1806), and Nikolaus Friedrich von Thouret (1767–1845) before Clemes Wenzeslaus Coudray (1775–1845) took charge of building. In Westphalia it was Münster-based builder Ferdinand Wilhelm Lipper (1733–1800) who established Neoclassicism. His pupil August Reinking (1776–1819) followed in his master's steps in his buildings for the Münster diocese. Hamburg passed through an Indian summer of the Baroque with the commercial, rational architecture of Ernst Georg von Sonnin (1713–94) before the next generation imposed an international-style Neoclassicism. Notable buildings include those by both Johann August Arens (1757–1806) and Carl Ludwig Wimmel (1786–1845), whose masterpiece was his Renaissance-style Hamburg Stock Exchange (1837–41).

Country houses, *Residenzen* and *Schlösser*

The mansion in Wörlitz and the park with its *fabriques* were accessible to all. It was only in the Gothic House (1785–86, ill. p. 161), which contained a collection of medieval stained glass among other things, that Prince Francis retained his privacy. The north-west façade of this small building is a direct copy of the Venetian church of S. Maria dell'Orto, which Prince Francis had seen for himself, while the south-west façade emulates north German brick Gothic. As one of the first Neo-Gothic buildings in Germany after the Nauen Gate in Potsdam (ill. p. 158, top), the Gothic House in Wörlitz marks the real start of the Gothic Revival, which at this point did not have nationalist overtones but was only intended to evoke Romantic associations of the medieval era. Reviving the "epoch of superstition, magic, ghosts and wandering knights" (Stieglitz, 1792) was also the intention of Landgrave William IX of Hessen-Kassel when he commissioned Jussow to construct the Löwenburg in the garden of the Kassel *schloss* in 1791 (ill. and ground plan, p. 162). Despite being built as an artificial ruin, and thus continuing an early-18th century tradition of erecting "ruined" relics of ancient Roman architecture, Löwenburg offers in its interior the usual comfort of a princely country house. Even more stark is the contradiction between the furnishings and design of the *Schloss* built 1794–9

Heinrich Jussow
The artificial ruin and castle of
Löwenburg, in the *Schloss* park at
Wilhelmshöhe, 1791–99
Kassel, Landgravate of Hessen-Kassel

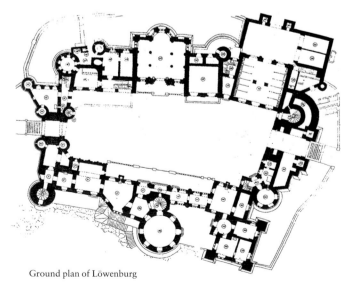

Ground plan of Löwenburg

on Pfaueninsel island in Berlin (ill. p. 163) by Johann Gottlo
David Brendel (documented c. 1794–1827). Apparently ruine
and reminiscent of a medieval castle gatehouse, the interior of th
building contains, among other things, a room decorated in
Tahitian style with painted palm trees. Moreover, the two towe
were linked in 1807 by an iron bridge, highlighting the contra
between the "medieval" building and the most up-to-da
building technology.

Fanciful *fabriques* like these, in all possible styles, we
constructed in virtually every princely residence in Germany, larg
or small. The Wörlitz example triggered off a veritable boom
Germany. Along with the gardens of Machern, Seifersdorf an
Bayreuth, mention should also be made of the garden
Hohenheim near Stuttgart. Here the Duke of Württemberg had
"prehistoric" settlement laid out over artificial Roman ruin
where "hermits" were installed. These gardens, which to mar
seemed like a pattern card of all peoples and styles, were soon cri
cized, as in Goethe's *Triumph der Einsamkeit* (Triumph
Solitude), for example. By the first decade of the 19th century, b

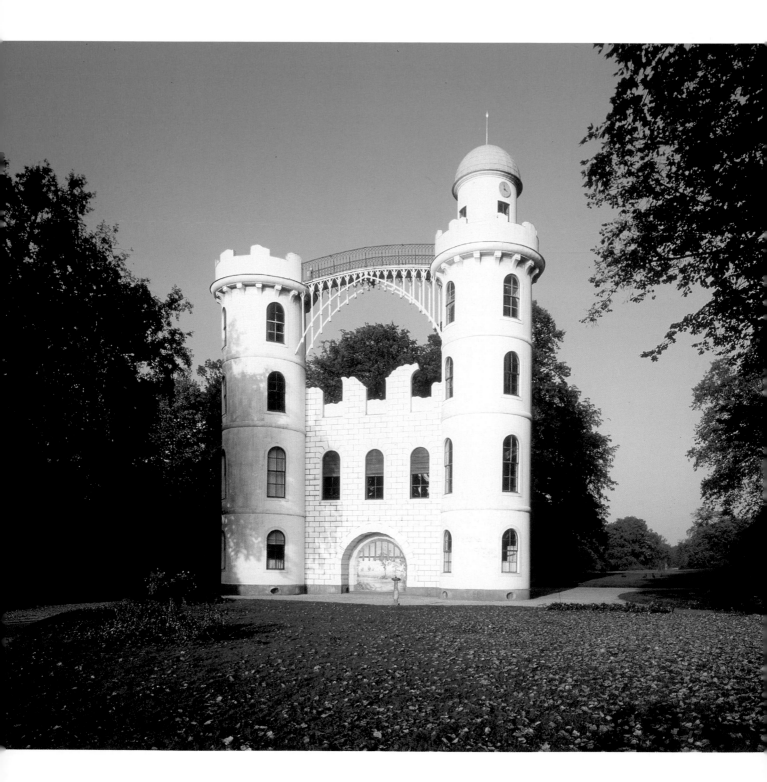

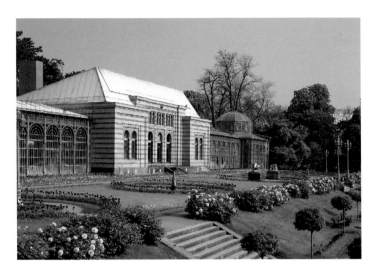

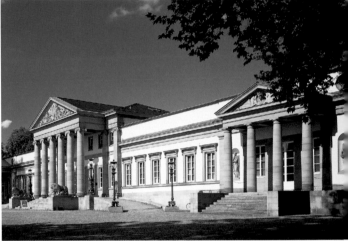

especially in the work of the landscape gardener Peter Joseph Lenné (1789–1866), such pedagogical and moralist objectives with their numerous small buildings had been abandoned in favor of gardens designed to an overall scheme with large plantations of trees, open areas and little architecture.

Work on planning Rosenstein Park, originally outside but now within the city of Stuttgart, began in 1817. The *Schloss* in Rosenstein was constructed for King William I between 1824 and 1829 by Giovanni Salucci (1769–1845), who had been trained in Italy and France and had been in Württemberg employ since 1817 (ill. p. 164, top right). The building is symmetrically laid out, with a two-story center pavilion looking like an afterthought in the two-court ground plan. The influence of Salucci's French and Italian training is quite evident. The side porticos, consisting of baseless Tuscan columns, frame the main portico, whose Ionic columns indicate the function of the house as a private retreat. Not far from Rosenstein Park, Salucci had planned a bathing house and classical house for the King since 1827, but these were never built. However, on the site of the proposed classical house work began in 1837 on the Wilhelma, designed by Zahnt in a Moorish style as a fantasy palace with a large ceremonial room, plant houses, oriental kiosks, fountains and a theater (ill. p. 164, top left). Nothing remains here of the socially instructive pedagogical intent of Wörlitz. The Wilhelma was reserved entirely for the pleasures of the king and court society. As the Wilhelma was being built, Gärtner created in Aschaffenburg a Pompeianum for Bavarian King Ludwig I, designed on the model of the Castor and Pollux house in Pompeii.

Similarly attuned to private mythology and a Romantic outlook is the Charlottenhof complex in the garden of Sanssouci near Potsdam, which Schinkel and Lenné laid out for the Prussian king

Frederick William IV from 1826 (ills. p. 165). The ideal landscape around Charlottenhof with the *Schloss*, Court Gardener's House and Roman Baths represented a utopian realm of peaceful human co-existence to match his Romantic ideal of a state where political and social contrasts were harmonized. Schinkel had to incorporate an existing building into his plan, but nevertheless succeeded in realizing this idea in architectural form by his deft grouping of building masses and prospects, a comprehensive program of sculptures and interior furnishings, and the inclusion of the garden in the scheme. The building is distinguished stylistically by Doric columns on the garden side and an Ionic doorway on the entrance side, while the Court Gardener's House is modeled on Italian country houses with open pergolas and vine arbors, with which Schinkel was familiar from his Italian journeys and French publications. However, in the Roman Baths, Schinkel combines the structure of a Pompeian house with the spatial arrangement of classical *thermae* and settings from Greek Antiquity, such as the caryatid porch of the Erectheion on the Acropolis in Athens.

By his choice and use of different styles Schinkel illustrates the notional ideal state of his employer, who could now retreat into an ideal world. However, the view from the exedra of the palace terrace is towards the showy Neues Palais, built by Büring and Heinrich Ludwig Manger in 1763–69. Thus, even in his ideal world and amid his marvelous architecture, the Prussian Crown Prince was reminded of the everyday public business of state. This demonstrates clearly the crisis that was bound to hit *Schloss* architecture after the end of the *Ancien Régime* and how difficult it was to build architecture appropriate to an obsolescent feudal class in a bourgeois age.

The crisis in the development of the *Schloss* can be clearly followed in the example of the planning and construction

164

Karl Friedrich Schinkel and Peter Lenné
Schloss and grounds of Charlottenhof, 1826–36
Potsdam, kingdom of Prussia

The palace was planned as a Utopian retreat for the
Crown Prince

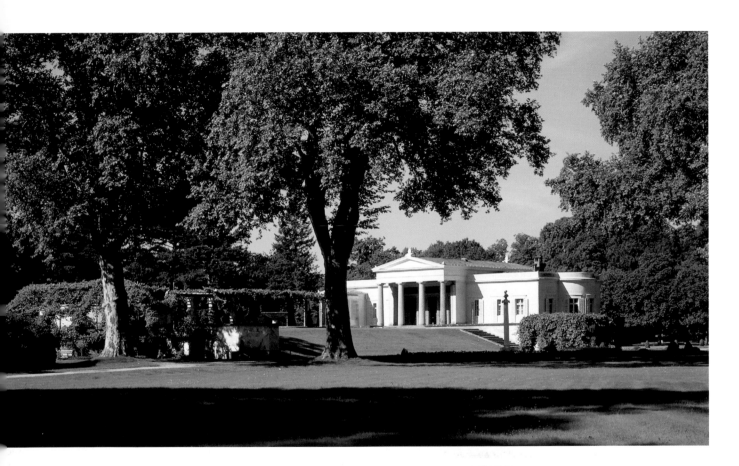

Karl Friedrich Schinkel
Roman Baths, Charlottenhof, Potsdam
1829–36

Heinrich Jussow and Simon Louis du Ry
Schloss Wilhelmshöhe, built for
Landgrave Frederick II of Hessen-Kassel,
1786–99
Kassel
Ground plan and side wing

OPPOSITE, TOP:
**Georg Adolph Demmler and Friedrich
August Stüler**
Schloss built for the Grand Duke of
Mecklenburg-Schwerin, 1840; 1843–57
Schwerin

OPPOSITE, BOTTOM:
Leo von Klenze
Royal *Residenz* for King Ludwig I of
Bavaria, 1823–32
Munich, kingdom of Bavaria

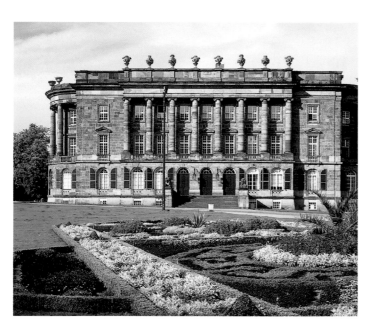

palaces. It sits astride the central axis of Wilhelmshöhe Palace Park with the Hercules octagon as the focal point of the outlook (ills. p. 166). Finally, on the instructions of Landgrave William IX, the long series of variegated and innovative designs was reduced to a conventional scheme and constructed by Jussow on English lines.

An alternative answer to this crisis elsewhere was the retreat into rustic idylls and evocation of medieval architectural forms, such as the Romantic castle of Löwenburg, near Wilhelmshöhe. The idealized chivalric virtues of their aristocratic builders constituted the notion behind the Romantic castle concept that developed in the 1820s and 1830s. The result was a string of newly built or rebuilt "medieval" castles sporting defensive walls, towers and battlements such as those at Rheinstein near Bingen, Hohenschwangau near Füssen (ill. p. 169), Babelsberg near Potsdam, Stolzenfels near Koblenz (ill. p. 168), Lichtenstein near Reutlingen and Landsberg near Meiningen.

A first high point in Romantic castle building was reached with the grand ducal *Schloss* in Schwerin (ill. p. 167, top) designed by Georg Adolph Demmler in 1840 and carried out by Friedrich August Stüler in 1843–57. Drawing heavily on decorative features of French and Italian Renaissance models and with the silhouette of a Loire castle, Schwerin attained a new high point in the Romantic *Schloss*, which was only to be surpassed by the dream castles of King Ludwig II of Bavaria in the second half of the century.

In his reshaping of Munich as a modern royal seat, Ludwig I of Bavaria likewise drew on sundry historical styles for palace building. Thus he commissioned from Leo von Klenze, who in 1816 had already built the Leuchtenberg Palais, one of the first Neo-Renaissance buildings in Germany, a royal palace (1823–32) using forms of the Florentine Renaissance (ill. p. 167 bottom). The outline of the façade follows that of the Palazzo Pitti, while the articulation and rusticated masonry were taken from the Palazzo Rucellai. The Wittelsbach Palais (1843–48) in Brinnerstrasse (destroyed in World War II), on the other hand, was designed by Gärtner as a box on a square ground plan with corner towers in a German High Gothic style.

An English-inspired Palladianism was the guiding style in the lengthy rebuild of the Guelph *Schloss* in Hanover by Georg Ludwig Friedrich Laves (1788–1864). Both in the overall layout and individual details, the *Schloss* in Brunswick built by Carl Theodor Ottmer in 1831–38 (destroyed 1944) adopted a vein of Baroque grandeur with borrowings from Perrault's east front of the Louvre and Andreas Schlüter's royal palace in Berlin. Schinkel's fantastic designs for a castle for King Otto on the Acropolis in Athens (1834) and a *Schloss*-style country house in the Crimea for Tsarina Catherine of Russia delve back further, to Antiquity, for inspiration.

history of Wilhelmshöhe (called Weissenstein until 1798), near Kassel. In 1785, Landgrave Frederick II of Hessen-Kassel called in Charles de Wailly (1730–98) from Paris, who submitted three designs in the tradition of the *Ancien Régime*'s palace architecture. In 1786/87, Heinrich Jussow (1754–1825) presented an alternative ideal project, which indulges in megalomanic grandeur and which, from the outset, was clearly not destined for completion. The commission was eventually given to Simon Louis du Ry (1726–99) in 1786, who initially only planned one of the later side wings of the *Schloss*. Only after 1787 was this turned, following designs by Du Ry and Jussow, into its present form as a three-wing complex in the tradition of despotist

OPPOSITE:
Karl Friedrich Schinkel and Friedrich August Stüler
Burg Stolzenfels, 1825–45
Near Koblenz, Prussian Rhineland
Exterior (top)
Knights' Great Hall (bottom left)
Knights' Chamber (bottom right)

Two crown princes, Frederick William of Prussia and Maximilian of Bavaria, built themselves ruined medieval castles as country retreats. In the years after the liberation wars, medieval castles came to symbolize national liberty and were rediscovered as witnesses to Germany's history and culture. In the castles, the princes could dream their romantic, patriotic dreams and be transported into an ideal world far from the social reality of nascent industrialization.

BELOW:
Domenico Quaglio
Burg Hohenschwangau, built for the Crown Prince of Bavaria, 1832–36
Füssen, Bavarian Alps

BELOW:
Carl Frederik Hansen et al.
Palmaille, Altona, Hamburg,
1806 onwards

BOTTOM:
Peter Joseph Krahe
Villa Salve Hospes, built for a merchant
in 1805–08
Brunswick, Duchy of Brunswick

Urban development and civil buildings

There is evidence in each of the examples of *Schloss* building quoted here that the choice of style was not a matter of whim, nor taken on purely aesthetic grounds, but was always dependent on special local conditions and traditions and the current political circumstances of the client. The aristocracy sought historically justified models in the history of architecture that they could assimilate to themselves and use for their own purposes. The middle class took its orientation largely from the architecture of the nobility, especially after the Congress of Vienna, which in Germany led to the re-establishment and reconstitution of the kingdoms. It is therefore difficult to identify a specific civil architecture in the period between 1750 and about 1830. Only as a result of the knock-on effects in Germany following the July revolution in Paris in 1830 and finally the bourgeois revolution of 1848 did a perceptible change come about that was linked with industrialization and the rapid increase of population in the cities.

From the 1770s, numerous authors wrote analyses of the problems of urban development and thus helped to propagate new qualities of middle-class life in the cities. The subject was launched by Marc-Antoine Laugier in his *Essai sur l'architecture* (1753), and his ideas were taken up by Johann Peter Willebrand in *Grundriss einer schönen Stadt* (Outline of a Beautiful City 1775–76) and Friedrich Christian Schmidt's *Der bürgerliche Baumeister* (The Civil Builder, 1790–99). Though the idea remains the detached house looking like a miniature *Schloss* people were aware that urban residences could not start and finish with this model and other models needed to be found. Baroque towns had been constructed according to a uniform plan, and now the desire was to see a succession of varied houses that, though they would be subject to the overall plan, would not surrender their individuality. Thus, though the houses along Palmaille in Altona, Hamburg, were conceived as continuous roadside building, every house nonetheless preserves its distinctive character (ill. p. 170, top left). Architect of many of the houses on Palmaille was the Dane Carl Frederik Hansen (1756–1845), who also erected numerous detached houses and villas for rich Hamburg merchants in the suburbs of Hamburg along the Elbe, before returning to Copenhagen as city architect. Similar distinguished and elegant villas were built in a very reduced, plain style by Peter Joseph Krahe (1758–1837) for middle-class clients in Brunswick. Thanks to the scrupulous balance of proportions, the Villa Salve Hospes (1805–08), built for the merchant Krause on the site of a former bastion, offers a touch of grandeur despite the very restrained use of decoration and traditional architectural trappings of dignity, and despite the small lunettes in the roof (ill. p. 170, bottom left). The three-story Feilnerhaus in Berlin built by Schinkel in 1829, now destroyed, was among efforts to create a new urban civic style, with the delicate molding of the window embrasures and breasts in the façade built of fair-faced brick. In contrast with this restraint, the villas that Semper built in Dresden and its environment in the 1830s and 1840s occasionally needed an inordinate wealth of Italian Renaissance motifs to express the status consciousness of their mostly middle-class owners. As with other types of building, the attempt failed to develop and uphold a functional and reduced formal grammar for the middle class.

Whenever an opportunity was offered for new construction in urban areas after a major outbreak of fire or in the development of new suburbs, the principle followed was of multiplicity in unity. Examples include Neuruppin (1787), Sulz am Neckar

Wilhelm Steinbach and Johann Gottfried Steinmeyer
Circus, Putbus, 1826

From 1815, the town of Putbus on the Baltic island of Rügen was developed into a small-scale ideal city of civilian character by an enlightened prince. The central location is no longer the *schloss*. Instead, open squares and streets lined with public buildings give the town its character. The Circus is, as its name implies, a circular park crossed radially with footpaths between grassed areas and clumps of trees, surrounded by whitewashed residential buildings. At the focal point is an obelisk, as a memorial to the founder, Prince Malte of Putbus.

Friedrich Weinbrenner
Karlsruhe market place with the town hall, Protestant church and pyramidal tomb of Margrave William, ruler of Baden in Baroque times
Karlsruhe, Grand Duchy of Baden, 1806–26

(1795) and Tuttlingen (1803), where opportunities were seized for total reconstruction after devastating outbreaks of fire. Elsewhere new urban developments remained confined to laying out suburbs (Kassel, Darmstadt, Mainz, Munich), the "restoration" of old towns (Aschaffenburg, Regensburg), and improvements of individual streets. When Prince Malte of Putbus enlarged his town on the island of Rügen into a princely seat from 1815, he had the civic areas laid out by architects Wilhelm Steinbach and Johann Gottfried Steinmeyer (1783–1851) as a "white town" with whitewashed houses. The central "square" is the Circus, which is ringed by condominiums (1826, ill. p. 171, top). The plain two- and three-story houses are decorated with cautious stylistic borrowings from Neoclassicism and the Gothic Revival, and generous amounts of green have been left between them. Layouts of this kind were to be found in England (Bath) or Munich, where Karl von Fischer (1782–1820) designed and carried out the Karolinenplatz in comparable form.

Demolished c. 1960, the *Schloss* in Putbus did not stand on a direct axis with the town. The enlightened Prince, wanting to develop Putbus into a *chic* resort, thus forewent a publicly pivotal position and left the focal points of the town to the bourgeoisie. In other towns, such as Karlsruhe, civic urban development had to accommodate itself to the existent Baroque town plan focused axially on the *Schloss*. Between 1806 and 1826, Weinbrenner created a civic center for the Baroque town (ill. p. 171, bottom) by means of a circus and a market place flanked by the town hall and Protestant church and marked in the middle by the pyramidal tomb of Margrave William. All the buildings are constructed in an international Neoclassical style, which Weinbrenner defended against the stylistic and nationalistic ambitions of the Gothic and Renaissance Revivals on the grounds that Europe was developing into a bourgeois, democratic society.

Theaters

As the aristocracy retired more and more into its Romantic retreats in the country, the main streets and squares in the towns were increasingly taken over by genuine civic institutions. Since the mid-18th century, one of the most important civil building tasks had been the construction of theaters, and the historical development from Neoclassicism through to Revivalism can be clearly followed in them. Though theaters continued to be added

LEFT AND BELOW:
Georg Wenzeslaus von Knobelsdorff
Opera House, designed 1740
Berlin

to or rebuilt in *Schloss* complexes, like that built by Nikolaus Friedrich von Thouret in Ludwigsburg, theater buildings now more often found themselves a home in the central squares and streets of the towns. Knobelsdorff's opera house on Unter den Linden in Berlin, designed in 1740, with its clear cubic separation of the building masses and the central portico, anticipates the trend towards Neoclassicism (ill. p. 172, top). The theater in Potsdam built by Carl Gotthard Langhans (1732–1808), now destroyed, took this cubic block system a huge step further. Other theaters took similar square forms, including the court theater in Zweibrück of 1775/76 (Johann Christian Mannlich, 1741–1822) with its Neo-Egyptian painted interior, the theater in Saarbrücken built 1786–87 by Balthasar Wilhelm Stengel and destroyed in 1793, and the Stadttheater in Koblenz, built in 1787 by Krahe and now incorporated in a row of houses. Fischer's Bavarian National Theater in Max-Josephs-Platz in Munich, built 1811–18 and restored in 1823–25 by Klenze after a fire, features a lofty Corinthian portico that goes over into the tall fly tower.

The same international Neoclassicism distinguished Weinbrenner's theater in Karlsruhe, which burnt down in 1847 and was replaced by Heinrich Hübsch's version, likewise now destroyed. Schinkel's theater in the Gendarmenmarkt in Berlin (ill. p. 173, bottom left), built 1818–21, had to incorporate the foundation walls of the burnt-out predecessor building by Langhans, and is divided into three large blocks which serve different functions. Because of these special conditions, Schinkel's theater could not act as a model for other theater buildings, unlike Semper's first opera house (1838–41) in Dresden, which burnt down in 1869 and was replaced by the still-extant second building. With its inner form shown on the exterior, it exercised lasting influence (ill. p. 173, bottom right). The Neo-Renaissance structure vaults towards Theaterplatz, repeating externally the structure of the auditorium inside. The

theater is also notable for the inclusion of a large foyer, beginning a development that would culminate in Garnier's Grand Opéra in Paris (1860–74). The opera house by Laves in Hanover (1845–52, ill. p. 173, top) designed in a round-arch style follows the lead of Hübsch's building in Karlsruhe and can be described as a rectangular, boxy variant of Semper's theater in Dresden. The theaters in smaller princely seats, such as in Coburg (former Hoftheater, 1837–41 by C. B. Harres) or the Wilhelma Theater in Stuttgart by Zahnt (1839–40) were lavishly decorated inside

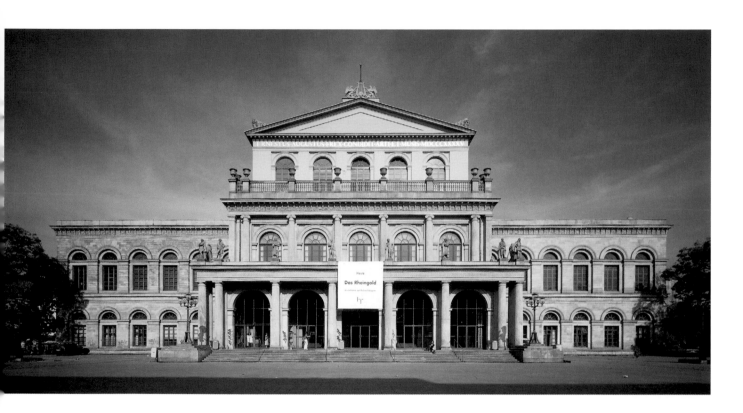

173

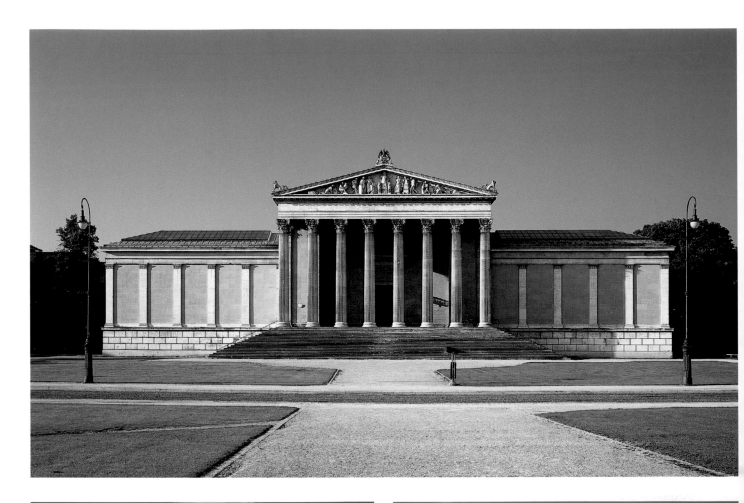

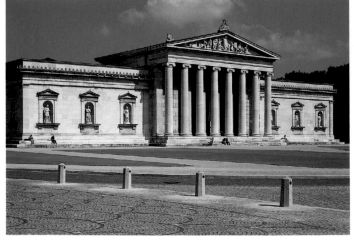

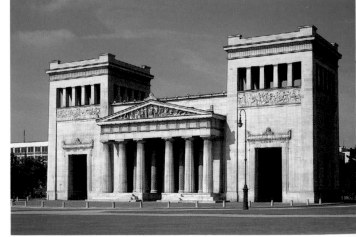

BOTTOM:
Simon Louis du Ry
Museum Fridericianum, 1769–77
Kassel

RIGHT:
Karl Friedrich Schinkel
Altes Museum, 1823–30
Berlin

BELOW RIGHT:
Leo von Klenze
Alte Pinakothek, 1826–36
Munich

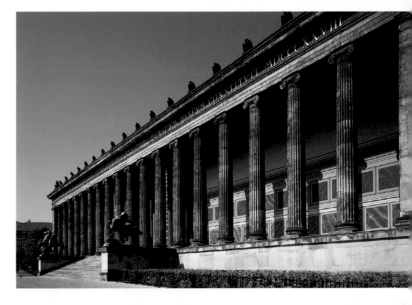

with paintings in the Pompeian style and imitated the styles of the great theaters.

Museum buildings

The stylistic range of theater buildings remained limited to Neoclassical façades, mostly with the Ionic Order and buildings in a round-arch style or Renaissance manner. The same applied to the next important civil building function, which could only come about once a historical consciousness had developed and people saw themselves as part of an ongoing historical process. This is, of course, the museum function. Disregarding predecessors among private collectors, the first building constructed as a public museum is the Museum Fridericianum by Du Ry (1769–77) in Friedrichsplatz in Kassel (ill. p. 175, bottom). The Ionic portico here indicates the museum function of the building and the Neoclassical allegiance of its architect. Admittedly, as a collection center for all sciences and arts with, moreover, an observatory added, the Museum Fridericianum is more like a monumental cabinet of rarities than a modern museum of art, for which an appropriate style, specific sequence of rooms and suitable lighting still had to be evolved. The latter was the objective of a competition launched in 1813 for the construction of the Glyptothek in Munich. Haller von Hallerstein, Fischer and Klenze submitted designs in different styles, and King Ludwig I opted for Klenze's classical version with an Ionic octastyle and low side wings articulated by framed figural niches (1815–30, ill. p. 174, bottom left). Later, Georg Friedrich Ziebland built the art exhibition building opposite (1838–45, ill. p. 174, top) in the same classical style in order to preserve the unity of the square, which was finally completed by the Doric/Egyptian propylæum designed by Klenze in 1846–53 (ill. p. 174, bottom right). Whereas the Glyptothek

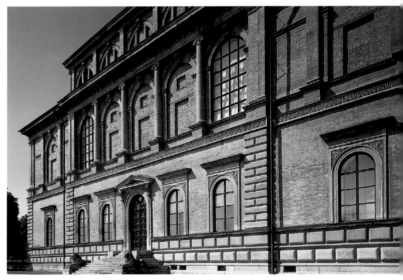

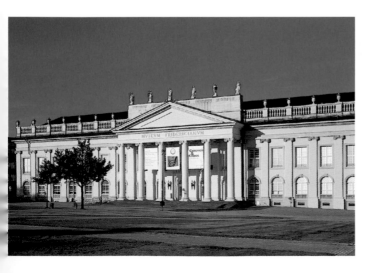

was designed only to exhibit ancient and modern sculptures, the Altes Museum in Berlin, executed 1823–30 by Schinkel, had to absorb a highly diversified collection of art (ill. p. 175, top right). Schinkel's building, in the pleasance opposite the royal palace in Berlin, opens to the square with a long colonnade of Ionic columns. The interior of the Altes Museum, a central hall (ill. p. 155) based on the model of the Pantheon containing an exhibition of sculptures, is reached across an open flight of steps. The remaining collection rooms, arranged as three-aisle halls, are grouped on two stories round two square courts, not always with the special lighting conditions required for works of art. Klenze made a particular effort to overcome these problems and find a reliable solution when it came to building the Alte Pinakothek in Munich (1826–36, ill. p. 175, middle). He opted for an Italian Renaissance style for the elongated building, with pronounced corner wings, involving large round-arched windows that allow light into the side rooms on the upper floor. The large rooms in the

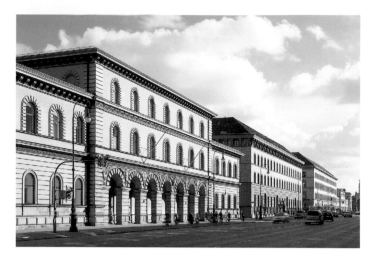

Public buildings

For other civil building functions in the educational and cultural sphere, such as universities and public libraries, similar central sites were sought in towns in order to provide a suitable framework to stress the importance and status of these institutions. In Munich in 1832–43, for example, the Bavarian State Library, State Archives, University and other public buildings were constructed to an overall scheme in the Ludwigstrasse to designs by Gärtner (ill. p 176, top left). This absolutist program of large-scale urban development designed by Gärtner is rounded off by the Ludwigskirche church, the Feldherrnhalle at the south end – based on the model of the Loggia dei Lanzi in Florence – and the triumphal arch at the north end of the boulevard, based on the Arch of Constantine in Rome. The Bavarian Ludwigstrasse in Munich has to be seen as vying in urban grandeur with the Prussian version Unter den Linden in Berlin, which also contained a university, library, theater, arsenal and museum, cheek by jowl with the royal buildings of the palace and the princely palais. There, Langhans' Brandenburg Gate of 1789 with its Doric architecture evoking the propylæum of the Acropolis in Athens (ill. p. 177) rounds off the street. The portico of Schinkel's Neue Wache guardhouse (1816–18), located between Andreas Schlüter's Arsenal and the Altes Museum, echoes Langhans' Doric theme, but goes a step further in the archaeological accuracy of its Doric order, with the battered pylons beside the portico emphasizing the military nature of the building.

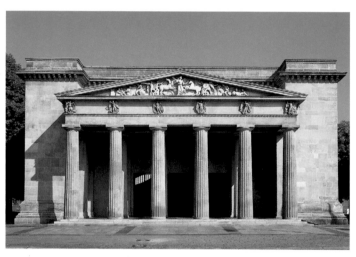

center on the upper floor are top-lit, thus allowing the best possible lighting for the paintings there. This was a solution which set the pattern. The art gallery in Karlsruhe, which Heinrich Hübsch erected in 1837–46 in his "techno-static" style specifically compiled from Romanesque and Renaissance elements (ill. p. 176, bottom right), adopts Klenze's ideas in its functional division. Similarly, the three-wing plan for the Museum of Fine Arts (now Staatsgalerie) in Stuttgart, completed in 1843 by Georg Gottlob von Barth (1777–1843), partially adopts Klenze's ideas, although the general layout is more indebted to designs in Durand's textbooks, which also supplied the principal design idea for Schinkel's Altes Museum. Semper's art gallery in Dresden, erected 1847–55, which completes the Zwinger built by Pöppelmann, displays a style reminiscent of Giulio Romano and Raphael that produces an exaggerated replica of Klenze's Munich building, whose functional attributes Semper adopts and enriches with a showy domed Salon Carré in the middle. The Neues Museum in Berlin, built by Friedrich August Stüler (1800–65) in 1843–55 behind Schinkel's Altes Museum, keeps to Schinkel's strict formal grammar in the exterior, while exploiting modern technology for the extremely fine iron roof and support structures.

Carl Gotthard Langhans
Brandenburg Gate, 1789
Berlin

Langhans designed the Brandenburg Gate on the model of the propylæum on the Acropolis in Athens. Just as in Pericles' day the citizens of Athens entered the shrines on the Acropolis through the ancient gate, so the citizens of Berlin were to cross the threshold into the new Athens on the Spree through the Brandenburg Gate.

In accordance with contemporary taste, Langhans added Attic bases to the Doric columns. In 1806, Gottfried Schadow's *Quadriga* on the top was carted off to Paris by Napoleon, only to return in triumph in 1814. Since then, the Brandenburg Gate has become a national monument.

Church building

Thanks mainly to their belfries, church buildings of both confessions were and remained, even after the French Revolution, the most visible urban structures. During the process of urban improvement and the construction of new suburbs, they remained among the leading construction jobs of the 18th and 19th centuries. New churches also appeared in the city centers, like St. Hedwig's in the center of Berlin in 1772–73, designed by Jean Laurent Legay (c. 1710–86). The round central plan with a portico in front derives, like so many Neoclassical churches, from the Pantheon in Rome. The same applies to the Benedictine abbey church of St. Blasien in the Black Forest, which Pierre Michel d'Ixnard constructed in 1768–83 in what became for the time being the last monumental building for a monastic order (ill. p. 178/179). It features a huge dome rising behind a massive portico on Tuscan columns. In the interior, the niched walls with the altars are flanked by Corinthian columns supporting the coffered dome. In Upper Swabia, as St. Blasien was being built, builders were giving the final flourishes to heavily over-decorated Rococo churches. Thus in St. Blasien, hard and uncompromising, a new style suddenly appeared. Even so, St. Blasien could not act as a model for the further development of church architecture because the monastic orders had lost their once so important role.

LEFT:
Johann Joachim Busch
Ludwigslust city church, 1765–70
Grand Duchy of Mecklenburg-Schwerin

BELOW LEFT:
Johann Carl Friedrich Dauthe
St. Nikolai church, 1783–97
Leipzig, Electorate of Saxony

Enlightened princes such as the grand dukes of Mecklenburg-Schwerin, who commissioned an ideal ducal seat and town from the architect Johann Joachim Busch (1720–1802) at Ludwigslust, encouraged the use of different styles and allowed stylistic experiments. The idiosyncratic façade of the Protestant church in Ludwigslust can only be described as such an experiment (ill. p. 180, top). The portico juts out excessively, the six Tuscan columns are widely spaced, and carry an architrave, pediment and pedestal-like superstructure – all of which is the introduction to a perfectly conventional hall interior. An experiment of a different kind was ventured by Leipzig's architectural supremo Johann Carl Friedrich Dauthe (1746–1816) during the rebuilding of the Late Gothic church of St. Nikolai (1783–97, ill. p. 180, bottom). While the outer walls of the parish church were left in their medieval condition, Dauthe transformed the interior into a veritable blooming garden, with piers converted into palm trees and late Gothic reticulated vaulting transformed into palm leaves. Though Dauthe is here following ideas propounded in the writings of Marc-Antoine Laugier and Francesco Milizia, he nonetheless tries to establish a combination of Gothic lightness and brightness with the grandeur of classical grammar by articulating the side walls and elongated choir with lesenes. Despite his contemporaries' enthusiasm for this unconventional approach, Dauthe's idea was not taken up. Instead, with the liberation wars from Napoleonic occupation as a backdrop, it was to the architecture of the Middle Ages that architects turned for an innately German architecture, and one that was especially suited to church architecture. Following the clarion call for the completion of Cologne Cathedral as a German national monument, reinforced by the splendid engravings of the cathedral by Sulpiz Boisserée, a rash of designs for monuments and churches in Gothic Revival styles broke out. It was, of course, some time before any churches were actually built to Gothic designs.

The Catholic church of St. Ludwig in Darmstadt (1820–27, ill. p. 181) by Georg Moller (1784–1852), who had designed a number of pioneering buildings in the royal seat of Hessen, once again turns to the Pantheon, but comes up with a design highly reduced both grammatically and decoratively. The scheme for the block-like structure of St. Nikolai in Potsdam goes back to designs by Friedrich Gilly in 1797, which was carried out by Schinkel in 1830–37 as a central building on a square ground plan with a lofty dome and extended in 1844–50 by Ludwig Persius (1803–45) with a tall tambour dome and additional corner towers. The Catholic church in Köthen (Gottfried Bandhauer, 1790–1837, ill. p. 182, bottom left), designed in 1827, features the typical cubic forms of the Berlin school of David and Friedrich Gilly and especially the country church designs of Heinrich Karl Riedel. When Schinkel was commissioned to do the Friedrich-Werder church in central Berlin, he

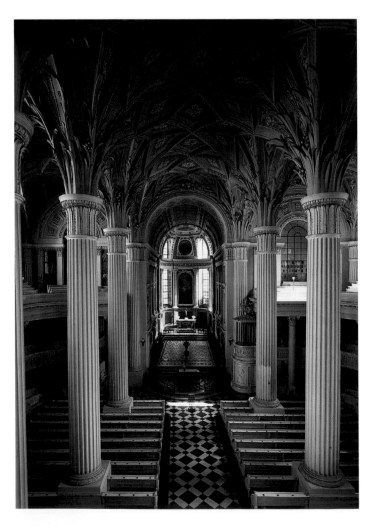

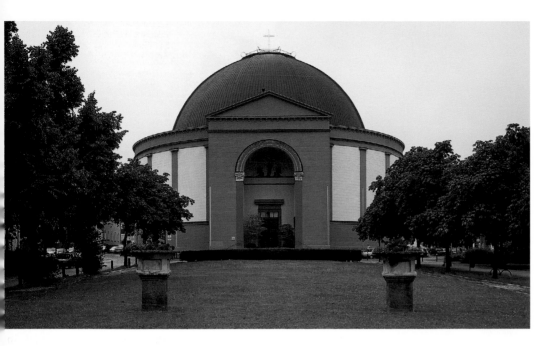

LEFT AND BELOW:
Georg Moller
St. Ludwig's Catholic church, 1820–27
Darmstadt, Grand Duchy of Hessen-Darmstadt
Exterior view (top)
Interior (below)

Moller saw his circular central building as an improved version of the Pantheon in Rome. The cylindrical lower part and semi-circular dome display the stereometric simplicity and clarity of Revolutionary architecture. Inside, the dome is carried on 28 free-standing columns. The original coffering was destroyed by bomb damage.

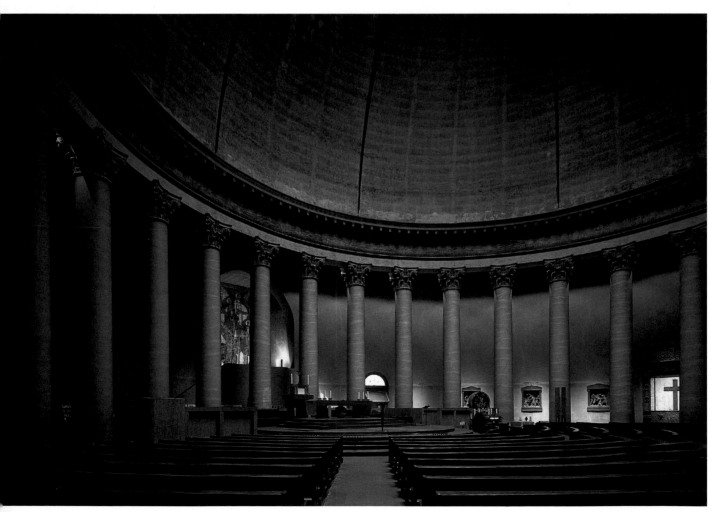

TOP LEFT:
Karl Friedrich Schinkel
Friedrich-Werdersche church, 1825–28
Berlin

BOTTOM LEFT:
Gottfried Bandauer
Catholic church, designed 1827
Köthen, Duchy of Anhalt (Saxony)

BELOW:
Daniel Ohlmüller
Mariahilfe church, 1831–39
Au, Munich, Bavaria

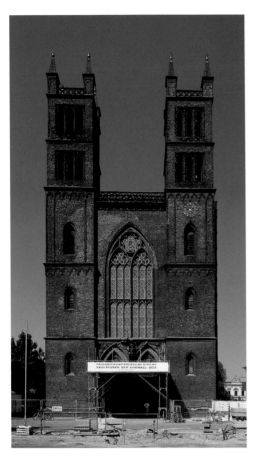

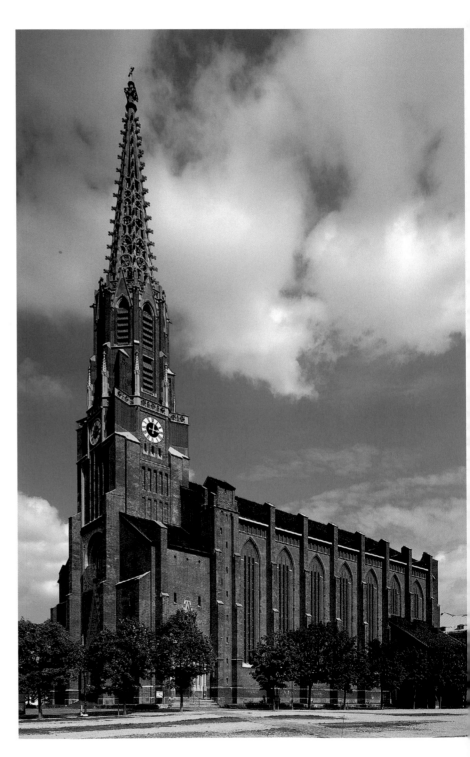

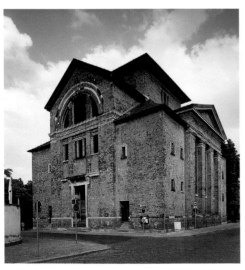

presented alternative designs in Renaissance and Gothic styles. The king plumped for the latter, and Schinkel carried out the work in brick between 1825 and 1828 (ill. p. 182, top left).

The two-tower façade leads into an aisleless church with wall piers and retracted choir. In the execution of the brickwork and details, Schinkel followed the traditions of brick Gothic in northern Prussia, although adapting these in keeping with the times. A similar approach was followed in the new church of St. Peter in Hamburg (1843–49) by Alexis de Chateauneuf (1799–1853) and Hermann Peter Fersenfeld (1786–1853), which as a structure in red brick continues north German tradition as well as introducing new ideas into church architecture. A different approach to the Gothic Revival is evident in the Mariahilfe church in the Munich suburb of Au (1831–39, ill. p. 182, right) by Daniel Ohlmüller (1791–1839), which sticks faithfully to historical Late Gothic to an almost embarrassing extent. Even the three-aisle hall church with ambulatory and west tower can be traced back to specific examples, which are here compiled in a novel unity. A similar picture emerges with the prominent church of St. Apollinaris on the Rhine near Remagen, which the later builder of Cologne Cathedral Ernst Friedrich Zwirner (1802–61) carried out between 1839 and 1843 as a four-tower central structure on a cruciform ground plan (ill. p. 183).

Alongside these Gothic Revival buildings, other styles for church architecture had also gained a footing. A "battle of styles," as it was described in 1844, broke out in the competition for the new church of St. Nikolai in Hamburg between the successful Gothic design of Sir George Gilbert Scott and the rejected Romanesque design by Gottfried Semper, and after the mid-century this led to the development of strange mixtures of styles, such as the Maximilian style in Munich. The roots of the latter can nonetheless be traced back to the late 18th century, where all the factors for the stylistic clashes of the 19th century were first found. Hübsch pursued a mixed style of Italian Renaissance forms for his churches in Bulach (Karlsruhe) and Rottenburg, which he enriched with a new, lighter vaulting design to create light, winsome interiors. In the search for "standard churches" for whole kingdoms, new, cheap-to-produce church designs were developed, though few became reality. Other architects and their clients relied on forms of historical buildings that were reckoned worthy of the high status of church architecture by virtue of their age and their history. For his church of St. Ludwig in the prestigious Ludwigstrasse in Munich, Gärtner turned to 14th-century Lombard church architecture (ill. p. 184) for models. Georg Friedrich Ziebland (1800–73) opted for the model of Early Christian Italian basilicas for St. Bonifatius (1835–50, largely destroyed 1944/45, ill. p. 185, bottom right). The huge five-aisle building with a round-arch arcaded porch not far from the Königsplatz in Munich draws particularly on both S. Apollinare in Classe in Ravenna and S. Paolo in Rome.

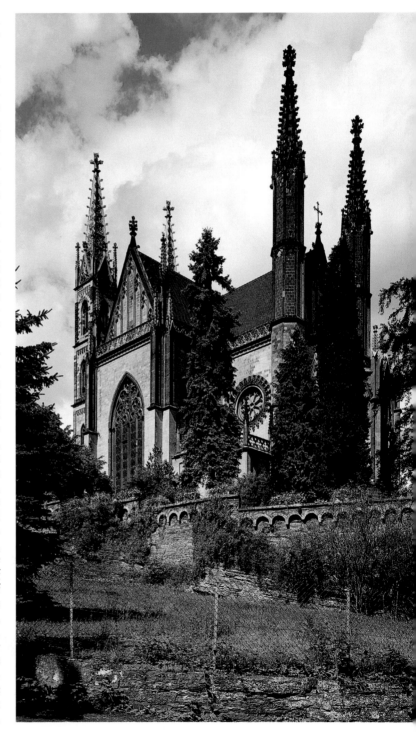

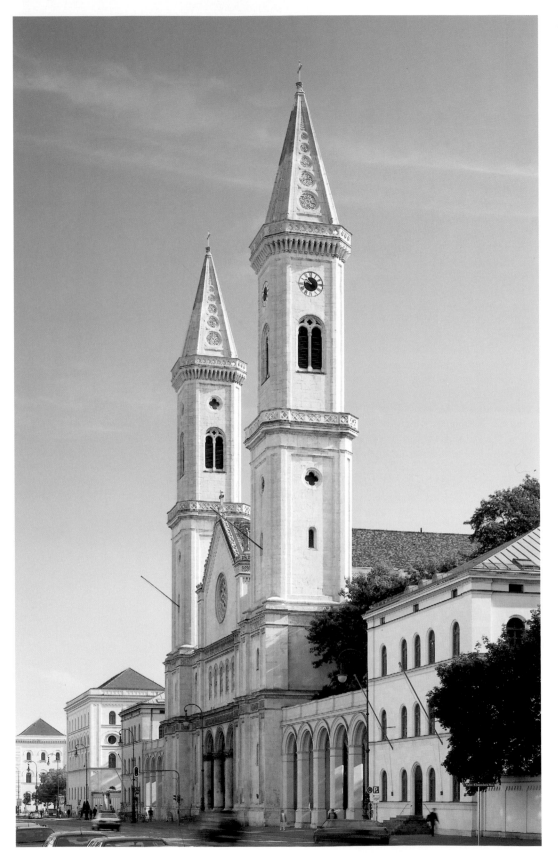

LEFT:
Friedrich von Gärtner
St. Ludwig's church, 1830–40
Munich

OPPOSITE, ABOVE:
Ludwig Persius
Church of the Redeemer
(Heilandskirche), 1841
Port von Sacrow, Potsdam, kingdom of
Prussia

A first sketch of the church of the
Redeemer as an Italianate building with
a detached campanile was made by the
new Prussian king, Frederick William IV.
Standing on an artificial terrace
surrounded by an open arcade, the
church resembles a ship in the water. A
particularly attractive feature is the
contrast between the arcading and the
delicate patterning in variegated brick
on the walls behind.

OPPOSITE, LEFT:
Ludwig Persius
Peace church (Friedenskirche), 1843–48
Potsdam, kingdom of Prussia

OPPOSITE, RIGHT:
Georg Friedrich Ziebland
St. Bonifatius church, 1835–50
Munich
Largely destroyed 1944/45

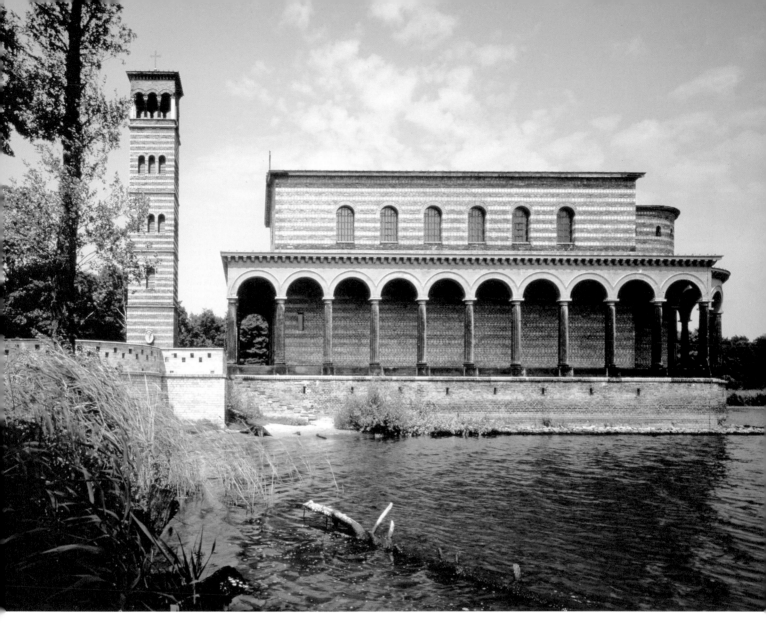

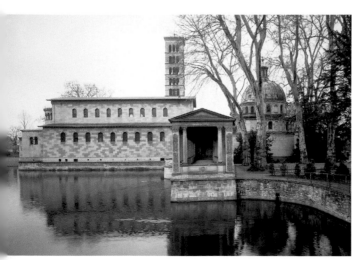

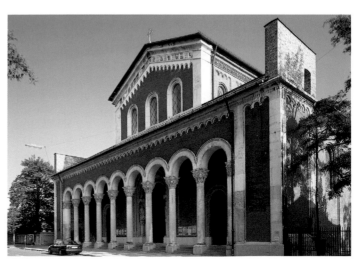

BELOW:
Emanuel Joseph von Herigoyen
Kepler monument, 1808
Regensburg, kingdom of Bavaria

BOTTOM:
Giovanni Salucci
Chapel on Rotenberg hill, 1819–24
Stuttgart, kingdom of Württemberg

OPPOSITE:
Leo von Klenze
Valhalla of the Germans, 1830–42
Donaustauf, Regensburg, kingdom
of Bavaria

enthusiasm for monuments of every kind in Germany, but especially in the whirl of the liberation wars this had led to a veritable cult of monuments. Of course, most of the projects for monuments to rulers, national monuments, Luther monuments to commemorate the 300th anniversary of the Reformation, monuments to the liberation wars and many other causes remained purely notional, and were either never executed or only realised on a small scale. Of the megalomanic designs for a monument to Frederick the Great of Prussia (competition 1796; ill. p. 154, above), all that emerged was an equestrian statue of the revered king. Effectively, all that came of Schinkel's large-scale Gothic designs for a German national cathedral was the spire, in the form of a monument on the Kreuzberg in Berlin, carried out 1818–21 (ill. p. 287). Typical of the late Enlightenment period are monuments to scholars and philosophers, where the classical motif of the monopteron was often chosen, as for example in 1787–90 for the Leibniz monument in Hanover or in 1806–08 for the Kepler monument by Herigoyen in Regensburg (ill. p. 186, top). The great minds of the German nation were also the subject of probably the most impressive monument project of the early 19th century, the Valhalla of the Germans built by Klenze on the Danube near Regensburg in 1830–42. In 1814, the Bavarian King, Ludwig I, had proclaimed a competition, for which Gothic designs were also entered. However, Ludwig favored a Doric peripteral on the model of the Parthenon

Schinkel's pupil Persius turned to S. Clemente in Rome for the Friedenskirche (Peace church) in Potsdam (1843–48, ill. p. 185, bottom left), adding to it a clock tower that is closely related to S. Maria in Cosmedin in Rome.

Monuments

Irrespective of the particular choice of style in each case, what these churches have in common is an isolated position, in the middle of an open space. This lent the churches the character of monuments, over and above their religious function. It is especially true of the chapel on Rotenberg hill near Stuttgart (1819–24, p. 186, bottom), which was planned and constructed by Salucci as a burial site for the prematurely deceased Queen Catherina. Salucci had managed to beat off Gothic Revival designs by Joseph Thürmer (1789–1833) and Weinbrenner's pupil Johann Michael Knapp (1793–1861), but had to scale down the gigantic dimensions of his project in order to carry it out. The circular structure now appears as a combination of Palladio's Villa Rotonda and the Pantheon, which is directly imitated in the coffered dome and oculus. Erected on the site of the Württemberg family *Schloss*, the burial chapel on Rotenberg hill assumes the functions both of a Greek Orthodox church and burial chapel plus a monument to the kingdom of Württemberg. Since the French Revolution, there had been great

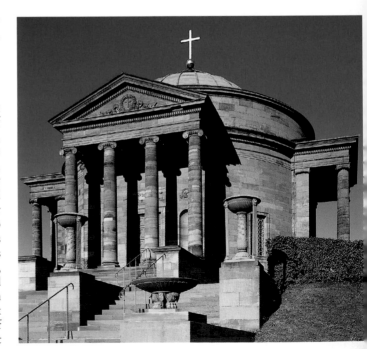

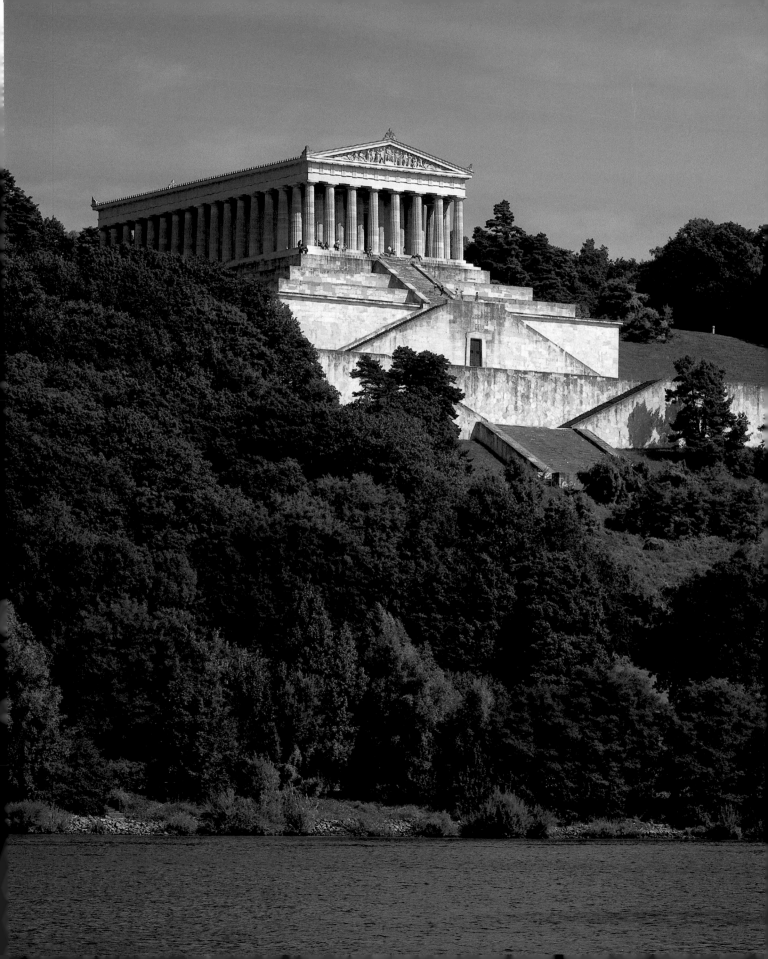

Leo von Klenze
Valhalla of the Germans, 1830–42
Donaustauf, Regensburg, kingdom of
Bavaria

The Doric temple of the exterior opens
up in the interior into a large hall, divided
into three parts by wall piers and top-lit
through an open roof. Several tiers of
marble busts of famous Germans line the
walls. The gallery level carries the names
of people from the Dark Ages and
medieval times who left no portraits
behind. The Valkyrie caryatids in the
loggias were carried out to designs by
Klenze. In the center of the entrance to
the side rooms, the enthroned figure of
King Ludwig I of Bavaria, founder of
Valhalla, was installed in 1890, blocking
the uninterrupted view into the
opisthodomus and the scenery outside
the window.

Leo von Klenze
Liberation Hall, 1836–44
Kehlheim, kingdom of Bavaria

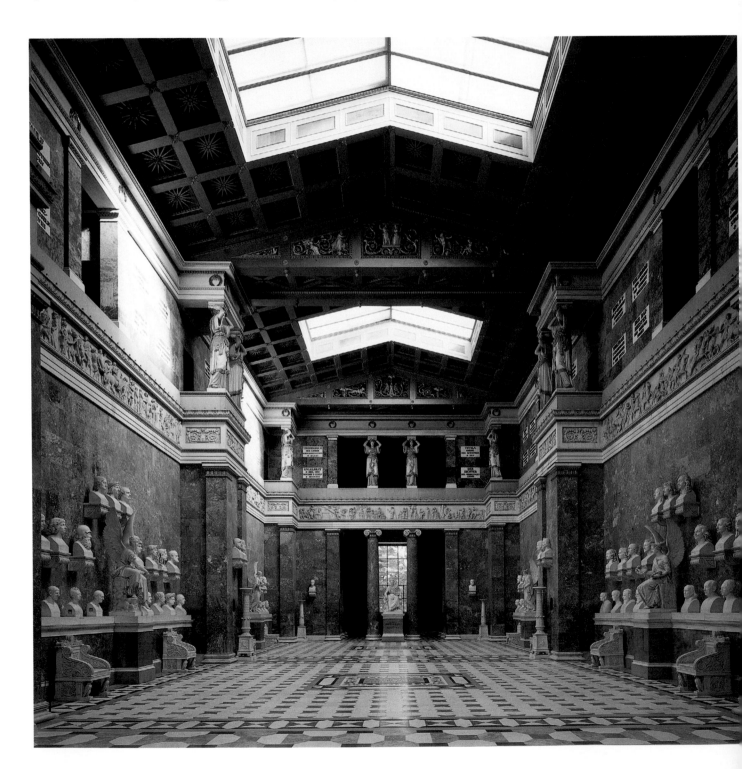

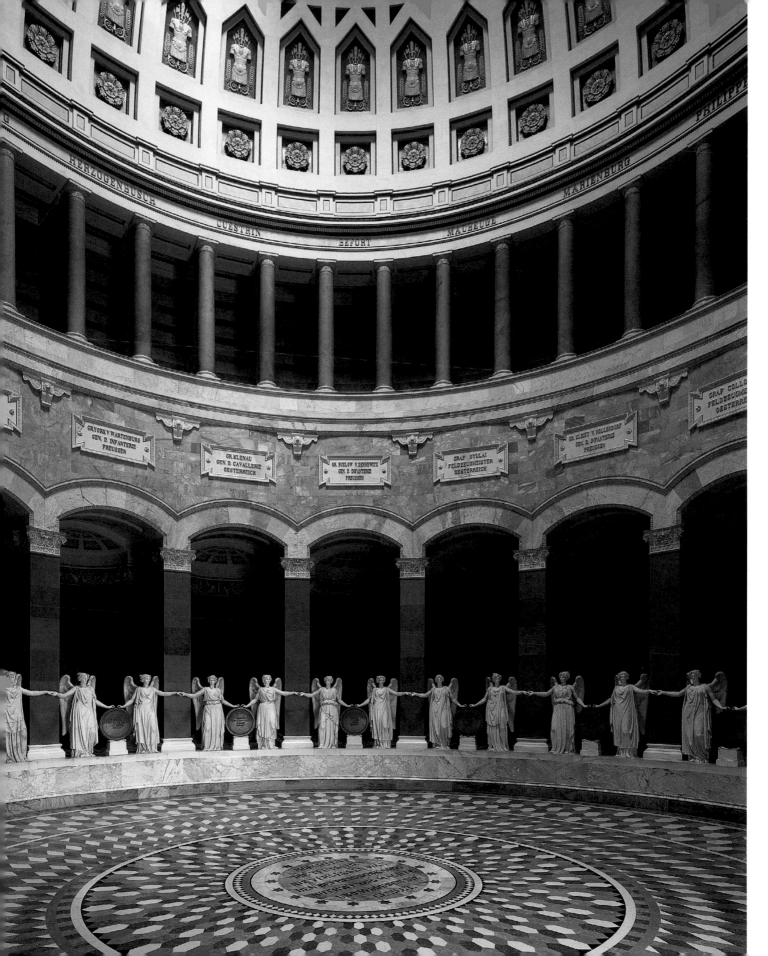

Leo von Klenze
Liberation Hall, 1836–44
Kehlheim, kingdom of Bavaria

OPPOSITE:
Ludwig Persius
Pumping house, 1841–43
Potsdam, kingdom of Prussia

on the Acropolis in Athens. It now dominates a riverside site at the head of a cascade of steps (ill. p. 187). Inside, the temple is designed in a thoroughly modern way as a hall with wall piers and top lights, while busts and statues of famous German people line the walls (ill. p. 188).

Klenze's hall of fame on the Theresienwiese in Munich (1843–50) again uses Doric columns, whereas his liberation hall in Kehlheim (1836–44, ills. p. 189/190), a round structure articulated by lesenes, is stylistically reminiscent of Durand, who had been the principal source of Klenze's design for a Luther monument in 1806.

New building tasks

In 1834, Semper had accused German architects of either following the "chessboard chancellor" Durand or copying historic façades on to oiled paper. It had, he felt, come to the point that all cities looked like the quintessence of all countries and centuries, and contemporaries no longer knew what century they belonged to. This negative assessment can largely be confirmed, because

even in the realm of architecture, where new ideas might at least be expected in industrial building, only history appeared to be up-to-date. The Schülesche Cotton Factory in Augsburg (1770–72) by Leonhard Christian Mayr is typical of the industrial architecture of the late 18th century, conceived in the style of an absolutist *Schloss*. Even later buildings fail to shake off historical antecedents, and in the age of the steam engine and nascent mechanization seek to beautify industrial processes with historical styles. An example is Persius' pumping engine house for Sanssouci, Potsdam (1841–42, ill. p. 191), constructed in a playful Moorish style that is more reminiscent of the *fabriques* of landscape gardens than a building for the latest pumping technology. In the train station building, too, where architects had the rare opportunity to come up with something really new, history was the sourcebook. Thus Ottmer built the first Hanover station in the Gothic style (1838) and the second (1843–45) in a Neoclassical style, while Friedrich Bürklein's Munich station (1848) adopted the round-arch style. In Germany, the use of

190

BELOW:
Heinrich Gentz
Royal Mint, 1800
Berlin
(demolished)

BOTTOM:
David Gilly and Peter Joseph Krahe
Offices for publishers Vieweg Verlag,
1800–07
Burgplatz, Brunswick

the concept of "character," in which every part of the structure is designed according to its function. The battered, rusticated plinth and ponderous center projection were intended to endow the mint building with the appropriate solidity. The Doric columns of the main entrance confirm this "heavily rustic" character. A frieze designed by Friedrich Gilly and carried out by Gottfried Schadow illustrating minting provided a transition to the main story, which received the mineral collection of the mint and was therefore emphasized by the large lunettes. The large Wyatt windows of the top floor were justified by Gentz on the grounds that the interiors needed a lot of light. The same approach was probably used by David Gilly and Krahe for the design of the Vieweg Verlag publisher's building in Burgpltz, Brunswick (1800–07, ill. p. 192, bottom right). Here too, the "strong, vigorous, solid and yet rich style" was intended to bring out the character of the publishers as a production center. Peter Speeth (1772–1831) designed the prison in Würzburg (1811–27) below the castle on the principle of "speaking" architecture: it is a three-story cubic block with a heavily rusticated plinth (ill. p. 192, bottom left). The door, set in a semi-circular arch, tapers towards the ground, producing an oppressive feeling on entering. The ten columns over the doorway are popularly said in Würzburg to represent the Ten Commandments. Less graphic, but just as uneasily hovering between rejection and instruction, was the character of the penal institutions in Insterburg (1832), Sonnenberg (1834), Cologne (1834), and Halle/Saale (1837). Great emphasis was now placed on the functional accommodation and surveillance of prisoners, and in

modern construction materials such as cast and wrought iron was limited to roof structures, ceilings, minor bridges, staircases and balconies. Modern glass and iron structures for station sheds, exhibition buildings and wide-span bridges date from after the middle of the century, by which time the country had caught up with England and France.

There were, of course, attempts to develop a new architectural grammar for industrial buildings. Gentz, for example, worked out a scheme for the Royal Mint in Berlin (1800, ill. p. 192, top) based on

Erik Palmstedt
Palace Theater, Gripsholm, 1781

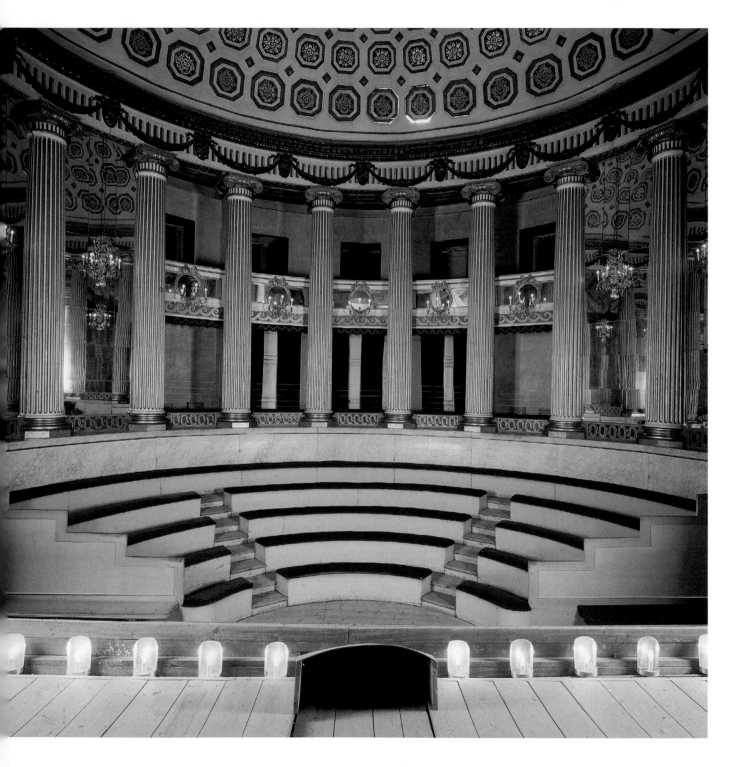

C.F. Harsdorff
Frederiks Chapel, Cathedral, Roskilde, 1774

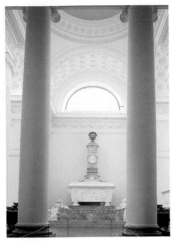

C.F. Harsdorff
Frederiks Chapel, Cathedral, Roskilde, 1774

C.F. Harsdorff
Moltke Chapel, Karise, 1761–66

Hamburg merchants. Simple façades featured rusticated stonework at the corners and flat rusticated stonework on the ground floor. Hansen employed a temple portico design with Ionic or Corinthian columns for the entrances, which were surmounted by a triangular pediment. When fire razed the Christiansborg Palace and Town Hall – as well as several nearby buildings in 1794 and 1795, Hansen was commissioned to reconstruct them. He designed the Town Hall and Courts from 1805 to 1815, providing the latter with a broad façade that was oriented towards the Kongens Nytorv and placing an impressive portico with Ionic columns on the central axis. The façades at the sides were furnished with portals, each with three tall windows in the upper floor. From the portico the visitor entered a spacious vestibule with four Doric columns, while the court room with Corinthian columns opened to the rear. From this room extended a niche for the judges' bench – a feature taken from the apsidal designs of Roman basilicas.

While Hansen was engaged on this work, yet another catastrophe befell the Danish capital. In their struggle to lift the continental system imposed by Napoleon in 1806, the English forced the Danes to hand over their fleet to prevent it from falling into French hands and so being used to seal off the Baltic Sea. Copenhagen was bombarded by the Royal Navy for three days and nights, and the city was extensively damaged. The buildings destroyed included the 12th-century cathedral, the Vor Frue Kirke (Church of Our Dear Lady, ill. p. 196, bottom).

RIGHT:
Christian Frederik Hansen
Vor Frue Kirke
(Church of Our Dear Lady),
Copenhagen, 1829

Hansen presented his first designs for the reconstruction of the church in 1808. Building began just a few years later and was completed in 1829. The architect positioned an antique temple frontage before a rectangular building. The triangular pediment of the façade featured a sculpted scene of Christ's Resurrection, while over this there rose a massive tower whose proportions seemed not to match those of the building itself. The interior space was divided by rectangular piers, which were provided with niches for figures representing the apostles. A gallery with an Ionic colonnade ran above the piers, and Hansen designed the apse to accommodate a statue of Christ made by the sculptor Bertel Thorvaldsen.

This pure "Greek" form of Neoclassicism was unable to make any headway in Finland. Carl Ludwig Engel, a German who had studied in Berlin under Schinkel, arrived in Finland from Estonia in 1809, later making the acquaintance of the leading Finnish architect Albert Ehrenström in 1814. Engel took up the Baroque idea of using multiple axes to divide his buildings, attempting to combine this technique with the clear lines of Neoclassicism. In 1818 he received a commission for the Senate in Helsinki, for which he designed four wings around a central courtyard. The ground floor was given a façade of rusticated stonework, while the central projection of the façade was empha-

sized by three great entry arches, which concluded at the second floor. Over these he set six Corinthian columns with a triangular pediment to highlight the importance of the Senate halls that lay behind them.

Engel's most spectacular building, however, was the Church of St Nicholas in Helsinki, which was raised to the status of a cathedral in 1959 (ill. p. 197, top). He designed the building in 1826 on the plan of a Greek cross, combining this with a monumental flight of stairs to the north. The church's four arms, each of which has its own portico, appear like two interlocking Roman temples. Engel placed a central cube flanked by four small towers over the crossing, and topped i

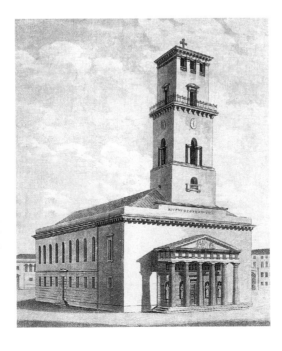

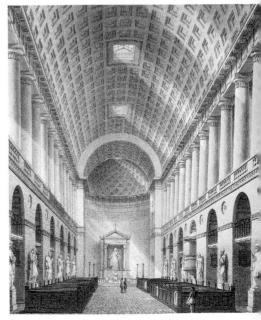

BELOW:
Carl Ludwig Engel
Church of St. Nicholas, Helsinki
begun 1826

BOTTOM:
Hans D.F. Linstow
Royal Palace, Oslo, begun 1823

with a drum and dome. This spectacular structure would eventually become the city emblem of Helsinki.

In the Treaty of Kiel, signed in 1814, Denmark ceded Norway to the Swedes, allowing Norway to develop politically and economically as an autonomous country under the Swedish crown. Sweden's Crown Prince Karl Johann, now King of Norway, built his royal palace on a commanding hill to the north of Oslo (ill. p. 197, bottom right). As his architect he selected the Dane Hans D.F. Linstow, who planned the building as a complex of two wings joined by a central section of three floors; each of the wings were to be two floors in height. The main façade featured a projection with an arcade on the ground floor topped with a portico. Designs for the interior were inspired by Schinkel – particularly a house he had built in the Pompeiian style, and which Linstow examined on a trip undertaken for this purpose to Germany. Linstow was able to engage the services of P.C.F. Wergmann to carry out the stucco and polychrome work in the interior.

Two years after starting work on the building, Linstow received a commission from the King to integrate the palace into an overall urban plan that would provide for the royal residence to be connected with the fjord along a central axis. Linstow designed for this a boulevard leading from the palace down to the city's cathedral. Today's Karl-Johann-Gate reproduces this route more or less exactly. At the foot of the palace hill, where the boulevard began, Linstow laid out a broad square, divided by streets, which was to accommodate the university. Today the National Gallery, the Historic Museum, the University and the National Theater are all located on this site.

Scandinavian Neoclassicism covers a wide range of styles, ranging from the late Baroque concept of multiple axes in the buildings of Finland, via the French – and later Roman/antique – tendencies of the Gustavian Style of Sweden and Norway, to Hansen's Danish architecture, which was modeled on the lucid idioms of Greek Antiquity.

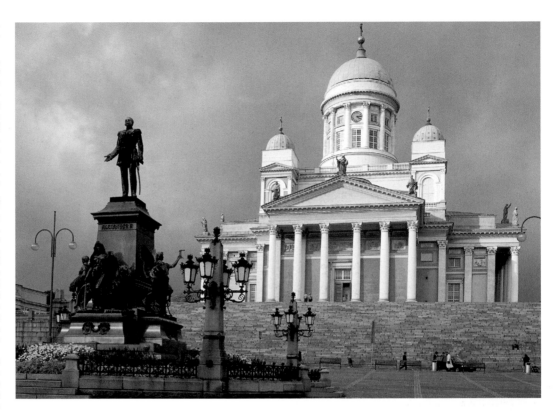

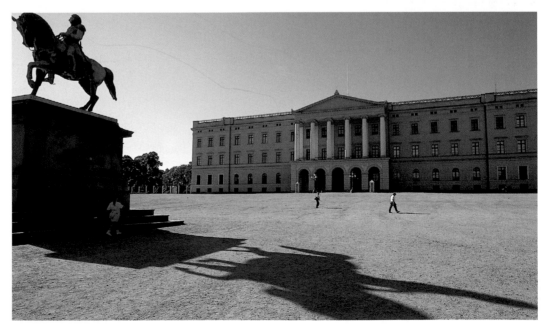

Peter Plassmeyer

Neoclassical and Romantic Architecture in Austria and Hungary

Like many other European countries, the variety of architectural styles in the Habsburg dominions is too wide-ranging for them to be encapsulated in terms of Romanticism and Neoclassicism. A highly diverse array of architectural forms and functions emerged between the late Baroque and Rococo eras of the first half of the 18th century and the urban influences of Historicism in the second half of the 19th century. Common features of the period can be seen most clearly in the more modest dimensions of buildings, and the design of clearly tectonic structures with a tendency to plain, open walls. An examination of several striking examples of architecture from this period will illustrate just how diverse building forms were in Austria around 1800, and what aspects they may have in common. Prominent Viennese buildings will, of course, occupy a dominant role in this overview, but important instances of architecture from former Habsburg domains in Hungary, Bohemia, Moravia and northern Italy will also feature.

After the reign of Maria Theresa, the idea of the monarch as an exemplary patron of architecture receded increasingly into the background. This trend reached a peak with the separation of court and state architecture under Franz II (I), when in the pre-1848 period "bureaucrats' architecture" became the genre's real flagship. From the beginning of the century the traditional relationship between the architect and his princely patron retained its importance only in the circles of the high nobility. The demarcation between client and architect was initiated in 1785 with the inauguration of an Office for Public Buildings, and it culminated in the establishment in 1809 of a Court Construction Committee which was responsible for examining the technical and financial aspects of all public projects. This measure led to a monotonous public architecture whose ideals were anchored in the principles of Joseph II's court. Court construction projects were largely restricted to altering existing buildings, the most significant of these achievements being the remodeling and extension of the Hofburg, together with the design of the square in front of it, and the reconstruction of the city's fortifications, which had been blown up by Napoleon's troops.

Residential and sacral buildings accounted for the greatest number of projects. The latter were characterized both by a series of mostly narrow-aisled hall churches and by places of worship for the Protestant, Orthodox, and Jewish communities, who were permitted to construct their own independent assembly room for the first time under the Edict of Toleration issued by Joseph II. In addition, the buildings of the public administration (schools, courts, hospitals, railway stations etc.) achieved an urban profile that could no longer be overlooked.

Joseph II and his favorite architect, Isidor Canevale, broke radically with the styles of Baroque tradition. Any kind of decorative element was avoided, and the proportions recommended in architectural treatises were dealt with in an almost ironi

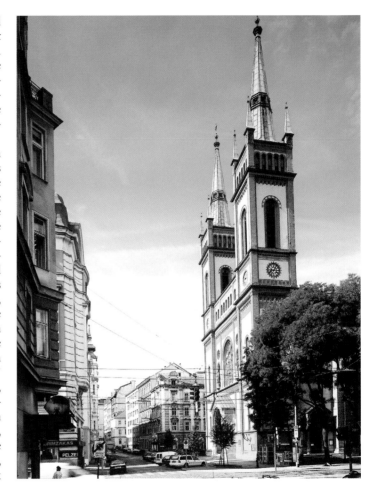

fashion. A classic use of pilaster and column did not appear until the reign of Franz II (I) (with the Festival Hall in the Hofburg). At the same time Franz had the so-called "Franzensburg," a complex of buildings with battlements, erected in the palace gardens of Laxenburg (ill. p. 209, top). While this type of monument is commonly known as "Romantic," anti-Classical architecture with battlements only emerged in Vienna after the revolution of 1848, after it had earlier appeared in the countryside alongside the Neoclassical style.

It is difficult, and even futile, to try and arrive at a clear definition of "Neoclassical" and "Romantic," especially as some buildings involved a mix of styles. One example of this is the building of the Altlerchenfeld Church (1848–1861). After the foundations were laid in 1848, events led to a sensational change of architect. The church's design had been provided by Paul Sprenger, director of the Court Construction Council and the most influential pre-Revolutionary architect in Vienna. Sprenger had more or less voluntarily committed himself to work in a severe, flattened Neoclassical style with limited décor. This official building policy, however, was successfully opposed by the Engineers' and Architects' Union, which had been founded in the wake of the March revolution. The decisive incident in Paul Sprenger's "overthrow" was a lecture given in 1848 by the young Swiss architect Johann Georg Müller to the Architects' Union. The title of his address was: "German church buildings and the new Renaissance church of Altlerchenfeld." Müller criticized the Neoclassical building – and, in particular, Sprenger's design – so resoundingly that work on it was immediately called to a halt. After a new competition was held, in which only members of the Architects' Union were invited to participate, Müller was commissioned to continue the construction. He proceeded to integrate Sprenger's foundations into his plan, building a basilica with a nave and two aisles of undressed brick

with a double tower on the western façade, a short transept and an octagonal dome over the crossing (ill. p. 199, right). Conspicuously, Müller's design is not as far removed from Sprenger's ideas as the building's complex history might indicate. It was essentially the style of the church's appearance that changed: pilasters were replaced by lesenes, and a frieze over a round arch took the place of the entablature. Apart from the altered décor, however, the basically Neoclassical building masses, preferred by the Court Construction Council, were retained. The individual parts of the building merely became more clearly graduated, and the building in general appeared more slender.

One of the architectural curiosities of the reign of Joseph II also has a similarly unusual relationship to Neoclassicism: the remodeling of several Viennese churches in Gothic style. In the 1780s Joseph commissioned the court architect Johann Ferdinand

could be seen in the open way the buildings' construction and disposition were structured. In that sense, the Gothic renovation project is much closer to the purist architecture of Canevale than to a form of "Romantic" Historicism.

Hungary

The first shot in the architectural war against Baroque frivolity in the lands of the Habsburgs was fired by Isidor Canevale in the Hungarian town of Waitzen (Vàcz), where he erected a triumphal arch (ill. p. 200, top) and cathedral for Cardinal Migazzi. The arch was commissioned by Migazzi to mark a visit by the royal couple. The radical nature of its form was impressive, as was the fact that it was not simply built from temporary material as a festival arch. As one of the first permanent triumphal arches, it heralded the arrival of this type of structure in the 18th century. In Waitzen its purpose was not only to welcome Franz Stefan and Maria Theresa, but also, more importantly, to mark the beginning of an urban revival after a long period of Turkish rule. The city was to be extended beyond the bounds of the old center, and this triumphal arch, therefore, was less a reminder of a specific historical event than a symbol of the beginning of a glorious future.

While the royal visit was occasioned by the marriage of Cardinal Magazzi's niece, it was also a state visit to a newly flourishing city. Migazzi was a life-long loyal subject of the Empress, who had appointed him Archbishop of Vienna, later also giving him the important Hungarian bishopric of Waitzen (a post he had already once held). Eventually Migazzi became a cardinal

Hetzendorf von Hohenberg – who was responsible for the city's outer districts – to remove the late Baroque chapels and altars from the Augustine and Minorite churches and to restore them to their medieval condition, by which was probably meant the creation of a uniform Gothic appearance.

What seems like a prologue to the Historicism of the 19th century is in fact only the continuation of Joseph's logical rejection of Baroque excess. Hetzendorf did not include any coffered barrel vaults or Corinthian columns, but instead consistently kept to the original architectural framework of both churches. Yet he maintained a fundamentally Neoclassical approach in the manner of Isidor Canevale. These buildings did not strive for a Neoclassicism of column and entablature, but rather for one that

Isidor Canevale
Cathedral façade, Waitzen (Vàcz), 1760–77

The façade was part of an urban design in which the church and an adjoining colonnade were to form the perimeter of a square on the model of St. Peter's in Rome.

Joseph Hild
Cathedral façade, Eger (Erlau), 1831–39

In Hungary the new Waitzen cathedral was followed by a whole series of new church buildings on Neoclassical lines. At Eger the façade is defined by a monumental stairway and a portico of columns, while the domes indicate Byzantine influences.

Work on extending the city had already been started by his predecessor, Archbishop Count Esterhazy, in 1759; a cathedral and college with a square defined by a colonnade – based on St. Peter's in Rome – had been started just outside the gates of the old city.

The most conspicuous feature of Canevale's triumphal arch is its complete lack of columns and pilasters. These architectural elements are replaced by a flat wall surface, which is designed to conceal the forward-facing walls of the arch, its unifying entablature and, as a highlight, its keystone – located in a recessed area of the wall. This latter feature is all the more noticeable for the fact that the feet of the arch rest on an impost. The arch's "cladding" sits on stately podia, while the attic is separated from the lower section by a denticulated cornice and a curious frieze, showing eagles bearing garlands. Only the portrait medallions and the inscription situated between them on the attic provide the viewer with information on the origins of the arch. On the city side, between the double portraits of the prince and princess, are the words AETERNAE DOMVI (To the eternal house). Guests are greeted on the entry side and there learn who it was that erected the triumphal arch in their honor. The city side expresses the hope that the dynasty will rule in perpetuity.

Canevale's design for the façade of the cathedral in Waitzen, in which the architectural elements are set against a flat windowless wall, is similarly consistent (ill. p. 200, bottom). The façade was planned as the focus of a square which was to be framed by colonnades in the manner of St. Peter's in Rome. The side façades of the church are indeed noticeably small and show a marked resemblance to the church of Sant' Andrea in Mantua by Leon Alberti Battista. Another prominent feature of the church is the way the dome with its distinctive lantern rises from the roof of the nave without the aid of a drum. Canevale had to incorporate the foundations of his predecessor, F. Anton Pilgram, into the building. In the interior, too, he continued the Baroque tradition magnificently represented by Franz Anton Maulbertsch's monumental ceiling fresco.

The cathedral in Waitzen served as a model for other Hungarian churches, such as the cathedrals at Esztergom (Gran, ill. p. 202), Eger and Szambathely (Steinamanger), all of which eagerly sought to express a monumental Neoclassical style, though in a less consistent fashion. The ideals of Neoclassicism were not exclusively used by the Catholic Church to show its reverence for

Rome, for the main Calvinist place of worship in Debrecen also employed a portico with columns and twin towers on its façade. Because the body of the church consists only of a transverse nave adjoined by a flat choir, the twin towers of the façade seem strangely outsized – an effect which is heightened still further by the uncompleted dome over the "crossing."

The Primatial Church at Gran represents the pinnacle of Neoclassical cathedrals in Hungary. It had been one of the most important churches in the country ever since its archbishops were granted the right to crown Hungary's kings in 1111. Devastated during the sieges of the Turks, this diocese was not occupied again until 1820, when Franz I transferred the primate's seat from Nagyszambat to Esztergom. Plans to build a new church to replace the one heavily damaged during the Turkish wars were pursued from the 1760s, when Canevale was charged with surveying the town's castle hill. The planning process did not begin to take on contours until 1820, however. Restoring the primate's seat to the town required extensive new building work. The director of the Court Construction Office in Vienna, Ludwig von Remy, and the Eisenstadt architect Paul Kühnel developed a complex of buildings which borrowed from the examples of the Escorial and the Vatican in Rome to link cathedral, chapter houses, bishop's palace and seminary. Johann Packh reduced the

scale of Kühnel's designs after 1824, and Joseph Hild completed the cathedral by 1845, after yet another revision of the plans.

Situated high above the Danube, the façade is dominated by the monumental columns of the drum – although the designs originally called for this to have a blank surface area. The dome reaches to over 70m in height and is supported by 24 columns. The frontispiece, with its 57-meter-high projecting corner towers and lavish sculptural ornamentation, rests on ten Corinthian columns. St Peter's in Rome provided the model for this church, as it had for the cathedral in Waitzen. An informative series of 24 design sketches by the architect Peter von Nobile, drawn in 1824, shows that the work was originally intended to be articulated in a more severe formal language, similar to that of the Waitzen cathedral. It also sought to compete with the world's most famous domed buildings, such as the Roman and Parisian Pantheons, St. Peter's in Rome and St. Paul's in London, as well as Fischer von Erlach's Charles Church in Vienna.

Sant' Antonio in Triest demonstrates that, of all Austrian architects, Nobile was the most sympathetic to Canevale's ideas. The relationship of windowless wall surfaces, portico, and building masses to the massive attics and calotte is a logical continuation of Canevale's approach. It was Nobile who was the first to use the classical Doric order in Austria, employing it in the Outer Burgtor and in the Temple of Theseus (ill. p. 209, bottom).

OPPOSITE:
Johann Packh, Joseph Hild
Cathedral, Gran (Esztergom), 1824–45
Rear façade on the Danube

BOTTOM:
Isidor Canevale
General Hospital and Fools' Tower,
Vienna, 1783–84
Historical Museum of the City of Vienna

BELOW:
Isidor Canevale
Portal for the Augarten, Vienna, 1775

MIDDLE:
Isidor Canevale
Josephinum, Vienna, 1783–85
Library

Vienna and environs

After work in Hungary and an interlude as architect to the Princes of Liechtenstein, Isidor Canevale arrived in Vienna, becoming Emperor Joseph II's court architect. In this capacity he had, amongst other things, special responsibility for the outskirts of the city. Just as Joseph introduced a new style of politics to the Hofburg, so too Canevale broke with the tradition of Viennese Baroque. This is most radically demonstrated in the so-called Fools' Tower in the grounds of the General Hospital, which was built as an asylum for the "deranged" (ill. p. 203, bottom). Canevale erected a cylindrical building whose walls were originally completely faced in rusticated stonework. Combined with its slit windows, this meant that the building took on the appearance of a fortified structure. Indeed, the design was closer to prison architecture than to the style normally used for hospitals. The limited space for building led to the construction of a compact, multi-floored building, while behind the narrow windows, cells were arranged in a radial pattern and were connected on the courtyard side by a corridor. The cells were only accessible through the warders' area, which divided the courtyard in two – an arrangement that enabled supervision and care of the patients to be carried out using a minimum of staff.

The portal of the Augarten is another demonstration of Canevale's knowledge of French Revolutionary Neoclassicism. As court architect, he was responsible for the royal parks, the Augarten and Prater, which Joseph II opened to the general public. For this reason he built an entrance portal at the Augarten which featured the motto "A place of recreation dedicated to all by he who cares for you." The semi-circular arch of the gateway is crowned by a heavy attic, and it is adjoined on both sides by tripartite entrances, which in turn are flanked by guardhouses in rusticated stonework. The almost radical self-sufficiency of this

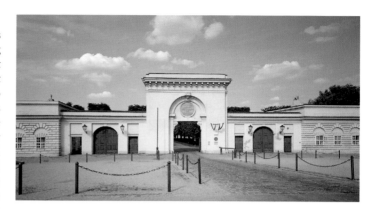

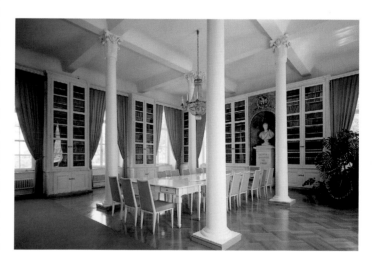

architecture could not be more distinct from the open space of the park itself. More radically than at Waitzen, the stereometric elements of Canevale's gateway appear here like a template whose sole decoration consists of a silhouette medallion and inscription of dedication.

Giuseppe Piermarini's designs for the Josephinum (1783–1785) on the Währingerstrasse were thoroughly reworked by Canevale, especially in the interior, so that no trace of the Baroque survives. Used as an academy of medicine and surgery, Canevale planned the arrangement of space and ornamentation strictly according to utilitarian considerations. In the library, for example, the ceiling is supported by simple cast-iron columns (ill. p. 203, middle). Composed of three wings and separated from the street by a grille fence, the building is part of the General Hospital complex, which Joseph II based on similar buildings in Paris. It has been described as Vienna's last Baroque building.

Canevale's reductionist architecture emerged against a Neo-classical backdrop and influenced his Viennese contemporaries. Ferdinand Hetzendorf von Hohenberg who, as court architect had long remained faithful to the Baroque tradition, built a city palace for the most prominent Viennese banker of the day, Count Fries, on the Josephsplatz between 1783–84. The radical quality of the design was not consistently adhered to in its execution, but it did show how influential Canevale's work was. The palace was built on the grounds of the dissolved Queen's Monastery, which was adjoined at the rear by apartment buildings. Initially the sole articulation of the façade was provided by the axes formed by the windows. The great portal with its caryatids, as well as the triangular pediments over the windows, were only added in response to the vehement criticism of this "naked" building by other architects. Hetzendorf also diverged from the standard design in the interior by locating the living space on a mezzanine floor in order to have a lower ceiling height, and thus save on heating costs. The reception rooms, which were less often used, were shifted to the top floor. Hetzendorf not only adopted the splendor of the established style of Viennese Baroque palaces; he also used contemporary forms in the spirit of Canevale. It remains uncertain whether the critical voices of his professional peers were raised against the architect or his client, who, as a recently ennobled banker, had dared to construct his Viennese residence directly by the Hofburg – so in an area hitherto reserved for the upper stratum of the aristocracy. Joseph II's efforts to eliminate the privileges of the aristocracy and, as Emperor, to withdraw from representative functions found concrete expression in the simplified façades of public buildings. At the same time, officers' careers were opened up to non-aristocratic candidates. Fries' "city house" was to demonstrate both aspects of this changing society: an aristocratic, even monarchic, understatement in form as well as proof of the new possibility of attaining to aristocratic privilege by virtue of diligence.

A monumental, Neoclassical architecture of the Western European type only became part of Viennese architecture with the proclamation of the Austrian Empire by Franz II (I) in 1804. Recognizing the increasing need to represent the interests of the state in architecture, he first had a ceremonial hall built in the Hofburg, in which freestanding columns support a coffered ceiling. The architect was Louis Montoyer, who had made a name for himself in the southern Netherlands with work of monumental Neoclassicism in the Palladian mold. Montoyer had arrived in Vienna in 1795 with Albert von Sachsen-Teschen. Soon afterwards, Montoyer also used columns in a façade when he designed a Neo-Palladian palace for the Russian envoy, Prince Rasumofsky, from 1803. The festival hall of this palace is patterned on the ceremonial hall of the Hofburg (ill. pp. 204/205 and p. 206 top).

The use of columns in façades was to remain the exception rather than the rule, but they can be found in two prominent

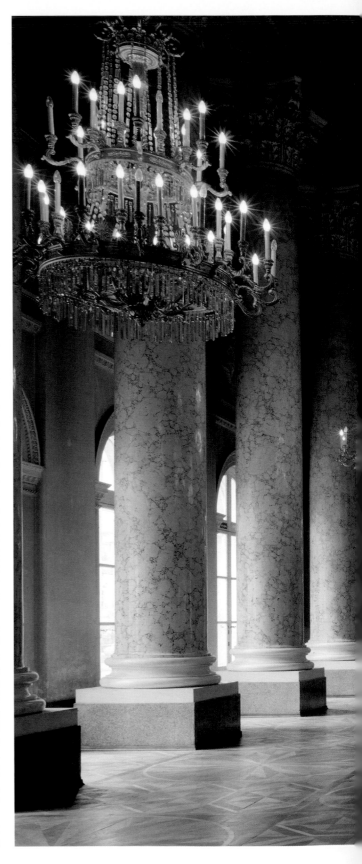

TOP LEFT:
Louis Montoyer
Palais Rasumofsky, Vienna, 1803–07
Façade

CENTER LEFT:
Joseph Kornhäusel
Weilburg, Baden near Vienna, 1820–23,
destroyed 1945. Historical photograph

BOTTOM:
Joseph Kornhäusel
Albertina, Vienna, 1822–24
Former ballroom and music room

to a disastrous fire in 1812, virtually all the most prominent architects in the capital took part in its reconstruction, thereby creating one of the most homogeneous ensembles of pre-Revolutionary architecture.

Kornhäusel was neither an architect of the court, nor was he otherwise graced with an official commission. His clients were members of the aristocracy, religious congregations and the aspiring bourgeoisie. Today, his tenement buildings are the clearest evidence of Vienna's growth prior to the construction of the Ringstrasse. They are an impressive synthesis of compact masses with flat wall surfaces and monumental Neoclassical elements – though it is his interiors that create the most striking impressions. He made up for the restraint in the design of his façades by lavishly furnishing his interiors. Whether it was the library of the Scottish Foundation, the synagogue in the Seitenstettengasse (ill. p. 207), or the music room and ballroom in the palace of Duke Albrecht von Sachsen-Teschen – remodeled for Archduke Karl and today the Study Hall of the Albertina – he invariably showed a playful treatment of monumental columns and pilasters, coffered ceilings, barrel vaults, calottes fitted galleries as well as a skillful use of light – elements which seem to go against the grain of his understated façades. It is Kornhäusel's interiors that, above all, challenge the faceless façades of the first decades of the 19th century.

That the architecture of the pre-Revolutionary period is often rated so low has much to do with the function of the Court Construction Council, which was required to test all public building projects for their technical and economic feasibility. In so doing it tended to "unify" façade designs. An impression of urban

palaces in the Vienna area. In Eisenstadt, Charles Moreau extended the Esterhazy Palace, enhancing the garden frontage with a colonnade. In a design only partially completed, Moreau reworked motifs by Claude-Nicolas Ledoux, whose "house of four belvederes" he quoted in the central section, extending the building at the sides with two wings ending in cuboid pavilions. He broke through the severity of Ledoux's designs, lightening them by adding colonnades of the early monumental type found in Victor Louis' theater in Bordeaux and Charles de Wailly's "Odéon" in Paris. Several years later Moreau's design was again taken up by Josef Kornhäusel when he built the Weilburg near Baden for Archduke Karl (1820–23, destroyed 1945) (ill. p. 206, middle). Weilburg was the most important Austrian palace of the pre-Revolutionary period, consisting of several distinct and stereometric components with separate roofs; a broad colonnade also extended in front of the compact central structure.

The small town of Baden, south of Vienna, is notable for its Neoclassical ensemble. When almost the entire town fell victim

Joseph Kornhäusel
Synagogue, Vienna, 1824–26
Interior

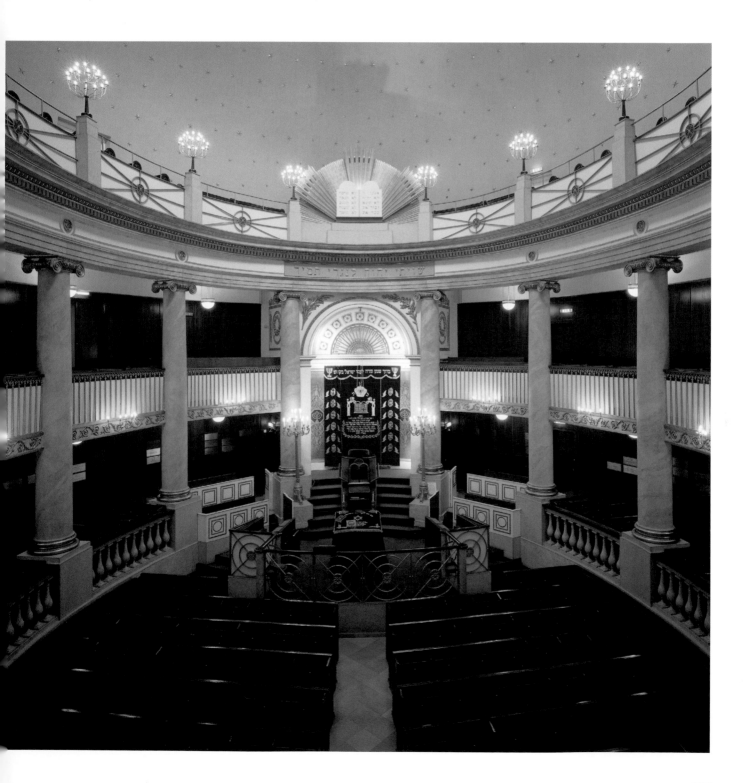

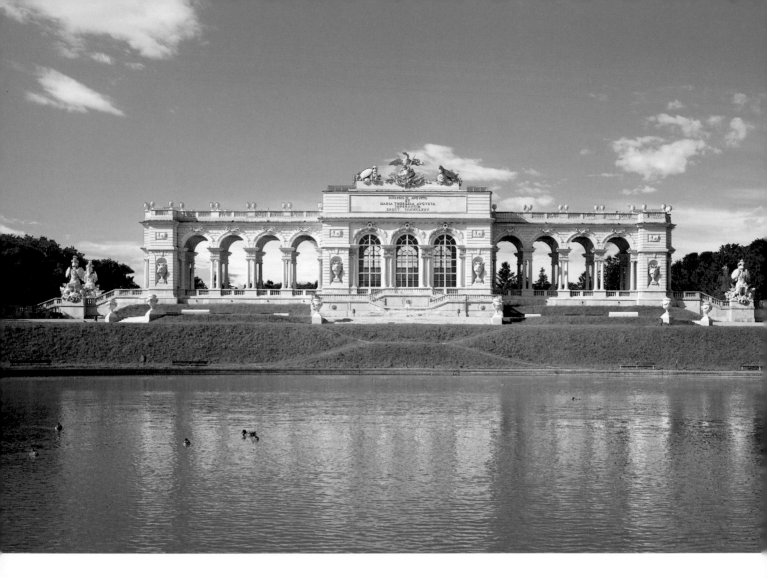

monotony resulted, especially from the uniform façades of buildings erected under the Council's direction such as Paul Sprenger's Central Mint and Johann Aman's Veterinary School with their vapid and formalistic façades. Recent research has shown, however, that these buildings do not necessarily reflect the skills of the designing architects, due to the official bureaucracy's insistence on following the regulations restricted the architects' creativity.

The most important art form of the late 18th century was landscape architecture. In contrast to other artistic genres in which the Baroque was followed by Neoclassicism, the Baroque French garden arguably had no Neoclassical successor; rather, it was replaced by an artificial conception of "Nature." The follies distributed throughout these parks represent a cross-section of architectural history with Greek and Roman temples and ruined castles. Renaissance palaces are situated alongside Neo-Gothic buildings, and cast-iron bridges and hydraulic technology appear as evidence of the Industrial Revolution (see pp. 230–249).

This type of park was developed in Britain in the second half of the 18th century and was emulated on the Continent in gardens at Wörlitz near Dessau, and in Prince Pückler's garden near Muskau. In Vienna Joseph II and Franz II (I) converted the garden of their summer residence at Laxenburg into an English garden, beginning in 1782, and they equipped this imposing Romantic park with numerous monuments and pavilions. The most notable buildings were the Concordia Temple (1795), the showgrounds with their tribune (1800), and the House of Whims (1799), which was built to resemble a ruin. Hetzendorf, too, used early forms of landscape garden in his redesign of the Schönbrunn Palace park, erecting an obelisk and an artificial ruin as *points de vue*. The most eye-catching feature, however, is a gloriette – situated on a hillock at the end of the main axis – whose architecture is taken from the Baroque tradition. The main building at Laxenburg is the Franzensburg, situated on an artificial island. Its halls integrate architectural set pieces taken from other Austrian palaces and monasteries (ill. p. 209, top). Built as a medieval castle with towers, battlements, walls, and graves, it was much emulated from the 1840s onwards. Other English gardens were created on the periphery of Vienna in the Wienerwald (for instance, the Schwarzenberg Garden in Neuwaldegg), but without employing architecture of any consequence. The most interesting landscape project involving an important architectural contribution was commissioned by the princes of Liechtenstein in the Moravian town of Eisgrub.

Ferdinand Hetzendorf von Hohenberg
Schönbrunn Palace Park, Vienna,
1775
Gloriette

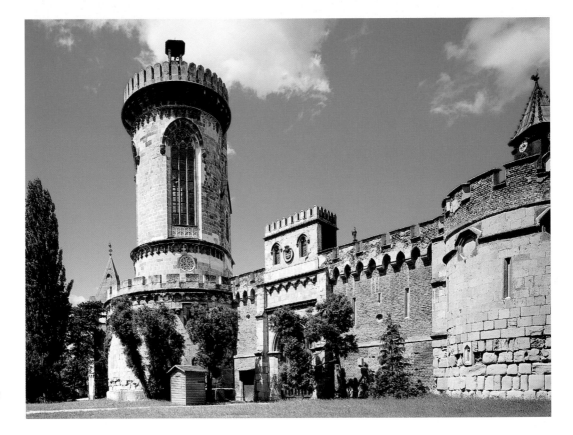

Franzensburg, Laxenburg
begun 1782

The battlemented architecture of the
Franzensburg, which is situated on an
island in the grounds of the royal
summer residence of Laxenburg, was,
until the mid-19th century, a model for
many of the palaces built in the
Habsburg domains.

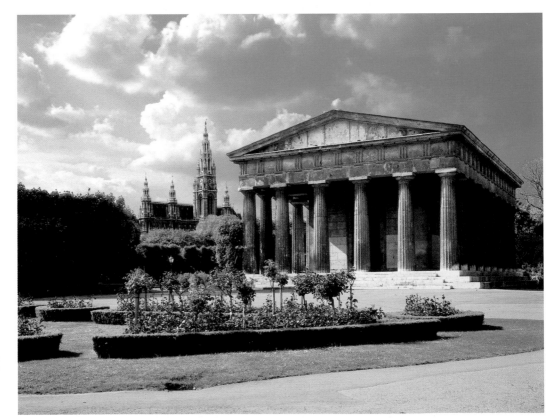

Peter von Nobile
Temple of Theseus, Vienna, 1820–23

The temple is built after the antique
Thesaion in Athens and was the first
building in Vienna to be used exclusively
as a museum: Antonio Canova's *Theseus
Fighting the Centaurs* was originally
exhibited here. Nobile used the classic
Greek Doric order here, as he also did
with the Outer Burgtor.

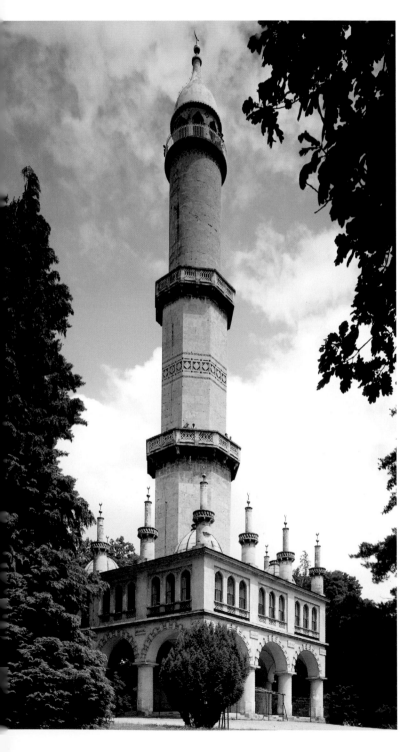

The Liechtenstein Garden at Feldsberg and Eisgrub

One of the most interesting collections of Neoclassical and Romantic buildings can be found situated along the Thaya on the border between Austria and Moravia. Along the seven-kilometer avenue which connected their residences at Feldsberg and Eisgrub, the princes of Liechtenstein laid out a landscape garden on the English model with buildings from a variety of different architectural styles. From the 13th century to 1945 both locations were inextricably linked to the House of Liechtenstein, and in the 16th century Feldsberg became the main seat of the princes, along with their summer residence at Eisgrub.

The extension of Eisgrub began when Prince Johann Adam commissioned the architect Johann Bernhard Fischer von Erlach to build stables for his horses. This "Palace of the Steeds" was built as a three-wing complex with a wall to the rear, and its dimensions overshadowed that of the palace itself. The region around the palaces was strongly agricultural, and it was developed by the princes into a flourishing economic enterprise. What horses were to Eisgrub, the princes' herd of Swiss cows were to Feldsberg. It was only towards the end of the 18th century that Prince Johann Josef I of Liechtenstein began to regulate the countryside, laying out the gigantic landscape garden that still exists today. Working from designs by Cajetan Fanti, marshes were drained, the course of the river altered, artificial lakes dug and islands built. The prince's botanists gathered exotic plants and trees from around the world, their preference being for species from America. The essential idea behind all these plans was to make agriculture more efficient as well as to breed new plants and animals. The princes' architects – Joseph Hardtmuth, Joseph Kornhäusel and Franz Engel – created an architecture of follies, pavilions, miniature palaces and all the other accoutrements of an English garden. The park was also a hunting ground, and this led to a whole series of buildings that were used during and after hunts.

Apart from various landscape gardens in England, the model for this park was principally provided by the garden at Wörlitz near Dessau. Nevertheless, the park at Eisgrub is unique both in terms of its dimensions and the size of its buildings, which are more than just follies. Among its most impressive buildings is the 68-m-high Turkish Tower (ill. p. 210), which Joseph Hardtmuth built in 1797 as a viewing platform by the Swan Lake (excavated in 1790). The podium of the octagonal tower is built on a square ground plan, whose perimeter is marked by an arcade. Each of the three arches of the arcade corresponds to three round arched windows in the floor above. Piers continue past the cornice to become small towers, and the individual floors of the tower are separated from each other by external galleries.

For several decades, architect Joseph Kornhäusel co-operated with the sculptor Josef Klieber, a working relationship possibly reaching its peak in the Temple of Apollo. At the foot of the

BOTTOM LEFT:
Joseph Hardtmuth and Joseph Kornhäusel
Landscaped garden, Feldsberg (Valtice)
Triumphal arch/Temple of Diana, 1812

BELOW:
Joseph Hardtmuth and Joseph Kornhäusel
Landscape garden, Feldsberg (Valtice)
Reistenberg colonnade, 1812

BOTTOM:
Franz Engel
Landscape garden between Feldsberg
(Valtice) and Eisgrub (Lednice)
Temple of the Three Graces, 1824

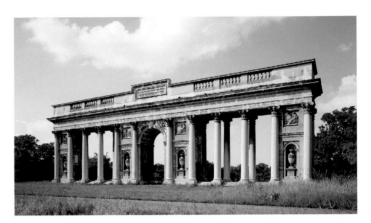

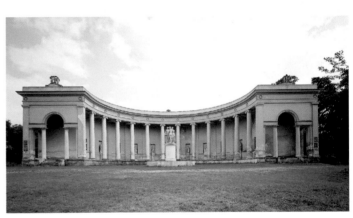

calotte on the great central conch is a frieze showing Apollo in his sun chariot. The barrel-vault in front of the calotte rests on the entablature of a Tuscan colonnade, enclosed on both sides by a balustrade of figures. In the evening the conch concentrates the rays of the setting sun.

Another variation on the colonnade theme is seen in the Reistenberg colonnade. It was begun in 1812 by Joseph Hardtmuth and completed by his successor, Joseph Kornhäusel, after Hardtmuth retired from royal service. The attic extends for four intercolumniations at both sides of a triumphal arch, the outermost supports of the structure featuring the same design as the arch itself. They also contain staircases leading up to the terrace on top of the attic. Johann Hohenberg von Hetzendorf's gloriette in the palace grounds at Schönbrunn clearly inspired this work, though Hardtmuth and Kornhäusel domesticated this type of architecture through their use of sculpture.

From 1812 Hardtmuth built the more traditional triumphal arch of the Temple of Diana, whose interior was also completed by Kornhäusel. A great hall is located on its top floor, reached by a spiral staircase. The room served as a breakfasting hall after the hunt. The various buildings in the park served as tribunes for guests as well as resting places during the hunt, and probably also as a type of raised hide. Because they were built on hills or in clearings, they offered excellent views. The Temple of the Three Graces (1824), and the Border Palace (1826/27), both by Franz Engel, also served as resting places for hunting parties. The Temple of the Three Graces is a semi-circular colonnade faced with Palladian motifs. The colonnade encloses the eponymous group of figures by Klieber. The small Lake Palace by Kornhäusel,

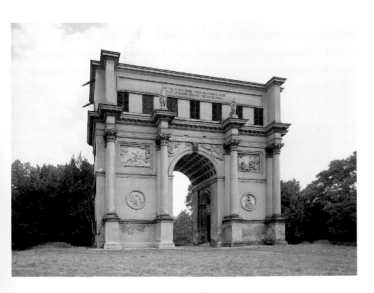

built less than a decade earlier, lay along a line of sight on a nearby hill. An almost square structure, the central projection of its façade is crowned with a gable. It also features a balcony and a barrel-shaped entrance.

The Border Palace by Franz Engel (1826/27) was named after its location on the border of Moravia and Austria and is a variation on a Palladian villa with a central section, two side pavilions and connecting wings (ill. p. 212, top). Its central axis has an arcade of three arches, which form a loggia. The connecting wings are lined with terraces with a wall to their rear; they offer a view over the landscape surrounding the lake and across to the Temple of Apollo.

Other buildings are the typical follies found in English gardens, such as Hardtmuth's ruin of a "Roman" aqueduct (1805), from which water originally flowed into the Swan Lake – the pumps required were constructed by the engineer Gabriel Burda. The Hansenburg, too, belongs to the traditional canon of landscape architecture. Ruined castles were built at several of the Liechtenstein estates in Lower Austria and Moravia. The four-winged complex of

the Hansenburg with its massive round towers was the largest of these. Its interior housed a great Knights' Hall and a collection of weapons.

The Neuhof (1809) was built by Hardtmuth in the tradition of the Eisgrub and Feldberg stables for the prince's then-famous herd of Swiss cows, and was located between these two residences. Both long sides of this extended rectangle are marked by arcades, and its arches are occupied by barred gates. The façades at the sides are formed by self-contained wings of cowsheds and barns. In the center of the side that faces towards Eisgrub, Franz Gruber inserted a circular building to accommodate the stables and a salon from which the cows could be observed.

The miniature Baroque palace at Eisgrub was replaced in the mid-19th century by an imposing Neo-Gothic complex (ill. p. 212, bottom). With its flag-tower, battlements and oriels it is modeled on castles found in England and Germany, but it also looks to the Franzensburg in the Laxenburg Palace park. Other examples of this type of architecture were later built in Bohemia and Moravia. The architect of the palace, Georg Wingelmüller, built the adjoining glasshouse – one of the earliest examples of its kind.

At the same time (1840–47), Prince Johann Adolf Schwarzenberg replaced his residence in Frauenberg (Hluboká) in southern Bohemia with a Neo-Gothic palace, designing it after Windsor Castle, but retaining a strict sense of symmetry. The Harrach Palace in Hrádek near Königgrätz in North Bohemia, too, was indebted to English models, but employed the principle familiar from the Franzensburg of re-using sections of older buildings. All three clients – Harrach, Schwarzenberg, and Liechtenstein – had been educated in Britain, administering their estates according to the latest British ideas. The original family seat of the Liechtensteins, a ruined medieval fortress near Mödling, was also reactivated in 1808, when it was redesigned in the Romantic manner. Large sections of the original building appear to have been intact, and it was not until after 1873 that it was "completed" when a second floor and a main tower were added. Both a conservation measure and a restoration, the castle at Mödling showed how far the "Romantic" castles of the second half of the 19th century had come from the artificial ruins popular in the second half of the 18th century, which had emphasized an intimacy with nature.

213

Hildegard Rupeks-Wolter

Neoclassical Architecture in Russia

Russia opens to the West

After the Baroque era of Elisabeth I (1709–61), the Neoclassical age in Russia was ushered in under, Catherine II (1729–96). In the first years of her reign she represented the ideals of enlightened absolutism, and her reforms led to a new political and social climate in the country. During her 34 years on the throne she ensured that the Russian Empire made a contribution to wider European debates, whether political, economic or cultural. Catherine was a worthy successor to Peter I (1672–1725), a monarch who had sought to bind his nation closer to Europe. Indeed, Catherine thought of herself as Peter's heiress – a fact testified to by the inscription on Étienne Maurice Falconet's equestrian statue for Peter the Great made between 1768–82: "Petru pervomu Ekatherina vtoraya"/ "Petro primo Catherina secunda."

An historical overview is required for a proper understanding of the background to this epoch. Peter I had initiated a comprehensive restructuring of Russia. A decisive, ambitious – and often ruthless – man, he abandoned old structures, broke with tradition and set his stamp on an entirely new lifestyle. His first European journey of 1697/98 arose out of his study of the European cultures and technology he had encountered in the foreign quarter of Moscow. The impressions gained on these travels led him to introduce fundamental reforms in administration, the economy and culture. The birth of this new era was represented by the rejection of the Byzantine calendar for the Julian calendar favored in the West. He showed enormous courage and energy in building a new city during the Great Nordic War (1700–1721), and from 1703 St. Petersburg finally provided Russia with access to the Baltic Sea. The Tsar brought artists and architects from throughout western Europe to this massive construction site on the River Neva. The new capital city (the imperial residence was transferred there in 1713) became, in the words of the poet Alexander Pushkin, a "window onto Europe." Victory in the Nordic war secured Russian hegemony in eastern Europe and brought Russia recognition as a European political power. This triumph caused Peter to drop the title of Tsar and assume the imperial title and epithet of "the Great."

The Age of Catherine II

In 1745, on the recommendation of Frederick the Great, the German Princess of Anhalt-Zerbst married the heir to the Russian throne, Peter III (1728–62). Later, as Catherine II, she ascended to the throne as the result of a coup and became a decidedly Russian and nationalist ruler. True to the spirit of the Enlightenment, Catherine was highly educated, who corresponded with Voltaire, Diderot, Rousseau, and Baron Grimm. Her attempt to reform the Russian state by means of legislation ultimately failed. In 1767, Catherine wrote the Great Instruction as an introduction to the preparation of a new legal code. Guided by the basic principle of "Russia is a European power," she

Jean Baptiste Vallin de la Mothe and
Alexander Kokorinov
Academy of the Arts, St. Petersburg
1764–1788, ground plan

adopted the ideas of western European philosophers, especially Montesquieu's "De L'Esprit de Lois." Peasant revolts occurred regularly from the time of Catherine's accession, though they were easily crushed. During her reign, her formerly enlightened attitudes receded ever further. Although Catherine considered abolishing serfdom, she retained it as she relied on the support of the nobility, thus it was to her advantage to entrench their privileges. The constant intrigues of domestic politics were balanced by successes in foreign policy, resulting in pushing the borders of the Empire farther to the west, extending them as far as the Black Sea in the south. The Empress devoted herself with the same vigor to matters of education, and was a committed patron of the arts and sciences. Catherine II was well aware that a modern state required a new architectural language, and this opened the path for a change in style to Neoclassicism.

Commission for Stone Architecture: St. Petersburg and Moscow

In St. Petersburg, Alexei Kvassov drew up a general development plan that took account of the needs of this growing city. He retained three main axes of the city center on the left bank of the Neva (the Admiralty side), and planned a regular network of streets, whose houses would have uniform frontages. The river banks were given granite walls and the canals spanned with stone bridges. The Baroque architecture of Elisabeth I emphasized the location of palaces, while under Catherine a wealth of new public building types were developed: educational institutions, judicial and administrative buildings, banks, hospitals, commercial buildings, and warehouses. As well as native Russians, the new monarch was able to draw on the skills of Italian and French architects who had previously taught at the Academy of Arts founded by Elisabeth. This institution promoted a lively exchange between Russian and western European artists, and a number of Russian scholarship holders from the Academy traveled abroad. In Rome – their preferred destination, along with Paris – they extended their knowledge of Antiquity. Later generations of architects encountered the writings of Winckelmann and the architectural treatises of Vitruvius and Palladio. The buildings of Moscow and St. Petersburg are evidence of these encounters, which provided a stimulus sufficient to allow a unique style to emerge.

The First Phase of Urban Architecture in St. Petersburg: Vallin de la Mothe, Velten, and Rinaldi

Between 1764 and 1788 the Academy of the Arts was housed in a new imposing building according to plans by Jean Baptiste Vallin de la Mothe (1729–1800) and Alexander Kokorinov. De la Mothe, a Frenchman, was one of the most important of the foreign architects and had been called to the Academy in 1759. The building, one of the first Neoclassical structures in the city

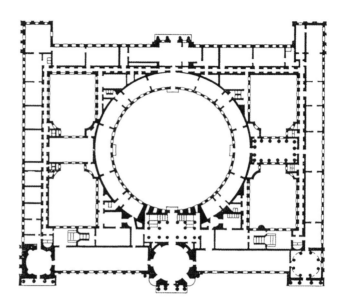

and erected on Vassilyevski Island, had a rectangular ground plan with a large, round inner courtyard surrounded by four smaller corner courtyards. Here the teaching and residential rooms were sited. The main façade was towards the Neva and showed a new, Neoclassical design: the plinth was in rusticated stonework with round windows; on top of this base were two floors, arranged in strict symmetrical fashion by three projections featuring porticoes and pilasters. The central section of the façade was given greater emphasis by its portico of Doric columns and loggia, though the concave and convex curves of the central projection still expressed the Baroque spirit.

Catherine II was a tireless collector of western European art. Through her ambassadors she systematically bought up whole collections abroad, advised by Baron Grimm, Diderot and the sculptor Falconet. The basis of the picture gallery was established in 1764 with the purchase of the collection of a Berlin businessman named Gotzkovsky. In the same year Catherine founded the Little Hermitage. With its imposing raised ground floor of rusticated stonework, this building merges with the neighboring Late Baroque Winter Palace, whose floors show a similar design in the vertical plane; above the ground floor sit the six Corinthian columns of the portico, regally surmounted by an attic (ill. p. 216, left).

The capacity of this building soon proved inadequate, however. Extensions carried out from designs by Yuri Velten (1730–1801) followed the model set by the Old Hermitage (1771–1787), thus the name Hermitage came to be applied to all the rooms in which paintings were exhibited. These buildings and the later addition of a theater meant that the Winter Palace developed into a prominently

Jean Baptiste Vallin de la Mothe
Little Hermitage, St. Petersburg
1764–1775, Neva façade

Yuri Velten
Old Hermitage, St. Petersburg
1771–1787, Staircase

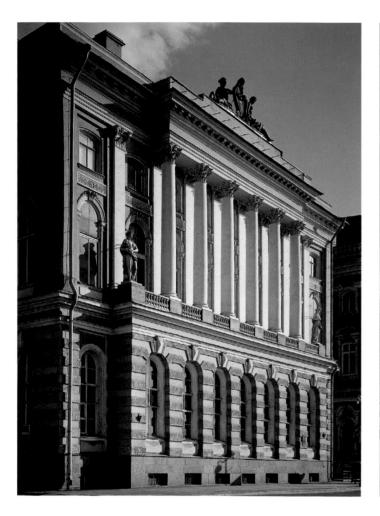

positioned riverside ensemble. The final form of the structure acknowledged both its status as a public building and the development of the collections as a new royal commission.

Another strand of Neoclassicism is found in the royal lodge and church at Tchesme, two buildings situated between St. Petersburg and the summer residence at Tsarskoe Selo. The palace, commissioned by Catherine in memory of a naval victory over the Turks, derives its architecture from English medieval castles. The five-domed church (1777–1780) marked the first appearance of a pseudo-Gothic style in Russia. Built on a quatrefoil ground plan, the church is virtually shrouded in a network of these stylistic elements, combined with exotic devices from Turkish architecture.

Catherine II attained the throne with the help of the Orlov brothers, and as a gesture of thanks she appointed them to high-

ranking positions in the government and military. Gregory Orlov was her particular favorite and she presented him with one of the most beautiful palaces in St. Petersburg, the Marble Palace (1768–1785). The Italian architect Antonio Rinaldi (1710–1794) designed the Palace as the terminus of the Neva Quay, and in so doing made it a counterweight to the Winter Palace.

The Old Capital of Moscow
The Planning of the Kremlin and Redevelopment of the City: Bazhenov and Kazakov

As well as building her capital in St. Petersburg, Catherine the Great devoted her attention to one of her most enduring projects the reconstruction of the old capital of Moscow, whose medieval appearance she disliked. Coronations continued to be held in this

BOTTOM LEFT:
Yuri Velten
Tschesme Church, St. Petersburg
1777–1780, view from the north-west

BELOW:
Kremlin complex, Moscow, view from
the Moskva, right: Great Kremlin Palace,
1838–1839, K.A. Thon

BOTTOM RIGHT:
Vasily Bazhenov
Façade of the central section of the
Kremlin Palace, Moscow,
1767–1775, design

"secret capital," and it was here that the seat of the head of the Russian Orthodox Church was located, as were the country's main economic interests. Catherine was determined to remodel the life and thought of Moscow according to the ideals of the Enlightenment, and she was encouraged in this by Diderot, who suggested "that Moscow is to be preferred to St. Petersburg." The capital of an empire, he thought, should not be situated "on the fringes of the state." Catherine wanted to have the center of the "venerable" city of Moscow, the Kremlin, completely rebuilt: a new Kremlin palace to symbolize the new, enlightened Russia. In 1767 Catherine entrusted the planning of the scheme to Vasily Bazhenov (1737–1799). Educated in St. Petersburg, Paris, and Rome, the architect worked for five years on a grandiose design (ill. p. 217, bottom) that incorporated the urban environment around the Kremlin. The massive frontage of the Great Kremlin Palace was the dominant feature of this ensemble and faced the Moskva river. The old cathedrals were retained in the interior, and Bazhenov arranged Senate and administrative buildings around forum-like squares, connected by streets. The entire

center of Moscow was to be oriented towards a palace that over-shadowed all other buildings. But just two years after the foundation stone was laid in 1773, work was halted for political and economic reasons. In spite of this, the Neoclassically-inspired architecture presaged future developments for a whole generation of Russian architects.

In order to regulate the process of town planning, a commission for urban development was established in Moscow. Designs from 1775 proposed replacing the dilapidated fortress walls of the "White City" with a ring of boulevards, straightening roads and providing squares with a unified architectural style. Important public and private buildings, especially in the area close to the Kremlin, were erected as a result of these guidelines.

The city palace of the Pashkov family (1784–1786), built on sloping ground opposite the Kremlin, is indisputably one of the highlights of Neoclassical architecture in Moscow (ill. p. 218, top). Here, too, Bazhenov sought to relate the building to its immediate environment. An unusual feature of the building – and a unique feature in the architecture of Moscow Neoclassicism – is the fact

that the entrance is on the courtyard side while the garden side towards the street acts as the main façade. The elevated central section is connected to side wings, each of two floors, by galleries of a single floor. A portico of four Corinthian columns with statues screens the two upper floors of the main building, which is surmounted by a balustrade with vases and crowned with a belvedere. The façades of the side wings feature Ionic gabled porticoes.

The Senate building (1776–1787) by Kazakov (1738–1813) bore witness to the spirit of Neoclassicism. The ground plan was an isosceles triangle (ill. p. 218, bottom), which enclosed a domed rotunda at its apex over the main hall – one of his favorite motifs. Adjoining rooms were connected by corridors and gave on to a large inner courtyard defined by diagonal wings. This spatial arrangement represented a new type of administrative building. The exterior rested on a tall plinth divided by Doric pilasters which bracketed two floors. A portico of Ionic columns, giving entry to the interior courtyard, provided the façade's only relief.

The construction of Moscow University presented the city with a new type of educational institution. Catherine II dreamed of a temple of the sciences that would teach the ideals of the Enlightenment. Kazakov impressed his contemporaries with an innovative concept of a large imposing hall which he perfected in the Nobleman's Club (today's House of the Trade Unions). His extensive hospital building for the aristocratic Golitsyn family demonstrated for the last time the genius that won him a place in the ranks of the leading architects of Moscow Neoclassicism at the end of the 18th century.

Country houses of the nobility near Moscow

The privileges that the Empress granted the nobility allowed them increasingly to retreat from the city and devote themselves entirely to building palaces in the country. The special characteristics of this architecture lay in the translation of Neoclassical vocabulary to the traditional building material of Russia – wood.

Matvey Kazakov
Senate building in the Kremlin
1776–1787
Ground plan

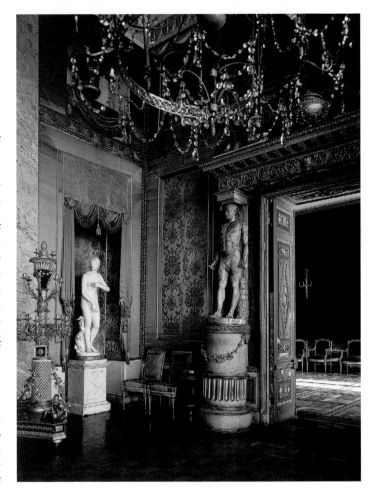

The two palaces of Kuskovo and Ostankino lie on the estates of the phenomenally wealthy Sheremetyev family. The Kuskovo palace (1769–1775) was designed by the renowned French architect Charles des Wailly, but execution and direction of the project was in the hands of native craftsmen. Here, as in the Ostankino palace (1792–98, ills. p. 219, bottom and top), there was a theater. The theater played an important part in the lives of Russia's aristocracy, and during the winter there were performances in the palace theaters of wealthy noble families. The theater in Ostankino called for a theater for an audience of around 250 to be integrated into the center of the palace. Vincenzo Brenna, an Italian, was responsible for the design. Access to the main apartments and theater, which was shaped like an amphitheater, was gained via a six-columned portico and staircase. If required, the stage could also be converted into a ballroom by the use of ingeniously contrived stage machinery.

The Second Phase of Urban Architecture in St. Petersburg: Starov, Quarenghi and Cameron

In Moscow, Catherine had to abandon her attempt to impose a unified urban plan with a new center, although the city did undergo fundamental changes during her reign. In St. Petersburg, the capital laid out in regular fashion by Peter I, such basic planning considerations never entered the equation. Here, in accordance with the

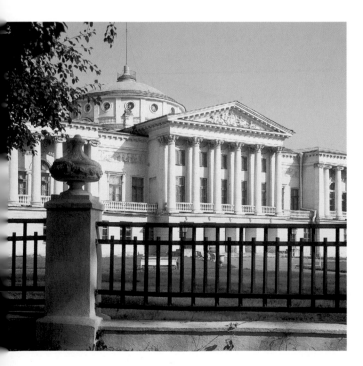

intentions of the city's founder, the construction of a "modern" city was proceeding apace. Catherine guaranteed this modernizing process by employing the talents of Ivan Starov (1745–1808), the third great Russian architect of the late 18th century.

Starov's first major construction project entered the planning stages in 1776. The Cathedral of the Trinity was built as the main church for the Alexander Nevski Monastery founded by Peter I, and as a mausoleum for that monarch (ill. p. 220). Starov emphasized the western façade through a Doric gabled portico and two bell towers. By graduating the heights of the building's various components, Starov reduced the dominance of the dome. The interior is characterized by Corinthian double columns grouped around the piers of the nave. These columns developed into a colonnade in the apse – a type of design which Starov would later perfect in his Tauride Palace. The design of the square at the main entrance to the complex was also significant in terms of urban planning: it is here that the 4.5-km-long Nevski Prospekt, the city's main thoroughfare, ends.

Between 1783–89 Catherine had one of the great monuments of Neoclassicism built for her favorite, Gregory Potemkin. After his success in annexing the Crimea (Tauride), this field marshal was rewarded with the honorary title of Prince of Tauride and given a palace. For the first time in Russian palace architecture

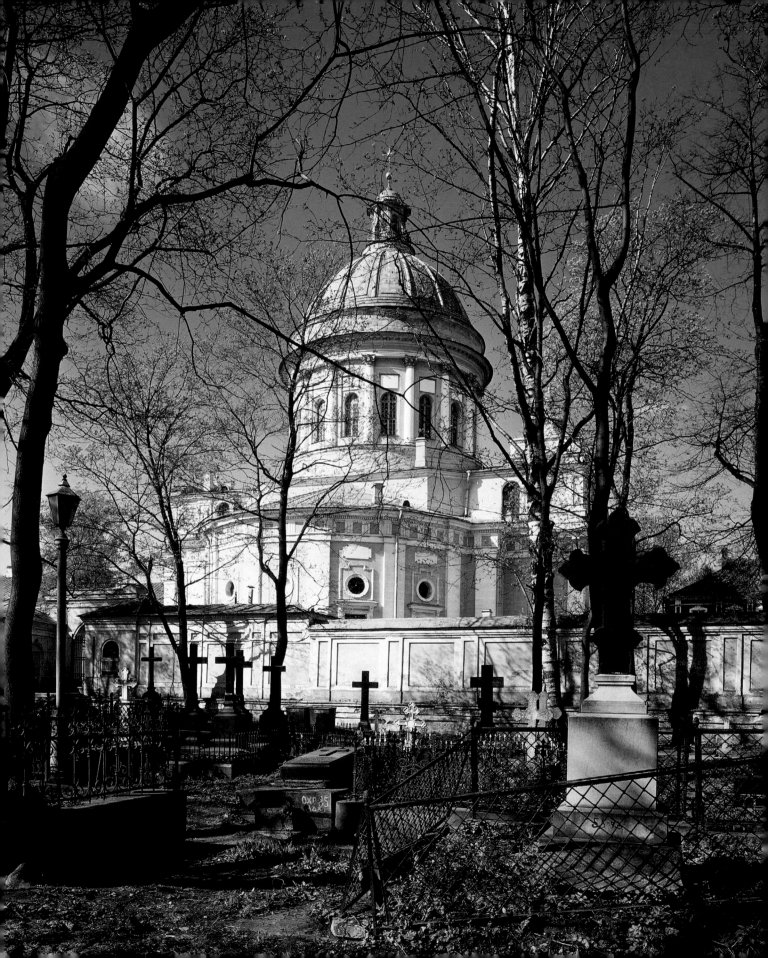

Starov separated state apartments from residential rooms, thus signaling a clear rejection of the Baroque. Rather than being situated along the main façade, the state rooms are located deep in the central axis. From a vestibule, entry is gained through an octagonal domed hall into a transverse gallery, and from there into a conservatory. The gallery was designed as a festival hall and was combined with a domed hall ("pantheon") on the Roman model. The passageways and crosswalks to the main hall, which was oval in shape, were magnificently expressed in two open colonnades, each with 18 Ionic columns. High windows and a conservatory establish a relationship between the building and the surrounding nature. The Tauride Palace served as the model for countless houses of the nobility built in and around St. Petersburg.

Giacomo Quarenghi and Charles Cameron, two architects who arrived in St. Petersburg in 1779/80, catered to Catherine II's then current tastes for the architecture of Palladio and Roman Antiquity. Both men were to have a lasting influence on the Neoclassical appearance of St. Petersburg. Palladio's architectural theory had so fascinated Quarenghi (1744–1817) during his studies in Rome that he traveled around Italy, working as an engineer and draughtsman and recording the country's monuments in his travel diaries. In Russia he acquired an encyclopedic architectural knowledge in the same way, eventually becoming one of Catherine's principal architects.

Quarenghi's public and private work in the city, as well as his buildings in Tsarskoe Selo, are frank geometrical constructions, and their exteriors display a monumental unity with sparing use of ornamentation. Of his many commissions, particular mention should be made of Russia's first bank, the State Bank, whose central building recalls a Palladian villa. In other work, such as the Raphael Loggias, the Hermitage Theater and the Academy of Sciences, Quarenghi had to conform to urban development strictures concerning the Neva Quay. The Hermitage Theater (1783–1787), a court theater which staged performances every evening – including the comedies of Catherine II – adjoined the sweeping palace frontage of the Hermitage in severe Neoclassical style. The auditorium had a unique design; instead of being equipped with boxes – as was normal for 18th-century theaters – Quarenghi arranged it as an amphitheater after Palladio's Teatro Olimpico in Vicenza. Corinthian columns of artificial marble dominate the internal walls, while statues of Apollo and the Muses decorate the niches placed between the columns.

Women were not excluded from higher education under Catherine the Great, and in 1766 the Empress founded a boarding school for noblewomen and the daughters of prominent families. It served as the prototype for all similar girls' institutes during the 19th century. Quarenghi was the architect responsible for the building's realization at the beginning of that century. Catherine's building program was not restricted to her capital.

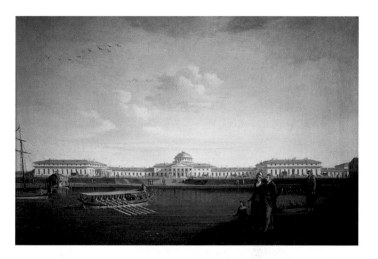

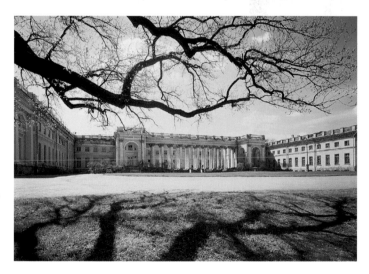

She also took a great interest in the renovation and redesign of the royal residences on the outskirts of St. Petersburg at Tsarskoe Selo and Pavlovsk, for which she was able to secure the services of her last court architect, Charles Cameron (1745–1812). She saw in Cameron an architect able to realize her desire for a "maison antique." Cameron had participated in the excavation of Roman imperial baths and had published the plans of their reconstruction in a series of engravings – The Baths of the Romans – in 1772. On the basis of this work, Catherine appointed him her chief architect in St. Petersburg.

At Tsarskoe Selo, Cameron's Classical-Roman baths (1780–85), Hall of Pillars with "Hanging Garden," and

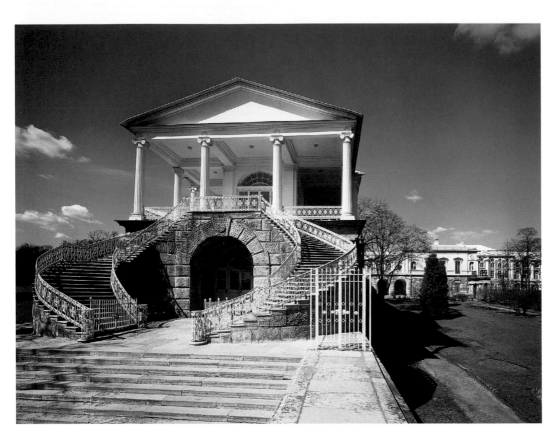

Charles Cameron
Palace, Pavlovsk, 1782–86, façade of the
court of honor

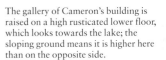

Charles Cameron
Cameron Gallery, Tsarskoe Selo,
1783–86, illustration showing, on the
right, the view to the Agate Pavilion

Cameron's design allowed for the
Tsarina to walk directly from her
favorite rooms in the Palace – the fifth
apartment – past the Hanging Garden
to the Agate Pavilion and from there to
the Cameron Gallery.

The gallery of Cameron's building is
raised on a high rusticated lower floor,
which looks towards the lake; the
sloping ground means it is higher here
than on the opposite side.

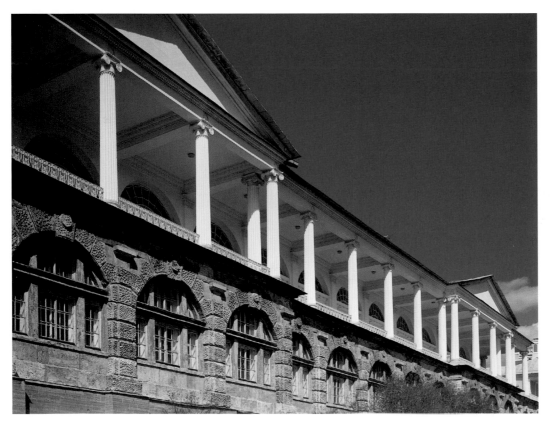

222

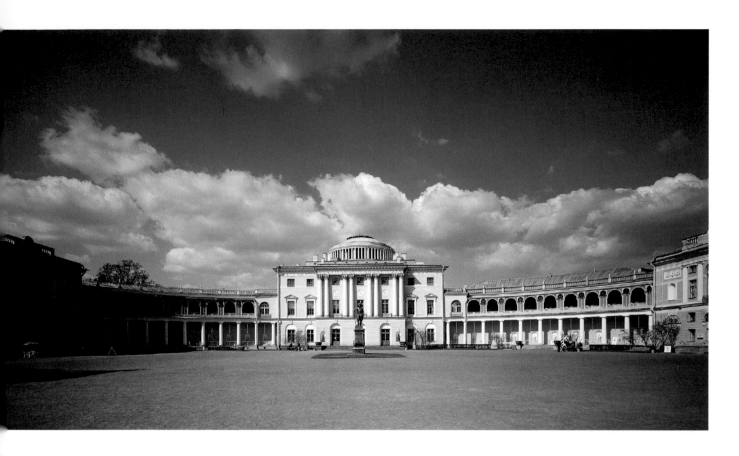

Cameron Gallery (1783–1786) combine to great effect with the late Baroque palace (ill. p. 222, top). The connection of palace and gallery created the building for the Cold Baths and the Agate Rooms. The great central hall of the Agate Pavilion, which Cameron ornamented with coffered vaults on the model of Roman baths, is particularly impressive. A rich variety of marble colors and the application of magnificent semi-precious stones underscore the uniqueness of this building. The route from the pavilion to the Cameron Gallery was formed by continuing in the colonnade the fluted Ionic columns that decorate the upper floor of this long building of two floors. These columns surround a glazed pavilion which the Empress used as a retreat and as a dining room. The only decorative elements in the gallery are bronze busts, mostly copies of antique originals. Cameron counterbalanced the sloping ground leading down to the lake with a sweeping double staircase on the model of Robert Adam's Kedleston Hall, a device allowing him to combine elegantly both park and gallery. Catherine also entrusted Cameron with the interiors of the palace. The design of her private rooms show the influence of the Adam brothers, in particular the Green Dining Room with its emphatic use of antique motifs.

For the suburban royal residence of Pavlovsk, Cameron was able to work free of restraint. The self-contained ensemble of palace (ill. p. 223) and landscaped park – with its pavilions, cascades, artificial ruins, avenues and river – harmoniously combined the principles of Neoclassical architecture with an English-style Romantic park (reconstructed after the Second World War). This Summer Residence was built for the future Tsar, Paul I. Catherine II had tried to keep her son, for whom she felt little affection, from all state business and had even planned to exclude him completely from the royal succession. Her joy at the birth of a grandchild, Alexander, therefore provided an occasion for presenting the Grand Ducal couple with this large property around 30 km south of St. Petersburg.

Palladian architecture clearly supplied the pattern for the palace, built 1782–1786. The façade on the courtyard side with its Corinthian portico is crowned by a dome set atop a drum ringed with columns. The central section is adjoined by two curved and columned galleries, each of which terminates in wings. Cameron was involved in the interior design, but most of the work was done by his Italian pupil, Vincenzo Brenna – this applies particularly to the central Italian Hall, which rises to the full height of the building, including the dome. Brenna balanced the great vertical dimensions of the hall by employing the optical effect of a surrounding gallery. The walls are decorated in stucco, and antique statues decorate the niches of the lower floor. The design for the 600-hectare park is the first example of an English landscape garden in Russia. Like the palace itself, the many buildings that Cameron placed throughout the park merge smoothly into the natural environment, for instance, the Temple of Friendship (ill. p. 224, right) (1780–82), which is situated beside the River Slavyanka. The pavilion of the Three Graces and the colonnade of Apollo are other structures devoted to antique themes. When Catherine II died in 1796, Cameron was dismissed from royal service.

223

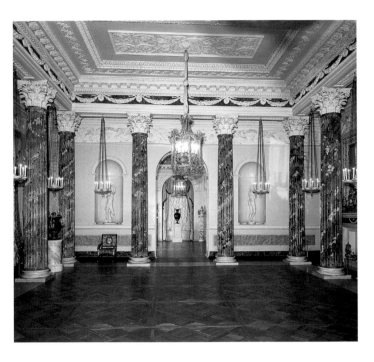

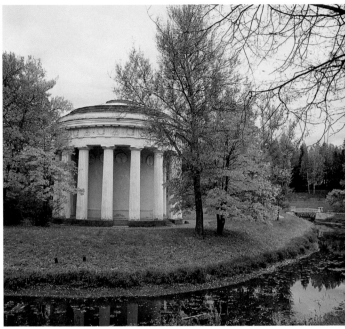

Paul I and Alexander I

The end of the 18th century witnessed turbulent changes that affected not just St. Petersburg but all of Russia. The "Golden Age" of Catherine the Great was over, and with it the privileged life of aristocratic society. Paul (1754–1801) succeeded his mother at the age of 42 after a long and humiliating waiting period. His reign, which lasted just four years, is considered an interim period in Russian history and was marked by the Tsar's unpredictable and arbitrary conduct. Paul's life had been characterized by suspicion and mistrust, and this combined with a growing overestimation of his own abilities. Many of his measures can be seen as a reaction to those taken by his mother. Paul curtailed the independence of the aristocracy, burdening them with taxation for the first time, and he banned travel abroad as well as the import of foreign books. In 1798 Napoleon threatened the island of Malta. After the island was liberated, Russia broke with its former coalition partner, England, and formed an alliance with Napoleon. It is largely for this reason that the St. Petersburg nobility formed an alliance against their ruler, whom they believed had deprived them of their economic lifeline (by banning grain exports). In 1801 the Emperor was overthrown in a palace coup and murdered in his recently built Michael Palace (from 1823 the Engineers' Palace).

The new ruler, Alexander I (1777–1825), was showered with goodwill from all sides. He had been raised in the spirit of the French Enlightenment, and his grandmother was determined to be a worthy successor to her. An intensive period of reform began with the restoration of rights to the nobility. The aristocracy were now also permitted to emancipate their serfs. Political events abroad, however, soon put an end to liberal reform. The year of 1805 saw war against France and was marked by a Russian defeat at Austerlitz. The Russian Emperor now entered the third anti-French coalition. From 1810, irritations in the French-Russian relationship intensified, finally leading to Napoleon's Russian campaign of 1812. The firing of Moscow in that year marked an historic turning point. France's eventual defeat, brought about by the political and military leadership of Russia, represented the zenith of Russia's political influence and established Alexander's reputation as the "savior of Europe."

This political about-turn went hand in hand with changes in Russian Neoclassicism. The first third of the 19th century saw a new epoch in Russia, which equates to the era known as "Empire" in western Europe. All the leading architects of the day were united in their belief that the architectural appearance of a city should be uniform. During the reign of Alexander the population of St. Petersburg increased to 440,000, and the area encompassed by the city grew accordingly. Entire districts sprang up from nothing. In order to co-ordinate the increasing number of construction projects in the imperial city, a Construction and Water Committee, including the most prominent architects, was established.

The Third Phase of City Architecture in St. Petersburg: Voronikhin, Thomon, Zakharov, and Rossi

Andrei Voronikhin (1759–1814) was born a serf on the estates of Count Stroganov, who sent him to study architecture in St. Petersburg, later financing his studies in France and Italy. From 1800 he taught at the Academy of Arts in St. Petersburg, and won the competition for the design of the Cathedral of the Virgin of Kazan (1801–1811). The building's exterior is in an 18th-century style, but Voronikhin was able to conceive a new design which integrated the cathedral into an urban ensemble, placing it in the context of surrounding streets and squares. In accordance with the wishes of Paul I, the building was provided with a colonnade in imitation of St. Peter's in Rome (ill. p. 225, top). Difficulties arose during the construction of the cathedral, however. According to the Russian Orthodox canon, the altar of a church should face east. Voronikhin therefore shifted the northern aisle, placing it next to the Nevski Prospekt. In front of it he built a broad, arched colonnade of 96 fluted Corinthian columns in four rows, which form a great square and conceal the actual church itself. Thus the side façade takes on the function of the building's main frontage, an effect completed in the vertical plane by the monumental 71.6-m-high dome over the crossing. Passageways to the surrounding streets are provided at both ends of the arched colonnade by massive portals. A second colonnade (on the southern side) as well as a square on the western side were never completed. Balanced proportions as well as rich sculptural decoration and monumental bronze statues by Russia's most prominent sculptors contribute to the cathedral's harmonious impression. The bronze doors of the north portal are recreations of Lorenzo Ghiberti's Gates of Paradise for the Florence Baptistery. The building, named after the icon of the Virgin of Kazan, became a memorial after the war of 1812.

At the same time as Voronikhin's major work was underway, the design by Thomas de Thomon (1754–1813) for the area of the city opposite the Winter Palace entered a protracted period of planning. Thomon, a Swiss who had studied in Rome and had been a pupil of Claude-Nicolas Ledoux in Paris, was soon appointed court architect by Alexander I.

Vassilevski Island is the largest of the 42 islands in the Neva, and its arrow-shaped head, or "strelka," forms the point at which the Neva divides in two before both arms flow into the Gulf of Finland. From the mid-18th century ships' masters preferred to moor at the "strelka" rather than at the Peter and Paul Fortress. The first design for the city's Bourse was prepared under Catherine II. Between 1806–10 Thomon replaced the wooden structure with a stone one, which was clearly indebted to the architecture of Greek Antiquity (ill. p. 225, bottom). This design corresponded perfectly to the taste of the Tsar, who preferred a Hellenistic style. The Bourse was built on a tall granite plinth on the model of a peripteral antique temple. The

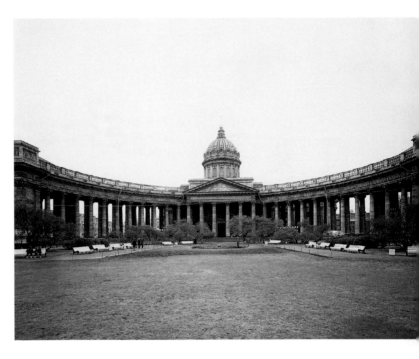

main section rose above the Doric colonnade and featured a triglyphic frieze and sculptural groups on the attics on the main façades. The sculptures are typical of the Late Neoclassical style and symbolize the importance of this maritime and commercial building. Two rostral columns ornamented with ships' prows flank the Bourse. Allegorical figures of the four great Russian rivers – the Volga, the Dnieper, the Neva and the Volkhov – are carved on their bases. The prominent position of the "strelka"

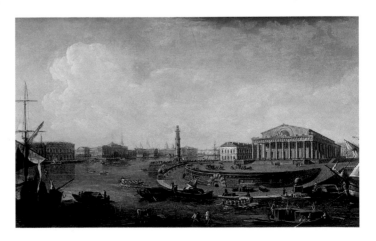

Andreyan Zakharov
Admiralty, St. Petersburg, 1806–23
Main façade

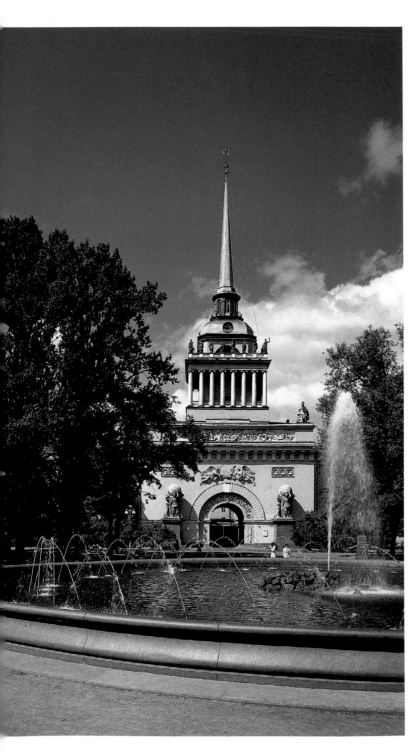

and Bourse means that they form one of the high points in the urban fabric of St. Petersburg, while functioning as a counterweight to the state functions of the palaces on the opposite bank.

At the same time as the Bourse was being built, another great complex was rising up on the opposite bank of the Neva – the Admiralty. The Russian architect Andreyan Zakharov (1761–1811) was already considered the Admiralty's own architect when he began construction of his truly monumental complex in 1806 (work was finished in 1823). The function of the building was – and remains – unusual in the context of St. Petersburg town planning: the tower with its golden "needle" (ill. p. 226) was preserved from the original building and today serves as an orientation point and terminus for the three main roads of the metropolis. The U-shaped complex was separated by a canal from two sets of inner buildings. The outer buildings were occupied by the Admiralty administration, the inner ones by the shipyards. The entire complex is of quite extraordinary dimensions: the main wing is 407 m long, and the two side wings are each 163 m in length. Both the architecture and rich sculptural decorations by Feodos Shtchedrin, Ivan Terebenyev and Stepan Pimenov form an indissoluble unity. The design of the façade was intended to glorify Russia as a sea power. The main entrance of the central Admiralty tower is in the shape of a triumphal arch, and the side wings are emphasized by a huge gabled portico. The Admiralty formed the architectural focus of St. Petersburg and ultimately led to the design of three squares which border it and act as accents for the city center.

After the deaths of Zakharov, Thomon, and Voronikhin and the victory of 1812, a new era in the architectural history of St. Petersburg began, in which Carlo Rossi (1775–1849) came to prominence as the last great late Neoclassical architect. Italian born Rossi came to Russia in 1787, remaining there until his death. He advanced to become architectural assistant to Alexander I and traveled for two years in Italy to further his education, before being appointed court architect in 1806. In Moscow he played a crucial role in reconstructing the old metropolis after the fire of 1812, and from 1816 he was director of the Construction and Water Committee in St. Petersburg. Rossi designed vast urban architectural ensembles in the manner of Voronikhin and Zakharov, and his work is still a decisive factor in shaping St. Petersburg today.

At the same time as the Grand Palace was being built on Yelagin Island, Rossi was realizing his first design for the plan of an entire city district in the center of St. Petersburg. The complex of the New Michael Palace (1819–25, today the Russian Museum, ill. p. 227), includes the square onto which it fronts, as well as a system of roads in which the former Michael Street connected the Nevski Prospekt. From there an imposing view of the palace was opened up for the younger brother of the Emperor, the Grand Prince Michael. Rossi's work is an exemplary piece of

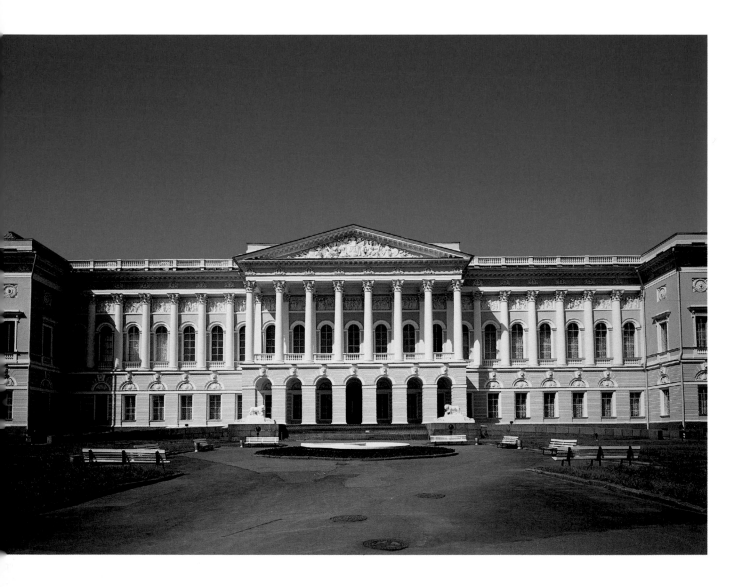

architecture in the Russian Empire style. The main façade features a gabled portico resting on eight columns, while the wings – with their projecting termini – are ornamented with engaged columns. A high cast-iron fence with war trophies around the gate marks the perimeter of the parade ground. Rossi was also responsible for the magnificent interior design. As with the exterior, every detail was documented in sketches. The main vestibule and Hall of White Columns still testify today to his wealth of ideas and to the former magnificence of the Grand Prince's apartments.

Rossi also began work on a second project at this time. The south side of the Palace Square was to be redesigned and an appro-priate pendant created for the Winter Palace (1819–29). The two unified General Staff buildings stand opposite the Winter Palace in a sweeping elliptical curve (600m long) and are connected with each other by a double triumphal arch, which leads on to the Nevski Prospekt (ill. p. 228). The arch facing the square is crowned by an attic, which bears a statue of Victory in a chariot drawn by six horses. The rest of the sculptural ornamentation glorifies the victory over Napoleon. Rossi also followed a similar concept in his construction of the Senate Square (today, the Decembrists' Square). On the street side opposite the Admiralty he built the symmetri-cally arranged Senate (the highest government department) and the

Carlo Rossi
Triumphal arch of the General Staff
building, St. Petersburg, 1819–29
View to the Alexander Column and the
Winter Palace

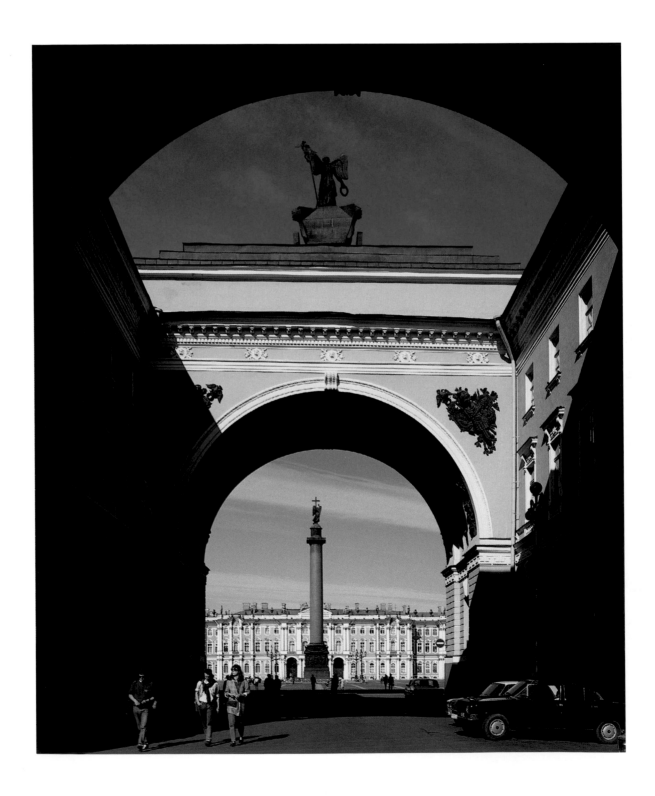

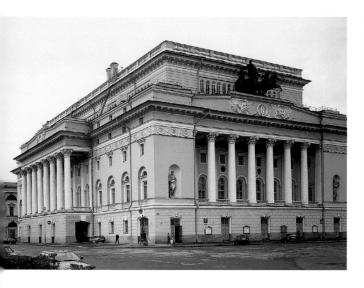

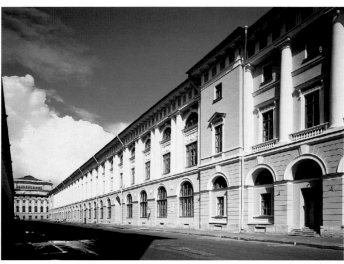

Synod (the highest ecclesiastical authority), which are united by a majestic arch (ill. p. 229, bottom).

Starting from the Nevski Prospekt, the theater complex (1828–34) includes a square, the buildings along Rossi Street and the Alexandra Theater. The focus of this urban ensemble is the theater itself, which opened in August 1832 and soon established itself as one of the city's foremost dramatic venues. The façade is decorated by a loggia of Corinthian columns, while niches at the sides house statues of the Muses Terpsichore and Melpomene. The loggia is crowned by an attic with the quadriga of Apollo. For the sculptural ornamentation Rossi was able

to rely on Stepan Pimenov, Vasily Demut-Malinovski and Paolo Triscori. The main façade is in stark contrast to the strict Doric colonnades of the symmetrically planned buildings of the theater or Rossi Street, which are uniform in appearance.

Carlo Rossi's oeuvre represents the pinnacle of St. Petersburg's achievements in the realm of urban planning. Like no other architect, Rossi knew how to integrate a building's design with it's urban environment. He even incorporated elements that would act as contact points for buildings in future plans. Rossi's achievements, based on a comprehensive planning concept, signaled the perfection of Russian Neoclassicism.

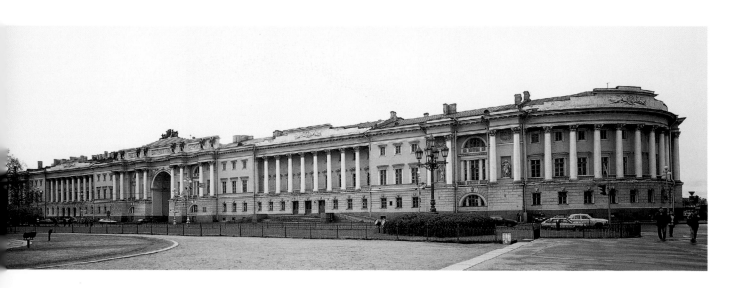

Ehrenfried Kluckert

The Landscape Garden

The main criterion of the landscape garden is often said to be the lifting of the barrier between the garden and the open landscape, to create the impression of free and untrammelled nature. These ideas first emerged in Britain in the early 18th century, but important aspects are to be found in the monumental Baroque gardens created by André le Nôtre and in the writings of the French garden theoretician Antoine Joseph Dézallier d'Argenville.

"Those who wish to lay out a garden must remember to hold more to nature than to art and to borrow no more from the latter than what is needed to lend support to nature." With these words in *La Théorie et la Pratique de Jardinage* (The Theory and Practice of Horticulture), which appeared in 1709, Dézallier d'Argenville assigned to art the task of serving nature. In future the artistic aim of the garden architect was to help the plants to flourish and enable them to develop freely.

"On the other hand," he wrote, "nothing embellishes a garden more than a good prospect or view into a fine landscape. The delight in seeing at the end of an avenue, or from a raised mound or terrace, for four or five miles around, with many villages, woods, rivers, hills, meadows and other things all forming a fine landscape, exceeds anything that could be said of it here; these things have to be seen to judge of their beauty."

The writer may well have been inspired to these thoughts by the magnificent gardens created by André le Nôtre, which were famed throughout Europe. The brilliant creator of the gardens at Vaux-le-Vicomte, Chantilly, and Versailles aimed to give the illusion of illimitable distance with his avenues and canals, which function like long axes (ill. p. 230). The garden was the landscape, and it was to present itself as a living painting in the style of Claude Lorrain. In this respect, Le Nôtre lifted the borders between the garden and the landscape.

Dézallier d'Argenville wrote his treatise just under ten years after the death of the great garden architect, who was content to call himself by the modest title of "gardener" to his sovereign, Louis XIV. He was, of course, familiar with Le Nôtre's work, and he considered evolving a kind of system of laws based on his garden designs, particularly the specific measures needed to create the feeling of distance. To enable the gaze really to move into the distance, all obstacles that could impede such a view, like walls, fences, bushes or hedges, were to be avoided, and for this purpose d'Argenville proposed using walled ditches to close off the ends of the garden. To describe these he used one of the strangest terms ever coined in cultural history, but one that has become firmly established: the ha-ha, or, as d'Argenville described it: "clairesvoies, appellées des ah, ah." He explained: "They are set level with the avenues, and there is no fence; before the wall is an open ditch, which is broad and deep and walled on both sides to hold the earth and prevent anyone climbing up. The viewer who approaches is surprised and exclaims 'ah ah!'. Hence the name of this structure. "

Britain

"Ahahs" or "ha-has" came to play an important part in the English landscape garden in preserving the continuity between the garden and the adjacent landscape. The British garden theoretician Stephen Switzer made a drawing of a ha-ha with a wall, which illustrates its function very clearly (ill. p. 230). The ha-ha was also used in Stowe in Buckinghamshire, which was one of the first English landscape gardens. It was laid out around 1730, and it had a major influence on the future development of the new type (ill. p. 231, top, and pp. 234/5). Stowe had been owned by the Temple family since 1593 and was developed by Richard Temple, First Viscount Cobham, between 1715 and 1726. The leading garden architect was Charles Bridgeman, a key figure in the early development of the English landscape garden.

The first designs for Stowe show an arrangement similar to the French Baroque garden, and the proximity in time to Le Nôtre's garden art is very evident. Apart from the irregular external limits, the architect has produced a free variation on the Frenchman's parterre structure. To enable the adjacent open landscape to be seen, he built a ha-ha following the instructions given by

Pierre Patel
A Bird's Eye View of the Palace and Gardens at Versailles, 1668
Oil on canvas, 115 x 161 cm
Musée du Château, Versailles

Dézallier d'Argenville, whose treatise
had already been translated into
English by John James in 1712. Only
under the direction of William Kent,
the "enemy of the straight line," as he
was mockingly called by contempo-
raries, was the garden transformed
into a typical Romantic ambience.
Kent created the Elysian Fields, a small
valley with a little round temple in the
style of Palladio, and winding paths
through groups of trees. William Kent
was also entrusted with designing the
landscape gardens in Holkham Hall in
Norfolk, where he attempted to struc-
ture the broad meadows with groups
of trees (ill. p. 231, bottom).

Stourhead in Wiltshire was, and prob-
ably still is, one of the most famous
gardens in England, and it is certainly the
most romantic (ill. p. 232). The property
was owned by Henry Hoare, a banker
and Lord Mayor of London, who had a
country seat built by Colin Campbell in
1721 on the model of the Venetian villas
by Andrea Palladio. The extensive
garden stretches to one side of the house
and is arranged around an irregular
chain of lakes. The basic ideas corre-
spond to those of William Kent, but the
owner himself planned the garden and
had it laid out to his specifications by
gardeners. The curving line of the banks
frequently affords surprising views of
temples, waterfalls or bridges. Rhodo-
dendrons surround a Roman Pantheon,
from which one looks across at the old
village church and the temple of Flora.
Henry Hoare was apparently so
delighted with his property that he
called it "a charming Gaspard picture,"
that is, it resembled a painting by
Gaspard Dughet, known as Poussin.

Hoare's exclamation reveals an
important source of English garden art
in the 18th century: landscape painting.

Unlike Le Nôtre, who wanted to imple-
ment in his gardens the distant effect
attainable in a painted landscape, like
those of Claude Lorrain, it was now the
limited section of a landscape, a motif
that particularly attracted painters, that
was to serve as standard for the garden
and its design.

The English landscape gardeners
saw the paintings of Poussin and
Claude Lorrain with new eyes. They
were less concerned with the misty
distance than to integrate antique
buildings. Before Henry Hoare
designed the landscape scenery at
Stourhead, he may well have studied
Claude Lorrain's *Landscape with*

Aeneas at Delos, now in the National
Gallery in London (ill. p. 233).

The landscape garden's beginnings
and theoretical basis lie in France, but
it developed more fully in Britain,
whose landscape gardens were then to
influence gardening on the Continent.
The French King Louis XV had the
Trianon gardens at Versailles laid out
like a romantic pastoral. Towards the
end of the 18th century the British
garden became ever more popular, and
British gardeners were eagerly sought.
The Baroque garden finally came to an
end as clients demanded nature
untamed, enriched with set pieces such
as rocks, waterfalls or wildly growing
banks and little antique temples.

A decisive role in the spread of the
new idea of the garden was played by
Jean-Jacques Rousseau, whose novel
*La Nouvelle Héloïse (Julie, ou la
Nouvelle Héloïse. Lettres de deux
amants habitants d'une petite ville au
pied des Alpes)* – or in English, Julie, or
the New Héloïse. Letters from two
lovers living in a little village at the foot
of the Alps – first appeared in 1751.
It was soon translated into other
languages. It propounded a new philos-
ophy based on ardent contact with
nature. Rousseau's model was the
garden, which he described in detail as
a natural event where man can find the
way back to the sources of his own self,

his natural self. Hence the garden
should not be ordered, it should not be
symmetrical or laid out in straight lines.
Following the motto "nature plants
nothing in straight lines," natural
growth was to be encouraged and the
character of a landscape preserved.

Germany
In Germany the idea of the landscape
garden based on Rousseau's philos-
ophy spread with particular intensity.
In the age of Enlightenment and
sensibility the garden at Wörlitz
rapidly became famous. It was the
creation of Prince Friedrich Franz of
Anhalt-Dessau, and soon after its
completion, around 1790, it was held
to be one of the major attractions of
Europe. Painters, philosophers and
poets went on pilgrimages to Wörlitz.
For the Prince, the garden was a model
of the enlightened state, and was to be
the aesthetic center of a model princi-
pality. It was clearly modeled on the
British landscape garden, and the
British diplomat Charles Stewart is
said to have exclaimed in delight
"Goddam, I am back in England!"

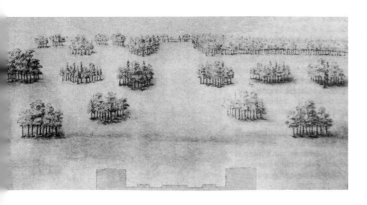

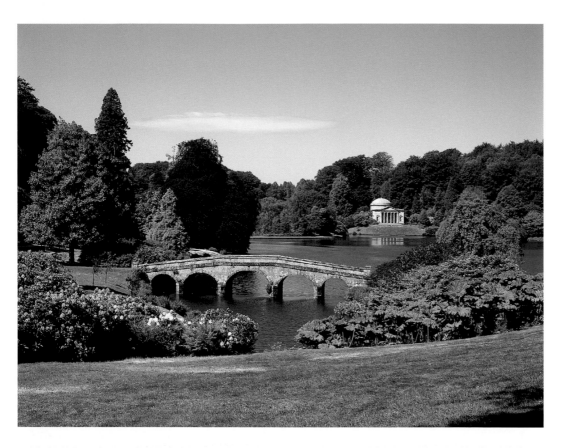

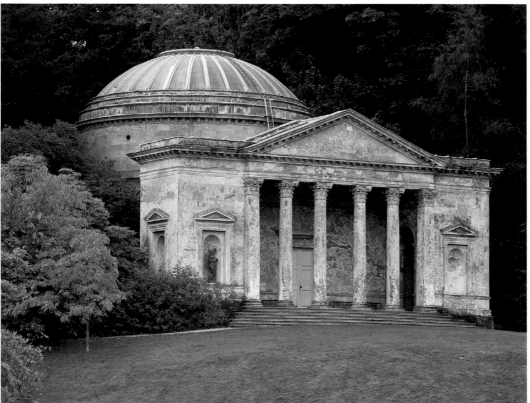

TOP AND LEFT:
Stourhead, Wiltshire
View over the bridge and the lake to the "Roman Pantheon" (above)
Close-up of the Pantheon (below)

The architecture in the landscape garden at Stourhead shown here (the Pantheon and the bridge) have some similarity with the architecture in Claude Lorrain's painting *Landscape with Aeneas at Delos*. Henry Hoare, who designed the landscaping at Stourhead, probably knew the painting and studied it for his purposes.

Claude Lorrain
Landscape with Aeneas on Delos, 1672
Oil on canvas, 100 x 134 cm
National Gallery, London

OVERLEAF:
Landscape Garden, Stowe
The Palladian Bridge

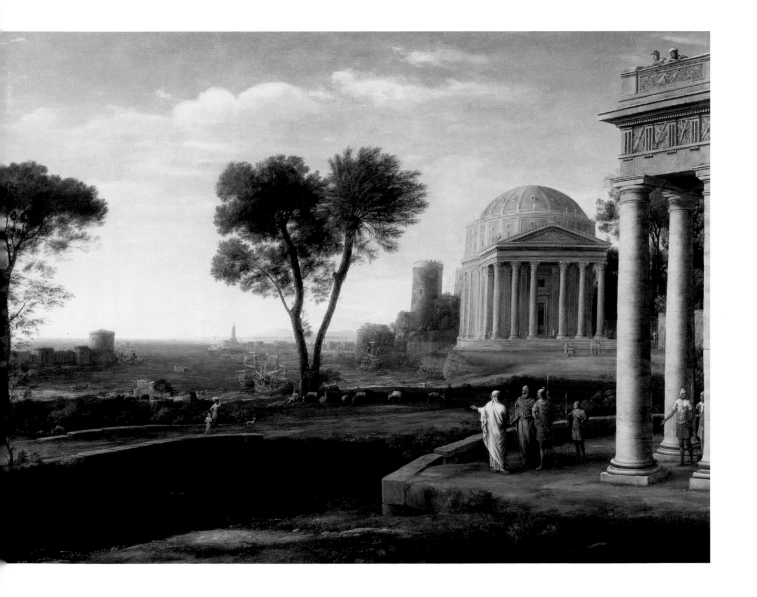

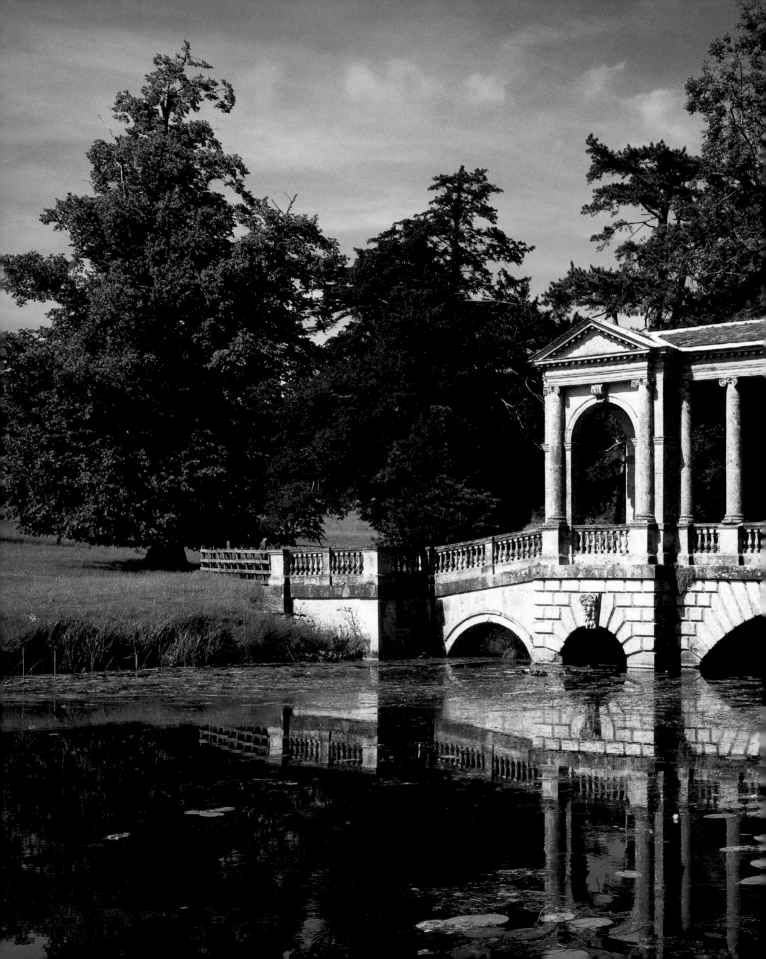

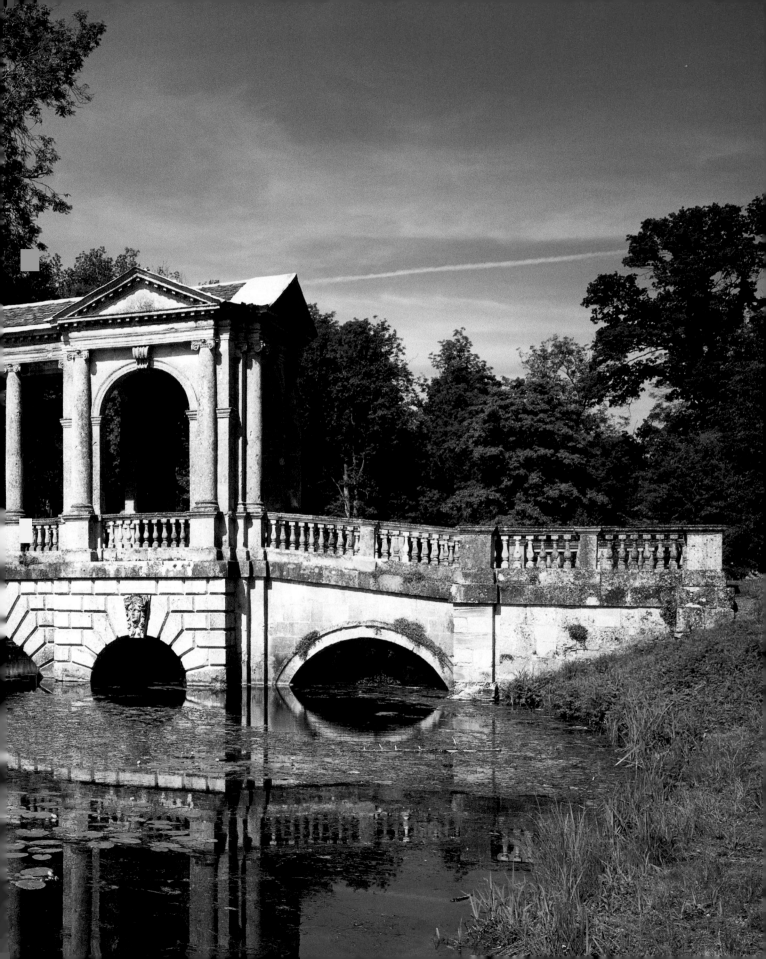

when he saw the extensive parks and the frequently surprising prospects.

Prince Friedrich Franz (ill. p. 236) had devoted himself intensively since he was a young man in the 1770s to the cultivation of landscape and the embellishment of his estates, after undertaking several extensive journeys to England and studying the gardens there. He was accompanied on his travels by the architect Friedrich Wilhelm von Erdmannsdorff and the gardener Johann Friedrich Eyserbeck, who was commissioned to direct the garden design in Wörlitz.

The Prince was able to realize his vision of a state of scholars, at least in part. He succeeded in persuading August von Rode, a classical scholar and translator, to settle in Wörlitz. In 1781 the Allgemeine Buchhandlung der Gelehrten und Künstler (General Bookshop for Scholars and Artists) was set up in Dessau, and 15 years later the Chalkographische Gesellschaft (Society of Engravers) attracted leading copper engravers. The educationalist Johann Bernhard Basedow was active in the "Philantropium," while the specialist library set up for garden architects from all over the world in the park at Wörlitz proved particularly popular. All this was the work of the ruler who was contemptuously called "il princillo," the little prince, by his mighty neighbor Frederick II of Prussia, for Friedrich Franz dissociated himself from Prussia and declared his principality neutral. He had to pay huge sums in contributions to Prussia for this wise move, but the financial expenditure was worthwhile, as he believed he was already very close to his objective of creating a republic of scholars in a state laid out as a park.

In order to present a visual image of the ideal roots of his philosophy of the state and life, the core of the Enlightenment, and in order at the same time to underline his personal acquaintance with the source of his ideas, Jean-Jacques Rousseau, whom he had met in Paris in 1775, the Prince had a Rousseau island set in the center of the lake, bearing a monument. The "English prospect" finds inimitable expression by the lake at Wörlitz as one walks along the bank and looks directly across at the picturesque

Nympheum surrounded by trees. It is like the citation of a landscape. Erdmannsdorff designed this temple-like pavilion between 1767 and 1768 as a roofed garden seat.

The park is full of allusions which constitute an assemblage of the prince's impressions of his travels. The "Stone Island" was made to mark a visit to Naples and enable him to delight in the Campagna at home. Strawberry Hill, the country seat that Horace Walpole built near London, inspired him to erect a similar building in the Neo-Gothic style. Surrounded by fir trees, the Gothic House (ill. p. 161), looks exotic and a little strange on the great lawn among the Neoclassical buildings. No doubt the Prince discovered his preference for the historical style in England, where, unlike the Continent, the architecture in the second half of the 18th century was Neoclassical or Historicist, that is, Neo-Romanesque or Neo-Gothic. This was only to develop in German architecture later. In Wörlitz the Prince succeeded, through the art of garden design, in creating a stylistic link between these totally diverse building styles.

Not only was the British landscape garden overwhelmingly successful on the Continent, but also British writings, which were available in translation in the 1770s, were intensively consulted by garden designers in Europe.

Alongside these treatises, a German theory of garden art soon became popular. It was put forth by Christian Cay Lorenz Hirschfeld, Professor of Philosophy and Aesthetics. He never had the opportunity to see the landscape gardens in England, but he analysed them and listed the elements and means of their composition. Unlike the earlier theories, Hirschfeld in his *Theorie der Gartenkunst* (Theory of Garden Art), which appeared in 1779 (ill. p. 240, top right), discussed the garden according to the different times of day and the seasons. He also differentiated according to the moods a garden would inspire in the visitor, identifying melancholy, serenity, sentiment and solemnity. These moods would be aroused by particular kinds of planting. Hirschfeld was the first to extend the typology of the garden

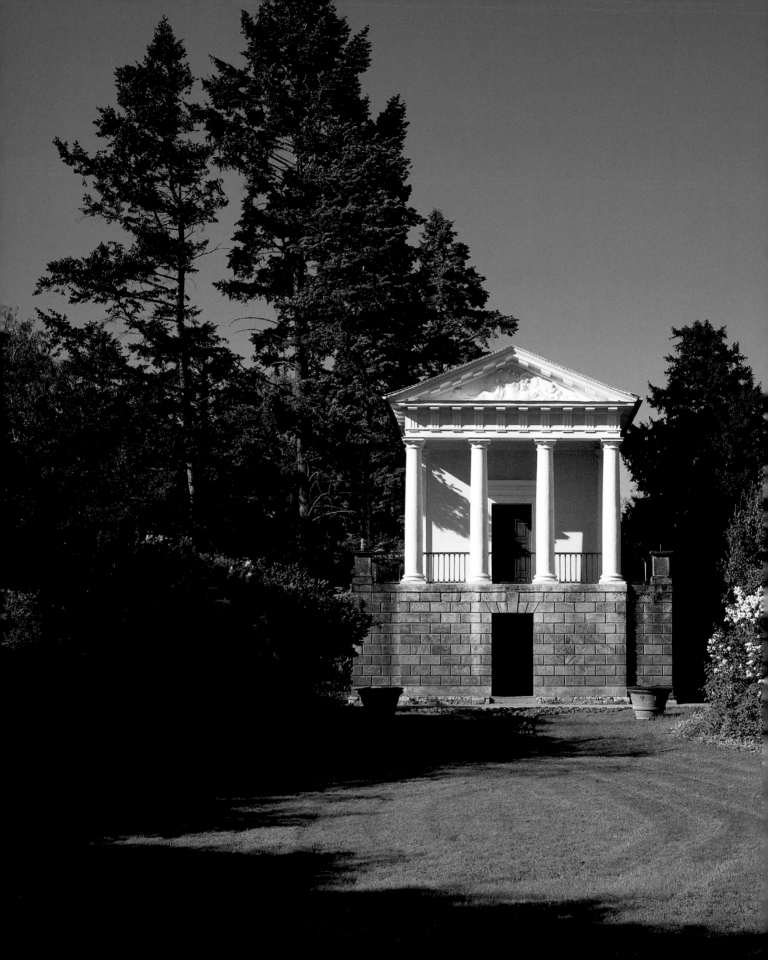

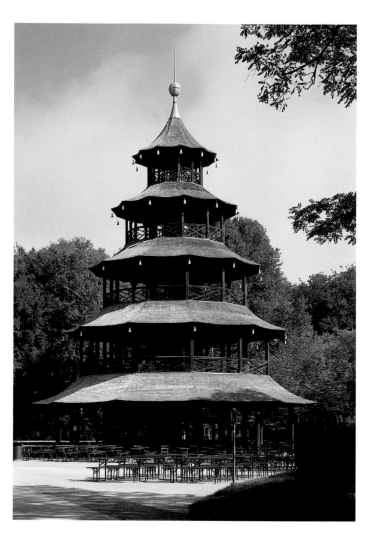

garden. Moreover, the Elector Prince, who was not very popular in Munich, wanted to give the park to the people as a gift. And so the new ruler issued a decree in 1789 through which he hoped to win the favor of the Bavarians: "The Hirschanger here is to be newly designed and planted for the general benefit and recreation of Our Residence City of Munich. It is Our most gracious desire that this most beautiful natural park shall no longer be denied the people, who may in future enjoy their leisure hours here."

In this early German park Sckell was able to implement Hirschfeld's recommendations. However, in the first phases of the planning and the work he came into conflict with Reichsgraf Rumford, an American in Bavarian service, and his successor, Count Werneck.

Then, when Sckell finally moved to Munich in 1804, he was raised to the rank of Court Garden Director by the new ruler, Maximilian Joseph. Now he was able to start work on transforming a huge stretch of land, more than five kilometers in length, into a harmonious and rhythmically subdivided park.

He divided it into four parts. The first, known as the Schönfeldwiese, or meadow, adjoined the Hofgarten. This was followed by a woodland, the Hirschangerwald, around the Chinese Tower (ill. p. 240, top left), which was reserved for the court at the time. North of this stretched the third section, around the Kleinhesseloher Lake, and last came the Hirschaugebiet, leading to the Aumeister. Sckell wanted to join the first two sections with a curving panoramic path to link the city visually with the park. He himself walked with a stick

adding the public park to the gardens of the monastery, the cemetery, the academy, the spa, the hospital and the palace garden. In the public park, he said, the townspeople could "enjoy exercise, fresh air and recreation in good company after their work." As far as the structure of the park was concerned, both the then-popular English style and the French Baroque garden should be considered in order to produce a specifically German garden. First Hirschfeld dismissed the "artificial," the Rococo manner in French gardens. He also saw elements in the English landscape garden that should be avoided, like Chinese tea houses and other decorative buildings. In making these recommendations Hirschfeld was trying to make the garden even more of a landscape garden. In other words, the "English line" was to be followed even more strictly and intensively than was the case in the country of its origin. Hirschfeld's theory soon became accepted as the standard work of German garden art.

Friedrich Ludwig von Sckell was to use it years later when, as Hirschfeld had proposed, he designed a garden that was to be programmatic in giving expression to "the particular form of German genius." This was the Englischer Garten in Munich. It was intended to be first a kind of pantheon for the great Bavarian princes and second a park for the gratification of the people of Munich, so demonstrating the munificence of their rulers.

When Elector Prince Karl Theodor, under whose aegis the gardens in Schwetzingen near Heidelberg had been laid out, moved from Mannheim to Munich in 1778, he had parts of the city walls removed to make way for new housing, declaring "Munich can no longer be a fortress." In the north of the city the Schönfeld estates were to be built, and in this context the Carl Theodor Park was created, which later became the Englischer Garten.

It was a unique opportunity for Sckell. He was free to realize the new ideals of garden art unhampered by the need to redesign an existing Baroque

Friedrich Ludwig von Sckell
Waterfall, Englischer Garten, Munich

Leo von Klenze
Monopteros
Englischer Garten, Munich, 1738

in hand through this stretch, marking out where the paths were to go, to ensure that the strollers would be able to "see the city of Munich in the foreground and the great Hirschanger woods in the background, with the other fine aspects of nature." The link between the royal sphere and the pastoral, the zones for court society and the rural population, was to be established with similarly curving paths. Sckell envisaged fluid transitions between the Hofgarten and the park that was around the village of Schwabing. However, he was not able to realize his plan to link the Hofgarten with the Englischer Park, as the construction of the Palais Salbert, later the Prinz Carl Palais, in 1803 in the Palladian style, created a barrier between the two districts.

Leo von Klenze
Sckell Memorial, Englischer Garten, Munich, 1824

In accordance with Hirschfeld's recommendations, Sckell only wanted to retain staffage buildings – those used for decorative rather than purely functional purposes – "in the good pure style," that is Neoclassicism. The sentimental and exotic motifs, particularly the Chinese Tower, built in 1790, were to be removed. But the Chinese Tower survived and has become the landmark of the Englischer Garten. Indeed, when it was destroyed in the Second World War, it was rebuilt in the original style.

Sckell died in 1823, too early to see his ideas on staffage buildings "in the good, pure style" realized by Leo von Klenze. One of the most imposing buildings is surely the Monopteros on the artificial mound near the Hofgarten, built in 1838 (ill. p. 241, top). It is a little round temple where Ludwig I had a memorial tablet installed to Karl-Theodor and Maximilian I. On the bank of the Kleinhesseloher Lake, in the public part, rises the Sckell Memorial, which was built to designs by Leo von Klenze and erected shortly after the death of the great garden architect (ill. p. 241, bottom). The inscription reads: "To the great master of fine garden art, who crowned his lasting achievements to promote the purest enjoyment of the earth with this park, his Sovereign Max Joseph caused this memorial to be set. MDCCCXXIV."

So which of Hirschfeld's types can the Englischer Garten be said to manifest – melancholy, serenity, sentiment or solemnity? As it is a public park, "serene" is probably the most fitting description. Neither the Monopteros nor the Chinese Pavilion makes the park look noble or imbues it with sentiment. And if Hirschfeld demands a very economical use of staffage buildings in his treatise, so that the character of a garden as landscape can predominate, he or his successors must also have considered whether pure nature, artistically designed, would suffice to evoke sentiment or melancholy. The garden of sentiment depended on the longings of the owner or visitors, and at this time these were almost always longings for Italy and the past.

The Neue Garten north of the city of Potsdam is a wonderful example of the garden art of poetry and sentiment. It was created in two phases. In the first, in 1790, Frederick William II commissioned Johann August Eyserbeck, who was well known as a member of the art circle in Dessau-Wörlitz, to take charge of the work. He adorned the banks of the Heilger Lake with a large number of buildings, and, following the English example, concentrated on the distant prospect. One of the most charming of these unfolds before the kitchen building, which is a ruined temple half sunk in the earth (ill. p. 242). From here the King wanted a subterranean passage to his summer residence, the Marble Palace, which was built by Carl von Gontard and extended in 1797 by the architect who designed the Brandenburg Gate, Carl Gotthard Langhans. Nearby are also the red brick houses of the Dutch Establishment, a group of gatehouses

and servants' dwellings, with stables and coach houses, and a pyramid that served as an ice house. The garden has a wealth of unexpected vistas, and it skillfully suggests a wide field of references. Anyone who thinks the pyramid contains a tomb or that the Roman temple is a relic from the past will be surprised to learn that they have practical functions. But for those who wish to wander through the garden and abandon themselves to sentiment, the decorative buildings and the Romantic arrangement of nature are essential.

The poetic dreams were taken up again about 20 years later – in the second phase of work on the garden. The architect now was Peter Joseph Lenné, the much-traveled royal landscape gardener. He shifted the emphasis of the design to the landscape garden. By then the park was almost totally overgrown and had to be cleared. Lenné had broad avenues opened up, and removed the planting on the banks to create open vistas and new prospects.

At the same time he tackled the huge area of the park, which adjoined the terraces at the Palace of Sanssouci, changing it into a Romantic landscape garden. The appropriate buildings, like

the Chinese Teahouse built in 1754 by Johann Gottfried Büring (ill. p. 243) or the Temple of Friendship built in 1768 by Carl von Gontard, were already standing, and Lenné linked them with a system of paths to create the desired "poetic prospects."

Probably one of the most spectacular landscape gardens and the crowning achievement of this type in Germany was created by the self-educated Hermann, Prince of Pückler-Muskau (ill. p. 245, top left), the much-read author of *Briefe eines Verstorbenen*

(Letters from One Deceased). In 1811 he inherited an estate in the Neisse valley and set about laying out a landscape garden almost 600 hectares in size. The work started in 1815 and took 30 years to complete. The lodestars of the design, in his view, were the paths, "silent guides for walkers," and water, "the eye of the landscape," as he called them in his treatise *Andeutungen über Landschaftsgärtnerei* (Remarks on Landscape Gardening), which appeared During 1834. In the final phase of the Second World War, bitter fighting here destroyed most of the park. Then, when the border was drawn along the river Neisse, the park, much of which has now been restored, was divided into a German section and a Polish section.

The Prince wanted a "super total work of art," to borrow Sedlmayr's phrase, and this involved transforming an entire landscape, with its villages and the town of Muskau, into a park. He saw man as a concentrate of his past and wanted to show him with his family as a historical image of life – in a park, surrounded by the testimonies to his activities and in confrontation with nature. In 1845 the Prince had to sell his estate. The unimaginable sums he

Johann Gottfried Büring
Chinese Teahouse, 1755–64
Palace garden, Potsdam

Hermann Ludwig Heinrich, Prince of Pückler-Muskau, around 1835 Lithograph after a portait by Franz Krüger, 1824

RIGHT:
Branitz, View over the lake to the former Baroque palace, restored and redesigned by Gottfried Semper in 1852

BELOW:
View of the park with the smithy

needed to carry out his grand design could not be raised. It was also well known that his extravagant lifestyle – people were talking about "mad Pückler" – had swallowed up most of his fortune.

Anyone wishing to explore the estate today has a network of paths 27 kilometers long to choose from. One can walk for hours, indeed for days, through an incomparable natural park. The paths take the visitor to lakes, past the Old Palace, which has been restored, through the Blue Garden and across the Eich Lake dam, allowing him to experience the "regulated whole" favored by the Prince, as a Romantic natural painting.

In 1845, after selling his estates in Muskau, the prince moved to Branitz, a village south of Cottbus. He was now 60, but he set to work again to transform a neglected estate into a landscape garden of sentiment, employing more than 200 workers, including casual laborers and prisoners, on extensive earth works to model the terrain in the way that he desired. Then he had about 300,000 trees planted – including several thousand large trees that were to form the horizon of the park. The park is about 70 hectares and in the center stands the former Baroque palace, which was redesigned by Gottfried Semper in 1852 (ill. p. 245, top). To the west lies the flower garden, with its artistic arrangement of sculpture and a blue rose arbor. To the

Prince, the separation of garden and park was an essential part of the design. The garden was part of the palace, and he regarded it as an extension of his living quarters, while the surrounding park was "an accumulation of nature idealized." The earthen pyramids in the archaic style could hardly be a more original idea and are certainly a testimony to the owner's extravagance. He created them after the death of his wife in 1852 and had his own tomb built in the pyramid on the lake (ill. p. 244). He was buried here in 1871 – after an

ancient Egyptian funeral rite, as he had instructed in his will.

France

France is certainly the land of the Baroque garden, but the less rigid British landscape garden very quickly became popular here as well. The park of the Palace of Canon in Normandy, south-east of Caen, was laid out by Elie de Beaumont, a friend of Voltaire, between 1768 and 1783. Today it presents the visitor with a harmonious combination of wildly flourishing

natural growth and ordered parts. The Baroque concept is still charmingly recalled in the rectangular fountain in front of the terrace. Dovecotes and a Chinese kiosk, with twisting paths, clearly point to the English origin of the overall concept.

The gardens at Fontainebleau (ill. pp. 248/9) have a long history. The first arrangement was made in the Renaissance and redesigned in the Baroque style by André le Nôtre in 1645. Last came the landscape garden. Under Napoleon the palace and gardens, which had been devastated during the French revolution, were restored – the latter in the style of an English landscape garden.

The park at Buttes-Chaumont, to the north-east of Paris, was laid out in 1867. With its steep rocks, a ravine traversed by a suspension bridge and a little ruined temple, it belongs in the Romantic category. Ermenonville is also worthy of mention. It was designed by the Marquise de Girardin, whose inspiration was drawn from Leasowe William Shenstone. The Marquis acquired the land, which lies south-east of Senlis in the Ile de France, in 1766. The estate covers 900 hectares and includes woods and wild parts, with a farm, known as a "ferme ornée."

During the 19th century the landscape garden spread all over Europe, finally becoming the most widespread type of garden in the 20th century.

Elie de Beaumont
Park at the Palace of Canon
Chinese Kiosk

OVERLEAF:
Park at the Palace of Fontainebleau with
an 18th-century pavilion

Uwe Geese

Neoclassical Sculpture

European sculpture in the late 18th century

A negative reaction to High Baroque sculpture had begun to spread very early. This applied especially to the works of Gianlorenzo Bernini, of whom it was said that marble turned to wax in his hands. Intended by art writer Friedrich Wilhelm von Ramdohr (d. 1822) as criticism, the comment does sum up Bernini's artistic method.

Thanks to his exploitation of particular optical techniques, he effectively succeeded in elevating the materials he used, such as marble or terracotta, to a more exalted reality. In this way, he conveyed to the observer the illusion of participating in a divine event. Bernini's sculptures had such extraordinary suggestive power that the frontiers between this world and the next seemed to dissolve before the viewer. Wholly in the spirit of the Counter-Reformation, Bernini managed to sway the observer's sense of reality so as to create a supersensory impression.

The ensuing Rococo age, on the other hand, marked a fundamental change of attitude – and at the same time of perception – in the understanding of sculpture. It featured profuse and delicate ornamentation, as well as reduced scale, lightness and grace, thus annulling a basic formal characteristic of High Baroque sculpture – the metamorphosis of the image into a sensory representation of unreal phenomena.

Franz Ignaz Günther (1725–75)

A work by Ignaz Günther, one of the main figures of late Rococo sculpture, is an adoring angel from an unknown altar retable (ill. p. 251, bottom). It probably dates from around 1770. The angel is kneeling on a volute, leaning forwards and clasping its hands in homage across the breast. Compared with similar sculptures of the Baroque, its physical presence is reduced to a minimum. A sharp outline pushes the three-dimensional, spatial qualities into the background, just as the grid-like surface lines of the fabric flatten the sculptural quality of the figure. The angel was originally silver-painted and thus once reflected its surroundings, the paint enhancing its incorporeal character. For Rococo sculpture, an illusion of the supernatural was no longer on the agenda. With its tendency towards abstraction, it is more concerned to invite consideration of its formal features, so observers can keep their distance from the sculpture.

Günther left the Altmühl Valley for Munich, where he became a pupil and colleague of Johann Baptist Straub (1704–84) in 1743. His apprentice years took him to Salzburg, Mannheim, Olomouc, and Vienna, until he finally settled in Munich in late 1753. He and his teacher, Straub, were the Bavarian sculptors most in demand in their day. Within the span of Günther's rather brief working life, sculpture took the decisive steps towards the new stylistic language of Neoclassicism.

A 21-inch-high (53.5 cm) statuette showing Chronos with the hourglass (ill. p. 251, top) is generally dated to 1765–1770 – just

before the angel was produced. As an allegorical representation of passing time and transitoriness in general, the figure may have adorned a clock case or memorial tablet. Though the movement of the soulful but tired old man and the sweeping outline remained essentially late Baroque characteristics, the classically developed body and uniform white of the paint indicate pictorial concepts of Neoclassicism.

Jean-Pierre-Antoine Tassaert (1727–88)

Before Tassaert was appointed to the court of Frederick II in Berlin through the mediation of Jean Le Rond d'Alembert, he had lived in Paris for 30 years, ultimately becoming court sculptor. He was born in Antwerp to a Flemish family of sculptors, and was first trained by his father. He soon left for London, and in 1746 moved on to Paris, where he entered the workshop of the sculptor René Michel (Michel-Ange) Slodtz (1705–64). Once in Berlin, he again became court sculptor, also being appointed director of the Academy of Arts and head of the royal sculptural workshop.

The sculpture collection of the State Art Collections in Dresden preserves a marble bust which is – with some uncertainty – described as a self-portrait (ill. p. 252, left). According to statements by the artist's descendants, in whose possession the

bust had been, it is the portrait of a certain Mr. Caesar. Possibly, over 170 years of oral tradition, the name had been corrupted from "Tassaert" to "Caesar." If we compare the bust with the drawn portrait of him done by the sculptor's daughter Henriette Félicité in 1788, the great similarity between the two allows us to conclude that it is indeed a self-portrait of Tassaert. Lifesize and full-faced, the sculptor is shown in middle age, with the dress and hairstyle in fashion around 1780. As a comparison with the portrait busts of Jean-Antoine Houdon will confirm, the work's closeness to the naturalism of French Rococo is evident not only in the handling of the hairstyle and ruffles, but also in the depiction of a wart to the right of the nose. Tassaert was best known as a master of mythological genre sculpture, and besides numerous portraits did many allegorical pieces clearly showing the transition from Rococo to early Neoclassicism. In his few large-scale works, such as those of generals von Seydlitz and von Keith, he was one of the first sculptors to show men not in the robes of Antiquity, but in contemporary clothing. Tassaert developed a Rococo Neoclassicism, transmitted via influences from Britain, that coincided with the taste of the time. As a professor at the school of sculpture in Berlin, his naturalistic, objective approach had a particularly notable influence on his pupil and successor Johann Gottfried Schadow, thereby setting the tone for the Prussian sculptural tradition of the whole 19th century.

Alexander Trippel (1744–93)

Alexander Trippel came from Schaffhausen in Switzerland, but moved with his family to London when he was ten. In 1763, he moved on to the Copenhagen academy of art. Numerous changes of base followed – Copenhagen, Berlin, Paris, Switzerland and Rome – until he finally settled in Rome. When the news of the death of Frederick the Great reached him there in 1786, Trippel designed a wax model of a memorial to the king, while Schadow was doing just the same in his workshop. Both works were conceived as equestrian statues modeled more or less on the statue of Marcus Aurelius. Trippel's design was clearly more interesting, because, though it did not get him the commission, it gained him honorary membership of the Prussian Academy of Arts. In his model, the notion first appears of adding sculptures of the nation's leading figures to the base of the equestrian statue. The idea would be put into practice almost 60 years later in Rauch's memorial.

Trippel's best-known work today, the outsize bust of Goethe in the princely Residenz at Bad Arolsen in Waldeck, came about after the sculptor met the poet in Rome in 1786 (ill. p. 252, right). Prince Christian von Waldeck, then staying in Rome, commissioned Trippel to do a model of the bust. Goethe wrote of it in his diary *Italienische Reise* (Italian Journey): "It is done in a very solid style. When the model is ready, he will make a plaster cast of it and immediately begin work on the marble, which he would then like to work on from life; because what can be done

Giovanni Volpato
Muses Thalia and Clio
Bisque, h. 31.3 cm / 30 cm
Liebighaus, Frankfurt

in this material cannot be done in any other." The portrait shows the 38-year-old Goethe in the style of a classical portrait bust. During the work, Trippel told the client: "The hair is long and hangs down very loosely, making from the front the shape of an Apollo head." Goethe himself noted about the head: "Trippel got wind of a head of Apollo in the collection of Pope Giustiniani which had hitherto been overlooked. He considered it a most noble of work of art and harbored hopes of buying it, but was unable to." The marble execution of the Goethe portrait, dated on the back by Trippel to 1789, was passed by Prince Christian as a present to his brother Prince Frederick, the ruler of Waldeck, who installed it in the stairwell of his palace in Arolsen.

As Winckelmann proposed, Trippel turned directly to the models of classical Antiquity for inspiration, and in doing so left the pictorial language of the Rococo far behind. He thus became, along with Canova, one of the main representatives of early Neoclassicism in Rome, and a source of considerable influence and ideas for the next generation of sculptors.

Giovanni Volpato (1733–1803)

Born in Bassano, Giovanni Volpato worked initially as a stone mason, but then trained as an engraver. After working in Venice making engravings of portraits and *vedute* based on paintings by sundry artists, he settled in Rome in 1772, where he did some pages for the *Schola Italica picturæ* at the behest of Gavin Hamilton, and

had some share in carrying out the color engravings of Raphael's frescoes in the Stanze at the Vatican. Volpato's main contribution to the development of Neoclassical sculpture consisted in establishing and running a porcelain factory in Rome from 1786. Pope Pius VI had granted him the privilege of reproducing in porcelain the classical sculptures in the Vatican Museums.

The Liebighaus in Frankfurt contains two bisque statuettes from Volpato's mass production that copy ancient Roman models on a reduced scale. Copies of this sort were produced in various sizes and sold in great quantities. Although these days they tend to be thought little of, they were of great importance for propagating knowledge of Antiquity in the late 18th and early 19th centuries. At the same time, they contributed considerably to the formation of the new Neoclassical style, providing an aesthetic consensus for the bourgeoisie in its ambition to become the dominant social class. Membership of the bourgeoisie could be expressed through manifesting this shared and indeed binding taste, and proven principally by the ownership of "stylish" (which in the language of the time meant classicizing) works of art.

The reproductions of Clio and Thalia, the muses of history and comedy (ills. p. 253), are made in bisque (or biscuit), a technique developed in Volpato's time. *Bis cuire* means "cook (i.e. fire) twice," with the material made up as ceramic clay. With copies of antique statues, special care was taken over surface effects, which had to be fine and satin-matt, to create an effect of fine Greek marble.

example, had proposed a fountain-based sculpture. However, as the plans had always assumed a rearing horse, Falconet opted in the end for an equestrian statue that – almost entirely lacking allegorical attributes – would be placed on a rising rocky slope. In this, though Falconet was adopting a pictorial type of the Baroque showing a prince at the height of his fame, he did not wish to show just the victorious commander, but also wanted to feature the lawgiver and benevolent ruler. The sculptor thus shows him with his right hand raised protectively over his people. The rear right hoof of the horse tramples on the serpent of Envy, while the rocky slope represents symbolically the difficulties and problems that the Tsar had to overcome in his tasks.

The monument, designed on a grandiose scale in its monumentality, still follows Baroque conventions for movement. Even if the message is set out rather unheroically, it nonetheless ignored the radical changes in progress at the time and can have hardly been comprehensible to contemporaries.

Jean-Antoine Houdon (1741–1828)

Jean-Antoine Houdon, reckoned the most celebrated "human" sculptor of the 18th century, came from Versailles. Like Falconet, he was a pupil of Lemoyne II, but also trained with Jean-Baptiste Pigalle (1714–85) and especially Slodtz. While staying in Rome from 1764 to 1769 on a scholarship from the Academy, he had applied himself to the study of classical sculptures, during which he undertook detailed anatomical studies. The results of this are visible in his figure of the "muscle" man dated 1767. Among his principal works is a seated portrait of Voltaire, which he carried out between 1779 and 1781 for the niece and main heir of Voltaire, later Madame Duvivier (ill. p. 254). Originally intended as a gift for the Académie Française, Houdon's sculpture depicts the great Enlightenment figure as a philosopher. Because of personal differences with some academicians, in 1779 the donor changed her mind and presented the sculpture to the Comédie Française, in whose foyer it still stands. This change of heart on the part of the donor resulted in contemporary critics sarcastically pointing out the incompatibility of a majestic portrait of the wise philosopher and the setting of a theater.

Jean-Baptiste Pigalle had earlier made an attempt to create a worthy memorial sculpture of the philosopher while still alive (1778), an honor previously granted only to rulers, if at all, but his design had been rejected. Nevertheless, a few weeks before his death, Voltaire did permit Houdon a few portrait sittings, at which – by mutual agreement – preparatory work for the later sculpture was carried out. The philosopher sits on an austere Louis XVI chair, wrapped in a long undergarment that reaches over his forearms and feet. On top of this is a mantle in the style of depictions of classical gods and heroes, which the sculptor himself called a "philosopher's robe." The garment falls in broad

Étienne-Maurice Falconet (1716–91)

The French sculptor Falconet worked largely in the tradition of 18th-century art. After his training under Jean-Baptiste Lemoyne II (1704–78), he became a member of the Académie in Paris in 1754, and was appointed professor there in 1761. Earlier, in 1757, he had become head of the modeling department of the Sèvres porcelain works, and later, from 1766 to 1778, he worked in St. Petersburg. In Russia, whither he had been summoned by Catherine II on the recommendation of Diderot, he worked on a long-planned equestrian statue of Tsar Peter the Great (ill. p. 255), first mooted in 1717. Though the model was ready in 1770, it took eight more years and two unsuccessful attempts at casting for the bronze statue to be completed. The unveiling ensued only in 1782, by which time the sculptor was long back in Paris and a deputy director of the Académie.

Falconet's artistic realization of the monument had been preceded by numerous discussions, during which Diderot, for

Jean-Antoine Houdon
The Cold Girl, 1783
Marble, h. 145 cm
Musée Fabre, Montpellier

swathes from the shoulders and over the arms and left thigh before continuing further to largely cover chair and plinth, thus lending the statue the feeling of a monumental memorial. Slightly bent forward and with the head partly turned to the right, Voltaire appears to be registering a point in an absorbing conversation. His firm grasp of the arm-rest underlines the expression of attentive listening. Despite this naturalistic representational feature, the impression is predominantly of a robed figure sitting in state. Thus the constant alertness and widely admired sharpness of Voltaire's mind becomes the subject of the monument. The "sash of immortality" wound round the philosopher's head is reminiscent of the sash worn by ancient rulers or victorious athletes, evoking their divine status. In this way, the philosopher is elevated to a level of veneration that distinguishes him as a hero of the mind.

A marble figure in the Musée Fabre in Montpellier is signed "Houdon 1783" (ill. p. 256). It goes back to a series of models of allegorical representations of summer and winter. Unlike Baroque allegories of winter in the shape of an old man or woman warming him/herself at the fire, Houdon opted for the figure of a young girl. She has wrapped a cloth round her head and upper body, while her abdomen and legs are nude. The closed leg posture goes back to the ancient motif of the *Venus pudica*, but the nakedness of part of the body is a consistent element of the allegory of winter. Ultimately, Houdon uses these starting points as a justification for creating a very erotic sculpture, which soon acquired great popularity.

Claude Michel, known as Clodion (1738–1814)

Clodion came to Paris from Nancy as a 16-year-old. Initially he worked in the workshop of his uncle, before becoming a pupil of Pigalle. Already in the same year he won the first prize for sculpture at the Academy, and was subsequently accepted for the École royale des élèves protégés. He spent from 1762 to 1771 on a scholarship in Rome, where he found models in plenty, especially for his numerous small, imaginative terracotta sculptures depicting satyrs and nymphs, bacchantæ and amorous topics, with which he soon made a name for himself among collectors.

In 1783 there were a number of pioneering events in and around Paris to do with man's dream of flying. The Montgolfier brothers got their first hot-air balloon off the ground on July 5, after which came the first manned flight of a *montgolfier* on November 21. In the same year, the French physicist Jacques Alexandre César Charles (1746–1823) undertook several experiments with hydrogen-filled balloons, which were therefore called *charliers*. On December 1 Charles went up in a charlier, which induced the *Directeur des Bâtiments de Roi* to set up a competition for a memorial for this new technical achievement. Among other sculptors invited were Houdon, Pajou, and

Clodion. However, the designs were never shown publicly because the project was abandoned in 1785.

Clodion designed a round, altar-like base with a fire burning on it, to maintain which a bevy of putti scattered straw (ill. pp. 258/259). Above the fire hovers the balloon, likewise surrounded by putti, but also flanked by Fama and the wind god Æolus. The fussiness of this design makes it appear inappropriate for a monument and more suited to a drawing room. Even the imagery itself, which seeks to honor the invention with the traditional resources of allegory, scarcely convinces. This is because the allegorical meaning of the renewal of cult and life at a higher level despite being inherent in fire, the image here is partially false. On the plinth is a montgolfier supported by fire and hot air. A charlier filled with hydrogen would explode under such circumstances.

Augustin Pajou (1730–1809)

Born in Paris, Augustin Pajou was likewise a pupil of the sculptor Lemoyne II. Long before Clodion, Pajou had won the academy prize for sculpture and thereupon been accepted for the École royale des élèves protégés in 1748. Between 1752 and 1756 he was in Rome on a scholarship, and four years after this return to Paris he was admitted to the academy, finally becoming its rector in 1792. Fifteen years earlier the king had appointed him to the *Garde des antiques*. He was also a member of the Institut Français from its founding in 1793.

Among the most famous of his mythological figures is *Psyche Abandoned* (ill. p. 257). With her extraordinary beauty, the King's daughter Psyche had aroused envy in the divine Aphrodite, who instructs her son Eros to destroy Psyche. But Eros, who corresponds to the Roman Cupid, falls in love with Psyche and carries her off to his palace, where he comes to her only in stealth and in darkness, because she must not see him. Driven by curiosity, she surprises him in his sleep, whereupon he abandons her. In despair, Psyche seeks her beloved everywhere, eventually finishing up in the temple of Aphrodite, where she has to carry out dangerous tasks. Her loving tenacity finally causes Zeus to bring the two together again.

In 1782, Pajou was commissioned by the Direction des Bâtiments du Roi to make a figure as a counterpart to an *Amor* (Eros) done by Edmé Bouchardon (1698–1762) in 1750 and displayed since 1778 in the Antiquities Room of the Louvre. Though the choice of subject was left to Pajou, Amor's lover seemed the obvious choice. Half-seated on a cushioned plinth, the nude girl rests her right foot on a round base, her left on the stool. Beside her, on the footstool, her attributes lie around her: an overturned oil lamp, and on the pedestal, a fallen dagger. She clasps her heart in a gesture of pathos, her gaze full of pain. With this pose Pajou succeeded in conveying Psyche's utter despair at her loss and awareness of her own fault in causing it.

Augustin Pajou
Psyche Abandoned, 1790
Marble, h. 180 cm
Louvre, Paris

257

Thomas Banks (1735–1805)

Among leading British sculptors of the period, Thomas Banks is considered the first to have produced work in the Neoclassical style. Born in London, he spent his childhood in the west of England, before returning to London as an apprentice to an ornamental carver, whose workshop lay close to that of the sculptor Peter Scheemakers (1691–1781). He made friends with the latter's pupils, and was allowed to spend the evening in the sculptor's studio drawing and modeling. There he also saw casts of antique sculptures that Scheemakers had brought with him from Rome. His very first relief on classical themes gained him various prizes from the Society of Arts, and in 1770 he won the Royal Academy's gold medal with a relief of the *Rape of Proserpine*. Two years later, the Academy awarded him a travel scholarship to Rome, where he remained for seven years. Johann Heinrich Fuseli (1741–1825) was in Rome at the same time, and the two young men struck up a lifelong friendship. Before Fuseli had come to Rome, he had translated Winckelmann's *Gedanken über die Nachahmnung der griechischen Werke in der Malerei und der Bildhauerkunst*

(Thoughts on Imitating Greek Works in Painting and Sculpture into English. Thus thoroughly informed as to the current state o the debate over classical art, he passed on his knowledge to his nev English friend. Indeed, Winckelmann's ideas had a lasting effect or Banks' art. The artist also developed a particular interest in ancien sarcophagi, and his relief of the *Death of Germanicus* of 177 (Earl of Leicester, Holkham Hall, Norfolk) was probably amon; the first sculptures produced by an English sculptor in : Neoclassical mode.

Presumably in 1778 Banks began work on his marble relief o Thetis rising from the sea (ill. p. 260) with her nymphs to comfor Achilles after the loss of Patrocles. Achilles and his best frien Patrocles had gone to the Trojan War together. When the Trojan threatened the Greek ships, Achilles gave his friend his ow armor. His friend managed to repulse the Trojans, but was the killed in a duel with Hector. In the 18th book of the *Iliad* Home describes the scene where Achilles' mother Thetis rises from th sea with her nymphs to comfort her beloved son. The heroic fat of Achilles, who led the Greeks in the Trojan War and was himsel

OPPOSITE:
Thomas Banks
*Thetis Rising from the Sea to Comfort Achilles on
the Death of Patrocles*, 1778
Marble, h. 91.4 cm, b. 119 cm
Victoria & Albert Museum, London

Joseph Nollekens
Portrait bust of Laurence Sterne, 1776
Marble
National Portrait Gallery, London

killed by an arrow from Paris, was a subject that inspired Neo-classical artists time and again. Banks' version sticks closely to the story as told by Homer, but used a style influenced by Fuseli, who tended to emphasize linearity. However, whereas the group around the rising Thetis fits within the oval frame, the figures of Achilles and Patrocles form a stark contrast in their angular poses.

Joseph Nollekens (1737–1823)

Writing on the death of Banks, the sculptor John Flaxman cites Joseph Nollekens as a sculptor who, even before Banks, had pursued the Neoclassical ideal with a sense of classical form. In 1828, J. T. Smith, one of the executive masons Nollekens employed, wrote about his former employer in *Nollekens and His Times*. It is one of the most spiteful biographies ever written. In it, he accuses the sculptor of being both money-grubbing and avaricious. Nollekens, mocked Smith, was a sculptor who followed almost any taste as long as he could expect to gain sufficient well-to-do clients and patrons from it. The all-consuming interest of his life had been to make money, claimed Smith.

Born virtually without means, by his death Nollekens had amassed a fortune of nearly £200,000, but foolishly only left £100 of this to Smith, who consequently vented his spleen posthumously. One might, of course, more charitably consider the size of the fortune as impressive proof of a thoroughly successful life as a sculptor. Smith may have missed no opportunity to sneer at Nollekens' skinflint behavior and the wretched conditions the artist lived in from pure avarice, but he could not deny that he was without a peer as a portraitist.

London-born Nollekens came from an artistic family originally from Antwerp. Father and grandfather were painters, while he had gone to Peter Scheemakers as a pupil in 1750. After winning various prizes from the Society of Arts, he made his way to Rome, where he spent ten years. He won the gold medal of the Accademia di San Luca, and in 1772 became a member of the Royal Academy in London. He had already established a reputation as a portraitist in Rome, and had been so successful at it that he had to repeat some of his busts up to 150 times.

The bust of the English novelist Laurence Sterne (1713–68), which Nollekens worked on in Rome in 1766 (ill. p. 261), follows classical models in being limited to the depiction of the head and bare shoulders. Although this echoes the idealized portrait type of early Imperial Rome, the fine modeling of the narrow face makes the portrait very lifelike. This impression is reinforced by the three-dimensional treatment of the eyes. The iris is not just suggested and left blind in the eyeball, as in Houdon; Nollekens hollows out the pupil except for a small point that shines in the light. This late-antique treatment was further developed by sculptors of the Baroque, and Nollekens uses it almost without exception in order to provide his busts with a lifelike expression.

Johan Tobias Sergel (1740–1814)

In Sweden it was initially immigrant artists who serviced the increased demand from the nobility and the royal house for new buildings and their furnishing with sculpture and painting. It was not until work began on the lavish new Stockholm royal palace between 1690 and 1770 that the need was recognized to have local craftsmen and artists involved in the planning and execution. With the founding of the Royal Academy of Drawing (now the Konstakademie) in 1735, Sweden first gained self-sufficiency in the training of highly qualified craftsmen and artists. The view of art the academy passed on, like many another newly founded academy of art in Europe, was strongly oriented to the Paris academy. But from now on Swedish artists also went on their travels in order to widen their horizons. It was thus through artists going to Paris in the middle of the 18th century that French Rococo came to exercise a strong influence on Swedish art.

The Stockholm-born sculptor and graphic artist Johan Tobias Sergel (1740–1814) was first apprenticed to Louis Adrien Masreliez (1748–1810) when he was 16. In 1757, he joined the

Joaquim Machado de Castro
Equestrian statue of Joseph I of Portugal,
1775
Bronze
Praça do Comércio, Lisbon

sculptor Pierre Hubert L'Archevêque as pupil and assistant during work on the allegorical figures in the Imperial Room of the Stockholm palace and the monuments to Gustavus Vasa and Gustavus Adolphus. In 1760 he was awarded the Stockholm Academy's gold medal. Three years later he set up his own workshop and produced mainly portrait medallions and classicizing reliefs. In 1767 he was granted a state scholarship to Rome, where he made numerous terracottas on mythological themes, and developed his own Neoclassical style in contact with artists from so many other countries. After his return in 1779, he was appointed court sculptor by King Gustavus III as successor to his teacher L'Archevêque, and one year later professor at the Stockholm academy. Sergel is the most important Swedish sculptor of the 18th century, but he also left an extensive *oeuvre* of impressive drawings.

Commissioned by the city of Stockholm to make a monument for King Gustavus III of Sweden, Sergel presented the first sketch in 1790, and one year later a proportional model in plaster (ill. p. 263). After the full-scale, no longer extant model was completed in 1793, it took six more years for the bronze to be cast, the unveiling taking place only in 1808. In designing his portrait statue, Sergel was inspired by one of the most famous of classical statues, the Apollo Belvedere, but the figure of Gustavus, which is in imaginary ancient military dress that echoes contemporary clothing as well, is the wrong way round compared with the distinguished model. The free leg of the model becomes the engaged leg, while the drapery over the right arm of the king corresponds to the cloth around the outstretched left arm of Apollo. Finally, the taut physicality of the young, muscular archer of Antiquity becomes a rather slack pose of a ruler in the transition between late Baroque and Neoclassicism.

As a patron of art and literature, Gustavus III had founded the Royal Opera in 1773, and in 1776 the Swedish Academy, on the French model. He was also a man of letters who wrote plays and operas. His foreign policy was aimed at weakening the anti-Swedish alliance between Denmark and Russia. This led to his declaring war on Russia in 1788, which ended in 1790 in the Treaty of Värälä without any territorial changes. Depicted by Sergel at the moment of landing from the campaign, Gustavus supports himself with his left hand on a kind of commemorative stone, holding the laurel wreath of the victor. In his right hand he holds the olive bough of peace (lost on the model), indicating the intention and success of his campaign.

Joaquim Machado de Castro (1736–1822)

The most important Portuguese sculptor during the second half of the 18th century was Joaquim Machado de Castro. He came from Coimbra, the old university town on the Mondego, and spent time at the school for sculptors founded by King Joaõ in

Mafra, north-west of Lisbon. The school's first director was the Italian Alessandro Giusti (1715–99), who produced 14 large figures of saints from Carrara marble in the former monastic palace of Mafra. De Castro was known best of all for his highly vivid Christmas crib scenes, examples of which are in the Museu Nacional de Arte Antiga, the Sé Patriarcal Cathedral and the Basílica da Estrêla in Lisbon.

The *Terremoto* or earthquake of 1755, comparable in its effect with the destruction of Pompeii by the eruption of Vesuvius in A.D. 79, was considered one of the greatest non-military catastrophes in human history. The Enlightenment's dream of nature controlled by the human mind, then in the throes of formulation, was shaken to its very roots. While all the world was lamenting a judgement from God, the royal permanent secretary Sebastião José de Carvalho e Mello (1699–1782) settled down to rebuilding the city. A man of the Enlightenment, his sole contribution to the debate over the judgement of God was to ask dryly why God had only spared the red light district. He is recorded in history as the Marquês de Pombal, a title later awarded him by the king. In the new design for the lower town of Lisbon he left the former royal square in its original position by the Tejo, but changed its name from Terreiro do Paço to Praça do Comércio. The square is surrounded on three sides by arcaded buildings, leaving the fourth side open towards the Tejo. In the middle on a lofty plinth is the equestrian statue of King José I (ill. p. 262), designed by Machado de Castro.

Castro's statue was the first equestrian statue produced in Portugal to be cast in bronze. The casting was carried out successfully in a single operation on October 15 1774 in the Arsenal do Exército. And on May 22 the following year, it began its journey to the Praça do Comércio in solemn procession. On June 6 1775 the monument was finally ready for unveiling, the ceremony forming part of splendid celebrations. The 46-foot-high (14m) high equestrian statue shows the king dressed in a cape and plumed helmet. His majestically grave gaze is directed downriver over the Tejo to where the city – and the land itself – opens out to the sea. Two allegorical groups flank the oval plinth, while under the royal emblem on the end face is a medallion bearing a portrait of Pombal.

Antonio Canova
Dædalus and Icarus, 1777–79
Marble, h. 200 cm, b. 95 cm, d. 97 cm
Museo Correr, Venice

Highlights of Neoclassical sculpture

Antonio Canova (1757–1822)

The stock of classical sculptures was nowhere greater and easier of access than in Rome. The collectors and artists of the Renaissance had already made them familiar throughout Europe. It is therefore scarcely surprising that the Neoclassical renewal of sculpture should have spread from Rome.

Just as Donatello, Michelangelo or Bernini dominated the sculpture of their day, Antonio Canova was the dominating personality towering over the sculpture of European Neo-classicism. Born in 1757 in Possagno in the province of Treviso, he was already a pupil in the sculpture workshop of Giuseppe Bernadi, called Torretti, in nearby Pagnano in 1768. In the autumn of the same year, his teacher took him to Venice, where he had another studio. There Canova came into contact with masterpieces of Antiquity and post-classical sculpture in the collections of Venetian patricians. He was only 12 years old when he got his first commission for two corbeils (decorative fruit baskets).

His family circumstances were rather unfortunate. Canova was only three when his father, the stone mason Pietro Canova, died. His mother remarried into a village west of Possagno, leaving little Antonio in the care of his grandfather, Pasino, who likewise worked as a stone mason. It was thanks to the latter's

circumspection that the education of the talented youngster was steered on to the right track. In 1770, the grandfather sold land in order to pay for his grandson's upkeep in Venice. In 1773, Senator Giovanni Falier, who had already commissioned the corbeils, lodged two more commissions with the young sculptor, one for a Eurydice figure, and following on its success, an Orpheus figure. Thus encouraged, Canova left Torretti's work-shop in 1775 and set up his own workshop in the monastery of Santo Stefano.

The main work of his early Venetian period was the *Dædalus and Icarus* group of 1777–79 (ill. p. 264), which aroused great admiration at the annual art fair in Venice and was also commercially successful. Still marked by a Baroque abundance of movement, in which the divergent motion of the figures is checked only by the strapping on of the wing, the group shows two characters who, while relating to each other, form a stark contrast. On the one side is the almost childish, carefree Icarus, full of anticipation of the forthcoming adventure, and on the other the canny, shrewd father, an inventor and the mythological ancestor of all artists. In the thoroughly naturalistic representation of him and unflinching depiction of his ageing physique, there is a strong element of portraiture. It has been convincingly suggested that Dædalus constitutes a portrait that renders homage to Canova's grandfather, who by selling his land had conferred the wings of independence on the ambitious sculptor. Another educated and convincing interpretation of the sculpture draws attention to the hammers, attributes of the mason, at the old man's feet. The image of Icarus "winged" by his father and dreaming of flying, who is ready to accept the risk of failure in order to fulfill an ancient dream of humanity, is a manifestation of the new self-image of an artist. Such an artist would shake off the traditional chains of the artisan, whose job in Settecento Venice was mainly to supply pleasing sculptures.

In autumn 1779, Canova undertook the obligatory study trip to Rome, where he not only became familiar with sculptural works of the past, but also came into close contact with the artists and critics of the contemporary avant-garde. A cast of the Dædalus-Icarus group confirmed him as having great sculptural talents, but he was nonetheless advised to work in future in the style demanded by Winckelmann. He was given an opportunity to do this when he was commissioned by Girolamo Zulian, the Venetian ambassador in Rome, to do a *Theseus and the Minotaur* group in 1781 (ill. p. 265, bottom). Supported by grants from the Venetian senate, Canova created a sculpture whose subject is not Theseus' struggle, but the victor in brooding pose sitting on the defeated enemy. Showing the melancholy, ruminative moment after the deed was more in keeping with the new view of art than the traditional scene of the dramatic struggle with the Cretan monster. It is at this moment that the – morally superior – powers of human virtue

BELOW:
Antonio Canova
Theseus and the Minotaur, 1781–83
Marble, h. 145.4 cm, b. 158.7 cm, d. 91.4 cm
Victoria & Albert Museum, London

Antonio Canova
Theseus and the Centaur, 1804–19
Carrara marble, h. 340 cm, b. 370 cm
Kunsthistorisches Museum, Vienna

come together in order to carry off the victory for good in the struggle with the monstrous and violent forces of nature.

In a later version of the Theseus myth, Canova shows a scene of turbulent struggle. Theseus raises his club in his right hand ready to strike, while already kneeling on the chest of the centaur, who is arched backwards and lying on the ground (ill. p. 265, top, and p. 266). The dominant shape of the design is a large triangle formed of Theseus's right foot, the centaur's left hand propping himself up, and the helmet as the apex. Other triangles correspond with this outline in subordinate position, formed by the upper arm and club or the bent leg. This formal structure to some extent offsets the drama of the event by conferring a degree of static stiffness, which Canova seeks to loosen by means of a trick scarcely perceptible in the illustration. He placed the two figures braced against each other at a slight angle in such a way that differentiated planes are generated, and the central event of the duel takes place in the front plane, while the bodies tend to develop out of the depth of the three-dimensional space. Although Canova's group resembles the Laocoön group of Antiquity in its expression of pathos and in the presentation of strain in a duel, the rhetorical and scholarly elements dominate in Canova's style, and it was on these that

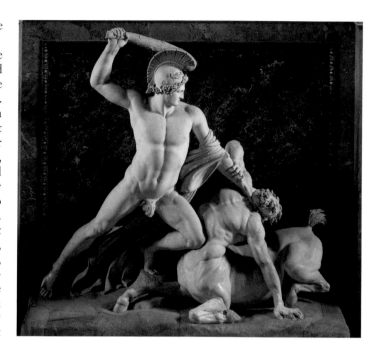

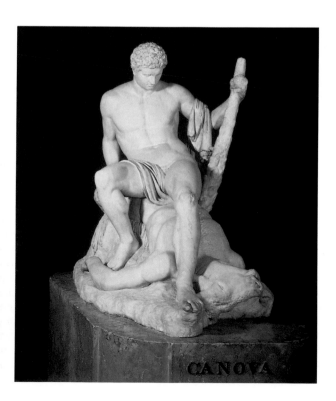

academic tradition would later be based. Whereas the one piece was created between 1777 and 1779, the other was produced between 1804 and 1819. Between the two came a sculpture that elicited violent applause from its admirers and the most disparaging remarks from its critics. *Amor and Psyche* are turned towards each other in sensual love (ills. pp. 267/268), a scene that aroused such enthusiasm in Gustave Flaubert, who saw it in a gallery, that he was compelled to return to it several times, till "in the end," he wrote, he "kissed the shoulder of the swooning woman as she stretches out her long marble arm towards the god of love. And the foot! The head! The profile! May I be forgiven. It was my first sensual kiss for a long time. It was indeed something more – it was beauty itself I kissed." He added apologetically that his enthusiasm applied only to the genius.

Indeed, Canova had succeeded in presenting a highly expressive treatment of the theme of love from Greek mythology. Lying on her right hip, Psyche turns backwards towards Amor (Eros), who approaches her in a kiss. While he embraces her body with his left hand and holds her head with his right hand, she puts her arms round his hair. The tension builds from the outer ends of the sculpture, the outstretched feet of the two lovers, towards the center, where the state of suspense before the kiss is framed by the circle of Psyche's arms. The upward ranged wings of Amor emphasize the divine, about to embrace mortal Psyche. The fulfillment of the love between the two is tangibly near.

265

Antonio Canova
Theseus and the Centaur (detail), 1804–19
Carrara marble, h. 340 cm, b. 370 cm
Kunsthistorisches Museum, Vienna

OPPOSITE
Antonio Canova
Amor and Psyche (detail), 1786–93
Marble, h. 155 cm, b. 168 cm
Louvre, Paris

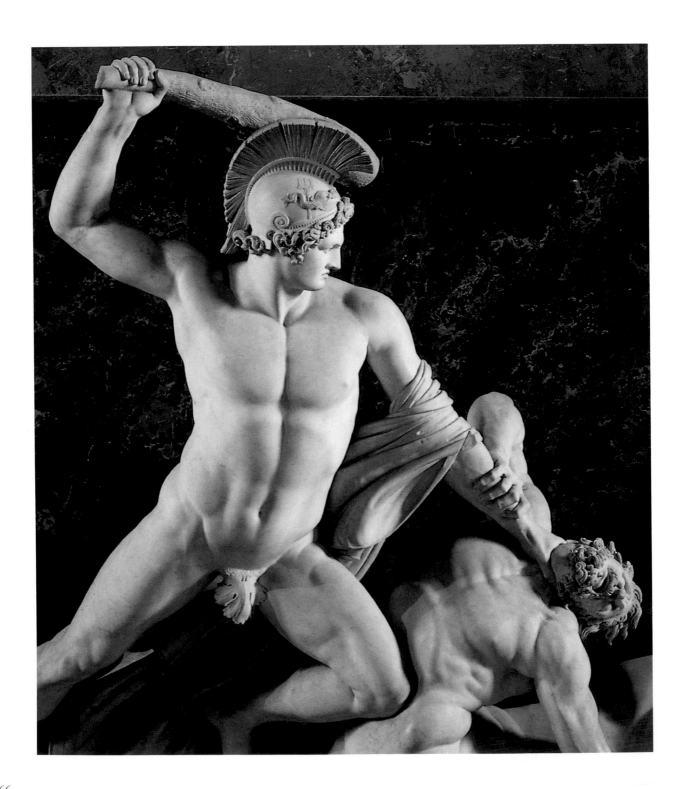

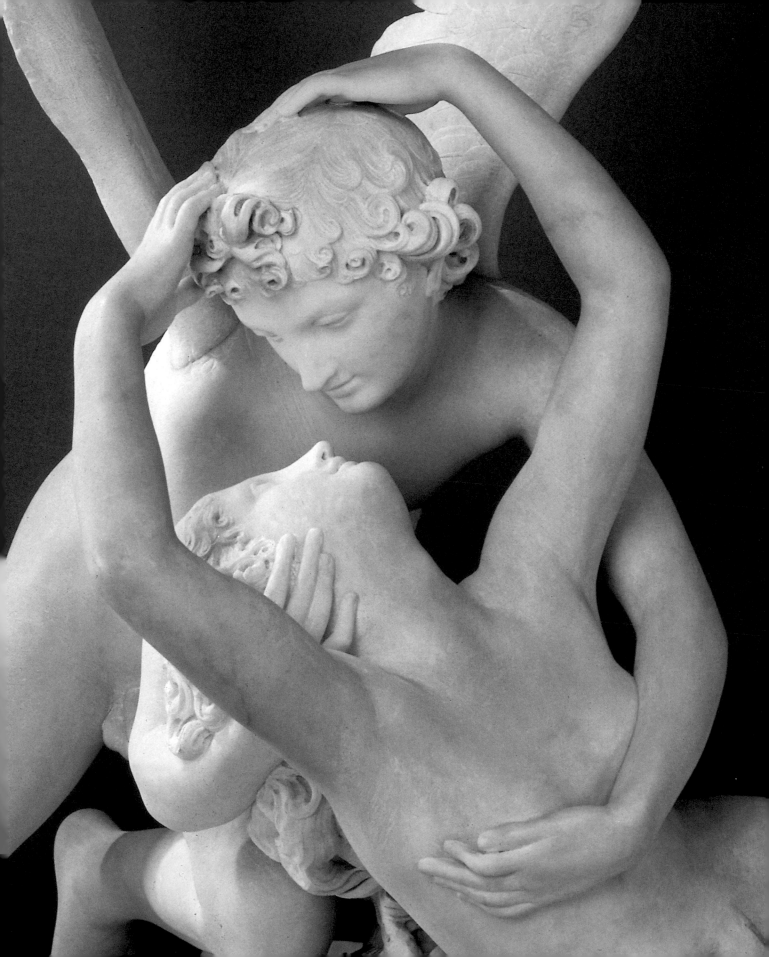

Antonio Canova
Amor and Psyche, 1786–93
Marble, h. 155 cm, b. 168 cm
Louvre, Paris

weakened position. Finally, in 1815, the year of Napoleon's final downfall, the British government presented it to the Duke of Wellington as a souvenir of his victory at Waterloo. In Licht's words, the work was planned as homage to a demi-god and finished up a memento of the transitoriness of earthly triumphs.

The bronze version, ordered by the Viceroy of Napoleonic Italy for the Foro Napoleonico in Milan, likewise failed to make it to installation. When the huge statue was finally cast in 1812, it could no longer be shown publicly, and landed instead in the courtyard of the Milan senate. From there, it was hastily moved on to the Museo di Brera, which put it into store. It could only be brought out for exhibition in a semi-public space, the courtyard of the Palazzo di Brera – as a work of art only, without any representational duties vis-à-vis the subject concerned.

Sometime around 1800, Canova realized that he could no longer definitely count on appropriate advance payments for public commissions. He therefore did his monumental sculptures initially from plaster, to be able to offer them to possible buyers for whom he could translate them into marble if necessary. The consequence was that the work initially possessed purely aesthetic and artistic value, and its later importance was conferred not by the artist, but by the buyer or the public.

A monument of this sort is found in Vienna in the *Tomb of Archduchess Maria Christina*, daughter of the Empress Maria Theresia (ill. p. 269). Designed between 1790 and 1795 as a

At the same time, the observer finds himself drawn into this tense moment before the kiss. He recalls his own amorous desires and maybe also his fruitless efforts in that direction. Possibly this is what happened to Flaubert. The as yet unrealized connection between the god of Love and the personification of the human soul gives shape both to the desire for fulfillment and also the knowledge of its possible failure.

In 1802, Canova traveled to Paris, to work on a portrait bust of Napoleon. The plan to make a statue of the First Consul led to a contract that reflects the whole problem of monumental sculpture at the time. Though the Baroque had found a suitable artistic treatment for public monumental sculpture depicting rulers, the French Revolution had rendered it obsolete. Moreover, the attributes of contemporary clothing no longer indicated, as in Baroque times, the subject's membership of the ruling class so as to compel appropriate respect from the viewer. Dress had become a matter of fashion. Napoleon expected to be shown in the uniform of a French general. Canova firmly rejected this. He wanted a statue in heroic nudity showing the ruler as the Greek god of War, Mars, who brings peace by his deeds (ill. p. 268, bottom). However, Napoleon appreciated that the public representation of modern power could not be done with the larger-than-life heroic nudity of the classical hero. Nudity as an attribute could not be used any more. Anyone shown naked tended to look unimportant.

Canova succeeded in capturing the double nature of Napoleon the person and the myth in his bust, but the statue to go with the bust no longer met the requirements of an all-purpose monument. The heroically naked body loses virtually all sense of dual characterization. Full-length, the portrait forfeits considerable substance instead of being elevated to a higher level of meaning. The complete marble sculpture reached Paris only in 1811, but was not installed because of the ruler's

LEFT:
Antonio Canova
Napoleon as Mars the Peacemaker,
1803–09
Bronze, h. 325 cm
Pinacoteca di Brera, Milan

OPPOSITE:
Antonio Canova
Tomb of Duchess Maria Christina of
Saxony-Teschen, 1798–1805
Carrara marble, h. 574 cm
Augustinians Church, Vienna

monument to Titian, its execution was no longer possible after the occupation of Venice by the French in 1797. The reallocation of a memorial monument to a different dead person – hitherto hardly conceivable – only became feasible because it was its artistic quality which came first. It was produced before the purchaser had attributed a specific meaning to it. This kind of "independence" of a work of art also finds expression in the relationship to the church interior, from which Canova deliberately sets his monument apart. The very form of a pyramid is alien to a

Gothic church interior, and the spatial depth implicit in its concept of a transition, from the steps in front through to the darkness of an entry through the wall of the church, again emphasizes its independence.

From the left, a solemn procession moves towards the entrance of the pyramid. At the back is an old, possibly blind man, who is led forward by a young woman. Rhythmically apart from this motif of age, another tall woman, accompanied by two girls, carries the urn with the deceased's ashes into the vault.

One of the girls follows, the other precedes her. This act of preceding represents the high point of the content, and constitutes an epoch-making new attitude towards death. Whereas in earlier tomb monuments people were always turned towards the viewer, mostly with moralizing intent to indicate the existence of life after death, here they are turned away from the viewer, leaving him alone with the fearful question as to what comes next. This procession no longer moves along the path of eternal life after death. The girl in the act of entering the doorway of the vault shows the viewer the sole of her feet and the unmistakable shape of her calf through the robe. Even her hair gleams with the light of the living. In the next moment she will have vanished into the darkness of the vault, i.e. passed into death. As will those that follow her. Only the viewer will be left behind in the uncertainty of his earthly existence, though left behind with the certainty that one day he will have to join this procession. Significantly, the figure that projects furthest from the picture plane, that is nearest the viewer, is the spirit of death, which sits on the steps, leaning on a resting lion.

Not intended for the public view was the full-length figure of Paolina Borghese, one of Canova's most masterly sculptures (ill. p. 270). Widowed very young, Napoleon's sister Paolina had, in the wake of her brother's meteoric career, made one of the noblest catches it was possible to make at the time. Intelligent and beautiful, she had also kept her carefree and unprejudiced ways even as a princess. Her unconventional manner and erotic appeal had gained her public attention. She now expected from Canova a portrait that showed her, the princess and sister of Napoleon, physically naked.

To lessen the tricky nature of the commission, Canova proposed to show her as Diana, whom he could have clothed in a robe. However, she insisted on appearing as Venus, because this was a goddess who had to appear nude. For the artist, the thorny issue was not just the nudity Paolina wanted. The conditions for allegorical representations had also changed, as the spirit of the time moved on around 1800. Nakedness no longer unquestionably represented the heroic element of Antiquity. It was all too easy to arouse suspicions of immorality. As well as being a princess and the Emperor's sister, Paolina was a "modern" woman, who represented a new type of beauty and who was certainly conscious of her erotic appeal. The commission required a good deal of imaginativeness and artistic skill if Canova was to live up to Paolina's expectations without exposing himself to the accusation of morally reprehensible exhibitionism from a prudish public.

In the event, Canova showed her relaxing almost carelessly on a chaise longue, her right leg stretched out, over which the left is casually placed. Her left arm rests on this, holding an apple in her hand, the trophy from the judgement of Paris. Bent at the hips, her upper body is supported by her right arm, which also supports her head. She turns in a three-quarters profile, directing her gaze into the distance, ignoring the viewer. Whereas for example the accessories, such as the cushion or the cloth round her hips, are shown naturalistically, the skin of her upper body is polished smooth and therefore removed from reality. Both closeness and distance are presented here, two elements that form part of the way our modern celebrity system works. In this respect, the portrait of Paolina Borghese has been cited as a direct predecessor of the self-projection of a Marilyn Monroe.

Bertel Thorvaldsen (1770–1844)

After Canova, the Dane Bertel Thorvaldsen was the most important Neoclassical sculptor in Europe, and after the death of his rival in 1822 he was considered incontestably the most inspired sculptor of his day. The son of an Icelandic wood carver, Thorvaldsen was born in Copenhagen in 1770, or possibly 1768, and grew up in the humble circumstances of an artisan family until, while still a boy, he was discovered to be able to draw. His first teacher was the painter Nicolai Abraham Abildgaard (1743–1804). Having finished the plaster course at the Copenhagen academy, he attended modeling classes. After winning various prizes and medals from the Royal Danish Academy of Art, in 1793 he won its grand gold medal with a relief of St. Peter healing the lame. The prize was a three-year scholarship to Rome. Thorvaldsen arrived in Rome on March 8 1797, and as this was the start of his artistic life proper, he henceforth celebrated the day as his "Roman birthday." Described by his friends as the Phidias of Denmark, he remained in the "capital of the arts" continuously, with only a few interruptions, until 1842, working as a freelance sculptor.

The figure of *Jason with the Golden Fleece* is considered Thorvaldsen's breakthrough piece (ill. p. 272). In October 1800, he had made a first version at life size, which was lost because he had no money to make a plaster cast. In 1802 he began a new, over-lifesize clay model, which, with outside support, he was able to have cast in plaster. When the English art connoisseur, furniture designer and banker Thomas Hope ordered a marble copy of the *Jason*, it was not only Thorvaldsen's finances in Rome that were stabilized for the time being. The commission marks the beginning of an extensive workshop business in which, besides numerous assistants, some of the most important 19th-century sculptors would work.

The circumstance that, directly after Hope's commission, Thorvaldsen concluded a contract with the sculptors Pietro Finelli (c. 1770–1812) and Heinrich Keller (1771–1832) to take over the work from obtaining the raw marble to carving out the figure, also throws light on the organization of labor in the Dane's workshop. The sculptors were to proceed according to the pointing technique developed by the French Academy in Rome for the

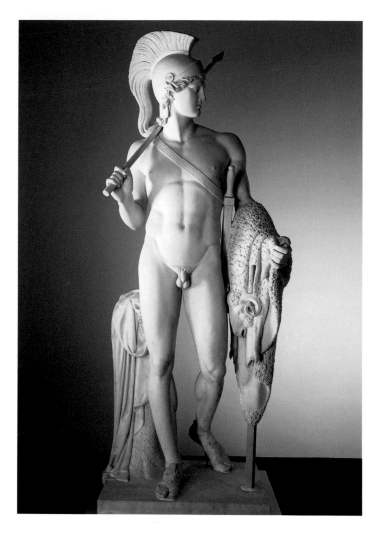

states, Thorvaldsen left the execution in marble entirely to his pupils and assistants. More and more frequently, Thorvaldsen did only the model. Indeed, later a clay sketch one foot high was considered enough, which was then modeled in clay over-lifesize by one of the more talented pupils. Copied in plaster, this model was finally replicated in marble by several sculptors. The less experienced pupils did the rougher work like chipping the figures from the marble block, at which point the more sophisticated work was taken over by skilled hands. In this way, Thorvaldsen could produce a whole series of sculptures in his workshop at once, with his job merely the supervision. "I visited his workshop several times," said the Polish writer Count Racynski. "He went from one worker to the next and marked with a pencil the places that had to be changed or improved." And with the help of the pointing technique it was possible for work to continue without interruption during Thorvaldsen's absence from the workshop or even from Rome. This is the only way the inexhaustible wealth of his sculptural output can be explained, individual pieces being found all over Europe. The Thorvaldsen Museum in Copenhagen (ill. p. 273) alone inventories 860 sculptures. At the same time, this huge output testifies to an immense productive vigor and unmatched creative potency that developed wholly on the lines proposed by Winckelmann.

In the figure of *Jason* (ill. p. 272) there are unmistakable echoes of Antiquity – principally the *Apollo Belvedere* but also the *Doryphorus* of Polyclitus (National Museum, Naples) can be considered as models. Following the instructions of Winckelmann, Thorvaldsen developed the representation of his mythological male figures not by imitating nature but by the close study of classical sculptures. A central feature of Neoclassical sculpture is the "contour," the outline of a sculpture. The clarity of the contour focuses the art on its "spiritual" form. "The noblest outline unites or circumscribes all parts of finest nature and the ideal beauty in the figures of the Greeks; or rather it is the highest concept in both," wrote Winckelmann, and advised: "If imitating nature could give the artist everything, correctness in the contour would certainly not be obtained from it; this can only be learnt from the Greeks." The frontal view of Jason shows how close Thorvaldsen was to Winckelmann's ideas.

The nude hero, presented to the viewer stepping forward, is filled with inner repose in an attitude of victorious certainty, in which as it were – surrounded by the contour – internal and external fuse to make an ideal. Contour and form enter a perfect symbiosis by virtue of the creative process, because the figure remains, unlike in the *Apollo Belvedere* for example, inside the marble block from which it is hewn. The cloth draped over the plinth shows that the block was only a little larger than the plinth on which the figure stands. Thus in Thorvaldsen's sculpture the design of the contour was also part of his management of costs.

purpose of copying antiques, which was already used systematically by Canova. "A wooden frame is put up over the block of marble from which plumblines hang down. After accurate measurement of the plaster model, these furnish the size and position of the outermost points of the model, which are then marked on the stone with black dots. Then, when the chisel has worked its way further into the block, more and more dimensions of the plaster model are measured and transferred to the marble statue with mathematical accuracy, but so as to leave the surface sufficiently raised so that the artist can bring the final touches to his work as he removes it," is how Thorvaldsen's fellow countryman Christian Molbech described this copying technique. But whereas Canova himself carried out that last phase of work on his marble

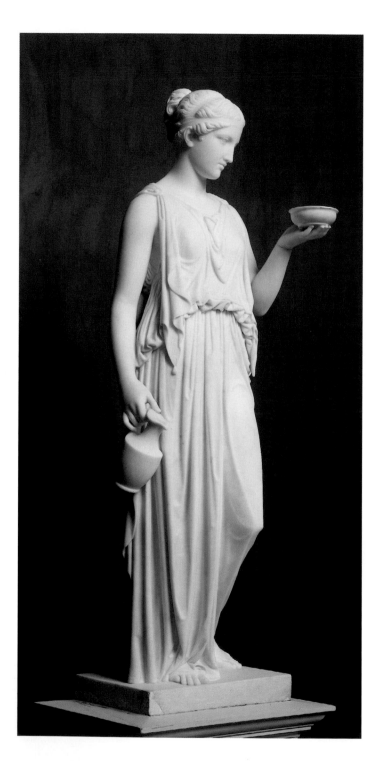

The contour features even more strongly as a design element in the figure of *Ganymede*. After various versions in which he presented the standing figures of *Ganymede Offering the Drinking Cup* (1804) and *Ganymede Filling the Cup* (1816), the work of 1817 shows him as a kneeling figure watering the eagle (ill. p. 275). The ancient tale tells how Ganymede, son of King Tros (who gave Troy its name), was the most beautiful of all youths. Ganymede is chosen by the gods as Zeus' cupbearer. Fired with great lust, the father of the gods clothes himself in eagle feathers and hunts out the youth on the Plain of Troy in order to lure him away to Olympus. Ganymede artlessly offers his drinking bowl to this eagle that drops from the sky, and the disguised supreme Olympic god dips his beak into the bowl. As a sign of his origin, the youth wears the Phrygian cap and holds a jug in his right hand.

Wholly designed for a single viewpoint, the sculpture is basically held together by its severe outline. This brings out the relief-like nature of the group and is a mark of Thorvaldsen's supreme mastery of line, which he had practised to perfection in numerous bas reliefs of the time. Influenced by the contoured drawings of fellow artists, he shaped the outline of his figures in clear lines traced on the relief ground. The forms of the contour are also wholly conceived in a Winckelmann manner. This tends to suppress the three-dimensional quality, the element of sculpture in which, for example, the emotion and drama of the protagonists can be expressed. As a result of this ideal, the Ganymede group likewise remains rather abstract in its three-dimensional realization. In its idealized beauty it appears cool rather than sensuous.

Thorvaldsen produced his first model of *Hebe* in 1806 (ill. p. 274). The daughter of Zeus and Hera, Hebe is the goddess of Youth and Spring, and proffers the cup of immortality at the table of the gods, a role later taken over by Ganymede. Thorvaldsen returned to this subject again and again, the figure of Hebe being conceived as a female counterpart to the standing Ganymede. She stands on her plinth, raising the drinking bowl with her left hand, her gaze focusing on it. She holds the jug with a lowered right hand beside her thigh. The treatment of the robe is unusual from the point of view of the history of fashion, because Thorvaldsen combined the classical type of the ankle-length peplos tied on both shoulders with the shorter and lighter chiton. In another *Hebe* modeled by Thorvaldsen ten years later, he corrected this illogicality of dress by presenting her solely in a peplos. The physicality and movement are also more restrained, the head is less bent forward, and the free leg is not so prominently displayed. Whereas the model of 1806 was executed in marble only once, sometime between 1819 and 1823, the 1816 version was carried out in several marble copies.

Bertel Thorvaldsen
Ganymede Waters Zeus as an Eagle, 1817
Marble, h. 93.5 cm, b. 118.5 cm
Thorvaldsen Museum, Copenhagen

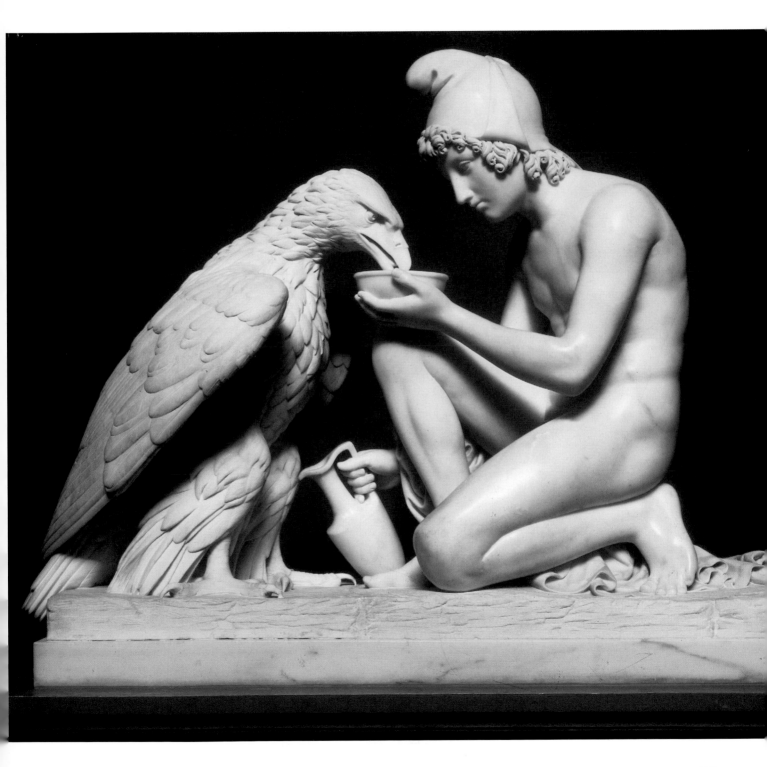

Johann Gottfried Schadow
Quadriga, 1793
Chased copper on wood
H. overall 550 cm, horses 370 cm,
chariot 320 cm, goddess 415 cm
Brandenburg Gate, Berlin

Johann Gottfried Schadow (1764–1850)

In German sculpture, it was the Berlin sculptor Johann Gottfried Schadow who established the fashion for Neoclassicism. In contrast with other German sculptors, his great inner closeness to Hellenism is particularly notable. Even so, thanks to their realism and the combination of canonical beauty with originality, his sculptures remain free of that cool rationalism of which Neoclassicism is often accused.

Schadow was taught drawing by an apprentice sculptor from the Berlin court sculpture workshop while still a child. At the age of 14, he was taken in by the family of the sculptor Tassaert, where he received a five-year training. During this time he and the eldest son of his teacher attended drawing lessons at the Academy of Arts, where he enrolled in the matriculation register on December 5, 1778. Surrounded by the Tassaert family, the adolescent had the best conceivable access to the bourgeois intelligentsia of his day, because the most prominent and influential scholars and officials of Berlin passed through the Academy's doors.

From 1785 to 1787 Schadow lived in Rome, where he had to become a Catholic because of his marriage. His first son Karl Zeno Rudolf (Ridolfo), who would follow him as a sculptor, was born here. In Rome, Schadow worked under Alexander Trippel and made friends with Antonio Canova. His discovery of the sheer inexhaustibility of classical sculpture finally led Schadow to

concentrate wholly on sculpture. His first success was not long in coming. In the Concorso di Balestra of the Accademia di San Luca on June 12, 1786, he won the gold medal with his version of the competition theme of *Perseus liberating Andromeda*.

Two years after his return from Italy Schadow started work on the piece that counts as the most monumental large Neoclassical sculpture in Berlin – the *Quadriga* on the Brandenburg Gate (ill. p. 276). Architect Carl Gotthard Langhans the Elder (1732–1808), director of the Court Office of Works from 1788, had envisaged a rich sculptural flourish for the top of his city gate. The *Quadriga* was conceived as the Triumph of Peace. Schadow, from 1788 director of the Court Sculptural Workshop, which was subordinate to the Office of Works, did the drawings for it from equestrian models in the Royal Stables and the Veterinary School. Turning these into a monumental group proved extraordinarily tricky, even though the work was in the hands of highly qualified technicians and assistant sculptors. The work was finally completed in chased copper, partly because there were no experienced bronze-casting workshops in Berlin, and partly because of the considerable problems inherent in the weight of such a monumental bronze group. For this, Schadow's plaster model was transferred to a large wooden model by a carpenter's workshop, which was then covered with sheet copper by a coppersmith. Completed in the second quarter of 1793, following frequent interruptions to the work through numerous planning mistakes, the individual sculptures were transported by water from Potsdam to Berlin.

As a familiar symbol of ancient military power, the quadriga was an obvious device to represent a victorious ruler. Linked with Victoria as the classical goddess of victory, as a symbol of peace it was of course so closely identified with a unilaterally nationalistic character that a mere 13 years later, in December 1806, it was carted off to Paris as war booty. Napoleon's theft had the effect of elevating the statue into a symbol of Prussian patriotism, and in 1814 it was brought back. Both journeys substantially damaged the work, so that extensive restoration work was necessary both in Paris and Berlin.

Among the best-known sculptures by Schadow today is the group of *Princesses Louise and Frederica of Prussia* (ill. p. 277). After Prussian Crown Prince Frederick William and his younger brother Ludwig had married the princesses of Mecklenburg-Strelitz in quick succession in December 1793, Schadow was commissioned to produce portrait busts of the sisters. During the work, Schadow must have opted for a full-length double portrait of the two women instead. A lifesize plaster version was already exhibited in 1795 in the autumn exhibition of the Academy of Arts. Initially it was intended to serve as a model for small-scale bisque figures from the porcelain factory, which were intended for public sale. But Schadow could not shake off the idea of doing

Johann Gottfried Schadow
Crown Princess Louise and Princess
Frederica of Prussia, 1796–97
Marble, h. 172 cm
Nationalgalerie, Staatliche Museen
zu Berlin – Preussischer Kulturbesitz,
Berlin

a marble version. After long negotiations an agreement was finally concluded, though the ultimate location was left open. The king wanted to leave the matter until the statue was complete. This had fatal consequences for the artist and the work itself. By the end of the academy exhibition of 1797, where the marble group was exhibited, Frederick William II died, and his son Frederick William III saw no reason to honor his father's obligations to Schadow.

Thus the group, neatly packaged, initially ended up in Schadow's workshop, until eventually it was installed in a lesser room of the royal palace in Berlin, hidden from public view. The sculpture is now in the National Gallery in Berlin. The early difficulties with the acceptance of the work brought Schadow to the brink of ruin, and not many people realize today that one of the masterpieces of early German Neoclassicism was hidden from the public for nearly a century and thereby robbed of its full art-historical effect.

The two sisters stand in a playful and charming pose side by side, the elder sister having her arm on the younger sister's shoulder, while the latter has her right hand on the other's hip. In imitation of classical depictions of clothing, the dress is gathered over the hips of the younger woman and laced up under the breasts of the older woman. Whereas the folds fall fairly close to the body on the older girl, they are dispersed more loosely on the younger one. On both, the free leg makes a visible presence through the material. Schadow made adroit use of the differing heights of the embracing women as a support motif.

The plaster model, where the clothing of the princesses was more noticeably influenced by current fashions, had a lasting effect on contemporary female fashion following the exhibition of 1795. In his memoirs *Kunstwerke und Kunstansichten* (Works of Art and Views of Art), Schadow comments: "The headdress of the Crown Princess and the bandage under her chin were to cover a swelling on her neck, which later disappeared. The ladies of the day took it as a fashion to copy."

Such naturalism in his depictions clearly distinguishes Schadow's style from the strict Neoclassicism of Thorvaldsen. When we consider what influence even the very briefly exhibited plaster model had on viewers, it is all the more regrettable that the first full-length sculptural double portrait of German Neoclassicism was practically condemned to artistic ineffectiveness.

Bavarian Crown Prince Ludwig's first plan for a hall of honor of *rühmlich ausgezeichneten Teutschen* (Germans distinguished by fame) – the later Valhalla – presumably dated from 1806, but had to be kept secret for political reasons, as he was under the forced military obligations of an alliance with Napoleon. In January 1807 he stopped off in Berlin on the way to the front to visit his troops, who were in Warsaw, engaged in battle with the

Russians. Both on the way out and the way back he called on Schadow to discuss the project. At the meetings, he commissioned a range of portraits, which came as a heaven-sent boon to the crisis-struck finances of the workshop. It appears that Schadow was one of the first people to be informed of his plans, because Ludwig enjoined secrecy on him.

Schadow was to carry out 15 of the 50 busts originally planned, which were to be allocated to three separate historical departments (ills. pp. 278 and 279). The Middle Ages were to be represented by German emperors such as Otto the Great and Conrad II, and kings such as Henry I and Henry the Lion. Only physicist Otto von Guericke and astronomer Copernicus (Nikolai Kopernik, considered German by Ludwig) represented the modern era, whereas the immediate past and present were the most strongly represented. Statesmen and military leaders, poets and philosophers were immortalized in portrait busts.

As one of the most knowledgeable connoisseurs of his time, Ludwig had recognized the importance of Schadow early on, but also discerned weaknesses, particularly in the Valhalla busts. On November 8, 1807, he wrote to him: "You have my warm

Johann Gottfried Schadow and other sculptors
Busts of emperors, poets etc.
Valhalla, near Regensburg

approval ... only a little more finish would be the sole wish," and one year later he renewed the mixture of praise and criticism: "My busts completely finished, quite superb. The treatment of the hair is cursory ..." In the end, it was Schadow's pupil, the Arolsen-born sculptor Christian Daniel Rauch, who encountered a warmer welcome from Ludwig with his greater attention to physical accuracy. A contemporary gibe at Schadow claimed that his fame had gone up in *Rauch* [= smoke].

Christian Daniel Rauch
Tomb of Queen Louise of Prussia (detail), 1811–14
Marble
Mausoleum, Charlottenburg Park, Berlin

European sculpture between Neoclassicism and Romanticism

Germany / Christian Daniel Rauch (1777–1857)

Born in Arolsen, the *Residenz* town of the little principality of Waldeck near Kassel, Christian Daniel Rauch was given his early training from 1786 to 1791 by the court sculptor Friedrich Valentin (1752–1819) from nearby Helsen. Under his guidance, Rauch did possibly his first works on relief carvings and marble fireplace decorations for the Schreibersches Haus in Bad Arolsen. Rauch moved on to the art academy in the neighboring margravate of Hessen-Kassel, where he was employed by the workshop of Johann Christian Ruhl (1764–1842) to work on the *Schloss* and gardens at Wilhelmshöhe. From there he went to Potsdam in Prussia in 1797 as a valet to King Frederick William II, and after the latter's death became a lackey in the service of the new Queen, Louise. During this time, he attended courses at the Berlin academy, and in 1802 had his first exhibition. His *Sleeping Endymion* and one of his busts caught the attention of Schadow, who took him on. In 1804 he was released from court service to take up a royal scholarship to Rome.

In Rome, Rauch quickly found access to the artistic and scholarly set around the Prussian diplomat Wilhelm von Humboldt and his wife Caroline. He was soon friendly with Thorvaldsen, who belonged to the same set, and for six years he was to live next door to him. From time to time, Rauch also worked in the

Dane's workshop. However, it was mainly through Welcker, archaeologist and domestic tutor to the Humboldts, and Thorvaldsen's mentor Zoëga that Rauch was introduced to the world of classical Antiquity.

It is characteristic of the time that Rauch became famous overnight with a memorial work. Directly after the queen of Prussia, Louise, died on July 19, 1810, King Frederick William III asked Humboldt to invite the Rome-based sculptors Thorvaldsen, Canova and Rauch to submit designs for a memorial tomb for the Queen for the mausoleum in Charlottenburg. The client wanted to see his deceased wife depicted on her sarcophagus in the form of death as eternal sleep, merely dozing, and ready to be wakened any moment. When he came to see the tomb executed by Rauch (ill. pp. 280 and 281), the king (wrote Caroline von Humboldt) "broke into a flood of tears as he saw the head of his beloved deceased wife laid down for sleep, so eloquently lifelike did he find her." Indeed, in this monument Rauch succeeded in combining two trends in Neoclassical sculpture of his day to make a new visual language. On the one side were the individualizing traits in the sculpture of his Berlin teacher Schadow, on the other the canonically idealized images of his Roman friend Thorvaldsen. By developing a kind of synthesis of these two approaches, Rauch succeeded in creating one of the masterpieces of Neoclassical sculpture, which received unqualified admiration.

Deceased at the age of 35, Louise rests her diadem-adorned head on a cushion embroidered with stars. The head is inclined to one side with eyes closed, as if sleeping, as though the Queen could be woken by her husband entering her apartments. Rauch did the portrait from a death mask that a sculptor friend of his had taken of the Queen directly after her death. The work on the model continued in 1811, accompanied by the king's lively attentions in Berlin, and although Rauch's greatest wish was to carry out the marble version of the tomb in Rome, he had it hewn out in Carrara, to keep the transport costs of the huge marble block within bounds. At the same time, he prepared a separate head and shoulders of the tomb figure, which served a model for numerous casts the King took to give to family and friends. Six marble versions were ordered besides these, at least four of which are in various museums and private ownership.

After his third sojourn in Italy from 1816 to 1818, Rauch was appointed professor at the academy in Berlin in 1819, and maintained a joint workshop with Christian Friedrich Tieck. He was also in touch with Goethe from 1820, and did several portraits of him. Six of the 12 spirits of battle for the monument to the Liberation War designed by Schinkel for the Kreuzberg in Berlin were designed by Rauch, but he modeled only two, the sole two female ones. In the academy's exhibition of 1824 he exhibited the seven-foot-high plaster model of Victoria, who symbolizes the Battle of Paris of 1814 (ill. p. 286). This figure has the features of Queen Louise,

Christian Daniel Rauch
Tomb of Queen Louise of Prussia, 1811–14
Marble
Mausoleum, Charlottenburg Park, Berlin

while the other figure of the *Belle Alliance* carries the features of her eldest daughter Charlotte, the Tsarina Alexandra Feodorovna. Whereas the majesty of the classical robed allegory alludes to the Queen as the *genius* or "tutelary spirit of the German cause," she carries the *Quadriga* of the Brandenburg Gate, which had been regained in the Liberation War after being carried off by Napoleon. Equally full of resonances was the introduction of the Iron Cross, which Frederick William III first awarded in Breslau (Wroclaw) on the Queen's birthday, March 10 1813, as an order for services for the fatherland in the struggle against France.

At the beginning of the 1820s, Rauch had promised to do some sculptures for the city church of his home town, Arolsen. Rauch took a long time to redeem this promise, and a reminder was sent in 1831. It was not until 1835 that Rauch began work on hewing the figure of a *Boy with a Book* from the monument to the famous theologian and pedagogue from Halle, August Herrmann Francke (1663–1727), to refashion as an independent sculpture. The boy no longer looks up but gazes at the Bible he holds open in his right arm, following the lines he reads with his fingers. Even before undertaking this reworking, Rauch had already been working on the design for a *Boy with a Bowl*, which was intended as a counterpart. Barefoot and in a short smock, the boy stands on a plinth holding the bowl in his outstretched hands. The head is slightly inclined and directed upwards with guileless gaze.

In the catalog of the academy exhibition of 1836, where the plaster models of the two figures were already shown, it was

281

Christian Daniel Rauch
Hope, 1852
Marble, h. 120 cm
City church, Bad Arolsen

OPPOSITE PAGE:
Christian Daniel Rauch
Charity, 1844
Hope, 1852
Faith, 1842
Marble, h. 110/120/107 cm
City church, Bad Arolsen

noted that they "were for execution in marble and intended as adornment for a church." However, still more years passed without Rauch redeeming his promise, because both figures enjoyed such popularity that for the time being he had to surrender them to the king as presents for his godchild Albert Edward, Prince of Wales. Thus the two figures were sent to England, and are still installed in the private chapel in Windsor Castle. Zinc casts made of them were placed in Windsor Home Park. A copy of the figure of the *Boy with a Book* was finally made for Arolsen in 1842, and two other replicas were made later, one of them for the king. The *Boy with the Bowl* was repeated even more frequently, with a marble version for Arolsen produced between 1842 and 1844. Finally, in June 1844, Rauch was back in his "dear, long-missed home town," where he had not set foot for 23 years, to see his two boys, now designated *Faith* and *Charity*, installed in the church at Arolsen (ill. p. 283).

From 1845, Rauch worked on the designs for a third figure in the series, to be called *Hope* (ill. p. 282). However, his heavy workload meant the work was constantly put off until November 1847. "The unclothed model (as a basis for the statue for Arolsen church)," he confided to his diary in February 1848, "completed as an independent work with the retouching in plaster and handed over for copying." Rauch clothed this figure with a long under-robe piled up from the feet and a knee-length garment doubly rolled up at the hips. The standing pose with the arms stretched up in welcome is borrowed from a classical nude worshipper, which, known as the *Praying Boy of Sanssouci*, was the most famous ancient sculpture in the Berlin area at the time. Later research has shown that the latter could have been in some way related to the 100-foot-high bronze *Colossus* of Rhodes, one of the seven wonders of the ancient world, in whose immediate vicinity it was found. Rauch's newest boy figure was carried out in marble in Carrara, and again many replicas were made. For example, the sculptor presented a statuette version to the royal couple as a silver wedding present. Another version, with a lotus blossom in the lowered left hand as a symbol of eternity, was produced by Rauch in 1855 for the tomb of his deceased brother, but finished up cast in bronze for his own tomb in the Dorotheenstadt cemetery in Berlin. The version for Arolsen church, standing on a red marble plinth specially donated by Prince George Victor of Waldeck, was ceremonially unveiled on Christmas Day 1852.

Rauch had been working on the equestrian statue of Frederick the Great for more than 20 years by the time it was unveiled on May 31, 1851 in Unter den Linden in Berlin (ill. p. 284).

It would become one of the most famous and frequently imitated monuments of 19th-century Germany. Rauch's execution had been preceded by numerous draft designs, mostly by Schadow, who had worked at this commission virtually all his

OPPOSITE:
Christian Daniel Rauch
Equestrian statue of Frederick the Great,
1839–51
Bronze, h. 566 cm
Unter den Linden, Berlin

life. It was finally the models produced by Rauch between 1836–39 that Frederick William IV opted for, after the death of his indecisive father in 1840. Executed in bronze, the equestrian statue shows the King in contemporary dress with a regal cloak and two-cornered hat. While he holds the reins in his left hand, his walking stick dangles by his right hand instead of a commander's sword. Nonetheless, he sits in a majestic pose on his horse surveying his realm with a kingly gaze. On the three-tier pedestal there are inscriptions at socle level, and fully developed equestrian statues at the corners of the middle level representing Duke Ferdinand of Brunswick, Prince Henry, Ziethen and Seydlitz. They are accompanied by 21 male statues depicting the most outstanding generals in Frederick's army and other leading personalities. Six other equestrian figures appear in the relief. At the corners of the upper level are the female allegories of ruler virtues, while the rather genre-like reliefs illustrate the life and merits of Frederick.

Referring mainly to the prolonged, hard battles with his hard-to-please client over many years, Rauch wrote to his friend Rietschel in Dresden on December 20, 1848: "I can tell you that I have been overcome by an exhaustion such as I have never known, which would make it impossible for me to continue a commission like this again. I am mentally shattered, tired in body and soul, wig, coat and boots from doing it nine years without a break!"

When the monument was unveiled in 1851, it had been 70 years in the planning, involving around 40 artists and around 100 designs. And it was finally the events of the revolution of 1848 which devastated the whole enterprise, because after that a monument to monarchy could no longer be considered a "national affair" in which king and nation sought the things that united them. This breach came full circle when, following its own strange logic, the German Democratic Republic moved the monument – albeit restored after the destruction of World War II – from the urban context of its capital to the park at Sanssouci. Returned to Unter den Linden after the fall of the GDR, it was extensively restored in 1998/99.

Under the influence of a pure, smooth Neoclassicism as represented by Canova and Thorvaldsen, Rauch had developed a style of his own. In combining their sculptural approach in his sculptures with the naturalistic detail of his teacher Schadow, he established an independent and influential style within the 19th-century Berlin school of sculpture. Numerous sculptors trained in his well-organized workshop took the style forward in sculpture until well into the Kaisers' day, and not just in Berlin.

Christian Friedrich Tieck (1776–1851)

The sculptor Christian Friedrich Tieck came into contact with the early Romantic literary set in Berlin through his brother, the Romantic poet Ludwig Tieck (1773–1853). Here he became acquainted with Rahel Levin, Wilhelm Heinrich Wackenroder and the Humboldt brothers, which enormously expanded his horizons. After five years of training under the sculptor Heinrich Bettkober (1746–1809), during which he also attended drawing classes at the academy, Tieck in 1794 entered Schadow's workshop. In 1797 he was awarded a scholarship to Rome, but because of the uncertain travel situation in northern Italy he spent three years in Paris instead. There he attended the workshop of the Neoclassical painter Jacques Louis David (1748–1825), which was open to all artists. Numerous busts and reliefs which he did in Paris have vanished without trace. On his return to Weimar via Jena in 1801, he became acquainted with the philosopher Schelling and the Shakespeare translator August Schlegel (1767–1845). In Weimar he did his first portrait of Goethe, and with the latter's help gained commissions for numerous works for the new *Schloss* there. Finally, in 1805, he reached Rome on another scholarship, where he got to know Rauch, striking up a profound, lifelong friendship with him. After various other works, including 25 monumental busts in Carrara for Valhalla, in 1818 he did a portrait of Rauch and also took over the supervision of his marble works, his friend having left for Berlin. Tieck soon followed Rauch, setting up a joint workshop with him, which was the start of a highly creative period. They received their first major commission in autumn 1818, to design and execute the models for the Kreuzberg monument in Berlin.

For some time, there had been a desire to erect a monument to commemorate the battles that liberated Prussia from subjection to Napoleon. The royal commission had been given to Karl Friedrich Schinkel (1781–1841), probably in winter 1816–17, to come up with a design for the monument. It was to be a "people's" monument, but also a "national" monument. Then in 1821 came the label "war" memorial. In the end it was a monarchic "victory" monument. Schinkel's vision ran on the lines of a classical column, but the royal client demanded a monument made of iron, which was cheap, in the Gothic style, considered the German national style at the time. Schinkel's plans had to take these restrictions into account. He took as his models the corner piers of late Gothic tabernacles, or even large-scale buildings like Cologne Cathedral. Thirty months after the foundation stone had been laid on the 131-foot-high (40 m) hill in Tempelhof, the monument was ceremonially dedicated on March 30, the anniversary of the Battle of Paris (ills. pp. 286 and 287).

The monument consists of a 62-foot (19 m) tower on the ground plan of a Greek cross, with a socle and a niche level in which 12 winged battle spirits are displayed. The crocketed pinnacles of the niches envelope the slender central tower, whose tip carries the Iron Cross. The name of the Berlin suburb of Kreuzberg goes back to this monument. Rauch designed six of the battle spirits, but modeled only two. Tieck designed four and

Christian Daniel Rauch
The Spirit of Paris, 1824–25
Iron and bronze, h. circa. 220 cm
Kreuzberg Monument, Berlin

OPPOSITE:
Kreuzberg Monument, 1821
Cast iron and stone, h. circa 1,900 cm
Berlin

style of the monument. The attributes of the lion skin and club are in keeping with the normal iconography for Hercules since Renaissance times, which chiefly represent monarchic virtues. Combined with the facial features of King William III, with which Tieck furnished the figure, the effect is to underline the character of the monarchic "victory monument." During the reshaping of Berlin in 1998/99, the monument was completely dismantled for restoration.

Tieck, who tended to prefer an ideal Neoclassical style in the Winckelmann mode, was ultimately unable really to assert himself against the immensely successful Rauch and the classicizing naturalism he represented.

Rudolph (Ridolfo) Schadow (1786–1822)

Ridolfo Schadow, Schadow's eldest son, was born during Schadow's time in Rome and was trained in his father's workshop. He was only 16 when his sculptures and reliefs of classical and mythological – and also religious – subjects made their appearance at academy exhibitions. They bear testimony not just to his talent, but also to his father's influence. In 1810, he and his younger brother Friedrich Wilhelm (1788–1862), the later founder and director of the art academy in Düsseldorf, went to Rome. The following year they took over Rauch's workshop there, Rauch being in Berlin, working on the tomb of Queen Louise. Self-doubt and home-sickness brought Ridolfo back to Berlin, but he returned almost immediately to Rome on a scholarship and with Rauch. And there he remained.

Influenced by Thorvaldsen, in 1812 he worked on the almost lifesize figure of *Paris*, which he had already worked on in his father's workshop and which he had already shown in a first plaster version in the academy exhibition of 1808 (ill. p. 288). Executed in 1820 in bronze, the weight of the youthful nude figure is placed on the right leg, while the left is slightly set back and touches the ground only with the ball of the foot. The hip above the engaged leg rotates slightly to follow a slight counter-rotation of the upper body, which is caught up in the head's inclination to the right. With a Phrygian cap on his head, Paris' gaze is directed at the apple in his right hand, while his left index finger rests pensively on his chin.

The royal son of Troy had been selected as a judge by Zeus to resolve the dispute between the goddesses Athena, Hera and Aphrodite as to which was the most beautiful. Paris was to award his choice a golden apple with the inscription "To the fairest" on it. Each of them promised him a particular reward: Athena military fame, Hera kingship, Aphrodite the loveliest woman. He plumped for the last, and with the goddess' help carried off fair Helen, the wife of Menelaus, from Sparta to Troy, thus triggering off the Trojan War. The statue that was exhibited at the academy exhibition of 1820 shows the moment directly before judgement

likewise modeled only two. The major part of the work was taken over by sculptor Ludwig Wilhelm Wichmann (1788–1859), who executed the six models by Rauch and Tieck and added two figures of his own design. By the date of the dedication only two casts had been completed, and these, complemented by two painted models, only conveyed a vague impression of the monument. The last of the missing statues was not put in place until June 1826.

The two spirits modeled by Tieck, those of Grossbeeren and Culm (Chemno), represent battles of lesser importance, which is why they are not on the front of the arms of the cross. The spirit of Grossbeeren, whose face presumably bears the features of the Crown Prince and later king Frederick William IV, is dressed in an outfit that is derived from late medieval dress. The pose itself is based on 16th-century northern European sculpture as well, lending the figure the flavor of monumental memorial architecture. The spirit of Culm is quite different. The pose emulates the classical contraposto, contrasting sharply with the Neo-Gothic

Rudolf (Ridolfo) Schadow
Paris, 1812, cast 1820
Bronze, h. 127 cm
Schloss Weissenstein, Pommersfelden

Rudolf (Ridolfo) Schadow
Girl with Doves (Innocence), 1820
Marble, h. 136 cm
Nationalgalerie, Staatliche Museen zu Berlin
– Preussicher Kulturbesitz, Berlin

Acquired by the art collector and patron Franz Erwein, Count of Schönborn, and delivered the following year, the statue is still in the Schönborn Collection in Pommersfelden.

After his return to Rome, Ridolfo devoted himself more to genre subjects, in which he combined Neoclassical formal structures with Romantic notions. His *Woman Tying her Sandal*, which marks the beginning of this phase, became so popular because of its combination of ancient classical borrowings – like for example from the famous scene of removing the thorn – with elegiac, Romantic feeling that he reproduced it seven times in marble himself. The *Spinning Woman* he had to replicate 13 times, according to his brother, which brought the young artist a reputation of almost European dimensions.

The third figure in this series, the *Girl with the Dove*, also known as *Innocence*, was made in 1820 (ill. p. 289). Like her two predecessors, she also sits on a rock. Her left foot rests on a protuberance, while she balances on the toes of her right foot on the plinth. The slight tilt of her upper body is answered by the turn of the head to the right and the raised arm. The girl holds a dove in her right hand, which she is looking at, and with her left hand balances a basket with more doves in it on her thigh. She is only skimpily clad with a robe tucked in at the hips, but has a garland of flowers in her wavy shoulder-length hair. The figure is an example of the newly developed type of the classicizing genre figure. What the Nazarenes were to painting, so the sculptors who – like Ridolfo Schadow – cultivated the new genre were to sculpture. They catered for a contemporary taste for classical line with Romantic feeling, and were accordingly very successful.

Ridolfo's work never, of course, gave him a sculptural reputation as great as his father's. All his life he had to endure the latter's authority and success, which ultimately must have been what drove him to return to Italy. When his contemporaries praised him for the "naturalness" of his figures and the virtuoso handling of marble that had brought him a name as a "graceful" sculptor, he tended to react with suspicion. Recognizing that "idylls enshrined in marble can wear out in the long run," as one art historian puts it, he later turned to heroic themes. Often dismissed as imitative, his work is due for reassessment.

Ernst Friedrich August Rietschel (1804–61)

According to his own testimony the product of an extremely impoverished family, Rietschel entered Dresden's art academy at the age of 16. Although the training he got there was highly inadequate and he received scarcely any encouragement, his extraordinary talent enabled him to keep winning prizes. In 1826 he went to Berlin on a scholarship, where he was admitted to Rauch's workshop and was given his real training. A close friendship sprang up between pupil and teacher, which resulted in considerable correspondence. All his life Rietschel maintained a

RUDOLF SCHADOW · 1786—1822
MÄDCHEN MIT TAUBEN · 1820

Ernst Friedrich August Rietschel
Bust of Felix Mendelssohn-Bartholdy, 1848
Marble, h. 60 cm
Staatsbibliothek, Berlin

academies, such as Berlin, Vienna, Munich, Stockholm, Brussels, Copenhagen, Antwerp, and Paris. There were prizes too: 1850 in Berlin, 1852 in London and 1855 in Paris. In 1858, the Prussian Order of Merit for science and the arts was conferred on him.

On November 4 1847, the composer Felix Mendelssohn-Bartholdy died in Leipzig at the age of only 38, after suffering several strokes. The family had had a death mask taken and asked Rietschel to come and look at the dead man himself once in order to do a bust. The portrait bust was completed by the end of January 1848, so that it could be presented to the public on February 3 within the framework of a commemorative and birthday celebration for the composer at the Hoftheater in Dresden (ill. p. 290). Rietschel created an extraordinarily lifelike and individual portrait of the composer, placed on an unclothed shoulderpiece. The hair falls beside the high forehead in a magnificent head of curls, passing over into sideburns that leave the chin bare. The facial features look almost tender, and testify in the frank gaze to a sensitive nature and artistic spiritualization. This was Rietschel's particular *forte* as a portraitist, to be able to go beyond the purely naturalistic and bring out the individual character and inner nature of the subject. In this he surpassed his teacher.

Johann Friedrich Drake (1805–82)

Born in Pyrmont near Detmold and brought up in poverty, Johann Friedrich Drake first came into contact with art as a woodturner, before becoming an assistant to his father in producing mechanical models and apparatuses. In 1824, he went to Kassel as a mechanic, to make mathematical instruments in the workshop of a medalmaker. Later these skills in mechanics would help him to construct a stand that would help life-class models to hold difficult positions naturally and easily over prolonged periods. On top of this, Rauch was constantly calling him in to solve mechanical problems at the academy. Through the mediation of court counselor Mundhenk, a cousin of Rauch, Drake was admitted to Rauch's workshop at the end of 1827. There he developed to become – alongside Rietschel – his teacher's most successful pupil and one of the most sought-after sculptors of his time. Numerous honors at home and abroad testify to the esteem in which Drake was held in his day. His most famous work was probably the bronze *Victoria* on the Berlin Victory Column, unveiled in 1873.

The monument to King Frederick William III in Berlin's Tiergarten (zoo), which is often considered Drake's masterpiece, recalls the transformation of the zoo into a public park at the king's instigation (ills. p. 291). In 1841, one year after his death, influential Berlin citizens called for a monument to be erected to the King in gratitude. Frederick William III had not really been a very independent sovereign. Guided by reactionary interests, he had refused the nation a constitution. The monument funded by the public

profound admiration for the older man. In 1830, Rietschel was awarded a scholarship by the Saxon state to go to Rome, where he stayed until 1831, returning via Berlin to Dresden. There, thanks to Rauch's intervention, he got his first big commission in the monument for the Saxon King Frederick Augustus. In 1832, he became professor of sculpture at the academy in Dresden.

In his memorial sculpture, he gradually moved away from the Neoclassical tradition of his teacher and increasingly gave priority to naturalistic traits. His monument to the playwright Lessing in Brunswick (1848–49) is thus one of the first representations of a writer of the previous century in contemporary clothing.

Rietschel soon acquired an international reputation, as can be seen by his honorary membership of numerous European

BELOW AND RIGHT:
Johann Friedrich Drake
Monument to King Frederick William III of Prussia, 1849
Carrara marble, h. 278 cm
Tiergarten Park, Berlin
Overall view (below)
Detail of pedestal relief (right)

could not thus relate to his entire reign. Drake's first design of 1841 provided for three female figures as allegories of the seasons on a cylindrical plinth. They would carry a basket of flowering plants like caryatids. In 1842, the design was changed, partly because Rauch found it somewhat incomprehensible, but also partly because many of the subscribers wanted to have a representation of the King. In the design as executed, a standing figure of the monarch replaces the three allegories. He wears plain contemporary dress. With his left hand against his chest, in his right hand, with which he supports himself on a memorial adorned only with the profile relief of his beloved Queen Louise, he holds a wreath of immortality. A relief round the base shows several crowded groups of nude or clothed figures in the open air (ill. p. 291, top).

The monument reflects the ideal of the Golden Age current in literature of the time, where man has established a balance within himself and with nature. With the king shown as a private man, a husband thinking of his deceased wife, he is brought closer to the world of the commoners. The relief on the base, on the other hand, illustrates the dissolution of the antithesis of wood and park. In the poetry of *Vormärz* – the years preceding the German revolution of March 1848 – the difference between wood and garden was seen as a concealed metaphor for the antithesis of court and liberal forms of government, sometimes even the antithesis between poor and rich. What had not been achieved in reality yet, the elimination of this antithesis, features as already resolved in this monument. It is a wishful but nonetheless positive gesture in presenting a socially desirable state as something already achieved, because the King is thereby associated with a forward-looking idea. Popular confidence in a reactionary monarchy would thus be strengthened, being not dependent on a mere constitution.

Johann Heinrich Dannecker (1758–1841)

In the south of Germany, it was principally Johann Heinrich Dannecker of Stuttgart who proved capable of matching the mastery of the great Prussian sculptors. The son of a ducal stable lad, in 1771 he managed to gain admittance – against his father's will – at the age of 13 to a military school. Initially as a dancer but very quickly as a pupil of sculpture, the boy was given a systematic and, for the time, wide-ranging and progressive basic education. Unlike his fellow pupil, the dramatist Friedrich Schiller, who hated being at a military academy notorious as a "slave plantation" and finally fled from Stuttgart, Dannecker remained, despite all adversities, loyal to the princely house all his life, though often reluctantly.

Court painter Nicolas Guibal (1725–84) provided intensive study of nature and classical art, and Dannecker soon made his

mark by winning the 1777 Founders' Day competition with a plaster model of *Milo of Croton* (Staatsgalerie, Stuttgart). Even after he was appointed court sculptor in 1780, he remained bound by the narrow confines of court service. In 1783, he and a colleague called Scheffauer walked to Paris, where they found accommodation with Augustin Pajou. The travel budget was so tight that, again in 1785, they set off on foot, with court permission, via Bologna and Florence to Rome, a journey that took from August 30 to October 2. They remained in this "paradise of art," as they called it in their letters, for four years. The famous Café Greco – which still exists – served not only as a meeting place, but also as a postal address. In Rome, Dannecker got to know Canova, who was the same age and whose talent deeply impressed him. Along with two allegories of the seasons for the library in Schloss Hohenheim, Dannecker also did a series of smaller works, of which a number of excellent clay drafts survive.

In 1790, Dannecker returned from Rome and was appointed professor at the academy, which meantime had been renamed the Carlsschule. The artist in him yearned to return to Rome. It was

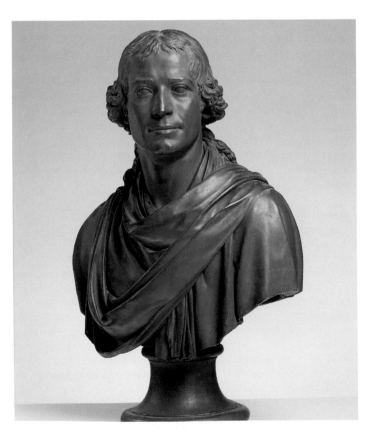

said that he would have been ready to sacrifice five years of his life to be able to live in Rome. How greatly he suffered from the artistic crampedness of Swabia is evident from a letter to Trippel: "The country is no doubt prosperous, but for an artist's soul like yours truly barren." Dannecker never left Stuttgart again.

This discrepancy between the thirst for cosmopolitan stimuli and the crabbed circumstances of his own environment is evident in his self-portrait of 1796 (ill. p. 292). The man he saw himself as in this bust – vigorous and self-assured, gazing into the distance as a free, independent artist living a life of his own making – could not exist in the confines of Stuttgart, where any self-determination was impossible. Autonomy of this kind, underlined by the classical robes, was massively restricted by court conventions. The idealizing features of this self-portrait do, of course, give voice to the timeless aspects of his art, which could lift him out of the depths of humdrum doings. It is characteristic that this self-portrait by the 38-year-old artist never left the private sphere. There is a noticeably strong resemblance between it and the famous bust of Schiller (1793/94), in which Dannecker reproduced the idealized image of the free artist.

Although Dannecker was not a free artist, it was nonetheless a work that he placed on the art market that would be his masterpiece. *Ariadne on the Panther* (ills. p. 293) is considered by some to be a modern classic, and is perhaps one of the best-known German sculptures of the 19th century. The sculptor himself, who was easily convinced of the quality of his work, wrote in 1811: "I will not budge for one moment from my aim of making it a principal work of my aesthetic output." Dannecker had been preoccupied with this subject from the Greek Theseus legend around 1800 – it enjoyed extraordinary popularity in all branches of contemporary art – and produced a small clay bozzetto, which is more or less the statue as produced in marble later.

In love with Theseus, Ariadne, the royal daughter of Crete, had passed the Greek hero the ball of thread for him to use to find his way back after overcoming the Minotaur in the labyrinth. After they fled together, Theseus abandoned her on Naxos, the island of Dionysius, the Greek god of wine and vegetation, who took her to wife. Since Antiquity, Ariadne had usually been shown where Dionysius finds her abandoned, but during the 18th and early 19th centuries she cast off her image of a tragically abandoned grieving lover and became the ideal woman, a model for mankind. Dannecker follows none of the mythological precedents in his representation. He shows Ariadne riding, lying in divine nakedness on one of Dionysius' panthers. Overall, the pose creates a contour of extended repose, embracing the whole sculpture.

After Dannecker had finished the clay bozzetto in 1803, he ordered a large block of marble from Carrara, even before he had a purchaser. At the same time, he produced the first full-size plaster model. As the court of Württemberg showed no interest

Johann Heinrich Dannecker
Ariadne on the Panther, 1812–14
Marble, h. 146 cm
Liebighaus, Frankfurt
Front view (left)
Rear view (right)

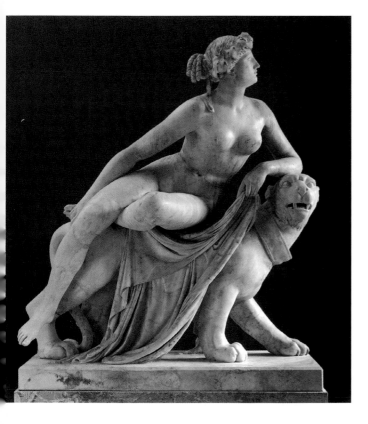
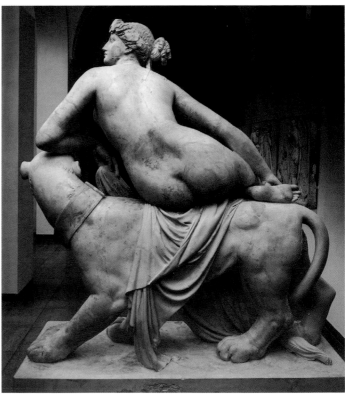

in it, he had to submit a humiliating request to have the free disposal of the sculpture, the model of which soon aroused enormous admiration in the contemporary art world. His request was allowed – but no more official commissions came his way until his colleague Scheffauer died in 1808. In 1805, the Frankfurt banker Simon Moritz von Bethmann finally took an interest in the now celebrated work. Even so, the sale was concluded only five years later for the sum of 11,000 florins, ten times Dannecker's annual salary as a professor and court sculptor. Work on the marble version occupied 1812–1814, and then two more years passed before the figure could be installed in Frankfurt. When Frankfurt was bombed in October 1943, the sculpture was so seriously damaged that restoration was inconceivable, and it had to be written off. Only in 1977/78 were restoration techniques sufficiently advanced to bring it back to its original shape.

Ludwig Franz von Schwanthaler (1802–48)

The last and possibly most successful artist of a sculptural dynasty active in Upper Austria and South Germany was Ludwig Franz von Schwanthaler, who worked in Munich. After a short period at an arts-oriented *lyceum*, he had an all-too-brief year, from December 1818 to October 1819, with his father Franz Jacob (1760–1820), before taking over the workshop on the latter's death. In 1824 a classicizing centerpiece for King Max Joseph I gained him the status of court sculptor, and two years later he went on a scholarship to Rome. Here he became a pupil of Thorvaldsen at the wish of King Ludwig I, so that he could acquire the "style and repose that the ancients have, [and] take note how Thorvaldsen does it." After numerous jobs in Munich came a further spell in Rome between 1832 and 1834. Ludwig wanted to enlist a Bavarian sculptor with the quality of the Dane, but Schwanthaler did not much favor the classical style. He once said that he would go mad with "the endless regurgitation of Antiquity."

After Schwanthaler had been appointed professor of the Academy of Fine Arts in 1835, he could scarcely cope with the flood of commissions. He set up three workshops with up to 50 employees, separating design and execution, and entrusting the supervision of the latter to his cousin Franz Xaver Schwanthaler

Austria / Franz Anton Edler von Zauner (1746–1822)

Born in Untervalpatann in Tyrol, Franz von Zauner, Austria's most important Neoclassical sculptor, was sent at the age of ten to his relatives in Passau, where he began training as a woodcarver. From there, he went in 1766 to the academy in Vienna. Here he was presumably engaged initially only as a stonemason working on the execution of models, but later he did very well in academic classes. In these, he came under the guidance of the professor of sculpture, Jacob Christoph Schletterer (1699–1774), who introduced him to the sculptural legacy of Antiquity and familiarized him with Neoclassicism. From 1773 he was employed in the workshop of sculptor Wilhelm Bayer, doing sculptures for the park of Schönbrunn, where he carried out an independent commission for a fountain in 1775. This work he based closely on the figures by the great Baroque sculptor Georg Raphael Donner (1693–1741) for the Neumarkt fountain. The result gained him a three-year scholarship to Rome, where he became a member of Alexander Trippel's private academy, a formative influence for him. He copied a series of classical sculptures, most notably the *Apollo Belvedere*. After his return in 1782, Zauner was appointed professor of sculpture at the Vienna Academy, becoming its director in 1806.

The Austrian metallurgist and satirist Ignaz Edler von Born (1742–91) had improved a process for isolating gold and silver from ore that had been applied in Mexico since 1590 and was first used in Selmecbánya in Hungary (now Banská Štiavnica, Slovakia). No less important was his leading role in Viennese freemasonry, which brought together the prominent members of Viennese society in the 1780s. Zauner himself joined the masons in 1784, the result of which was an important contract to produce a monument to the selfsame Ignaz von Born.

The work survives only as a bronzed plaster cast of the model. It shows an unclothed and winged male spirit (*Genius Bornii*) holding an unclothed female statuette in the right hand (ill. p. 294). In its left hand the spirit holds the chain that fetters an owl squatting on the ground. The two attributes stand for light and darkness. On the stump of a column in the background are the symbols of freemasonry. The *Spirit* derives from a model by Praxiteles that is very often imitated in Neoclassicism. Nonetheless, Zauner's *Spirit* is no mere copy of the antique sculpture. Every aspect of the body develops completely from its own internal logic and yet relates to the whole, giving the figure a unique character of its own, which makes it both authentic and animated from within.

Zauner's masterpiece is his equestrian statue of the *Emperor Joseph II* (ill. p. 296), in front of the Hofbibliothek in Vienna. Based on the classical equestrian statue of Marcus Aurelius in Rome, it shows the popular emperor in the classicizing dress of a Roman general with breastplate, sandals and cloak. The emperor holds out

(1799–1879). By employing so many pupils, he also complied with the royal wish for a "Munich School of Sculpture."

Despite progressive gout, in 1837 he signed a contract for his master work, which would preoccupy him for the rest of his life, the colossal statue of *Bavaria* (ill. p. 295). Its erection in front of the classical Greek-style Hall of Fame on the Theresienhöhe was meant to equate her with the goddess of Athens, just as Munich was to be the new, resurrected Athens. Back in 1819, Schwanthaler had already gathered a set of young artists and literati around him, who had devoted themselves to German history and the Teutonic ideals of chivalry. Equally radical was Schwanthaler's break with the models of Antiquity, which had still served him for orientation in the first designs for the Munich statue. His *Bavaria*, who holds an oak wreath in her raised left hand and is clothed in a bearskin, looks, with the Bavarian lion by her, utterly Germanic. It was only on October 9, 1850, two years after Schwanthaler's death, that Bavaria was unveiled as the "new, Romantic, Germanic symbol of state."

Johann Martin Fischer
Hygieia, 1787
Cast metal
Josephinum, Vienna

his right arm as an imperial gesture, without any other attribute. To depict the pacing of the horse as naturally as possible, Zauner provides the rear left hoof with a small, almost imperceptible support. Inserted into long faces of the ample rectangular granite plinth are massive bronze reliefs, which with the involvement of spirits and various figures from ancient mythology depict the work of the emperor for the progress of his country and his subjects.

As bronze casting had no tradition in Vienna, the wish of the ruling emperor, Francis I, to have the work executed in bronze posed a great problem for Zauner. He set to work with great diligence, trying out the casting initially on a reduced-scale model. For this he used the ancient technique of lost-wax casting, which he sought to improve and refine. Because the sculptor himself both supplied the model and carried out the casting, the production time and costs were considerably reduced. The process made Zauner famous overnight throughout Europe. Schadow and the Royal Academy in London sought his advice, and Canova worked with Zauner's assistants, later in demand everywhere, in casting his Napoleon statue.

Johann Martin Fischer (1741–1820)

Besides Zauner, the second important sculptor in Vienna around the turn of the 18th/19th centuries was Johann Martin Fischer, who was some five years older. Born in Bebele in Allgäu and trained by the village sculptor, he went to the academy in Vienna in 1760. Between 1762 and 1766 he was employed by Schletterer, who as a former colleague of Donner's passed on his style to pupils at the Viennese academy. Although Fischer had never been to Rome, as an adjunct (associate) of Zauner's he became in 1784 a member of the academy, which the following year appointed him professor. He drew his knowledge of Antiquity from the study of plaster casts in the academic collection and from engravings in the academy library. As a professor, Fischer also taught anatomy, which was useful in the study of the fine arts. As an enlightened representative of the Emperor Joseph's era, this ensured him a regular and remarkably large audience.

Perhaps his most important, because most purely Neoclassical, work is at the same time his first large-scale sculpture, namely the fountain figure of *Hygieia* (ill. p. 297). As a female counterpart to Asclepius, the god of medicine, she forms the centerpiece of the fountain in Munich's Währingerstrasse. Her calm pose and the closed contour show Fischer at the peak of his sculptural abilities. His later works, however, do not match the quality of his fellow sculptor Zauner. Despite his great efforts to capture a "classical" spirit, ultimately Fischer was unable to quite shake off the formal language of the Baroque. That is perhaps the reason why his commissions came mainly from the general public.

As a result of Napoleon's invasion of 1797, Venice had passed into Austrian subjugation, which made Canova technically a

fellow countryman of the Austrian sculptors. The consequence was that he was given the task of looking after young sculptors from Vienna during their stay in Rome and assisting them with advice and practical help. He obtained permission for them to attend classes at the Accademia di San Luca, and to visit the Vatican museums or other important collections. They were able to use his library, and he gave them subjects to work up and showed them his techniques for handling marble.

Johann Nepomuk Schaller (1777–1842)

The Viennese sculptor Johann Nepomuk Schaller had his early training from various masters (including Zauner) before he joined the Viennese porcelain factory as a modeler. From 1812 he was in Rome, where he modeled his work strongly on Canova. He also made friends with Thorvaldsen, who became a great patron. On receiving a commission from the court to work up a "lifesize male statue of youthful age," he opted for a group based on *Bellerophon Fighting the Chimæra* (ill. p. 298).

back. In both figures, the hero presses his left knee against the body of his opponent, but whereas in Canova the posture is massively underlined by Theseus' seizure of the centaur's throat, Schaller's Bellerophon – almost irresolutely – merely grasps the monster's tail. Likewise, the treatment of the musculature in Schaller is rather superficial. Schaller's weakness was that in his sculptures he was scarcely able to convey the sense of resolution that imbues Canova's sculptures. Despite his talent, he belonged among the ranks of his Austrian colleagues who remained long under the sway of the visual language of the Baroque.

France / Pierre-Jean David (David d'Angers) (1788–1856)

Born in Angers and hence known after his birthplace as David d'Angers, Pierre-Jean David studied under various people, including his great namesake Jacques Louis David (1748–1825). He spent 1811–1816 in Rome, where he became acquainted with Canova's works. However, the Italian's Neoclassicism seemed too elitist to him, impressing him only briefly. His first piece to be exhibited at the Salon in Paris (1817) was a successful model for a statue of Prince Condé. His endeavors to reach a broad public and didactically instill morality and patriotism in it are already perceptible in this piece. In portraits, for example, he insisted on showing subjects in contemporary dress. These principles were universally approved by his contemporaries. A statue of Thomas Jefferson, third president of the United States, for Washington in 1832 established his reputation in that country as well. In 1833, he embarked on an extended tour of Europe, especially Germany, making numerous portrait busts of famous personalities, such as Goethe, Rauch, Tieck and Schinkel. His importance as an artist can be judged from his membership of academies as diverse as those in Rome, Berlin, London, and New York.

In his relief for the pediment of the Pantheon, he was given a chance to display his patriotism (ill. p. 299). The church of Ste-Geneviève had been subjected to several secularizations, the first being undertaken in 1791 after the death of Mirabeau. It was to become a *Panthéon français*, a public building containing tombs of or memorials to the heroes of the Revolution. The façade bore the inscription "To Great Men. A Grateful Fatherland." It briefly reverted to being a church again, before being transformed once more into a pantheon. The commission for new work on the pediment was given in 1830, when the inscription was also restored. The artistic program was tailored to the political circumstances of Louis-Philippe's policies. As the first constitutional king, he sought national reconciliation and endeavored to present himself as a defender of civil liberties.

David d'Angers places the allegorical figures of *Patria* in the center. On her right sits *Liberté*, handing to her the crowns to be awarded to the great men. Seated opposite her, *Histoire* notes in the book of history the names of those thus distinguished. Whereas

The grandson of Sisyphus and a national hero of Corinth, Bellerophon is slandered at the court of King Prœtus in Tiryns, following a failed love affair, and sent with a letter to the court of Iobates, King of Lycia. The letter requests the King to kill the bearer. In order not to have to do the dirty work himself, Iobates gives Bellerophon some highly dangerous tasks to carry out. First he has to kill the chimæra – a monster with a body made up of three animals, a lion at the front, a goat in the middle and a snake at the end – which is ravaging the country with its fiery breath.

As his model, Schaller used Canova's recently completed group of *Theseus and the Centaur* (ill. pp. 265/266). Like Canova's hero, Schaller's Bellerophon also stands over his victim, but the restrained energy of the model is lost in the almost Mannerist execution of the added drapery fluttering behind his

David d'Angers
Pediment relief of the Panthéon, 1830–37
Stone, h. 600 cm, b. 3,080 cm
Place du Panthéon, Paris

she is surrounded by numerous people representing French culture and intellectual history, the other side of the pediment contains French military figures, none of whom carries individual features except Napoleon Bonaparte, who is singled out in this way.

François Rude (1784–1855)

Before Rude came to Paris, he trained as a coppersmith in his native town of Dijon, but also took drawing lessons from François Devosge III (1732–1811). From 1805, he studied under the Neoclassicist Pierre Cartellier (1757–1831) in Paris, and six years later won the Académie de France's Prix de Rome. Unfortunately, the academy did not actually have the money to fund his trip to Rome. As Rude was a known sympathizer of Napoleon, he had, moreover, to leave France once Napoleon was banished, and so went to Brussels. Here he gained numerous commissions. After his return to Paris in 1827, he worked on a figure of a fishing boy (Musée du Louvre), which was bought by the French state two years after he finished it. After this first

great success, his subsequent work included one of the reliefs for the Arc de Triomphe in the Étoile (ill. p. 300), begun under Napoleon and completed under Louis-Philippe.

The relief of the *March of the Volunteers in 1792*, on the right socle of the east side of the monument facing the city, shows the army of volunteers that marched out of Marseilles on July 5 that year to defend the Revolution against counter-revolutionary forces. As they marched through France, they sang the song only composed by Claude Joseph Rouget de Lisle in Strasbourg on April 26. They called it the *Marseillaise*, and in 1879 it became the French national anthem. Under the same label, Rude's relief also gained worldwide fame. With some figures clad in classical armor and others naked or only wearing a helmet, the volunteers march forth into battle. They are spurred on by a mailed and winged Bellona, the allegory of War, who roars overhead. Influenced by the revolutionary pathos of a David, the relief is too imbued with a naturalism reminiscent of Baroque notions of form for any Neoclassical qualities to be evident in it.

Among the main works of his ultimately Romantically-oriented late *oeuvre* is the monument called *Napoleon Rising to Immortality* (ill. p. 301). Executed in 1845–47 for Noirot, one-time commander of the grenadiers of Elba, at his estate in Fixin-lés-Dijon, the initial plaster design showed a representation of the dead emperor besides a live eagle. The version actually carried out shows a rejuvenated Napoleon with eyes closed and laurel wreath on his head rising out of the funeral pall. The eagle lies dead on the rock below. The monument stands out from other monuments of the age, which present the subject in his history. By showing the longed-for "resurrection" of Napoleon, the client was clearly displaying his desire for a change of regime. And the presence of several thousand veterans at the unveiling in 1847 gives an idea of the explosive nature of the political context that had led up to the design of the monument. It was the same context that led to the revolution of 1848.

Jean-Jacques Pradier (1790–1852)

Jean-Jacques (also James) Pradier left Geneva to study in Paris, and at the age of 23 won the coveted Prix de Rome. He remained in Rome for five years. His sculptures, which were heavily influenced by Canova and mostly made of marble, were regularly shown at the Salon from 1819. After he had become a member of the Académie des Beaux-Arts in 1827 and was appointed professor at the École des Beaux-Arts, he was given numerous public commissions.

The Palais Bourbon, located on the other side of the Seine opposite the Place de la Concorde, had been confiscated during the Revolution and transformed into a parliament building. It has been the seat of the National Assembly since 1871 and is still generally known as such. However, particularly in respect of its sculpture, this building is one of the most important products of the July Monarchy. On the north façade, between 1837 and 1839 Pradier carried out a relief showing *Public Education* (ill. p. 304, top).

The subject probably derived from proposals put forward by the mathematician and politician Condorcet (1743–94), who had joined the Revolution. Elected by the city of Paris to the Legislative National Assembly in 1791, he was nominated its president in February 1792. He had drawn up a scheme for comprehensive "national education" based on an educational system without class distinctions and independent of Church and state. He was also the first to envisage adults going on for further training – the "instruction of all generations, ... the perfection of human reason." However, as a member of the Gironde, Condorcet was arrested in 1794 and found dead in prison the following day. It was not until fundamental school reforms were carried out under the Third Republic that his ideas were taken up again and largely implemented. His dream of achieving social equality through public

education remained unfulfilled, however. In the center of the relief sits Athena, teaching the children around her with an ABC slate on her knee. Women dressed in Greek robes are placed at the sides, symbolizing the various arts, myths, and muses.

Seen by renowned French artists as one of the "last Greeks," Pradier was fond of mythological subjects. In these he was able to explore the female body sculpturally, especially female nakedness. The marble *Odalisque* dated 1841 (ill. pp. 302/303) is, however, far removed from any classical model. Attired only in an oriental head-scarf, she sits on a molded plinth, which has a cloth of some sort spread on it. She rests one elbow on her bent left leg and leans forward to grasp her right ankle. Her head is turned round as though she had just become aware of someone behind her entering the intimate space of her nakedness.

The oriental subject matter, which, thanks to Napoleon's campaign in Egypt in 1798–99, had become an excuse for European artists' erotic fantasies of harems, serves Pradier more as a thematic disguise for a nude, described by him as *Odalisque*. The dubious nature of this Romanticizing term arises in the contrast with historical reality. Odalisques (Turkish *odalik*, i.e. chamber companion) of the great Ottoman harems were in fact harem slaves, kidnapped by dealers from Armenia, Georgia, the Caucasus or the Sudan for sale to the Sultan's court. They could only hope for liberty when they had borne the Sultan a legitimized child. Although contemporary Europe opinion protested against the practice, no criticism is evident in the artistic treatment of the subject, even in painting. No doubt this was partly because artists themselves were partial to the erotic voyeurism associated with the subject of harems, but also because even in the West the notion of the submissiveness of women and their defenselessness was still hardly questioned.

England / John Flaxman (1755–1826)

John Flaxman is far and away the best-known English sculptor, though initially fate did not seem to promise him nearly so much. An ailing, disabled child, he learnt to read, draw and model in his father's plaster-casting workshop. Constant contact with plaster casts of antique sculptures, combined with an untiring zest for work and adolescent alertness, soon enabled him to develop his artistic powers of expression. His public career began at the age of ten, when he attracted attention with his drawings from Homer and even received commissions. Two years later he exhibited models copied from classical works, and was still only 15 when he won the Royal Academy's silver medal.

From 1775, he gained his livelihood as an employee of the firm of Wedgwood & Bentley. In 1759, the potter Josiah Wedgwood (1730–95) had founded the (still operational) Wedgwood works in Etruria (the village built by him and named after his manufactory near Newcastle-under-Lyme in Staffordshire) to manufacture various utensils in stoneware and other wares. Flaxman supplied the models for Wedgwood's famous Jasper Ware, a hard stoneware with white reliefs on a coloured background. With support from Wedgwood, Flaxman traveled to Rome in 1787 to improve his style by extending his knowledge of Antiquity and to direct the Wedgwood studio there. In Rome

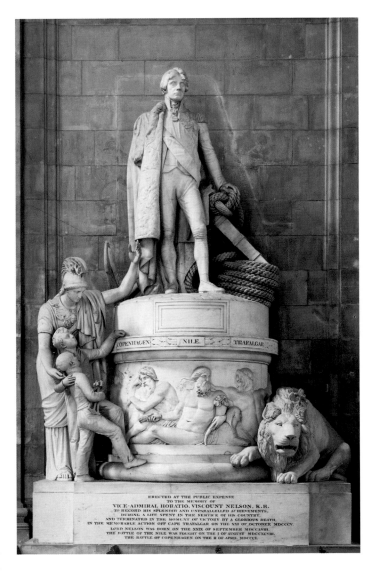

John Flaxman
Monument to Vice-Admiral Horatio
Nelson, 1808–18
Marble
St. Paul's Cathedral, London

he began work on the model for a marble group depicting *The Fury of Athamas* (ill. p. 304, below), commissioned by Frederick Hervey, Bishop of Derry and 4th Earl of Bristol, and still at his house in Ickworth. This depicts the dramatic moment when Athamas, King of Thebes, snatches his son Learchus from his mother and smashes him against a wall. The fact that Ino, his second wife, thirsted for the blood of his children by his first wife had driven him mad. He therefore laid hands on his children by Ino, who is only able to save herself and the second child by leaping into the sea. The sculptor proved unable to reduce the graphic nature of this grisly subject in the spirit of Neoclassicism. Despite his highly developed technique and visible efforts to bring the figures together, they remain disjointed for want of the taut contour of the kind that can be seen in Canova's *Hercules and Lichas* (Galleria Nazionale d'Arte Moderna, Rome, 1795–1815), which artistically intensifies the dramatic event solely through its formal vigor. Even so, the piece was highly admired by contemporary observers.

In an age of patriotism, Flaxman was firmly convinced that an artist had to serve the nation at large, and although it was not really his *forte*, he endeavored to obtain commissions for large-scale monuments. Among the more important of these was the monument to *Vice-Admiral Horatio Nelson* (1758–1805) in St. Paul's Cathedral, London (ill. p. 305). Decorated with honors, the admiral stands on a round pedestal, the lower face of which is decorated with reliefs of naked sea gods. Above them are listed his major victories at sea. While the uniformed Nelson balances with his left hand on an anchor and rope – he lost his right arm in 1797, during the attack on Tenerife – two marine cadets are brought forward by Britannia. On the other side is the British lion. The monument is a strange mixture of contemporary and classicizing elements, with the allegorical figure of Britannia deriving from the Minerva of Antiquity.

Sir Richard Westmacott (1775–1856)

Sir Richard Westmacott received his early training from his father, the London sculptor Richard Westmacott. The father, who was quite educated, sent his son to Rome in 1793, where the lad entered Canova's workshop. Two years later he not only won the gold medal of the Accademia di San Luca, but also became a member of the Accademia del Disegno in Florence. Directly after his return in 1797, he set up his own workshop in London and exhibited at the Royal Academy for the first time, something he continued to do every year until 1839. In 1805 he became an associate, in 1811 a full member of the Academy. Appointed professor of sculpture there in 1828, he was knighted in 1837. In 1839, he gave up his sculptural activities and concentrated entirely on teaching.

His principal artistic work is probably the monument for *Charles James Fox* in Westminster Abbey (1810–23, ills. pp. 306–307).

When the great Canova visited Westmacott's workshop and saw the figure of an African, one of the secondary figures of the monument, he is supposed to have declared he had never seen a marble piece to surpass it either inside or outside England (ill. p. 307). Statesman Charles James Fox (1749–1806) had been a Member of Parliament since 1768, became a lord of the Admiralty in 1770, and from 1772–74 was a commissioner of the Treasury. Among his notable merits were his attempts to abolish the slave trade and his support for the rights of the North American colonies. Westmacott pictorialized three basic elements of Fox's political career. Fox dies

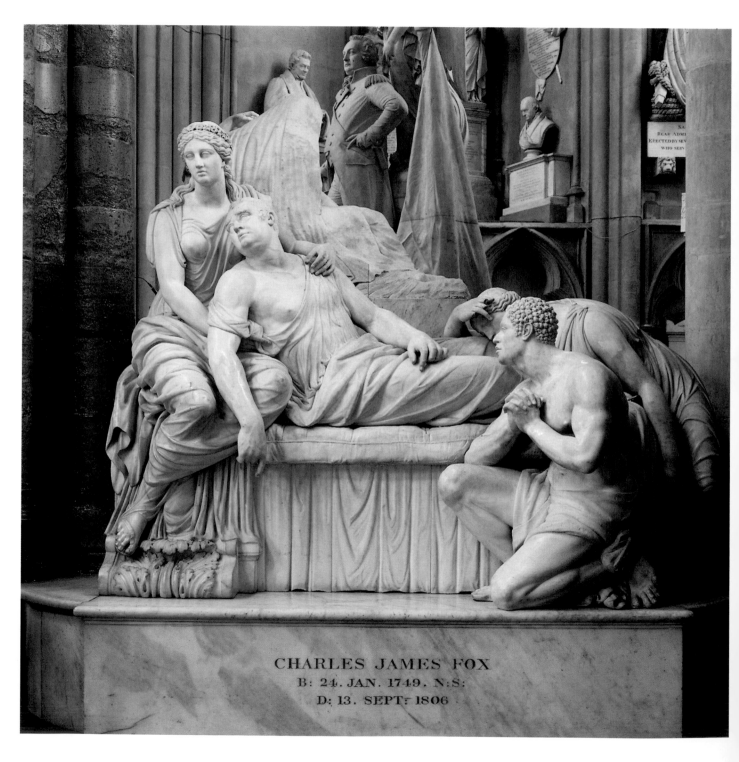

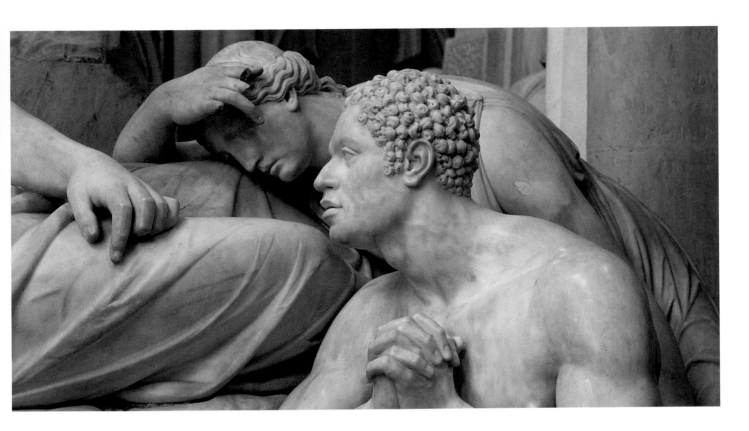

in the arms of the allegory of Liberty; leaning over his feet is the mourning allegory of Peace; and the African squats before him to thank him for his forceful intervention on behalf of his race. Both in terms of content and composition the seated figure of Liberty forms the high point of the enclosed group.

Sir Francis Chantrey (1781–1841)

Born on a farm near Sheffield, the son of a carpenter, Chantrey was largely self-taught as a sculptor. At 16, he was apprenticed to a carver and gilder in Sheffield, where he first came into contact with classical casts, engravings and plaster models, his master's trading wares. At the same time he learnt drawing from various engravers. After five of the anticipated seven years had passed, he broke off his studies as a wood carver to devote himself entirely to drawing portraits. He shuttled between Sheffield and London, occasionally working as a wood carver and sometimes visiting the Royal Academy. His first commission for a marble bust (of Revd. James Wilkinson in Sheffield Cathedral), which he did in Sheffield in 1805, prompted him to go over to sculpture entirely. Through Flaxman, he obtained in 1809 a commission for four colossal busts of admirals (Hospital Collection, Maritime Museum, Greenwich), which brought him into contact with influential personalities. The following year, King George III granted him two sittings for a later bust.

His first masterpiece, a bust of the Revd. John Horne-Tooke (ill. p. 308, bottom), brought him such fame in 1811 that he was subsequently commissioned to do a prestigious marble statue of the king (destroyed in 1940). The subject is shown in a coat buttoned over the chest and a close-fitting cap. Whereas the eyes are deep set under heavy brows and the pupils hollowed out, the skin is shown soft. Even in this early work, Chantrey shows his ability to render skin and flesh in marble sensitively. Often praised for this, over the following 20 years he did countless busts, but few of them that surpassed this one in quality.

In the Academy exhibition of 1817, Chantrey caused a sensation that considerably enhanced his fame, presenting the model for a marble group known as the *Sleeping Children* (ills. p. 308, top, and p. 309). In 1815, he received a commission from Mrs Ellen Robinson for a monument to her daughters Ellen Jane and Marianne, who had died in a fire. Chantrey had taken a death mask of one daughter, but this was only for orientation in the facial form. The children do indeed lie there as if they could be

307

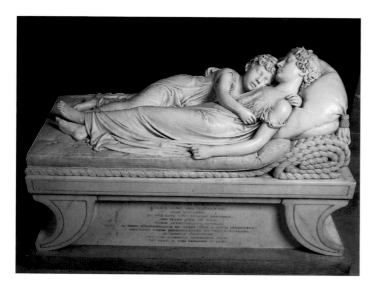

conflicts of content, if only because the immortality and blame-lessness of the classical gods contrasted as radically with the culpable entanglements of the Nordic gods as with the knowledge of their own downfall.

The Swedish sculptor Bengt Erland Fogelberg (1786–1854) was trained by his father in the brass foundry business. In 1803 he came to Stockholm, where he worked initially for a court engraver. After a few years he abandoned this craft, feeling drawn to art, enrolled at the academy of art in Stockholm, and in 1811 won its highest medal. A scholarship from the academy in 1820 enabled him to go to the Académie des Beaux-Arts in Paris. A year later he went to Rome, where he settled for good. In 1818, he had entered sketches for colossal statues of *Odin, Thor* and *Freya* in a competition organized by the Götiska förbundet. These were the first attempts in Swedish art to represent Nordic mythology in sculptural form. In 1828, the King commissioned him to do *Odin* in marble, which was completed in 1830 (ill. p. 310). On its arrival in Stockholm a year later, the

awoken at any moment. The naturalism of the depiction is enhanced by a breath of poetry. Both the embrace with which the younger girl turns to the older one for help and the snowdrops that she holds in her hand were details that stirred the emotions in an age easily and willingly moved to tears. "So great was the throng wishing to see the children, … that people could not get near them. Mothers stood with tears in their eyes, went away and came back. Meanwhile Canova's now far-famed figures of *Hebe* and *Terpsichore* stood alongside almost unnoticed," wrote Lord Holland.

Scandinavia

Whereas the countries of the former Roman Empire could relate to the legacy of Antiquity via their own histories, this tradition was absent in the Nordic countries of Scandinavia. Instead, the awakening nationalism that came with Romanticism revived interest in the old Nordic gods, knowledge of whom had been limited to Danish and Swedish antiquarian circles since the 16th and 17th centuries. In Denmark it was the sculptor Hermann Ernst Freund (1786–1840) who did images of gods from the pre-Christian era for the Danish King Frederick VI. His *Twilight of the Gods* frieze for Copenhagen Palace in 1840–41 was largely destroyed during the fire of 1884. In Stockholm, a *Götiska förbundet* – or league of young artists – was set up in 1811 with the aim of reviving old Nordic virtues. As they knew from literature that there had been temples with pictures of the gods, although no one knew what they looked like, the artists were obliged to resort to models from classical Antiquity. Combining two different mythologies in this way was bound to give rise to

Bengt Erland Fogelberg
Odin, 1830
Marble
Nationalmuseum, Stockholm

figure aroused great admiration among the public. The highest-ranking Nordic god, but an enigmatic figure, Odin stands in a classic *contraposto* attitude, clad in the robe of a Roman general. Fogelberg emphasized the warrior aspect of the god, who holds a spear in his right hand while the left grasps the inside straps of his shield. On his headgear, a mixture of a cap and a crown, sit two birds, possibly in a multiple allusion to Mercury as a comparable god. It was chiefly this introduction of the Nordic gods that established Fogelberg's reputation as an innovator in Swedish sculpture. After becoming a member of the Swedish Academy of Art in 1832, he became a professor there in 1839, though without residential obligation.

Spain

Damià Buenaventura Campeny y Estrany (1771–1855), born in Catalan, trained first as a saddler in his father's workshop, before being apprenticed to the Barcelona-based sculptor Salvador Gurri (documented 1756–1819). In 1795 he went to Rome, immediately winning a first prize at the Accademia di San Luca and ending up as one of the Canovan school. After his return in 1816 he became a teacher at the Escuela de Nobles Artes and at the same time an honorary member of the Madrid Academia de San Fernando. Soon after, Ferdinand VII appointed him court sculptor. He turned down the coveted posts of Vice-Director (1827) and Director General (1840) of the art school *Llotja* in Barcelona.

His plaster figure of the dying Lucretia (*Lucrecia moribunda*) dates from 1804, though it was only 30 years later that he translated it into marble (ill. p. 311). According to legend, St. Lucretia of Mérida was converted from Islam to Christianity and subsequently persecuted by the Moors, until finally being martyred in 859. The dying saint collapses on her chair, blood issuing from a wound in her heart and the death-dealing dagger lying at her feet. Even in death, the sculptor gives his figure something of a classical *contrapposto* pose. The right leg stands bent, firmly on the ground, while the disengaged left leg stretches out of the edge of the plinth. The body continues the line up to the head, which has fallen on the left shoulder. The light, almost silky dress of the saint has slipped from the right breast and is piled up in folds on the ground. In the exposed parts of the body, an imitation of Canova's Neoclassical treatment of skin surfaces may be noted.

Little is known of the life of the sculptor Antonio Solá (1787–1861). After training in Barcelona, he continued his studies in Rome around 1802 – when he was only 17 – and took up residence there. Elected a member of the Accademia di San Luca in 1816, he became its president in 1841, being one of the few presidents of this important academy of art not to come from Italy.

However, as is evident from numerous sculptures he did for Spain, he always remained attached to his homeland. The group

depicting freedom fighters *Daoìz and Velarde* dates from 1820–30. Solá based the work on an event in the Peninsular War, still clearly in the public consciousness, as his countrymen were fighting Napoleonic rule (ill. p. 311, bottom). The two warrior heroes stand beside an artillery gun. The almost religious exaggeration of the successful war of independence was aimed at developing a new national awareness. Remembering the events and venerating the heroes would unite people beyond the barriers of political ideology.

Italy

Despite being descended from Lorraine ancestors, Giovanni Dupré (1817–82) was born in Siena. From his earliest days, he spent a lot of time with his father in his workshop, where he learnt how to handle a drawing pencil with both pleasure and concentration. The family could not afford to send him to school. In 1821, his father took him to Florence, where eventually, as a young man of 23, Giovanni won joint first prize in a sculpture competition.

The sculpture that was his breakthrough, making him "an artist overnight," as Dupré wrote in his *Thoughts and Recollections*, was in every respect a highly unusual work. Dupré said of his success, not without a certain satisfaction: "It was only said and constantly repeated that I had never studied and had jumped myself up from being a wood-carver to a sculptor without so much as a by-your-leave." It had been Dupré's explicit aim to explore an unusual subject, and his choice fell on a representation of the *Defeated Abel* (ill. p. 312). The preliminary studies for the work almost cost him and his model Brina their lives. On the last Thursday of Carnival in

1842, he and Brina withdrew to a small studio that was difficult to heat. While the rest of the world was following the Carnival parade, Dupré was studying pose, proportion and shape on his live model. They were so absorbed in their work that they did not notice that something was wrong with the stove. In mortal panic and with his last strength, which reached him as fresh air through the keyhole of the door, Dupré was finally able to save himself and Brina from the burning studio.

Questioned about the casting model, Lorenzo Bartolini (1777–1850) commented: "The lifelikeness displayed by character and form show that you are not from the Academy" – an accolade worth more than a prize. With the help of his friends, Dupré's figure was cast in September that year. The sculpture attracted great attention, because in view of the unusual lifelikeness, many could not believe that it was modeled freehand. To prove the "deception" that a cast had been made from a living model, Brina was summoned, told to disrobe and adopt Abel's pose. But all the measuring and comparing was of no help, because Dupré had

"made the statue a hand's width larger and reduced the breadth of the thorax by half a hand." Dupré's *Abel* not only brought academic Neoclassicism to an end. Its unsparing naturalism also opened the way to a new era in European sculpture.

Neoclassical sculpture in the United States of America

After the founding of the United States of America following the Declaration of Independence from Britain in 1776, there was great demand for public art, especially in the realm of sculpture. As the young republic had no native sculptors with adequate qualifications, they had to rely on those who came from Europe.

It was thus the Frenchman Jean-Antoine Houdon who was given the major task of making the first notable statue of an American statesman and first president, the great George Washington (1732–99). Commissioned by the parliament of Virginia, Thomas Jefferson had ordered it direct from the sculptor, who had then traveled to America in the company of Benjamin Franklin to make Washington's likeness. The statue was only part of a larger commission for Houdon, who was asked to draw up a bronze equestrian statue of Washington as well. Nothing ever came of the latter, but the marble statue (ill.

p. 314) was erected in the rotunda of the State Capitol in Richmond, Virginia, in 1792.

The sculpture depicts, life-size, the first president of the United States of America supporting himself on the *fasces* (a bundle of rods with a projecting ax symbolising authority) of the Roman magistrate. Each rod in this case represents one of the original 13 American federal states, whose unity was their strength. Jefferson placed particular emphasis on Washington being presented life-size: there was to be no exaggeration, and he was not to appear divine or regal, but just as the first among equals, the statesman citizen. His simple civil dress is also to be interpreted in this same context, expressing democratic philosophy right down to the missing button on the coat.

Beside the *fasces* there is a second reference to Roman Antiquity, which is set in a biographical context: as a Virginian plantation owner Washington was invited to lead the patriotic armies in the American Revolution. He enters the public arena not as a victorious general, but as the founder of a new political order. In this, he is a successor to the legendary Roman hero Cincinnatus, who, responding to the call of the Roman senate in 458 BC, leaves his plow and, appointed dictator of the Republic,

Lorenzo Bartolini
Tomb of Princess Sophia Zamoyska,
1837–44
Marble, b. 187 cm
Salviati Chapel, Santa Croce, Florence

Enrico Causici
Daniel Boone Fighting the Indians, 1826–27
Sandstone relief
Capitol, Washington

destroys the enemy, saving the Roman army. After only 16 days he relinquishes his rank with its extraordinary powers and returns to his farm. The plow at Washington's feet alludes to this event and the Roman farmer, who through his action had become a model of American civil virtues. In comparison with this neoclassical masterpiece by Houdon, in which political concepts and human reality are brought together in a unique expression of the ideals of a young democracy, all other attempts to realize a similar idea appear unsatisfactory.

Little is known of the life of Enrico Causici (1790–1835), except that he came from Verona, Italy, was presumably a pupil of Canova, and died in Havana. Between 1822 and 1832 he was in the United States, where he left behind a number of reliefs and statues as well as an equestrian statue of George Washington erected in Baltimore in 1826. Between 1823 and 1827 he was engaged on developing reliefs for the Capitol in Washington. One of these, commissioned from Causici in 1827, shows the legendary pioneer Daniel Boone in a life-and-death struggle with an immense Indian (ill. p. 315). The relief depicts an event in October 1773, when Boone had to lead a group of settlers over the Appalachian Mountains and across the Kentucky frontier. As they progressed across the new frontier, they were attacked by Indians, but, spurred on by Boone's bravery, they managed to resist the Indians. This was a symbolic moment, which shows the frontiers being pushed back and the continent being conquered. Opinions vary as to whether the Indian is depicted as a beast and savagery personified, with Boone displaying the supercilious coolness of the supposedly superior white man; or whether the Indian is portrayed as a brave warrior who is defending his land.

For German sculptors, the United States was less attractive, the artistic challenge being considered too insubstantial. In the reverse direction, interest was also only limited, if we disregard the request to Rauch in 1849 to work out an equestrian statue of George Washington for New York, or the posthumous award to him of Honorary Foreign Membership of the American Academy of Arts and Sciences in Boston in 1860. The acceptance of German sculptures in the public spaces of American cities came relatively late, and even then it was often older, already existing work that was drawn on. In Philadelphia, where a large German-speaking population had settled relatively early, the German sculptor Rudolf Siemering (1835–1905) set up an equestrian statue of George Washington in the square in front of the view of the Philadelphia Museum of Art in 1897. The grandiose flight of steps behind him are flanked by casts of two sculptures from the Rauch school: on the left, the *Lion Fighter*, by Albert Wolf (1814–92), and on the right *The Amazon* by August Kiss (1802–65).

Albert Wolff, himself the son of a sculptor from the Pomeranian town of Neustrelitz, was orphaned at a young age.

August Kiss
Amazon, 1834, cast 1842
Bronze
Altes Museum, Berlin

Original used for cast of sculpture
in Philadelphia

OPPOSITE:
Albert Wolff
Lion Fighter
Design based on studies by Rauch 1847,
erected 1861
Bronze
Altes Museum, Berlin

Original used for cast of sculpture in
Philadelphia

promises something so outstanding I am ready to sacrifice my compositions on this subject"), the concept of the whole seemed to Schadow "very bold and the execution daring." The monumental group was cast in 1842 and erected the following year on the eastern side of the Altes Museum in Berlin. Its counterpart, the *Lion Fighter* by Wolff, on the western side was installed only in 1861.

Both groups enjoyed great and sustained popularity, so that they were reproduced on a reduced scale and in various materials by numerous foundries many times over. A colossal zinc cast of the *Amazon*, financed by Kiss himself, was greeted by rapturous reviews at the Great Exhibition in London in 1851. Since 1928/29, original-size casts of both groups based on the arrangement in the Altes Museum in Berlin have graced the Philadelphia Museum of Art.

He came to Berlin in 1831, becoming a pupil of Rauch. He remained an assistant for a considerable time, and did not set up his own studio until 1844, following a brief trip to Italy. From 1866 he was a successful teacher at the academy in Berlin. His lion statue is based on preliminary studies begun by his mentor Rauch in 1829, which the latter finally passed on entirely to his pupil in 1847, as he no longer even considered doing it himself. The combat scene depicted by Wolff (ill. p. 317) shows "the three finest creatures: man, horse and lion" combined in a single sculpture. Following the iconography of St. George, Wolff's rider fights the lion with a spear, with the lion replacing the dragon.

However, the actual execution of the work was motivated by that of another sculptor, the *Amazon* by August Kiss. The son of a Silesian foundry inspector, Kiss had been familiar with iron casting of art pieces since his youth and knew about casting techniques, modeling and chasing. Once in Berlin, he too like Wolff became a pupil, assistant and collaborator of Rauch's for 15 years, from 1825. Kiss also developed his *Amazon* from early studies, which started in 1834. Prompted by Schinkel, the architect of the Altes Museum, who wanted to furnish the steps of the building with decorative sculpture, Kiss designed an amazon combat of extraordinary expressivity (ill. p. 316). With a leopard springing at the throat of the horse, the amazon endeavors to fend it off with a spear. Praised effusively by Rauch ("the model

Alexander Rauch

Neoclassicism and the Romantic Movement
Painting in Europe between Two Revolutions 1789–1848

"The past lies, because it sets the outstanding individual in place of the average person."

ERNST HEILBORN

The quotation above is true of any attempt to depict a past epoch in art, yet artists are challenged to present as realistic a picture as possible. An attempt to present the painting of the Neoclassical and Romantic periods through selected pictures cannot make any claim to objectivity or truth, for our image of an epoch is too determined by the achievements of the famous artists of the time. And what is regarded as important is itself subject to constant change, while many a disregarded work may open up surprisingly new perspectives, or relativize what was believed to be a truth. Even to select the pictures is to make a value judgement. It is like an appeal to particular witnesses of the time to tell us something about that bygone age. Of the many witnesses who could tell us relevant information about the period under discussion, only some can be presented here

The period between the last years of the 18th century and about the middle of the 19th – basically, the period between the revolutions of 1789 and 1848 – was an age of great upheaval. Europe was in shock as opposing political tendencies followed fast upon each other in the build-up to the outbreak of the French Revolution in 1789. The continuing upheaval included, notably, the execution of Louis XVI on January 21 1793, on the machine invented by Dr. Guillotin – intended to let undesirables be eliminated "humanely" for the first time.

The situation continued through the Directorate governments in France from 1795 to 1799, and the rise of Napoleon, which many saw as liberation (up to 1815), was soon followed by opposition to him and his troops as they flooded over Europe. Then came another reversal. The *Ancien Régime* was reinstated under Louis XVIII and Charles X, under Ferdinand VII in Spain, and the Congress of Vienna met in 1814–1815. The July revolution in Paris in 1830 brought the bourgeois king Louis Philippe to the throne, and in Austria Count Metternich ruled instead of mentally retarded Ferdinand I.

Goethe said in his *Annals*: "While every corner of the world was set alight and the whole face of Europe was changing, Germany was enjoying a feverish peace in which we abandoned ourselves to a dubious sense of security." But things changed in Germany as well with the Wars of Liberation in 1813–1815. Then after the 1848 revolution, when the old structures were reinstated in a new guise, many there too may well have wondered for what purpose so much blood had been shed. But in the same year Karl Marx published his *Communist Manifesto*, although the effects would not be felt for a long time to come. It is often said that the French Revolution of 1789 brought new attitudes and ideas to art and culture that are still ultimately determining our culture today. But this is only half the truth. The roots of the Enlightenment had

already undermined the rock of the old order much earlier – in 1789 they just broke it open. The new ideas had already been formulated by philosophers in the 17th century, and they were lying fertilized long before the new age was born amid the labor pains of 1789.

Both the styles and subjects of this period really proclaim a new beginning. But a new beginning in what way? Was this only a change in political and social conditions, from absolutism to the rule of the people? The new political system was the result of a process of philosophical thought that had long preceded it and that attacked the very basis of the old system of rulership. Again, there had been civic unrest and peasants' revolts in earlier times, but they were bound to fail as long as the ruling class could claim to rule by the grace of God, as an institution based on religion and faith. The Reformation showed that to shake faith immediately tears open social structures as well, and it was then that the saying was coined: "When Adam sang and Eve span, where was then the nobleman?" It is not by chance that the epoch of the Reformation coincided with the art of the Renaissance, or that now the time of the French Revolution coincided with Neoclassicism, with its rediscovery of the forms and the ethical values of Antiquity. Significantly, the ensuing developments were also very similar. Where the Counter-Reformation attempted to restore the old order and ideas on religion, in the 19th century the period that brought a break with religion and hierarchy was followed by the Restoration, a period of deeper religious feeling.

Even without a more in-depth interpretation of the background of ideas, which we shall discuss later, a brief look at the paintings of this period will show that in the years between the end of the Rococo and the Restoration entirely new themes were formulated and entirely different problems tackled from those in preceding epochs. We can group the new phenomena into at least six themes that painters now tackled:

1. Fate, its remorselessness and cruelty, and horror at this
2. The sublime and isolation
3. Dream and vision
4. History as an educative model, genius and the enthusiasm for Egypt
5. The child, and
6. The sane and healthy world of Biedermeier.

One could also call these themes or phenomena inventions, for the invention, the new approach, the startling and shocking became the dominant tenor of pictorial language. The artist saw himself as creator, as the moving spirit of his work, and in the century of the "demiurge" this was closely connected with the idea of the genius. This in turn opened up another new theme, science. Suddenly, the name of Newton was on everyone's lips. One had to be able to

Maurice Quentin de la Tour
Mademoiselle Ferrand Meditating on Newton, 1753
Pastel, 73 x 60 cm
Alte Pinakothek, Munich

converse about his theories. The scholar Count Francesco Algarotti even made *newtonianismo* accessible "for the ladies," and Mademoiselle Ferrand had herself painted by Maurice Quentin de la Tour meditating on Newton (1753, ill. p. 319). Around 1760 Paul Sandby depicted one of the physicist's folios in his *Laterna magica* (ill. p. 332, below left), and a few years later Januarius Zick painted *An Allegory on Newton's Achievements and the Theory of Gravity* (ill. p. 420). Towards the end of the century William Blake "transformed" the figure of *Isaac Newton* into a surreal metaphor of the new age (ill. p. 320). Finally, in 1827, Pelagio Palagi created a theatrical depiction of *Newton's Discovery of the Refraction of Light*, attempting to explain the way a genius conceives an idea in psychological terms (ill. p. 416, bottom).

So now the central figure was no longer the martyr, as in the story of salvation, but was the hero of Antiquity, the genius, the great man of history – and of the modern age. At the same time, the ordinary person also became a focus of attention, with his

319

feelings and his suffering, even his painful appearance in a lunatic asylum, as in the work of Goya and Géricault. The feelings and suffering of ordinary people played an important part in art, and this was something entirely new. Fate became a major theme, as if there had been a change from belief in religion to belief in fate.

Literature was tragic, like Goethe's *Die Leiden des jungen Werther* (The Sufferings of Young Werther), as was drama and painting. Tragedy became a theme in itself, and concern with the sublime and the inevitability of fate, or Providence, to use Leibnitz's term, can be traced like a scarlet thread from Heinrich von Kleist's *Penthesilea* (1808) to the theoreticians of tragedy, Friedrich Schiller and Christian Friedrich Hebbel (whose *Maria Magdalena* was written in 1844). One of Beethoven's symphonies became known as the *Symphony of Fate*, and one of Francisco de Goya's wall paintings (1819–1823) would also be entitled *Destiny*. The tragedy was always played out without the saving intervention of a merciful God, and ethics no longer meant the dictate of divine laws, but meant philosophical experience or the historical model. The didactic novel and the pedagogical aspect

of a painting were both designed to educate through presentation of a model: example and warning. Jacques-Louis David showed the suffering of "Belisarius" (ill. p. 369) and painted Marat lying dead (ill. p. 374). Here and in many other pictures he thematized his sense of right – as did Pierre-Paul Prud'hon in *Revenge* – as the rejection of formalistic theological norms, which were replaced by the models of right presented by history. This certainly goes back to Charles de Montesquieu and his work *De l'esprit des lois* (On the Spirit of the Laws) of 1748.

But tragedy evokes pity. All the more so, as a society that lacked religion also lacked the comfort of the after-life. Instead of Christian charity there was the *misericordia* (mercifulness) of Antiquity, the expression of a rationalism that appealed to feeling. Tragedy and upheaval became the main features of the painting of the period. The Lisbon earthquake in 1755 cost more than 30,000 lives, and it shook faith throughout Europe. The discussions on whom God had wanted to punish went on for decades. In the same year Immanuel Kant (1724–1804) published his *Allgemeine Naturgeschichte und Theorie des Himmels*

William Blake
Isaac Newton, 1795
Copper engraving with pen and ink and watercolor, 46 x 60 cm
Tate Gallery, London

Blake sought to exemplify the deeper significance of his philosophical thought in the tension between the immediate realism of his image and fantastic symbolism.
Newton, man naked and created out of chaos, appears to be breaking through that chaos. He is discovering the law that is inherent in his own physical nature. Man has tasted of the fruit of the tree of knowledge, and now his intellect reveals to his astonished gaze the abstract reality of creation.

(General History of Nature and Theory of the Heavens) and Saverien published the first dictionary of physics.

The long secreted writings, only discussed in elite circles, which had questioned the relation between faith and knowledge long before, only now began to have their effect. It was the English thinkers Francis Bacon (1561–1626) and Thomas Hobbes (1588–1679), and particularly David Hume (1711–1776) in his *Dialogues Concerning Natural Religion* of 1779, who helped to develop the new philosophy and a new ethics. Since Georg Christoph Lichtenberg (1742–1799) many had seen *Die Weltgeschichte als Geschichte des Kosmos* (The History of the World as the History of the Cosmos), a view which in itself must have been shattering. Only in this context can one understand the work of a painter like Turner, and the many paintings by other artists intended to arouse a "sublime" shudder by depicting earthquakes and shipwrecks, storm-filled nights, floods or thundering cataracts. In 1785, for instance, soon after Pompeii was discovered, Angelika Kauffmann recalled the eruption of the volcano that in 79 A.D. had destroyed the city.

For good reason, many artists chose the ship as a powerful symbol to express the theme of "man and destiny" in a painting. It conveys the idea of *navigatio vitae*, which Caspar David Friedrich depicted so vividly in *The Stages of Life* around 1835 (ill. pp. 440–441). Even more, the ship at sea was also a metaphor for man caught in the incalculable forces of nature. Merciless superior force had replaced the humane and benevolent God. We need only mention a few paintings here, for they can serve as examples of a whole range of related images in this period.

Again Britain starts the list. Turner had taken up the subject from 1802, following his travels, and it was to occupy him until into the 1840s. His *Shipwreck* (ill. p. 320) is remarkable, like *Slavers*, *Snowstorm* and many more of his paintings, not only for its stylistic advance, but also for the basically fatalistic vision of man at the mercy of the forces of nature. In 1819 Théodore Géricault painted *The Raft of the Medusa* (ill. p. 411), a work discussed in more detail later. Tragic events like the loss of the Medusa in 1816 had, until then, been depicted at best by illustrators – such events had not been regarded as suitable subjects for high art. Where the death of individuals was shown, it was in a

religious context, the martyr's death for his faith. Now the fate of the nameless had also become an appropriate vehicle for art.

From about 1817, Caspar David Friedrich also turned to the subject of shipwreck and in 1822 painted *A Ship Wrecked on Greenland's Coast*. Now lost, it was the first of his variations on the theme of the sea of ice. In the painting that is now often called *The Wreck of the Hope*, but which he actually entitled *Arctic Shipwreck* (1824), the painter imbued the subject with unsurpassable dramatic intensity (ill. p. 322). The particular feature of this work is that the drama has already happened. The huge towering pinnacles are the slowly moving icebergs that have long become fixed here. The bold attempt by man to burst the bounds of his allotted sphere ends in death. The picture is so powerful and oppressive not only because we surmise the eternally frozen corpses in the split body of the ship, but also because the idea is still acutely relevant today. The title *The Wreck of the Hope* is philosophy in paint. It is the philosophy of deism, cosmotheism, pantheism. The Christian idea of a God that can be moved by prayer has long been abandoned, and a modern view, like that in Ernst Bloch's *Prinzip Hoffnung* (The Principle of Hope), has not yet been found. We will have a better understanding of this painting if we recall how greatly Caspar David Friedrich had become engrossed in the philosophy of Spinoza, via Goethe, Schleiermacher, Jacobi, Herder, Schlegel and the Jena circle, to which he was so strongly attached. Many other painters were drawn to these subjects as well.

The ship as a symbol of life retained its force of expression for a long time. Charles-Gabriel Gleyre, whom we will encounter again, exhibited his painting *Evening* in the Salon of 1843, and his contemporaries added the appropriate subtitle ... *Or Lost Illusions* (ill. p. 323, above). It is probably a reference to the novel by Honoré de Balzac, *Les Illusions perdues*, which had appeared that year. Gleyre's painting is a dreamlike representation of a vision he had on the bank of the Nile in 1835, as his diary shows. He depicts himself as a weary singer, whose lyre has slipped from his hand, as he can no longer find words. The image of the singer was not new; Gérard, Girodet, Ingres, and Runge all handled the subject of "the singer's dream," with the legendary Gaelic bard Ossian, who was a popular subject for a long time, as the centerpiece.

Gleyre's vision of "lost illusions" is melancholy. The silent, leaden water is a foreboding of death. Under a waning moon and a fig tree bending its boughs in longing the painter "dreams" of the golden age of youth – "chères et douces illusions de ma jeunesse" (dear and tender illusions of my youth), as Gleyre himself wrote. Conrad Ferdinand Meyer saw the painting and wrote a poem, the first verse of which is:

"Jüngst im Traume sah ich auf den Fluten
Einen Nachen ohne Ruder ziehn,
Strom und Himmel stand in matten Gluten
Wie bei Tages Nahen oder Fliehn."
(In a dream a bark I saw
Drifting silent with no oar.
Dull red glowed both stream and sky
As at dawn or eventide.)

In the seventh and last verse the vision culminates in the recognition of death:

"Flehend küsst ich dich in wildem Harme,
Die den bleichen Mund mir willig bot,
Da zerrannst du lächelnd mir im Arme
Und ich wusst es wieder – du bist tot."
(Wild with grief I kissed you madly
Your pale mouth you offered gladly
With a smile you faded from me
Death – I knew – had claimed you from me.)

The man meditating and his dreamlike vision of happy maidens are on the same level of reality, although they inhabit different worlds. The decline of the west, which Gleyre evoked so often in his paintings, is here related to himself. The seated figure derives from marble portraits of the philosophers of Antiquity (like that of Chrysippus in the Louvre). We encounter the man meditating on destiny again in many works, right through to Auguste Rodin's *The Thinker*. Wherever the artist needed to express horror, incredulity, helplessness in the face of fate, like Pierre Narcisse Guérin in his *The Return of Marcus Sextus* (1799), or David in his *The Death of Socrates* (1787, Louvre) or his *Brutus*, where the dead bodies of their sons are being carried past the parents (ill. p 372), we find the seated figure with his hollow gaze. In keeping with his style and temperament John Henry Fuseli intensified this expression in *Ezzelin and Meduna* (1779, ill. p. 323, below), and even more so in *Silence* (c. 1799–1801, ill. p, 324, below).

"Dream and vision," "sleep and death" were frequently combined as subjects at this time, as we see in Goya's *The Dream (Sleep) of Reason* (1797, ill. p. 365), Fuseli's *The Shepherd's*

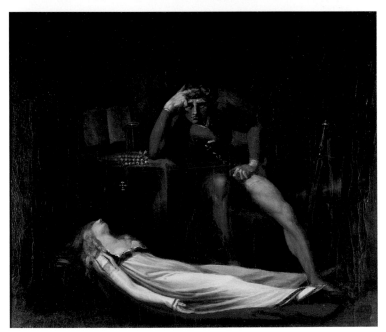

Dream (1793, ill. p. 324) and *The Nightmare* (1781, ill. p. 338). Asmus Carstens depicted *Night with her Children, Sleep and Death* in 1795 (ill. p. 12), and, as the Romantic movement became interested in illustration, Shakespeare's *A Midsummer Night's Dream* was chosen as a subject by Fuseli and many others. The Ossian theme mentioned above was also treated as a dream vision by painters, and Jean-Pierre Franque actually depicted the current political situation in France in 1810 as a vision seen by Napoleon in a dream in *Allegory on the Condition*

BELOW:
John Henry Fuseli
The Shepherd's Dream, 1793
Oil on canvas, 154.5 x 215.5 cm
Tate Gallery, London

BOTTOM:
John Henry Fuseli
Silence, around 1799–1801
Oil on canvas, 63.5 x 51.5 cm
Kunsthaus, Zurich

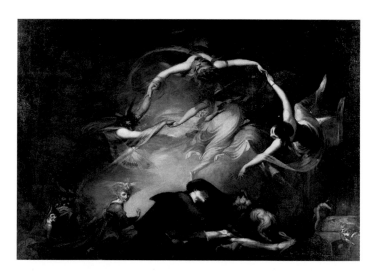

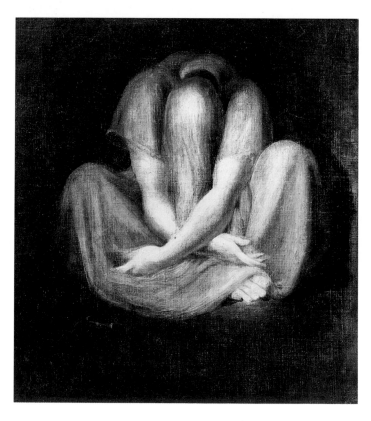

of France before the Return from Egypt (ill. p. 398). This was to thematize history in a way that is quite alien to us today. But we must remember that the irrationality of the Romantic movement played a major part in history painting in the next few decades – often in the form of a heroic idealism.

Isolation and sublimity were basic metaphors in painting for extended periods at this time. The whirling society life of the Rococo was followed by a withdrawal into isolation, combined with the search for the sublime. Friedrich Hölderlin wrote *Hyperion oder Der Eremit in Griechenland* (Hyperion, or the Hermit in Greece) in 1797–99, and Achim von Arnim published his *Zeitung für Einsiedler* (Hermits' News-Sheet) in 1808. The dreamer was also a lonely figure, often with sublime and visionary dreams, as was the wanderer on his winter journey, as portrayed by Caspar David Friedrich, to quote one example, and set to music by Franz Schubert. It is not necessary to mention in this introduction all the pictures of isolation that will be discussed later, for the subject was a continuous theme for decades. Landscape as a projection of the spiritual state of the lonely hermit or dreamer occurs in the work of other artists beside Friedrich, although he gives it a particularly intense interpretation.

What gave rise to this new view of the world and of society? It was certainly an artistic crisis, but initially it was an intellectual one, such as occurred once before at a turning point in cultural history, during the Reformation and the Renaissance. Writing in 1934, Paul Hazard put the subliminal beginning of this crisis as early as pre-1700 in England. And Hans Sedlmayr (1948) has shown how the symptoms became visible in France only much later. But he was also the first to recognize the upheaval as one that formed a whole epoch in art. However, he drew the negative conclusion that it was a "loss of the center," as he entitled his book (*Verlust der Mitte*), and this led him to judge the Modern Movement. Apt as his arguments are, his judgement is untenable (and that is probably why his conclusions are so often cited without the author's name being mentioned). The loss, which he quite rightly recognized, can be identified much more directly than through the generalization "center." It was the loss of the old Western religion of Christianity, and with it the concept of salvation that had offered spiritual protection and confident belief in the life hereafter for centuries. The Enlightenment, deism, cosmotheism, pantheism and then rationalism, atheism and materialism split the old sense of security apart, and the loss created a true vacuum, which in turn led to a search for a new direction. This search for a divinity of whatever form found expression as longing and permeated every sphere of art.

So, longing was the key feature of the time. Novalis searched for the blue flower, others searched for Arcadia or a lost paradise. Like the inward look of longing for the "lost illusions" in Gleyre's work, they were all expressions of the same feeling. Ultimately

BELOW:
Isidore-Stanislas Helman after Charles Monnet
The Fountain of Youth
Copper engraving, 35.5 x 46 cm
Kunsthalle, Hamburg

BOTTOM:
Eugène Delacroix
Algerian Women in their Apartment
(Detail of illustration on pp. 400/01),
1834
Oil on canvas, 180 x 229 cm
Musée du Louvre, Paris

the longing for the south, for the Italy of Antiquity or Greece, described so vividly in humanist education, was another form of the same search. In that sense Neoclassicism is only one of these forms. For a time it seemed as if the Antique Pantheon could fill the vacuum with its gods, for in the new pantheistic philosophy – like Goethe's, for instance – these gods were largely seen as personifications of natural forces.

In the very early days of the upheaval Novalis demanded in his *Fragments*: "The world must be romanticized!" And he himself provided the explanation: "Romanticizing is only a qualitative increase in potential... By imbuing the commonplace with high significance, the ordinary with a mysterious regard, the familiar with the dignity of the unknown, the finite with the appearance of the infinite, I romanticize them." Again it was Novalis who provided a trenchant formulation of the solution: "Those who are unhappy in the world as it is now, who cannot find what they seek, let them go into the world of books and artists, into nature, which is eternally ancient and modern at once."

"Ex oriente lux"

Orientalism was not only a consequence of Napoleon's Egyptian campaign. As centuries before, to look to the Orient was also to search for different philosophies – orientation in the literal sense. We are familiar with this in Venetian painting after the conquest of Constantinople by the Turks in 1453, in the work of Gentile Bellini, Vittore Carpaccio and Lorenzo Costa. In the 17th century the forerunners of the Enlightenment turned much more intensively to the East, initially motivated by research into biblical history. Right into the 19th century unraveling the culture of Ancient Egypt was regarded as a task of primary importance, a kind of secret science. The English theosophist Ralph Cudworth (1617–1688), whose writings on moral theology were read with enthusiasm by revolutionary and anti-clerical intellectuals in Europe, also revealed some of the secrets of Egypt in his book *The True Intellectual System of the Universe* (1678). His surprising conclusion was that, for all their secret theology, the Egyptians did not worship a divine being, apart from stars and planets, nor did they recognize a non-corporeal principle or a creative reason as originator of the universe.

That struck a chord! While the revolutionary years brought the desire to exclude the Christian religion, there was a search for new (perhaps old!) theistic, pantheistic (Spinoza) or cosmotheist concepts of the world and the divine, that could also offer moral authority. The search for the new in Ancient Egypt also found an appropriate image in a painting by Charles Monnet (1732 – after 1808), *The Fountain of Youth*, which was widely distributed in an engraving made in 1793 (ill. p. 325). It shows the goddess Isis with water flowing from her breasts. A crowd of people surrounds the fountain, worshipping the goddess. One is raising a goblet to fill

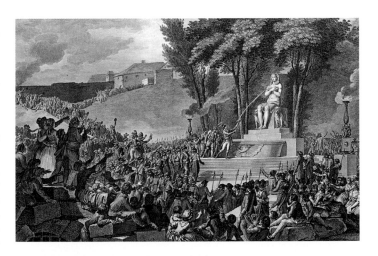

it. The image of the fountain of youth was not, of course, a reference to the hope of physical rejuvenation, but meant intellectual renewal; the water was what the words "Oh Isis and Osiris, give spirit to wisdom" in Wolfgang Amadeus Mozart's *The Magic Flute* mean. So the Egypt fever that swept through Europe around 1800 had a philosophical origin. English landscape gardens all had a pyramid, an obelisk or a sphinx, and furniture and fitments were in the Egyptian style these interior designs also signalled that the owner was esoterically knowledgeable, a free thinker, a theosophist. The garden of one of Mozart's brother Freemasons near Salzburg had an Egyptian grotto, which, like the stage direction for the second act of *The Magic Flute*, was to be understood as the location of mysterious initiation rites.

In his essay "Über das Erhabene" (On the Sublime, 1793) Friedrich Schiller said: "All that is veiled, all that is shrouded in mystery, seems more fearful, and so it can seem sublime. The inscription over the temple of Isis in Sais in Egypt: 'No mortal has ever lifted my veil' is of this nature." An engraving by Bertel

Thorvaldsen was equally mysterious. It is the dedication to Goethe in Alexander von Humboldt's *Ideen zu einer Geographie der Pflanzen* (Ideas on a Geography of Plants) of 1807 and is entitled *The Genius of Poetry Unveiling the Image of Nature.* Here, too, the figure of the genius is unveiling the goddess Isis in the form of the Artemis of Ephesus. And John Henry Fuseli illustrated Erasmus Darwin's poem "The Temple of Nature" (Edinburgh 1803) with a title page showing the statue of Isis being unveiled by a priestess.

This was one aspect of the interest in the Orient. Another was the world of Islam, the beauties of Arab poetry and oriental wisdom. Goethe turned to the theme of the Orient in the *West-Östlicher Divan* (East-West Divan) (1819) and *Mohammed* (1802). Gotthold Ephraim Lessing's *Nathan der Weise* (Nathan the Wise) of 1778 is a didactic play based on Moses Mendelssohn's concept of tolerance and on the pantheism of Baruch de Spinoza, and was seen as an intellectual revolution a decade before the political revolution broke out in France.

The movement, therefore, started in Britain in the 17th century, but a century later the English writings on the Enlightenment were being widely read in France and Germany. Eyes turned to Egypt, and the search for a new concept of divinity was addressed to the mysterious Sphinx. The English deist John Toland (around 1670–1722), who was in contact with the philosopher Queen Sophie-Charlotte of Prussia, should be mentioned here, as should the free thinker William Warburton (1698–1779), and particularly the German philosopher of the Enlightenment, Karl Leonhard Reinhold (1757–1825). In the latter's circle we encounter a number of familiar names, most of whom, characteristically, like Goethe, were in the emergent free-thinking and Freemason movements. They included Friedrich Heinrich Jacobi, Lessing, Mozart and even Schiller, who was also a member of the Secret Association of Illuminati (Geheimbund der Illuminaten). We owe Mozart's opera *Zaide* (1779–80) to the peak of Egyptophilia, and particularly *The Magic Flute* (1789–91), set to texts by Emanuel Schikaneder, who in turn drew on Reinhold. One of the most impressive incunabula of this intellectual enthusiasm for Egypt was Karl Friedrich Schinkel's stage design for *The Magic Flute*. For the Queen of the Night it shows the Egyptian starry sky (1815, ill. p. 326).

Thus the feeling of reverence was transferred from the Christian God to any other phenomenon that could evoke the sense of the sublime. The mysterious element in old cultures was eagerly sought. And nature itself, the greatest mystery of all, the mother of all life and the lap of death, was given its monuments, of which Schinkel's *The Gate in the Rocks* (ill. p. 327) was just one of many examples. But the idea of the sublime had already been discussed in England in the middle of the 18th century, by Edmund Burke (1729–1797). Statesman, philosopher and founder of a psychological aesthetic, his *A Philosophical Enquiry into the Origin of our Ideas of the Sublime and Beautiful* (1757) had a lasting influence on the aesthetics of the second half of the 18th century. As a consequence Kant discussed the subject in a lengthy passage in his *Critique of Judgement* entitled "An Analysis of the Sublime," coming to the conclusion that only the strongest spirits were capable of confronting the mysteries of nature. Significantly, he not only names natural phenomena like mountains and thunder storms as examples through which we may experience the sublime, but also includes the pyramids.

The philosopher Moses Mendelssohn (1729–1786) was the link to the man who was perhaps the most important thinker, with the most profound influence on the intellectual world, particularly, and almost exclusively, in Germany: Baruch de Spinoza (1632–1677). It is far too little known that it was his *Ethics* (Opera posthuma, 1677) that had so impressive an impact on the leading figures in German literature: Goethe, Herder, Schleiermacher, Schelling, and Jacobi. One of the main reasons why this is not generally known is that these men themselves could not openly confess their debt to Spinoza for a long time. A minister of state like Goethe, or a preacher like Schleiermacher, did better to conceal their inclination to pantheism. In August 1780 Lessing visited his fellow poet Johann Wilhelm Ludwig Gleim in Halberstadt, and wrote the words "Hen kai pan" in Greek letters on the wallpaper in his garden house – "One and All" or "the All-One." The secret of the motto was only revealed after Lessing's death, when Friedrich Heinrich Jacobi published *Über die Lehre des Spinoza in Briefen an den Herren Moses Mendelssohn* (On Spinoza's Doctrine in Letters to Moses Mendelssohn). Both Lessing and Jacobi were members of the secret society of Freemasons. According to Jacobi, their discussions centered on Goethe's writings, and Lessing exclaimed: "I can no longer accept the orthodox concepts of the Godhead, I can no longer take pleasure in them. Hen kai Pan – it is an essential concept," adding: "That is also the tendency in Goethe's writings." The admission of Lessing's Spinozism came like a shock,

Eugène Delacroix
Liberty leading the People, 1830
Oil on canvas, 260 x 325 cm
Musée du Louvre, Paris

and from then on "Hen kai Pan" became – as Spinoza's panthe-
istic formulation "deus sive natura" – a general motto. So the
ground had been prepared for the acceptance of "Hen kai Pan"
or "One and All," as Hölderlin put it, since the end of the 17th
century, as it had for the deism of the British philosophers.

In his autobiography *Dichtung und Wahrheit* (Fact and
Fiction) Goethe said: "I hastened back to the works (of Spinoza),
to which I owe so much, and the same breath of peace wafted
towards me. I became absorbed in reading and thought, as I
looked within myself, that I had never seen the world so clearly."
The importance of this philosophical basis only becomes clear
when one sees its effects in literature and painting. Eichendorff's
line "Es schläft ein Lied in allen Dingen" (A song slumbers in all
things) and most of the paintings of the time are largely poetic or
painterly reflections of this idea of "All-One" or Spinoza's "Deus
sive natura." The motto occurs in countless debates between
philosophers, in discussions between intellectuals and artists, and
it became the creed of cosmotheism.

The paintings of Caspar David Friedrich and those of Philipp
Otto Runge will be much better understood against this intellectual
background, and the difference between Turner and Friedrich, for
example, will also be clearer. Turner's "chaos" is fueled by English
deism (through to atheism), while Friedrich's symbolic landscapes
and the paintings by other German artists in his circle are based on
pantheism. The issue is not whether the painters read the philo-
sophical works; the parallels are evident all the time.

This new approach also created new motifs in painting. One in
particular recurs with remarkable frequency: the figure seen from
behind, looking out of a window. Representing the viewer of the
painting, he is shown studying the horizon, the sky, the moon or
the landscape itself. German artists of this period devoted them-
selves much more intensively to landscape painting than did their
counterparts in France. Friedrich Haack commented on this in
1904: "For the countless number who could no longer find what
they needed in church faith, but still retained a religious sense of
longing, a truly passionate love of nature was bound to replace the
spiritual elevation they had lost. So in the 19th century, landscape
replaced religion as the main theme of all art." The French
Romantic movement was much more concerned to depict histor-
ical events or adventures in distant lands, in narrative works that
could be read like novels. Here too the aim was to arouse fellow
feeling. The painter developed his narrative choreography like a
theater producer, setting gestures and creating stage effects.
Delacroix's image of *Liberty Leading the People* is an allegory, a
beautiful woman with naked breast stepping over the bodies of
the fallen, her standard raised. This is a Jacobin Joan of Arc, and
the composition is theatrical (ill. pp. 328–29). The difference
between the German and the French approach cannot be shown
more clearly than through a comparison with Alfred Rethel's

Another Dance of Death, which takes up the same theme of the barricades (ill. p. 330, left), or with Adolph Menzel's *The Slain of March 1848 Lying in their Coffins* (ill. p. 330, right).

Finally the question of the style of the period must be considered. Attempts to differentiate between Neoclassicism and Romanticism have always proved fruitless. It is correct to say that Neoclassicism was a style, and Romanticism was not a style, but an intellectual approach. Nevertheless, it is hard to draw a clear distinction between the two concepts. As we can identify a Baroque Neoclassicism in the 18th century, we can also identify a Romantic Neoclassicism, and a Neoclassical Romanticism.

Johann Georg Sulzer (1720–1779), a writer on art theory, defines "the classical" in his book *Allgemeine Theorie der schönen Künste* (General Theory of the Fine Arts), which appeared in 1771–1774, in these terms: "The artists for whom nature is no longer sufficient belong in the highest class; they strain their genius to seek out in the contradictions in nature that which does not serve its purpose and create their own idealistic forms from these elements through the creative force of their genius." Two phenomena are mentioned here that had a marked influence throughout the century: "Classe" (class), the core of the terms "classicism" and "Neoclassicism," and "genius," the idea of an ability inherent in the gifted person that is given expression through art to benefit mankind. Joseph Anton Kochs concluded that: "Art must give what nature does not have." Is Neoclassicism not also a product of the romantic longing of the time? The penetrating Lord Byron wrote to Goethe from Ravenna as early as 1820, saying he noted that in Germany and in Italy there was much dispute over what was called "classical and romantic," terms that were without significance in Britain.

At the end of the epoch under consideration here we shall see how the change took place. The sobering acceptance of Spinoza's doctrine that instead of a beneficent God only a cold cosmos could be regarded as sublime, was a comfort to only a few of the "strongest minds," as Kant said. Goethe, "the old heathen in Weimar," was one. His early novel *Werther* had caused more suicides "than the most beautiful woman," as Rahel Varnhagen said. A wave of conversion to Roman Catholicism was the result; even Schelling bent his knee after coming under the influence of the religious philosopher Franz von Baader in Munich.

In art a similar change took place. The Nazarenes sought their salvation in religion and a childlike naivety. The child, to whom Philipp Otto Runge devoted his deepest thoughts, became an important theme in painting. Ultimately, this was due to Jean-Jacques Rousseau (1712–1778) and his writings *Emile* and *Back to Nature*. Runge's statement "We need to become children" is only a consequence of this. But soon, particularly in the work of Ludwig Richter, this idea became linked to the idea of a seemingly sane and unspoilt world. It cannot be overlooked that in the decades between 1820 and 1848 the deep gulf that separated the Protestant north from the Catholic south became evident again. The philosophical cool of the painters Friedrich, Blechen or Runge is not to be found in the painters in the south, like Richter, von Führich or Schwind. But that is to anticipate. The romantic Biedermeier idyll, with its children playing on a green meadow, was of only short duration. Soon realism was to show what conditions were really like.

The urge to search that was so characteristic of this period led in many different ways, and into many a dead end, but ultimately it was in vain: people had to be content with the occasionally more comforting sense of longing. We are still seeking today.

Nathaniel Dance
Timon of Athens, c. 1765
Oil on canvas, 121.9 x 137.2 cm
H.M. Queen Elizabeth II, London

The Artists and their Works
Britain

From the 18th century to the middle of the 19th Britain occupied a unique position stylistically. This is all the more remarkable, as pioneering achievements came from Britain and exercised a profound influence on the continent, like the paintings of Fuseli, Blake, Wilkie, Constable, and, above all, Turner. Unlike earlier periods, when artists from the continent settled in Britain and put the local art in the shade – one only need mention Holbein, Van Dyck and Kneller – Britain was now isolated. The interruption to artistic links was largely due to the many years of war with France, which went on until the defeat of Napoleon in 1815. The history painter Benjamin Robert Haydon said that the Continental blockade had protected British art from the "brick dust" of the Neoclassical French painter David. At the latest since the foundation of the Royal Academy in 1768, British art had developed a hitherto unknown self-confidence. Britain began to build up its colonial power at the end of the Seven Years War and the struggle with France. Now the ideas of the Enlightenment, the way for which had long been prepared in Britain by Bacon and Hobbes, were being propounded by Hume and were spreading to the Continent. Britain's most important intellectual gift to the Continent was the new philosophy of pantheism and deism, which enjoyed a victorious progress. Edmund Burke stimulated the new ideas, as explained in the Introduction, with his *Essay on the Sublime and Beautiful* of 1757, and English poets were also the first to set "meditative grief" in the place of traditional belief in God. Examples include Edward Young's *Night Thoughts* (1742), Thomas Gray's *Elegy in a Country Churchyard* (1750), and James Hervey's *Meditations among the Tombs* (1745–47). Sensibility was conquering Europe.

After the paintings of social criticism by William Hogarth (1697–1740) the novel of sentiment also soon reached the Continent, as did the sentimental garden and the sentimental portrait. They were followed by New Hellenism and New Gothic in its atmospheric ambience, with the spiritualism of Fuseli, Flaxman and Blake, then finally the unconventional revolutionary painting of Turner and its astonishing contemporary, iron architecture. In this way Britain played a pioneering role in the period between the two revolutions.

Initially, Britain too was caught in a post-Rococo Neoclassicism, in which the Scot Gavin Hamilton (1723–98), for instance, devoted himself to Homeric scenes. Sentiment plays a striking part in his subjects: *Achilles Mourning the Death of Patroclus*, *Achilles Dragging Hector's Body into the Camp*, and so on. Hamilton's interest in Antiquity even influenced David during his stay in Rome. Like Angelika Kauffmann, who lived in England from 1766 to 1781 and exhibited in the Royal Academy, Nathaniel Dance (1735–1811) also remained faithful to the

Sir Joshua Reynolds
The School of Athens, 1751
Oil on canvas, 102 x 137 cm
The National Gallery of Ireland, Dublin

Rococo and its touching subjects (ill. p. 331, top). That the view of Antiquity could have another face, too, is evident from the ironic humor of *The School of Athens* (1751, ill. p. 331, bottom) by Sir Joshua Reynolds (1723–92). This is a caricature in the spirit of Hogarth. The reference, of course, is to Raphael's fresco, but it is also directed at the "culture consumers," the British men who were then undertaking the usual Grand Tour to Italy, but who really only felt at home with their Gothic. Thomas Patch (1725–82) saw his fellow countrymen's attitude to the works of Antiquity in a very similar light, and in *The Members of the 'Society of Dilettanti'* he shows them gathered around the Venus de Medici (ill. p. 332, top left). This is pure self-irony, though his subjects were pleased to be shown as connoisseurs. Patch himself appears on the ladder, examining the proportions of the statue.

The British also took an ironic and self-critical attitude to modern technology, as Paul Sandby (1730–1809) did in *Laterna Magica* (around 1760, ill. p. 332, below left). The contemporary passion for optical instruments, of which Britain was a leading producer, is referred to here, but the painter is also poking fun at the scientific achievements of the Enlightenment. So the pile of books before the canvas includes the name of Newton, which we shall encounter frequently in paintings of this period. It is no coincidence that the painter shows the projection on the screen in a drawing-room; this is, so to speak, an anticipation of the fact that photography would ultimately come to compete with painting. But there was also objective documentation of technical innovations, as in *George Biggins' Ascent in Lunardi's Balloon* (1785, ill. p. 333, top) by Julius Caesar Ibbetson (1759–1817). The stylistic gap between this and a painting on the same theme by Francesco

BELOW:
Julius Caesar Ibbetson
*George Biggins' Ascent in Lunardi's
Balloon*, 1785
Oil on canvas, 50.5 x 61 cm
Neue Pinakothek, Munich

BOTTOM:
Thomas Jones
An Excavation, c. 1777
Oil on paper, 41.9 x 55.9 cm
Canon J.H. Adams Collection

Guardi of 1784 is very striking. A new age had come, not only in the technical sense, but also in the tasks facing painting.

Antiquity was the great theme. Its influence can be traced in two areas particularly – in literature, which often comes close to the macabre in these decades, and in the excavations of antique sites, which were followed with intense interest at the time. Joseph Wright's (1734–97) painting *Miravan Opening the Grave of his Forefathers* (ill. p. 332, right) illustrates an example from literature. One story is that Miravan found on the grave of his forefathers the inscription "In this grave lies a greater treasurer than Croesus possessed." But the central character finds only bones and another inscription: "Here dwells rest! Criminal, you seek gold among the dead? Go, greedy one, you will never find rest!" The subject has a double meaning. It not only illustrates the legend itself, but was also probably intended as a criticism of the growing desecration of antique sites. Thomas Jones (1742–1803) documented one of these excavations (1777, ill. p. 333, below). It may be the site of the Villa Montalto in Rome, where the Termini railway station now stands. Sites like these attracted the British travelers on the Grand Tour, and soon a fever for collecting developed that dominated elegant taste throughout Europe. Charles Towneley (1737–1805) was the most famous of the many English collectors. Johann Zoffany (1733–1810) portrayed him in his library (ill. p. 334, top right) with an imaginary assembly of the entire collection in the one room. The owner of the house and his counterpart, the art historian Pierre d'Hancarville, who is wearing a Rococo costume, are still seated in Baroque armchairs, but the rest of the interior decoration is in the new style. This is determined by the collection itself, which was later donated to the British Museum.

As with the French Romantics, such as Delacroix and Géricault, tendencies to use the mobile brushwork of Baroque painting for narrative purposes were also apparent in England. The same Reynolds encountered above as a caricaturist put the sublimity of Antiquity into portraiture at an early stage (ill. p. 334, top left). Sophia Heywood, or Mrs. Musters (1758–1819), was then renowned for her beauty, and she is depicted as Hebe, that is the handmaid of the gods, filling the bowl for Jupiter. Both her pose and the proportions recall Guido Reni's *Aurora*, while the colors are reminiscent of Guercino.

It was not only in portraiture that England returned trends to the continent. We need only mention one example: James Ward (1769–1859) painted *Stallions Fighting on the Bank of a River* in 1808. Rubens was clearly the inspiration here, but Ward has intensified the drama even further. When Géricault was in London in 1821, the picture fascinated him enormously, a reaction later shared by the whole of France.

On the other hand, English painters also registered events in France and on the Continent with great attention. Nine years after the Battle of Waterloo on June 18 1815, which abruptly ended Napoleon's rule of 100 days, Ward illustrated the drama of political events with a simple image of a horse (ill. p. 334, below). A British officer apparently found the Berber stallion, Marengo, Napoleon's left behind after the battle. The horse is said to have carried the world conqueror safely through almost all his campaigns, and is now wandering lost, in search of the rider who has fled. His wide eyes and quivering nostrils reflect the panic and fear that drove Napoleon's army to flight.

The English painter could not have given
a more apt or dramatic depiction of
Napoleon's fall from power than in this
psychological image of his tragic fate.
Marengo was Napoleon's horse. We see
it fretting to and fro, trembling on the
brink, as it looks out over the sea for its
lost rider. The animal's emotional state
mirrors the catastrophic events. Lonely,
riderless, and unsaddled, the stallion's
fear is visible in its eyes, the restless
unease expressed in every muscle of its
body. The distant horizon present under
the darkening evening sky, into which
the former world conqueror has had to
flee, leaving his faithful steed behind, is
the metaphor in the painting for the
historic event.

Joseph Mallord William Turner
War, The Exile and the Rock Limpet, 1842
Oil on canvas, 79.5 x 79.5 cm
Tate Gallery, London

William Turner directs the gaze to the same act in the theater of world history in quite a different way (ill. p. 335). His painting *War, The Exile and the Rock Limpet* is not a psychological study, but reduces the events retrospectively to a single point in history. Power and decline, greatness and absurdity, importance and banality coincide here. The man who once ruled the world is reduced to a costumed doll, his reflection conversing in a puddle with a rock limpet. The dying sun dominates the center of the picture and symbolizes world chaos, in which history is played out only as the downfall of an individual. The futility of man's existence, which Caspar David Friedrich thematized in *The Monk by the Sea* (ill. p. 433, below), is presented to us by Turner as the ultimate futility of history – each painter contrasts this with the incomprehensible immensity of the cosmos.

Narrative painting also became fashionable in Britain, and one of the most celebrated painters in this genre was Sir David Wilkie (1785–1841). Initially he devoted himself to moral and humorous subjects that recall Hogarth's heritage. His *Reading the Will* (ill. p. 336) recounts a whole family history, inspired by Walter Scott's novel *Guy Mannering*. The viewer is invited to interpret the context from the gestures of the figures. The picture woos the viewer by challenging him to incorporate his own experience of life and unravel the story behind the painting.

Reading the Will was commissioned by the King of Bavaria, Max I Joseph, and it immediately made the artist famous. This type of painting was to remain in mode throughout the century in Europe.

Josephine and the Fortune-Teller (1837, ill. p. 337, top) is strongly psychological in approach, and here Wilkie has taken up the style of Van Dyck. Only when we know that this is Josephine as a young woman in Martinique, hearing the fortune-teller reading her palm predict her elevation to Empress, do the expressive gestures become clear, which are presented as if in a play. The subject is taken from Josephine's *Memoirs of Napoleon*, which appeared in 1829 and was translated into English in 1830. Wilkie has painted history, but not the official event. He has chosen an intimate moment in the life of the future Empress, the moment when her historical destiny is foretold. Josephine is still sitting in a darkened room, but the brilliant future is glimpsed as if through a triumphal arch. The court is approaching, champagne is being offered, and even the little dog is looking at her devotedly. Anecdotal treatment of great historical themes or events became a very popular genre in painting. Other examples are the works of Richard Parkes Bonington (1802–28) in England, such as *Henry IV and the Spanish Ambassador* (1827, Wallace Collection), and the work of Delacroix in France.

But let us look at the picture as a whole again for a moment, particularly at the great swinging lines with which Wilkie brings his often elongated figures to life. For all the citations of the Baroque, this is a style that became extremely important for a time in England, and was used by painters from Fuseli through Blake and Wilkie to Turner. One could call it corporeal fluidity, and in Turner it becomes landscape flowing and dissolving. It did not come unprepared.

John Henry Fuseli (1741–1825)

As early as 1781 the anglicized Swiss painter Johann Heinrich Füssli (John Henry Fuseli) portrayed a young woman on the back of his painting *The Nightmare* (ills. pp. 337, below and 338). If it is true that both images are his beloved Anna Landoldt, a niece of Lavater (W. Hofmann), whose parents refused to allow her to marry him, then is *The Nightmare* not to be interpreted as an allegory on disappointment? In that case, the grisly ape is the man who is ultimately allowed to "possess" the revered lady with his jealous glance. But it is at the price of her life, and Fuseli shows her sunk down and breathing her last.

In both paintings Fuseli uses the highly expressive line that was so characteristic of his work. It has been said that his art derives on the one hand from Michelangelo, and on the other from the "storm and stress" of his own artistic temperament. He was inspired by contemporary German literature, but he put what he had read much more expressively on to his canvases. Fuseli went to Rome in 1770 and remained there for eight years. First he was influenced by Mengs, whom he knew personally, then he became friendly with David. It was Fuseli who made David's severe linear approach known in Britain, although he himself used a different language, one that was entirely new and would never have been accepted in France. He was the same age as David and Goya, and followed the latter particularly in his love of the macabre, the disturbing, the spiritual. A preference for the repetition of forms is evident. Form appears as metaphor, as cipher for emotion and expression, as theatrically staged gesture and body language. His *Lady Macbeth Sleepwalking* or *Lady Macbeth with the Daggers* (ill. p. 339) is a scene from the theater, appropriately lit against a black background; it recalls like no other work by a European painter the mysterious and disturbing wall paintings in Goya's house a few years later. Fuseli's *The Artist in Despair over the Magnitude of Antique Fragments* (ill. p. 11, below) is also like a scene on a stage. The artist is like an actor displaying a well-rehearsed affectation, rather than a painter. There can be no doubt that Fuseli's art is close to Italian Mannerists like Pontormo or Luca Cambiaso, and the Surrealists of the 20th century, because they all had one thing in common: they broke with tradition by abandoning the usual view of reality. That is how they all reached similar results.

CONTINUES ON P. 342

John Henry Fuseli
The Nightmare, 1781
Oil on canvas, 101 x 127 cm
The Detroit Institute of Arts, Detroit

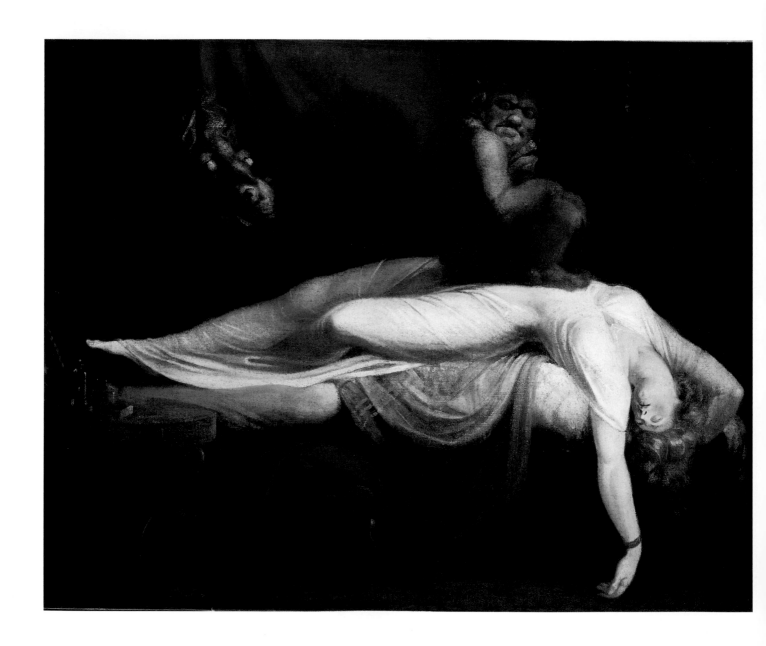

John Henry Fuseli
Lady Macbeth with the Daggers, 1812
Oil on canvas, 101.6 x 127 cm
Tate Gallery, London

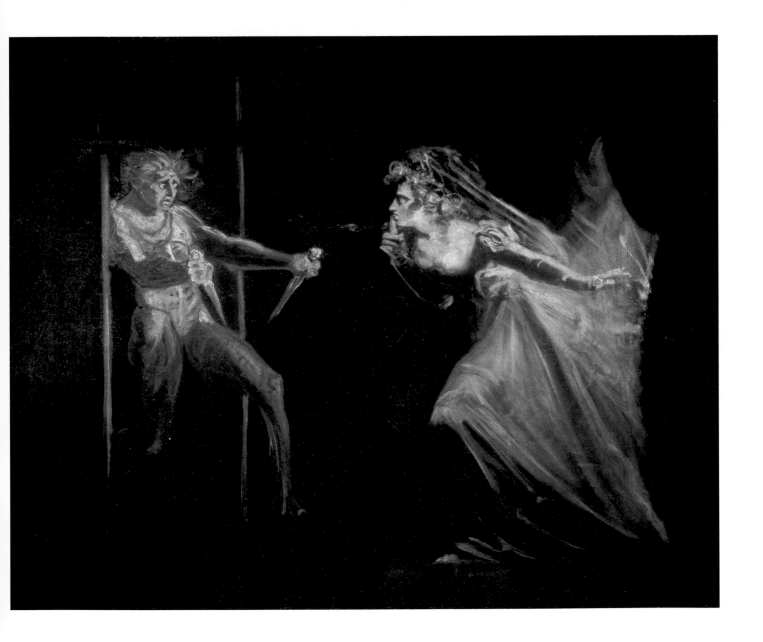

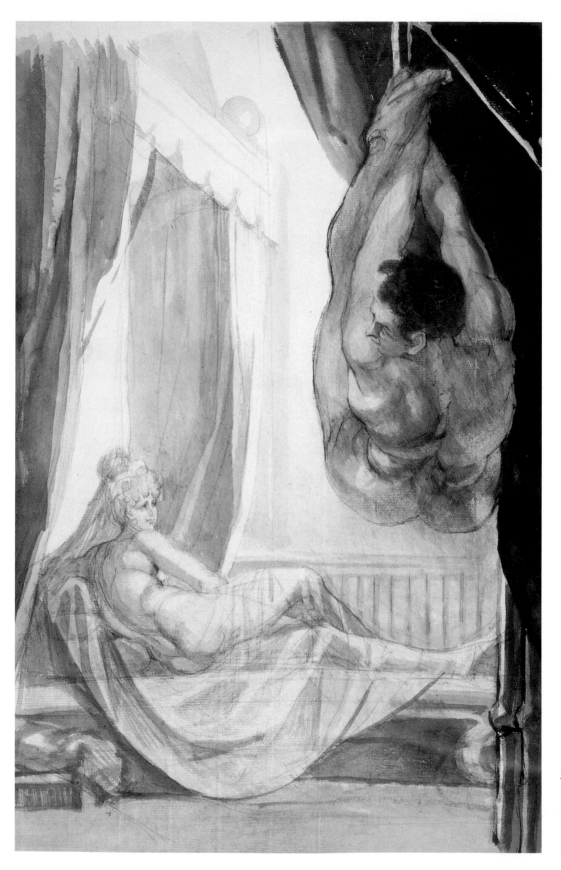

Johann Henry Fuseli
*Brunhilde Observing Gunther, Whom
She Has Tied to the Ceiling* (Niebelung
Saga X, 648–50), 1807
Pencil, pen and ink and wash
48.3 x 31.7 cm
City Museum and Art Gallery,
Nottingham

ABOVE:
John Henry Fuseli
Courtesan Wearing a Feathered Headdress, 1800–10
Pencil and ink, watercolor
28.3 x 20 cm
Kunsthaus, Zurich

RIGHT:
John Henry Fuseli
Symplegma of a Man with Three Women, 1809–10
Pencil, tinted in grey and pink
19 x 24.8 cm
Victoria & Albert Museum, London

LEFT;
John Henry Fuseli
Symplegma of a Man with Two Women, 1770–78
Pen and ink, 26.8 x 33.3 cm
Gabinetto dei disegni e stampe, Uffizi, Florence

Between 1770 and 1778 John Henry Fuseli created a number of erotic drawings which he called "Symplegma." They are very different from the erotic depictions that were usual in the late Rococo period, and in which the lascivious element is modestly concealed in a pleasurable, anecdotal bedchamber manner. Fuseli is uncompromisingly direct. In these drawings the erotic element often comes close to suffering, as if he were taking his native German word for passion, "Leidenschaft," literally, for "leiden" means to suffer. The orgiastic state of utter oblivion has evident parallels with the violent emotion in all Fuseli's works. These drawings also contain reminiscences of Antiquity, figures or herms of Priapus occur, and this makes the relation to the intoxicating cult of mysteries all the more evident. Not until around 1900 did artists like Franz von Bayros and Aubrey Beardsley again see erotic related to pain and suffering.

341

342

William Blake
Hecate or *The Three Fates*,
or *The Night of Enitharmon's Joy*
c. 1795
Pen and ink with watercolor,
43 x 58 cm
Tate Gallery, London

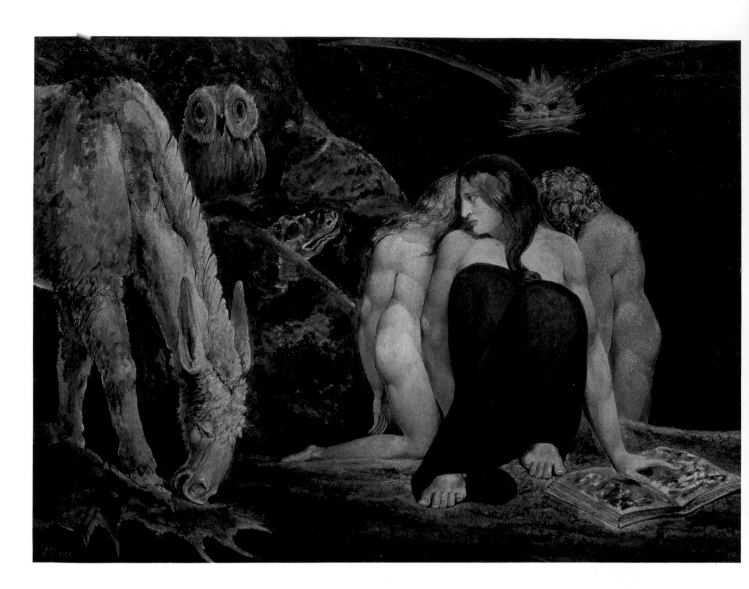

William Blake (1757–1827)

In that sense William Blake is most closely related to Fuseli. As a gnostic he was more a poet and mystic than a painter in the traditional sense, and his pictures are more like "poetical sketches" (the title of one of his volumes of poetry) or presentations of his thoughts on his universal philosophy. That is also why he – like Fuseli – has only just been rediscovered by the Modern Movement. The figure of Urizen, an allegory of evil as the creator of the material world, appears repeatedly in his work, and imagination and vision are victorious over conventional morals and reason. Like Caspar David Friedrich, although with different stylistic means, Blake also sought to discover and save the soul in the chaos of material creation. His direct dependence on the theosophy of the mystic Emanuel von Swedenborg (1688–1772) is undeniable. Ideas of rebirth, the transfer or traffic between body and soul, the field of tension between heaven and hell are the subjects of writings by Swedenborg and the contents of pictures by Blake. Finally, Blake's adoption of Manichaeism strengthened the pseudo-religious tendencies in which he developed the tension between good and evil in symbolic compositional schemes. *The Three Fates* of 1795, formerly called *Hecate* and more recently *The Night of Enitharmon's Joy* (ill. p. 34?

William Blake
The Lovers' Whirlwind, Francesca da Rimini and Paolo Malatesta
(From Dante's *Divine Comedy, Hell*), 1824–27
Pen and ink and watercolor, 37.4 x 53 cm
City Museum and Art Gallery, Birmingham

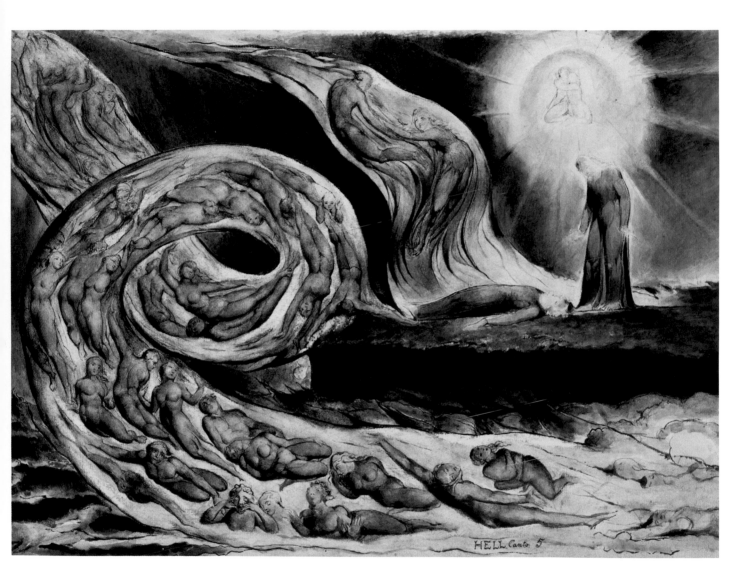

shows the many levels of meaning, or the impenetrable mystery, of Blake's work, if only in the search for an appropriate title. These works are located between reason and dream. Two years later, but very certainly independent of Blake, Goya also summoned up the nocturnal ghostly figures of the owl and the bat from the mysterious depths of the imagination in his etching *The Sleep of Reason Produces Monsters* (ill. p. 365, left), calling into question the consistency of reason. It has long been recognized that Blake's work is like a twin to that of Runge, 20 years his junior. Goethe's comment on Runge: "A man so on a knife edge will die or go mad" could apply to Blake as well.

Both thought in systems, created systematically constructed paintings, and perhaps also believed that they could trace the secret of creation from chaos, the inner system of material become spirit. Inevitably, both failed.

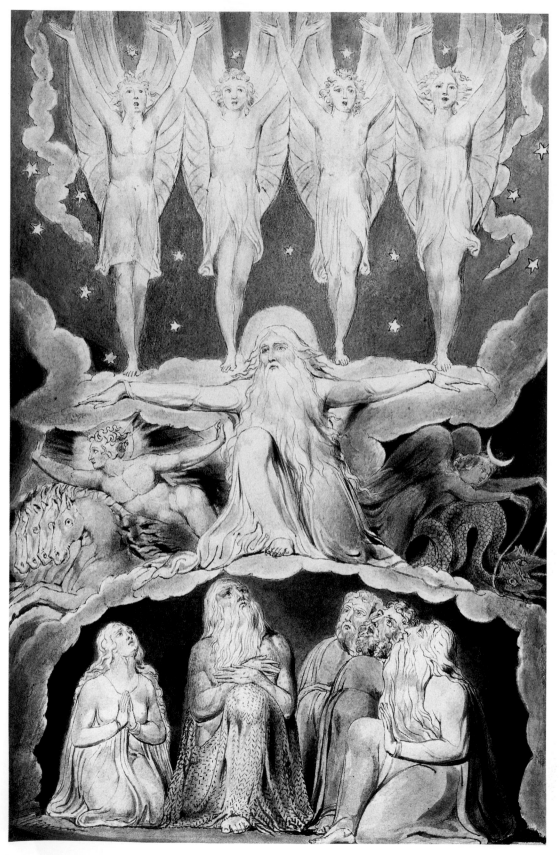

William Blake
The Book of Job: When the Morning Stars Sang Together, 1820
Watercolor, 28 x 17.9 cm
The Piermont Morgan Library,
New York

Blake's images oscillate between dream and reason. Even direct references to the Bible, as here to the Book of Job, do not necessarily mean that this is an illustration of the Bible. The scenes are too much a part of the artist's private religious vision. Here we see Job, who has been through torment and suffering, taken up by God. With His arms outstretched, God appears as the Lord of Light and Darkness, but the depiction could also be intended to show God as the Lord of the Earth. There is a striking similarity in the faces of God and of Job. The sheet is a drawing for one of the sequences of engravings that appeared from 1825.

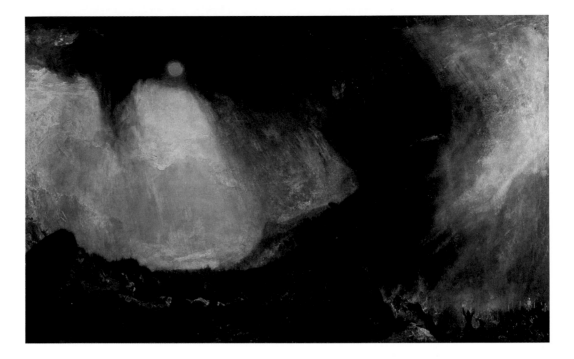

Joseph Mallord William Turner (1775–1851)

Turner reveals his cosmotheistic world view in quite a different way. He is a painter through and through, and probably the most revolutionary of his time. He was so modern in the present sense that many of his landscapes can stand beside paintings by Francis Bacon, born in 1909, and make the viewer forget that a hundred years lie between them. It would be quite wrong to call Turner an early Impressionist, but that is not the point at issue here. However, it is important to state that the seeming violence of his application of paint was not designed to split up the world as it is into phenomena of light – Turner shows the world as a visionary inter-realm between its origin in chaos and its infernal end. Even

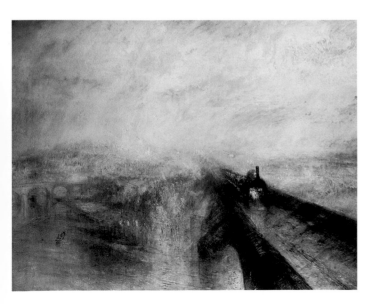

his paintings in the landscape tradition of Nicolas Poussin and Claude Lorrain, with their early Neoclassical light, like the matching pair *The Rise of the Carthaginian Empire* and *The Decline of the Carthaginian Empire* of 1815 and 1817, betray the painter's interest in the contrast between emergence and decline. *A Snowstorm, Hannibal Crossing the Alps* (ill. p. 345, top) confounded his viewers by the coexistence of traditional painting and the depiction of chaos through a chaotic application of paint. Here, too, Turner was depicting the impotence of seemingly powerful humans faced with the primeval forces of nature. Where Caspar David Friedrich arouses a shudder with the silent icy waste, Turner whirls the achievements of humans, and their ideas of progress, into a cosmic suction, as in the painting *Rain, Steam and Speed* (ill. p. 345, below). *The Morning after the Deluge* (ill. p. 347) could not be more modern – in the present sense as well. It is characteristic of the painter's mental state – his basic belief was formed by deism – that the painting he called *Peace* depicts a burial: that of his famous fellow painter David Wilkie (1842, ill. p. 346). Theodor Fontane commented: "Everything is gray, the sky, the sea, and the rocks rearing up in the distance; only a rocket signal rises into the air in a glitter of white light. Through the still gray sea the steamer sways on, its stern black, its sails black and its steam black, blowing like a flag of mourning. The whole is a huge coffin… Turner's totally different way of painting struck me years ago and … it impressed me, offering much food for thought."

John Martin (1789–1854) and John Constable (1776–1837)

Scarcely less dramatically, John Martin claimed the forces of nature for his work, but how much more theatrical does his *The Evening of the Deluge* appear (ill. p. 348, bottom). Martin never left Britain, and his illustrations for John Milton's *Paradise Lost* made him famous. In *Manfred and the Alpine Witch* (ill. p. 349, top) he turned to a literary theme, which Ford Maddox Brown

Joseph Mallord William Turner
Peace – Burial at Sea, 1842
Oil on canvas, 87 x 86.5 cm
Tate Gallery, London

Joseph Mallord William Turner
The Morning after the Deluge, c. 1843
Oil on canvas, 78.5 x 78.5 cm
Tate Gallery, London

and many others have also handled: the poem by Lord Byron in which Manfred is condemned to eternal life without sleep. He calls upon the witch to find peace, but she demands his soul, and so he dismisses her. The drama of the contents is projected onto the natural forms, in a technique that would become a favorite with the Romantic artists as a means of expressing emotion. The practice would continue for decades.

John Constable is one of Britain's greatest artists. A "natural painter," he sought inspiration directly from nature for his landscape painting. In accordance with his desire for "pure and unaffected representation," calm, almost realistic depictions of scenes in his native Suffolk form the larger part of his work. But his careful studies of nature are as evident in *Malvern Hall in Warwickshire* (ill. p. 348, top), which he executed around 1809. Although the scene is so still and there is no trace of sentimentality or theatricality, the painting is full of flickering light despite the cool objectivity, and this anticipates the Impressionists. Around 1820 Constable painted many cloud studies as expressive of moods. "Painting is another word for feeling," he said.

Especially in his last years, after 1830, his work underwent a marked change, and mood appears as the vehicle of meaning, which may possibly be ascribed to Turner's influence. Thus the painting of *Stonehenge* which Constable executed in 1835 (ill. p. 349, below) is very different from the sketch made in 1820. Now the theatrically composed stone group looks as if it is illuminated by quivering shafts of lightning, while the drama of the clouds suggests the ruinous powers of time. Constable himself said: "The mysterious monument of Stonehenge, standing remote on a bare and boundless heath, as much unconnected with the events of past ages as it is with the uses of the present, carries you back beyond all historical records into the obscurity of a totally uknown period."

The influence of Rubens is evident in Constable's work in several respects, not only in the contents or the compositional structure. This is a deeper level of understanding which the two artists shared – it is the Baroque view of landscape as an "image of the world."

Thus for a long time the unusual or fantastic remained an essential element in both British literature and British painting. Artists sought to turn the whole order of the world upside down and open the way for new, creative and visionary ideas. One may also recall here the work of the American writer Edgar Allan Poe, who had a strong influence at this time. Often the artist had to pay a high price for this concern in a neglect of the general aesthetic taste. Basically, this has also been a powerful driving force in

Thomas Cole
The Architect's Dream, 1840
Oil on canvas, 136 x 214 cm
Museum of Art, Toledo, Ohio

OPPOSITE:
Thomas Cole
The Titan's Goblet, 1833
Oil on canvas, 49 x 41 cm
Metropolitan Museum of Art, New York

20th-century art. To judge by the paintings shown, Britain went furthest in recourse to Italian Mannerism, and so pointed most clearly forward to our own time in this as well.

The interest in the fantastic also took root in America. There was no lack of landscape painters in the New World, either, to handle moonlight and the effect of waterfalls. One was Washington Allston (1779–1843). Moreover, in America a straight line development can be traced from the scrupulously faithful rendering of reality in a Neoclassical-Biedermeier style, as in the work of John Woodside (1781–1852), to the later "naive painters."

Thomas Cole (1801–1848)
Thomas Cole was by birth an Englishman, but he emigrated to the New World as a youth and in 1833 created the painting *The Titan's Goblet* (ill. p. 351). It is as fantastic as it is surreal. Cole

called Turner the prince of evil spirits, and he sought a form of expression for his megalomanic visions that at first sight looks more peaceful. In *The Architect's Dream* (ill. p. 350) the excessive size of the capital, on which the architect has reclined in reflection, only becomes clear on a closer inspection. However, the reversal of the real conditions is intrinsically threatening, and this is hardly more peaceful than Turner's chaos. If exaggeration to more than life size can express sublimity in Burke's sense to a certain extent, crossing the border to the gigantic is to tip over into the demonic, as Goya's *Giant* so impressively shows.

Spain/Francisco José de Goya y Lucientes (1746–1828)
Goya published his etching *The Giant* around 1820. A naked, muscular figure is seated above a wide landscape against a clear sky. He is a bearded colossus. His back is turned to the viewer, and his feet are bathed in the sea beyond the horizon. So we see

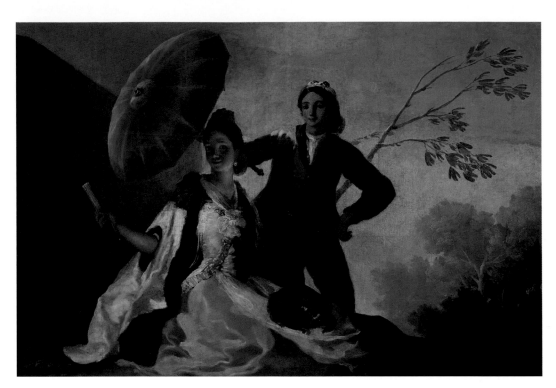

Francisco de Goya y Lucientes
The Parasol, 1777
Tapestry design
Oil on canvas, 104 x 152 cm
Prado, Madrid

Goya's paintings not only document the torment in the artist's soul, but also mirror the torment in his country. No other painter in Europe could give expression to the two sides of the changes in the epoch as clearly he could. Here we have the Rococo idyll of a sunny garden, in self-deceptive peace and calm; the other side is the enlightened critical vision that in an age of political catastrophes became a violent screaming appeal.

that the earth is round, and we also realize with a shock how huge the crouching figure must be. His head rears up into the moonlit night, shadows creep up the massive body, and the hard last light illuminates only part of his face. His eyes are dull, and he gazes blindly from their black hollows. This giant has little interest in the world upon which he has seated himself. He is looking calmly back over his shoulder, into the air, as if he had heard a sound that disturbed his cosmic rest. In this frightening creation Goya is demonstrating very clearly that the giant is deaf to the cry of pain from mankind, the rattle of swords, the thunder of cannon. The colossus remains calmly seated. In their old cosmic theory Ancient Egypt and Antiquity knew that the gods had turned away from the world, and here we have another image of it. The hopes that a thousand years of Christian painting expressed in pictures have proved illusory. Reality mocks at the Christian, humane God.

The print was sold all over Europe, and it was based on Goya's great oil painting, now in the Prado, *The Colossus*. Sometimes also called *Panic*, it was painted in the summer of 1808 (ill. p. 353). Here the giant is shown standing, his fists clenched for battle. The landscape is full of streams of people fleeing with their cattle. The oil painting makes it even clearer that mankind is dominated by fate, a force between heaven and earth. The demonic element, that has power over the earth, is depicted like a dream. This seems to be the negative of the ancient figure of Pan, and the outbreak of Panic fear has reached infernal dimensions. Goya is basically using a Baroque device, allegory. He just makes the painting difficult to interpret, for we do not know whether the figure is intended to be a personification of revolution itself, of mankind exploding in rage, or its opposite, danger taking on visionary form. The landscape in this painting is timeless, and

more than ever we can see the bunched and fleeing mass as a parable on the experience of our recent history, with its mass displacements and genocides.

Goya's work is realistic. He presents his subjects in a reportage manner, his technique refraining from any demonstration of virtuoso painting, long before realism was under discussion as a style. So, even at an early stage in his career, his pictorial message concerned the gulf that separated enlightened critical vision from the self-deceptive spiritual peace of the old faith – in one of the most strictly Catholic countries. His style also broke with the requirements of the official academies. Goya was a loner, and it is difficult to place him in the development of painting in his time. His style was so individual that he has never been imitated, only posthumously forged.

Goya's full name was Francisco José de Goya y Lucientes, including the name of his mother's side of the family in the Spanish tradition. She came from an old but impoverished noble family, a fact her son would later frequently recall with pride. He was the sixth child, born in 1746 in what is now the desolate village of Fuendetodos near Saragossa, a town in which he grew up. He was given instruction in drawing by a sculptor, Juan Ramirez, and then studied under José Luzán, after which came his unsuccessful attempts to enter the Academy in Madrid. But he was able to see works by Anton Raphael Mengs (1728–1779) and Giambattista Tiepolo (1696–1770) in the capital as early as 1766. The painter Francisco Bayeu y Subias, who came from the same province as Goya, became his teacher and landlord.

In 1769 Goya went to Italy, where he became familiar with Renaissance painting, and in 1770 he won second prize in a competition in Parma, but was admonished for "some carelessness." Nevertheless, he was commissioned to paint frescoes for

Francisco de Goya y Lucientes
The Colossus, or *Panic*, 1808
Oil on canvas, 120 x 100 cm
Prado, Madrid

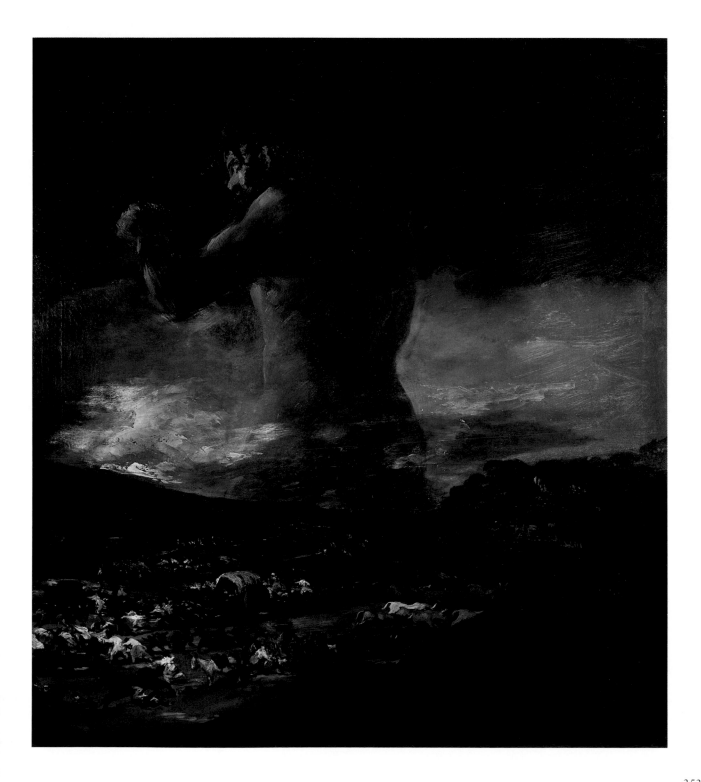

Francisco de Goya y Lucientes
Witches' Sabbath, 1789
Oil on canvas, 43 x 30 cm
Museo Lazaro Galdiano, Madrid

OPPOSITE:
Francisco de Goya y Lucientes
Charles IV and the Royal Family,
1800
Oil on canvas, 280 x 336 cm
Prado, Madrid

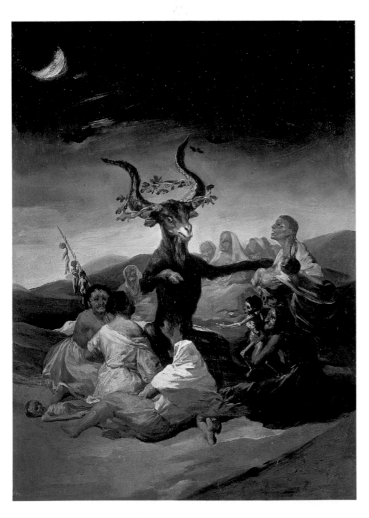

the king." His new commission took Goya to rural life for subjects, and from here he derived the inspiration for his idyllic Rococo scenes in the manner of the French painters François Boucher and Jean-Honoré Fragonard. But Goya's *The Parasol* (1777, ill. p. 353) and *The Rendezvous* (1780), *The Grape Harvest* (1786) and *The Stilt Walkers* (1788) differ markedly from their French models. The bare landscape, the proud serious gaze of the country girls, the "majas," and the cloaked forms of the "majos" have come to be regarded as quintessential Spanish painting between Rococo and early Neoclassicism. Now nothing could hold Goya back or prevent his acceptance in the Academy. He could have enjoyed a brilliant life to the full, but he immediately became an accuser. The old superstitious, heathen cult of Pan, for instance, that was persecuted by the Church, but which still persisted in the more remote corners of the country, was the subject of his attack in *Witches' Sabbath* (1789, ill. p. 354). Among a group of fanatic and stupidly credulous women and witches sits a huge ram, demanding one of the children as sacrifice. On the ground lies the emaciated body of a child. The moon and a swarm of bats overshadow the day and darken the sky. The symbols all point to the Spanish Inquisition.

In 1798 Goya designed frescoes for the dome of the church of San Antonio de la Florida in Madrid, a task in which he was assisted by the painter Asensio Julia. He depicted a miracle that was performed by the patron saint of the church, a murdered man being brought back to life. A wealth of figures surrounds the scene, and their features express every conceivable emotion and reaction, from pious simplicity, through bigoted devotion and indifference, to doubt and critical disbelief. But that did not suit the Church authorities who had commissioned the work, and Goya was never given another religious commission.

But Goya was the eternal rebel. Later the French writer Théophile Gautier would state from rather dubious sources that Goya painted with his fingers, with a broom, a cooking spoon, with any conceivable instrument except a paint brush. He certainly remained true to his non-academic concept of the art. And even if this was only a legend that grew from his later works, it is undeniable how little Goya was concerned, even at an early stage in his career, with finished painting, either the French "peinture" of the late Rococo period or that of the younger Neoclassicists. He was not interested in values like composition, perspective or the refinement of bold proportions. The limbs in his portraits are often strangely foreshortened, and frequently his subjects have been said to look as stiff as manikins. But that did not matter to him. Goya's self-confidence was given a further boost when he was appointed Deputy Director of the Academy upon Bayeu's death and, in 1789, *pintor de cámera*.

Goya certainly did not flatter his subjects. It is still hard to understand how the royal family could accept so satirical a

the Basilica of El Pilar in Saragossa in 1771, as well as for the Aula Dei in the Carthusian monastery. Tiepolo's style is recognizable, though this is not so much the sunny Venetian character of the father Giambattista as that of the son Giovanni Domenico (1727–1804), whose often satirical and grotesque manner influenced Goya.

He married the sister of his teacher, Bayeu, and she was to bear him 20 children, of whom only one son survived. Again it was Bayeu who helped him on. He had connections with the German painter Mengs, who was the model for Spanish painting at this time. Mengs had come to Madrid from Rome and been appointed court painter to Charles III. Bayeu obtained an important commission for Goya, to make designs for the tapestry manufactory of Santa Bárbara, and overnight he became "painter to

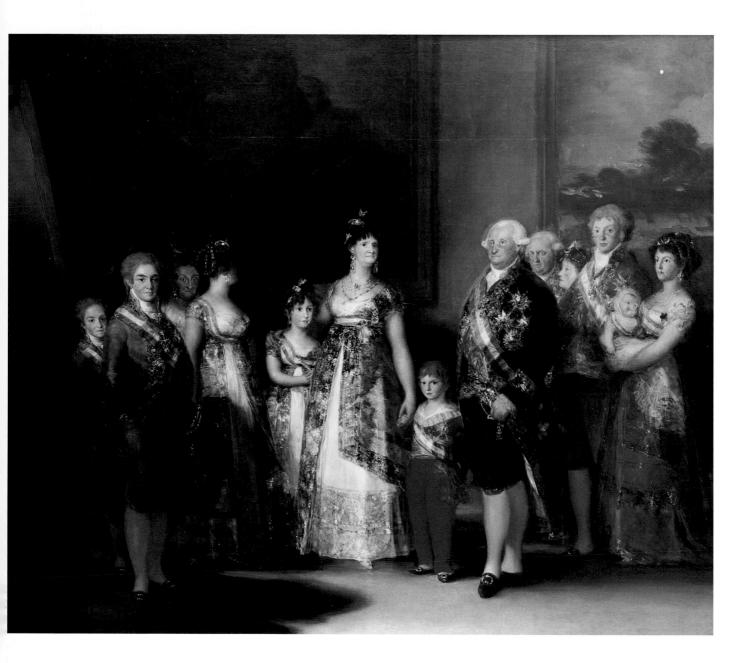

depiction as the large commissioned group portrait *Charles IV and the Royal Family* of 1800 (ill. p. 355). Even assuming that the royals were as decadent, indeed stupid, as they are always supposed to be from this portrait, it is still not clear why they were satisfied with this. The painter does nothing to flatter them, either in the composition, where the hierarchic arrangement usual in state portraits is ignored, or in his treatment of their physiognomies. The group looks disunited, seemingly separated by the figure of the child dressed in brilliant red and holding the Queen's hand. The suggestion is that the well-fed King, with his rosy face and fish-like eyes, gazing vacantly before him with an air of embarrassment, is not the father. And indeed, Goya has given the boy the features of the man who was thought to be his father, the notorious Don Manuel Godoy. Only

the younger members of the family give the painting some semblance of dignity, but behind the "faceless" daughter-in-law of the Queen on the left the viewer meets the owl-like gaze of the old Infanta, Maria Josega. Only one person is looking directly out of the picture over the King's shoulder, with wrinkled brow and a critical suspicion that is probably directed at the painter. One must remember that Goya was already familiar with Lavater's (1741–1801) *Physiological Fragments*, which had appeared in 1775/78; and he proudly also puts himself into the royal family portrait, in the background at an easel, so including a reference to the revered old master Velasquez.

One must still ask why the royal family liked the portrait. Perhaps they wanted to appear modern and enlightened in circles within a state where the Enlightenment never happened, because

it was suppressed at birth by the Inquisition. They will certainly have liked the unconventional placing of the figures. Large and small stand in a loose arrangement like groups of trees in one of the landscaped parks that had just become fashionable. The abandonment of the hierarchic Baroque composition was indeed new. The Spanish royal family knew of the casual poses that had become the practice throughout Europe, and they accepted their own inadequacies as long as they could delight in those of others. That was probably in keeping with the well-known disharmony within this family.

But Goya was not painting a caricature. This is a satire on human nature generally. His accusations are not limited to one particular social class nor to individual political events. He has left bitterly critical works that document the fanatical stupidity of enraged citizens and the brutality of simple peasants, the cruelty of an army of occupation, the arrogance of the Inquisition and the vanity of the nobility, all equally.

Only his portraits of children and those of his true friends radiate real tangible warmth, which makes them all the more moving. They include the portrait of his tutor *Bayeu* (1794) and *The Duchess of Alba* (1795, ill. p. 356). Goya had a close and lasting friendship with the Duchess, who was the last of an old noble line, and famous for her beauty, wit and intelligence. Educated in the liberal tradition, familiar with the writings of Rousseau and the Encyclopédistes, the Duchess was the center of an illustrious circle of aristocrats, writers and painters. Herself childless, she adopted a colored colonial girl, and when Goya was stricken with the mysterious illness that paralyzed him for a time, she arranged devotedly for his care. The full figure portrait can be interpreted as fervent thanks for her friendship. The painter has put his affection into the picture in a dedication written in the sand, to which the Duchess is pointing: "A la Duquesa de Alba. Fr. de Goya 1795." The band of friendship on her wrist also bears his initials. Goya wanted to show her to posterity with a mild but watchful gaze. Her candid expression is emphasized by the raised brows and the framing curly hair. The palette is reduced to a few colors, the landscape is bare and the simplicity of the handling may stand for the sincerity of their friendship. Goya kept the painting, intending never to part with it. He painted the Duchess again, two years later, dressed in black lace, and the motto to which she is pointing betrays the relationship, or was it only Goya's wishful dream? – "Solo Goya!"

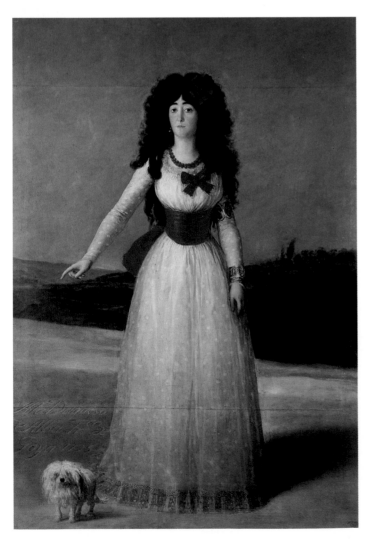

The change in the political situation after 1808, when Napoleon entered Spain on the pretext of saving the peninsula from revolution, also forced Goya to come to terms with the holders of power. The court painter to Charles III, Charles IV and Ferdinand VII had overlooked neither the social conditions, nor the intellectual suppression, nor the Inquisition in Spain. Familiar with the writings of contemporary philosophers and the Encyclopédistes, he had also once been one of Spain's patriotic free thinkers, hoping that the new spirit of liberalism under Napoleon would bring release from the tyranny of the old regime. But that dream – as everywhere in Europe – came to an abrupt end when French troops entered Spain. In 1808 Charles IV abdicated, Napoleon's brother-in-law Joachim Murat occupied Madrid and Joseph Bonaparte was crowned King of Spain.

Goya had to swear allegiance to the new King, but he was also witness of the cruel events of May 2 and 3, 1808, the executions of the *guerilleros*, a name that came into usage then. These lasted from early morning until into the night. Only after the French were driven out of Spain again by Wellington in 1814, and

Francisco de Goya y Lucientes
Maja Clothed, 1799
Oil on canvas, 95 x 190 cm
Prado, Madrid

Maja Unclothed, 1799
Oil on canvas, 97 x 190 cm
Prado, Madrid

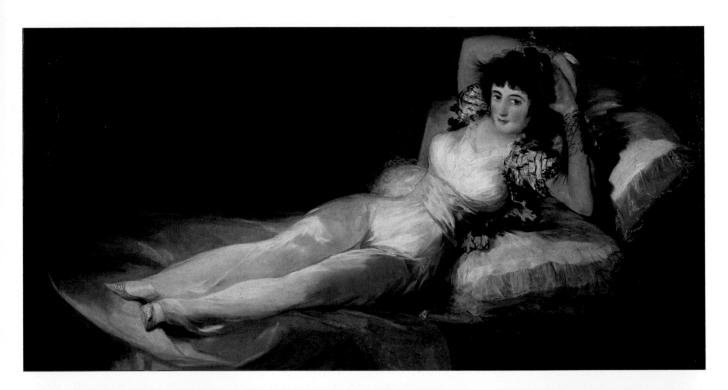

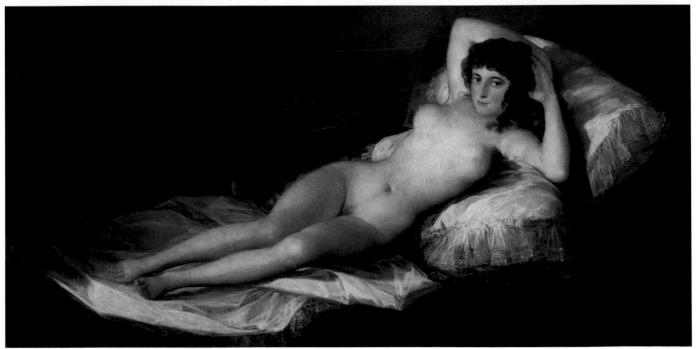

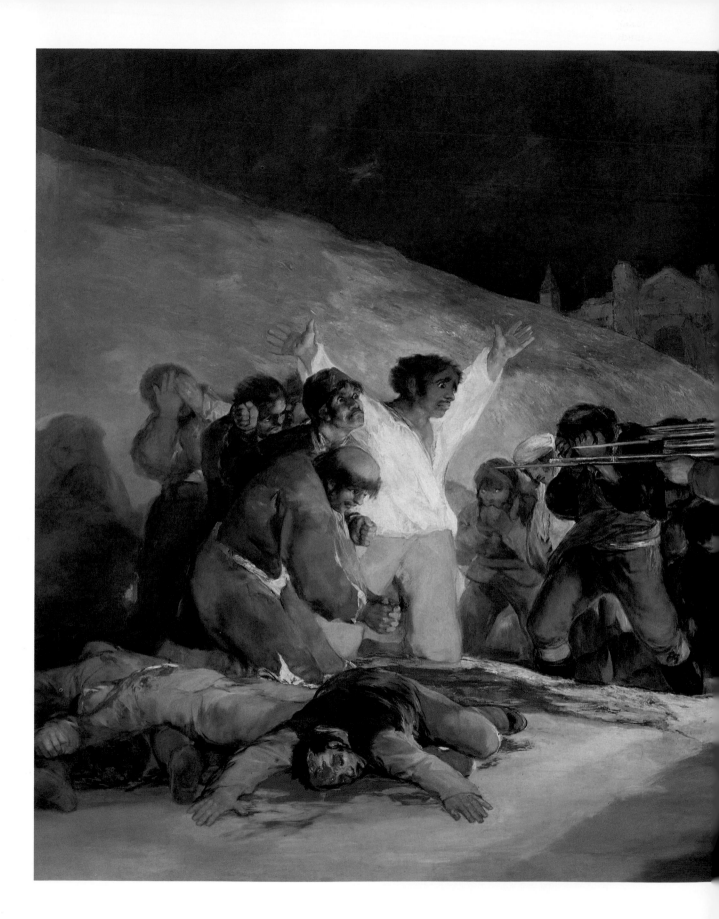

Francisco de Goya y Lucientes
The Third of May (Executions), 1814
Oil on canvas, 266 x 345 cm
Prado, Madrid

Ferdinand VII came back to Madrid, could Goya dare to paint *The Third of May (Executions)*, a painting that is accusatory and deeply moving (ills. pp. 358–59). He does not idealize the victims as heroes, he shows them as simple people, screaming in protest, while the firing squad is in shadow, an anonymous group, faceless, merciless, switched off and functioning like machines. The facial expression on the victims is not a cry for revenge from rebels facing death, but is incredulous horror. Their eyes are wide open, weeping tears of impotent rage. The message of the painting is made more dramatic because it concentrates on the brief instant before the shots are fired. The viewer experiences the eternity of that second, an eternity between the finger on the trigger and death. The victim's shirt still stands out white, in the same second it will be colored red. The body will fall into the blood of its fellows.

Goya was given his old post back, but the sword of Damocles of constant control hung over him. The King's comment: "You deserve to be banished or even garroted, but We forgive you, for you are a great artist," must have warned him to be careful. The Inquisition was reinstated and regained power. It also began to concern itself with old sinners. As late as 1815 Goya was interrogated about the paintings he had started in 1797, *Maja Clothed* and *Maja Unclothed* (both ill. p. 357). He was asked whether the paintings were by his hand and for whom they were painted, what the intention was, and on what occasion they had been painted. We do not know what he replied, but Goya was probably helped in that the owner was no less than Godoy himself. The reference to Velázquez' *Rokeby Venus* is evident, particularly because the painting of nudes had always been banned in Spain, and still was in Goya's day. Velázquez gave his nude a little Cupid, the necessary attribute to identify her as Venus, and he sufficiently disguised the model by painting her back view. So we see how great a step Goya took. His naked Maja is not in mythological guise, she is a picture of a living model. We see the significance of this when we learn that Velázquez' naked beauty was not entered in early inventories as "Venus" but as a "nude lady" (Andreas Prater). So the taboo had long been broken. Goya's nude was certainly not respectable, and she was certainly not the Duchess of Alba, as Baudelaire and others surmised. She was a country girl, a Maja, and probably, like Velázquez' model, a woman with whom the man who had commissioned the painting amused himself. Here we should recall that Goya painted "nude" and "clothed" versions of another subject in the same period (1797–1800) – *Truth, History and Time* (Museum of Fine Arts, Boston, and Nationalmuseum, Stockholm).

Opinions differ on which of the two Maja paintings was created first between 1797 and 1803. One (unconfirmed) assumption is that the clothed version was the earlier, around 1797/1800, and the nude version not painted until 1800/1803. But another viewpoint is based on the fact that, although the

Félix Trutat
Nude Girl on a Panther Skin, 1844
Oil on canvas, 110 x 178 cm
Louvre, Paris

composition and pose are identical in the two versions, the difference in the handling of the paint is very striking. Much more attention has been devoted to the material quality of the cushions, the sheet, the hair and the fine details of the face in the nude version, and this creates a more intimate portrait effect. In the clothed version, much of this is handled far more summarily. So it seems likely that the first commission was for the nude and the modest covering with clothes made later, making it possible to show the beauty. It was the practice at the time to hang one painting on top of another; the one on top could be shifted or removed to reveal the more "delectable" version beneath. Nevertheless, the clothed version exudes as much eroticism as the nude, although here it is the girl's eyes that draw the viewer. This is not the sparkle of a society beauty, but is a seductive, lascivious weariness, triumphantly aware of its victory over the eager viewer and his weakness. If one compares the two heads, both closely framed with curls, it looks as if Goya has skillfully presented an image of "afterwards" in the disordered hair and dulled expression of Maja clothed, to contrast with the open invitation of "before."

The effect of these paintings on later artists has been evident again and again. Manet's *Olympia* is only one example. The French painter Félix Trutat (1824–48), who is rarely mentioned and died far too young, at only 24, offers a very interesting comparison. He made his debut at the age of 20 with *Nude Girl on a Panther Skin* (ill. p. 360). In this painting one senses not only that the young painter had perceptions and sensibility in advance of his time, in that he anticipates an almost naturalistic approach that was only to be cultivated by Jean-Jacques Henner (1829–1905), Charles Chaplin (1835–91), and Eugène Carrière (1849–1908), but one recognizes also that the presentation of intimacy is comparable with that in Goya's *Maja* paintings. Trutat, too, lets there be no doubt that this is a painting of a real person, and

not a model transformed into a general aesthetic. He did lay a Tyrsos stave on Bacchus' panther skin, to create a mythological identity for the nude, and the head of the old man in the background – borrowed from the biblical iconography of Susanna with the elders – makes the girl seem even more youthful, as it is slightly enlarged.

But back to Goya: the illness he repeatedly had to combat started in 1792, when he suddenly collapsed blind, deaf and paralyzed. The *Self-Portrait on a Sick Bed*, which he painted 28 years later (ill. p. 361, left), is fervent expression of thanks to a true friend, Dr. Arrieta. One only need see the devotion and sympathy in the doctor's face, the mild but knowing eyes and Goya, sunk back in exhaustion, his tired eyes seeking his friend, to recognize that this is one of the most astonishing self-testimonies produced by any artist. This is not self-pity, but is realism with no trace of pathos. On the lower edge of the painting are the words: "Painted in 1820 by Goya for his friend Arrieta, in gratitude for his excellent care during a terrible and dangerous illness suffered at the end of 1819 in his 73rd year."

When Goya recovered, his deafness remained, and this changed his character in a way that is reflected in his work. It may also have caused a new depth of depression, so that he has been compared with Beethoven. The constant fear of a relapse made him impatient, and this is also evident in his technique. One can only look with amazement at his immense output between 1796 and 1800, after an illness that left him with earache for years. While he was forced to keep his bed, too weak to work at the easel, he produced his cycles of etchings. At the end of 1819 he withdrew into his country house, which was known as the "Quinta del Sordo" (House of the Deaf Man).

As his monstrous imaginings found expression, he darkened the walls in two rooms with terrible scenes of witches and visions of evil spirits. A fantastic horde of cynically grimacing hags and

Francisco de Goya y Lucientes
*Self-Portrait on a Sickbed with
Dr. Arrieta*, 1820
Oil on canvas, 170 x 79 cm
Minneapolis Institute of Art, Minneapolis

Francisco de Goya y Lucientes
Saturn Devouring One of His Children
Plaster mounted on canvas, 146 x 83 cm 1819–23
Prado, Madrid

ghosts fill these rooms, and one shudders to think of the deaf painter dining in candle light in such terrible company. These *Black Paintings* were later taken down from the walls and are now in the Prado. *Saturn Devouring One of his Children* (ill. p. 361, right) is perhaps the cruelest of them. The nightmare quality is combined with myth to make an epochal statement: this is the madness of truth. Whether this is a reflection of Goya's own mental state, or an allegory on the situation in a country that was consuming its own children in bloody wars and revolutions, or a statement on the human condition generally, may remain open. It could also be a reflection of the situation of the enlightened man who has lost his God and is able to experience only mercilessness on a cosmic scale.

After 1820 a dark time began for the painter, who was now 74. His health worsened, and politically too his situation deteri-

orated. He was exposed to constant danger from the Inquisition, and he bequeathed his house to his grandson, probably to save it from being confiscated. He secretly prepared to leave Spain. He applied for permission to travel and was allowed to go abroad for a health cure. This enabled him to escape to Paris, but he was spied upon there. He finally settled in Bordeaux. Only two years before his death, when he was 80, was he freed of controls and investigations at the command of the Spanish King. He died in Bordeaux in April 1828, and only in 1919 were his mortal remains transferred to the church of San Antonio de la Florida, which he had decorated.

Goya's work is not only a bequest of his own time, but also marks a *caesura* in the history of painting in Europe. Until then, the artist was neither required nor desired to pass moral judgement upon his own time. Morally, paintings were in any case bound to religion, or they followed the general principles of a firmly established philosophy. Where suffering was depicted, it was always related to martyrdom in the religious sense. Pain in this world was rewarded by the promise of joy in everlasting life. Goya's martyrs, on the other hand, are exposed to a meaningless malice, the mercy of God not being his theme. His paintings are observations without judgment. And he never set the individual in the limelight, but always the individual's role, the situation, the tragic cumulation.

The moral in his paintings is like the logic of the bull fight, which he painted and etched again and again: the inescapable death of the creature as the bloody climax of a murderous battle, in which the question of meaning or divine reward does not arise.

Destiny is the title of one of his frescoes of 1819–23. With the anti-clerical attitude that is evident in many of his works, there can be no question of God in the old sense. In this Goya has freed himself of the "Old Masters," and is part of the Modern Movement, his work speaking the language of today. His still-lifes, cadavers tossed down in a deliberate anti-aesthetic (ill. p. 363, bottom) are to be found in today's art as well, as is the absurd taken to the limits of the imaginable. Faces like those in his *Pilgrimage* (ill. pp. 362–63) could be inventions of the 20th century. In these visionary grimaces Goya has turned against the requirement to present people as beautiful. They also point to an art of the future, the art of our time. A comparison of Goya's work with modern art shows that we are still in the midst of the same epoch, the Enlightenment is still in progress, and the question of whether the artist is remote from reality or crazy may still be asked. The monsters produced by the sleep of reason in his *Caprichos* etching (ill. p. 365, left) also people our paintings today, and they take us on a narrow path between enlightened understanding and a sense of the inexplicable.

It was not Spain but France that took up Goya's heritage, and here his approach to painting and his philosophy were eagerly followed. Eugène Delacroix created a series of *Caricatures in the Manner of Goya* from 1824, and the later realists, from Gustave Courbet and Honoré Daumier through to Edouard Manet and Odilon Redon, were all influenced by the great Spaniard. They all took up the heritage of his use of black with its powerful effects, Manet in particular with the contrasts of his black shadows, while Odilon Redon paid *Hommage á Goya*. A contemporary of Goethe, the same age as David, Goya was not only the forerunner of later realism and Impressionism, indeed of Surrealism and Expressionism, he was also the model for the explosive formal power in his fellow Spaniard, Picasso.

France
Jacques-Louis David (1748–1825)

Jacques-Louis David was born in Paris in the same year that Goya was born in Spain. David was the undisputed master of Neoclassicism in any country, but his influence was neither immediate nor unconditional. Forms in the antique manner and classical citations had long invaded the Baroque and Rococo rooms when the Louis Seize style straightened all furniture and wall divisions with its fluting. French painting in the second half of

Francisco de Goya y Lucientes
The Disasters of War (Los desastres de la guerra), No. 1, c. 1810
"Mournful Foreboding of What is to Come"
Etching, 17.5 x 22 cm

While he was still busy on commissions from the royal palace, Goya went out into the streets, recording in his drawings the collapse of the political structure that was supporting him, too. He was more than a mere reporter of the terrible events. In violent, nightmare depictions his cycles of etchings "Los desastres de la Guerra" and "Caprichos" show the brutality man is capable of imagining. Goya knew that a banal, realistic account of the crimes would be inadequate to convey the pain and tragedy – this would only be possible by alienating the events into the unreal and fantastic. Broken by the sight of the tragic events, he shows himself, his head sunk on the table as if in unbelieving despair, wrestling with the questions of "dream" and "reason" – and with the monsters both could give rise to.

Francisco de Goya y Lucientes
The Disasters of War (Los desastres de la guerra), No. 64, c. 1812/15
Loading Carts for the Cemetery
Etching, 17.5 x 22 cm

364

BELOW:
Francisco de Goya y Lucientes
Los Caprichos, No. 43, 1797/98
"The Sleep of Reason Produces
Monsters," first state
Etching, 21.6 x 15.2 cm

TOP RIGHT:
Los Caprichos, No. 56, 1799
"Rise and Fall"
Etching, c. 21 x 15 cm

BOTTOM RIGHT:
Los Caprichos, No. 50, 1799
"The Chinchillas"
Etching, c. 21 x 15 cm

LEFT:
Jean-Baptiste Greuze
The Broken Jug, 1785
Oil on canvas, 110 x 85 cm
Louvre, Paris

BELOW:
Hubert Robert
Design for the Grande Galerie in the Louvre, 1796
Oil on canvas, 112 x 143 cm
Louvre, Paris

Robespierre, he inveighed against the "undisciplined smearers" of Rococo boudoir art and was commissioned to direct the official state festivals. When the political situation changed, all this cost him nearly six months imprisonment in the Palais du Luxembourg, where he painted views from the window and had to bow and scrape in opportunist declarations before he was able to rise to become court painter under Napoleon.

One may, perhaps, understand the deep passions of this painter, his ardent search for justice, nobility, not to say a dominant authority, when one learns that his father was killed in a duel in 1757, when the boy was only nine. He was given instruction in art by relatives, among them Jacques Desmaison, an architect and member of the Academy, and no less an artist than François Boucher recommended him to the tutor Joseph-Marie Vien and the Académie Royale. But David had to wait long for success, and there were times when he contemplated suicide. After finally achieving the Grand Prix, he left for Italy in 1775 with Vien. Rome was then full of enthusiasm for Antiquity, which was just being rediscovered. Pompeii and Herculaneum had recently been reawakened from the slumber of centuries, and the Marquis de Marigny, Comte Anne Claude Philippe de Caylus, and the German archaeologist Johann Joachim Winckelmann were presenting a really tangible antique world in these newly excavated original sites. The wealthy of the world were collecting wagons full of found objects, and Pius VI set up a special museum for antique remains in the Vatican. Antique forms, the spirit of Rome – or what it was thought to be – and the rediscovery of Roman virtues were creating a new and fashionable pictorial world.

the 18th century in particular displays the overlapping or intermingling of pre-Romantic and Neoclassical pictorial ideas, and nowhere is this clearer than in the work of the "painter of ruins," Hubert Robert (1733–1808). Robert obtained his ideas from Italy, where he admired the paintings of ruins by Giovanni Paolo Pannini and witnessed the first excavations in Pompeii. Praised by Diderot, he was immediately consulted when antique pieces were to be placed in the park of Versailles. But his great work was the realization of the Louvre Museum. A comparison of two of his paintings (ills. pp. 366, bottom right, and 367), the first showing a ruined barrel-vaulted hall, and the second the Grande Galerie in the Louvre, immediately reveals the source of the idea for the top lighting and the "antique effect" that the newly designed gallery is open to the sky. The sublimity of antique ruins was to be transferred to the real building, and this in turn was to be a treasure chest of art and a worthy successor to its antique models.

But between Robert and David, 15 years younger, ideas changed, and this resulted in a corresponding change in style. It was no longer the Antiquity that had collapsed in ruins, but a modern version of the Roman Republic that was the focus. And the carefree life of the late Rococo period, which Robert was still able to enjoy, was not granted to David. Like Goya, he too was to be drawn into the dangerous maelstrom of political life. He threw himself into the 1789 Revolution with ardor, and in 1792 was one of the extremists in the Convention. A year later he voted for the execution of the King. He was chairman of the Jacobin club. A close confidant of

Hubert Robert
An Imaginary View of the Grande Galerie in the Louvre as a Ruin, 1796
Oil on canvas, 114 x 146 cm
Louvre, Paris

David, too, abandoned the old style he had so vehemently defended until then: the manner of Jean-Baptiste Greuze (1725–1805), which was in the classical manner but still soft and gentle. A brief glance at a well-known work by Greuze, who was 23 years older than David, *The Broken Jug*, will illustrate the difference. It shows a young girl at a well (ill. p. 366, top left), and one sees immediately that Greuze was concerned to convey child eroticism in the Rococo manner, the badly proportioned lion in the antique style being only a fashionable attribute. David, by contrast, sought to come closer to Antiquity by making accurate copies of reliefs, architectural fragments and statues, which he practised untiringly. In his large-scale work of 1780, *St. Rochus Asking the Virgin Mary to Heal Victims of the Plague*, for the hospital in Marseilles (ill. p. 368), David displays the entirely new style, in which clear color is a postulate together with clarity of form and the clear delineation of the bodies. Although the painting was

greatly admired, Denis Diderot, who saw it in the Salon in 1781, was critical. He thought the victims of the plague were "terrifying images," repulsive yet difficult to ignore. That is the point where David and French painting stood around 1780, or, rather the line that separated two stylistic epochs, the Baroque and Neoclassicism.

David had tried to combine a depiction of a miracle, a visionary Baroque subject constructed according to traditional rules, with the new manner of representation, which was no longer appropriate for the traditional approach. His clear Neoclassical coloring, the evidently measurable proportions of the bodies, and the overall metrical construction all reveal the painful inability to combine on one level the earthly and the heavenly, the real story of the plague

Jacques-Louis David
*St. Rochus Asking the Virgin Mary to
Heal Victims of the Plague*, 1780
Oil on wood, 260 x 195 cm
Musée des Beaux-Arts, Marseilles

and its victims, with the historically intangible figures of salvation. Not without reason had Baroque painting in the course of two centuries evolved a system of veils of mist, cloud formations and visionary color effects to link past and present and combine both in turn with eternity in a cosmic, heavenly sense. David's *St. Rochus* sets the three time levels of past, present, and eternity in one and the same light, with one and the same color scheme. The reality, and so the realism, of his materially clear painting thus contradicts the unreal aspect of the belief in miracles. The painting is beautiful, but the realistic depiction of the suffering figures is much more moving for the viewer than is the Madonna, who is concerned with the child and not the pleading figure. The real and present suffering looks credible, but the religious aspect is no longer convincing. Paintings like these documented the end of religious painting for a long time.

Diderot's criticism went straight to this disproportion. Basically it was a demand for the classical element to be developed further and the religious abandoned, and this pushed religious painting into the sphere of history painting in the 19th century that followed. David was very quick to draw the necessary conclusion, and his next work, *Belisarius Begging for Alms* (ill. p. 369), transposes the emotions of Christian charity derived from faith onto "Sym-Pathos," pity as an element in an ethics based on the idea of a just fate. This example from history was intended to offer a new moral derived from experience, as *ersatz* (substitute) for religious requirements. David sought to make the contents appear true by a faithful depiction of the costumes and other items, which are painted in scrupulous verisimilitude. Belisarius, once so powerful, is dismissed by Justinian and descends into poverty. Blind, he arouses pity, the *misericordia*, or sense of mercy, of Antiquity. In retrospect we can see that the theatrical history paintings of the Neoclassicists, with their stage-like compositions, were no more exact or faithful to the original in their depictions of Antiquity than Nicolas Poussin or Claude Lorain before them. But at the time the ability to breathe new life into a past age by the seemingly historically exact reproduction of details aroused ardent enthusiasm. How far from reality this scene of Belisarius begging really is can be seen if only in that the old general is still wearing his costly armor and helmet while begging for pennies.

However, David owed his rise to fame – after many reversals – to a painting for the execution of which he took his family specially to Rome, in order to absorb himself totally in the world of antique forms. It was *The Oath of the Horatii* (ill. pp. 370–71). "Not only artists, art-lovers and connoisseurs but the general public are trooping in from morning to evening to see it – no papal election has ever aroused such commotion," said the correspondent of the *Teutscher Merkur* from Rome, deeply impressed by the "antique simplicity" of David's work. A short time later the *Journal de Paris* said: "On seeing the painting, one is seized with an emotion that elevates the soul, for, as J.J. Rousseau would put it, this work has a quality that lifts the heart and fills one with ardor."

The story is from the 7th century B.C., and it tells of the triplet sons of Publius Horatius, who decided the struggle between Rome and Albalonga. One survived, but he killed his own sister because she wept for one of the fallen foes, to whom she was betrothed. Condemned to death for the murder of a sibling, Horatius' son is pardoned by the will of the people. Patriotism and the power of the people are the true subjects, and they were also the theme of the play *Horatius* by Pierre Corneille that had just been performed again in 1782. David had seen the play and was fired with enthusiasm by it. Although his painting was certainly not intended to give support to the idea of conspiracy against the authority of the state, the work was interpreted along those lines in the

Jacques-Louis David
Belisarius Begging for Alms, 1781
Oil on canvas, 288 x 312 cm
Musée des Beaux-Arts, Lille

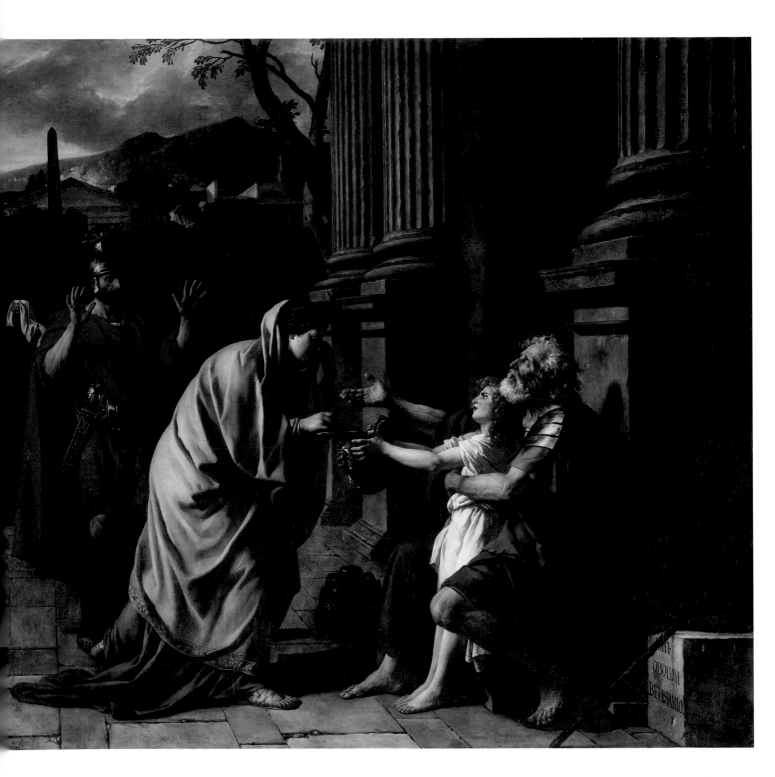

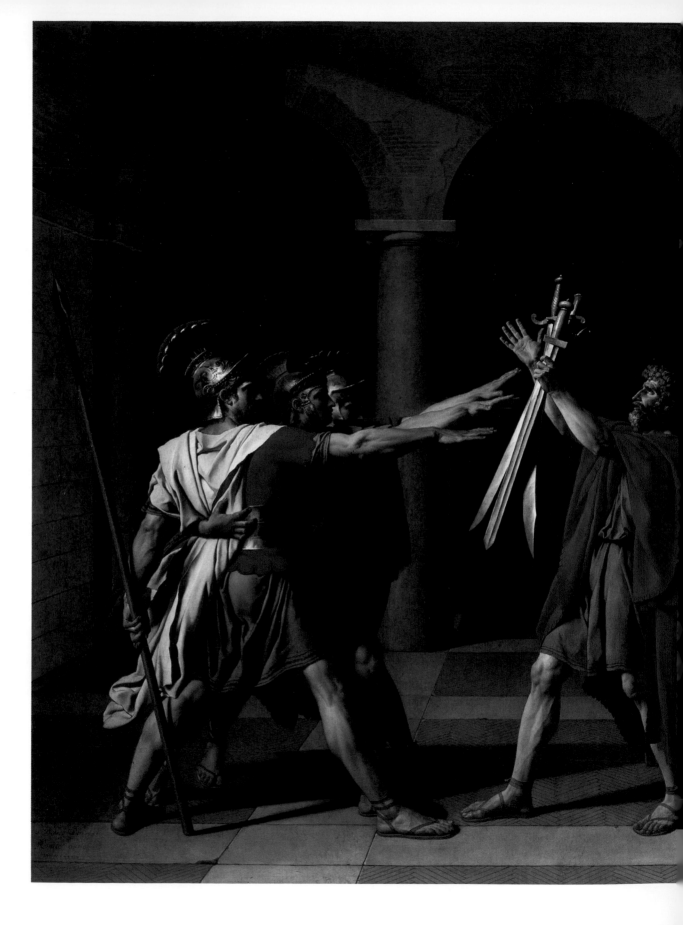

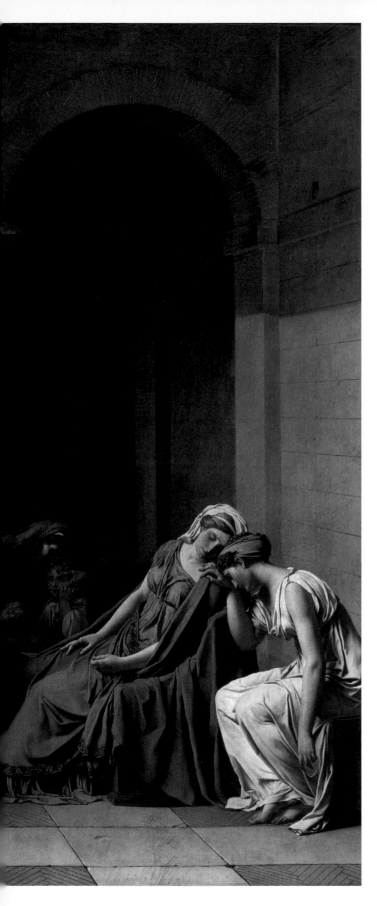

Jacques-Louis David
The Oath of the Horatii, 1784
Oil on canvas, 330 x 425 cm
Louvre, Paris

overheated atmosphere of the years leading up to the revolution. It proved to be a triumph for David. The public was overwhelmed by his break with the Baroque stylistic tradition. For the first time, the unity of time and action had been brought into a deliberately severe composition. The story of the passionate readiness of these heroes for self-sacrifice was known, and it was also recognized that the weeping women in the composition are an expression of foreboding, symbols of the tragedy to come. In the arcades that form a dark background David has used impenetrable depth to strengthen the drama of the action. Composition and statement form a unified whole. In the center is the order to bear arms, personified by the figure of the father. The swords glitter in the center of the picture, and the outstretched arms raised in oath point to the weapons, indicating the coming deed. The finely judged angles of the arms form a melodious tripartite harmony, while the variously shaped swords express another aspect: this is not ordered preparation, it is spontaneous action by ardent individuals. A few years later the revolution was to unite many different voices and weapons. Soon the stiff, statuesque attitude of the figures and the theatrical presentation came under criticism, but it was precisely these qualities that filled the public with enthusiasm. And if the scene seems exaggeratedly declamatory to us today, we should remember that only recently a similarly theatrical cult of oaths to the flag with outstretched arms enthralled a whole people. One of the preliminary sketches shows the moment the father defends his last surviving son after he has murdered his sister. This is the paradox: killing may be legitimized by a higher ideal. That was the belief that inspired the Revolution!

Another painting by David also deals with the subject of death in service of the state, *Return of the Sons of Butus* (ill. p. 372). The date, 1789, was not, of course, coincidental, and the subject was acutely relevant. It should be borne in mind that this was not the Brutus who murdered Caesar, although in the year of revolution his name would be highly significant, too, symbolizing liberation from tyranny. This is Lucius Junius Brutus, who proclaimed the Republic of Rome around 510 B.C. A political fanatic, he had his own sons executed because they had taken part in a conspiracy against the Republic. This was another inflammatory subject, speaking out for self-sacrifice, the sacrifice of one's own flesh and blood for a higher ideal, and the political propaganda had its effect.

David skillfully illuminated the grief and allegorized the suffering, fear and pain of his figures. He shows the mother, accusing and suffering, her daughter beside her, hands raised defensively, and finally the younger daughter sunk down in pain at her impotence. Another figure on the right edge of the painting personifies grief. In the shadows sits the "hero" with the dark mien of a thinker. His features are stoic and harsh, his left hand is holding the written accusation in a claw-like grip, and he is seated

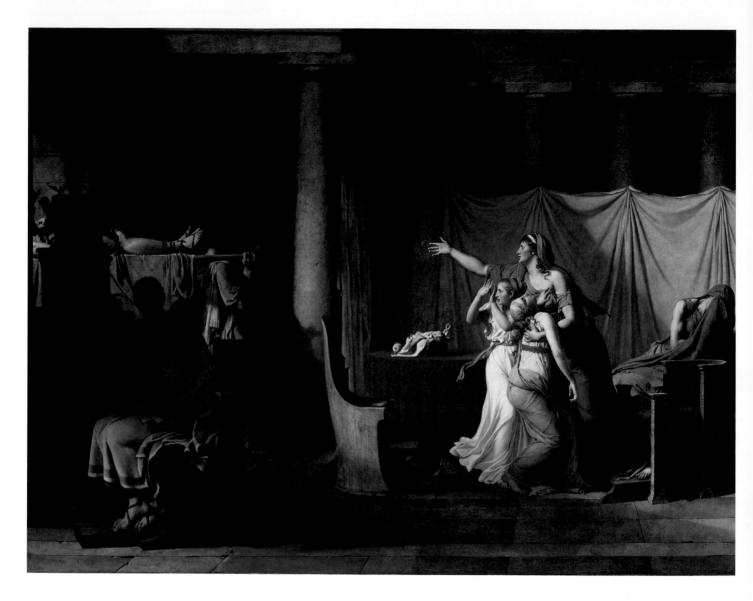

in the shadow of the Roma, the symbol of the state to which the sacrifice is ultimately being made. Behind him, the son whose life has fallen victim to the requirements of the state is being borne in. A column strictly divides the theatrical arrangement into the representation of the dark force of destiny and the obvious emotional effect of the event.

Ten years later Pierre-Narcisse Guérin (1774-1833) gave a theatrical depiction of a similarly tragic historical subject, although this one was invented. In *The Return of Marcus Sextus* (1799, ill. p. 373) Sextus, returned from exile, is also seated in a stoical pose beside the deathbed of his wife. His fixed gaze reflects his inner questioning of the meaning of life. The scene is of heathen times, but it makes concealed use of the old Christian iconography. The cruciform in which the grieving man and the dead woman are so strikingly composed underlays the painting with an additional metaphorical significance, and the position of the daughter, who is clinging to her father's knee in pain, recalls the old Mary Magdalen motif in Christian art.

On June 20, 1789 more than 500 deputies of the third estate took the oath of allegiance in the tennis court in Paris. It was apparent that only the revolutionary painter David could be commissioned to depict this event. But to represent 500 people – could such a compositional problem be solved at all? How were rank, equality, and fraternity to be represented? Who should be in the background, who in the foreground? And how could the event be idealized in view of the confusion the scene actually presented? Suddenly painting was faced with a new challenge, and in the century that followed countless attempts were made to solve it. The challenge was history painting with a large number of figures. It was one thing to idealize the past and make it a model, as in *The Oath of the Horatii*, but it was quite another to idealize the profane present. David did not succeed in solving the problem. Hundreds of sketches for *The Oath in the Tennis Court* slumber in the storeroom at Versailles. The oil painting, six meters wide, has remained a torso (ill. p. 373, top), an accumulation of Herculean male nudes in pen and ink and oil paint.

David planned to produce a painting
more than six meters long
sublimating the historic oath taken in
the tennis court in 1789 and
preserving it for posterity. He failed:
the scrupulously detailed
representations of the individual
figures would not resolve into a
unified composition. The time in
which David was working was not
ripe for the transmutation of a very
profane present into a convincing
history painting, and the work
remained unfinished.

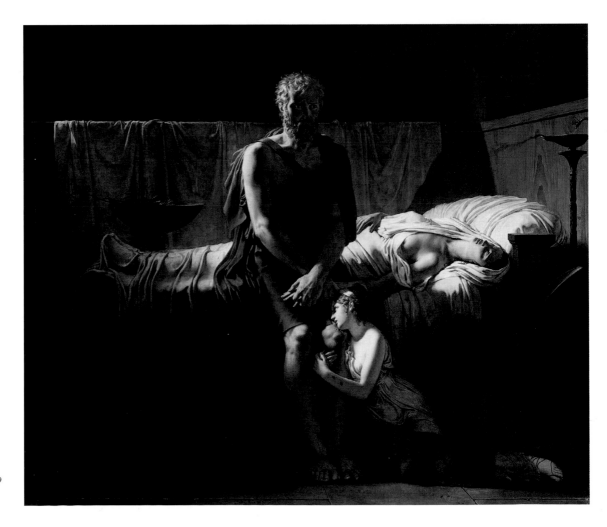

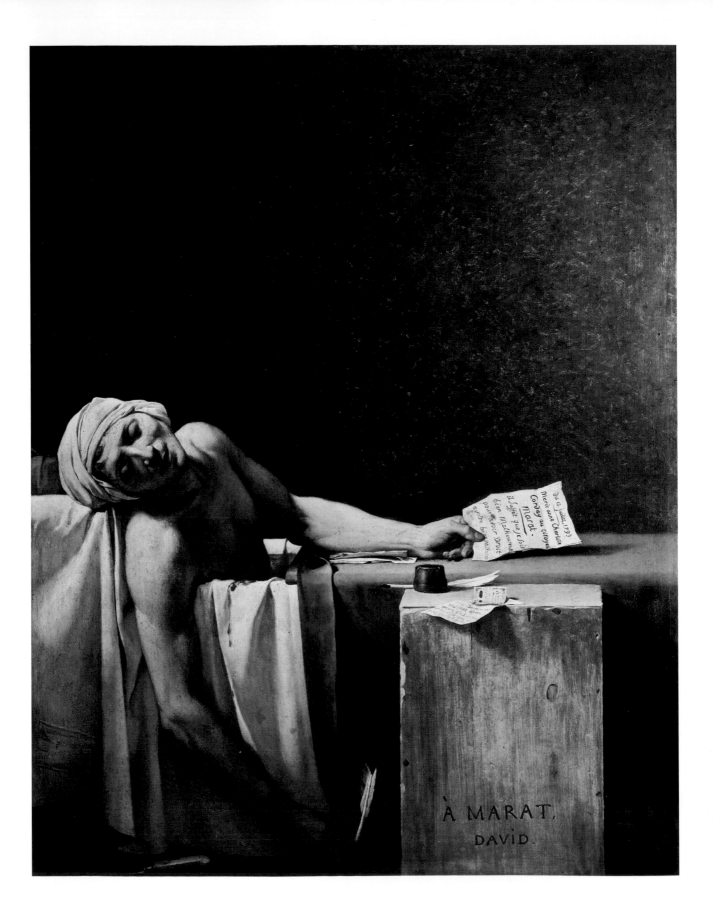

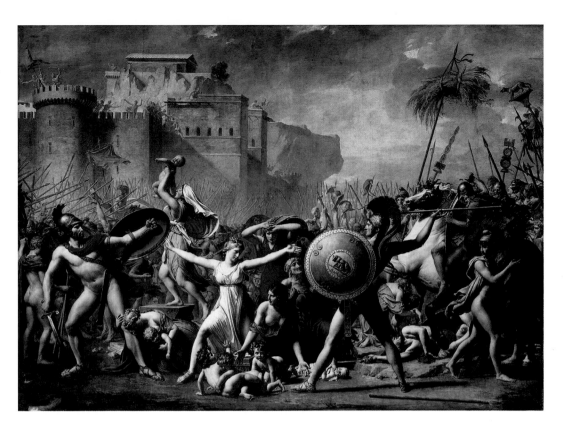

The Death of Marat, on the other hand, (ill. p. 374) can be regarded as David's finest work, in which he has perfectly succeeded in immortalizing a contemporary political event as an image of social ideals. Nor did the painting fail to have its effect. Jean-Paul Marat saw himself as a friend of the people, he was a doctor of medicine and a physicist, and above all he was editor of the news-sheet *Ami du peuple*. He suffered from a skin disease and had to perform his business for the revolution lying in a soothing bath. This is where David shows him, in the moment after the pernicious murder by Charlotte Corday, a supporter of the aristocracy. David had seen his fellow party member and friend the day before. "The position in which I found him surprised me … his hand was writing his last thoughts for the welfare of the people while he lay in his bath." Under the impact of their personal friendship David created his painting "as if in a trance," as one of his pupils later reported.

David takes the viewer into Marat's private room, making him the witness of the moments immediately after the murder. Marat's head and arm have sunk down, but the dead hand still holds pen and paper. This snapshot of exactly the minute between the last breath and death in the bathroom had an immense impact at the time, and it still has the same effect today. By contrast, contemporary news-sheets produced drawings of the act of murder, some of which are highly inventive. Again David has used a dark, immeasurable background to intensify the significance. The boldness of the high half of the room above the figure concentrates attention on the lowered head, and makes us all the more aware of the vacuum that has been created. The distribution of light here has been reversed from the usual

practice, with dark above light. This is not only one of the most moving paintings of the time, but David has also created a secularized image of martyrdom. The painting has often, and rightly, been compared with Michelangelo's *Pietá* in Rome; in both the most striking element is the arm hanging down lifeless. Thus David has unobtrusively taken over the central image of martyrdom in Christianity to his image of Marat. Revolutionary and anti-religious as the painting of this period claimed to be, it is evident here that it very often had recourse to the iconography and pictorial vocabulary of the religious art of the past.

The Revolution, which consumed so many of its own children, spared its painters. David, the political activist, was imprisoned in 1794, but he was able to preserve the museums from iconoclastic attack, achieved the suspension of the Académie, organized national festivities and, as a sideline, made drawings of the events of these violent times, like Marie-Antoinette being taken to the guillotine. He survived the political change, filled time painting portraits, and while still in prison devised *The Sabine Women* (ill. p. 375). Again, handling so many figures proved a problem that would only be solved by painters with a later stylistic approach. So great an accumulation of detail painted with scrupulous accuracy was bound to be at the expense of liveliness. The main figures stand as if they were modeling for a sculptor, and the whole scene looks rigid. But most of the antique models available were marble sculptures, and this sculptural rendering was regarded as appropriate for a subject from Antiquity.

David was celebrated as the leading painter in Europe. He was surrounded by famous pupils, such as Antoine-Jean Gros, Anne-Louis Girodet, Jean Claude Naigeon, and François Gérard, and he

became tutor to a large number of portrait painters and history painters, who documented and sublimated the Napoleonic era. It has been said that more than 400 painters studied under David, who became the leading court painter. Full of enthusiasm for the new ruler of France, he painted *Bonaparte, Calm on a Fiery Steed, Crossing the Alps* (ill. p. 376). The title shows what could be expected of the general: he would be capable of ruling supremely well over an unruly Europe. Appointed *Premier Peintre de l'Empéreur* in 1804, David was allowed to immortalize on a huge canvas the coronation, which was organized down to the last detail by Charles Percier and Pierre François Fontaine (ills. pp. 376, left, and 377, above). The canvas is nearly ten meters in length, and David had to arrange more than 80 people according to rank as well as portraying their characters accurately. But the result is more convincing than his other large paintings with a multitude of figures. His style was highly appropriate to convey the calm required by the crucial moment of the ceremony, and there can be no doubt that his pupils had their hands full as well.

There are two cases where a comparison will give a good idea of how differently the same subject was handled by the tutor David and one of his pupils. The pupil was François Gérard (1770–1837). Gérard was also commissioned to paint a coronation, that of Charles X in 1827 (ill. p. 377, below). The heavy draperies of the *baldachin* (brocade canopy), the costumes and the sweeping gestures look back to the Baroque, as might be expected at the Restauration. It is significant that the center of the painting is not occupied by the act of coronation but by the bishop, who is standing with his back to the king, his eyes raised in suppliance to heaven. The wish expressed here is that the old order that is being restored may prove permanent. As we know, history did not grant the wish. The second example is the portrait of *Madame Récamier* (ill. p. 378, below) which David started in 1800, and which, incidentally, helped a contemporary item of furniture to become known under her name. However, David's painting was never finished. When the master learned that the lady had also commissioned Gérard to paint her, he is said to have refused any further service. Was this only anger at

François Gérard
Madame Récamier, 1802
Oil on canvas, 255 x 145 cm
Château de Versailles et de Trianon,
Versailles

her choice of his pupil, or did his painting not meet with his client's approval?

Noble simplicity, expressed by the simple dress and the Spartan decoration, is also eloquent in the open face. This might well appeal more to the modern viewer than Gérard's version (ill. p. 378, above), which was judged to be more representative and flattering at the time. And comparisons with portraits of Madame Récamier by other artists suggest that Gérard had achieved a better likeness than David. The Spartan severity of David's composition, the Neoclassical sparseness of the arrangement, the cool handling of the room, the distanced pose, with the lady turning her shoulder to the viewer, were all elements with which Neoclassicism had operated for long enough. Gérard, by contrast, sets the lady in a noble park loggia, where she seems to be inviting to conversation. Her low-cut bodice is seductive, the red curtain flatters the subject and gives the flesh a rosy tint. Where David gave the beautiful woman a rather severe touch around the mouth, Gérard embellishes her features with the hint of a gentle smile, making her look younger. By contrast, David's portrait in the antique manner looks rather forced. Perhaps these were the reasons why his painting was never finished. Madame Récamier gave Gérard's portrait of

Jacques-Louis David
Madame Récamier, 1800
Oil on canvas, 173 x 243 cm
Louvre, Paris

Franz Krüger
Prince Augustus of Prussia, c. 1817
Oil on canvas, 63 x 47 cm
Nationalgalerie, Staatliche Museen zu
Berlin – Preussischer Kulturbesitz, Berlin

her to her admirer Prince Augustus of Prussia (1779–1843), a nephew of Frederick II, who had met the French beauty at the salon of Madame de Staël. For state reasons a marriage was impossible, but in the painting Madame Récamier was ever present in the palace which Schinkel furnished for him in 1817, as we see from a portrait painted of the prince (ill. p. 379) by the Berlin artist Franz Krüger (1797–1857). In his painting-within-a-painting, Krüger has left us evidence of the difference in painting styles between Paris and Berlin. After his death the portrait was returned to Madame Récamier.

When Napoleon's empire collapsed, David received no more public commissions, and he devoted himself more to portrait painting. When the Bourbons were returned to power, he could have been rehabilitated, like all the revolutionaries, by bending the knee, but the old revolutionary preferred to go into exile in Brussels, where he died in 1825, widely celebrated. Of his countless pupils at least Girodet and Jean-Baptiste Regnault should be mentioned, and particularly Antoine-Jean Gros (1771–1835), whom David named his successor when he went into exile. Gros continued his tutor's cool Neoclassical style while Regnault, and above all Gérard, often introduced an appealing, narrative undertone, which was criticized by purists as shallow.

Antoine-Jean Gros (1771–1835)

In Gros we encounter a truly unique situation. It was clear from his frequent statements that he was a forerunner of the later Romantic school, but he forced himself to sustain David's heritage and counter the Romantics, although he had himself inspired them. One only need see works depicting a large number of figures by three painters together, such as David's *The Sabine Women* (ill. p. 375), Gros' *The Battle of Abukir* (ill. p. 380), and Delacroix's *The Massacre of Chios* (ill. p. 381), to recognize that Gros led to the French Romantic movement. He was also filled with enthusiasm for the events of the Napoleonic era, for he was just 18 when the revolution broke out. This and Bonaparte's rise to imperial power were to be the formative influences on his work. In 1797, when Napoleon was still a general, he gave the young Gros his first commission. It was *Bonaparte on the Bridge at Arcole* (ill. p. 388, below). In the dynamic handling of the subject, all trace of David's Neoclassicism has gone. Seeing himself depicted as full of stormy energy, but determined and controlled as well, Napoleon must have felt flattered. In the same year Gros was appointed a member of a commission to concern itself with Italy's art works. He did not return to Paris until 1800, when he devoted himself to large-scale works depicting events from the Napoleonic wars, such as *The Victims of the Plague in Jaffa* (1804) and *Napoleon on the Battlefield at Preussisch-Eylau* (1808). But the artist who could sublimate battles could also make himself ridiculous with pictures such as *Cupid Stung by a*

Bee Complaining to Venus in the Salon in 1833. He lapsed into depression, convinced that he belonged in the past. "Actually I am already dead," he said, and at the age of 65 he committed suicide by throwing himself into the Seine. Gros was destroyed by his own inner contradictions. He did not want to stand by the Romantic movement, in which he had played so pioneering a role, and the Neoclassical movement, which he persisted in trying to revive, had long been overtaken by others, such as Jean-Auguste-Dominique Ingres. The conflicts that tortured Gros also reflect a symptom of these decades. The Neoclassical and Romantic styles had become established as two co-existing forces. This was bound to lead to polarization, and Gros was caught between them. The co-existence of such different views of painting was to be characteristic of the coming century and

ABOVE:
Antoine-Jean Gros
The Battle of Abukir, 1806
Oil on canvas, 578 x 968 cm
Musée national du Château, Versailles

OPPOSITE:
Eugène Delacroix
The Massacre of Chios, 1824
Oil on canvas, 417 x 354 cm
Louvre, Paris

LEFT:
Antoine-Jean Gros
Bonaparte on the Bridge at Arcole
Oil on canvas, 73 x 59 cm
Louvre, Paris

culminate in the stylistic pluralism of the end of the 19th and the early 20th centuries – with eclecticism, Neoclassicisms, and Impressionism. The imperial-classical style with its incisive contours was not by chance the vocabulary in which the first revolutionary generation found expression, and they were followed by the dictatorships of the 20th century with their state-controlled art.

Francois-Pascal Simon Gérard (1770–1837)

Gérard, the young master of the delicate line, was often criticized for being too shallow and appealing, and this, too, was a signal that the attitude to Neoclassicism was changing. The second generation of the style cultivated an aestheticism of beautiful physiques that seemed to be trying to discover the limits of what was feasible. Ingres was to reach the goal. The new intention was already evident in Gérard's *Cupid and Psyche* (ill. p. 382), which was shown in the Salon of 1798 and came under attack. The intention was to take physical beauty, line, composition, color and delicacy of the handling of flesh to perfection. The subject was to appear untouchable. Antonio Canova was pursuing the same aim in the melting loveliness of his marble bodies. This is the erotic sensuality of suggested contact between bodies as smooth as wax, as the artist aimed to immortalize beauty unblemished but transient. It was also a renunciation of any suggestion of aggression or attack. This style in painting probably also required a particular character in the artist, and one is not surprised to learn that Gérard, when he was appointed to the revolutionary tribunal, would always send a message to say he was ill to avoid having to attend the meetings. He only occasionally turned to history painting, as in *The Battle of Austerlitz*, preferring portraiture. Only when the Restauration promised a more peaceful existence did he enjoy a new period of success.

Jean-Baptiste Regnault (1754–1829)

The previously-mentioned Paris painter Jean-Baptiste Regnault was, like David, a pupil of Jean Bardin and Nicolas Bernard Lépicié. He was not a very prolific painter, and he never completely freed himself of the Baroque ideal of Guido Reni and the Carraccis. But his subjects are all taken from Antiquity. His first successful work, which won the Rome prize in 1776, was *The Education of Achilles*. It was followed by *Cupid and Hymen* (Louvre), *Cleopatra* (Düsseldorf), and *Vulcan and Proserpina* (St. Petersburg). His *The Genius of France between Liberty and Death* (ill. p. 383) is one of the works in which the influence of David is still evident, particularly in the rendering of the materials. But the recourse to Baroque models is undeniable in the composition of this allegorical scene. Rightly, Raphael's Mercury has been recognized as the origin of the figure of the Genius, but the image is much more strongly rooted in Baroque rhetoric, with its Christian repertoire of forms. The outstretched arms of the naked youth are like a resurrection, and the flame above his head may, perhaps, be a reference to the fiery mission of the Genius. It certainly derives from Christian iconography, where it is part of the imagery of the miracle at Whitsuntide. The flame of the Holy Spirit has always been a symbol of the divine message, and it is used here to represent the "enthusiasm" for the new philosophy. Not by chance is the figure of Death set lower in the composition, and not without reason is the skeleton resting its arm on its scythe. It is a sign that Death's mission is ended. That is the message of the painting: the Genius is announcing "It is done," France has overcome death after the Revolution and attained liberty. The allegory of Liberty is crowned with stars, triumphantly holding

elegiac representatives of the Rococo. His early work may have looked well in late Rococo salons, and this puts him in the circle around Jean-Baptiste Greuze, Margarethe Gérard, Michel-Martin Drolling, Jacques Réattu, and the portrait painter Elisabeth-Louise Vigée-Lebrun (1755–1842), who was only a few years older than he. She advanced to become court portrait painter to Marie-Antoinette, before moving into Neoclassicism when she became friendly with Joseph Vernet and David. But her self-portrait *Self-portrait in a Straw Hat* (1782, ill. p. 384, bottom right) clearly looks back to Rubens and Van Dyck.

But let us go back to Prud'hon. We encounter him only rarely as a Neoclassical painter of the linear style, and if so, the mood of the end of the Rococo period is very evident. This is clear in the full-figure portrait of *The Empress Josephine* (1805, ill. p. 384, left), in which the late 18th-century love of nature is still having its effect. The meditative gaze that the Empress is directing on to an antique urn touched the central nerve of the time. The lady is shown to have great feeling, indeed this is almost pensive melancholy. But Prud'hon achieved a sensational success with a totally different picture painted in 1808 for the Palais de Justice: *Justice and Divine Vengeance Pursuing Crime* (ill. p. 385). Stylistically

aloft the Jacobin hat. Its throne displays the snake symbol of eternity, and the figure holds the sounding and measuring instruments as signs of symmetry, while the lictors' fasces lies at her feet as the authority of the law. The globe should be interpreted as a reference to the comprehensive nature of the message. It is an appeal to all peoples – "Be embraced, Ye millions!" – to follow the example of France, even in face of death. The complex set of references is what makes the painting so majestic, and with it Regnault has put all his other works in the shade.

Pierre-Paul Prud'hon (1758–1823)

Pierre-Paul Prud'hon also started to paint in a style that was entirely rooted in the 18th century. His subjects were taken from Antiquity, but sfumato (tones shading into each other without sharp outlines) and grace, the gentle folds of cloth and the idealized little faces of his girlish fairies show him to be one of the last

the work occupies a middle position between the careful attention to detail of a Neoclassical painter like Gérard and the ensuing dramatic mobility of the Romantics, as in Delacroix. But Prud'hon's success was probably due mainly to the contents of the painting. This is understandable when one remembers what epoch-making changes the Enlightenment and the Revolution had wrought in ethics. Concepts like justice, atonement or punishment had until then been categories in Christian morality, but now, with religion robbed of its authority, the subject needed to be treated in a new way, free of religious references. People were turning to deism, atheism and free thinking, and the Napoleonic Civil Code was being introduced, with recourse to the civic virtues of Antiquity.

Prud'hon himself supplied an account of the contents: "Under the dark veil of night, in a wild and remote place, the greedy criminal murders his victim, snatches his gold and looks to make

sure there is no sign of life to betray his fearful deed. He does not see that Nemesis, that terrible aid to justice, is pursuing him, and is about to seize him and deliver him up to its unyielding assistant." The painter says that gold was the object of the theft, but he shows the victim left entirely naked. We may surmise that this was an academic exercise. The depiction of nudes – particularly as openly as this – was essential for success in the Salon. But the recumbent nude reveals more than this. A comparison of this picture with Regnault's *Genius between Liberty and Death* (ill. p. 383) will show that the outstretched arms again recall the formal repertoire of the crucifixion, in this case Peter crucified upside down, and the flight with the sack of gold recalls the figure of Judas in Christian painting.

This shows what enormous problems the epoch faced in developing its own iconography free of religion. In mood as well, Prud'hon turned to traditional models. His scene recalls the

Anne-Louis Girodet de Roucy-Trioson
Mademoiselle Lange as Venus, 1798
Oil on canvas, 170 x 87.5 cm
Museum der bildenden Künste, Leipzig

murder by Cain and is presented with the theatrical means of moonlight. Evidence that the references to biblical subjects were intentional was provided later by Alexandre Falguiére (1831–1900), for he adopted key elements from Prud'hon's painting for his version of *Cain and Abel* in 1876. The new idea of justice and the conviction that punishment was a logical sequence of crime, and as such a constant element in human community, gives Prud'hon's painting social and political relevance as well. The wild scenery also points to the Romantic movement that was soon to start, conveying the mood of the robber novels of the time.

Prud'hon's *Zephyr* of 1814 and *The Rape of Psyche* (both in the Louvre) owe much more to Correggio and Leonardo – Prud'hon described himself as their pupil – than to his contemporary David. And here one must ask whether Prud'hon should then be seen as retrogressive? But stylistic recourse to the past soon found its echo in the rapidly changing political scene, in the new taste of the Restauration period, when artists deliberately went back to the forms of the Renaissance and the Baroque. Prud'hon, whose finely tuned painting betrays a sensitive soul, also suffered great tragedy in his personal life. His first wife was committed to an asylum, and his second committed suicide with his shaving knife. He himself became mentally confused and depressive, and simply to survive financially had to undertake commissions that were unworthy of him. Only Delacroix later reaffirmed his importance and his standing as one of the greatest masters of the French school.

Anne-Louis Girodet de Roucy-Trioson (1767–1824)

Anne-Louis Girodet de Roucy-Trioson was said to have been David's favorite pupil. With a strong leaning to literature, he began to paint only after studying philosophy. The sense of the mysterious and poetic that he shows in many of his works is what many call the Romantic spirit, although it was already latent in Neoclassicism. One could also say that Girodet sensed the coming direction at an early stage, although he had been trained since the age of 18 to be a Neoclassicist by David. Orphaned at an early age, he was endowed with sufficient means by his guardian, the army surgeon Trioson, to be able to choose his commissions, and it is hardly surprising to learn that he cared little for any criticism his clients might pronounce. He first depicted the actress Mademoiselle Lange as *Venus* (ill. p. 386), standing on her couch, her face turned from the viewer. In the mirror that Cupid is holding up to her, the painter, who delighted in hidden references, has shown only one ear! When the actress expressed her annoyance at the painting, Girodet painted her again, this time in mythological form, *Mademoiselle Lange as Danae* (ill. p. 387, top). This was clearly a reference to favors for sale. The oval canvas again reveals her lap unclothed, her empty gaze falls on the gold that is raining into her cloth, and in light fingers she

BELOW:
Anne-Louis Girodet de Roucy-Trioson
Mademoiselle Lange as Danae, 1799
Oil on canvas, 65 x 54 cm
The William Hood Dunwoody Fund,
The Minneapolis Institute of Arts,
Minneapolis

BOTTOM:
Laurent Guyot after A.-C. Caraffe
The Sans-culotte Thermometer
Copper engraving, 32.3 x 36.2 cm
Bibliothèque Nationale de France, Paris

holds a broken mirror, the symbol of vainglory and Vanitas. At her feet lies the attribute of Jupiter, a bundle of fire. But Jupiter is not present in the form of the royal eagle, instead we see a turkey-cock. Enchanted with the sight of the beauty, he has dropped the fire, singeing the roll of manuscript containing Plautus' play *Donkeys*. Cupid is looking out of the picture at the viewer and holding up the cloth that covered the actress' lap with an inviting gesture, as if the most intimate private parts are on show for the high price. The painting caused a scandal in the Salon of 1799 and had to be withdrawn. The actress' career was over, and Girodet fell into disfavor. This was certainly not because he had painted his client nude, nor because of the injury he had done the actress, whom he adorned with a ridiculous headdress of peacock's feathers, for she was well known as a courtesan. His fall from public grace was due more to the anonymous patrons of the lady, who feared they could be talked about. Many may have feared they would be recognized as the adulating turkeycock, whose feathers are being plucked by a putto.

Girodet certainly intended his act of revenge to have a general effect, for we see that a widely distributed leaflet of the Jacobin party served as model for the composition. It contains an engraving by Laurent Guyot after Armand-Charles Caraffe's *The Thermometer of Sans-Culotte* (ill. p. 387, bottom). The leaflet is also composed as an oval with corner medallions and mottoes. Moreover, the Jacobin motto "Sansculotte" could have a number of negative connotations: not only does it mean "wearing no trousers," but there are the associative terms "sansculotterie," which meant "mob rule," and "culotte," which is the rump of a dove or an oxtail. One of the medallions contains the well-known motto "nec pluribus impar," and in his painting Girodet has drawn an ox. So the painter has literally and symbolically denuded the lady (or her admirers). In the medallion upper right he has painted an antique grasshopper with the motto "Risum teneatis amici" (Fear laughter, friends!).

If we have discussed this painting in rather more detail than is usual in a general survey of an epoch, it is because this episode gives us a good insight into the social importance of the Salon. It was by no means only pure interest in art that drew the public and the critics to these exhibitions; to a certain extent the Salon acted as a journal of the educated world. The artist could rise to be the pictorial commentator on contemporary events.

A Forgery that Entranced the World

If Girodet's nude *Mademoiselle Lange* was (despite the irony of its contents) formally an anticipation of the aesthetic of the younger Ingres, his *Ossian Receiving in Valhalla the Generals of the Republic Who Have Fallen for their Fatherland* (ill. p. 388) was an early example of the new subjects that would occupy the emergent French Romantic movement. The commission was

Anne-Louis Girodet de Roucy-Trioson
*Ossian Receiving in Valhalla the
Generals of the Republic Who Have
Fallen for their Fatherland,*
exhibited 1802
Oil on canvas, 192 x 182 cm
Musée National du Château de
Malmaison, Rueil

given to Girodet in 1801 by the architect Pierre François Léonard Fontaine for the decoration of the small palace of Malmaison, which Napoleon was having furnished for his own use. Two paintings on the subject of Ossian were to flank the chimney breast in the reception room. The other was to be painted by Gérard. They were the only two paintings to be praised by the owner of the palace, and not without reason. Napoleon was also seized by the current wave of enthusiasm for the prose epics of the legendary Gaelic poet Ossian, which even Goethe could not evade. The originator of the "unearthed, old Irish fragments" *Fingal* and *Temora*, published in 1762 and 1763, was a Scot, James Macpherson (1736–1796). The French translation was already in print by 1777. Readers were deeply affected by the style, so unclassical, as well as the violent, Nordic, expressive language of the bard who – like Homer – was blind. A comparison with the language of Ancient Greece made the Nordic style seem all the more feeling.

How greatly the newly-discovered Nordic mood and ideal touched the nerve of the time can be seen in Germany: Herder enthused about the utterly natural poetry, totally lacking in artificiality, and that even Goethe's Werther read passages from *Ossian* to his revered Lotte in deep emotion. Only the English philosopher

David Hume was skeptical even when the texts appeared, but it was not until ten years after Macpherson's death that the poems were discovered to be forgeries, written by Macpherson himself from fragments of sagas. Goethe, at any rate, skillfully disentangled himself from the embarrassing situation years later, by explaining to critics that Werther praised Homer "… when he was fully in possession of his faculties; he only praised Ossian when he had lost his reason." Napoleon certainly read *Werther* and had dramas written based on Ossian. He is said to have exclaimed: "What a difference between your Homer and my Ossian …"! So the legend made its Romantic contribution to official state Neoclassicism. Possibly the world conqueror was moved less by the poetry than by the selfless readiness for combat on the part of the Nordic warriors described in the poems, who thirst for a hero's renown with the utmost determination and a complete disregard for death. Fighters like these were what the conqueror needed. The same attitude is evident in Girodet's painting. The heroes surround the blind prophet in Valhalla, in fanatical devotion and ready for battle. In his train we see fallen warrior heroes of history, illuminated as with an inner radiance, and, as if in reward, surrounded by fairy-like floating maidens. The impact of the painting was fatal: the dream invented by the bard became the model for an entire nation and an entire epoch. The smaller oil sketch for Girodet's painting is in the Louvre. It shows that the idea of presenting the figures as illuminated only came in the main painting, while the bard himself is still in armor. It has been argued that this is a "satirical replica," but that has never been proven.

We know of at least four versions of the counterpart to Girodet's painting in Malmaison. Napoleon gave the first to the future King Charles XIV, John of Sweden, but it was lost. The replacement was commissioned before 1814. The Hamburg Kunsthalle has ascribed its *Ossian*, which is said to have come from Malmaison, to François Gérard (ill. p. 389). It shows the bard "awakening the spirits on the bank of the Lora with the sound of his harp" (ill. p. 389). The blind singer is engrossed in his song, his pale hair tousled and his head bent. His fingers grip the strings, and in the moonlight the dream figures appear, the heroes of his song: on his throne Fingal, who is Ossian's father, beside him Malwina, and behind them the train of warriors.

One is inclined to doubt that Gérard painted this, or that he could have moved so far from the Neoclassical style. The contours are too Romantically blurred, the color effects too fluid, quite apart from the expressive posture of the hero and the handling of the ruined castle in the moonlight, all of which are utterly un-French. The provenance merely states that the painting is from a Swedish private collection. It is understandable that the painting, which is unsigned and undated, was formerly (Lichtwark and Romdahl) ascribed to the Danish painter Jakob Asmus Carstens (1754–1798). The lost first version from Malmaison was

François Gérard
*Ossian Awakening the Spirits on the Banks
of the Lora with the Sound of his Harp,*
after 1801
Oil on canvas, 184.5 x 194.5 cm
Kunsthalle, Hamburg

are figures of crystal that he has created for us here." Whereas in Girodet's painting the glowing light causes the figures and contours to blur, Ingres' dream figures are like transparent alabaster sculptures. Moreover, Ingres' work has a timeless, dream-like quality. Even the dream figures look exhausted, lying almost lifeless, as if they themselves are dreaming the dream. All movement sinks down in sleep. But all three pictures have the luminous dream figures, shining as if with an inner radiance, or, as David called them, "figures of crystal." That was not an invention of the artists, but derives from the poem itself, from Macpherson. Goethe quoted these lines when he let Werther read to his Lotte the words that describe this phenomenon: "Thou liftest thy unshorn head from thy cloud: ... What dost thou behold, fair light? ... The waves come with joy around thee: ... Farewell, thou silent beam! Let the light of Ossian's soul arise. And it does arise in its strength. I behold my departed friends. Their gathering is on Lora, as in the days of other years. Fingal comes like a watery column of mist ..." The lines from the saga are particularly helpful in regard to the vision of the rigid dream figures in Ingres' work: "His heroes are around (him, Fingal) ... but ah, they are silent; silent forever! Cold, cold are their breasts of clay."

The motif of paranormal visions floating above a landscape, and dematerialized, luminous figures accompanying and interpenetrating the real and visible world, as a second level of existence, occurs again and again in this period. The idea derives from the philosophical concept of different periods of time co-existing, the elimination of the idea of time, in other words, and the intimation of eternity. It also expresses the idea of history penetrating our own time, which makes it possible for history – and saga and fairy tale – to be seen as spiritual entities above and beside real things. The religious ceiling paintings of the Baroque era with their representation of miracles had long understood and applied these principles. But now the ideas of "miracle" and "mercy" were being replaced by "vision" and "Providence," a term used by Leibniz. This was ultimately the result of the abandonment of the Christian doctrine of salvation with its teleology.

Jean-Auguste-Dominique Ingres (1780–1867)

Ingres sustained David's Neoclassicism into the second half of the 19th century. The light in his paintings is the same as the light in David's work. It is a light without mist or veils, the "en-lightened" illumination of figures clearly defined and delineated. Ingres also won the Rome Prize, and he too went to the Eternal City, the center of Antiquity and the art of Raphael, in 1806, spending nearly two decades there. Ingres was not a genius at artistic invention, but rather a genial eclecticist and a very fine craftsman, with a highly sophisticated sense of line, balance, and harmony of composition. That is why his drawings are of unsurpassable quality. He developed a highly sensitive aestheticism, particularly

published as an engraving by John Godefroy in 1801, and Goethe said of the figure of the bard: "Ossian looks not so much like an enthusiastic poet as a fanatic." Similar motifs are easily recognizable in a drawing by Philipp Otto Runge of 1805.

In 1812 David's pupil Jean-Auguste-Dominique Ingres (1780–1867) was also commissioned to paint the subject of Ossian. This was for the ceiling of one of the rooms used by Napoleon in the Quirinal Palace in Rome, and Ingres chose *Ossian's Dream* (ill. p. 390). Three years after Napoleon left, the Pope gave the painting back to the artist, understandably, for the heathen visions were hardly suitable for the Catholic ambience.

But let us compare the three Ossian paintings. It is striking how much the Neoclassical, demonstrative version by Ingres differs from the painting ascribed to Gérard. With what monumental simplicity Ingres has handled the theme, and how fluid is Girodet's version, with its many figures. David commented: "He must be mad, or I have lost all understanding of painting. These

BELOW:
Jean-Auguste-Dominique Ingres
Rüdiger Freeing Angelica, 1819
Oil on canvas, 147 x 190 cm
Louvre, Paris

ON PP. 392/3
Jean-Auguste-Dominique Ingres
La Grande Odalisque, 1814
Oil on canvas, 91 x 162 cm
Louvre, Paris

in depicting the beautiful naked body. He excelled his teachers in this, and it was here that he sought an ideal of form that goes to the limits of what can be done in painting. It is hard to find an equal anywhere in the history of art for the back turned to us by *The Valpinçon Bather or La Grande Odalisque* (ill. p. 392), or the body of the young girl in *Rüdiger Freeing Angelica* (ill. p. 391), modeled in soft lines. The position of the young Angelica, with her head tilted back, is highly exaggerated by modern standards, but the exposed and defenseless neck and the eyes cast up to suggest

that she has fainted are intended to signalize pure feminine submission. In order to portray this unconditional surrender to her rescuer, Ingres has almost made her look as if she has a goiter. But this calculated disruption to the aesthetic of the nude makes it no less erotic precisely because the very evidence of a weak spot in her beauty makes her seem less remote from the viewer.

We find the same position of a head in his *Zeus and Thetis* (1811). Both these paintings, like *The Turkish Bath* (ill. p. 394), are evidence of a very deliberate use of erotic attraction. The arti-

Jean-Auguste-Dominique Ingres
The Turkish Bath, 1862
Oil on canvas, tondo, diameter 108 cm
Louvre, Paris

ficial quality of the line and the choice of mythological subjects create a distance, making the scene appear outside time, outside our own world and outside history, a stratagem enabling the artist to present arousing depictions of nude young girls. Again we see the old religious motifs integrated in, or even interchanged with, new profane themes. This was possible at the time, indeed was often sought in painting. For although the story of Angelica goes back to Ariosto's "Roland Raving," and derives formally from compositions by Paolo Uccello, the fusion with the traditional figure of the knight, St. George, is undeniable. Again the religious element has been transmuted into the erotic. Ingres has also combined landscape effects from Leonardo here with modern elements that point forward to Gustave Moreau (1826–98) – in the figure of the knight, for example, who is floating down in a surreal fantastic form. This is evidence of his central position in 19th-century painting.

The effects in Ingres' paintings largely depend on drawing and linearity, but he also used color to supremely calculated effect. What choice of color could better have intensified the warm flesh tones of the *Grande Odalisque* than the cold turquoise of the silk curtain with its decoration of red flowers? This nude was painted in 1814 for Napoleon's sister, Queen Caroline Murat. Unlike the realism of Goya's *Maja*, Ingres' nude is hardly intimate, the eroticism here emerging only slowly from the reserve and the questioning, assessing glance of the naked woman. This is a tradition that goes back to Titian and Giorgione, but Ingres has painted a living woman and not an allegory of Venus. Nevertheless, the realistic intimacy is lessened by setting the scene in the distant world of the Orient.

In portrait painting as well, Ingres far surpassed all his contemporaries. He could combine realistic exactitude with psychological insight, but still remain the sober observer, not involved in the inner life of his subjects. If one reviews his many portraits, one sees that the objectivity is always sustained. There appear to have been no subjects that he found easier than others, and none he faced helplessly. He could paint old men with the same supreme ease as young princesses, and capture the critical eyes of fellow painters as exactly as the dignity of political office, as in the portrait of Louis-François Bertin, one of the leading personalities between the July monarchy and the Second Empire (ill. p. 395), or Baroness Betty de Rothschild in her gentle dignity. As a portrait painter he has often been compared to Holbein, and in portraiture particularly the severity of line and exactitude of detail so typical of Neoclassicism often lend the subject a touch of special historical dignity.

Intellectually, Ingres seems to represent the quintessence of academicism, and he continued to paint in the Neoclassical style throughout his career, although the style came under attack from younger contemporaries like Delacroix or Géricault. *The Vow of Louis XIII* (ill. p. 395) is a kind of Neoclassical votive

LEFT:
Jean-Auguste-Dominique Ingres
The Apotheosis of Homer, 1827
Oil on canvas, 386 x 515 cm
Louvre, Paris

With this giant painting which was
intended as decoration for the ceiling in
the Salle Clarac of the Louvre, Ingres
created what he regarded as the "most
beautiful and important work of his
artistic career." The most famous artists
in history are depicted here: Dante and
Molière and painters such as Poussin,
but Homer reigns above them all. The
painting was intended as the sum of all
aesthetic rules. However, it could hardly
live up to all the expectations. Today it
seems stiff and unnatural. Paul
Delaroche addressed the same theme a
little later in his *Hémicycle*.

BELOW:
Jean-Auguste-Dominique Ingres
Paolo and Francesca, 1819
Oil on canvas, 480 x 390 cm
Musée des Beaux-Arts, Angers

painting. In it Ingres adopted whole passages of Raphael's
Madonna di Foligno, but he also borrowed forms that were
developed by the Carraccis. He has relied here on the traditional
iconography that was based on the concept of rule by divine
grace, which hardly seems apposite after the events of the
Revolution. The gesture with which the secular crown and
scepter are being handed to the Queen of Heaven looks theatrical
and artificial, and the image of the earthly power bending the
knee seems to be not so much homage to the Mother of God as
homage to divine art, in this case the art of Raphael. For art had,
indeed, long replaced religion, and this also explains why the
composition looks so contrived – it is as calculated as if made to a
recipe, a geometrical theorem. The same can be said of *The
Apotheosis of Homer* (ill. p. 396, top) of 1827, in which a whole
number of well-known artists are portrayed. The huge canvas
was commissioned for the ceiling in one of the rooms in the
Louvre. Using a practice not unusual at the time, Ingres painted
on canvas that was then attached to the ceiling, so he made no use
of the Baroque scope for multi-perspective. The symmetrical
composition, with its rigid devotional figures standing like stone,
gives the painting the appearance encountered again in Historicist
decoration in courtrooms and academies in the following period.

Ingres continued to paint into the second half of the 19th
century. In the last decade of his life he received many honors,
culminating in his appointment as Senator. He died in 1867 at the
age of 87, leaving an output that enforced deep respect from
younger colleagues for his adherence to tradition. Highly sensi-
tive, and a virtuoso violinist at the age of 14, he sought to transfer

Joseph-Désiré Court
Young Girl at the Scamander River, 1824
Oil on canvas
Musée des Beaux-Arts et de la Dentelle
d'Alençon, Alençon

his musicality into pure form and beauty of line, in total dedication to producing and transmitting the idea of beauty. One looks in vain in Ingres' work for the cruelty and fear, the diabolism and horror of Goya. Ingres displays the powerful and lasting influence of the Italian art of Raphael, to which he was devoted.

It would be an oversight not to mention the influence of German artists on Ingres. While in Italy he kept a studio on the Via Gregoriana, next door to the Casa Bartholdy, which was decorated with frescoes by the German Nazarenes. He was also familiar with the wall paintings in the Casino Massimo al Laterano, created between 1820 and 1829 by the German painters Julius Schnorr von Carolsfeld, Friedrich Overbeck, Joseph von Führich, Joseph Anton Koch, and Peter Cornelius. Many of Ingres' paintings reflect these encounters, such as *Paolo and Francesca* (1819, ill. p. 396, bottom), and particularly *The Entry of the Heir to the Throne, the Future Charles V, into Paris in 1358* (1821). It is not surprising that Ingres' pupils and followers also oriented to these examples, as did, for example, Hippolyte Flandrin (1809–64) in his Christian cycles.

In his cultivation of aesthetic and physical beauty Ingres had a lasting influence on younger artists of the Restauration period and the Second Empire under Napoleon III. They include Joseph-Désiré Court (ill. p. 397) – a pupil of Gros who was born in Rouen in 1797 and died two years before Ingres in Paris in 1865 – Thomas Couture (1815–79), Adolphe-William Bouguereau (1825–1905) and Paul Baudry (1828–86), to name only a few. Ingres' scenes of harems and seraglios influenced the Orientalists, such as Horace Vernet, Alexandre Cabanel, and Paul Delaroche, and of all painters Ingres, the Neoclassical academicist, numbered outstanding artists in the early modern movement, such as Edgar Degas, Chaim Soutine, Pierre-Auguste Renoir, and Pablo Picasso, among his most ardent admirers.

The Swiss painter Charles-Gabriel Gleyre (1806–74) also devoted himself to the aim of aestheticizing the past and bringing it to life in painting. He studied at the Ecole de Pierre in Lyons and in Paris under the history painter Saint-Louis Hersent (1777–1860), and practised watercolor with the English painter Richard Parkes Bonington. He had contact with the German painters in Rome, in Paris with the composer Hector Berlioz, the painters Carle Vernet, Robert Nanteuil, Jean Perrin and Paul Chenavard, and particularly his fellow Swiss Léopold Robert (1794–1835). In 1834 he accompanied a wealthy American to the Orient, but fell seriously ill there and barely survived. He returned first to Lyons, but after fully recovering his health returned to Paris in 1838. In 1840 he exhibited in the Salon, after which his fortune seemed to change, for the Duc de Luynes commissioned him to decorate the staircase in the palace at Dampierre. However, hardly was the commission executed to the satisfaction of the duke and his architect, when Gleyre suffered a heavy blow. The

duke asked no less a painter than Ingres to judge the work. The frescoes were immediately destroyed, and Ingres created in their place his well-known *Age d'Or* (1843–47). Neither Gleyre nor Ingres ever spoke of the incident for the rest of their lives, but Gleyre was deeply humiliated and suffered years of neglect, until he had a great success in 1843 with *Evening*, later subtitled *Lost Illusions* (ill. p. 323, top). He had touched the nerve of contemporary society. Like Ingres, Gleyre continued to paint in his Neoclassical style into the second half of the century, and his painting of 1853 *The Romans Put Under the Yoke* (Lausanne) can possibly be seen as his most important history painting. The enthusiasm of the public for *Sappho's Sleep* shows that the ideal of beauty derived from Ingres was still eagerly sought after the

middle of the century as well. Despite his great gifts, the unfortunate circumstances of Gleyre's life meant that he left only a small output, but it is one that deserves acknowledgment.

Orientalism in France

The thoughts that turned longingly to Egypt and the Orient were not specific to France – the subject aroused intense interest throughout Europe, and there are also paintings by British, German and Swiss artists in this genre. But Bonaparte's Egypt campaign of 1798–99 affected French artists particularly. The undertaking was not solely the upshot of political interest, but marked a peak in an intellectual quest, as we can see today. Certainly, no economic benefit was to be expected from subjugating a stretch of land that had fallen into decline. But Napoleon thought in historic dimensions. He saw himself as the new Alexander, and his advance to the Nile had the same significance as Alexander's campaign to the Ganges in India. Ultimately, he was driven by the determination to push back the frontiers of knowledge, and – by physically occupying North Africa – to conquer the mysterious and unknown, thus symbolically to rule the world.

The campaign itself is easily sketched. After their victory over the Mamelukes near the pyramids in 1798, the French took Cairo, but the same year the victory of the English fleet under Admiral Nelson at Abukir prevented their retreat. Napoleon's army was cut off. In 1799 the French fought on into Syria, but Napoleon had to withdraw from Egypt in 1801. After his return to Paris the Directorate was brought down and the Council of the Five Hundred dissolved.

Nine years later David's pupil Jean-Pierre Franque (1774–1860) exhibited a large painting, in which he allegorized the condition of France at the turn of the 18th and 19th centuries in retrospect, relativizing Napoleon's heroic deed in a grandiose

manner (ill. p. 398). The painting was probably a joint production by Jean-Pierre and his twin brother Joseph, and in older catalogues it was originally ascribed to Joseph. More interesting than the question of its origin, however, is the function of key elements in the painting. For on a closer inspection the work proves to be a mirror image of Gérard's Ossian painting (ill. p. 389), although now the seer is Napoleon himself, and his vision is not one of mythical figures, but is an allegory on France, her arms outstretched in longing, as she suffers and grieves for the absent savior. In the vision the pyramids swim in veils of cloud, as if the painter saw the Egyptian campaign as the pursuit of a *fata morgana*. The leaves of the trees appear as if they are being shaken by a sudden storm, an indication of the way the political wind is blowing.

In cultural history the Rosetta Stone, which an officer in Napoleon's army discovered in 1799, and which enabled Jean-François Champillion to decipher Egyptian hieroglyphics in 1822, was initially of less importance than the encounter of an entire army with the sandy, sun-drenched landscape of the pyramids, the colorful life of these strange oriental lands, the bazaars, minarets, ruined temples, and sphinxes. In the next few years artists acted as "reporters," recording the new world in countless drawings and watercolor sketches, numerous variations of which were later compiled into oil paintings. In works like *Bonaparte with the Victims of the Plague at Jaffa*, *The Battle of Abukir* (mentioned above) and *The Battle of Nazareth*, Antoine-Jean Gros showed that he was no less fascinated by the glittering light, the brilliant uniforms, the oriental turbans and costumes than was Delacroix later. But the encounter with the Orient has a further significance for the development of painting: it marked the start of the Romantic movement. The philosopher Friedrich Schlegel had already said in his *Rede über die Mythologie* (Speech on Mythology) in 1800: "We must seek the supreme Romantic element in the Orient!"

In France, therefore, Orientalism was closely bound up with the Romantic movement, the most important representatives of which were, no doubt, Delacroix and Géricault. Beside these outstanding figures the list of painters of oriental themes extends unbroken to the end of the century and beyond, in a seemingly endless stream. They have become known as the Orientalists throughout Europe. Of course, almost all of them handled other subjects as well – only a few, mainly in the second half of the century, devoted their entire output to oriental themes. These included the English artist John Frederick Lewis (1805–75), the Pre-Raphaelite William Holman Hunt (1827–1910), the Austrian Ludwig Deutsch (1855–1930) and Gustav Bauernfeind (1848–1904).

Among the early French Orientalists, Horace Emile Jean Vernet (1789–1863) should be mentioned, who came from a celebrated family of painters. Initially he sublimated Napoleon's

deeds, but later came into favor with the Bourbons and the Orléans. From 1828–1835 he directed the French Academy in Rome, then undertook several journeys to North Africa. His *The Conquest of the Smalah* (Versailles) grew to be a major opus, more than 100 square meters in size, which engulfs the viewer to such an extent, if only through its size, that he may well feel he is in the middle of the battle. The trend was to be continued in the panoramas that soon developed.

Vernet's *Jehuda and Tamar* (ill. p. 399) dates from 1840. Ingres' aestheticism is very evident in the rendering of the female body, in the beauty of line and the harmonious coloring. Generally, however, the artist has aimed for virtuosity in narrative detail and a meticulously faithful rendering of the textiles and accessories. Ingres' aim to make a scene timeless, and so eternally relevant, has deliberately been abandoned here. A dialogue that can be repeated word for word is taking place between Jehuda

Eugène Delacroix
Women of Algiers in Their Chamber,
1834
Oil on canvas, 180 x 229 cm
Louvre, Paris

and Tamar, and the act of handing over the ring is a very specific moment in the Bible story. It is not by chance that the ring is placed exactly on the central axis of the painting. The picture, which is an interpretation of a literary model, is no longer, as it would have been for Ingres, a symbolic motif of general relevance, but it is an illustrated commentary. That is why, although Vernet has taken such pains to give a faithful rendering of the materials, the painting is an interpretation, moreover in keeping with public expectation in the 19th century. Tamar's unblemished breast and naked leg are concessions to the Salon visitor, who was highly receptive to eroticism, but it makes nonsense of the reality of life in the Orient for the woman to veil her face but display her intimate charms so freely and with such skillful pretense of modesty. While Tamar's gaze is dreamy, Jehuda's features express eager expectation of the happiness that awaits him. His hand has carefully reached for the ring, and she is holding hers ready for the exchange. In gestures like these Vernet has reinterpreted the Biblical story and given a psychological account of a 19th-century sexual relationship. He has even given the camel an expression that seems to be a comment on the painted dialogue.

In works like these painting turned to a completely new field – the psychological interpretation of a literary subject. The viewer is encouraged to think the words spoken by the characters in the scene, or to quote them from the literary text on which the picture is based. This artistic exercise was to be the great challenge for painting generally throughout the second half of the century. Pictures were naturally judged by how far the painter had succeeded in portraying the emotional context and bringing the theatrical scene and figures to life. Subsequent history, action, and genre painting in the academies, first in Belgium and soon throughout Europe, particularly in the work of the Düsseldorf, Frankfurt, and Munich schools, lived on such expectations.

The countless painters who personally experienced the colorful attractions and fairytale exoticism of the Orient on their travels or through literature, as in the highly imaginative *Arabian Nights*, and then set about representing them in their paintings, created the image Europe had of the Orient. Mention should be made of at least three of the most important: Eugène Delacroix (1798–1836), Charles-Gabriel Gleyre (1806–1874), and Jean-Léon Gérôme (1824–1904).

Delacroix was sent to Morocco as subject painter by King Louis-Philippe after the conquest of Algeria. The impression made on him by the new colors, the unusual light, the brightly painted architecture and the costumes of the people, mingling in the public squares and the bazaars to create multiple patterns and forms, stimulated him to adopt Rubens' stylistic means and particularly those of Rembrandt, in whose oeuvre oriental subjects play a rich part. However, it was not the chiaroscuro of the Dutch painter but the swirling brushwork of the Baroque that

OPPOSITE:
Eugène Delacroix
The Death of Sardanapalus (detail from illus. p. 405, top), 1827
Oil on canvas, 395 x 495 cm
Louvre, Paris

LEFT:
Charles-Gabriel Gleyre
Egyptian Temple, 1840
Oil on canvas, 36 x 49 cm
Musée cantonal des Beaux-Arts, Lausanne

The two paintings by Gleyre show the stylistic breadth of Orientalist painting – on the left a faithful rendering of detail in a realistic depiction of the state of Egyptian ruins, and below the fairy-tale world of the Orient, fantastic and theatrical in both coloring and scenery.

BELOW:
Charles-Gabriel Gleyre
The Queen of Sheba, 1838
Oil on canvas, 54 x 43 cm
Musée cantonal des Beaux-Arts, Lausanne

he needed to handle such vivid coloring. Delacroix' early response to his encounter with the Orient was to depict the Greek wars of liberation, starting with the *Massacre of Chios* (1824). Only later came *The Lion Hunt* and the many pen and ink and oil sketches in which he recorded the vicious struggles or wildness of the Arab horses. Between, fueled by his experience of oriental painting, came a large number of works on Biblical or literary themes. These were executed "in the original, oriental manner," like *The Death of Sardanapalus* (Louvre). A few stand out through the beauty of the authentic rendering of the milieu, like *Jewish Wedding in Morocco* or *Women of Algiers in Their Chamber* (1834, ill. pp. 400–41). But as with Ingres, the artist's main concern here is to offer a glimpse into the unknown and peer into forbidden spheres, experiences to which the Salon was highly receptive.

Gleyre, too, handled oriental themes as well as his antique Neoclassical subjects. Numerous watercolors document his travels and depict ruined Egyptian temples. In adventurous compilations of oriental components he succeeded in intensifying the fairy-tale element into historic imaginative depictions, as in *The Queen of Sheba* (ill. p. 402, bottom right).

Jean-Léon Gérôme was born in 1824. He is the youngest of our group and his work points far into the second half of the century. He needs to be mentioned here because he is representative of the artists who combined Neoclassicism as a style with the Romantic longing for distant places. His *General Napoleon in Cairo*, painted around 1863, is a testimony not only to his Orientalism, but also to the political rehabilitation of the Napoleonic empire that was beginning at this time.

Géricault, Delacroix, and "Theatrical Romanticism" in France

Théodore Géricault (1791–1824) and Eugène Ferdinand Victor Delacroix (1798–1863) are the two most important representatives of the French Romantic school of painting. The great range of what is known as "Romanticism" becomes clear if we compare their work, with their recourse to Baroque techniques, their strong emphasis on color and wildly swirling brushwork (which sometimes seems to dissolve the contours), with the cool control of an artist like Caspar David Friedrich in Germany – whose work is also called Romantic – or the idylls of Ludwig Richter or Moritz von Schwind. But, different as the effects are, there is one common denominator: the establishment of worlds counter to the reality of the present. Delacroix' work had a lasting influence throughout the century that followed. The Impressionists also acknowledged their debt to him. And although Géricault, who was seven years older, stands at the start of this new movement, it is remarkable that in many of his paintings he was actually the first to point to the realism that came later, as we shall see.

Delacroix (1798–1863) was related on his mother's side to the Oeben and Riesener carpenter families, who were of German descent and had worked for Louis XV. His father was a diplomat and active in political life, where he became a member of the Convention and a préfect before he died prematurely in 1805. But it was rumored that Delacroix' real father was the Prime Minister, Talleyrand, who often helped the family and assisted the young painter in his career. Through Riesener he entered the studio of Pierre Guérin, where he met Géricault, who was just finishing *The Raft of the Medusa*. Delacroix was influenced and entranced by Rubens' Medici cycle, by the painting of Italian

artists like Titian and Tintoretto, and by Goya's drawings, but he then focused increasingly on contemporary British painting. He became known as extremely anglophile, and is said to have been so deeply impressed by the work of Constable, which had just been displayed in the Salon, that he reworked the colors of *The Massacre of Chios* after the 1824 Salon opened. The encounter with Constable and his friendship with Richard Parkes Bonington (1802–28) took Delacroix to London in 1825. Shakespeare's dramas and his reading of *Faust*, which was then a subject of eager debate in London, strengthened Delacroix' theatrical manner. This was accompanied by the new approach to color he had brought from Britain and which, as a critic said, was "magnificent, frightening and wild." Shakespeare and Byron were not only his literary favorites, but like them, he sought to bring out the "tragic highlights," the moments that contain the ultimate unfolding of the emotional action. Like his contemporary, the poet Alfred de Musset (1810–57), who described the aims of the new direction in *Confession d'un enfant du Siècle* in 1836, he literally sought pain to engage the feelings of the viewer. "To assemble the fear, terror, horror and despair of the world and depict it" was his aim. After experiencing a storm at sea in 1840, he put this experience into his painting of the shipwreck in Byron's *Don Juan*. And in the sparkling and witty articles he wrote for the *Journal* he proved himself one of the most knowledgable of art theoreticians. He was a friend of Balzac and Stendhal, and above all Victor Hugo. In old age he was revered by Baudelaire. The list of his models, which he named himself, ranges from Titian, Tintoretto, Rembrandt, and Rubens to Poussin, and is evidence of the coming eclecticism.

1827 is regarded as the year of the Romantic movement in the Paris Salon. No fewer than nine paintings by Delacroix were accepted. A year later he showed *The Death of Sardanapalus* (ills. pp. 403 and 405, top), again painted under the influence of Lord Byron. Seeing that he is surrounded by his enemies and cannot escape, the oriental prince shuts himself in with all his treasures and gives himself up to the flames with his wives. So this is not only a depiction of the Orient, but is the illustration of a tragic story that combines sensuous lust with untimely death.

Affected by the July Revolution of 1830, which brought a change in the political system and a new occupant to the throne, ending the period of the Restauration, Delacroix embarked upon his famous work *Liberty Leading the People* (ills. pp. 328–29 and 404). It was characteristic of the situation at the time of political change that the painting was purchased by the bourgeois King's government in 1831, but returned to the artist two years later from the Palais du Luxembourg for fear of unwanted political repercussions. Only after the 1848 revolution was it shown in public again. The painting appeared once in an exhibition in 1855 under Napoleon III, and was then put in the Louvre.

The student in the top hat is said to bear the artist's features. But, according to Delacroix' friend Alexandre Dumas, the artist was "too proud, too sensitive, too spiritual to take part in a popular movement; however, as the son and brother of leading supporters of Napoleon he welcomed the reappearance of the tricolor."

Delacroix is said to have regarded historical changes as natural events "that are incalculable, and so release people from the pressure and boredom of everyday life." Here the artist has elevated a girl of the people to allegorical significance. Charles Blanc said at the time that the artist was aiming to pay tribute to intellectual rather than political freedom. The idea is much clearer when we see the same event depicted by Jean-Victor Schnetz in *The Battle for the Town Hall, 28 July 1830*, which was shown in the Salon of 1834 (ill. p. 405, bottom). Here, too, the composition is designed to heighten the drama of the event, but Schnetz has refrained from the use of symbolism. In Delacroix' version, on the other hand, the idea of personifying Liberty is Baroque. The figure's floating progress in her fluttering robe is entirely in the Baroque tradition, recalling Rubens' *The Consequences of War*.

The bare breast of Liberty plays an important part in the impact the painting makes, being as provocative as it is graceful. The idea of incorporating an erotic element in a political painting was entirely new. Political paintings of the Baroque era did not present allegorical female figures as erotic. Here, for no apparent reason, one of the dead soldiers lying on the ground is naked from the waist down. But the effect is entirely theatrical. The simultaneous depiction of vulnerable nudity and naked horror dramatizes the contrast between the beautiful and the terrible, and this deliberate

405

use of tension is what creates the dramatic effect. Heinrich Heine admired the painting in the 1831 Salon and called Liberty "an almost allegorical figure," "a strange mixture of Phryne, Poissarde, and the goddess of Freedom." That the rescuer is a woman has less to do with modern ideas of emancipation, and more to do with the tradition of rendering allegories in female form, a tradition stretching back to Antiquity. The central figure here is also the worldly version of a Christian iconography, as we have seen so often already. In this case there is also a reference to the resurrection of Christ. The Salvator Mundi with the flag has been transformed into a female figure of Liberty. It was presumably this that induced Heine to speak of a "sacred subject." But the "great idea" that Heine recognized, and which he believed would "ennoble and sanctify the ordinary people," derives from a different source. It is the courage of the woman, fighting unprotected, that demands respect. Delacroix has invested the boy holding the heavy pistols in his small hands with the same courage, although he is only a child. The courage of the defenseless and helpless is the disarming message which this painting conveys to all people.

Delacroix was finally accepted as a member of the Académie des Beaux-Arts after applying seven times, and then with Talleyrand's support. His work was despised by Ingres and his supporters as impure painting, but he came to play the leading part in the French Romantic movement, although many critics thought they could see "uncertainties" and "certain weaknesses" in his painting. And indeed, on reviewing his work one gains the impression that he was not always concerned with technical correctness. Many an arm looks strangely foreshortened, many a movement doughy, and the posture of individual figures – particularly in multi-figure compositions – is not always convincing. But it is the great comprehensive sweep of color and forms that gives his painting unity. The emphasis is not on virtuoso painting, not on complete mastery of figure and movement, in which Delacroix was far surpassed by Géricault, who was only a little older, but on the message, the appeal to emotion. The ease with which Delacroix could let forms and colors fight wildly with each other points to the modern movement. It is not any lack of technical ability, but the fact that he attached little importance to this that prepares the way for the art of the 20th century.

This is closely related to the cult of the genius in the 19th century. In 1824 Delacroix wrote: "What people of genius create are not new ideas; they are driven by the idea that everything that has been said has not yet been said well enough." And just as the theater, which can be seen as a symptom of its time, cultivated the genius, Delacroix the genius painted the heroic deeds of geniuses. Even his brushwork was seen as a stroke of genius. He turned away from the deliberate, finished painting of the Neoclassical artists and applied his paint rapidly and loosely. This enabled him to master whole series of large paintings of events, like the battle scenes in Versailles, in a very short time.

History painting and the cult of the genius were as closely related as twins in the 19th century. History painting derived, among other things, from the depiction of the Christian story of salvation. But the Enlightenment and revolution had called in question, once and for all, the claim of religion to provide models for every individual in its images of saints. Now the "heroes" or the great men of history who, in the opinions of the time, had also brought salvation to the world, had replaced the Christian saints. Instead of martyrs came heroes, and where the prophet once stood genius now pointed the way. In return, the deeds of earlier criminals were a warning to the present. Many history

painters initially turned to Christian themes before tackling historical subjects. Paul Delaroche (1797–1856) was one. His early work consists mainly of subjects from the Old Testament, while later he chose subjects from French and English history. Delaroche was one of the most popular painters of his time, and was once called "the hero of his age." His paintings satisfied the need for education through art and the demand for sensibility. Both his carefully researched interiors and costumes and the

theatrical content made his paintings so popular. In *The Death of Queen Elizabeth I of England* (1827) the cultivation of the material, which actually distracts attention from the real subject, struck viewers even then, and it was criticized as "coquetterie patiente des accessoires." But that was in keeping with contemporary taste, for decorative history painting, which had gone to extremes in its meticulous attention to detail in the objects, furniture, and costumes. However, Delaroche's work led to an unusual development. Where other painters frequently worked from theater designs, the theatrical nature of one of his paintings, *The Death of the Sons of King Edward in the Tower* (1831, ill. p. 407, bottom) led to the image being put back on to the stage. The painting aroused so much interest that Casimir Delavigne felt impelled to write a tragedy with a stage set built exactly like Delaroche's painting.

In 1837 Delaroche was given an important commission. It was to decorate the apse of the Ecole des Beaux-Arts with a cycle of more than 70 of the most famous artists since Antiquity (ill. pp. 406–07). This pantheon of art was known as the *Hemicycle*, and for decades it served artists from every country as a model of allegorical fresco painting. In the execution Delaroche went back to the antique technique of encaustic, and was the first artist to do so. This is a method in which hot melted wax is poured over the plaster, and it gives the painting a smooth quality that also repels damp. The German artist Julius Schnorr von Carolsfeld used the same technique for the wall paintings in the Residence in Munich which he executed for King Ludwig I (ill. p. 461, bottom).

Delaroche's last major work, *The Bodies of Girls in the Tiber* (1855), was immediately designated "the young girl martyrs in the Louvre." Here, too, we see the secularization of religious sentiment

outlined above, but Delaroche had already crossed the border into the sentimental painting of the second half of the century.

A peak in theatrical Romanticism came in the Salon of 1847, when Thomas Couture (1815–79), a pupil of Gros, exhibited a painting nearly eight meters long, *Romans of the Decadence* (ill. p. 408). This had been commissioned by the government for the Palais du Luxembourg. Couture was paid 12,000 gold francs and the critics exclaimed "Couture has topped them all!" – a comment with double meaning. In fact, the enthusiasm of contemporaries is easier to understand if one sees the work as the sum of all that French painting had striven for between the Neoclassical period and Romanticism. Not only does the work cite painterly and compositional devices from Old Masters like Veronese, Tiepolo, Rubens and Poussin, but to Couture's contemporaries, open to theatrical effects, the artist also seemed to have succeeded in combining Antiquity and the present. It is all to be found united here: the antique columned hall, sculpture competing with living figures, beautiful forms created with line in the manner of Ingres, and Delaroche's delight in detail. The subject itself derives from lines by Juvenal, but we may assume that the erotic and sensuous attraction of the painting drew viewers more than the Latin poem. Here, too, a woman is the central figure, placed so that she will draw all eyes. She is stretched out in the middle of a large crowd of people who are abandoning themselves to all the vices that are supposed to have led to the downfall of Rome. The scene is framed by five larger-than-life-size sculptures representing men

from Roman history, their gestures seeming to demand a return to virtue. The actual message of the painting is in the suffering, pensive expression on the face of the woman in the center. The subject recurs, particularly at the end of the 19th century, in a period that itself suspected it was "decadent." One of the main exponents of subjects like this was the Austrian artist Hans Makart (1840–84). While Couture's influence on other painters in France cannot be seen as very great, he had an enormous influence on a German painter who lived and worked in Rome, Anselm Feuerbach (1829–1880).

Not without reason do we only now turn to an older artist, Jean Louis Théodore Géricault (1791–1824). Géricault died in Paris at the age of only 33, too young to experience the effect of his art. He came from a highly educated family and grew up during the years of Napoleon's rise to power. At 15 he entered the studio of Carle Vernet (1758–1836) to train as a horse painter. In 1810 he enrolled as a pupil of Guérin (1774–1836), who continued David's style. All his life Géricault was devoted to horses, a fact significant if only because he derived a more profound view of the world from his experience with the animals. His numerous paintings of horses are of high quality, but they deserve attention not so much for their delicate sensitivity, the eloquent nostrils and the expressive position of the heads and hooves, as for Géricault's aim to reflect the essence of nature itself through this species of animal. Horses, with their wild or gentle eyes, were for him the language of nature, and he made the fine distinction of details that the average observer would

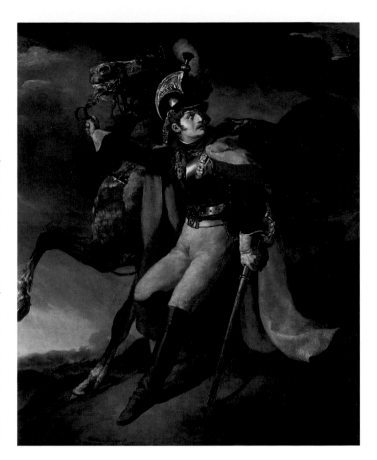

hardly notice into a very special study of nature. As Philipp Otto Runge devoted himself to color theory, Géricault devoted himself to this living natural species. In *Horses' Rumps* (1812–16) he painted 30 different animals, one beside the next in a stable. Each one is an individual, with its own individual character. To Géricault horses were the symbol of nature's violence, which man could tame in a variety of ways.

His first major work, and the one in which he moved away from Gros' influence, was *Portrait of an Officer of the Chasseurs Commanding a Charge* (1812, ill. p. 409, bottom). The rider is turned round so far from the waist that the forward movement of the charging horse is exactly the opposite of the rider's gaze. The curving sabre underlines the turn of the body. The whole painting makes an immediate and spontaneous impression, with all its elements forming one dramatic whole – the rising diagonals, the violence of the backwards movement, the glance down at the slaughtered foe and the onward rush of the charge into the flaming red front line.

The painting was commissioned by an officer, Dieudonné, who wanted to be represented in uniform, and Géricault has created the supreme image of the wildly charging fighter. He won a medal

for the painting in the Salon of 1812. His *Wounded Cuirassier* of 1814 (ill. p. 409, top), on the other hand, was criticized in the Salon. The wounded officer, who can still clutch the reins of his rearing horse, is casting his eyes upwards to the dark, clouded sky. This was interpreted as a symbol of France in defeat, vainly trying to summon up the strength for a heroic stand. The criticism was such that the painter threatened several times to destroy the work.

Géricault's private life was tragic. The wife of a friend bore him a son, who was brought up in the country and never learned who his mother was. Géricault provided for the child, but to forget the unhappy affair he went to Italy, where he sought distraction in making studies from Michelangelo, Raphael, the paintings in the Sistine Chapel and Antiquity.

In 1816 the frigate Medusa set sail for Senegal. Apparently owing to the captain's inexperience it foundered. The catastrophe was brought to public attention by the survivors, and it was publicized by the press and in a book that sold out overnight. Géricault had the nerves and the instinct to seize the opportunity to take painting into a new field: the depiction of current events affecting ordinary people. In his view, a painting of such an event should not be seen as a factual report. The artist should interpret the event through the means of art and let it serve as a general warning. That is how *The Raft of the 'Medusa'* (ill. p. 411, top), which became famous, is to be read. The 149 passengers on the ship took refuge on a raft that was to be towed to shore by one of the boats accompanying the Medusa, but the ropes broke and the people on the raft

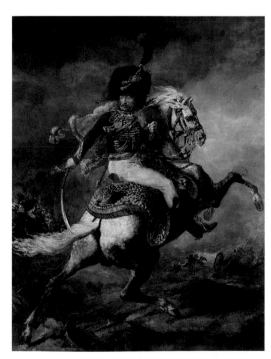

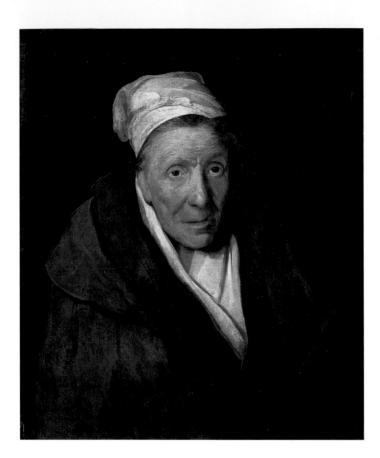

Jean Louis Théodore Géricault
*A Madwoman and Compulsive
Gambler*, 1822–23
Oil on canvas, 77 x 64 cm
Louvre, Paris

brush" was praised, but the painting was also misinterpreted as a "revolutionary composition," "a call to revolt." Géricault was accused of "slandering the entire Marine ministry," but he countered: "People who say such stupid things have evidently never spent two weeks starving and thirsting, otherwise they would know that neither poets nor painters will ever be capable of representing the full horror of what those people suffered on that raft."

It is appropriate here to compare Géricault's painting of 1818–19 with a work that is thematically closely related, Caspar David Friedrich's *The Wreck of the 'Hope'* of 1821 (ill. p. 322). We see that the emotions and values are the same, but Friedrich's painting is cold, indeed incisive in its drastic treatment of the subject, lacking the violent theatricality of the French work. But Friedrich has given much clearer expression to the desolation of a world without God. This was also a real tragic event, the shipwreck of the expedition vessel 'Hope' in the Arctic as it froze in the ice. It is an irony of fate, in the deist sense as well, that the ship was called 'Hope,' and the other vessel the 'Medusa,' the mortal of the three Gorgons who could defy disaster with a gaze that turned all it rested upon to stone. But the all-powerful forces of fate teach those who dare to defy them that even titans can fall, as shown by the more recent tragedy of the Titanic in 1912.

Géricault seems to have felt something like an inner mission when – a supporter of the Bourbons – he chose the most pitiable creatures in society for his subjects. In his studies of neurotics, he made shattering documentations like *A Madwoman and Compulsive Gambler* (ill. p. 410), pursuing the same aim as in his studies of horses, or the picture *The Heads of Executed Prisoners* (Stockholm) – to cover as completely as possible all the species of natural phenomena. Here the painter on the one hand becomes a scientific documenter, and on the other shows people suffering a fate for which they are not responsible. We are drawn hypnotically to these images by the sheer confusion they present, the terrible loneliness on the faces of people who have lost their minds. The painter's interest in psychological studies and the scope for interpreting expression and character must be seen in connection with *Physiological Fragments* by the scientist Johann Caspar Lavater (1741–1801), a friend of Goethe's, which were widely read in Germany, or with the studies of expression by the sculptor Franx Xaver Messerschmidt (1736–83).

Like Goya, who elevated animal carcasses to still-life painting between 1808–12 (ill. p. 363, bottom), Géricault also sought horror in the preliminary studies for his *Medusa*. He made careful studies of *Heads of Executed Prisoners, Parts of Corpses* (1817–20) before tackling the great work. A somewhat macabre anecdote relates that while he was looking for possibilities for studying dead flesh, Géricault met in the street a friend who was fatally ill with jaundice and exclaimed in delight: "Oh, how beautiful you are!"

suffered hunger, thirst and despair for 12 days. There was said to have been cannibalism. Of the 15 who were eventually rescued only five survived. It is characteristic that Géricault pondered long on what point in the story would be most suitable for a major painting – the moment when the ship went down, the moment when the ropes snapped, or the mutiny on the raft. He decided for the moment when the despairing passengers catch sight of a ship, wave to it, but soon recognize they are not going to be seen. A comparison of the work as executed with the many preliminary sketches is highly informative. From the first to the last variant Géricault intensified the drama, seeking the moments that would best express both horror and pity. In the final sketch all the stops are drawn to create a theatrical vision of hell. The dead and exhausted already hang in the water, while the threatening sky hangs low, its color feverish and evil. The ship that might have rescued the people and has failed to see the raft can just be made out as a tiny dot in the distance. As the people wave their rags of clothing, hope turns to despair, in the recognition that this is useless. This is not God's divine power, as we see in Baroque paintings like Rubens' *The Shipwreck of Aeneas*; it is the representation of a merciless fate affecting people who were not necessarily well-known figures.

This is not the martyrdom of saints or national heroes, but the tragic destiny that can overtake people from very simple origins, and such an event is now regarded as a worthy subject for high art. As might be expected, the painting was immediately interpreted in terms of national symbolism. Géricault's "patriotic

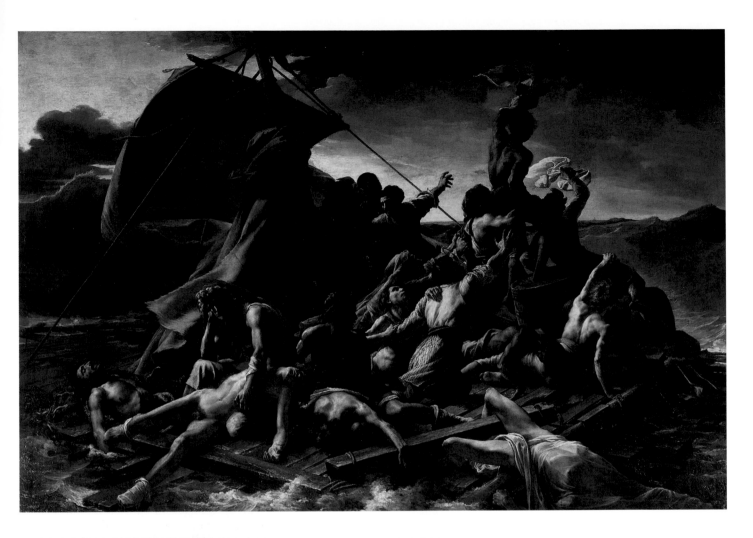

ABOVE:
Jean Louis Théodore Géricault
The Raft of the 'Medusa,' 1818–19
Oil on canvas, 491 x 716 cm
Louvre, Paris

LEFT:
Jean Louis Théodore Géricault
The Wreck of the Luisa de Mello (The Wreck,
The Storm), 1821–24
Oil on canvas, 14 x 25 cm
Louvre, Paris

"Fate painting" displaced the older religious forms in
the 19th century. Artists depicted man helpless at the
mercy of the forces of nature, either as a group, in
images of horror and despair, or as individuals, as here,
cast up senseless on a beach by a storm. The German
poet, Heinrich Heine, paints a similar scene in his poem
"The North Sea":

"Hope and Love – all dashed!
And myself, like a corpse
Washed up by the growling sea
I lie on the beach
The bare, desolate beach
…"

LEFT:
Giovanni Domenico Tiepolo
The Walk, shortly before 1800
Fresco from the former Villa Tiepolo
in Zianigo
Museo di Ca' Rezzonico, Venice

BELOW:
Giovanni Domenico Tiepolo
The Chatterbox
Fresco in the Villa Valmarana near
Vicenza

stood by him, like his friend the poet Baudelaire, and another painter Horace Vernet. It is not coincidental that when *The Raft of the 'Medusa'* had a much better reception when it was shown in London, or that Géricault was full of enthusiasm for English painting, confirming as it did his move to realism. He died at only 33, having been confined to his bed for a long time in pain and suffering after a fall from a horse, but he went on drawing. "I have painted nothing, absolutely nothing," he said in despair, just before his death. Consolation came too late. Subsequently the whole of the later 19th century looked up to him, and both copied and forged his works. Géricault was one of the major pioneers of Realism.

Italy

Italy occupied a special position in the decades between the last phase of Rococo and the Restoration. Art historians have often spoken of the "decline" of painting, and a certain standstill is certainly evident after the great festive period of Giovanni Domenico Tiepolo (1727–1804), Francesco Guardi, Antonio Canal and Bernardo Bellotto. The main impression given by the paintings is one of calm meditation, and this accords well with the themes. The Romantic attachment to ruins was not only the last manifestation of the Rococo, but is also to be found in the work of the Italian Veduta painters, most of whom came from

Géricault returned to the theme of shipwreck again between 1821 and 1824, but here he restricted himself to showing a dead woman washed up on rocks (ill. p. 411, bottom). He was not the only one to tackle this subject in the 19th century. We have already mentioned Delaroche's *The Bodies of Girls in the Tiber* (1855) and there is another painting of girls washed up on a beach, *The Death of Virginie* (1869, Musée Chateauroux, Bertrand) by James Bertrand (1823–87), derived from a novel written in 1788. And we should also recall *Virginie Found Dead on the Beach* by Alfred Dehodencq (1822–82), painted in 1849. These are all repetitions of the same theme, painted by the generation of artists around and after Géricault. Only a few years after Géricault's *Body on the Beach* Heinrich Heine described the same scene in his cycle "Nordsee" (The North Sea) of 1825–26.

Géricault's few landscapes, like *Heroic Landscape with Fishermen* (1817–20) and *Marine Painting* (1821–24, private collection, Switzerland), also show nature as a gigantic primeval force in a grandiose display of colors that is much more vivid than any image of God painted before. Man is only to be seen on the fringe and as if by chance, a puny creature in the cosmic immensity.

The public and the critics were not always favorably disposed towards the artist, and Géricault could be admonished for "incorrect lines" or too broad an application of paint. Only a few

Francesco Guardi
Venetian Gala Concert, 1782
Oil on canvas, 68 x 91 cm
Alte Pinkothek, Munich

Italy to give Germany her town views. Conversely, Italy's ruins also brought artists from every country in Europe to the south to seek inspiration at the original sites of the ruins.

The economic situation and the power positions in Italy were now such that very few major commissions could be given. The late frescoes by Giovanni Domenico Tiepolo in the Palazzo Ducale in Genoa were burnt in the 19th century. Shortly before 1900 Tiepolo, leading a secluded life, decorated the walls of his own villa in Zianigo near Venice with moral paintings and carnival scenes, and it is evident that he had moved away from Baroque patterns of composition (ill. p. 412, top). Among his finest wall paintings are the frescoes in the Villa Valmarana dei Nani near Vicenza (ill. p. 412, bottom), and here we already encounter the cool Neoclassical style in the figures and costumes. However, the works also surprise us with a Neo-Gothic Romanticism. In the last decades before the turn of the century the late Baroque interior changed as well; even great halls were darker, and Francesco Guardi painted concert-goers robed in more uniform colors against cooler walls (ill. p. 413). In Italy, as in France, it was the age of the bourgeoisie – some historians even say, of the masses. The anonymous group of people were themselves a subject for art, and this is very evident in the two paintings mentioned above.

Giuseppe Borsato
The Arrival of the Viceroy Eugène
Beauharnais and his Vicereine Auguste
Amalie of Bavaria in Venice, c. 1806
Oil on canvas, 63.5 x 92.5 cm
Private collection

BOTTOM:
Robert (Jacques François Faust) Lefèvre
Princess Pauline Borghese, 1808
Oil on canvas, 214 x 149 cm
Château de Versailles et de Trianon,
Versailles

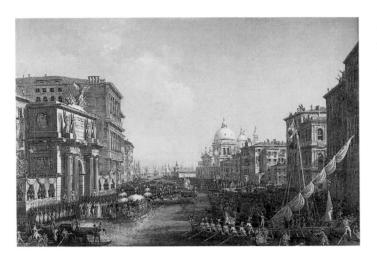

in 1808 in Versailles, showing her as *Princess Pauline Borghese*, in her robe of state (ill. p. 414, bottom). But another painting by Lefèvre bearing Pauline's features deserves attention for several reasons. It shows the princess, who had a great zest for life, as a mythological figure: *Pauline as Daphne Fleeing from Apollo* (ill. p. 415, top). The subject gave Lefèvre the opportunity to display his talents both as a practiced portrait painter and as master of the mythological subject. But that also shows that the Baroque tradition of allegory was not entirely broken. The landscape in the painting suggests Arcadia, but the Tempietto at Tivoli also documents the Princess' new domain. Necessarily the subject faced the Neoclassical Lefèvre with a particular problem: the movement of running figures could hardly be reconciled with David's demand for figures to be statuesque, their robes falling in quiet folds. Here the figures look as if they are floating, the fluttering cloths form sharp-edged bunches, and Daphne's light feet

A picture like *The Arrival of the Viceroy Eugène Beauharnais and his Vicereine Auguste Amalie of Bavaria in Venice* by Giuseppe Borsato (1771–1849) (around 1806, ill. p. 414, top) would hardly have been conceivable in this manner earlier. Apart from an ephemeral triumphal arch, the crowd of people themselves and the veduta are the main contents. They embody the festivity, in which the ruler and his spouse and court are only an integral part. But the cool objectivity, the way for which had already been prepared by Canal and Bellotto, was the appropriate vehicle for the new Napoleonic painting that was to predominate in Italy from now on, like the Emperor and his family themselves. Klaus Lankheit has drawn attention to Borsato, who is relatively unknown, and to this rather neglected period in Italian painting.

After Napoleon came to the throne and all reminders of the old dynasties were removed from the Palazzi, the demand for portraits of the new rulers and their society increased. After David and Gérard many of their pupils were given commissions, even if they were neither resident in Italy nor had competed for the Prix de Rome. The only requirement was to be good enough.

One of them was Robert Lefèvre (1755–1830), who was born in Bayeux and had studied under Regnault. He had made a name with mythological subjects, and was soon, rather over-hastily, being compared as a portrait painter to David and Gérard by his contemporaries, and entrusted to paint state portraits of the Emperor and his family. Lefèvre probably painted Napoleon's favorite sister, Marie-Pauline (1780–1825), more frequently than any other artist, although we are more familiar with her in the work of the Paris painter Giovanni-Francesco Bosio (1764–1827) and in Canova's generous rendering of her as *Venus Victrix*. After two earlier marriages Pauline married Prince Camillo Borghese in 1803, and Lefèvre's representative portraits include one painted

LEFT:
Robert (Jacques François Faust) Lefèvre
Pauline as Daphne Fleeing from Apollo
Oil on canvas, 119 x 105 cm
Private collection

BOTTOM:
Andrea Appiani
*Vicereine Auguste Amalie in Court
Dress*, 1806
Oil on canvas, 218 x 142 cm
Palace of Wolfsegg am Hausruck

His painting *Newton's Discovery of the Refraction of Light* (1827, ill. p. 416, below) demonstrates the change. It also reveals the emergence of a Romantic, narrative undertone. Newton's discovery is "presented" like a scene in a play. The child's soap bubbles stop the scientist in his tracks as he makes the spontaneous discovery. The picture can be seen as genre painting as well as history painting, and it also shows Palagi's inclination to psychological interpretation, a preference that was shared by Italian painters generally in the next few years, as we see with Giovanni Fattori or Domenico Morelli. The trend continued until the *Machiaioli*, the Realists, rejuvenated Italian painting.

Finally we may mention Francesco Hayez (1791–1882) as representative of the many other artists who brought the transition to the second half of the century. He was the most celebrated during his lifetime, and his long career enabled him to play a formative role in Italian painting throughout almost the entire

are like those of a ballet dancer. It is a feature frequently to be found in Lefèvre's work.

In Andrea Appiani (1754–1817) Napoleon commissioned the premier court painter of Italy within the country itself. The Lombardy master had become famous with a ceiling painting of *Cupid and Psyche* in the palace of Monza, and was celebrated as "pittor delle Grazie." He was immediately allowed to paint the conqueror of Europe as *Jupiter and the Conqueror of the Globe* in a fresco for the Palazzo Reale in Milan, and then immortalize the family. August Wilhelm Schlegel told Goethe at the time that "there is no one who can equal Appiani in Milan today." The painter used a very much softer application of paint than his younger colleague Pietro Benvenuti (1769–1844) or Pelagio Palagi (1775–1860), as is evident in his *Allegory on the Peace of Pressburg* (1808, ill. p. 416, top) and in the state portrait of the Bavarian princess, who is here shown with mild grace as *Vicereine Auguste Amalie in Court Dress* (1806, ill. p. 415, bottom).

Palagi's *The Nuptials of Cupid and Psyche* (1808, ill. p. 417) shows that painters in Italy at this period were well able to combine their dependence on France with their own studies of Antiquity and their encounter with Mengs. The painting would be inconceivable without the transmission of ideas from France. We see this again in the work of Vincenzo Camuccini (1771–1844). In his own day it was recognized that Palagi had adopted some elements from famous works of Antiquity – we can see that the *Jupiter Verospi* in the Vatican served as model, Psyche is oriented to the *Venus Victrix*, and Cupid derives from Raphael. Altogether, however, this is what Lankheit has called "a hitherto unknown softness in the Italian Neoclassical movement," particularly in comparison with the painting by Ingres a little later on a similar theme, although the trend only lasted a few years, in Palagi's work as well.

OPPOSITE:
Pelagio Palagi
The Nuptials of Cupid and Psyche, 1808
Oil on canvas, 254 x 188.5 cm
The Detroit Institute of Art, Detroit

For a subject like *The Nuptials of Cupid and Psyche* it was appropriate to seek formal models in the works of Antiquity or the Renaissance. Roman marble statues, like the *Venus Victrix* or *Jupiter Verospi* in the Vatican Museum provided the inspiration for the translation into paint, while the figure of Cupid owes much to a similar figure by Raphael.

LEFT, ABOVE:
Andrea Appiani
Allegory on the Peace of Pressburg, 1808
Oil on wood, 38 x 46 cm
State Pushkin Museum of Fine Art, Moscow

LEFT, BELOW:
Pelagio Palagi
Newton's Discovery of the Refraction of Light, 1827
Oil on canvas, 167 x 216 cm
Galleria d'Arte Moderna, Brescia

second half of the 19th century. His early work still shows the influence of Ingres in its delicate painting and severity of line, but he soon adopted the Romantic approach, as we see in *The Last Kiss of Romeo and Juliet* (1823, ill. p. 419, left), which is composed like a stage set. In *The Refugees of Parga* (1831, ill. p. 418) he reveals himself entirely as a didactic history painter, able to express patriotic feelings through the depiction of a particular event, and to elevate a subject like displacement and exile – which is still so relevant today – and imbue it with such strength of expression that it becomes a timeless accusation, albeit highly emotive.

Hayez' painting of 1850, so far known as *Meditation on the Old and New Testaments* (ill. p. 419), should rightly be called *Meditation on the History of Italy*. South of the Alps, painting, like society, had not reached a clearly defined position after 1848 and before the Wars of Liberation. Questions of religion and history, and whether the historical route that Italy had taken up to then was right or wrong, were acutely relevant in the middle of the century here, where the Enlightenment never really happened. The darkened glance of the beauty in this painting is not really directed at the viewer. She is sunk in thought, looking out of the canvas in a pre-occupied way. In her right hand she holds a folio bearing the words "Storia d'Italia," this is to say a

symbol of knowledge. Her left hand holds the symbol of faith, the Cross, that has played so great a part in Italy's history. But she has lowered it. Her naked breast, always a symbol of truth, is highly provocative when seen with the black cross of mourning. In attempting to interpret the arrangement of these iconographic elements one must ask: Is Hayez contrasting truth with faith, or placing history between faith and truth? Has he only shown the breast naked because man can always only half grasp the truth, between knowledge and faith? With her bent head and loosened hair the beauty seems to be weighed down with problems. Does her glance betray the difficulty of deciding between faith and knowledge, religion and science? Is she herself an allegory of Italy in the 19th century? The gaze with which this figure of *Italia* confronts the viewer creates a suggestive, almost hypnotic effect. She seems to be in a state between waking and dreaming. This is meditation that has not yet reached a solution, meditation in which grief predominates.

Francesco Hayez
The Refugees of Parga, 1831
Oil on canvas, 201 x 290 cm
Pinacoteca Civica, Brescia

The huge format of this painting has two
effects: firstly, the fate of the people who
were driven out of their native town in
1818, when the British handed it over to
the Turks, is raised to monumental
proportions, serving as a warning, and
secondly, the large scale draws viewers
into the scene, making them, so to speak,
witnesses of the event.

Francesco Hayez
The Last Kiss of Romeo and Juliet, 1823
Oil on canvas, 291 x 202 cm
Villa Carlotta, Tremezzo

Neoclassical and the Romantic Movement in Germany

Neoclassical tendencies at the end of the Rococo were largely
determined by France. European Princes, especially German,
naturally turned to French literature and drama, and either
obtained their architects and painters from France, or sent their
own to Paris. When court architecture was modernized in what
became known as the "periwig style," that is, the Louis XVI style
with its early Neoclassical forms, the strictly ordered decorative
painting with garlands, grisaille medallions and meander friezes
entered the interiors as well.

Francesco Hayez
Meditation on the History of Italy (also
known as *Meditation on the Old and
New Testaments*), 1850
Oil on canvas, 90 x 70 cm
Private collection, Rovereto

Anyone who wanted to be in tune with the age went to study in Paris or followed French style at least, like Januarius Zick (1730–97), who was born in Munich and executed the decorations in the Watteau room in Bruchsal. In his oil painting his colors became increasingly cooler as he turned from Rococo to Neoclassical. His landscapes and antique figures, like *Mercury in the Sculptor's Workshop* (1777, Mittelrheinmuseum, Koblenz), were still very much in the Rococo spirit, and these paintings have rightly been called "Neoclassicism of sensibility." But the antique subjects, and the confrontation with the new scientific ideas, already occupy an important place in his work, as we see in *An Allegory on Newton's Discovery of the Theory of the Force of Gravity* (around 1780, ill. p. 420). It is impressive to see how Zick has endeavored to integrate three of the crucial elements of his age: the Romantic love of ruins, the citation of Antiquity, and the actual subject of the painting, homage to the Enlightenment and modern science. Newton himself appears as the representative of the Enlightenment, between the temptations of the intoxicating drink that Bacchus is handing to him, and science, chained and bound to the earth. The subject is Enlightenment, but it is still allegorized in the Baroque sense. When, as we have seen (ill. p. 416, below), the Italian painter Pelagio Palagi handled the same theme later, also presenting Newton as the Enlightened thinker, the change that had taken place in just under 50 years from Baroque allegory to the presentation of a psychological and didactic message in a painting can hardly be clearer. However Zick did not develop his own Neoclassical formal vocabulary.

Instaed the German painters sought this in the original lands of classical forms, first in Italy, especially in Rome, and then in Greater Greece. All the painters who have since been known as the "Roman Germans" gathered in Rome, individually and in groups. Some spent only a brief time in the Eternal City, others, like Johann Christian Reinhart (1761–1847) and Joseph Anton Koch (1768–1839), married Italian women and stayed for the rest of their lives. The Berlin artist Franz Ludwig Catel (1778–1856) – who also died in Rome – has left a vivid impression of the life of the German artists in Rome in a painting commissioned by the crown prince and future King Ludwig I of Bavaria in 1824: *Crown Prince Ludwig in the Spanish Wine Tavern in Rome* (1824, ill. p. 421, top). The artists are sitting in a tavern opposite Mount Aventine, and Catel listed the men he has portrayed in a letter: the Crown Prince, gesturing to the landlord, beside him Berthel Thorvaldsen, the architect Leo von Klenze, Johann Martin Wagner, who was in Rome to buy antique figures for Munich's collection, then Philipp Veit, Julius Schnorr von Carolsfeld and Catel himself.

Remarkably, the search for Antiquity concentrated not so much on antique works of art as on their mediation by the Renaissance, and even more on the humanist tradition of the idealized Homeric Pantheon. This was the path taken by the Greek scholar Johann Joachim Winckelmann (1717–68), who was born in Stendal. In Ideas on the Imitation of Greek Works in Painting and Sculpture, published in 1754, and his History of the Art of Antiquity ten years later, he created the concepts of the "ideal," of "true beauty" the "beautiful and true" and the now-famous phrase – "noble simplicity and silent greatness."

Winckelmann had lived and worked in Rome since 1757, and in 1763 he became President of the Antiquity Society there. In the same year his Treatise on the Ability to Perceive Beauty was published. Winckelmann not only founded a new branch of scholarship – art history – but he also created a new ideal of Greece. The fashion for antique interiors in the late Rococo period now had a theoretical basis, and soon this in turn fundamentally changed what was expected of a painting.

One of the first to follow Winckelmann and devote himself to the new ideals was Anton Raphael Mengs (1727–79). During his lifetime he was regarded as one of the most important painters in Europe, and he was probably the first major representative of German Neoclassicism. His theoretical works, such as Thoughts on Beauty and Taste in Painting, 1762, largely derived from Winckelmann, and they soon dominated ideas in the Academies. Mengs was regarded as the "reformer" who pointed back to Raphael's purity of line. Nevertheless, he did not succeed in fulfilling his high claims in his own painting, and the goal was only to be achieved by younger men. Mengs' father, a miniature painter, gave him the Christian names of Antonio Allegri (Correggio) and Raphael, and instructed him to regard these

Johann Christian Reinhart
*The Invention of the Corinthian Capital
by Callimachus*, 1844–6
Oil on canvas, 65.4 x 135.2 cm
Neue Pinakothek, Munich

fundamental reason for the very characteristic difference between art in France and art in Germany: the "Kleinstaaterei," the German system of many small principalities, made Germany more provincial, but it also offered inestimable advantages over the pressure to centralize that dominated France. Many an artist was able to realize his own ideas by fleeing into the protection of a different ruler. Moreover, the pictorial vocabulary in the Protestant north of Germany differed markedly from that in the Catholic south, while in France uniform lines were laid down ruthlessly. And while the political situation largely determined the picture in France during the revolutionary decades, Germany looked to France as if from out of a glass bowl, while devoting itself to higher ideals: education to the noble, the search for the sublime, and not least – after secularization and a renunciation of denominational ties – the search for a new universal idea of the divine. The French sculptor David d'Angers said of a painting by Caspar David Friedrich: "This man has discovered the tragedy in landscape!" The Romantic elements now cultivated in Germany were a sense of being transported into alien worlds, the flight into the sacred grove, distant lands, history, the past. The new genres were the Arcadian, ideal, romantic and heroic landscape, and history painting.

Perhaps Johann Christian Reinhart, born in Hof an der Saale in Bavaria in 1761, was the first to see landscape as "classical." The subject of his painting is not nature as it lives and breathes, but foreground and depth, with elements that evoke moods in an ideal composition. Reinhart studied theology in Leipzig and then took drawing lessons from Adam Friedrich Oeser. In Dresden he was a close friend of Christian Klengel and Conrad Gessner, as well as Schiller, whom he frequently portrayed. He settled in Rome in 1789, dying there in 1847. As already mentioned, Carstens came to Rome in 1792 and Koch in 1794; Reinhart conducted a kind of private academy there that provided a center for nearly all the immigrant artists. What bound these early German landscape painters in Rome together was the idea of the freely-invented landscape, the heroic and the emphasis on the sublime. The writer Friederike Brun said of a painting by Reinhart in 1796: "The cool, whispering shade envelops you, and you are not alone – you are in the sacred grove …." Even later, when his art was long bypassed by the styles and concepts of others, Reinhart, at the age of 85, completed the painting that made him famous in his day: *The Invention of the Corinthian Capital by Callimachos*, which was commissioned by King Ludwig I of Bavaria (ill. pp. 424–25).

Joseph Anton Koch can probably be regarded as the great master of Neoclassical landscape. He continued the achievements of Reinhart, who was seven years older, in a way that corresponded to his very personal temperament. The adventurous delight in variation in his paintings corresponds to his

Joseph Anton Koch
Heroic Landscape with Rainbow, 1815
Oil on canvas, 188 x 171.2 cm
Neue Pinakothek, Munich

OPPOSITE:
Joseph Anton Koch
The Schmadribach Falls, 1821–22
Oil on canvas, 131.8 x 110 cm
Neue Pinakothek, Munich

lifestyle. He grew up in the mountains of the Tyrol, and felt the first urge to be a painter when he saw the ceiling painting in his local parish church. And it was the priest who arranged a scholarship for him, before he went to the strict Hohe Karlsschule in Stuttgart for seven years. Like Schiller before him, he fled from it in 1791, although he had been taught there together with the above-mentioned Schick by a pupil of David, Philipp Friedrich Hetsch, who transmitted the ideas of French Neoclassicism to many German artists, recommending them to study David. When Koch fled to Strasbourg, he cut off his pigtail on the bridge over the Rhine and set a Jacobin cap on his head. These were the outer signs of his inner journey into the camp of the idealists who were storming for liberty. He was determined to mark himself off from Hackert, saying: "I choose the sublime goddess and reject fashion ... a man who has not spent long in studying nature and processed it within himself could perhaps be a Hackert, but never a landscape painter."

We will understand Koch's ideal landscapes better if we compare them with the approach of those who preceded him. Koch criticized the "mechanical copying of nature". He preferred idealization, that is, the combination of several individual observations in nature to a whole that is not real but a painterly intensification. His statement that "merely to copy nature is far below art" says everything. In a letter written in 1797, offering his services as engraver to the publisher Frauenholz in Nuremberg when he was short of money, he said: "My main genre is landscape painting, historic or poetic landscape."

To understand what Koch meant by "historic" and "poetic" landscape, one need only compare two paintings which are also

cornerstones in his output: *Heroic Landscape with Rainbow* started in 1804 and finished in 1815 (ill. p. 426) and *The Schmadribach Falls* of 1821–22 (ill. p. 427). The difference is immediately apparent. *Heroic Landscape* affords a wide view into an idealized cosmic landscape. It is timeless and placeless, as if a curtain had been raised in a theater on a vision of archaic history. Biblical scenes could easily be presented in imaginary landscapes like this, as we see in Koch's *Landscape with Ruth and Boas* (Innsbruck, Ferdinandeum). Koch's pictures of the type of the *Heroic Landscape* give an idea of Ancient Greece that is derived from literature. Behind them are Poussin and the traditions of the 17th century. We are shown an ideal that is remote from reality, with shepherds, whose work appears to be effortless, and "people of few needs and great thoughts," as Goethe put it. This is the dreamlike, original state of a golden age. By abandoning aerial perspective, Koch is able to give a clear view into the distance, and both the peaceful rural scene in the foreground and the town with its temple in the middle ground, which is very remote from the present, are overarched by the rainbow, the symbol of eternal peace after the deluge. Koch painted several versions of the motif, and he himself thought very highly of it, praising it as "of a power, richness and clarity greater than any I produced before."

The second painting, of which there is also a second version, is in quite a different mood. We see a view out of the Lauterbrunnental to the Schmadribach falls in the Bernese Oberland. This brings us closer to Koch's idea of the "poetic" landscape, and to "heroic" landscape as well. By "poetic" he meant the combination and compression of several elements that are never experienced together in nature. Here, in this powerful depiction of the mountains, the view is directed both downwards and upwards at once. Peaks that in reality conceal each other now tower one behind the other, all in view.

This makes the Alps look as monumental as a range in the Himalayas. But at the same time details in the foreground are clearly visible. A central construction has been abandoned and perspective is deliberately "bent," so that the eye is taken from the nearby river over the peaks, as if in rapid flight. It is important to know that the "aggregate perspective" developed by the Veduta painters of the 18th century prepared the way for views like this. Even more important than this optical construction is the "heroic" statement in the painting. Koch himself provided an explanation of what a "heroic" landscape actually was. After walking to the Rhine Falls at Schaffhausen, he wrote in his diary in 1791: "An immeasurable vista opened before me ... the Alps, enveloped in cloud, raised their ancient, venerable heads to the heavens, which almost seemed to rest upon them ... The sublime drama moved my soul, that was suppressed by gods, to its innermost depths, my blood raced like the wild river and my heart pounded. It seemed to me as if the god of

softened the drama, and so how much more Romantic, indeed Biedermeier his painting is. It is more idyllic, despite the imposing mountain peaks. A couple of houses offer shelter to the wanderer, and the foreground looks as if one could step on it, unlike the isolated scene and wild, forbidding water that create so great a distance to the viewer in Koch's painting.

This raises the question of truth and reality, of the ideal, and the real. A critic enthused about Koch's painting in 1829: "*The Schmadribach Falls* stands as a work of immense truth and intensity, outdoing all others ... The formative and destructive power of nature is manifest here in its grandiose truth." So the concept of truth was not understood as the depiction of real conditions, but meant evocation of the timeless, the eternally valid of a higher order.

King Ludwig I of Bavaria, who bought Koch's *Schmadribach Falls*, intending to transform Munich into an "Athens on the Isar," also noticed Carl Rottmann (1797–1850), a landscape painter born in the Palatinate, and gave him several major commissions. Two series need to be mentioned: the one known as the Italian cycle, painted in 1833–38 from journeys undertaken in 1826–27, and particularly the Greece cycle, which was intended for the arcades in the Hofgarten in Munich, and was to be entirely in the antique style. The journeys proved extremely arduous and the result was initially disappointing, for the rich vegetation and joyous life that was expected in Munich and idealized in the paintings of the early Neoclassicists were nowhere to be found in a land sucked dry and ravaged by war. The historic sites that continued to blossom in the humanist imagination were stony, the landscapes eroded and bare. But Rottmann succeeded in creating a new vision out of this sobering reality. He transmitted the heroism of the sagas to the topography, which itself now became the active hero. Like Koch, Rottmann showed the earth formations in a struggle against cosmic forces, as if Greek history could be read off from the shapes with their shattered stones or from the former battlefields ravaged by storms. However, he intensifies his subject, taking it into the realm of the fantastic. *Sparta-Taygetos* (around 1841) or *Marathon* (1848, ill. p. 429, bottom) can be seen as the ultimate expression of the heroic landscape. Originally there were to be 38 paintings, but finally 23 were executed, all in the encaustic technique. Rottmann's affinity with the Romantic landscapes of Caspar David Friedrich is very evident, although he has used a theatrical lighting effect. Often the shadows in the foreground intensify the illuminated center of attention like a stage on which clouds and mountains are engaged in dramatic struggle with each other. But as in Friedrich's paintings, humankind, as shown in the painting and as the viewer, is intended to be "overwhelmed" by cosmic forces.

In complete contrast to this, the Munich court painter Wilhelm von Kobell (1766-1853) painted decidedly sober views of life on earth. He also came from the Palatinate and was the son of the landscape painter Ferdinand Kobell. Stylistically he based

the Rhine were calling to me from the sharp pointed rock: 'Arise, act, be steadfast in thy strength and action, make a powerful stand against despotism ... be as unshakable in defense of the freedom of mankind as the rock which I am combating' ... the seven colors of the rainbow of peace floated three times one above the next over the misted waves" Koch personalizes nature and sees the struggle of the elemental forces as a mission. There is not another mention in Koch's writings – or in those of any other artist of his time – of a Christian God. Spinoza's pantheistic concept of "deus sive natura" also occurs in Koch's diary entry here: "Everything is total unity in the manifold." That was to formulate the new ethical imperative in "sublime" and consequently "elevating" views of nature.

Shortly after he arrived in Koch's studio in Rome in 1824, Ludwig Richter, to whom we move forward here, painted a kind of counterpart to the *Schmadribach Falls*: namely *The Watzmann* (ill. p. 428). A comparison shows where the younger artist

Wilhelm von Kobell
The Siege of Cosel, 1808
Oil on canvas, 202 x 305 cm
Neue Pinakothek, Munich

Carl Rottmann
Marathon, 1848
Encaustic on stone, 157 x 200 cm
Neue Pinakothek, Munich

his work on Dutch art. He spent time in Paris, but evaded the influence of the theatrical battle scenes in vogue there, as his large painting *The Siege of Cosel* (1808, ill. p. 429, top) shows. He has placed his groups of horses like figures on a chess board, and the painting can be "read" like a strategic map. Kobell does fulfill David's demand for clarity and emphasis, but he also veils these in his own very personal stylistic language. His appealing, sunny landscapes are crystal clear, motionless immortalizations of the area around Munich. In *View of Lake Tegern* (1822, ill. p. 430) the elimination of anything that is not essential is remarkable, as is the artificial compilation of typical local elements. This is an almost schematic, Biedermeier world, sane and whole, clean and sunlit. The contrast to Rottmann could not be greater.

This is perhaps the point where we should consider the style and compositional practice of two painters who, almost of the same age, were also both architects, painting in an architectural style. They are Leo von Klenze (1784–1864) in Munich and Karl Friedrich Schinkel (1781–1841) in Berlin. Both studied in Berlin

under Friedrich Gilly, both visited Italy, both went to Paris, and both then occupied high office in the state as architect exerting a determining influence on the appearance of their cities. The extent to which the design practice of architects was built upon, and depended on, painting at this time should not be underestimated. It explains why the painter-architects worked in both genres. The "ideal" presentation of the design had decisive weight in architectural competitions. The sketches and paintings made at original antique sites were not only proof of the ability to paint, but they also proved that the architect had a knowledge of the models that the age eagerly pursued. The ideal could, of course, be conveyed much more convincingly and boldly in such projections than was feasible architecturally or financially. So many of Klenze's and Schinkel's paintings are, to a certain extent, idealized proposals for styles, if not utopian visions. Klenze's ideal view of *The Acropolis at Athens* (ill. p. 431), painted in 1846 from a sketch he had made in 1843, had two purposes. First, it demonstrated his competence in the reconstruction and care of historical monuments in Athens, which was then governed by a member of the Bavarian royal family, and second, the measurements he took on the spot provided data for the propylaeum on Königsplatz in Munich. And if his painting lacks the drama we are familiar with in the heroic landscapes by his friend Rottmann, the sober Klenze also sublimated his ideal or reconstructed views of Udine, Zante, Pisa, Pirano, and Amalfi with restrained heightening. In accordance with his love of Antiquity and the Renaissance, Klenze chose his models mainly from these epochs, and the same can be said of Schinkel and his inclination to Gothic.

Schinkel's *Cathedral above a Town* (ill. p. 432), painted around 1813, was burnt in 1931 in the Glass Palace in Munich, but a faithful copy will show us Schinkel's idea just as well. Although the Gothic cathedral rising high above the town dates from much earlier than Klenze's painting, Schinkel's more modern style is immediately apparent. The Romantic trait is expressed in a monumental quality that would appeal to national sentiment, and during the Wars of Liberation it seems literally to have lifted German architecture on to a pedestal. The cathedral rises into the evening sky, sublime and flooded with light, which was also taken as a warning sign. The impression of remoteness is intensified by the long rising flight of steps and the high columned bridge that links the cathedral with the town. The whole image celebrates holy dignity. The concern here is clearly not to emphasize denominational religion, but the Christian culture of the German Fatherland generally. Schinkel's comment: "Architecture is in the work of man what landscape is in the work of God" is itself an interpretation of the painting. It is characteristic that in the following decades Gothic Revival church architecture attempted to isolate and emphasize its buildings in

this or similar ways. Only one other point need be mentioned: Schinkel, painter and art philosopher, the architect of numerous buildings, including Gothic Revival ones, has presented this cathedral as an intact building, and although it is heightened here emotionally to make it a universal work of art, it could certainly have been built. This distinguishes his Neoclassical painting very decidedly from the Romantic church ruins by an artist like Caspar David Friedrich (ill. p. 433, top).

Karl Friedrich Schinkel
Medieval Town by Water, or *Cathedral above a Town,* after 1813
(Copy by K.E. Biermann c. 1830)
Oil on canvas, 93.8 x 125.7 cm
Neue Pinakothek, Munich

OPPOSITE:
Caspar David Friedrich
Abbey in an Oak Wood, 1809–10
Oil on canvas, 110.4 x 171 cm
Schloss Charlottenburg, Berlin

A comparison of the two paintings clearly shows the difference between Schinkel and Friedrich and their utterly contrasting views of Romantic landscape. Schinkel shows a medieval town at its peak, a vision that he has raised to monumental quality in national pride. The longing to resurrect the national idea is evident, and we can quote Schinkel himself on this: "The charm of the landscape is increased if one allows the traces of human activity to stand out very clearly... so that one can see a people enjoying the bounties of nature in their earliest golden age... or the landscape should display the culture of a highly educated people in all its abundance..." Friedrich's *Abbey in an Oak Wood,* on the other hand, is the expression of grief at the loss of a great past. The artist has chosen to depict an architectural ruin; it may testify to the sublimity of the past, but it is a monument in a graveyard.

OPPOSITE, BELOW:
Caspar David Friedrich
The Monk by the Sea, 1808–9
Oil on canvas, 110 x 171 cm
Schloss Charlottenburg, Berlin

Georg Friedrich Kersting
Caspar David Friedrich in his Studio, 1811
Oil on canvas, 51 x 40 cm
Nationalgalerie Staatliche Museen zu
Berlin – Preussischer Kulturbesitz, Berlin

BOTTOM:
Georg Friedrich Kersting
On Outpost Duty, 1815
Oil on canvas, 46 x 35 cm
Nationalgalerie Staatliche Museen zu
Berlin – Preussischer Kulturbesitz, Berlin

Friedrich Schelling, Friedrich Schleiermacher, August and Friedrich Schlegel, and, above all, Goethe. Hölderlin commented on Friedrich's paintings: "My heaven is of iron and I am of stone." A monk standing by the sea facing the immensity of the cosmos is no more or no less than the stones of prehistoric burial mounds. He is transient, simply absorbed in the cosmos of which he is a tiny particle. The figures in Friedrich's paintings, who are occasionally standing or sitting on large stones, looking at the horizon, are also waiting for an answer that does not come. Samuel Beckett has expressed in modern language the same "lack of fulfillment of meaning" of being in his play *Waiting for Godot.* This cosmotheistic world view is one of the basic conditions of Friedrich's art. The other is certainly the very personal spiritual language of these paintings. The basic mood is lethargy, but it would be wrong to call this pessimism. It is a thoroughly sincere but inherently oppressed view of life, which seems to be rooted in the soul of the artist himself. It not only speaks from his self-portraits (ill. p. 493, top left), but was also felt as such by his contemporaries. Friedrich's friend Georg Friedrich Kersting (1785–1847) portrayed the pensive Friedrich in his bare studio several times (ill. p. 434, top left). Kersting was a draughtsman and

Caspar David Friedrich (1774–1840)

There could probably hardly be a greater contrast in German landscape painting at this time than that between the "heroic" manner which was the aim of Koch and his circle, and the pantheistic world view, based on subjective sensibility, such as is demonstrated by the landscapes of Caspar David Friedrich. Friedrich does not show nature as it is, either, but unlike Koch he projects his own emotions on to it.

This is why Friedrich fiercely attacked Koch and his circle. According to him: "What they see in a curve of 100 degrees in nature… they compress into an angle of 45." By contrast, Friedrich's paintings have a solemn emptiness, with only a few carefully calculated elements subdividing the surfaces. His landscapes are imbued with a harmonious severity and a puritanical sparseness, which in turn bears unintentional traits of formal Neoclassicism. But these are only outer appearances, immediately forgotten through the inner force of the statement. All Friedrich's paintings are concerned with the dialogue between the individual and the immensity of the cosmos, a dialogue in which the participant waits in vain for an answer from God. To call Friedrich's paintings "religious," as has often been done, does seem understandable at first glance, but religion here can only be understood in a philosophical, not a denominational sense. This is the painted evocation of a philosophy shared by the group of friends who were inspired by Spinoza's pantheism and of which Friedrich was a member. The group included the philosophers

Caspar David Friedrich
The Cross in the Mountains, or *The Tetschen Altar*, 1808
Oil on canvas, 115 x 110 cm
Gemäldegalerie, Dresden

painter of great originality, and his paintings take us into a more carefree Biedermeier world. *On Outpost Duty* (ill. p. 434, bottom right) is an appealing document of the Wars of Liberation and an intimate monument to his friends Körner, Friesen and Hartmann, who fell in the war.

The wife of the painter Gerhard von Kügelgen, Helene-Marie, wrote a record of her visit to an exhibition of Friedrich's *The Monk by the Sea* (ill. p. 433, below). She said: "A wide endless space. Beneath it the restless sea, and in the foreground a bright strip of sand, where a hermit in dark robes or cloak is creeping around. The sky is clear and indifferent in its calm; there is no storm, no sun, no moon, no thunder – indeed, a thunderstorm would have been welcome, would have been a comfort to me, for at least then there would be life and movement somewhere. There is no sign of a boat, no ship, not even a sea monster on the endless surface of the sea, and not a single blade of green is growing from the sand, just a few seagulls flutter around, making the lonely scene seem even more vast and lonely." This contemporary report gives a good description of the picture, and it also betrays much of its basically pantheistic tenor: "The sky is indifferent in its calm!" And the critical observer laments that she cannot even see a sea monster, while acknowledging that the seagulls only make the loneliness more intense. This is a good account of the artist's underlying intention, which is to reflect the relation between man and the cosmos.

Modern psychology has made us well aware that decisive experiences form character and determine people's mode of expression. So we will not be surprised at the melancholy in Friedrich's paintings when we learn that, the sixth of ten children born to a soap boiler in Greifswald, he lost his mother at the age of seven. When he was 13, an accident occurred that, perhaps subconsciously, formed part of the shadow that seemed to darken his temperament throughout his life. While ice skating he was saved from drowning by his younger brother Christoph, but Christoph himself drowned in the icy water before his eyes. Even those who hesitate to employ psychological interpretations will hardly deny that Friedrich's various "sea of ice" paintings (ill. p. 322) must be seen in relation to this traumatic experience.

At the age of 20, Friedrich went to the Academy in Copenhagen, where Jakob Asmus Carstens, Johan Christian Clausen Dahl, and Philipp Otto Runge were fellow students, all receiving their initial tuition. Four years later, in 1798, Friedrich moved to Dresden, where he was to remain for the rest of his life, except for trips to the Harz, the Erzgebirge and the Riesengebirge, to Rügen and back to his native Pomerania. In Dresden he was surrounded by a small group of serious admirers: his former fellow students Runge and Dahl, fellow painters Kersting, Kügelgen and Carus, and then the writers Kleist, von Arnim, Brentano and even Goethe, who spoke well of Friedrich. The Jena group also gave Friedrich something of a reputation outside Dresden, and he became a contributor to the periodical *Athenäum* in Berlin, with his friend Schleiermacher. In the house of Professor August Wilhelm Schlegel, who was then editor of the General Literature Periodical, he met the Schlegels, Schelling, Fichte and Novalis. But the links with this noble company were only of brief duration. After 1820 Friedrich's paintings were eagerly sought – even Crown Prince Frederick William of Prussia and the future Csar Nicholas I came to his studio. But the ties loosened again, and in the last years of Friedrich's life they had gone altogether. Styles changed and passed him by, and he was not flexible. Frau von Kügelgen said: "If my father had not regularly drawn the attention of visitors to Friedrich, and publicized him as much as possible, the greatest landscape painter of his time would have starved." In fact, Friedrich was forgotten soon after his death, and it was not until the early 20th century that the Norwegian Andreas Aubert drew attention to him again.

It is not coincidence that he was so thoroughly forgotten. His paintings were so subjective, so committed to certain moods, that, although some may have admired them, very few could really stand them. Achim von Arnim said after visiting an exhibition: "It is a good thing these paintings cannot hear, otherwise they would have hidden themselves completely; the criticism is so harsh, the people are firmly convinced the pictures are on display here for some secret crime which it is their job to uncover." It was the freedom of the artist to document his own subjective experience within the field of tension of man, world and cosmos that was felt as provocation. The step would take the artist into the modern movement, and indeed the nature and tenor of the criticism has remained the same. Friedrich was not painting – as Richter, Schwind, and Spitzweg did later – to lift spirits, he was trying to present the tacit truth of the force behind nature, and the sublime silence of a God who, according to Spinoza, could

Caspar David Friedrich
The Wanderer above the Sea of Mist, c. 1818
Oil on canvas, 74.8 x 94.8 cm
Kunsthalle, Hamburg

only be grasped as a *logos*. In this view Friedrich's Romanticism – and that of Runge – cannot be seen as a counter movement to the Enlightenment, but was rather its ultimate fulfillment!

Many, including Kammerherr Basilius von Ramdohr, urged Friedrich to paint more appealing, less oppressive landscapes. They meant well, but they had totally failed to understand Friedrich's artistic aim. But von Ramdohr did show real understanding of *The Cross in the Mountains* (ill. p. 435) – and perhaps he was the only one who did – when he called it a danger to denominational religion. For on a closer inspection it was apparent that the religious sentiment which the painting appears to express at first sight is heretical cosmotheism, and it was suspected of being "mysticism projected onto nature." Friedrich painted the picture in 1808 to a commission from Countess Theresia Maria of Thun-Hohenstein for the little Palace of Tetschen, which did not have its own chapel. Even while the painting was on show in Friedrich's studio, it caused controversy. The arguments focused at first on art theory. He was accused of failing to observe the rules of perspective and of not making the position of the viewer clear enough. Ramdohr warned that landscape could have the audacity to sneak into church as altar art. But Kleist and the painters Hartmann and Kügelgen defended Friedrich. In fact the break went much deeper. Friedrich's "altarpiece" – it is still often misinterpreted as a deeply religious work – is a farewell to denominational faith as such, as Ramdohr rightly suspected. Marie von Kügelgen recalled: "The painting deeply affected all who entered the room, for it was as if they were entering a temple. The loudest talkers lowered their voices and spoke in hushed whispers, as if they were in a church." The feeling that filled all who entered the exhibition at the time was not necessarily religious, but was respect for the sublimity with which Friedrich had imbued his painting. This altarpiece contains no image of God, but shows an artifice made by human hand and set up on high as a religious symbol. It is set up against the eternity of nature, but its back is to the viewer. Trails of plants, symbols of transience, are creeping up the pole. Man has created his own God, and he now sets up the image as invocation in face of the "eternal," the illuminated cosmos, "deus sive natura." Friedrich himself left an important comment. He compared the sun, sinking behind the peak, with the Old World that went down with Christ's doctrine. What is "unshakable" is not religious doctrine, but only "belief" in it. In a letter to the painter Louise Seidler he explains the meaning of the cross in *Cross on the Shore of the Baltic* (1815, Berlin-Charlottenburg): "Let it be a comfort to those who see it as such, but to those who do not see it as such, a cross." The double meaning is not only in his words, but was also a central element in his paintings.

Friedrich's attitude to Christianity must be seen as "modern," like that of Freiherr von Hardenberg (Novalis), who wrote: "There are only three epochs in Christianity: the Catholic, the Lutheran, and the (new, contemporary form of the) Idealists."

Friedrich also turned decisively against fellow painters who sought their salvation in a retrogressive flight into a manifestation of religious sentiment. "Is it not rather offensive, indeed often repulsive, to see withered Marys with their starving Christ child on their arm, clothed in paper robes…? They ape all the mistakes of the old masters, but what is good in those paintings, the deep, pious, childish spirit – that cannot be imitated and these hypocrites will never succeed in doing so, even if they take the pretense as far as becoming Catholic." He was referring to the Nazarenes or, as Goethe called them, "those spineless creatures with their monkish habits."

In view of this, the question arises whether the monk in the painting *The Monk by the Sea* is also intended in an anti-clerical sense. With her sensitive perception Frau von Kügelgen said he was "creeping around" in the picture, and so she does not appear to have felt his figure as sublime. His appearance before the omnipotence of nature is like a prayer which even the monk is not addressing to his God in church – he is addressing it outside in natural surroundings to a force that is incomprehensible or cannot be depicted. This painting is one of the most exciting works created in the 19th century. Never before had the impotence of human existence been compared so pitilessly with all-embracing nature. Certainly, Turner also made similar statements, but his swirling drama is very different from the emptiness, silence and isolation of Friedrich's vision of eternity. That there is "nothing to be seen" in this work, as Frau von Kügelgen wrote, gives the painting its meditative effect. When one steps closer, so that the frame is no longer in the field of vision, the view of nature opens like a panorama and appears limitless. Clemens Brentano said: "It is as if one's eyelids were cut away."

Around 1818 came *The Wanderer above the Sea of Mist* (ill. p. 437). Again Friedrich has shown a lonely figure confronting nature in astonished reverence, and one may well recall Goethe's line: "Über allen Gipfeln ist Ruh" (Calm rests on all the peaks). This is an anticipation of the philosophy Nietzsche expressed in "Zarathustra" and "Vor Sonnenaufgang" (Before Sunrise). Zarathustra is also remote from the world, on a high mountain, "six thousand feet beyond man and time," as Nietzsche said, a man meditating above the mists. But in Friedrich's painting the sublime shudder in the face of natural phenomena is intended without literary references, as Wagner was later to see.

Friedrich only rarely incorporated aspects of his own life in his painting, but where he did the statement loses nothing of its objective force. After his marriage to Carline Bommer in 1818, a step that astonished his friends, he produced paintings that include the figure of a woman. *Man and Woman Looking at the Moon* is probably one of the most ardent acknowledgments of their relationship (ill. p. 438, top left). According to a fellow painter, Johan Christian Clausen Dahl (1788–1857), the motif was painted in

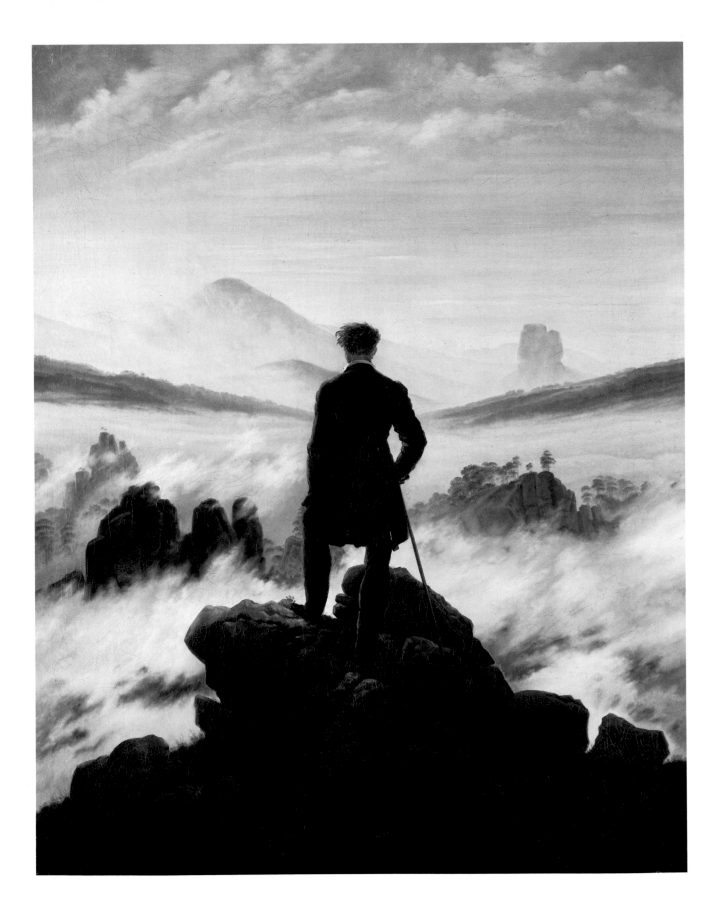

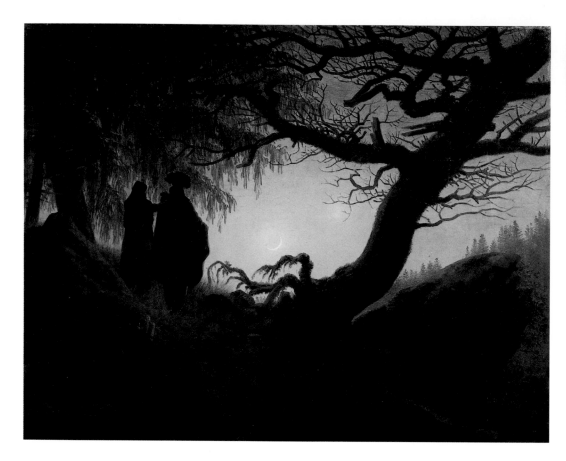

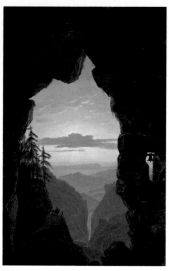

1819, and was repeated more than once. Dahl said he recognized the figures of Friedrich and his wife in the painting. A later dating, as has been suggested, is hardly convincing, in view of the variant on the motive, *Two Men looking at the Moon* (Dresden), which was probably only painted after the death of Friedrich's pupil August Heinrich in 1822. Nor need one necessarily accept the Christian interpretation of the *Moon* painting, where critics have claimed that the dead oak and what is said to be a prehistoric burial stone represent the collapse of heathen times, while the fir trees are Christianity. These ideas were probably fueled by the pious desire that soon emerged in the 19th century to ascribe Christian faith to the cosmotheist Friedrich.

Now let us turn to two other paintings in which Friedrich presents a landscape in symbolic interaction with groups of people. *Chalk Cliffs on Rügen* (ill. p. 439) was painted in recollection of his honeymoon in 1818. We may assume that the figures are the painter, his wife, and his brother Christian. Again a double meaning is apparent, and the first impression of light and happi-

ness is counteracted on a closer inspection. The three have ventured right up to the edge of the precipice. The man on the right is relying on the bush to prevent him from falling, while the woman is securing her hold by sitting down, and is also clutching a bush while she points down. The oddest figure is the painter himself; his hat seems to have fallen in the grass or been tossed down in haste. He has crawled to the edge, feeling his way carefully, as if wishing to plumb the dizzying depth into which his companion is pointing. The double meaning between recollected experience and the "profound depths" of the symbols of life is evident. The view of the sea with the two sailing boats looks like a chasm that has opened beneath the figures, framed by the cliffs and the intertwining tops of the trees. The similarity of this pictorial idea with Schinkel's *The Gate in the Rocks*, painted in 1818 (ill. p. 438, top right), is so striking that one must wonder whether there has been influence. But with his daring construction Friedrich has succeeded in making a visual combination of two extremes: the plunging ravine with its view of the sea and at the same time the endless horizon. This bent

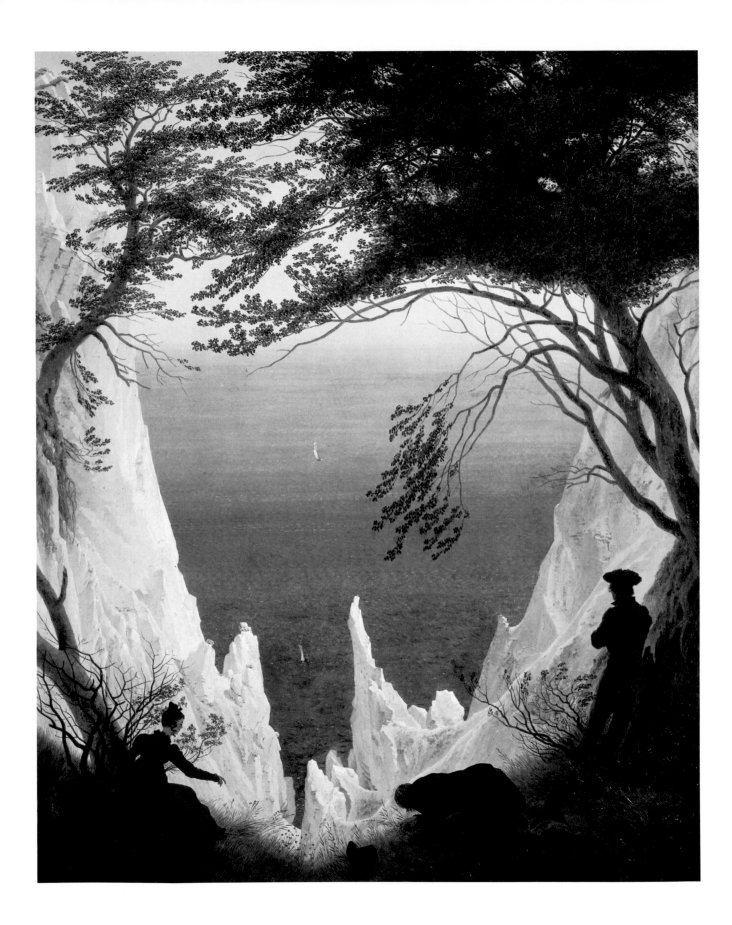

Caspar David Friedrich
The Stages of Life, c. 1835
Oil on canvas, 72.5 x 94 cm
Museum der bildenden Künste, Leipzig

perspective forces the viewer to look from the depth in the foreground into the distance, and its boldness could hardly be exceeded. Nor would Schinkel have wished to do so. It is evident that this depiction invites multiple interpretations. The cheerful daylight mood is intertwined too remarkably with the symbol of death in the terrifying drop.

Again Friedrich takes his viewers to the edge of the sea, and again he presents them with symbols of life in an image with double meaning. In his painting *The Stages of Life* (around 1835, ill. p. 440) Friedrich again, as so often, describes the time of day through a mood of transition, here between sunset and moonrise. The waxing moon is just visible. The evening has brought the group out, and their number corresponds to the number of the ships we can see. That the two unseaworthy sailing boats correspond to the children is an obvious interpretation. Then the large ship furling its sails to return to port is a symbol of the aging painter himself, here looking at his family. So the ships should be seen as metaphors for the journey through life. Names have been put forward for the people, but that is not what really matters here. Much more informative is the relationship between them. Is the old man being called to join them? Leaning on his stick, he is closer to the old abandoned and upturned dinghy. One only need see what each of the figures is doing. The children are absorbed in their game with their flags, and nothing will distract them. The young woman – or elder daughter – has eyes only for the children. The middle-aged man is turning, evidence both of his concern for the children and a dialogue with the old man. The latter is the only one who can see the whole scene, the landscape, his loved ones and the eternity that awaits him.

The "externalities" of Friedrich's style were imitated, but the "inner truth" of his art was what lifted it above the work of his followers, and none could imitate that. For his paintings must be seen as "outpourings of the heart," to quote Wackenroder, in which two elements combine: the artist's search for the all-embracing unity of existence that was inherent in the age, fueled by the loss of a defined religion, and at the same time Friedrich's very particular emotional character, which made him take general questions personally all his life. A man driven by his own inner pain could express everything that others could only grasp as an idea of "Weltschmerz" (cosmic pain), and that is why they often drifted into sentimental variations. If Friedrich's work seems so important to us today, it is because our metaphysics is basically the same, still shaking religious faith. Friedrich owed his life to the death of his brother, and he dedicated his life's work to death. His gnarled branches are like monuments, while the cold of the mountain peaks and the impenetrable mist are images of death as a precondition for new existence. In this regard, his search for answers still corresponds to the unresolved questions of our time.

Man looking at the sunset or the immense expanse of the sea was not Friedrich's pictorial invention; it was a contemporary

of his time with the metaphysics of the observing scientist. There is good reason to assume that Carus also encouraged his friend Friedrich in his pantheistic views.

Dahl settled in Dresden in 1818 and was appointed tutor at the Academy at the same time as Friedrich. He too became a member of the group of friends around Tieck and Carus. But quite unlike Friedrich, who never saw Italy, the Scandinavian was fascinated by his impressions of the ever-changing landscape there. It was not the classical landscape but the landscape of light and the different morphology between Italy and the North that inspired him to paint, mostly in small format. Stylistically little linked him to Friedrich, although thematically they shared an interest in mist formations and changing moods of light, which Dahl treated more sketchily, thus giving a strikingly modern appearance (ill. p. 442, top). Dahl soon became the most famous Norwegian artist of his time, and he is often seen as a forerunner of *plein air* painting. He

phenomenon, and its roots are to be sought in the change in religious views. The observation of nature as service to God became a general pictorial image, and it was repeated in countless variations that went right through to a touching sentimentality.

Three other painters who were closely associated with Friedrich were Carl Gustav Carus (1789–1969) from Leipzig, Norwegian Johan Christian Clausen Dahl (1788–1857), and Karl Eduard Ferdinand Blechen (1798–1840) from Berlin. Carus, who was physician to the royal family in Dresden, painted in his leisure time, but it was his writing on art theory that made him a leading scholar of his period. In 1831 his Letters on Landscape Painting, appeared, in which he attempted to refute the accusation from Cornelius in 1825 that landscape was at most "moss or undergrowth on the great trunks of art." He had taught himself the techniques of painting, and found his own way intellectually. Friedrich had already demonstrated his inner conviction that painting should be "philosophy," and so he became a close follower and associate of the artist. In *Pilgrim in a Rocky Valley* (Berlin), for example, he adopted the view of a figure seen from behind which Friedrich had introduced; here he is hastening ahead of the viewer into the picture and anticipating his view. Carus' *Gondola on the Elbe near Dresden* (ill. p. 442, bottom right) follows the same principle, so that the viewer experiences the boat trip. At the same time the view out of the boat is framed like a vista from the window, creating a picture within a picture. This was an effect that Friedrich used in many of his interiors where he shows a view out of a window (as in *Woman at the Window*, ill. p. 472, bottom left).

In 1867 came Dahl's Observations and Thoughts before Selected Paintings in the Dresden Gallery. His Recollections and Memorable Moments, tell us much about the concern of an artist

Karl Blechen
Building the Devil's Bridge, 1833
Oil on canvas, 77.6 x 104.5 cm
Neue Pinakothek, Munich

At first sight the picture seems full of mystery, indeed it creates a sense of unease. The very title seems designed to evoke a shudder, and this impression is strengthened by the darkening evening with its long shadows, and above all the building crane, which looks like a gallows. The viewer may well be attracted by the Romantic mood of the painting, but the true message is clear, and it is rather sombre. Man is bringing even the most distant and seemingly inaccessible regions under control through civilization and technical advance, and he is mastering the aspects of nature that have till now seemed unapproachable and fearful. But there is also allegory here – it is in the reference to transience. The new bridge that is being built will one day be as crumbling as the old one is now.

BELOW:
Karl Blechen
The Bay of Rapallo, c. 1829–30
Oil on wood, 25 x 34 cm
Nationalgalerie, Staatliche Museen zu Berlin – Preussischer Kulturbesitz, Berlin

certainly shared with his Dresden friends the new world view in which great and small, the important and the minor, are united in the painting as elements of equal significance.

Perhaps the only artist who was gifted enough to continue Friedrich's work was the Berlin painter Karl Blechen, 24 years his junior. He too first used an abstract color symbolism, but rejected the mysticism of Friedrich's view of nature. To him, even the strangest moods of nature had a physical explanation even though they were worthy to be represented for their own sake. Unlike Friedrich, Blechen does not suggest a depth of mystery in his work. He does not see nature as a wonder, but seeks to open the viewer's eyes to what can at most be called the "wonderful" aesthetics of nature. But he goes further and, as in *Building the Devil's Bridge* (ill. p. 443, top), demystifies pictorial elements that look symbolic. On a closer inspection it is not the open question that remains, as it is with Friedrich, but a simple answer: the "gallows" is in reality only a crane, the ghostly light in the dark gorge is a real daylight phenomenon in these mountains, and the figures who are lying down do not have a double meaning, but are simply workmen who are tired. We may surmise what will happen to the new bridge, but that is the way things go. This is how Blechen demolishes the ambivalence of the frightening visions that were so popular and so frequently painted at this time.

Particularly after 1828/29 Blechen's impressions of his travels in Italy were already taking him to the verge of naturalism. Occasionally his effects are theatrical, but these derive from the drama of nature itself, like the coming thunderstorm in *The Bay of Rapallo* (ill. p. 443, bottom). Here Blechen, who only survived his teacher Friedrich by two months, is close to the Frenchman Camille Corot (1796–1875), who was two years older.

In his proximity to Corot and the new approach to landscape that became known in France as *paysage intime*, Blechen was a forerunner of the younger generation in painting of the next decades in Germany. It was their aim not to represent natural phenomena in the studio from drawings made outside, but to record these straight on to the canvas in the open air. This prepared the way for Naturalism.

Philipp Otto Runge (1777–1810)

Another pair of opposites stands out among the main figures in the German Romantic movement – Friedrich and Runge. They

Philipp Otto Runge
The Hülsenbeck Children, 1805
Oil on canvas, 131.5 x 143.5 cm
Kunsthalle, Hamburg

both emerge in these decades as highly individual personalities. Neither saw himself as owing a debt to a school, for the Copenhagen Academy, where they had both studied, did not form a very characteristic style. Nor did either give rise to a real movement, apart from superficial imitators. Both were such strong characters that they are often set up against each other to be honored as the two most outstanding painters of their time. Each sought his own formal language in order to express a new view and approach. They were not concerned to depict a real mood in nature; what was seen was to become the vehicle for the artist's own interpretation. The soul sought answers in the soul of the world, to borrow one of Schelling's terms. But while Friedrich's paintings leave questions open, Runge attempted to present solutions, or mythical interpretations of the relation between this soul of the world and humankind. This is often presented through a poetic idea of metamorphoses, transformations of the human soul and the soul of nature, of which he presented the "image." So Runge went the intellectual way, and this took him to his theory of color. Hence landscape became the true content of Friedrich's paintings, while for Runge it was the human form, and its symbolic metamorphosis. But what does that mean?

Philipp Otto Runge's brief life ended just as he believed he had, at last, found his way. After barely ten years of work he was able to take only a few steps down the path, and where it would ultimately have led can only be surmised; certainly the later Symbolists carried on his thoughts from where he left off. Like Friedrich, initially he saw landscape as the chance to renew art, in contrast to the Academies' "cursed idea" of "reviving the old art." In the end he left an *oeuvre* in which landscape is only the foil to his symbolism. To Runge art was "nature made potent." And man or, better, the relation between man and organic matter, was nature to him. It is this connection between plant and man that Runge interprets symbolically. This is entirely in the spirit of

Goethe's acknowledgment, which owed a debt to Spinoza: "Alles Vergängliche ist nur ein Gleichnis" (All transient things are only an image). Runge soon appears to have realized that landscape was not enough to fulfill his demand and provide adequate expression for the "symbol" or "allegory and clearly fine thoughts." So for him the human form became the vehicle for the symbolic expression of man's essential unity with the all-one of nature in pictorial form.

In this respect Friedrich is indeed like an opposite pole to Runge. Where he puts people as tiny figures into landscapes of cosmic dimensions, Runge fits the landscape to his human figures in carefully calculated compositions, with a well considered theory of color and clear co-ordinates of reference. Landscape becomes the "symbol" of the organic process. Where Friedrich seeks limitless isolation, Runge finds the terms of reference for his paintings in the community of the family and the group of friends.

The symbolic correspondences which Friedrich presents to us, as in *The Stages of Life* (ill. p. 441) discussed earlier, where he sets the five people in relationship to the ships, served Runge, too, in his early painting *The Hülsenbeck Children* (ill. p. 444). The children are matched by the three sunflowers on the left. The thickness of the stems reflects the different ages of the children, and the turning bodies and positions of the heads also correspond. The smallest flower, which is not quite open, is supported by the leaves of the other two, and the boy walking to the viewer's right has a counterpart in the flower facing right, while the eldest child, who is looking back, has an analogy in the flower on the left. The system of analogies is continued in the rest of the painting. The fence, which limits the children's freedom and ultimately directs them to the protective house, can be taken as an example of the adoption of Spinoza's concept of the freedom of action of man, as Schelling interpreted it.

The Artist's Parents, painted a year later (ill. p. 445), uses the same symbolism. Here, too, the path is prescribed. The fence is leading the old couple out of the picture. The physical appearance of the parents is wonderfully represented as the fading of the physiognomy of human beings, as life passes by. What remains is the spirit, and this meets the viewer like a farewell from the eloquent glances. The children are not only descendants, they are counterparts to the old couple and also signify the changes in nature. This is the co-existence in time of youth and age, to a certain extent the symbol of rebirth. The girl is pointing to a flower and the old mother also holds in her hand a rose that has been plucked, and so will soon wither. And just as the father is leading his old wife by the arm, so the boy is also holding the girl tight, while himself leaning to pick a flower.

The many layers of possible interpretation cannot be discussed exhaustively here, but we should mention one point: In Runge's depictions of children we never find saccharine small-child anonymity, but always a remarkably mature physiognomy, as if

Philipp Otto Runge
The Artist's Parents, 1806
Oil on canvas, 196 x 131 cm
Kunsthalle, Hamburg
Full view (left) and details (above)

Philipp Otto Runge
Rest on the Flight into Egypt, 1805
Oil on canvas, 96.5 x 129.5 cm
Kunsthalle, Hamburg

The painting was donated to the Kunsthalle in Hamburg in 1872 by the artist's wife, Pauline Runge, née Bassenge. Runge's brother Daniel brought the 18-year-old artist to Hamburg from Schwedisch-Pommern, where he was living in modest circumstances and suffering bouts of serious illness. He has left a description of the painting, which is a realistic representation of the Christian story as it is told in Matthew 2: 13, but which does not enter into the deeper symbolism. The avoidance of any religious sublimation in the picture is striking; for instance, there are no halos or any similar elements from the traditional Christian iconography. The Christ child is deliberately placed off-centre, but he is looking up and gesturing towards the child in the blossoming tree, and this creates the child-nature relation familiar in other paintings by Runge. By contrast, the large figure of Joseph in the foreground appears to be only providing a frame. The unfinished painting was probably originally intended for a church in Greifswald, but was then retitled *The Dawn of the Eastern World*, as counterpart to *The Evening of the Western World*. The two were to form a pair of allegorical paintings entitled *The Poet's Source*. Hamburg Kunsthalle also has a pen and ink drawing by Runge showing the overall composition for the large group of paintings.

Philipp Otto Runge
We Three, 1805
Oil on canvas
Burnt, formerly Kunsthalle, Hamburg

BOTTOM:
Philipp Otto Runge
The Lesson of the Nightingale
Second version, 1804–05
Oil on canvas, 104.7 x 85.5 cm
Kunsthalle, Hamburg

ophy of identity, which also affected Hölderlin and Goethe, and influenced the Jena group of Novalis, Tieck and the Schlegels. According to Schelling "identity" – again starting from Spinoza – can be understood as the unity of the spirit with natural phenomena. Accordingly, nature should not be seen as a lifeless or mechanical conglomeration of atoms, nature and spirit – the real and the ideal are identical in their innermost being. According to the 45th tenet in Spinoza's *Ethics*, in the view of timeless eternity man is also the flower, the plant, and its endless stages of transformation, all of which have their unity in God. So the "lesson" is not an hour of time, but an eternal state. For, in accordance with Schelling's Spinozism, the "real sequence of time is a confused idea," and this is the explanation of the "dialogue" of this lesson that is immortalized in silence.

On aesthetics Schelling said: "What we call nature is a poem that lies locked in secret, wonderful script." Runge repeatedly presents such transformations of nature. Human creatures emerge from the cups of flowers or are revealed within them. We see this here in the monochrome painted surround of the picture, and in the flowering tree in *Rest on the Flight into Egypt* (1805, ill. pp.

the face already expressed the whole life and destiny of the young person. "We need to become children...," Runge said, "if we are to achieve the best."

As with Friedrich, for Runge, too, marriage to his wife Pauline Bassenge, whom he met in 1801 when she was 16 and married three years later, brought a change in his work. From that point he began to make the human form the centerpiece of his work. The picture *We Three* (1805, ill. p. 448, top left) is unfortunately burnt, but in reproductions we see the painter with his new bride and his brother Daniel. We find the same system of analogies here, too. One only need observe the position of the two young trees in the background and compare them with the S-shaped curve of the postures of Runge and his wife, who is leaning against him, to see the analogy.

Probably just before he painted this picture, Runge produced one of his first major works, *The Lesson of the Nightingale* (ill. p. 448, bottom right). The painting was inspired by an ode by Friedrich Gottlob Klopstock, and it also includes his wife. But one will look in vain for a nightingale in it, and it is immediately clear that this is a metaphorical equation of the idea of the young songbird with the human child. This is one of the countless ways of interpreting the soul of the world, as Schelling understood it. The lesson itself is soundless eye contact between the two figures. Basically, this derives from Schelling's philosophy, in which the secret of the unity of spirit and nature can only be "surmised through the intellect." Many of the questions raised by Runge's pictorial idea can be answered by reference to Schelling's philos-

Philipp Otto Runge
The Small Morning 1808
Oil on canvas, 109 x 85.5 cm
Kunsthalle, Hamburg

Philipp Otto Runge
Times of Day: Day, 1805

Philipp Otto Runge
Times of Day: Evening, 1805
Both copper engravings, 71.2 x 47.5 cm
Staatliches Kupferstichkabinett, Dresden

tation of Spinoza. We will also encounter children emerging from flowers and the classical framing in painters like Eugen Neureuther in Munich. Certainly, the idea for *Morning* can be seen as the implementation of this metaphysic. The pictorial vision has survived in a smaller version (1808, ill. p. 449, right) and a large version, *The Large Morning* (ills. pp. 450 and 451), that was cut up by one of Runge's descendants but later reassembled. The various levels of meaning of *Times* – they are not only times of the day or seasons – must be seen in the context of Schelling's fragment The Ages of the World, 1813, and his essay On the Soul of the World, that appeared in 1798. The idea of transformation as outlined above is evident in *The Small Morning*, not only in the images on the frame, but also in the central picture, where the simplest stage of transformation, duplication in a mirror, is shown. Every viewer will be struck by the grandiose idea that is expressed in the child lying on the grass, looking with open eyes at the wonder of being. It seems to be born of the all-nature itself, like a drop of dew. It has been remarked that the independent images on the frame enable the viewer to see two images at once. This is not to be understood as "splitting" the single view, on the contrary. As eternity can never really be represented – Friedrich's landscapes only suggest it, too – Runge has gone back to the method usual since Antiquity of showing different times co-existing in an attempt to indicate eternity. Here, too, children are emerging from flowers, and the heads of angels or children appear behind the clouds, in a way that suggests an endless throng, illuminated with a blue light at the wonder of the birth of nature. The idea was not new or an invention of Runge's. We find the same device in Renaissance painting, in works by Mantegna and Fra Filippo Lippi, and right through to Raphael, all of whom expressed eternity in countless repetitions of angels' heads. Of course elements like these, that are taken from religious art, lend the painting a reverence that in turn raises art to the altar of religion. It is substantiated by the frames that recall the books of hours, and by the symmetry of the figures, although here the altar is that of a cosmotheistic religion of nature. In 1808 Runge went back to the colored version of the *Four Times*, which he himself regarded as his most important work. But he died in 1810, when he was only halfway through the work.

In Runge's painting we are clearly dealing with the attempt to present contemporary philosophy in art. We know that Tieck directed him to this purpose. Runge's relations to Herder and Novalis, and to Goethe, whom he visited twice with Tieck, could only strengthen this approach. For Runge, as for Novalis, human nature was, like "every landscape, an ideal vehicle for a particular kind of spirit." That is in accordance with Spinoza's *Ethics*, where the 24th tenet is: "The more we recognize individual things, the more will we recognize God" – deus sive natura! Runge was in close contact with Goethe over questions of color theory. Four years before Runge's *Color Sphere* appeared in 1810

446–47), above all in the variations of *Four Times* (ills. p. 449, left), that only appeared as copper engravings.

In 1802 Runge made another attempt to allow landscape to speak with a stronger voice, as he thought. But ultimately he did not present a real landscape as a whole, only segments of it in the framing construction. The idea did not come by chance. In order to earn his living after he married, he turned to wall painting "in the style of the time." But what was the style of the time? In the Neoclassical ambience the principles of the Roman subdivisions of walls, Pompeian wall painting, were popular. *Four Times* was to be executed in the same manner as large wall paintings. This gave Runge the opportunity to fill the frames with the "transformations" that derive from his view of Schelling's or Goethe's interpre-

he wrote to the poet prince in Jena from Wolgast: "I recently discussed my ideas on color with someone, who pointed out that they were not new, as Newton had already said the same thing more completely... I would be very grateful, therefore, if – should you know – you would tell me where I can find this... Should a few expressions in the essay I am sending have appealed to you, I shall be very glad to have repaid something of the debt I owe you." In these lines Newton's name crops up again, the person present in the spirit of the whole age, an age as Enlightened as it was searching. In his painting, therefore, Runge sought to derive the visible "images" or "symbols" for the "all-unifying" principle not only from form but from color too.

The Nazarenes and the Catholic South
The art of Runge and Friedrich turned away from society in its absolute individualism. It was a self-sufficient art that had no real followers, and this was largely due to the fact that middle-class viewers and buyers could not take Runge's mysticism or

Friedrich's isolation for long. The Romantic movement developed very largely in conjunction with the emergence of the new bourgeoisie, which wanted artists to give pictures everyone could understand and that accorded with bourgeois intellectual life. And here the most important representatives of the age, Runge and Friedrich, did not comply. This also gave rise to the long-held erroneous belief that remoteness was the aim of the Romantic movement generally. The pseudo-monastic retreat of the artists known as the Nazarenes could also be seen in that light, but that is to misunderstand their very great sense of community. Moreover, as they returned to religion, the supporters of the group attempted to revive the traditional piety of the people. It is no coincidence that the formation of these "monks' brotherhoods" in Germany coincided with the desire for fraternity, for national unity. The Frenchman François Rabelais, one of the most bourgeois intellects ever, told the tale of the establishment of the Abbey of Thelem in the 16th century. It was a kind of monastic "community of individualists." The idea was, of course, absurd, but it still underlies the groupings of today's Modernism.

The rejection of natural philosophy in Spinoza's sense and as Schelling interpreted it was a general phenomenon. Schelling himself – after he was offered an appointment in Munich – returned to denominational religion, converting to Catholicism. Like him, other intellectual groups came under the influence of the Catholic thinker Franz von Baader (1765–1841) and were impressed by the deeply religious intellectual world of Jakob Böhme and the Frenchman St. Martin.

The reaction against the Enlightenment had started, and the artists followed rapidly. On July 10, 1809 Franz Pforr (1788–1812) from Frankfurt and Friedrich Overbeck (1791–1859) from Lübeck founded the first association of artists in the modern sense in Vienna, the St. Luke's Brotherhood. It was established in opposition to the schematic historicism of the Vienna Academy, which was then the foremost institution of its kind under its Director, the Neoclassical Heinrich Füger. Pforr was probably the more meditative character, while the quieter but more talented Overbeck was immediately drawn to religion. Other, less gifted artists joined them, like the Düsseldorfer Josef Wintergerst (1783–1867) and Ludwig Vogel (1788–1897) from Zurich. As a result of the rule of Napoleon they were all patriotic, swore by the art of the old German masters, and wore their hair long under a beret. They wanted to live spartan lives like monks, and undertook to sustain religious morals. While he was still in Vienna, Pforr created one of the most remarkable examples of the new school, *The Entry of Emperor Rudolf of Habsburg into Basle* (1809–10, ill. p. 453). Pforr's brief life was overshadowed by illness and depression and this is probably most evident in *St. George and the Dragon* (ill. p. 454, top), which he painted a short time later. The combatants are self-sufficient, in a way that

is quite out of keeping with a struggle; only the large and penetrating eye of the horse takes up contact with the viewer. This is a fight without effort, as if the knight were dreaming his own experience in a lethargy remote from time. The artist's melancholy is eloquent. The contrast between the French and the German approach could not be demonstrated more clearly than in a comparison of this painting with Ingres' *Angelica* (ill. p. 391), which is on a related theme.

At the suggestion of the painter Eberhard von Wächter (1762–1852), who was totally absorbed in Catholic Italian family life, Pforr and Overbeck followed him to Rome in 1810. The Heidelberg artist Carl Philipp Fohr (1795–1818) joined them in 1816, adding his highly individual achievement to Romantic landscape under Koch's influence (ill. p. 454, bottom); but he met an early death at the age of 27 in the Tiber and left only five paintings. Koch himself was asked to participate in joint productions, like the decoration of the Casino Massimo with scenes from Tasso's *Gerusalemme Liberata*.

Then in 1817 Julius Schnorr von Carolsfeld (1794–1872) joined the circle, followed by Joseph von Führich (1800–76) in 1827. The latter subsequently became one of the most important painters of religious subjects among the Nazarenes. While still in Rome he acknowledged that "the Bible would be the range I would wish to move in if I were free to choose my occupation here…." He realized his wish (ill. p. 455, top) and after he left Rome in 1829 devoted himself mainly to biblical subjects.

The last artist to join the group was Edward von Steinle (1810–86) in 1829. But in this late phase the idea of community art was already outlived. Ultimately the brotherhood had their greatest influence when some members took their ideas on idealized depictions in a smooth, flat style – in opposition to the sober realism of Biedermeier – into the various schools in Germany. This applies to Cornelius and Schnorr in Munich, Schadow in Düsseldorf, and von Führich in Vienna.

They called themselves "The Brethren of San Isodoro" after they took up residence in the abandoned monastery on Monte Pincio in

LEFT:
Franz Pforr
St. George and the Dragon
Oil on wood, 28 x 21 cm
Städelsches Kunstinstitut, Frankfurt a.M.

1810, and sought "to devote ourselves to the old sacred art, alone and in quiet contemplation," as Overbeck said. Remembering the painter monks of the early Renaissance, Fra Angelico, Fra Filippo Lippi, and Fra Bartolomeo, they sought to return to simple form, created in line, as in Perugino or the early Raphael. They regarded perspective as "degeneration from the earlier pinnacle of art." They deliberately based their appearance on Dürer's self-portrait, with his long hair parted in the center, a style worn by the former inhabitants of Nazareth and the revolutionary Jesus. In Italy it was known as "alla Nazareno." The derisive name "Nazarenes" seems to have occurred for the first time in 1817 in a letter written by Goethe, who, as already mentioned, saw the movement as "those spineless creatures with their monkish habits."

Overbeck had already familiarized himself with Italian painting in Germany, and his encounter with Runge in Hamburg must have made an impression on him. Through the mediation of Wilhelm Tischbein he was accepted at the Vienna Academy, but it

RIGHT:
Carl Philipp Fohr
Knight before the Charcoal Burner's Hut, 1816
Oil on canvas, 51 x 64 cm
Nationalgalerie, Staatliche Museen zu Berlin – Preussischer Kulturbesitz, Berlin

Only five oil paintings by Carl Philipp Fohr are known, but the mastery evident in his small output indicates the career this artist, who drowned in the Tiber at the age of twenty-seven, would surely have had. Dark, deeply glowing colors and a feeling for landscapes elevated to the romantic ideal show his supreme ability in this painting as well.
Unable to accept the severe Neoclassical teaching of his tutor at the Munich Academy, Peter von Langer, he went to Italy, a visit to which we owe 70 drawings and watercolors. Fohr continued to study independently in the group of Munich artists around Ludwig Ruhl, and this is when "Knight before the Charcoal Burner's Hut" was painted. It is very evident that the late mediaeval painting of the Danube school, and particularly the work of Adam Elsheimer, had a greater influence on him than studying at the Academy, which he had not greatly enjoyed.

Joseph von Führich
Jacob Encountering Rachel with her Father's Herds, 1836
Oil on canvas, 66 x 92 cm
Österreichische Galerie, Vienna

BELOW:
Friedrich Overbeck
Italia and Germania, 1815–28
Oil on canvas, 94 x 104 cm
Neue Pinakothek, Munich

was only under Pforr's influence that he turned to the old German masters, such as Holbein, Cranach and Dürer. He also created a monument to his friend (ill. p. 457). From an arched Gothic window Pforr is challenging the viewer with a penetrating but pious eye, as if asking: "Why have you not yet found the peace of piety?" His wife is deep in reverence, as if blessed by the lily, and the church tower provides an appropriate background. Pforr's sign, the cross over the skull, the vine tendrils, the watchful cat or falcon of hope, are all symbolically included. And it was Pforr's novel and painting *Shulamit and Mary* (ill. p. 456) that inspired Overbeck to his own work of the same title (ill. p. 455, bottom right).

But how different are the two works! In his diptych Pforr separates the Italian and the German worlds, the Old and the New Testament, while Overbeck eliminates the division and creates a sisterly unity. He felt it as his task to "melt the elements," or, as he said: "this is the longing that constantly draws the north to the south, to its art, its nature, its poetry." Rightly the title was changed to *Italia and Germania* (ill. p. 455, bottom) five years later, for the clothes, the laurel and myrtle wreaths and of course the different landscapes and houses make it very evident what is meant. The physiognomy and character of the two women is Overbeck's interpretation of Italian and German girls. But this is a Renaissance typology as well: the "vita contemplativa" of meditative Italia and the "vita activa" of lively Germania, who has taken her friend's hand. The girls are shown as imaginary brides, wonderfully idealized and so delicately perceived that they have hardly an equal in Nazarene art. Overbeck has set a monument to the encounter of German artists with Italy that could hardly be more ardent or worthy of its subject.

In 1811 Peter Cornelius from Düsseldorf (1783–1867) joined the brotherhood and became their most active member. Together with Overbeck, Friedrich Wilhelm von Schadow (1788–1862) and Philipp Veith (1793–1877) from Berlin, he decorated the Casa Zuccaro with frescoes on the story of Joseph (ill. p. 458, top) commissioned by the Prussian Consul-General. The subject of the adviser to Pharaoh was certainly intended as a reference to the

Franz Pforr
Shulamit and Maria, 1810–11
Oil on wood, 34.5 x 32 cm
Schäfer Collection, Schweinfurt

OPPOSITE:
Friedrich Overbeck
Portrait of the Painter Franz Pforr, c. 1810
Oil on canvas, 62 x 47 cm
Nationalgalerie Staatliche Museen zu
Berlin – Preussischer Kulturbesitz, Berlin

LEFT:
Peter von Cornelius
Joseph Interpreting Pharaoh's Dream,
1816–17
Fresco overpainted in tempera,
246 x 331 cm
Nationalgalerie, Staatliche Museen zu
Berlin – Preussischer Kulturbesitz, Berlin

This fresco was originally part of a cycle of
five paintings in the former reception room
of the Casa Bartholdy in Rome. They were
painted in 1815–17. At the end of the 19th
century the frescos were taken down and
moved to Berlin. *Jacob's Lament* is by
Schadow, while Veit painted the lunette
above it, *The Fat Years* and the large-scale
Joseph and Potiphar's Wife. Cornelius'
painting was beside this, also crowned by a
lunette, *The Lean Years* by Overbeck. The
artists regarded the cycle as their main
work and they all made watercolor
versions on a small scale, which were
shown in the Berlin Academy exhibition in
the autumn of 1818, framed with
architectural divisions.

BELOW:
William Blake
Job and his Daughters (Plate 20 of *The
Book of Job*), 1823–26
Copper engraving, 21.7 x 17 cm
Tate Gallery, London

client's position as a diplomat. Schadow painted *Jacob's Lament*, while Veit and Overbeck painted the lunettes, Cornelius himself painting *Joseph Reveals himself to his Brothers* and *Pharaoh's Dream*. Pharaoh sits listening attentively, deep in thought, to the prophecies of the future that Joseph is counting for him on his fingers, like an arithmetical exercise. In the listeners Cornelius has shown the whole range of reactions – from the scribe's factual record, through keen attention and scepticism to disbelief in the figure disappearing into the dark. But the painter's idea to show the dream in the round panels on the sides is interesting. They are like a projection by a laterna magica as demonstrated by the English artist Sandby (ill. p. 332, below left). Of course there is no direct connection between Sandby's ball of light and Cornelius' *Joseph's Dream*, but the correspondence of dreamlike idea and circular projection recurs a short time later in the 20th plate of William Blake's illustrations to the Book of Job (ill. p. 458, below). That would not appear to be coincidental, for we know how successful these wall images were and how strong Cornelius' influence in England was. Nevertheless, it must be pointed out that color did not play an important part in these frescoes. Similarly, particular attention has not been paid to the composition as a whole; the individual figures are conceived as part of a cumulative show. The narrative coexistence determines the picture – as in Nazarene art generally. That characteristic was to pose difficulties for Cornelius a short time later in Munich.

The Catholic South – Munich and Vienna
With the patronage of King Ludwig I, Munich had now established itself beside Jena, Berlin and Vienna as an art center of the first rank, and the "Athens on the Isar" was to remain Germany's leading art center for a long time. Around 1920 Munich still had more than 3000 registered artists, but then Berlin displaced the south German metropolis. The palace buildings by Klenze and Gärtner and the churches by Ziebland and Ohlmüller also created more work for painters. The Academy proved more modern than its counterparts in Berlin or Vienna, and anyone from the north who was aiming for Italy could not bypass Munich.

Eugen Neureuther
The Arts Flourishing in Munich, 1861
Oil on canvas, 73 x 101 cm
Schack Galerie, Munich

Eugen Napoleon Neureuther (1806–82), who was permitted to decorate Goethe's poems with arabesques and margin drawings, set a monument to Munich's rise to artistic fame (*Art Flourishing in Munich*, ill. p. 459). Cornelius is shown enthroned in a triple-arched hall, surrounded by celebrated Munich painters like Peter von Hess, who is executing a ceiling painting, Schnorr with a smoking pan of paint in reference to the encaustic technique, and Kaulbach in his workshop. Architects and art-lovers are also to be seen.

Cornelius had come to Munich in 1819 and was soon appointed director of the Academy, being ennobled by the king. His first work there was lunettes and dome paintings in the Glyptothek and the Pinakothek, which were among the best art produced in Munich at this time. Unfortunately they were destroyed much later, in the air raids. In 1836 he was honored with a major commission, to decorate Gärtner's Ludwigskirche with the image of *The Last Judgement* (ill. p. 460), which forms the altar wall. Basically, it is oriented to Michelangelo's fresco in the Sistine Chapel, but is easily half as big again, so it is now the largest fresco in the world. It proved fatal for Cornelius. The individual elements simply would not resolve into a unified composition, and a generation of art historians did great injustice to the painter over this. After all, faced with the same problem, Michelangelo moved into the Baroque concept of spatial handling. Cornelius was expected to perform the impossible, namely to translate the current fashion for detailed execution into the monumental. But the manner was intrinsically hostile to composition on a larger scale. There were acrimonious disputes with the royal client, from whom the idea for the huge painting originated. When the king transferred his favor to Cornelius'

pupil, Wilhelm von Kaulbach (1804–74), whose sickly sweet style almost caricatured his own, Cornelius left Munich for Berlin, deeply embittered. However, he did not give up. After offering his services to Frederick William IV of Prussia in 1840, he set about producing sketches for the decoration of the Camposanto in the cathedral that was being planned. And, as he finally abandoned the rigid adherence to the Nazarene linear vocabulary, he did succeed in producing the grand design in these pictures. When they were exhibited, Cornelius now 80, was celebrated once more as Germany's greatest painter. Again he enjoyed an intoxicating success, but the sketches were never executed, the cathedral remaining, for the time being, a vision. Nevertheless, when he died three years later, at the age of 83, the painter may well have gone to his grave content in the knowledge that he had won his immortality.

Today Julius Schnorr von Carolsfeld, who was born in Leipzig, seems to us closest to Cornelius. A study of his subtle drawings will show what he was aiming for. It was not a humble objective. Schnorr wanted to stand with Raphael or the early Renaissance painters in melodious line, intensity of expression and delicacy of stroke or outline. Occasionally he actually outdid his models, although only on the formal level. *The Wedding Feast at Cana* (ill. p. 461, top) contains such a variety of themes and motifs that the later "Neo-Nazarenes," such as Gebhard Fugel, Martin Feuerstein, and Karl Wurm, were still drawing on it for their church paintings into the first decades of the 20th century.

Schnorr had an instinctive feeling for composition on a grand scale, and it is evident from the encaustic wall paintings he created for the Residenz in Munich that the criticism that seared

OPPOSITE:
Peter von Cornelius
The Last Judgement, 1836–39
Altar wall fresco
Ludwigskirche, Munich

This is the largest fresco in the world and
it proved fatal for the artist. Inevitably,
the work was compared with
Michelangelo's fresco on a related theme
in the Sistine Chapel, although Cornelius
endeavored to avoid formal similarities.
He was overwhelmed with criticism as
soon as the painting was finished, and
there were acrimonious disputes with
King Ludwig I of Bavaria.

RIGHT:
Julius Schnorr von Carolsfeld
The Wedding Feast at Cana, 1819
Oil on canvas, 140 x 210 cm
Kunsthalle, Hamburg

BELOW RIGHT:
Julius Schnorr von Carolsfeld
Encaustic wall paintings in the Saal der
Rache, 1831–67
Nibelungensäle, Residenz, Munich

Cornelius could not touch him. A whole cycle was destroyed in
the war, but the Nibelung halls have survived (ill. p. 461,
bottom), and they show with what consummate ease Schnorr
could handle the huge surfaces. But these works – like Cornelius'
Berlin sketches – were created later, and the work on them
continued until 1867. Schnorr was assisted by Friedrich Olivier
(1791–1859), the brother of Ferdinand (1785–1841) and
Heinrich Olivier (1783–1848), who were also in the Nazarene
group, although they never equaled Koch in their landscapes nor
Overbeck or Schnorr in their religious paintings.

But Cornelius, Schadow, and Schnorr were also pioneering in
monumental history painting, which was to play so great a role in
the second half of the century. Huge panoramic paintings were
installed in nearly all the public buildings, training centers – like
the Maximilianeum in Munich – museums, town halls, and
universities to make them centers of culture. They taught history
and were intended to have a didactic influence as historical
models. Wilhelm von Kaulbach's huge painting *The Destruction
of Jerusalem by Titus* (started in 1836, ill. p. 462, top) is the most
mature example of the new theatrical history painting. The artist
does not show the real event, rather this is idealistic didacticism.
We are given an interpretation that transcends time and is
intended to be of significance for the whole world. But when
Kaulbach places "Christianity" on the right in his painting and an
extremely ugly figure of "the Wandering Jew" fleeing the city in the
opposite direction, the facets and dangers of the 19th-century view
of history are only too plain. This was ridiculed even in Kaulbach's
time, for Bonaventura Genelli (1798–1868) caricatured the painter,
showing him enthroned like a prince rather than creative. Genelli
was a pupil of Carstens, and he went to Koch in Rome, seeking to
build a bridge between the two ideals, between Michelangelo's

BELOW:
Wilhelm von Kaulbach
The Destruction of Jerusalem by Titus, 1846
Oil on canvas, 585 x 705 cm
Neue Pinakothek, Munich

BOTTOM:
Heinrich Maria von Hess
*Portrait of Fanny Gail, Sister-in-Law of
the Painter Peter Hess*, c. 1820–21
Oil on canvas, 55 x 45.5 cm
Schäfer Collection, Schweinfurt

sublime pathos. We see this in the work of Cornelius, Kaulbach, Genelli and Schorr. But in none of the romanticized works in southern Germany or Vienna do we find the Spartan severity that the Protestant north produced in Friedrich, Runge, or, in a softer Biedermeier version, even in Dahl or Kersting. It was a break that ultimately went back to the Reformation, and it split the German cultural landscape again for many years. Certainly, art should not be seen solely in terms of the social and political conditions of the time, but this is perhaps the place to point out that the north of Germany had seen the wars fought by Frederick the Great as campaigns for the Protestant cause. So in the Protestant states Napoleon was also the enemy for advancing the cause of Catholicism. Attitudes were rather different in the south. Bavaria, which owed its status as kingdom to the Imperator, first allied with Napoleon in the wars, then secularized the arch-Catholic state, confiscated church property and dispossessed the monasteries. The reversal came later than in the north, with its numerous conversions to Catholicism. Rahel Varnhagen, a Jewess who had converted, spoke of "finding rest and calm" in Catholicism, and it reflected a similar development when the Schlegels in Berlin advised their son

mobility and the Neoclassicists' linear vocabulary. The outline, stimulated by Greek vase painting, was his leitmotif, as it was for the English painter Flaxman. Ignored by the King of Bavaria, Genelli was last sponsored by the Munich patron Count Schack. As the final offshoot of German Neoclassicism he found his lasting resting place in Weimar, where he spent his final, bitter years.

Specialization, the 'Fächler'

The fierce competition between the painters, of whom there were now too many for all to enjoy a successful career, nourished the growth of thematic specialization in the academies. In the second half of the century the term "Fächler" (subject specialists) became current, as painters specialized in landscape, portrait, history or religious painting. Some fought their way through the fierce competition to become widely celebrated. They include the portrait painter Joseph Karl Stieler (1781–1858), who was commissioned by King Ludwig I of Bavaria to paint a portrait gallery of the most graceful ladies in the land, making a "gallery of beauties." The subjects include Nanette Kaula, the 17-year-old daughter of the head of the Jewish community, who was married to a nephew of Heinrich Heine, and Amalie von Schintling (both ill. p. 463), who died young. Stieler was not only technically highly accomplished, but has also left a document of the ideal of beauty of his time.

In Munich, as in Vienna, the Romantic movement had long been developing parallel to Neoclassicism; or, beside the purist Neoclassicists like Kobell or Stieler, the Neoclassical formal requirements were intermingled with Romantic delight in narrative and

and stepson, Philipp Veit, who had also converted from the Jewish faith to Catholicism at the age of 17, to participate in decorating the Garnisonskirche: "If the walls are not Catholic, they may well yet be; and what they are not, they can always become."

The shudder of Spinoza's cosmotheism as propounded by the philosophers Jacobi, Schleiermacher, Hegel and Schelling was much closer to Protestantism, and it never had the same broad influence in the Catholic south. Now its time was past in the north as well. It had brought "pure inner happiness" to only a few – chief among them Goethe and Lessing – but for the average man and woman it required too great a sacrifice: they lost the sense of community that religious faith could provide. Now people were pious, at least the new mood of the time enveloped society with a mantle of piety. Even the non-religious Wilhelm von Humboldt sensed the trend: "I am so very glad the little creatures [his daughters] are so pious; it flows out of them and mingles so well with the time." All of a sudden a new-old attitude to marriage was popular, as the idea of the patriarch in the family gained ground with the idea of the Fatherland. The saying "thy lord and master" was being taken seriously again. The knitted stocking conquered the marriage chamber, but also many a portrait, for example Heinrich Hess used this motif in the picture of the sister-in-law of his brother, the painter Peter Hess (ill. p. 462, bottom). So did Carl Begas (1794–1854) in his group portrait of his family (ill. p. 464). In a malicious poem by Tieck, the knitting of the stocking continues even in the conjugal embrace. Nor did it prevent absorption in the "spiritual book," as Overbeck proved as early as 1810 in his portrait of Pforr's wife (ill. p. 457).

Attitudes to femininity became more difficult to define, and beside the maternal, womanly woman a new form of idealization appeared, "the eternal feminine being," who, according to Goethe, "drew man upward." First she appears as the sum of noble qualities, as in *Mignon* (ill. p. 465, top) by Wilhelm von Schadow (1788–1862) – angelically pure, artistic but pensive. *Judith* (ill. p. 466) by August Riedel (1799–1883) is powerful and strong, but even after her murderous deed a touch of gentleness remains in her eyes. At the same time "the lady" was born, a figure who combined

BELOW:
Wilhelm von Schadow
Mignon, 1828
Oil on canvas, 119 x 92 cm
Museum der Bildenden Künste, Leipzig

BOTTOM:
Johann Peter Krafft?
*Maria Angelica Richter von Binnenthal,
née Freiin von Zach* and
Franz Xaver Richter von Binnenthal,
1814–15
Oil on canvas, each 53 x 43 cm
Private collection

both images. Women of culture, like Angelika Kauffmann, Rahel Levin (who married Varnhagen von Ense), Henriette Hertz and Dorothea Schlegel, had started the emancipation movement by acting as intellectual centers in their salons, but the picture was soon to change. Now the lady of the house stood in respectful inferiority at the side of her husband, whose aim was to be as successful as possible. Certainly an ennobling touch of suffering now played around her mouth. When Lessing's Minna von Barnhelm appeared before Tellheim, she was "in mourning," and now painters and poets always envisaged the lady in black robes, which were high fashion. Natalie in Goethe's *Wilhelm Meister*, Leonore in his *Tasso*, the "wild English woman" in Tieck's novella *Das Zauberschloss* (The Magic Castle, 1830), and Wutzkow's Wally in his novel of the same name (1835), who is tied to a man she does not love, are representatives of this type in literature. We find her in painting, above all in portraiture. But one must not forget that the Wars of Liberation had exacted their price, and the heroism of the fallen also found expression in the black widow's weeds. Death invested the insignificant with greater significance, and Ludwig Börne's observation was very characteristic of its time: "Because black suits them, the ladies mourn for their most distant relatives." If the call to arms elevated the courageous volunteer to the Wars of Liberation against Napoleon to heroic stature, the fashionable black atlas dress ennobled the women. The "fine soul" bearing the traits of grief forbade loud laughter.

The mood of the time is also very evident in a matching pair of portraits (ill. p. 465, bottom) of Richter von Binnenthal, who was a Viennese official who had been ennobled, and his wife. The paintings are ascribed to Johann Peter Krafft (1780–1856). The graceful wife bears the 25-year difference in age from her husband with the same dignity as he wears his 1814 medal. Moreover, the colors of the clothing are skillfully balanced: her black dress with its white collar is the inversion of his Habsburg uniform. Her white lace collar also indicates a fashion during the Restauration, when the House of Habsburg liked to look back to its old Spanish empire. So this couple returns us to the origin of the fashion for black and white, which is still prevalent all over the world today, and which was the former court dress of the Hapsburgs. The lady in black lived on for a long time in 19th-century art. Later Anselm Feuerbach painted her again and again, meditating in her black robes as she renounces earthly pleasures. Once again it was Börne who found the apt remark: "For the man eating is a sensual pleasure; for the woman it may only be an aesthetic one. Don't laugh, just smile; don't eat, just nibble!" The lady was elevated to a mystery, her piety bearing aristocratic traits. Finally she stands before the sacrificial altar, a priestess enveloped in black, in Böcklin's *Island of the Dead*, before she undergoes a renewed transformation around the turn of the 19th/20th centuries into Franz von Stuck's male-murdering sphinx or "Sin."

August Riedel
Judith, 1840
Oil on canvas, 131 x 96 cm
Neue Pinakothek, Munich

OPPOSITE:
Peter Fendi
The Sad Message, 1838
Oil on wood, 37 x 30 cm
Historisches Museum der Stadt
Wien, Vienna

Ideal and reality contrast in these two paintings in a very striking way. If artists often saw woman as a noble, self-confident personality, a heroine, but one who could still preserve a hint of mildness in her eyes after her heroic deed, like August Riedel's *Judith*, reality was sometimes very different. The news of the death of the father of the family on the battlefield of the Wars of Liberation demanded true heroism from many women, as shown in the tragic scene on the right.

In both paintings we see the tendency to psychological interpretation that was to become a feature of 19th-century art. While Riedel seeks to convey the message of the Bible story in Judith's facial expression, making this the overall statement, the painting on the right shows the dramatic moment when the wife learns her fate. This is genre painting brought to a peak of intensity through psychological understanding.

moved to Karlsruhe in 1840, then went to Frankfurt, and was back in Munich around 1847. The odyssey shows that Schwind's art met with eager acceptance all over Germany. Schwind was a Romantic artist and music was of great importance to him as thematic reference. In 1852 he "composed" *A Symphony* in oils (ill. p. 469), and provided the commentary on it himself: "The whole should be imagined as the Beethoven wall of a music room … and it is based on a composition by Beethoven, the Fantasia in C for Piano, Orchestra and Choir…" Schwind said that the individual zones of his painting, into which he wove a love story, correspond to the four movements of Beethoven's composition. At the

Painting and Music

In the decades before and around 1848 the world, and especially the artists of the time, looked from the north to musical Vienna, and listened to the music of the classical Viennese period. The crow on a dead branch, or the painting of the lonely wanderer between bare trees in Caspar David Friedrich's "composition" *Winter Landscape* (ill. p. 468, top), was set to music by Schubert in his *Winterreise* or in lieder such as *The Crows*. Schwind also painted himself in an illustration of Schubert's song "Fremd bin ich eingezogen, fremd zieh ich wieder aus…" (A stranger I came, a stranger I leave) (ill. p. 468, bottom). Friedrich's moonlight paintings and those of other Romantics have a counterpart in Beethoven's *Moonlight* sonata. Storm and silence, the drumming of thunderous waterfalls or the harp-like sound of quiet water found expression in heroic and romantic painting as much as in music. Initially this affinity was limited to landscape. Friedrich Schlegel said that architecture was music become stone, and Prince Pückler-Muskau saw the principles of music in the Romantic landscape garden as "music in vegetation" "Nature also has her symphonies, adagios, and allegros, … which likewise profoundly move the spirit."

It has often been said that Friedrich's landscapes are music in painting, but musicality was not limited to landscape. It was remarked that the very frescoes in the Casa Bartholdy had a melodious execution of line: "exciting and calming like music," said Heilborn. Painters suddenly became very aware of the similarity of rhythm in music and rhythm in painting; moreover, the word "tone" has two meanings and applies to both media. The Viennese artist Joseph Danhauser (1805–45) painted the effect of music on the people of his day in his famous picture *Liszt at the Piano*. The virtuoso composer's eyes are cast up in longing, while the eyes of his listeners are locked in community of feeling.

A key figure in Vienna was Moritz von Schwind (1804–71), a pupil of Julius Schnorr von Carolsfeld and Peter Krafft. In his *Melusine Cycle* he transformed female forms into harmonious waves. He went to Munich in 1828, traveled in Italy in 1835, and from 1838 was receiving commissions in Baden and Saxony. He

bottom we see a chamber music rehearsal (Introduction), in which one of the young listeners falls in love with the singer; later they meet in a wood (Andante); above this again we see the young man declaring his feelings at a ball (Adagio); and finally, in the little castle, the happy husband and his bride are setting off for their honeymoon in the stronghold of bliss (Rondo).

Schwind's painting and his explanation of it indicate a basic phenomenon of the time – the combination of story and music to make program music. The artist wanted "the whole" to be a large wall painting. The sequence of motifs was to unfold like a panorama, marking the spatial dimensions of social life. In his decorations for the Wartburg, Schwind brought the old sagas to life within the ancient walls, and in *The War of the Singers* he sought to revive the long-silenced music of the Minnesänger in his colors. Soon the fairy-tale King of Bavaria, Ludwig II, was to have his palace of Neuschwanstein decorated in a similar fashion by pupils of Schwind with projections of his dream of reality, a stage set in which people could walk around. So here – in Schwind's work – we find the beginnings of the total work of art Wagner was to proclaim. But Schwind was not prepared to set painting in the service of ideological discussion, and he was certainly not prepared to expose himself to party-political criticism. "I prefer music to political correctness, as it is now being interpreted," he said. It was also a characteristic of Restauration painting to abhor conflict. The flight into music was part of this, the harmonizing effect of music transcending day-to-day political conflict.

"Waldeinsamkeit" and Biedermeier Cosiness

The fairy tale was also a unifying element, sung to people of all social classes in their cradle. The term "Waldeinsamkeit" (forest seclusion) comes from Ludwig Tieck's fairy tale "Der blonde Eckbert" (Blond Eckbert). It implies the search for a spiritual refuge. It was not coincidence that while the Brothers Grimm were collecting their fairy tales, painting also turned to this genre, as something felt to be specifically German. In the fairy tale the mysterious forest provides a stage rich in symbols, where real experience can be combined with dream and fear. This explains why the motif of the forest became so popular. The forest is both here and nowhere. The glades are a promise of light and hope, the dark depths arouse a shudder, and the tree is a witness to eternity. The forest is both a threat and a home. It was at this time that nationalistic ideas began to be linked with the forest. Just as Gothic (which developed in France) was immediately declared a German style, the forest was now always "the German forest." The German painters in Rome collected their most ardent drawings of forest scenes in the Albani Mountains, but they went on to discover their native woodlands, as Richter found the forests of Thuringia.

The early Romantics' longing for distant places became a longing for home. The charming village, the "cosy" small town

and the forest were the objectives of this new homesickness. The idea of returning home could not have evolved without the wanderings of the Nazarenes and the German painters in Rome. One may recall Faust in Goethe's dramatic poem exclaiming that he is "back on earth" during his Easter morning walk. In painting the theme also recalls old German landscape painting, as in the works of Albrecht Altdorfer and Wolf Huber, who were much later classified as the "Danube school."

Ludwig Richter's *Genoveva in the Lonely Forest* (ill. p. 470) shows us a sunlit opening in the depths of such a forest. Deep faith in God appears to lie like a protecting hand over the little group, seated amid the overpowering vitality of nature. And this shows the great difference between Richter and Friedrich. In Friedrich's works, man endures the hostility of nature to find

The forest seclusion and the appealing
life of the hermit, the quiet of the trees
and the retreat into a simple life close to
nature were the expression of a new
attitude to life. What Schwind has
painted here is the longing of the
Biedermeier period for happiness in
simple surroundings and for a calm that
had long vanished in pre-industrial urban
society. In his contemplative life
committed to God, the pious hermit
seemed to be manifesting a kind of
religious feeling that was ideal because it
was "private." The musician feels at
home here too, before setting off once
more for the bustle of the towns.
"The forest stands silent…" said the
poet, and, for that very reason, the quiet
wood was the object of silent, but often
devout or religious fervor.

OPPOSITE:
Ludwig Richter
Bridal Train in a Spring Landscape, 1847
Oil on canvas, 53 x 150 cm
Staatliche Gemäldegalerie, Dresden

Philipp Otto Runge said we need to become children if we want to achieve the best. Runge and Richter agreed about that, even though they had very different approaches to art. Runge also saw his paintings of children as images of his philosophy, and he often incorporated figures of children into an intellectually constructed composition that occasionally poses puzzles for the viewer. Richter, on the other hand, sought to awaken the viewer's innate joy at contemplating the merry games of children. His *Bridal Train* shows a Utopian world, happy people emerging from the enveloping shadows of the wood on to sunlit meadows. Richter could transform real events, like a wedding, children's games or the reading of a fairy tale into dreamlike memories.

LEFT:
Moritz von Schwind
Early Morning, 1858
Oil on canvas, 34 x 40 cm
Schack-Galerie, Munich

RIGHT:
Caspar David Friedrich
Woman at the Window, 1822
Oil on canvas, 44 x 37 cm
Nationalgalerie, Staatliche Museen zu Berlin – Preussischer Kulturbesitz, Berlin

FAR RIGHT:
Georg Friedrich Kersting
At the Mirror, 1827
Oil on canvas, 46 x 35 cm
Kunsthalle, Kiel

God, while Richter shows man protected from all the forces of nature by faith. *The Hermit* has a special part to play. The Romantic longing for "Waldeinsamkeit" is projected on to him, a longing which the late Romantic man and woman, who have become sociable again, no longer permit themselves (ill. p. 471). As the community admired Catholic celibacy, the town dweller sees in the hermit an unworldliness and contentment in seclusion that he himself, smoking his pipe, only need experience at second hand, through Richter's or Schwind's illustrations. The overwhelming awareness of nature in Friedrich's north German Romanticism is transformed into appealing reading matter in Richter's "illustrated magazine." The cosy home, the clean and tidy Biedermeier bedroom with its scent of fresh linen and open to the cool morning air, is the subject now, as we see in Schwind's *Early Morning* (ill. p. 472, top). And the view from the window is as inviting as the room itself. The idea in this painting derives from a drawing the painter made in his youth in 1820, so it is two years older than Friedrich's *Woman at the Window* (ill. p. 472, bottom left). Apart from the fact that both represent the popular rear view of a figure looking out of a window – Kersting has left us an example as well (ill. p. 472, bottom right) – the difference between Biedermeier painting and Friedrich's severe simplicity could not be clearer.

Faith and the order that results from it are the message of Richter's and Schwind's illustrations. They paint the picture of a contented petit bourgeoisie, regardless of whether the people in this class really got their just deserts. The happy naivete of the child is true contentment. Richter's *Bridal Train* (ill. p. 473) shows this particularly clearly. All the stops are pulled to arouse positive feelings in the viewer: he will naturally feel intense pleasure at the sight of the happy, playing children, who are celebrating a wedding. Richter's paintings of children are among the best things produced by the German Romantics. If it was their objective to translate the Utopian, the distant, the ideal or the dream into pictures, these carefree children are the supreme Utopia. We never see children crying, or if so, they are silly tears at which we may smile. The striking feature of this art is the impression these visions give that the Biedermeier world, with its appealing contentment, could be realized somewhere.

In a certain sense the political conditions of the time, which is known as the "Vormärz," that is, the period from 1815 to the March revolution in 1848, was indeed a time of peace and calm in Germany. Despite the strong political pressure and burgeoning activities of spies under Prince Metternich, who was joked about as "Prince Midnight" or "State Hemorrhoidarius," the peace after the Wars of Liberation did offer a brief period for contemplation. Cosy domesticity, in which the loving couple were an essential part, the husband in dressing gown and nightcap, smoking a long pipe, and his wife in a lace cap with her knitting or book, were the subject of many a painting (ill. p. 474, bottom). But the burgeoning cultivation of the bourgeoisie soon encouraged a naive self-awareness in the lower middle class, who were self-righteous in maintaining their values. The two types of philistine whom Victor von Scheffel invented for the magazine *Fliegende*

OPPOSITE:
Friedrich von Amerling
Rudolf von Arthaber with his Children,
Rudolf, Emilie and Gustav, Looking at
the Portrait of their Dead Mother
Oil on canvas, 155 x 221 cm
Österreichische Galerie, Vienna

LEFT:
Carl Spitzweg
The Poor Poet, 1835
Oil on canvas, 36.2 x 44.6 cm
Neue Pinakothek, Munich

Spitzweg was regarded as the secluded
"painter-poet of Munich's Heumarkt,"
an eccentric who never displayed his
extensive travelling. Three versions of
The Poor Poet are known. It is thought
that Etenhuber (1720–82), a poet living
in impoverished circumstances in
Munich, was the model. Spitzweg shows
the poet writing in bed to keep warm, for
there is snow outside on the roofs and he
has no wood to heat the stove. But he
seems unconcerned at his scant means
and the leaking roof, as, his pen in his
mouth, he counts off the meter of his
rhyme on his fingers.

BELOW:
Joseph Danhauser
Siesta (The Sleepers), 1831
Museum of Fine Arts, Budapest

Blätter, "Biedermann" and "Bummelmaier," were combined to
create the term "Biedermeier," which became the designation of the
period and its style. Initially the name was intended to be ironic. The
poet Ludwig Eichrodt first used it in a publication, "Biedermeiers
Liederlust" (Biedermeier's Song Book), as the title for the
poetic outpourings of Sauter, a village schoolmaster in Baden.

In painting, no one could poke fun at the world of the insignifi-
cant, harmless man living on scant means better than Carl
Spitzweg (1808–85) in Munich. He remained somewhat on the
fringe of the Munich art scene, but his position as an outsider
made him a wonderful observer of human frailty and folly.
Spitzweg traveled widely, and he could look at the small corners
of his native town with fresh eyes. He delighted in the eccentric,
and his genre scenes of the lower middle class, with their secret
longings and gentle lifestyle, go straight to the point. With
Spitzweg, Biedermeier painting as such really comes to an end.
He is still describing this world, but with the objectivity and
distance of the critical observer. This is an artist who can invest
the seemingly idyllic scenes and subjects with a humor that is
often biting. *The Poor Poet* of 1839 (ill. p. 474, top) is an apt
example of this. Only a few decades later this view had
changed. Ferdinand Georg Waldmüller (1793–1865) devotes
many of his paintings to children and their games, but he
shows them with very different, and often contradictory char-
acters. And soon we find criticism of social conditions
emerging, as in his painting *The Soup Kitchen* (ill. p. 476). The

images of carefree games were beginning to yield to the serious problem of survival. The Romantic movement was finally over, Realism was displaying its sterner colors, as we see in the work of the Viennese painter Jospeh Danhauser (1805–45) as well. Moreover, the bourgeoisie of the Biedermeier period wanted realistic portrait art, as did court society. Waldmüller, Krafft, and Danhauser were the main figures here, and above all Friedrich von Amerling (1803–87). He had studied under Thomas Lawrence in London, where he became familiar with the work of Reynolds at the same time. He rose to become the favorite court portrait painter and from 1830 was one of Vienna's most popular artists, alongside Moritz Michael Daffinger, Franz Eybl, Rudolf von Alt, and Peter Fendi. His reputation was based on the life-size portrait of the Emperor Franz of 1832 (ill. p. 477). Looking at this work today one feels impelled to ask what can have appealed so strongly to the emperor and the public at the time. What mainly strikes the modern viewer is the huge crown over a small, tired face. It seems to be oppressing the head of the fragile man rather than crowning it. The seated figure does not fill the frame, he is wrapped in the heavily embroidered ermine that

weighs upon his shoulders, and enveloped by the draperies of the curtains; the column and the niche enclose him like a stage set. This is the whole Baroque repertoire of the court portrait, brought out of the treasure chambers and "restored" for the sitting. Never did theatrical costuming with historical insignia seem more crass. The gap between the bearer of office, whose careworn features speak of the man of state aware of his responsibility, and the weight of tradition could not be presented more clearly. The gnarled hand of the man who wanted peace would never wield the sword; it lies limp between knee and the arm of the throne. The scepter seems to have been thrust into his hand by a dresser. But then there are the graceful silk-clad legs! Anyone who does not know that agility was highly prized and men were expected to be light on their feet must find this display of thigh undignified. So the painting is composed of disparate elements. The traditional attributes of a royal portrait are combined with a depiction of "natural" man, here only consisting of face and legs. This is what makes him so unconventional. The throne, enveloped in draperies, appears to be an uncertain seat, that was indeed soon to be shaken. But this portrait of the Emperor, in

Ferdinand Georg Waldmüller
The Soup Kitchen, 1859
Oil on wood, 93.8 x 121.6 cm
Österreichische Galerie, Vienna

Friedrich von Amerling
*Emperor Franz I of Austria in his
Coronation Robes*, 1832
Oil on canvas, 260 x 175 cm
Schönbrunn Palace, Vienna

One will better understand Waldmüller's
Soup Kitchen, or *Monastery Soup*, if one
brings to mind social conditions during
the years before it was painted. The
idealistic depictions of the Biedermeier
period largely passed over what was
happening in institutions like these every
day, even as late as 1850. There was a
severe food shortage in 1816 and 1817,
and this brought poverty and hence
social problems that the authorities could
no longer cope with. All over Germany
the district councils imposed "poor
taxes" in the – usually vain – hope of
financing poor relief. The birth rate of
illegitimate children rose drastically
because most of the people were not by
law permitted to marry owing to their
financial circumstances. In 1838/39, for
instance, 1,365 children were born in
wedlock and 1,046 out of wedlock in
Munich. The number of orphans and
semi-orphans with no parents to care for
them also rose drastically. The police
records of this period give a frightening
picture of what conditions were like.
Against that background the charm with
which Waldmüller has invested his
children here must be seen as glossing
over reality. Only the realists of the
following generation dared to represent
conditions in their truly fearful state.

whose face the cares of the Restauration are very evident, has an undeniable element of Romanticism. It works with the old myth of the emperor by trying to bring it up to date and rescue from an older age whatever promises to be of duration.

Despite the pragmatism in politics around and after 1848, grief at the failure to find paradise played a considerable part in the renewed interest in fairy tale. Alfred Rethel (1816–59), who died insane at an early age, shows the old Emperor Karl rising out of a damp grave, as a warning, as a judge, as seer, certainly as a myth whose center is the longing of the late Romantic period for salvation.

The man gazing longingly into the distance from a dizzying height painted by the young Edward von Steinle (1810–86) in *The Tower Watchman* (ill. p. 478) expresses the spiritual need of the time. His outward gaze betrays his sadness, as he stands between the mourning bell above his head and the hope expressed by the swallow building its nest below his feet. He is as if caught between them, while the little Biedermeier town far below is sunk in dreams.

But there was another fairy-tale myth, the one of the song that lures men to their death, and it was the response to an age that was spellbound by melody. Not by chance did poets from very different parts of the country recount the story of the Lorelei on her rock. Clemens Brentano was the first to give shape and form to the dangerous beauty in the 19th century, but a German writer in the Middle Ages had done so much earlier, when he maintained that the gold of the Nibelungs lay in the Lorelei mountains. The legend said that to raise the gold was to raise Germany. But what dangers lay in the path! According to the legend, the Lorelei is a fairy seated on a high rock luring poor sailors to their death. Before 1827 Heinrich Heine wrote the lines that became famous:

"I know not what it may mean,
That sadness fills my mind.
A tale of ancient times it seems
Lingers in my mind."

Few songs have been sung as often as this one. For a long time it was regarded as the ultimate expression of German sensibility. Male voice choirs intoned the "powerful melody" for a century in minor keys and were not ashamed of their tears. They sang of how the sailors kept on dying, one after the other, as they gazed back and upward, dazzled by the golden hair, forgetful of time and the waves. It was a "tale of ancient times" that exercised a tremendous pull. Only fairy tales can do that. Fairy tales are not questioned, but are followed to the death. And in Germany's deepest romantic time, after 1933, when the people gazed upward again in blind fascination, dazzled by the sublimation of the blond type, they were drawn into a deep whirlpool. This

shows the deeper connection between the archaic fairy tale and the false archaic world view - "national romanticism" and its dangerous, deadly legend.

But when Edward von Steinle painted the Lorelei, the "enchantress on the rock, a figure in the Nordic legend, a female of demonic beauty" (ill. p. 479), as his client Count Schack described it, it did not seem strange for the myth to be given life or that it was a Jewish poet (Heine) who gave it lasting fame. But this also shows that the call of that time went out to all and that – however different Friedrich and Schwind, Runge and Führich, Brentano and Heine were – religious ardor transcends religions.

In his comment on the 1848 Salon Charles Baudelaire found words that are still as relevant today as they were then, at the end of the epoch of Neoclassicism and Romanticism, the time of seeking between Antiquity, Revolution, Imperialism, Restauration and democracy: "It is true to say that the great old tradition is lost and the new one has not yet evolved."

Edward Jakob von Steinle
The Lorelei, 1864
Full view (left), detail (above)
Oil on canvas, 211 x 135 cm
Schack-Galerie, Munich

Angela Resemann

Neoclassical and Romantic Drawings

An unprecedented number of drawings were created in the period between 1750 and 1850 by both artists and laymen. That most famous of all dilettantes, Goethe, alone produced more than a thousand. Drawing was seen as part of an aristocratic lifestyle and so was taken up by the aspiring middle classes. Soon, a new profession developed – the drawing teacher. For the artist, drawing formed the basis of all his work. Sketches, designs, studies and preparatory drawings were useful finger exercises or an early stage on the road to a completed work of art – in other words, "purposive" drawings. "Autonomous" drawings, on the other hand, are independent works of art and constitute a large part of those created in the early 19th century. Available drawing materials comprised graphite pens, black and colored chalk, and charcoal; pen drawings used mainly brown and Indian ink; wash drawings and works produced with brushes used water colors or gouache. The invention of the pencil around 1800 – a tool still in use today – amounted to a technical revolution, though it was no longer made of lead, but rather of graphite and purified clay. The pencil quickly became the most popular instrument for drawing; produced in industrial quantities, it was both easy to obtain and consistent in quality.

The vast numbers of drawings made in the Neoclassical and Romantic period contrasts with the paradoxical situation that many artists kept their drawings private and only showed their sketchbooks to friends – if indeed to anyone at all – and it has taken the research of art historians to unearth these treasures. As these light-sensitive and fragile works of art are generally maintained in graphics collections, and therefore seldom exhibited, they have traditionally been less highly regarded than paintings. Drawings are considered an art form for connoisseurs. Like no other branch of the fine arts, drawings challenge the viewer, requiring him to give his imagination free rein. They do not possess the three dimensions of sculpture, and no "colorful glow" (Goethe) serves to convey a sense of life as it does in painting. The world of the drawing is a more or less abstract structure of lines on a flat surface and requires decoding by the viewer. The often fragmentary nature of drawings sometimes makes it difficult to appreciate the artist's vision, but they are, nonetheless, often the clearest revelation of his artistic spirit, spontaneously expressing ideas. As is the case with handwriting, the artist's lines express his spirit and personality. The primacy of drawing over all other art forms has frequently been emphasized, for while the imagination may be capable of adding color (to a drawing) it cannot replace the actual invention of the image as the really meaningful creative act. The most sensitive of artistic genres, drawing is also capable of responding the most quickly to new movements in art and to stylistic innovations.

Art echoed the far-reaching changes which took place in Europe after the end of feudal rule, the events of the French Revolution

Hubert Robert
The Draughtsman of the Borghese Vase, c. 1775
Red chalk, 36.5 x 29 cm
Musée des Beaux-Arts, Valence

and the Napoleonic Wars. New themes and forms of images arose, whose variety eclipsed the last unified artistic style, the Rococo. Many of the artistic tendencies from the beginning of the 19th century did not come to fruition until decades later, and anticipated the art of modernism. Throughout the 1800s, idealist and realist tendencies competed with each other. Artists emancipated themselves from the princely academies and worked for a free market. By reverting to the notion of an idealized past, art set out once again to portray an untainted and undiminished world. While Neoclassicism is underpinned by a rational ethos oriented towards universal values, Romantic art – which initially made its appearance in the guise of classicist forms – was defined by its emotions and subjectivity.

"Noble simplicity and calm grandeur" (Winckelmann)
From the Rococo to the *beau idéal* of Antiquity

The beginnings of the Neoclassical style can be dated back to the middle of the 18th century. Its rise occurred during the era of the Enlightenment, and spread rapidly throughout Europe from its centers in Rome and Paris. A necessary precondition was a historical consciousness: people at the time saw themselves as part of an historical process and therefore connected to the very origins of European culture. Herculaneum and Pompeii were excavated and antique art works were published in graphic series. The theoretical framework for the movement was provided by Count Caylus from France and Johann Joachim Winckelmann, a German. Convinced that a reform of the arts would also have positive repercussions for society, they turned their backs on the stylistic forms of the Rococo. Their goal was to imitate the ideal beauty of Greek art, which was characterized by its noble simplicity and calm grandeur. The art of Poussin and Raphael was also considered exemplary. A critical role in the dissemination of Neoclassicism was played by the French Academy in Rome, the cultural center for French artists who held scholarships; it was also a magnet for international travelers to Rome who would crown their Grand Tour with a sojourn in the Eternal City. Paintings by the Academy's teachers were copied, and drawings made from casts of the most famous antique sculptures as well as from live models. Rome's ancient ruins were another source of inspiration, as a work by Hubert Robert (1733–1808), *The Draughtsman of the Borghese Vase*, shows (ill. p. 481). Distorting the proportions of the scene like Piranesi, Robert composed an architectural *capriccio* from a number of set pieces that were freely designed and rendered in the manner of vedutà. The artist of the title is seen sketching the gigantic Borghese Vase on a square above the Forum, which had a view to the Coliseum – a building whose vertical dimensions Robert extended by adding an additional series of arcades. The Borghese Vase was actually never exhibited close to the Coliseum, but was situated in the Borghese Gardens. The inscription illuminates an idealized relationship to

Antiquity: Rome's former glory is still revealed in its ruins. With the brownish red-chalk crayon typical of the late 18th century, Robert achieved subtly drawn as well as painterly effects. The fragile, delicate contours and the schematic manner in which the foliage of the trees is depicted recall the Rococo – as does the head of an attractive woman made by the then greatly esteemed portrait painter Elisabeth Vigée-LeBrun (1755–1842, ill. p. 482, bottom). In pastel – a popular medium in the 18th century – the artist modeled the laurel-wreathed head of an allegorical figure of peace over a preparatory drawing in black chalk. The work was intended as a study for a painting. While the theme and technique are conventional, the flattened composition and the idealized beauty of the head with its cool, lustrous and porcelain-like skin tones correspond to Classicist ideas.

Jacques-Louis David (1748–1825) was the most perfect representative of the *Zeitgeist*. His painting *The Oath of the Horatii*

481

LEFT:
Jacques-Louis David
The Grief of Andromache, 1782
Black chalk, pen and ink with gray wash,
29 x 24.6 cm
Musée du Petit Palais, Paris

BELOW:
Elisabeth Vigée-LeBrun
Woman's Head (study for the painting *La Paix ramenant l'Abondance*), 1780
Charcoal and colored chalk on blue paper, 47.9 x 40.5 cm
École des Beaux-Arts, Paris

Napoleon, but more popular and even more sentimental themes again began to make an appearance. The erotic female nudes of Pierre-Paul Prud'hon (1758–1823) showed that beauty did not also have to be virtuous (ill. p. 483, right). Studies of nudes were usually undertaken during an artist's education or served as the basis of paintings. This was not the case with Prud'hon: even as a mature artist he drew from life without seeking to exploit the work further in any way. His model here reveals her back in a classical pose. The idealized beauty of the body – inspired by ancient sculpture – is formed by a flickering pattern of light and shade with soft transitional areas. The sensuousness of the depiction is further enhanced by a *sfumato* technique reminiscent of Leonardo da Vinci. Prud'hon too was in Rome, but he kept an artistic distance from David. His conception of painting forms a bridge between the 18th century and the art of French Romanticism.

The work of Asmus Jakob Carstens (1754–1798) represents a contrast to the revolutionary pathos of David with its richness of ideas and "calm grandeur." Imbued with a sense of his artistic mission, Carstens renounced all ties to live as an independent artist

(ill. p. 370) made him famous overnight, its strict composition and uncompromising theme setting new standards. It was no longer the task of historical paintings merely to please the viewer – they had also to convey political as well as moral ideas. Ancient authors, especially Homer and Plutarch, provided an inexhaustible source of virtuous models. Especially popular was Andromache's lament taken from *The Iliad*, for her dead husband Hector. The Trojan Hector had been killed doing battle with the Greek champion, Achilles, and the hero's funeral bier was a symbol of virtue and courage. In his preparatory drawing for his painting *The Grief of Andromache* (ill. p. 482, top) David borrowed elements from the works of Nicolas Poussin and the reliefs of antique sarcophagi.

The classically strict, box-like space is occupied by just three figures arranged in the foreground; there is no middle ground, and spatial limits are defined by the drapery, shield and lance on the bare wall to the rear. The scene is evenly illuminated by light from the left, and a sense of authenticity is provided by Hector's magnificent weapons and the furnishings, which are depicted exactly according to antique models. But this is more than just a middle-class family drama. Expressions of private grief are restrained. Heroically, Andromache points to the dead warrior who sacrificed himself for his country. Even Hector's small son, Astyanax, sheds no tears and maintains his composure. In the figure of Andromache, David refers to the anguish of the Virgin Mary: artists working around 1800 were able to adapt the pictorial traditions of Christian art to other contexts. David and his school also left their mark on the art of the First Empire under

BELOW:
John Flaxman
Odysseus in the Underworld, 1792
Illustration to Homer's *Odyssey*, Book XI, 779
Pen, 22.9 x 29.8 cm
Royal Academy of Arts, London

BELOW:
Pierre-Paul Prud'hon
Nude Viewed from Behind, 1810–1820
Black chalk with white highlights on blue paper
Forsyth Wickes Museum of Fine Arts, Boston,

in Rome in the most humble circumstances. His ideal was an art of pure contour modeled on Greek sculpture, and he considered color an undesirable addition. Probably partly as a matter of necessity, he elevated the cartoon – a tool of fresco painting – into an independent work of art. Carstens believed that sketches represented ideas that were already fully expressed, requiring no further work. His allegory *Night with her Children Sleep and Death*, a scene inspired by antique poetry, is just such a cartoon (ill. p. 12, top). At the entrance to a cave, Night spreads out her cloak over her children, who are identified as Sleep and Death by their attributes of poppies and a torch. She is surrounded by Nemesis, the scourge of mortals; the Goddess of Fate, who reads from the book of life; and the three Fates. Michelangelo provided the model for this dense and relief-like arrangement of monumental figures, who are not united in a real space and whose actions are merely symbolic. Night, the origin of all fate, is seen reflecting on being and time.

For the first time the theme of night is dealt with as part of a cycle on the times of day. Just as Goethe hoped to find the origins of all plant life, so too Carstens attempted to depict primal mythical powers in his pictures. This is already an early Romantic notion, but as a Neoclassicist Carstens captured it in the form of pure line. Carstens exerted a strong influence on following generations of artists after his death through Eberhard Wächter, a pupil of David's, who went from Rome to Vienna. Like Joseph Anton Koch he was considered by his contemporaries to be a renewing force in German art.

The English artist and sculptor John Flaxman (1755–1826) had a lasting influence on the taste of his age. His outline drawings

produced from the 1790s were considered brilliant illustrations of antique literature for their striking simplicity. As engravings his work quickly became known throughout Europe, where they had an enormous effect; according to Goethe, Flaxmann became the "dilettantes' idol." His style imitated that of antique vase paintings, but was more graceful and less severe. It was also therefore suited to conveying Romantic pictorial themes, such as irrational events, as shown in his drawing of *Odysseus in the Underworld* (ill. p. 483, top). Here the hero waits for his deceased comrades, but is finally driven off by a host of spirits. Flaxman traced the contours with precise but sensitive penstrokes, and there is only a hint of sketching within the figures. Parallel lines were used as a decorative element to indicate clouds and intangible space: Odysseus can therefore be seen to act against the background of a void, surrounded by mere schema. There is not a single superfluous stroke in Flaxman's drawings. Their typological plot elements, clear construction and abstract use of line make them dense, expressive formulas, whose wealth of motifs were exploited for decades.

"We are no longer Greeks" (Runge)
From noble simplicity to pious diversity

The ideal of Antiquity lived on after 1800, but although Neoclassical forms may have survived, new themes started to emerge. The old order that had collapsed was to be set against a new vision of the world and a resurgent feeling for religion. Experiences of Nature could become experiences of God, and the practice of art a religious rite. The painting of the 15th and 16th centuries began to assume a greater importance, with Dürer and Raphael becoming the new guiding stars in the artistic firma-

ment. Instead of Homer and Plutarch, people now read Ossian, Milton and the *Bible*. Fairy tales and sagas gave voice to an awakening sense of nationalism. The new freedom of the individual led to absolute subjectivity, and Caspar David Friedrich (1774–1840) stated that the artist's emotions were his only law. He demanded a unique art appropriate to the 19th century. True to his maxim that the artist should paint not only what he saw before him but also what he perceived in himself, he composed symbolic landscapes from realistic details. The fine but emphatic drawing style of his *Giant's Grave by the Sea* (ill. p. 484), with its almost dissolving outlines seems, in its rows of trees, stones and bushes, as though it were taken directly from a panoramic landscape. This objective impression is deceptive, however: God and Nature were one for the Protestant Friedrich. The empirical study of Nature was merely a cipher that enabled the depiction of the spiritual world lying behind the physical one and which revealed God. Friedrich's motif of the giant's grave was in line with contemporary enthusiasm for the poetry of Ossian and his melancholy praise of pagan heroes. Friedrich found the appropriate landscape motifs on the island of Rügen in the Baltic Sea. Without any intervening middle ground, the transience of earthly life in the objects of the foreground contrasts directly with the infinite expanse of the sky symbolizing immortality. Friedrich used sepia – the ink produced by the octopus – for this drawing. From 1780 it had replaced ink made from brown soot and allowed for differentiated chiaroscuro effects. It was very popular with Neoclassical artists because of its monochromatic properties. Friedrich developed the image in the work illustrated here to its fullest extent in a form that he would later use in his paintings. His works, however, were so cryptic that their meanings soon became incomprehensible, and Friedrich himself, increasingly isolated, was forgotten.

Philipp Otto Runge (1777–1810), the other great north German Romantic artist, also looked to landscape painting as a means of renewing art. He formulated the concept very broadly, however; all painting genres were to be united in landscape to illustrate the cosmic and organic order and the divine spirit that watched over it. Runge formulated these concepts in an allegorical and symbolic language, creating meaningful relationships through the use of the typically Romantic arabesque. Symmetry for Runge was an indispensable artistic tool for depicting abstract themes. His drawing *Lily of Light and Morning Star* (ill. p. 485) belongs to *The Times of Day*, his life's work, which was begun in 1802. It depicts a lighting study for *Morning* and shows the upper section of the painting (cf. ill. p. 451). Light is shown as the creative principle of the universe; it means the beginning of life as well as the promise of eternal bliss after death. Morning is, therefore, the origin and goal of the eternal cycle of Nature. Runge solved the difficult artistic challenge of adequately rendering the lighting of a

William Blake
Christ as the Redeemer of Man (illustration
for Milton's *Paradise Lost*, III), 1808
Pen and watercolor, 49.6 x 39.3 cm
The Museum of Fine Arts, Boston

scene that is illuminated from a variety of sources. The light of the morning sun appears from below and immerses the Lily of Light – on whose petals children seem to sit weightlessly – in a warm reddish light, even reaching the group of cherubs who float over them. From above, the scene is lit by the cooler and weaker light of the morning star. As a symbol of divine light, the lily radiates light from within itself, an effect Runge achieved by using white chalk highlights. The artist created a play of light by subtly graduating the levels of brightness and creating delicate transitions on a medium of grayish-brown paper. The density of regular hatched patterns in black chalk is modulated – becoming more thickly layered towards the top to represent darkness – and is used to give form to the natural process of dawn. The subtle yet precise outlines in red chalk swell and then recede; they are, as it were, organic and are fundamentally different from Flaxman's use of line, which had initially influenced Runge.

Like Runge, the English poet and painter William Blake (1757–1827) belongs to that group of mystically inspired artists whose work deals with ideas. Blake placed the powers of the creative imagination above those of reason. The main theme of his illustrations was the fall of Man and his redemption at the Last Judgement. His ideal literary model was John Milton's Baroque

Johann Friedrich Overbeck
Christ Resurrects the Daughter of Jairu,
1815
Pen with black ink over pencil,
watercolor, 30.7 x 37.3 cm
Kupferstichkabinett und Sammlung der
Zeichnungen, Staatliche Museen zu
Berlin, Berlin

Peter Cornelius
The Vision on the Rabenstein, 1811
Pen drawing with gray ink on thin
vellum, 39.3 x 51.6 cm
Städelsches Kunstinstitut Graphische
Sammlung, Frankfurt

verse epic *Paradise Lost*, which describcd the struggle between light and chaos, and the battle of God against Satan. Blake's visionary drawing style – which was later echoed in the art of the Pre-Raphaelites, Symbolists, and Art Nouveau movement – is demonstrated in his watercolor and pen-and-ink depiction of *Christ as the Redeemer of Mankind* (ill. p. 486). Christ floats in the air before God the Father, the position of his body referring to his death on the cross. The expressive, outsized hands of his father touch him lightly. Four angels accompany Christ on his way to Earth. The unremitting movement contains tension. Even in terms of color the divine realm is sharply divided from the void, in which Satan, armed with a spear, attempts to prevent God's plan of redemption for the world. The scene is characterized by symmetry and repetition, and is not only illuminated by the artist's technique, but is also enlightened spiritually. The penstrokes are flowing and often executed in parallel. Blake was inspired by Flaxman and Gothic sculpture, and he insisted on the classicist type of outline as being the only means of adequately representing the world of ideas.

Flaxman's outline style also held for the Nazarenes, a group of young artists who in 1809 joined together to form the Guild of St. Luke in Vienna. Their aim was to create a new art imbued with a Christian spirit and a sense of nationalism free from academic constraints, while their ideals were the pious artists described in early Romantic texts. The Nazarenes hoped their art would resurrect the spirit of the Middle Ages – an age in which, for them, the world was still whole and untainted. The Guild of St. Luke, who were mockingly called "Nazarenes" because of their appearance, moved to Rome in 1810. Here, in an atmosphere of monastic brotherhood, they created devotional images that were to serve as the popular art of a religious revival. Johann Friedrich Overbeck's (1789–1869) drawing *Christ Resurrects the Daughter of Jairu* is modeled on Italian Renaissance paintings (ill. p. 486, bottom). In spite of the color, the figures appear to be composed of flat surfaces; the cool, transparent color scheme simply serves to differentiate the forms. Laid retrospectively over a framework of lines, color remains within the boundaries defined by contour. Overbeck made no attempt to reproduce the qualities of the figures' clothing; in fact, their robes have the appearance of paper, which removes them still further from the realms of reality. The place of aesthetic charm is taken by the spiritual content: the miracle of the resurrection is attended by Christ's disciples and the parents of the girl. Their facial expressions and gestures do not demonstrate desperation but rather the certainty of salvation according to the saying: "Fear not but believe in me."

Together with Overbeck, Peter Cornelius (1783–1867) became the artistic leader of the Nazarenes. Less of a missionary than Overbeck, who had converted to Catholicism, he devoted himself in particular to national themes. His Faust illustrations mark the beginnings of Nazarene drawing. Medieval art was thought to

blurred lines alternate with fine but hard pencil strokes in which all possible nuances of gray through to black can be found. The composition is reduced to its absolute essentials. Delacroix' line is not "beautiful," like that of Cornelius, but abrupt and violent, and can only be read in the context of its interrelationship with other lines. In contrast to the ornamental use of line in Neoclassical work it conveys a sense of space and plasticity.

"I walk alone on untrodden paths" (Michelangelo)
The crisis in art c. 1800 and its great innovators

Delacroix introduced completely new elements into the art of the period. Like Delacroix, Théodore Géricault (1781–1824), John Henry Fuseli (1741–1825), and especially Francisco de Goya (1748–1828), broke with the themes and styles of dominant traditions. These artists cannot easily be defined by or forced into the straitjacket of narrow stylistic categories. With their new creative visions they surpassed their contemporaries and pointed the way to future developments. The more intense emotions of their subjective art form a channel for a world of dreams, drives,

represent ideal and typical features of the German character. Nothing could therefore have been more appropriate than to illustrate Goethe's writings in an "Old German" style. Such a pictorial tradition did not exist, however, and Cornelius created his compositions from older graphic models. He also felt no need to study Nature. His vividly executed pen and ink drawing *Vision on the Rabenstein* (ill. p. 487) shows his technique, which was taken from that of copperplate engravings. Cornelius' figures are modeled in the subtlest of parallel lines and cross-hatching, and he took the greatest care to recreate each detail in order to attain that "painstaking" precision that was considered a virtue of the art of the old masters. The delicate outlines occasionally take on an independent ornamental value as shown by the curving arabesque folds of Mephisto's cloak. Translations, adaptations, and musical versions of the story meant that Goethe's *Faust* also became a firm part of the French cultural elite's repertoire.

A comparison with Eugène Delacroix' (1798–1863) drawing on the same theme (ill. p. 488 top) shows the direction taken by French Romanticism. In this work, everything is movement and expression. The snorting horses are pictured flying through the dawn, while the conflict between Mephisto and Faust, whose conscience was pricked by the sight of Gretchen during the Witches' Sabbath, is indicated in the posture of his body and the turn of their heads. In Cornelius' work, in which Faust dominates the scene, external events and narrative details become more important. Delacroix depicts a spiritual experience, and his composition is concentrated in the two main figures. Even with the pencil he achieves painterly effects and the play of light. Soft,

and instincts. Their work was exemplary for all that was new in art around 1800.

One of the most brilliant artistic figures of the time was the Swiss painter, Fuseli, who lived in England. He mixed Neoclassicist and Romantic elements in an art influenced by antique sculpture and the works of Michelangelo. Fuseli depicted contorted bodies in order to generate tension and pathos, to captivate the viewer's emotions and convey the terrors of the sublime. The inferno of Dante's *Divine Comedy*, which was "rediscovered" in the mid-18th century, was especially suited to this purpose. Dante was seen as the very embodiment of the creative individual. As a wanderer burdened with the cares of the world, he is equated in 19th-century interpretations with the rootless and brilliant artist figure. The pen and ink drawing of *Dante and Virgil on the Ice of Kocythos* (ill. p. 489) shows the poet standing amongst the heads of those who have been frozen into the sea of ice which fills the crater of hell. The poet is pictured looking at the traitor Ugolino, who is suffering unspeakable torments as he starves together with his innocent sons. Due to its emotional content, Ugolino's fate was a popular theme in the Storm and Stress movement. Dante expresses intense spiritual shock at the sight of their suffering. To depict this state Fuseli used the theatrical gesture of raised arms, which, a contemporary manual for actors explained, should only be used in the most exceptional circumstances. Pictorial events are concentrated in the figure of Dante. Light from above models the figure in vivid chiaroscuro contrasts; Dante is seen isolated from a flatly sketched Virgil by non-contiguous but parallel layers of space. The stone wall in the background conveys a sense of hopelessness, and gigantic feet hint at dizzying heights. In contrast to the temporal sequence which describes this scene in Dante's poetry, the essential features of the narrative are depicted by drawing together and concentrating different aspects of the action. Fuseli's Dante feels and reacts, and the viewer too should respond emotionally. With his unconventional images Fuseli ventured into previously unexplored regions of the soul, and this constitutes his modernity.

Goya acknowledged only Nature, Velázquez, and Rembrandt as his teachers. He was the greatest draughtsman since Rembrandt and equalled him for his depictions of human behavior. In his great series of etchings Goya attacked humanity's stupidity, injustice, and cruelty. Collected in sketch books, these drawings are autonomous, complete artworks, but were not intended for a broader public. Goya often provided them with admonishing or ironic titles. The inkbrush sketch *"You'll See Later"* shows a burly lower class man drinking greedily from a leather bottle (ill. p. 488, bottom). He has clearly been arguing with his wife, and Goya shows a moment of discord and dramatic action. With just a few precise brushstrokes and without any prior drawing, Goya conveys an emotionally charged expression. The contours of his figures are not self-contained; they are drawn nervously and with

frequent interruptions. He dabbed, spotted, and applied wash with the brush, creating three-dimensional figures through dynamic contrasts of light and shadow. As a metaphor for the loss of the old world view, Goya destroyed the Baroque conception of space, which consisted of a logical and perspectively coherent series of spaces – foreground, middle ground, and background. His figures act out their roles crammed into a narrow pictorial stage without any connection to the empty surfaces around them, and often they do not reach beyond the lower half of the picture. Because of this distorted spatial relationship they appear apathetic, constrained and lost. Goya attacked the social injustices of his age mercilessly, and adopted the figure of the defeated and tormented individual as fundamental to human

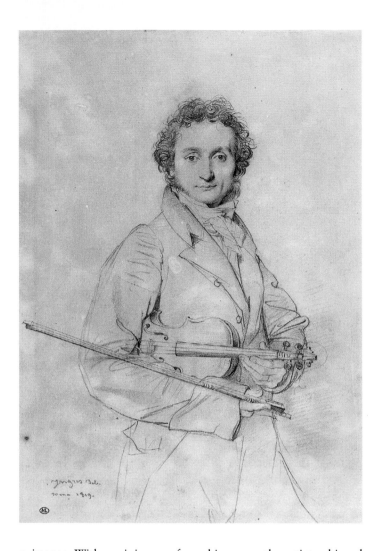

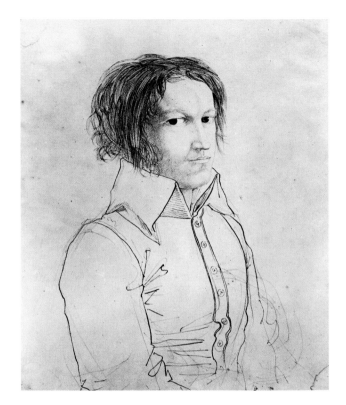

existence. With a minimum of graphic means the artist achieved moving universal statements. Goya placed his drawings at the service of morality and it is the timeless validity of their themes which makes his work so modern.

In spite of their Classical schooling Géricault and Delacroix broke with traditional themes and forms to set the tone for the developments in French Romanticism. Known especially for his tempestuous pictures of horses, in his *Wounded Soldiers Retreating from Russia* (ill. p. 490) Géricault took up the theme of a topical historical event which ran through his work like a leitmotif. Exhausted almost to the point of death by the hunger and cold, these wounded men struggle through a desert of ice. Far from glorifying the soldier's life, Géricault depicted the misery of their extreme situation – an approach in tune with the spirit of his age. Géricault's use of line is highly expressive. A small curved line like that of the trouser seam of the seated soldier masterfully conveys volume and texture. Géricault abandoned pure outline, achieving a painterly effect through light and shade. He distanced himself from classicist premises with this figurative composition, which diagonally penetrates pictorial space. In order to find an appropriate expression for interior events, Géricault liberated himself from prevalent ideas of form, and the intensity of his style is already a step towards Realism.

Delacroix, too, aimed for the greatest possible expression of emotion in his drawings; a rapid technique served to heighten his imaginative faculties. Hardly any of his drawings reached a wider audience during his own life, as Delacroix kept them to himself to use as a reservoir of ideas for his paintings. Despite its fragmentary character his watercolor *Two Women at a Well* (ill. p. 491), made during a journey to Morocco and Algiers in 1832, is entirely comprehensible. Delacroix established the essential features of his composition with just a few gestures in pencil before he summarily reworked them with the brush. Volumes and the relationship of light and shade are indicated by washed sections in various shades of brown and, as is typical for watercolors, the paper background provides a source of light. Delacroix' rendering of Mediterranean ambience is altogether convincing, and the fascination of his North African watercolors resides in their simplicity. The journey he undertook to North Africa out of a Romantic fascination for the East not only altered the artist's palette and sharpened his sensibility for the phenomena of light; Delacroix saw in the Arabs the legitimate descendants of ancient peoples, who had retained classical social forms and antique dignity. It was through them that Delacroix was able to find a path to Neoclassicism and to "living Antiquity."

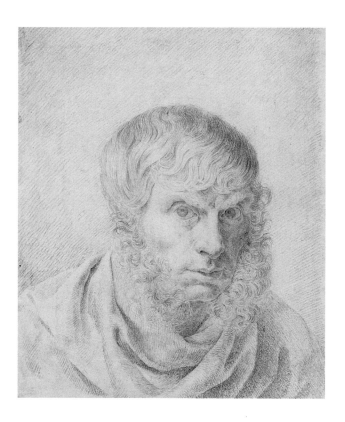

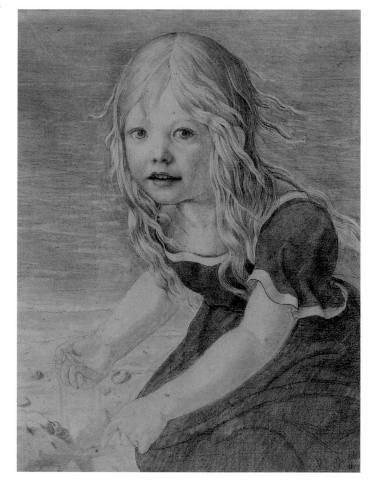

"Drawing is the honesty of art" (Ingres)
The Portrait as a Mirror of the Soul

Jean Auguste Dominique Ingres (1780–1867) took up a conservative, almost spiteful, counter-position to Delacroix. Always on the search for a timelessly valid, classical beauty – which he saw in the art of Raphael and Antiquity – he was a life-long proponent of the primacy of line over color. Whereas Delacroix' paintings represented a pioneering feat, Ingres' service to art lay in his abilities as a portraitist and as one of the most important draughtsmen of the century. His portrait drawings are remarkable for their psychological empathy and the enormous subtlety with which light and surface areas are treated. Because his ambitions were largely confined to historical painting, portraits were a burdensome duty to Ingres, who saw them as merely a means to earn a living. Although they only achieved modest prices in their day, they are now among the most sought-after collectors' items. As a rule, Ingres estimated that it took four hours to make an individual portrait, a period of time which would be interrupted by a meal, when the artist was then able to observe his sitter unposed. Ingres, himself a talented violinist, drew a portrait of Niccolò Paganini (ill. p. 492, left) – at that stage at the very beginning of his career – probably as a reminder of concerts the two friends had performed

together. Beneath the calm exterior there are hints of Paganini's demonic temperament, which was later to become the stuff of legend. Every detail emphasizes an expression of vitality and subdued passion; his posture seems dynamic, his finely-shaped hands sensitive, and his face with its fine hatched lines is modeled to convey a sense of alert tension. The musician's unruly locks are rendered in hard pencil and reinforce the impression of vigour and barely restrained passion. The smudged soft pencil and the variation in the force with which the strokes are applied meant Ingres was able to differentiate the heavy cloth of Paganini's coat from the finer material of his fashionable shirt collar. In spite of this objective depiction, Ingres remained discreet: his incorruptible gaze is not employed to cause his sitter harm, but shows instead a purified and idealized image of an individual.

The pictures of Carl Phillip Fohr (1795–1818), a painter closely allied to the Nazarenes, who died at a young age, are also marked by a similarly refined art of characterization, showing the same clarity and succinctness of disciplined line that was used to emphasize the contours of figures and objects. Like all German artists, however, he preferred whole or three-quarter figures in the tradition of Dürer and Holbein. During a stay in his hometown of Heidelberg, Fohr was accepted into the "Teutons," the

very first student fraternity made up of a group of students with nationalist leanings. Here he portrayed one of the first proponents of German unity, the lawyer and journalist Heinrich Karl Hofmann (ill. p. 492, right). Fohr achieved a heightened sense of animation through the use of a sharp pen over pencil. The dark eyes of his subject burn with a critical gaze from a brightly illuminated three-quarter view composed of gently modeled pencil strokes, while his features express decisiveness, a thirst for action and a concealed passion. Here too his unruly hair, with its disorderly curls at the tips, expresses an individual personality. Both the face and clothing are handled differently also. Fohr manages to balance perfectly the demands of realism and an idealized expression in this image of his friend. With this typically Romantic type of picture, artists conveyed an image of themselves and their contemporaries to posterity, bearing witness to a community that they treasured highly and that provided them with social support.

Space, setting, clothing, and other such details played a subordinate role in Romantic portraits. Here, the artist concentrated on the face and eyes as the essential expressive elements. A person's eyes were considered the noblest of his senses and a window onto his soul; through the eye, Man could gain an insight into God's creation. In his self-portrait (ill. 493, left), Friedrich therefore represented himself as a serious, thoughtful man. His self-confident, interrogating gaze penetrates the viewer in order to expose his innermost images. By placing the head and the eyes in the very center of the depiction, the intellectual contribution to artistic creation is emphasized, while the classical drapery removes the subject from the context of his own age. It may have been that Friedrich wanted to portray himself as a successor to the visionary Ossian. The Neoclassical architect Karl Friedrich Schinkel (1781–1841) continued Runge's superb style of portraiture with the enchanting image of his little daughter, Marie (ill. p. 493, right), which shows the graceful and original infant spirit in harmony with Nature. The child, a key figure of the Romantic era, embodied the dawn of human existence and the development of all living things. Portraits such as these depicted not only external appearances, but also the intellectual and spiritual life of mankind.

Julius Schnorr von Carolsfeld
The Vine of the Archpriest in Olevano
Sepia, pen, 23 x 30.5 cm
Albertinum, Staatliche
Kunstsammlungen, Dresden

OPPOSITE:
Ludwig Richter
*The Fuschlsee with the Schafberg
Mountain in the Salzkammergut*, 1823
Watercolor, pen and brown ink, pencil,
18.3 x 24 cm
Kupferstichkabinett, Staatliche Museen,
Berlin

Ferdinand Olivier
*View of Salzburg and the Hohensalzburg
Fortress from the Mönchsberg*, 1818
Pencil, 32.6 x 40.6 cm
Albertina, Vienna

"Everything tends to landscape" (Runge)
Landscapes: Ideals, Idylls, and Realism

Runge and Friedrich's work clearly showed that the boundaries between genres were becoming eroded in the 19th century, while previously minor genres like the portrait and the landscape were ennobled and invested with greater meaning. Landscapes, too, were characterized by the tension between Nature and Art, and oscillated between the poles of idealizing or realistic depictions of Nature, which were later to reach their peak in the *plein air* painting of Impressionism. The watercolors of the Silesian artist Christoph Nahe (1753–1806) have been described as the "birth of Impressionism." His *Village Street* (ill. p. 494, top) depicts an accurately observed piece of Nature of the sort seen in Dutch landscape art of the 17th century. The evening sun of an autumn day breaks through the clouds after a downpour of rain. A richly contrasting play of light and shade and wind-tossed trees conveys the impression of a constantly changing atmosphere. Delicate watercolors merge and flow beyond the shapes drawn with quick skillful pen strokes, combining them in a dynamic and organic structure to painterly effect. Nathe's lively rendering of the natural phenomena of light and air were well ahead of his time.

The Neoclassical artist Joseph Anton Koch (1768–1824), on the other hand, was not concerned with capturing fleeting moments but in the timeless, ideal character of landscape. His *Hospice on the Grimsel Pass* is a lucidly structured study of the bleak world of a high mountain range – a subject that was the very embodiment of the sublime in the 18th century (ill. p. 494, bottom). The Swiss Alps drew travelers from throughout Europe not least because, due to the influence of Rousseau, it was thought that an alpine environment was conducive to a life of freedom. Koch meticulously drew the sparse vegetation of lichens and mosses, tracing every tiny irregularity in the formation of the ground. The rugged mountains, mirrored in the mountain lake, are accentuated by a subtle use of wash. The peaks of mountains unobscured by atmospheric perspective can be seen behind dark clouds, and this heightens the inhospitable effect of the pass. Man appears insignificant in the context of the work of the Creator; a caravan of muleteers on the left hand side of the picture can scarcely be seen as they near the hospice. Koch did not merely wish to "ape" Nature in a realistic fashion. For him, art meant first selecting what was beautiful and grand before piecing it together in an ideal view. By elevating the horizon and using multiple perspectives, he created a composition which could not be found in Nature. In the Roman *campagna* Koch found a southern counterpart to his sublime images of mountains. His heroic, idealized landscapes exerted a great influence on Romantic artists, but attracted the criticism of Friedrich, who claimed that a picture should not be invented but discovered within oneself. Koch discovered the idyllic village of Olevano in the Sabine mountains, which became a popular place

to stay and study. Here, between the shepherds and their herds, the Arcadia of Antiquity was still preserved *in natura*.

View of Olevano by Franz Horny (1798–1824), who was one of Koch's most gifted pupils, gives an impression of this Arcadia (ill. p. 495). The cuboid buildings of the village rise up in a plastic form, surpassing anything that Koch had achieved. A linear clarity and transparent use of watercolor, which is applied in entire surfaces, create a dynamic relationship with the pictorial space. Independently of the subject, the lucid calligraphic lines assume an independent aesthetic identity – as can be seen in the two tree trunks in the foreground. The signs of the artistic process – which are generally scrupulously eliminated – are evident here: Horny recorded his first ideas in pencil and either left them on the page as they were or drew over them. The incomplete nature of his work was intentional with the consequence that the finished picture – in spite of its sketched form – hovered between artistic vision and authentic representation of Nature. With his abstract and flowing use of line, Horny went beyond the drawing techniques of the Nazarenes.

Julius Schnorr von Carolsfeld (1794–1872), who joined the Brotherhood of St. Luke in 1817, representing the Protestant wing of the movement, was considered the best draughtsman of the group. Like no other artist, Schnorr knew how to exploit the potential of the sepia technique. He drew in pen over pencil before applying wash with a brush. His works are characterized by dark and illuminated sections, dynamic sketching within the contours of objects and gently curving contours balanced by a relaxed use of line as in the *Vine of the Archpriest in Olevano* (ill. p. 496, top). For Ludwig Richter this drawing featured "the most graceful of figures" and signified "all the magic of Romanticism." For Schnorr the Nazarene, however, Nature was but a starting point from which to push forward to an ideal of human existence, and this he found in the simple way of life of the Italian people. He conceived his figures in accordance with the character of the landscape, placing them harmoniously into his compositions.

Some of the greatest of all Nazarene landscape drawings were done by Ferdinand Olivier (1785–1841), a friend and teacher of

LEFT:
Moritz von Schwind
Landscape with Wanderers, c. 1835
Brown pen on yellowish ribbed
handmade paper, 42.8 x 27.1 cm
Graphische Sammlung, Albertina,
Vienna

BOTTOM:
Carl Blechen
Alpine Pass in Winter with Monks, 1833
Watercolor on pencil, paint partly scratched
away with the point of the brush, 23 x 32 cm
Staatliche Graphische Sammlung, Munich

The watercolor *Artists Resting in the Mountains* (ill. p. 12, bottom) by Johann Christoph Erhard (1795–1822) is evidence of the enthusiasm which the Romantic artist brought to the drawings they produced directly from Nature. Flooded with light, the realistic style of this work shows that it is still related to the traditions of the 18th century. Together with two friends, Erhard had undertaken an "artistic walk" in the popular region around the Schneeberg mountain near Wiener-Neustadt. Composed of various layers, the landscape gradually grows lighter towards the horizon, becoming increasingly diffuse due to the use of atmospheric perspective. In contrast to Koch's rough mountain landscapes, Erhard's view appears more inviting and accessible, as the walking figure in the middle ground shows. The artist's back, seen in the foreground, allows the viewer to become involved in the Romantic atmosphere of a delightful summer's day. The intimacy of the artists is heightened by the two beech trees beside them. In addition to depicting a landscape, the image is also a document of a friendship.

Ludwig Richter (1803–1884) also transformed Koch's monumental landscapes into a more human environment and one that aimed at harmoniously securing a unity of Man and Nature. His early watercolor *The Fuschlsee and the Schafberg Mountain in the Salzkammergut* (ill. p. 497) anticipates the Biedermeier idylls which were to color his later works. Richter's figures do not merely stand and gaze at landscapes, but also animate them through their actions. The artist's gestures with the brush – an artistic tool he had made little use of up until that point – and the clearly differentiated colors of the wash applied in a Nazarene style recall the work of Fohr and Horny. Their nature studies

Schnorr. Richter's comments are particularly relevant to Olivier's work: "The pencil could never be too hard nor pointed to capture these outlines in their finest and most exacting detail ... We fell in love with every blade of grass, every delicate branch, and we allowed not a single aspect of beauty to escape our attention." Olivier's views of the region around Salzburg – the so-called "Garden of God" – made the area famous, and are reminiscent of Old German drawings in silver point. These drawings form a series in which landscape and figurative elements also convey religious themes. His *View of Salzburg and the Hohensalzburg Fortress from the Mönchsberg* shows his brother and sister-in-law gripped by Romantic awe in the presence of Nature's wonders (ill. p. 496, bottom). Both figures are wearing the tall "plug hats" typical of pious country folk. Using a sharp pencil that gradually becomes lighter towards the background, Olivier captures everything in the scene with the same artistic intensity and precision, a practice in line with the Nazarenes' requirements of authenticity.

probably also encouraged Richter to rework this pencil sketch in color when he was in Rome, where he perfected the somewhat awkward yet graceful and refreshing style of the figures under the friendly guidance of Schnorr, who ran a composition club there.

While Schnorr and Richter's idyll was still a genuine one – they depicted a rural population not yet alienated from its environment – the landscapes of the Viennese artist Moritz von Schwind (1804–1871) were poetic and fairytale-like creations (ill. p. 498 top). Below a mountain bridge with a view of a distant, hilly landscape a man can be seen sunk in contemplation of a medieval castle; the back of the wanderer with a harp slung over his shoulder also has a nostalgic effect. Two different trees – one young, the other almost dead – represent life and death in the context of Romantic nature symbolism, while the figure of the harpist and the music he implies represent the ongoing process of history. Schwind had the ability to empathize deeply with different styles of drawing in such a way that they flowed confidently and spontaneously from his hand. This drawing, rendered in pen on paper without the aid of pencil, has a wonderfully easy touch. Schwind himself can be seen as a wanderer between various historical eras: his formal language, for example, recalls the masters of the 16th century.

Karl Blechen (1798–1840) countered the comfortable, almost jolly atmosphere of an artist like von Schwind with the deep abyss of Romantic visions. His *Alpine Pass in Winter with Monks* is an impression of the wild region of the Bode valley in the Harz mountains (ill. p. 498, bottom). The pencil sketch was drawn from nature and later worked up into a more complete picture. In the deep snow of a rugged and lonely forest, two monks are at the mercy of the forces of Nature. Behind them the maw of a chasm can be seen while a sense of horror is provided by a memorial which serves as a reminder of death and misfortune. Thin, bare trees, which are abruptly cut off in the upper part of the picture, reinforce the deathly atmosphere in the same

way as they do in Friedrich's winter images or Franz Schubert's *A Winter's Journey*. The landscape reveals an independent life that is threateningly directed against humanity. Blechen achieved a high degree of abstraction in this work with his vehement brush strokes, ornamental structures and calligraphic abbreviations. Although snow is not actually depicted, its presence is suggested by the white background of the paper. As was the case for a number of artists, a trip that Blechen undertook to Italy in 1828–29 marked a turning point in his art, in which he discov-

ered his own style. Impressionist tones resonate in his light-filled watercolors with their flowing surfaces of color and blurred contours. After his return to Berlin, the effects of color and light also dominated his depictions of German forests.

Ernst Fries (1801–1833) also sought a realistic recreation of the phenomenon of light and absorbed the latest developments from painting into his watercolors under the influence of his friend Camille Corot, whom he had met in Rome. His *From the Park of the Villa Chigi in Ariccia* (ill. p. 499, top) with its

500

subtly graded tones in attractive colors shows a sunlit "enchanted forest" (according to Richter). Fries combined precision – in his drawing of the half-ruined staircase and the tree roots – with a rich application of wash which only hinted at detail, and which united the foreground and foliage. There were similar attempts to elevate light itself into a motif, such as those of the Munich school of painting, in which Wilhelm von Kobell (1766–1855) occupied an important position. Over a number of decades he produced variations on the theme of "the encounter," which he had developed around 1800. The watercolor *Gentleman on Horseback and Country Girl on the Banks of the Isar* is one of the best examples of this (ill. p. 499, bottom). Immobile and aloof, peasants and a member of the upper classes face each other in this minutely observed scene. Due to the cool classical composition, however, an impression of Biedermeier Realism is prevented from becoming too obtrusive. Apart from a few pieces of lawn at the sides of the picture, Nature has been eliminated entirely, and the landscape is dominated by the human figures. A bright, even light from the upper left spreads throughout the pictorial space, elevating reality into a scene of festive harmony. The city dweller thus is given an illusion of life in the country that is transfigured by light.

No other Romantic artist was as radical in his depiction of atmospheric phenomena as William Turner (1775–1851), who was responsible for taking the British watercolor tradition of the 18th century into the modern era. His watercolors of Venice, painted during his first journey to Italy, amount to a minor revolution, in which the artist recreated the fleeting impressions of a passing moment with the most sparing of means by using pure, transparent surfaces of color. The colored background was composed of various layers, each applied while the previous one was still wet. Then before drawing began. In his picture *San Giorgio Maggiore at Dawn* (ill. p. 500), San Maggiore sits above the reflecting surface of the water. The scene takes place early in the morning and there is a hazy light which changes shapes, causing buildings to appear flattened and blurring contours. The sea, the city's skyline, and the broad sky merge in subtle gradations of color at the horizon. Venice became Turner's central theme. Although the city did not the have the same importance as Rome, it was especially popular with English tourists: its fleeting beauty and obvious signs of decay touched Romantic souls like Lord Byron, inspiring melancholy observations. Turner's art swung between an idealism and an empirical outlook. Turner too blazed a trail into previously uncharted territory, earning himself a place alongside the great painters of the 19th century.

Romantic artists shattered the sentimental clichés of the 18th century, depicting an original and unmediated feeling for nature instead. It was Nature, rather than the studio, that became the preferred workplace. Nature was seen by the Romantic artist as his greatest teacher even if, by fleeing from the present, he set up an opposing world – a world of culture – which expressed his own hopes and desires for social and religious utopias. In their work, these artists made use of regional and familiar landscapes which, until that time, had not been thought worthy of art. The encounters of the Romantics with Italy were, in many respects, liberating. Italy brought them into contact with both antique and native art, and revealed grandiose, arcadian landscapes. Their common experiences also intensified the bond of camaraderie in the artistic community. The experience of Mediterranean light was central to the development of Realism.

As there were fewer stylistic constraints than in painting, drawing gave artists more latitude to develop, and drawing became the main area of artistic innovation. In addition, large commissions for paintings had become rare, and this contributed to the flourishing of the art of drawing. It was not only the more painterly drawings which were considered the equal of oils by artists and their new middle-class public; the fragmentary genre of the sketch increasingly began to attain the status of an autonomous work of art. From today's point of view, in fact, sketches often represent the more important achievement. The 19th century finally saw the bonds of tradition severed, and the modern artist became dependent solely on his own resources. Art was judged by the criteria of uniqueness and inner necessity, rather than previously acknowledged universal norms. From now on in art there were "as many different types of beauty as there were ways of seeking happiness" (Baudelaire).

Appendix

Glossary

absolutism A system of government where absolute power is in the ruler's hands, as opposed to a constitutional monarchy. In the Age of Enlightenment, enlightened monarchs were sometimes known as "benevolent despots"

acanthus A plant of the thistle family whose leaves feature on Corinthian columns

acropolis The fortified area of a city on a hill, where all the important buildings stood. The most famous is in Athens

acroteria Pedestals for statues at the top and ends of pediments

aedicula Aperture (e.g. door) or niche surrounded by a frame of columns or pilasters supporting an entablature

aisle In a basilica, the side parts parallel to the nave. In a hall church, any of the longitudinal strips between two rows of supports.

aisleless church A church with no aisles to subdivide the space

alcázar (Arab.) A citadel in Spain of Moorish origin, usually an enclosed, four-wing arrangement

alternating supports Alternation of columns and square piers

ambulatory In a church, a continuation of the aisles round the back of the high altar

amphitheater A round or elliptical arena with rising terraces of steps all round as seating

anagogic To do with symbolic or spiritual interpretations, e.g. the explanation of Old Testament events as foreshadowing New Testament events

Ancien Régime The monarchy in France before the Revolution

antæ (Lat.) The pilasters at the end of a temple wall, usu. enclosing a columned porch

anthropomorphic Shaped like a human being

apartments A suite of rooms in a palace

apotheosis Deification or glorification of a person

apotrophaic Warding off evil

appartement double (Fr.) A double suite of rooms in a palace

appliqué A pre-prepared decorative feature that is added to a surface

apse Semi-circular chapel at the east end of a church, or similarly shaped niche in a secular building

arboretum A collection of trees in a park, grown for scientific or study purposes

Arcadia A landscape in the Peloponnese that is considered an idyllic pastoral landscape; a symbolic country of nature and freedom

architecture parlante (Fr.) "Speaking" architecture: architecture whose design indicates its function

architrave The lowest horizontal crosspiece of an entablature, that rests on the capitals

archivolt A curved group of moldings round an arch

articulation The system of building masses and applied features (columns, porticos etc.) used to give a building shape

ashlar Stone dressed on all sides

Atlas A man-shaped supporter of a beam or architrave

atrium In Roman houses, the inner court; in early Christian basilicas, a colonnaded vestibule

attic A wall above the main cornice of a façade. Sometimes hides the lower part of the roof, and can be incorporated into it to form a low extra story

azulejo (Sp./Port.) Colored glazed wall or floor tiles

baldachino A canopy or similar roof-like superstructure over an altar or cult object, sometimes made of brocade, sometimes of marble or stone

baluster A post in a balustrade supporting the handrail or coping

baptistery Detached part of a church (usually a central building) for baptismal functions

barrel vault A continuous round vault with no ribs. Also *tunnel vault*

barrière (Fr.) A toll-house, esp. on the outskirts of Paris

base The molded part of a column or pier between the shaft and the plinth

baseless (A column) not having a base

basilica Originally a Roman market hall or magistrates' hall. In Christian architecture, a nave and aisles with raised clerestory over the nave

bas-relief A virtually two-dimensional relief sculpture

battered Sloped, like the sides of a pylon or a buttress

bay window A ground-floor polygonal or semi-circular window recess projecting from a house. May also include an upper floor. If it is on the upper floor only, it is called an *oriel*.

bay A vertical section along the longitudinal axis (e.g. along the nave of a church) containing a complete section of vaulting

Beidermeier A made-up word formed from Beidermann and Bummelmaier, two Philistine characters invented by Victor von Scheffel. Originally an ironic term, describes the artistic style liked by the lower middle class in Germany in the early 1800s.

belt walk A path round a park providing a continuous view of it from the outside

belvedere A roof room/ turret with a view (cf. *gazebo*)

bisque Twice-fired porcelain

blind façade A façade purely for show that does not relate to the structure of the building behind it

boasted stone Roughly worked stone ready to be finished in situ

boiserie (Fr.) Wainscoting

bond The arrangement of bricks in a wall (e.g. all with the headers or all the stretchers facing outwards, or various alternating combinations). *English bond*, for example, is a row of headers, then a row of stretchers. Rarely used in masonry

bosket A grove or copse in a less formal part of a garden

bow window A shallow bay window whose ground plan is a segmental arc

box A small room open to the auditorium in a theater

bozzetto A rough model

breast A section of solid wall under a window sill

broderie (Fr.) Embroidery, trimming; in French gardens, ornamental borders laid out in colored stones

calotte A hemispherical dome that has no drum, i.e. sits directly on the pendentives

camarin (Sp.) Chapel-like space behind or above the altar in a church

capela mor (Port.) Main chapel (usu. in choir) of a Portuguese church

capital A decorative, usually sculptured feature between the support (column or pier) and the arch or architrave

capriccio A lively composition in art or music

caractère (Fr.) The style of a building that befits its purpose

cartouche A shield-shaped ornament embellished with foliage, acting as a frame for a coat of arms, inscription etc.

caryatid A female figure used as a support instead of a column

castrum doloris (Lat.) Funeral trestle, usu. ornate, on which notable persons lie in state

catafalque Raised structure on which the coffin of an important person is carried

central building A circular building or a polygonal building with arms of equal length, i.e. there is no main longitudinal axis

chiaroscuro (Ital.) The technique of rendering shapes through light and dark in painting

chinoiserie (Fr.) Styles supposedly in imitation of Chinese style, popular in the 18th century

choir screen An ornate screen east of the crossing, separating the lay part of the church from the clerical part

choir The clergy's part of a church, containing the altar. In a basilican church, the part between the crossing and the east end

chthonic Relating to the deities of the underworld or earth

churriguerismo (Sp.) Early 18th-century style associated with the Churriguera family of artists

cinquecento (Ital.) 1500–1599

circus A circular area in a town with buildings round it, often at a junction of major streets, or as a focal point of a planned development

clerestory/clearstory The raised center story of a basilica above the aisle roofs through which light is admitted

cloister garth The courtyard of a monastery, generally surrounded by the cloister walk and domestic buildings

clover leaf church A church with three semi-circular or polygonal apses at the east end

coffering Classical form of ceiling or vaulting decoration, breaking the surface into small (square or lozenge-shaped) recessed panels

columniation The arrangement of columns

communs (Fr.) Subsidiary buildings of a French château housing servants or domestic functions

concetto (Ital.) The content of a work of art

conch Half a dome. May also include the niche beneath it

console table A table permanently placed against a wall, usually beneath a matching mirror

console Bracket projecting from a wall to support something (e.g. an arch)

contrapposto A poise in classical sculpture whereby the figure stands slightly twisted, with the weight on one leg

convenance (Fr.) Seemliness in Classical architecture

corbeil (Fr.) A motif featuring a basket of fruit

cornice The top part of an entablature, usually projecting

corps de logis (Fr.) The principal building of a château

cottage orné (Fr.) Small house in a rural setting, used to house laborers, or as a country retreat

country house A large house or mansion built for a wealthy landowner

county "The county": in the 18th century, the gentry who knew each other in a county

cour d'honneur (Fr.) A courtyard in a château surrounded by the principal wings

crocketed Adorned with crocket leaves (a 13th-century curved, knob-shaped foliate motif)

crossing The area where the nave meets the transept in a church. The end of the lay part of the church. Often the tower was placed over it

cruciform Cross-shaped

dilettante An amateur artist or lover of art

disegno interno/externo (Ital.) The intellectual concept and concrete realization of a work of art

dome percée/carrée (Fr.) A dome with an oculus at the top/ a square-based dome

dormer A window in a pitched roof that has its own separate roof and cheeks. The window is not parallel with the outer wall but set back

drum see *tambour*

eclecticism A mixture of discrete historical styles

egg-and-dart Sculptural molding motif of classical architecture adopted by the Renaissance, containing ovals interspersed with arrowheads

emblem Symbolic design containing 1) the icon; 2) the *lemma* or superscript; 3) the *subscriptio* or subscript

embrasure The wall surfaces inside a splayed window

en face (Fr.) Opposite

enfilade (Fr.) In a baroque château, a succession of rooms with the doors on a single axis

engaged column A column attached to or partly set in a wall. In a statue, an *engaged leg* is the one which bears the weight

English garden An informal, "natural" landscape garden contrasting with a strictly formal, geometric French garden

Enlightenment 18th-century European philosophical movement characterized by reliance on reason and experience rather than dogma and tradition, and by an emphasis on humanitarian political goals and social progress

entablature In classical architecture, the system of horizontal members at the top of an arch, doorway, window or portico, consisting of the architrave, frieze and cornice

entre cour et jardin (Fr.) Between court and garden

entrée solonnelle (Fr.) Ceremonial entrance

exedra Semi-circular apse or extension, often containing seats round the outside

fabrique (Fr.) A small ornamental garden building, e.g. temple, folly

fair-faced (Brickwork) with crafted pointing, to make it more ornate

fan vault Intricate 15th/16th-century English Gothic vault, where the ribs spread out from a single support like a fan

ferme ornée (Fr.) see *cottage orné*

festoon A decorative motif of flowers and fruits suspended in a swag

figura serpentinata (Ital.) A figure sculpture in which the body is in an S-shaped pose. Associated with Mannerism

filled wall Composite wall with rubble or mortar between the outer and inner wall

fluting Parallel concave grooves in a column or pilaster

folly A building built to create a picturesque view, with no practical purpose

fret pattern A variety of Greek key pattern. Also *meander*

gable The endpiece of a roof, or top feature over a wall, window, aedicula, portico etc. It can be triangular, stepped, semi-circular, or a combination of these. A triangular or semi-circular gable in classical architecture is a *pediment*

gallery In a church, a raised story, often for segregated groups, e.g. the royal household or women; in castles, a covered walkway; in great houses, a long room for exercise; derived from this, more recently a building for displaying art

gazebo A belvedere, i.e. a small apartment or turret room in the roof, with a view. Also, a free-standing garden pavilion with a view

Genius Mythological tutelary god or guardian spirit that governs the fortunes and determines the character of individuals or places

genre picture A scene of everyday life

Georgian The style of architecture in Britain from 1714 to the early 19th century (reigns of George I–IV)

giant order (colossal order) Columns or pilasters spanning more than one story

gloriette A garden temple or pavilion functioning as a *point de vue*

Gothic The rococo style of the 18th-century Gothic Revival in Britain

Greek cross A cross with arms of equal length

groin arch Arch intersecting a tunnel vault to produce arrises, e.g. in front of a window

groin vault A vault without ribs, produced by two simple vaults intersecting to produce X-shaped arrises

grotto Artificial rocky cave symbolizing a primeval condition in the connection between nature and art. A popular garden feature since the Renaissance

ha-ha A discreet dry ditch surrounding the pleasure grounds of a house, intended to keep livestock out and provide an uninterrupted view. Introduced into landscape gardens by Charles Bridgeman

half-timbering Wooden skeleton construction system using uprights, beams and struts, infilled with wattle, brick or laths and plaster

hall choir A choir with several aisles of equal height

hall church Church with aisles of equal height, esp. in the Late Gothic period

herm A tapering, square support or pedestal with a carved human head at the top. If it also includes a torso and feet, it is a *term*.

hermitage A small, secluded dwelling, grotto or gazebo serving as a retreat for the owners of a mansion or palace

hexastyle A portico with six columns

Historicism 19th-century re-use of any past style. Historical accuracy was important

history painting The highest category of painting under the academic system, depicting scenes from the Bible, history, mythology or great literature

hôtel (Fr.) The town house of a nobleman

iconography The interpretation of the content of pictures

impost The point from which an arch springs, e.g. the top of a capital.

impresa Motto, often combined with a picture, acting as a coded reference to a person

intercolumniation The spacing between columns

inventio The concept of the content of an image

Jacobethan Another word for *Elizabethan Revival* in English architecture, because it included *Jacobean* and *Restoration* features

keep The strongest building at the heart of a castle, the final resort for refuge and defense. Called *donjon* in French

keystone A wedge-shaped stone completing the top of an arch

lantern A glazed addition to the top of a dome, to let in light and air

Latin cross A cross in which one axis is longer than the other

lesene A plain pilaster with no base, capital or ornament

liberal arts The subjects of instruction at a medieval university: the trivium (grammar, arithmetic and geometry) and quadrivium (music, astronomy, dialectic and rhetoric)

loggia An arcaded or roofed gallery built into or projecting from the side of a building, especially overlooking open court

long gallery A room in a great house, used for exercise, and often containing portraits

lucarne A tall dormer whose window is parallel to the front wall

lunette Semi-circular opening, e.g. window

maison de plaisance (Fr.) Country retreat in delightful surroundings for the seasonal entertainment of the court

Mannerism 16th-century post-Renaissance style that introduced subjective distortions in place of the classical balance of the High Renaissance

mansard roof Named after architect François Mansart (1598–1666), the roof contains two planes, the lower one steeply sloping, the top one shallower

Manueline style Late Gothic/Early Renaissance in early 16th-century Portugal, named after Manuel I of Portugal (1469–1521)

mausoleum Monumental tomb, named after King Mausolus of Halicarnassus (tomb completed 353 BC)

meander Cf. *fret*

metope/ triglyph Triglyphs are the vertical blocks in a Doric frieze, between which are the metope panels

mezzanine A low story between two taller ones

mirror vault A Baroque vault with a rectangular raised ceiling inside the larger rectangular of the walls. The corners of the ceiling curve to the corners of the room

monolith An obelisk or column made of a single piece of stone

monopteron A circular peripteral temple that may have no walls inside

narthex A vestibule in early medieval churches. Later called a *galilee*

naturalism Style of art that aims to represent visual "reality", but without the artistic exaggeration of "realism"

nave The center longitudinal section of a basilica. In a Christian church, the lay part of it from the crossing to the west door

Neoclassicism Styles of art or architecture based on both Greek and Roman precedents

nymphaeum A shrine at a spring, usually containing several floors, columns, niches and a pool

obelisk Upwardly tapered monolith of square section and pyramidal top. Type of monument found in ancient Egypt, and again popular in late 18th/early 19th centuries

octastyle A portico with eight columns

oculus Small round window

ogee arch A pointed Gothic arch made up of two concave and two convex quadrants

opaion (Gk.) A lantern on a dome opening, to allow light in

open roof Roof with no ceiling inside, so the pitched timberwork can be seen.

opisthodomus (Gk.) The space at the back of a temple, matching the porch at the other end

orangery Single story south-facing plant house of the Baroque period

oratory Small private chapel, or private gallery in the choir of a church

order A style of column used in classical architecture. The main orders are Doric (the plainest), Ionic (with corner volutes) and Corinthian (ornate, with acanthus leaves and volutes). Tuscan is a simplified version of Roman Doric

oriel A projecting window recess on an upper storey

orthogonal Relating to the use of right angles

overdoor (sopraporta) Decorative feature (e.g. painting) over an internal door

ox-eye An elliptical window

pagoda Tower-like building of East Asian origin, with roofs constructed on each floor

palazzo (Ital.) A nobleman's town house or important public building

Palladianism Dominant style of English architecture post-1700 that was also influential in other European countries. Based on the work of Andrea Palladio (1508–80)

Pantheon A temple of all the gods. The most famous is the domed Pantheon in Rome, used as a model for countless later buildings

paseo (Sp.) Promenade, tree-lined walk

paso (Sp.) Procession, or portable image of saint carried in procession

pavilion 1) A prominent block of a mansion or palace, usually at the end or in the center; 2) a pleasure building in a garden or park

pediment Triangular or semi-circular gable. The field inside the pediment is the *tympanon*, which may be filled with sculpture.

pendentive A concave spandrel enabling a round dome to sit on a square base.

pergola Path or paved area flanked by columns or timber joists on which climbing plants can grow

peripteral Temple with colonnades all round

peristyle Interior peripteral, i.e. a hall or court surrounded by columns

Perpendicular Late Gothic style in England, from 1330

Pfalz (Ger.) Medieval palace of a prince with no fixed *Residenz*

piano nobile (Ital.) The main floor, usually the first upper floor

picturesque An 18th-century aesthetic theory that defined buildings in terms of landscapes

pilaster A flat equivalent of a column, applied to a wall, with a similar capital and base

place royale (Fr.) A square built in a uniformly grand style (esp. in 17th-cent. France), usually containing a statue of the king.

plaza mayor Spanish equivalent of a *place royale*, usually surrounded by porticoes

pleasance A secluded pleasure garden. Not to be confused with a *plaisance*, which is a summer house or pavilion

pleasure ground area of lawn next to an English country house, often separated from the park by a small lake

plinth see *socle*

point de vue (Fr.) An architectural or sculptural feature or pool in a garden or park that forms the focal point of a view

pointing technique The technique for copying ancient sculptures by using careful measurements and dots

polychrome Of many colors

polygon Many-sided geometrical shape. Includes *hexagon, octagon* etc. A polygonal chapel may be just half a hexagon or octagon.

ponderated Having distributed weight

porch A covered entrance to a door

porte-cochère (Fr.) A porch big enough to accommodate coaches or biers

portico A columned porch in front of a building that is at least as high as the main entablature. There must be a space between the columns and the main building line

presbytery A raised ceremonial area by the altar of a medieval church

projection A section of a grand secular building (e.g. country house) standing forward of the main horizontal building line. A common arrangement is a bold center projection (e.g. a pedimented portico) and two lesser but similar projections at the ends

pronaos The portico and vestibule in front of a temple, enclosed at the side by walls

propylæum A formal gateway to a temple courtyard

proscenium A projecting stage in a theater

prostyle Having a row of columns in front, e.g. a portico

putto (Ital.) plump, young, male angel or cupid

pylon The massive sloped structures flanking the entrance to an Egyptian temple, or anything of this shape

quadriga (Lat.) A sculptural group consisting of a charioteer and team of four horses, often placed on top of a triumphal arch

quadro riportato {Ital.) Framed wall or ceiling painting with no Baroque foreshortening and set in a larger decoration

quatrefoil A symmetrical leaf-pattern with four lobes

quattrocento (Ital.) 1400–1499

querelle des anciens et des modernes (Fr.) Late 17th-century Parisian academic dispute concerning ancient and modern, and the value of *dessin*, contour and color. Exemplified by the contrast between Poussin and Rubens

redoute Public dance hall

reducción (Sp.) Jesuit missionary colony for Indians in Latin America

reductionism Style that reduces the features of classical buildings to simple geometrical shapes

Regency The Georgian style in Britain from 1800–1830

repoussoir (Fr.) Object or figure in the foreground of a picture placed to lead the eye into the pictorial depth

Residenz (Ger.) The principal seat of a ruler, usually in a town called the *Residenzstadt*

ressaut A projecting or forward-standing feature

Restoration (Restauration) Re-establishment of the French monarchy after Napoleon. The term is also used to describe the re-establishment of the British monarchy under Charles II in 1660

retable Pictorial or monumental altarpiece

reticulated vault A vault with a net pattern

retrato a lo divino (Sp.) Picture of a saint with portrait features

return wing A wing at 90 degrees to the main wing

reveal The narrow inside wall each side of a window or arch

Revolutionary architecture Term to describe the unrealized, largely megalomanic architectural designs of Boullée, Ledoux and Lequeu, with a strong tendency towards memorial structures

rib The arched load-bearing support in a medieval vault

ribbon work Delicate ornamental patterns of ribbons [Bandelwerk]

Rococo Late Baroque (c. 1720–70), characterized by a light, delicate playfulness more to do with surface decoration than architecture

Romanticism Style of around 1800 opposed to classicism and strongly inclined to emphasize subjective features, e.g. emotion

rood screen A solid, usually ornate screen separating choir and crossing in English medieval churches

rotunda A central building with a circular ground plan

rubble work Undressed or roughly dressed masonry

rustication Masonry ornamentation, often consisting of boasted stone, used to emphasize the lower part of a building

sacristy A vestry in a church where the priest dresses and liturgical utensils are kept

sail dome A segmental dome supported only at the corners

Salomónica (Sp.) A twisted column. Also called *barley-sugar* column Supposedly derived from the Temple of Solomon in Jerusalem

sanctuary The liturgical area in a choir around the high altar

scagliola A type of hard, colored plaster that when polished looks like marble

Schloss The German equivalent of a château. The house of a ruler. May range from a castle to a smallish pleasure house

serliana cf. *Venetian window*

sfumato an effect of tones shading into one another so there are no sharp outlines

skeleton construction Form of construction where all load-bearing functions are in the skeleton. The infills have no static purpose

socle Base or lower part of a building. Also called *plinth*.

soffit The underside of an arch

spandrel The corner area of a doorway on the shoulders of a curved arch, above the imposts. A similar area in the corner angles beneath a dome

staffage Architectural feature in a garden to enhance the emotional power of a view, e.g. small decorative building

stairwell The area enclosing the staircase. In a large house, often constitutes a separate, semi-detached building or pavilion

steeple The tower and spire of a church

stereometry The measurement of volumes

still life Painting of dead or lifeless objects

strainer arch Horizontal arch between two parallel walls

stucco A hard plaster used to cover brick exteriors

tabernacle Receptacle for the host, or free-standing architectural canopy

tambour A cylindrical or polygonal lower part of a dome. Same as *drum*

tempietto (Ital.) Little temple, often a small garden feature

tenebrism A style of Baroque painting where most of the picture is in shadow and the main subject is dramatically illuminated. Associated with Caravaggio, esp. for everyday "realistic" or unpleasant scenes

terrace A row of houses joined together in a single design

tetrastyle A portico with four columns

thermæ A classical Roman bath complex, e.g. Baths of Caracalla in Rome

thermal window A semi-circular window divided by two mullions

tholos (Gr.) Circular temple

thorn house A building used for producing salt by the graduation method

three-wing house The standard plan of a Baroque château, consisting of a *corps de logis* and two side wings around a *cour d'honneur*

tondo (Ital.) Round painting

toplighting Windows in the roof

tracery Ornate patterns of mullions in a medieval stone window

transept The shorter arm(s) of a church built as a Latin or double cross

transsubstantiation Transformation of bread and wine into the body and blood of Christ during Communion

transverse arch A loadbearing arch at right angles to the main longitudinal axis

travis, travated *Travis* is a bay. *Travated* means divided into bays

Trent, Council of The Catholic council (1545–63) that launched the Counter-Reformation. Adjective: *Tridentine*

triumph A triumphal procession for a Roman general after a victory; also, any artistic representation of it

triumphal arch Monumental arch celebrating a military victory

trompe l'œil (Fr.) Baroque illusionist trick to suggest a three-dimensional object (e.g. a building) in a flat painting. A way of displaying artistic virtuosity

trough vault A Baroque vault with a center crest, curving elliptically down from the crest to all four sides

truss roof A framed timber roof

tumulus Grave mound of the ancient world

turnpike road A road financed and maintained from tolls. The turnpike is a spiked barrier, i.e. the toll bar

tympanon The space inside a pediment. Often filled with sculpture

umbrella dome A dome with a parachute-shaped vault on a round base

urbanistics The study of urban planning

vanitas scene Pictorial type illustrating the vanity of existence

vault The arched internal roof over an interior (e.g. nave of a church)

veduta (Ital.) Topographically correct view of a town or picturesque landscape

Venetian window Tripartite window consisting of a broad round-arched center light flanked by two lower flat-topped narrow lights. Also called *Palladian window* or *serliana*

villa A country house. In the 19th century, the concept grew steadily smaller until it just meant a suburban house

volute Scroll feature on a capital or gable

votive picture Picture or structure donated because of a vow

wall pier church Aisleless church built with internal buttresses with chapels between them

world landscape Perspective painting of an extensive unreal landscape

Wyatt window A rectangular tripartite window like a Venetian window, but with no semicircular arch on the center light, i.e. all three lights are the same height but not the same width

zopf style A south-west German 18th-century style of architecture derived from official French palace architecture. Named for the late 18th-century period, when *Zöpfe* (pigtails) were worn

Zwerchhaus Substantial full-height attic story with a gabled front

Bibliography

The bibliography is subdivided according to the order of the chapters of the book. It contains works used by the authors as reference and also for further reading. Given this arrangement, repetition of some titles may be inevitable.
The bibliography is only a limited selection.

UTE ENGEL
Neoclassical and Romantic Architecture in Britain

Ackerman, James S.: The Villa: Form and Ideology of Country Houses, Princeton 1993
Aldrich, Megan: Gothic Revival, London 1994
Boase, Thomas: English Art 1800–1870, Oxford 1959
Clark, Kenneth: The Gothic Revival: An Essay in the History of Taste, London 1962
Burke, Joseph: English Art 1714–1800, Oxford 1976
Buttlar, Adrian von: Der Landschaftsgarten. Gartenkunst des Klassizismus und der Romantik, Cologne 1989
Colvin, Howard: A Biographical Dictionary of British Architects, 1600–1840, Yale ³1995
Crook, John Mordaunt: The Greek Revival: Neoclassical Attitudes in British Architecture, London ²1995
Cruickshank, Dan: A Guide to the Georgian Buildings of Britain and Ireland, New York 1985
Dobai, Johannes: Die Kunstliteratur des Klassizismus und der Romantik in England, 4 vols., Berne 1974–84
Ford, Boris (ed.): The Cambridge Guide to the Arts in Britain, Vol. 5: The Augustan Age, Vol. 6: Romantics to Early Victorians, Cambridge 1990–91
Girouard, Mark: Life in the English Country House, London/New Haven 1978
Hammerschmidt, Valentin/ Wilke, Joachim: Die Entdeckung der Landschaft. Englische Gärten des 18. Jh., Stuttgart 1990
Hussey, Christopher: English Country Houses: Mid-Georgian 1760–1800, London ²1986
Hussey, Christopher: English Country Houses: Late Georgian 1800–40, London ²1986
Hussey, Christopher: The Picturesque. Studies in a Point of View, London ³1983
Jones, Edgar: Industrial Architecture in Britain, 1750–1939, London 1985
MacCarthy, Michael: The Origins of the Gothic Revival, London/New Haven 1987
Macauly, James: The Gothic Revival 1745–1845, Glasgow/ London 1975
Pevsner, Nikolaus: A History of Building Types, London 1976
Stillman, Damie: English Neoclassical Architecture, 2 vols., London 1988
Summerson, John: Architecture in Britain, 1530–1830, London/New Haven ⁹1993

Summerson, John: Georgian London, London 1991
Worsley, Giles: Classical Architecture in Britain: The Heroic Age, London/New Haven 1995

BARBARA BORNGÄSSER
Neoclassical Architecture in the USA

Sources:

Thomas Jefferson Architect: Original Designs in the Collection of Thomas Jefferson Coolidge Jr, with an essay and notes by Fiske Kimball, Boston, Mass. 1916, reprint 1968
Asher Benjamin: The American Builder's Companion, or, a New System of Architecture: Particularly Adapted to the Present Style of Building in the United States of America, Boston, Mass. 1806, reprint 1967

Literature:

Brown, Milton Wolf: American Art to 1900: Painting, Sculpture, Architecture, New York 1977
Burchard, J. and Bush-Brown, A.: The Architecture of America, A social and cultural history, Boston, Mass. 1961
Condit, Carl: American Building Art, the 19th Century, New York 1960
Hamlin, Talbot: Greek Revival Architecture in America, New York 1944, reprint 1966
Handlin, David P.: American Architecture, London 1985
Kidder-Smith, G. E.: The Architecture of the United States, 3 vols, New York 1981
Kimball, F.: Domestic Architecture of the American Colonies and Early Republic, new impression New York 1950
Kirker, Harold and James: Bulfinch's Boston, 1787–1817, New York 1964
Martin, Jennifer et al.: Die Kunst der USA, Freiburg, Basle, Vienna 1998
Reps, John W.: Monumental Washington; the Planning and Development of the Capital Center, Princeton, N. J., 1967
Whiffen, M. and Koeper, F.: American Architecture, 1607–1976, Cambridge, Mass. 1981

GEORG PETER KARN
Neoclassical and Romantic Architecture in France and Italy

The Age of Neoclassicism. Exhibition catalog, Royal Academy and Victoria & Albert Museum, London 1972
Christian Baur: Neugotik, Munich 1981
Fortunato Bellonzi: Architettura, pittura, scultura dal Neoclassicismo al Liberty, Rome 1978
Allan Braham: The Architecture of the French Enlightenment, London 1980
Johannes Erichsen: Antique und Grec. Studien zur Funktion der Antike in Architektur und Kunsttheorie. PhD thesis, Cologne 1980
Georg Germann: Neugotik. Geschichte ihrer Architekturtheorie, Stuttgart 1974

Henry Russell Hitchcock: Architecture: 19th and 20th Centuries, Harmondsworth 1977
Christian-Adolf Isermeyer: Empire, Munich 1977
Wendt von Kalnein: Architecture in France in the 18th Century, New Haven, London 1995
Emil Kaufmann: Architecture in the Age of Reason. Baroque and Postbaroque in England, Italy and France, Cambridge, Mass. 1955
Hanno-Walter Kruft: Geschichte der Architekturtheorie, Munich 1991
Klaus Lankheit: Revolution und Restauration, Baden-Baden 1980
Anna Maria Matteucci: L'Architettura del Settecento (Storia dell'Arte in Italia), Turin 1988
Carroll L.V. Meeks: Italian Architecture, 1750–1914, New Haven, London 1966
Gianni Mezzanotte: Architettura neoclassica in Lombardia. (Collana di storia dell'architettura, ambiente, urbanistica, arti figurative), Naples 1966
Robin Middleton, David Watkin: Klassizismus und Historismus, Stuttgart 1986
Claude Mignot: Architektur des 19. Jh, Stuttgart 1983
Winfried Nerdinger, Klaus Jan Philipp, Hans-Peter Schwarz: Revolutions–architektur. Ein Aspekt der europäischen Architektur um 1800. Exhibition catalog of the Architekturmuseum, Frankfurt, Munich 1990
Jean-Marie Pérouse de Montclos: De la Renaissance à la Révolution. (Histoire de l'Architecture Française), Paris 1989

BARBARA BORNGÄSSER
Neoclassical and Romantic Architecture in Spain and Portugal

Anacleto, R.: Neoclassicismo e romantismo (Historia da Arte em Portugal, X), Lisbon 1986
Bonet Correa, Antonio: Bibliografía de arquitectura, ingenieria y urbanismo en España (1498–1880), 2 vols. Madrid, Vaduz 1980
Bonet Correa, Antonio: El Urbanismo en España y en Hispanoamérica, Madrid 1991
Bottineau, Yves: L'Art de Cour dans l'Espagne des Lumières (1746–1808), Paris 1986
Camón Aznar, José, Morales y Marín, José Luis, Valdivieso González, Enrique: Arte español del siglo XVIII (Summa Artis XXVII), Madrid 1984
Cruz Valdovinos, José Manuel et al.: Arquitectura barroca de los siglos XVII y XVIII. Arquitectura de los Borbones. Arquitectura Neoclásica (Historia de la Arquitectura Española IV), Zaragoza 1986
França, José Augusto, Morales y Marín, José Luis, Rincón Garcia, Wifredo: Arte Portugués (Summa Artis XXX), Madrid 1986
França, José Augusto: A Arte em Portugal no século XIX, 2 vols., Lisbon

²1981
França, José Augusto: A Arte Portuguesa de Oitocentos, Lisbon 21983
França, José-Augusto: Lisboa Pombalina e o Iluminismo, Viseu 1987
Hänsel, Sylvaine and Karge, Henrik (ed.): Spanische Kunstgeschichte. Eine Einführung, 2 vols., Berlin 1992
Hernando, Javier: Arquitectura en España. 1770–1900, Madrid 1989
Kruft, Hanno Walter: Geschichte der Architekturtheorie von der Antike bis zur Gegenwart. Chap. 18.: Der Beitrag Spaniens vom 16.18. Jh., pp. 245–256, Munich 1985
Kubler, George and Soria, M.: Art and Architecture in Spain and Portugal and their American Dominions 1500–1800, Harmondsworth 1959
Levenson, Jay A. (ed.): The Age of the Baroque in Portugal, Washington 1993
Moleón Gavilanes, Pedro: La Arquitectura de Juan de Villanueva. El Proceso del Proyecto, Madrid 1988
Noehles-Doerk, Gisela: Madrid und Zentralspanien. Kunstdenkmäler und Museen (Reclams Kunstführer Spanien, 1), Stuttgart 1986
Pereira, Paulo (ed.): História da Arte portuguesa, Vol. III, Do Barroco à Contemporaneidade, Barcelona 1995
Pereira, José Fernandes (ed.): Dicionário da arte barroca em Portugal, Lisbon 1989
Reese, Thomas Ford: The architecture of Ventura Rodriguez, New York 1976
Sambricio, Carlos: La Arquitectura española de la Ilustración, Madrid 1986
Triomphe du Baroque. Exhib. cat. Brussels 1991
Varela Gomes, P.: A cultura arquitectonica e artistica em Portugal no século XVIII, Lisbon 1988

EHRENFRIED KLUCKERT
Neoclassical and Romantic Architecture in Holland and Belgium

Architecture du XVIIIe siècle en Belgique: baroque tardif, rococo néo-classicisme, Brussels 1998
Ching, Francis D.K.: Bildlexicon der Architektur, Frankfurt 1996
Centro Internazionale di Studi di Architettura Andrea Palladio: Palladio nel Nord Europa, Vicenza 1999
Schönfeld, Stephan: Zum niederländischen Einfluss auf den Kirchenbau in Brandenburg im 17. und 18. Jh., Berlin 1999

KLAUS JAN PHILIPP
Neoclassical and Romantic Architecture in Germany

Background:
Bolenz, Eckhard: Baubeamte, Baugewerksmeister, freiberufliche Architekten – Technische Berufe im Bauwesen (Preußen/Deutschland 1799–1931), PhD thesis, University of Bielefeld 1988
Germann, Georg: Neugotik. Geschichte ihrer Architekturtheorie, Stuttgart 1974
Lankheit, Klaus: Revolution und Restauration, Baden-Baden 1965
Lorenz, Werner: Konstruktion als Kunstwerk. Bauen mit Eisen in Berlin und Potsdam 1797–1850, Berlin 1995.
Mellinghoff, Tilmann und Watkin, David: Deutscher Klassizismus. Architektur 1740–1840, Stuttgart 1989
Mann, Albrecht: Die Neuromanik. Eine rheinische Komponente im Historismus des 19. Jh., Cologne 1966.
Mignot, Claude: Architektur des 19. Jh., Stuttgart 1983
Milde, Kurt: Neorenaissance in der deutschen Architektur des 19. Jh., Dresden 1981
Mittig, Hans-Erich and Plagemann, Volker: Denkmäler im 19. Jh. Deutung und Kritik, Munich 1972
Pevsner, Nikolaus: A History of Building Types, London 1976
Pevsner, Nikolaus: Die Geschichte der Kunstakademien, Munich 1986
Pfammatter, Ulrich: Die Erfindung des modernen Architekten: Ursprung und Entwicklung seiner wissenschaftlichen Ausbildung, Basle 1997
Philipp, Klaus Jan: Um 1800: Architekturtheorie und Architekturkritik in Deutschland zwischen 1790 und 1810, Stuttgart/London 1997
Plagemann, Volker: Das deutsche Kunstmuseum, Munich 1967

Individual landscapes and places:
Bechtholdt, Frank-Andreas, und Weiss, Thomas: Weltbild Wörlitz. Entwurf einer Kulturlandschaft, Ostfildern-Ruit 1996
Betthausen, Peter: Studien zur deutschen Kunst und Kultur um 1800, Dresden 1981
Biehn, Heinz: Residenzen der Romantik, Munich 1970
Börsch-Supan, Eva: Berliner Baukunst nach Schinkel 1840–1870 (Studien zur Kunst des 19. Jh., Vol. 25), Munich 1977
Deuter, Jörg: Die Genesis des Klassizismus in Nordwestdeutschland, Oldenburg 1997
Dittscheid, Hans-Christoph: Kassel-Wilhelmshöhe und die Krise des Schloßbaus am Ende des Ancien Régime, Worms 1987
Mielke, Friedrich: Potsdamer Baukunst. Das klassische Potsdam, Berlin 1981
Nerdinger, Winfried: Klassizismus in Bayern, Schwaben und Franken (architectural drawings 1775–1825), Munich 1980
Nerdinger, Winfried: Romantik und Restauration. Architektur in Bayern zur Zeit Ludwigs I. 1825–1848,

Munich 1987
Schönemann, Heinz: Karl Friedrich Schinkel: Charlottenhof, Potsdam-Sanssouci (complete works, ed. by Axel Menges, vol. 12), Stuttgart 1997

Architects :
Bussmann, Klaus: Wilhelm Ferdinand Lipper. Ein Beitrag zur Geschichte des Frühklassizismus in Münster, Münster 1972
Clemens Wenzeslaus Coudray: Architektur im Spannungsfeld zwischen Klassizismus und Romantik, Wissenschaftliche Zeitschrift, Bauhaus University Weimar, Vol. 42, No. 2/3, 1996
Doebber, Adolph: Heinrich Gentz. Ein Berliner Baumeister um 1800, Berlin 1916
Dorn, Reinhard: Peter Joseph Krahe. Leben und Werk, 3 vols., Brunswick/Munich 1969, 1971 and 1997
Forssman, Erik: Karl Friedrich Schinkel. Bauwerke und Baugedanken, Munich 1981
Franz, Erich: Pierre Michel d'Ixnard 1723–1795, Weissenhorn 1985
Giesau, Peter: Carl Theodor Ottmer (1800–1843): Braunschweiger Hofbaurat zwischen Klassizismus und Historismus, Munich 1997
Giovanni Salucci 1769–1845: Hofbaumeister König Wilhelms I. von Württemberg 1817–1839. Exhibition catalog, Stuttgart 1995
Hammer-Schenk, Harold, and Kokkeling, Günther : Laves und Hannover. Niedersächsische Architektur im 19. Jh., Hanover 1989
Hannmann, Eckhardt: Carl Ludwig Wimmel. Hamburgs erster Baudirektor, Munich 1975
Hauke, Karlheinz: August Reinking 1776–1819. Leben und Werk des westfälischen Architekten und Offiziers, Münster 1991
Kadatz, Hans-Joachim: Friedrich Wilhelm von Erdmannsdorff. Wegbereiter des deutschen Frühklassizismus in Anhalt-Dessau, Berlin 1986
Karl Friedrich Schinkel: Lebenswerk, ed. by von Paul Ortwin Rave, 1962–1994 by Margarete Kühn, Munich 1939 ff.
Lammert, Marlies: David Gilly. Ein Baumeister des deutschen Klassizismus, Berlin 1964/1981
Laudel, Heidrun: Gottfried Semper. Architektur und Stil, Dresden 1991
Nerdinger, Winfried: Friedrich von Gärtner. Ein Architektenleben 1791–1847, Munich 1992
Nestler, Erhard: Christoph Gottfried Bandhauer. Baumeister des Klassizismus in Anhalt-Köthen, Köthen 1990
Nicolas de Pigage 1723–1796. Architekt des Kurfürsten Carl Theodor. Exhibition catalog, Düsseldorf and Mannheim, 1996
Oncken, Alste: Friedrich Gilly 1772–1800, Berlin 1935/1981
Reidel, Hermann: Emanuel Joseph von Herigoyen. Kg. bayer.

Oberbaukommissar 1746–1817, Munich/Zurich 1982
Schirmer, Wulf (ed.): Heinrich Hübsch 1795–1863. Der grosse badische Baumeister der Romantik, Karlsruhe 1983
Springorum-Kleiner, Ilse: Karl von Fischer 1782–1820, Munich 1982
Valdenaire, Arthur: Friedrich Weinbrenner. Sein Leben und seine Bauten, Karlsruhe 1919/1985

EHRENFRIED KLUCKERT
Neoclassical and Romantic Architecture in Scandinavia

Donelly, Marian C.: Architecture in the Scandinavian Countries, Cambridge/Mass. 1992
Henningsen, Bernd (ed.): Wahlverwandtschaft: Skandinavien und Deutschland 1800 bis 1914, Berlin 1997

PETER PLASSMEYER
Neoclassical and Romantic Architecture in Austria and Hungary

[Exhibition catalogs]
Österreich zur Zeit Kaiser Josephs II. Mitregent Kaiserin Maria Theresias und Landesfürst. Lower Austria exhibition, Melk Abbey, Vienna 1980
Liechtenstein. The Princely Collections. New York (The Metropolitan Museum) 1985
Joseph Wenzel von Liechtenstein. Fürst und Diplomat im Europa des 18. Jh. Vaduz 1990

Literature:
Christian Bauer: Neugotik. Munich 1981
Johann Kräftner: Am Ozean der Stille. In: Parnass 4/1987, pp. 32–43
Ulrich Nefzger: ÆTERNÆ DOMVI. Stil, Wandel und Dauer am Triumphboden zu Waitzen. In: Alte und moderne Kunst 169 (1980), pp. 13–19
Ulrich Nefzger: Die Romidee des Frühklassizismus und die Kathedrale von Waitzen. In: Alte und moderne Kunst 190/191 (1983), pp. 15–22
Gerhard Stenzel: Österreichs Burgen. Vienna 1989
Renate Wagner-Rieger: Wiens Architektur im 19. Jh. Vienna 1970
Renate Wagner-Rieger: Vom Klassizismus bis zur Sezession. In: Geschichte der bildenden Kunst in Wien, Vol. 7,3. Vienna 1973
Gustav Wagner: Joseph Hardtmuth 1758–1816. Architekt und Erfinder. Vienna/Cologne 1990

HILDEGARD RUPEKS-WOLTER
Neoclassical Architecture in Russia

Beljakowa, Z.: The Romanov Legacy. The Palaces of St. Petersburg, London 1994
Brodskij, B. I.: Kunstschätze Moskaus, Leipzig 1986
Brumfield, W. C.: A History of Russian Architecture, Cambridge 1993
Fleischhacker, H. (ed.): Katharina die Große, Memoiren, Frankfurt/ Leipzig 1996
Geschichte der russischen Kunst, Vol. 6, Dresden 1976
Hallmann, G.: Sommerresidenzen russischer Zaren, Leningrad 1986
Hamilton, G.H.: The Art and Architecture of Russia, Baltimore 1975
Hootz, R. (ed.): Kunstdenkmäler in der Sowjetunion. Moskau und Umgebung, Moscow/ Leipzig 1978
Hootz, R. (ed.): Kunstdenkmäler in der Sowjetunion. Leningrad und Umgebung, Moscow/ Leipzig 1982
Katharina die Große, exhibition catalog, Kassel 1997
Keller, H.: Russische Architektur (Propyläen-Kunstgeschichte Vol. 10), Berlin 1971
Kennett, V.A.: Die Paläste von Leningrad, Munich-Lucerne 1984
Kovalenskaya, N.: Istorija russkogo iskusstwo 18. weka (History of 18th-cent. Russian Art), Moscow 1962
Pavlovsk: Le palais et le park. Les Collections, 2 vols., Paris 1993
Pevsner, N., Honour, H., Fleming, J.: Dictionary of Architecture, 4London 1991
Schumann, H. (ed.): Katharina die Große/ Voltaire: Monsieur-Madame, der Briefwechsel zwischen der Zarin und dem Philosophen, Zurich 1991
Shvidkovsky, D.: The Empress & the Architect. Architecture and Gardens at the Court of Catherine the Great, New Haven/ London 1996
St. Petersburg um 1800, exhibition catalog, Essen 1990
Torke, H.-J.: Die russischen Zaren 1547–1917, Munich 1995

EHRENFRIED KLUCKERT
Landscape Gardens

Beenken, Hermann: Das 19. Jh. in der deutschen Kunst, Munich 1944
Hammerschmidt, Valentin and Wilke, Joachim: Die Entdeckung der Landschaft, Englische Gärten des 18. Jh., Stuttgart 1996
Maier-Solgk, Andreas and Greuter, Frank: Landschaftsgärten in Deutschland, Stuttgart 1997
Pückler-Muskau, Prince Hermann of : Andeutungen über Landschaftsgärtnerei verbunden mit der Beschreibung ihrer praktischen Anwendung in Muskau, Stuttgart 1995
Wimmer, Clemens Alexander: Geschichte der Gartentheorie, Darmstadt 1989

UWE GEESE
Neoclassical Sculpture

Exhibition catalogs:
Ethos und Pathos. Die Berliner
Bildhauerschule 1786–1914, 2 vols., ed.
by Bloch, S. Einholz and J. v. Simson,
Berlin 1990
Europa und der Orient. 800–1900. ed.
by. G. Sievernich and H. Budde, Berlin
1989
Künstlerleben in Rom. Bertel
Thorvaldsen (1770–1844). Der dänische
Bildhauer und seine deutschen Freunde.
ed. by G. Bott and H. Spielmann,
Copenhagen/ Nuremberg 1991
Verborgene Schätze der
Skulpturensammlung. M. Raumschüssel.
Staatliche Skulpturensammlung, Dresden
1992

Literature:

Barral i Altet, X. (ed.): Die Geschichte
der Spanischen Kunst, Cologne 1997
Beck, H.: Bildwerke des Klassizismus.
Führer durch die Sammlungen (Guide to
the sculpture collections at the
Liebighaus etc), Frankfurt 1985
**Beck, H., Bol, P. C., Maek-Gerard, E.
(ed.):** Ideal und Wirklichkeit der
bildenden Kunst im späten 18. Jh.
Frankfurter Forschungen zur Kunst, Vol.
II, Berlin 1984
Bloch, P.: Anmerkungen zu Berliner
Skulpturen des 19. Jh. Offprint from
Jahrbuch Preussischer Kulturbesitz
VIII/1970
Bloch, P.: Bildwerke 1780–1910. Aus den
Beständen der Skulpturengalerie und der
Nationalgalerie. Die Bildwerke der
Skulpturengalerie Berlin, Vol. III, Berlin
1990
Burg, H.: Der Bildhauer Franz Anton
Zauner und seine Zeit. Ein Beitrag zur
Geschichte des Klassizismus in
Österreich, Vienna 1915
Dupré, G.: Gedanken und Erinnerungen
eines Florentiner Bildhauers aus dem
Risorgimento, Munich 1990
Essers, V.: Johann Friedrich Drake
1805–1882. Materialien zur Kunst des
19. Jh., Vol. 20, Munich, no date.
Feist, P. et al.: Geschichte der deutschen
Kunst 1760–1848, Leipzig 1986
Geese, U.: Liebighaus – Museum alter
Plastik, Frankfurt. Scholarly catalogs,
Nachantike großplastische Bildwerke
Vol. IV (Italy, Netherlands, Germany,
Austria, Switzerland, France
1540/50–1780), Melsungen 1984
Holst, Chr. v.: Johann Heinrich
Dannecker. Der Bildhauer. Monograph
for Johann Heinrich Dannecker
exhibition, Stuttgart 1987
Hughes, R.: Bilder von Amerika. Die
amerikanische Kunst von den Anfängen
bis zur Gegenwart, Munich 1997
Jäger, H.-W.: Politische Metaphorik im
Jakobinismus und im Vormärz, Stuttgart
1971
Jedicke, G.: Christian Daniel Rauch und
Arolsen. Museumshefte Waldeck-
Frankenberg 15, Arolsen 1994

Keller, H. (ed.): Die Kunst des 18. Jh.
Propyläen Kunstgeschichte. Special
number, Frankfurt am Main, Berlin 1990
Krenzlin, U.: Johann Gottfried Schadow.
Ein Künstlerleben in Berlin, Berlin 1990
Lankheit, K.: Revolution und
Restauration, Baden-Baden 1965
Licht, F.: Antonio Canova, Munich 1983
Mielke, F. and Simson, J. v.: Das Berliner
Denkmal für Friedrich II., den Großen.
Ein Sonderdruck zum Jahreswechsel für
die Freunde der Verlage Propyläen,
Ullstein, Frankfurt, Berlin, Vienna 1975
Museo Correr, Guide Artistiche, Milano
1984
Osten, G. von der: Plastik des 19. Jh. in
Deutschland, Österreich und der
Schweiz. Re-issue, Königstein 1961
Rietschel, E.: Erinnerungen aus meinem
Leben. ed. by A. Löckle, Dresden 1935
Schadow, J. G.: Kunstwerke und
Kunstansichten. Ein Quellenwerk zur
Berliner Kunst- und Kulturgeschichte
1780 1845. Annotated reprint of 1849
edition, ed. by Götz Eckardt. 3 vols.,
Berlin 1987
Skulptur. Die Moderne. 19. und 20. Jh.,
Cologne, Lisbon, London, New York,
Paris, Tokyo 1993
Skulptur. Renaissance bis Rokoko. 15.
bis 18. Jh., Cologne, Lisbon, London,
New York, Paris, Tokyo
Stephan, B.: Skulpturensammlung
Dresden. Klassizistische Bildwerke,
Munich 1993
Tesan, H.: Thorvaldsen und seine
Bildhauerschule in Rom. Cologne,
Weimar, Vienna 1998
Thorvaldsen Museum, Copenhagen.
Museum catalog, Copenhagen 1962
Toman, R. (ed.): Wien. Kunst und
Architektur, Cologne 1999
Whinney, M.: Sculpture in Britain 1530
to 1830. Harmondsworth 1964, 21988
Zeitler, R. (ed.): Die Kunst des 19. Jh.
Propyläen Kunstgeschichte. Special
number, Frankfurt, Berlin 1990

ALEXANDER RAUCH
Neoclassicism and Romanticism:
European Painting between Two
Revolutions

Anderson, Jorgen: De Ar i Rom;
Abildgaard, Sergel, Fuseli, Copenhagen
1989.
Andrews, Keith: The Nazarenes, A
Brotherhood of German Painters in
Rome, Oxford 1964
Angelis, Rita de: L'opera pittorica
completa di Goya, introdotta e
coordinata da Rita de Angelis, Milan
1974
Antal, Frederick: Classicism and
Romanticism, London 1966
Bätschmann, Oskar: Die Entfernung der
Natur. Landschaftsmalerei 1750–1920,
Cologne, 1989
Bazin, Germain: Théodore Géricault,
étude critique, documents et catalogue
raisonné, Vols. 1–5, Paris 1987–1992
Berger, Klaus: Géricault und sein Werk,
Vienna 1952

Bindman, David: Blake as an Artist,
Oxford 1977
idem: The Complete Graphic Work of
William Blake, London 1978
Bisanz, Rudolph M.: German
Romanticism and Philipp Otto Runge,
De Kalb, 1970
**Börsch-Supan, Helmut and Jähning, Karl
Wilhelm:** C.D. Friedrich, Œuvrekatalog
der Gemälde, Druckgraphik und
bildmässigen Zeichnungen, Munich
1973
idem: Caspar David Friedrich, Munich
1974
Brieger, Lothar: Die romantische
Malerei, Eine Einführung in ihr Wesen
und ihre Werke, Berlin 1926
Brookner, Anita: Jacques-Louis David,
London 1980
Brunner, Manfred H.: Antoine-Jean
Gros. Die napoleonischen
Historienbilder, PhD thesis, Bonn 1977,
1979
Burda, Hubert: Die Ruinen in den
Bildern Hubert Roberts, Munich 1967
Burke, Edmund: A Philosophical Enquiry
into the Origin of our Ideas of the
Sublime and Beautiful, London 1757,
London/New-York 1958 (ed. von J.T.
Boulton).
Busch, Werner: Das sentimentalische
Bild; Die Krise der Kunst im 18. Jh. und
die Geburt der Moderne, Munich 1993
Butlin, Martin: William Blake, Tate
Gallery, London 1978
Butler, Martin and Joll, Evelyn: The
Paintings of J.M.W. Turner, New Haven
1977
Buttlar, Adrian von: Der englische
Landsitz 1715–1760. Symbol eines
liberalen Selbstentwurfs, Mittenwald
1982
Büttner, Frank: Peter Cornelius. Fresken
und Freskenprojekte, Vol. I., Wiesbaden
1980
Camesasca, Ettore and Ternois, Daniel:
Tout l'œuvre peint d'Ingres, Paris 1971
Carus, Carl Gustav: Briefe und Aufsätze
über Landschaftsmalerei, ed. by Gertrud
Heider, Leipzig/ Weimar 1982
Coupin, Pierre A.: Œvres posthumes de
Girodet-Trioson, Vols. I–II, Paris 1829
Daguerre de Hureaux: Alain, Delacroix,
Dobai, Johannes: Die Kunstliteratur des
Klassizismus und der Romantik in
England, Vols. 1–4, Berne 1974–1984
Eitner, Lorenz: Géricault, His Life and
His Work, London 1983
Geschichte der deutschen Kunst
1760–1848, Leipzig 1986
Frank, Hilmar and Keisch, Claude:
exhibition catalog by Staatliche Museen,
Berlin: Asmus Jakob Carstens und Joseph
Anton Koch – zwei Zeitgenossen der
Französischen Revolution. Berlin 1990
Frey, Dagobert: Die Bildkomposition bei
Joseph Anton Koch und ihre Beziehung
zur Dichtung, in: Wiener Jahrbuch für
Kunstgeschichte XIV, 1950, pp. 195–224
Friedländer, Walter: Hauptströmungen
der französischen Malerei von David bis
Delacroix, Cologne 1977
Friedrich, Caspar David: Caspar David
Friedrich in Briefen und Bekenntnissen,
ed. by Sigrid Hinz. Munich 21974

Frodl-Schneemann, Marianne: Johann
Peter Krafft, 1780–1856. Monograph
and catalog of the paintings, Vienna/
Munich 1984
Gage, John: Colour in Turner. Poetry and
Truth, London 1969
idem: Turner, Rain, Steam and Speed,
London 1972
Gassier, Pierre, and Wilson, Juliet: Goya,
His Life and Work, London 1971
Geller, Hans: Die Bildnisse der deutschen
Künstler in Rom, 1800–1830, Berlin
1952
Gerstenberg, Kurt, and Rave, Ortwin:
Die Wandgemälde der deutschen
Romantiker im Cassino Massimo zu
Rom, Berlin 1934
idem: Italienische Dichtungen in
Wandgemälden deutscher Romantiker in
Rom, Munich 1961
Goldschmit-Jentner, Rudolf Karl (ed.):
Eine Welt schreibt an Goethe –
Gesammelte Briefe an Goethe,
Heidelberg 1947
Gombrich, Sir Ernst H.: The Dream of
Reason, Symbolism of the French
Revolution, in: The British Journal for
18th Century Studies II, 1979
Gonzales-Palacios, Alvar: David e la
pittura napoleonica, Milan 1967
Grunchec, Philippe: Le Grand Prix de
Peinture, Les concours de Prix de Rome
de 1797 à 1863, École des Beaux-Arts,
Paris 1983
Guiffrey, Jean: L'Œuvre de Pierre Paul
Prud'hon, Paris 1924
Gurlitt, Cornelius: Die deutsche Kunst
seit 1800, ihre Ziele und Taten, Berlin
1924
Hamann, Richard: Die deutsche Malerei,
vom 18. bis zum Beginn des 20. Jh.,
Leipzig/Berlin 1925
Heilborn, Ernst: Zwischen zwei
Revolutionen, Der Geist der Schinkelzeit
1789–1848, Berlin 1927
Herbert, Rober L.: David, Voltaire,
Brutus and the French Revolution,
London/New York 1972
Hofmann, Werner: Das entzweite
Jahrhundert, Kunst zwischen 1750 und
1830, Munich 1995
von Holst, Christian: Joseph Anton
Koch, Ansichten der Natur. Catalog,
Staatsgalerie Stuttgart 1989
Honisch, Dieter: Anton Raphael Mengs
und die Bildform des Frühklassizismus,
Recklinghausen 1965
Jensen, Jens Christian: Malerei der
Romantik in Deutschland, Cologne 1985
**Justi, Karl, Winckelmann und seine
Zeitgenossen,** Leipzig 1898
Kemp, Wolfgang: Das
Revolutionstheater des Jacques-Louis
David. Eine neue Interpretation des
Schwurs im Ballhaus, in: Marburger
Jahrbuch für Kunstwissenschaft XXI,
1986, pp. 165–184
Lankheit, Klaus: Revolution und
Restauration, Kunst der Welt series,
Baden-Baden 1980
idem: Von der napoleonischen Epoche
zum Risorgimento, Studien zur
italienischen Kunst des 19. Jh., Munich
1988

Lavater, Johann Caspar: Physiognomische Fragmente zur Beförderung der Menschenkenntnis und Menschenliebe, Leipzig/Winterthur 1775–78, selected and annotated by Friedrich Märker, Munich 1948
Levitine, George: Girodet-Trioson, An Iconographic Study, Cambridge/Mass. 1952, New York/ London 1978
Licht, Fred: Goya, The Origins of the Modern Temper in Art, New York, 1979
Lindsay, Jack: J.M.W. Turner, His Life and Work, London 1966
Macpherson, James: Fragments of Ancient Poetry, collected in the Highlands of Scotland, Edinburgh 1760, reprinted 1917
Matile, Heinz: Die Farbenlehre Philipp Otto Runges, Berner Schriften zu Kunst XIII, Berne 1973
Moreno de las Heras, Margarita and Luna Juan J. (eds., Comisario de la Exposición): Goya, 250. Aniversario, Prado/Madrid, 1996
Muther, Richard: Ein Jahrhundert französischer Malerei, Berlin 1901
Myers, Bernard: Goya, London 1964
Pascal, Roy: The German Sturm and Drang, Manchester 1959
Praz, Mario: Girodet's Mlle Lange as Danae, in: The Minneapolis Institute of Arts Bulletin LXIII, 1969, pp. 64–68
Prochno, Renate: Joshua Reynolds, Diskurse und Gemälde, PhD thesis, Munich/Weinheim 1990
Richter, Ludwig: Lebenserinnerungen eines deutschen Malers (ed. by Max Lehrs), Berlin, no date (1922).
Sala, Charles: Caspar David Friedrich und der Geist der Romantik, Paris 1993
Sauerländer, Willibald: Davids Marat à son dernier soupir oder Malerei und Terreur, in: Idea, Jahrbuch der Hamburger Kunsthalle II, 1983, pp. 49–88
Scheffler, Karl: Deutsche Maler und Zeichner im 19. Jh., Leipzig 1920
Scheidig, Walter: Goethes Preisaufgaben für bildende Künstler, 1799–1805 – Schriften der Goethe-Gesellsch. LVII, Weimar 1958
Schiff, Gert: Johann Heinrich Füssli, 1741–1825, Vols.1–2, Zurich/Munich 1973
Schnapper, Antoine: David – Témoin de Son Temps, Fribourg (Switzerland) 1980
Schoch, Rainer: Das Herrscherbild in der Malerei des 19. Jh., Munich 1975
Schöne, Albrecht: Goethes Farbentheologie, Munich 1987
Sells, Christopher R.S.: Jean-Baptist Regnault, 1754–1829, Biography and catalogue raisonné, PhD thesis, London 1981
Sommerhage, Claus: Deutsche Romantik, Literatur und Malerei, Cologne 1988
Stevens, Mary Anne (ed.): The Orientalists: Delacroix to Matisse, European Painters in North Africa and the Near East, London 1984
Tischbein, Johannes H.W.: Briefe aus Rom, hauptsächlich Werke jetzt daselbst lebender Künstler betreffend, in: Der teutsche Merkur 1785, pp. 251–267,

LIII, 1786, pp. 69–82, 169–186
Traeger, Jörg: Philipp Otto Runge und sein Werk, Munich 1975
idem: Der Tod des Marat. Revolution des Menschenbildes, Munich 1986
Wildenstein, Georges: Ingres, London 1954, London/ New York 1956
Wilton, Andrew: The Life and Work of J.M.W. Turner, London 1979

Exhibition catalogs
[Place of exhibition given first, the editor(s) in brackets]

Berlin:
Martin-Gropius-Bau, 4. Festival der Weltkulturen Horizonte '89 (Sievernich, Gereon and Budde, Hendrik, eds.): Europa und der Orient, 800–1900, Berlin 1989
Staatliche Museen: (Frank, Hilmar and Keisch, Claude), Asmus Jakob Carstens und Joseph Anton Koch – zwei Zeitgenossen der Französischen Revolution. Berlin 1990
Staatliche Museen, Nationalgalerie: (Schuster, Peter-Klaus), Carl Blechen zwischen Romantik und Realismus., Berlin 1990
Cologne:
Wallraf-Richartz-Museum, (Mai, Ekkehard / Cymmek, Götz): Heroismus und Idylle. Formen der Landschaft um 1800. Cologne 1984
Düsseldorf:
Kunstmuseum, (Baumgärtel, Bettina, ed.): Angelika Kauffmann – Retrospektive, Düsseldorf/Ostfildern-Ruit 1999
Frankfurt:
Städtische Galerie im Städelschen Kunstinstitut (Dorra, Henri / Eich, Paul / Gallwitz, Klaus): Die Nazarener, Frankfurt 1977
Hamburg:
Hamburger Kunsthalle
(Toussaint, Helene / Hohl, Hanna): Ossian und die Kunst um 1800, Hamburg 1974
(Grohn, Hans-Werner / Holsten, Siegmar): Caspar David Friedrich, Hamburg 1974
(Schiff, Gert): Johann Heinrich Füssli, Hamburg 1975
(Bindmann, David): William Blake, Hamburg 1975
(Wilton Andrew / Holsten, Siegmar): William Turner und die Landschaft seiner Zeit, Hamburg 1976
(Hohl, Hanna / Schuster, Peter-Klaus): Runge in seiner Zeit, Hamburg 1977/78
(Hofmann, Werner / Hohl, Hanna): Goya. Das Zeitalter der Revolutionen, 1789–1830, Hamburg, 1981
Karlsruhe:
Kunsthalle, Moritz von Schwind, Meister der Spätromantik, Karlsruhe, 1996
Lausanne:
Musée cantonal des Beaux-Arts (Berger, René, ed./Koella, Rudolf) Charles Gleyre ou les illusions perdues, Lausanne 1974/75
Leipzig
Kunsthalle Bremen, Museum der Bildenden Künste, exhibition catalog,

Julius Schnorr von Carolsfeld, 1994
Madrid:
Museo del Prado (Villar, Mercedes Agueda): Antonio Rafael Mengs, 1728–1779, Madrid 1980
Munich:
Haus der Kunst (Gage, John): Zwei Jahrhunderte englische Malerei, Munich 1980
Haus der Kunst (Wichmann, Siegfried): Spitzweg, Munich 1985/86
Haus der Kunst (Wichmann, Siegfried): Gedächtnis-Ausstellung zum 200. Geburtstag des Malers Wilhelm von Kobell 1766–1853. Munich/Mannheim 1966
Bayerische Akademie der Schönen Künste, im Königsbau der Münchner Residenz (Hederer, Oswald / Lieb, Norbert / Hufnagl, Florian): Leo von Klenze als Maler und Zeichner, Munich 1977/78
Schack-Galerie (Heilmann, Christoph), Ein Führer durch die Sammlung deutscher Maler der Spätromantik. Munich 1983
Paris:
Le Grand Palais (Rosenberg, Pierre): De David à Delacroix. La peinture française de 1774 à 1830, Paris 1975
École des Beaux-Arts (Grunchec, Philippe): Les Concours de prix de Rome, 1797–1863. Paris 1986
Le Grand Palais: La Révolution française et l'Europe, 1789–1799. Paris, 1989
Le Grand Palais: (Laveissiäre, Sylvain / Michel, Régis): Géricault, Paris 1992
Stuttgart:
Staatsgalerie (von Holst, Christian): Joseph Anton Koch, Ansichten der Natur, Stuttgart 1989

ANGELA RESEMANN
Neoclassical and Romantic Drawings

Background:
Bernhard, B. (ed.): Deutsche Romantik: Handzeichnungen. 2 vols., 2nd revised edition, Munich 1974
Bott, G. / Schoch, R.: Meister der Zeichnung. Drawings and water colors from the Graphische Sammlung of the Germanisches Nationalmuseum, Nuremberg 1992
Christoffel, U.: Die romantische Zeichnung von Runge bis Schwind, Munich 1920
Dörries, B.: Zeichnungen der Frühromantik, Munich 1960
Gallwitz, K. (ed.): Die Nazarener in Rom. Ein deutscher Künstlerbund der Romantik, Rom 1981
Gauss, U.: Die Zeichnungen und Aquarelle des 19. Jh. in der Graphischen Sammlung Stuttgart, catalog, Stuttgart 1976
Heise, C. G.: Grosse Zeichner des XIX. Jh., Berlin 1959
Hofmann, W.: Das Irdische Paradies. Motive und Ideen des 19. Jh., 2nd newly illustrated edn., Munich 1974
Jensen, J. C.: Aquarelle und Zeichnungen der deutschen Romantik, Cologne 1978

Koschatzky, W.: Die Kunst der Zeichnung. Technik, Geschichte, Meisterwerke, Munich 81996
Müller-Thamm, P.: Nazarenische Zeichenkunst (19th cent. drawings and water colors in the Kunsthalle, Mannheim, Vol. 4, ed. by Manfred Fath), Berlin 1993
Rosenblum, R.: The International Style of 1800. A Study in Linear Abstraction, New York/ London 1976

Individual artists:

Andersson, U./ Frese, A. (ed.): Carl Philipp Fohr und seine Künstlerfreunde in Rom, zum 200. Geburtstag des Heidelberger Künstlers, Kurpfälzisches Museum, Heidelberg 1995
Asmus Jakob Carstens: Goethes Erwerbungen für Weimar. Catalog of art collections in Weimar, ed. by R. Barth; Part II: Zeichnungen aus Goethes Besitz. Stiftung Weimarer Klassik, ed. by M. Oppel. Schleswig-Holsteinisches Landesmuseum, Schloß Gottorf, Schleswig 1992
Badt, K.: Eugène Delacroix. Werke und Ideale. Three essays, Cologne 1965
Becker, C. / Hattendorff, C.: Johann Heinrich Füssli. Das verlorene Paradies. Staatsgalerie Stuttgart 1997–98
Bindman, D.: William Blake. His Art and Times. Yale Center for British Art, New Haven, Art Gallery of Ontario 1982–83
Blühm, A. / Gerkens, G. (ed.): Johann Friedrich Overbeck 1789–1869. Zur 200. Wiederkehr seines Geburtstages, Museum für Kunst und Kulturgeschichte Lübeck, Behnhaus 1989
Börsch-Supan, H. / Jähnig, K. W.: Caspar David Friedrich, Munich 1973
Brown, D. B. / Schröder, K. A. (ed.): J M W Turner, Munich-New-York 1997
Butlin, M.: The Paintings and Drawings of William Blake, 2 vols., New Haven/ London 1981
Gassier, P.: Francisco Goya. Die Skizzenbücher, Fribourg 1973
Goldschmidt, E. / Adriani, G. (ed.): Ingres et Delacroix, Aquarelles et dessins, Kunsthalle Tübingen und Palais des Beaux-Arts, Brussels 1986
Grunchec, P. (ed.): Géricault, Accademia di Francia a Roma, Villa Medici 1979–80
Irwin, D.: John Flaxman 1755–1826. Sculptor, Illustrator, Designer, London 1979
Hofmann, W. (ed.): John Flaxman, Mythologie und Industrie, Hamburger Kunsthalle 1979
Hohl, H., Mildenberger, H. and Sieveking, H.: Franz Theobald Horny. Ein Romantiker im Lichte Italiens, Kunstsammlungen zu Weimar, Kunsthalle, Hamburg 1998–99
Holst, C. von (ed.): J. A. Koch – Ansichten der Natur, Staatsgalerie, Stuttgart 1989
Jacques-Louis David 1748–1825. Musée du Louvre, Paris, Musée national de château, Versailles, Paris 1989

Laveissière, S. (ed.): Prud'hon ou le rêve de bonheur. Galeries nationales du Grand Palais, Paris and Metropolitan Museum of Art, New York 1997–98

Märker, P.: Selig sind, die nicht sehen und doch glauben. Zur nazarenischen Landschaftsauffassung Ferdinand Oliviers, in: Städel-Jahrbuch 1979, pp. 187–206

Moritz von Schwind, Meister der Spätromantik, Kunsthalle/ Karlsruhe and Museum der bildenden Künste/ Leipzig, 1996–97

Naef, H.: Die Bildniszeichnung von J. A. D. Ingres, 5 vols., Berne 1977

Neidhardt, H. J. (ed.): Ludwig Richter und sein Kreis, Ausstellung zum 100. Todestag im Albertinum zu Dresden (centenary exhibition), Kupferstich-Kabinett, Dresden 1984

Philipp Otto Runge im Umkreis der deutschen und europäischen Romantik. 2nd Greifswald Conference on Romanticism, Lauterbach/ Putbus 1977 (Wissenschaftliche Zeitschrift, Ernst-Moritz-Arndt University of Greifswald, Gesellschafts- und Sprachwissenschaftliche series 28, 1–2, 1979), Greifswald 1979

Riemann, G. (ed.): Karl Friedrich Schinkel 1781–1841, Staatliche Museen zu Berlin, 1980–81

Riemann, G., Czok, C. and Riemann-Reyher, U.: Ahnung & Gegenwart. Drawings and water colors of German Romanticism in the Kupferstichkabinett, Berlin.Berlin 1994–95

Scheffler, G. / Hardtwig, B.: Von Dillis bis Piloty. German and Austrian water colors, drawings and oil sketches 1790–1850 owned by the Staatliche Graphische Sammlung 1979–80, Munich 1979

Schiff, G.: Johann Heinrich Fuseli 1741–1825. 2 vols, Zurich/ Munich 1973

Schoch, R. (ed.): Johann Christoph Erhard (1795–1822): Der Zeichner, Germanisches Nationalmuseum, Nuremberg 1996

Schuster, P.-K. (ed.): Carl Blechen. Zwischen Romantik und Realismus, Nationalgalerie Berlin, Berlin 1990.

Sonnabend, M.: Peter Cornelius. Zeichnungen zu Goethes Faust aus der Graphischen Sammlung, Städtische Galerie im Städel, Frankfurt 1991

Stuffmann, M.(ed.): Eugène Delacroix. Themen und Variationen. Arbeiten auf Papier, Städtische Galerie im Städelschen Kunstinstitut, Frankfurt 1987

Traeger, J.: Philipp Otto Runge und sein Werk. Monograph and critical catalog, Munich 1975

Vogel, G.-H. (ed.): Julius Schnorr von Carolsfeld und die Kunst der Romantik. Contributions to 7th Greifswald Conference in Schneeberg, Greifswald 1996

Wichmann, S.: Wilhelm von Kobell. Monograph and critical catalog of works, Munich 1970

Index of Personal Names

Index of Place Names

Picture credits

The publishers thank the museums, photo libraries and photographers for supplying pictorial matter and granting permission for reproduction. Up to the time of publication, the editor and publisher have made intensive efforts to locate all other owners of picture rights.

l = left; r = right; m = middle; a = above b = below

Any persons or organizations who have not been approached, and who claim rights to illustrations used, should contact the publisher.

Besides the museums and institutions mentioned in the captions, mention should be made of the following:

Alinari, Florence: 108 b, 112 bl, 112 br, 115 bl, 118 b, 312

Architect of the Capitol, Washington D.C.: 315

Archiv für Kunst und Geschichte, Berlin / Foto: 324 b, 331 b, 340, 341 ar, 364 a, 364 b, 365 l, 384 r, 421 b, 434 a, 434 b, 449 al, 449 bl, 468 a, 472 br; Erich Lessing: 323 a

Archiv für Kunstgeschichte, Munich: 415 a, 465 bl, 465 br

Archives Photographiques de la Comédie Française: 254 l

Archivio Iconografico, S.A./CORBIS: 65

Artothek, Weilheim / Foto: 322, 330 ar, 363 b, 374, 433 a, 435, 444, 445, 446/447, 448 b, 449 r, 456, 462 b, 470, 473, 500; Bayer & Mitko: 421 a, 474 a, 479; Joachim Blauel: 319, 413, 424/425, 426, 427, 428, 429 b, 430, 431, 432, 437, 443 a, 455 b, 459, 463 l, 466, 471, 498 b; Blauel / Gnamm: 33 a, 336, 429 a, 462 a, 469, 472 a, 478; Hans Hinz: 355, 356, 395 a, 439; Joseph S. Martin: 345 b, 352, 353, 357 a, 357 b, 358/59, 361 r; Photobusiness: 477; Christoph Sandig: 440/441, 465 a; Alfred Schiller: 474 b; von der Mülbe: 460; G. Westermann: 349 a, 442 b, Peter Willi: 362/363, 376 l

Artur, Cologne / Oliver Heissner: 177

Bassler, Markus, Dosquers (Girona): 125, 126 l, 126 r, 127 a, 127 b, 128, 129 a, 129 b, 130, 131, 132 a, 132 b, 133, 134 a, 134 b, 135 a, 135 b, 136 l, 136 r, 137 a, 137 b, 138 b, 139 a, 140 a, 140 b, 141 l, 141 r, 142 al, 142 bl, 142 br, 143 a, 143 b, 144, 145, 146 al, 146 ar, 146 b, 147, 262, 311 b

Bayerisches Nationalmuseum, Munich: 251 r

Bayerische Verwaltung der Staatlichen Schlösser, Gärten und Seen, Munich: 461 b, 463 r

Bednorz, Achim, Cologne: 63, 66 b, 67, 70, 70 b, 71 a, 73 a, 73 b, 74/75, 76, 77 a, 77 bl, 78 a, 78 b, 81 ar, 81 br, 82 al, 82 ar, 87, 88/89, 90, 91, 92, 93, 94, 95, 96 a, 96 b, 97, 98 l, 98 r, 99 l, 99 r, 100, 160, 162, 164 l,164 r, 166, 167 a, 167 b, 168 a, 168 bl, 168 br, 175 ar, 175 cr, 175 bl, 176 al, 176 cl, 176 br, 178, 179, 180 a, 180 b, 181 a, 181 b, 182 al, 182 bl, 182 r, 183, 184, 185 br, l86 a, 186 b, 187, 188, 189, 190, 192 bl, 192 br, 246 a, 246 b, 247, 248/249, 252 r, 278, 279, 282, 283, 291 a, 291 b, 295, 299, 300, 301, 304, 316, 317

Belluco, Antonio, Padua: 116 a

Bibliothèque Nationale, Paris: 7, 71 bc, 81 bl, 84 a, 84 c, 84 b, 85, 86 a, 86 b, 105 a, 105 b, 387 b

Bildarchiv Foto Marburg: 442, 448 a

Bildarchiv Preußischer Kulturbesitz, Berlin / Foto: 154 b, 280, 281, 284; Jörg P. Anders: 173 bl, 193, 327, 379, 433 b, 438 l, 438 r, 442 a, 443 b, 454 b, 457,

468 b, 472 br, 486 b, 493 l, 493 r, 494 a, 495, 497, 499; Klaus Göken: 277 l, 289, 458 a; Reinhard Saczewski: 154 a, 173 cl, 326; Ruth Schacht: 290; Elke Walford, Hamburg: 13, 325 a, 383, 389, 450, 451, 452, 461 a

Bollen, Markus, Bergisch Gladbach: 106 a, 106 br, 107, 109, 110 a, 110 b, 111, 112 a, 113, 114, 115 a, 115 c, 116 b, 117, 118 a, 119 a, 119 b, 120, 121 a,121 b, 122, 123 l, 123 r

The Bridgeman Art Library, London: 332 r, 334 ar, 341 b, 343, 365 ar, 365 br; Lauros-Giraudon: 71 bl, 77 br, 79 a, 368

The British Museum, London: 332 bl

A. Burkatovski Fine Art Images, Rheinböllen: 216 l, 216 r, 217 ar, 217 bl, 218 a, 219 a, 219 u, 220, 221 a, 221 c, 222 a, 222 b, 223, 224 l, 224 r, 225 a, 225 b, 226, 227, 228, 229 al, 229 ar, 229 b, 255

Bunz, Achim, Munich: 169

Civica Raccolta delle Stampe Achille Bertarelli, Milan / Foto Saporetti: 108 a

Caisse Nationale des Monuments Historique et des Sites, Paris / Foto: Pascal Lemaitre: 377 u; Caroline Rose: 68

Copenhagen City Museum: 196 bl, 196 br

Courtauld Institute of Art, Potographic Survey / Sir Brinsley Ford, London: 332 al

Crown Copyright NMR, Swindon (UK): 21 o

The Detroit Institute of Art; Founders Society Purchase with funds from Mr. and Mrs. Bert L. Smokler and Mr. and Mrs. Lawrence A. Fleischmann, 1983: 337 b, 338; Founders Society Purchase, Benson and Edith Ford Fund and Henry II Fund, 1977: 417

Divisão Documentação Fotográfica, Instituto Português de Museus, Lisbon / Foto: Francisco Matias: 139 b; Carlos Monteiro: 138 a

Dulwich Picture Gallery: 42

École Nationale Supérieure des Beaux-Arts, Paris: 406/407, 482 r

English Heritage Photo Library: 334 al

Fitzwilliam Museum, Cambridge: 308 r

Fotoflash, Venice: 264

Fotostudio Rapuzzi, Brescia: 416 b, 418

Klaus Frahm: 155, 158, 165 a, 165 b, 172 b, 185 a, 185 bl, 191, 242 a, 242 b, 243

Frimand, Jens-Jørgen, Copenhagen: 196 al, 196 ac

Germanisches Nationalmuseum, Nürnberg: 236 b

Gottfried Keller-Stiftung, Depositär Kunsthaus Zurich: 341 al

Graf von Schönborn/Kunstsammlungen Schloß Weißenstein: 288

Graphische Sammlung Albertina, Vienna: 496 b, 498 r

Henkelmann, Jürgen, Berlin: 276, 286

Historisches Museum der Stadt Vienna: 467

Iwarsson, Mattias, Uppsala: 194 b

Kreuzberg Museum, Berlin / Foto: Knud Petersen: 287

Kunsthalle Bremen: 12 b

Kunsthaus Zurich: 11 b, 341 al, 489

Kunsthistorisches Institut, Florence: 415 b

Kunstsammlungen Weimar / Foto: Dreßler: 484

The Library of Virginia, Richmond: 314

LOOK, Munich / Foto: Hauke Dressler: 197 b; Max Galli: 197 a; Christian Heeb: 56, 58 bl, 59 b, 60 a; Karl Johaentges: 58 a, 58 br

Magyar Képek, Hungarian Pictures, Budapest: 200 a, 200 b, 201; Attila Mudrák: 202

The Metropolitan Museum of Art; Purchase Rogers Fund and Anonymous Gift, 1944 (44.21ab): 258, 259; Gift of Samuel P. Avery, Jr., 1904 (04.29.2): 351

Ministero per i Beni e le Attività Culturali, Milano / Foto: Antonio Guerra: 268 b

The Minneapolis Institute of Arts: 361 l, 387 a

Monheim, Florian; von Götz, Roman / Bildarchiv Monheim.de: 15, 17, 18 a,18 b, 19, 20 a, 20 bl, 20 br, 21 b, 22, 23 a, 23 b, 24 b, 25 l, 25 r, 26, 27 a, 27 b, 28 a, 28 b, 29, 30, 31, 32 a, 32 bl, 32 br, 33, 34 l, 34 r, 35, 36 a, 36 b, 37 a, 37 b, 38, 39, 40, 41 al, 41 ar, 41 b, 47, 48 a, 48 b, 49 a, 49 b, 50, 53 a, 53 b, 54 a, 54 bl, 54 br, 55, 148 a, 148 br, 149 al, 149 ar, 149 bl, 149 br, 150 al, 150 ac, 150 cr, 150 br, 151 al, 151 ar, 151 b, 158 b, 159, 161, 163, 231 a, 232 a, 232 b, 234/235, 236 a, 237, 238/239, 240 al, 240 br, 241 a, 241 b, 244, 245 ar, 245 b, 305, 306, 307, 308 a, 309

Musée d'Angers: 396 b

Musée des Beaux-Arts et de la Dentelle, Alençon: 397

Musée des Beaux-Arts, Dijon: 360

Musée des Beaux-Arts, Rouen / Foto: Didier Tragin / Catherine Lancien: 490

Musée des Beaux-Arts, Valence: 481

Musée Cantonal des Beaux-Arts, Lausanne / Foto: J.C. Ducret: 402 a, 402 b

Musée Fabre, Montpellier: 256

Museum der Bildenden Künste, Leipzig / Foto: Maertens: 386

Museum of the Fine Arts, Boston; Bequest of Forsyth Wickes, Forsyth Wickes Collection: 483 r; Gift by Subscription: 486 a

National Galleries of Scotland, Edinburgh: 337 a

The National Gallery Picture Library, London: 233

National Museum, Copenhagen: 196 ar

National Portrait Gallery, London: 261

National Trust Photographic Library, London / Foto: Andreas von Einsiedel: 43, 304 b

Niedersächsisches Landesmuseum, Hannover: 420

Österreichische Galerie Belvedere, Vienna: 294, 298, 455 a, 475, 476

Oronoz, Archivo Fotográfico, Madrid: 354, 488 b

Petit Palais, Musée des Beaux-Arts de la Ville de Paris / Foto: 405 b; Pierrain: 482 x

Photo Scala, Florence: 106 c, 270, 313, 390

The Pierpont Morgan Library / Art Resource, New York: 344

Privatbesitz Norddeutschland: 423

Redwood Library and Athenaeum, Newport, R.I. / Foto: Thomas Palmer: 57 a

Réunion des Musées Nationaux, Paris / Foto: 360, 373 a, 377 a, 378 a, 378 b, 385, 388, 392/393, 396, 398, 400/401, 411 b, 414 b; Arnaudet: 366 a, 411 a; Arnaudet / Jean: 375; Arnaudet / J. Schor: 391; Michèle Bellot: 492 l; Gérard Blot: 64 a, 230, 380 b, 382, 394, 409 a, 410, 491; G. Blot / C. Jean: 370/371, 372, 384; G. Blot / J. Schor: 366 b, 367; C. Jean: 268 al, 395 b; Hervé Lewandowski: 328/329, 369, 381, 405 a, 407 b, 408, 409 b, 488 a; R. G. Ojeda: 257, 302, 303, 373 b, Peter Willi: 380 a

Rheinisches Bildarchiv, Cologne: 464, 485

The Royal Academies of Arts, London: 483 l

The Royal Collection, Her Majesty Queen Elisabeth II, Windsor: 331 a

The Royal Pavilions, Libraries and Museums, Brighton: 520 a, 520 b

Sir John Soane's Museum, by courtesy of the Trustees, London / Foto: 44, 45 a, 45 b, 46 b, 323 b; Martin Charles: 46 al, 46 ar

Staatliche Kunsthalle Kaarlsruhe: 499 a

Staatliche Kunstsammlungen Dresden: 252 l

Staatliches Puschkin-Museum für Bildende Künste, Moskau: 416 a

Staatsgalerie Stuttgart: 2, 11

Städelsches Kunstinstitut, Frankfurt / Foto: Jochen Beyer: 10

Städtische Galerie – Liebieghaus, Frankfurt / Foto: Ursula Edelmann: 253 l, 293 l, 293 r, 487

Stockholm Nationalmuseum / Foto: 195; Erik Cornelius: 263, 310

Sveriges Teatermuseum, Stockholm: 191 al, 191 ar

The Tate Gallery, London: 320, 321, 324 a, 333 b, 335, 339, 342, 345 a, 346, 347, 348 a, 458 b

Thomas Jefferson Memorial Foundation, inc. / Foto: Lautmann, R. Monticello: 57 b

Thorvaldsen Museum, Copenhagen / Foto: Ole Woldbye: 272, 274, 275

The Toledo Museum of Art, Toledo, Ohio; Purchased with funds from the Florence Scott Libbey Bequest in Memory of her Father, Maurice A. Scott: 350

Trustees of his Grace the Duke of Northumberland: 38, 334 b

Tandem Verlag GmbH, Königswinter / Foto: Achim Bednorz: 66 a, 69, 72, 79 b, 80, 83 a, 83 b, 148 cl, 208; Gerald Zugmann: 199 a, 199 b, 203 ar, 203 cr, 204/05, 206 al, 206 b, 207, 209 b, 265 ar, 266, 269, 296, 297

Ullstein Bilderdienst, Berlin: 277 r

Wallace Collection, by permission of the Trustees, London: 399

Wruba, Ernst, Sulzbach a. Taunus: 24 a

Victoria & Albert Picture Library, London: 9, 260, 265 b, 348 b, 349 b

Zugmann, Gerald, Vienna: 209 a, 210, 211 ar, 211 cr, 211 bl, 212 a, 212 b, 213 a, 213 b

Supplement to the picture credits, illustrations from the museums of Boston, Detroit and New York:

pp. 258 and 259:
Clodion, balloon monument
Metropolitan Museum of Art; purchase by Rogers Fund and anonymous gift, 1944
Photo: © 1990 The Metropolitan Museum of Art, New York

p. 337 below and p. 338:
Fuseli, Portrait of a Lady and The Nightmare
Detroit Institute of Art/Founders Society Purchase with funds from Mr and Mrs Bert L Smokler and Mr. and Mrs. Lawrence A. Fleischmann
Photo: © 1983 The Detroit Institute of Art, Detroit

p. 351:
Cole, The Giant's Cup
Metropolitan Museum of Art, New York, Gift of Samuel P. Avery, Jr., 1904
Photo: © 1992 The Metropolitan Museum of Art, New York

S. 417:
Palagi, The Marriage of Amor and Psyche
Detroit Institute of Art/Founders Society Purchase, Benson and Edith Ford Fund and Henry Ford II Fund
Photo: © 1977 The Detroit Institute of Art, Detroit

p 483 right and p. 486 top:
Gift by subscription
Courtesy of the Museum of Fine Arts, Boston